Les XX and the Belgian Avant-Garde: Prints, Drawings, and Books ca. 1890

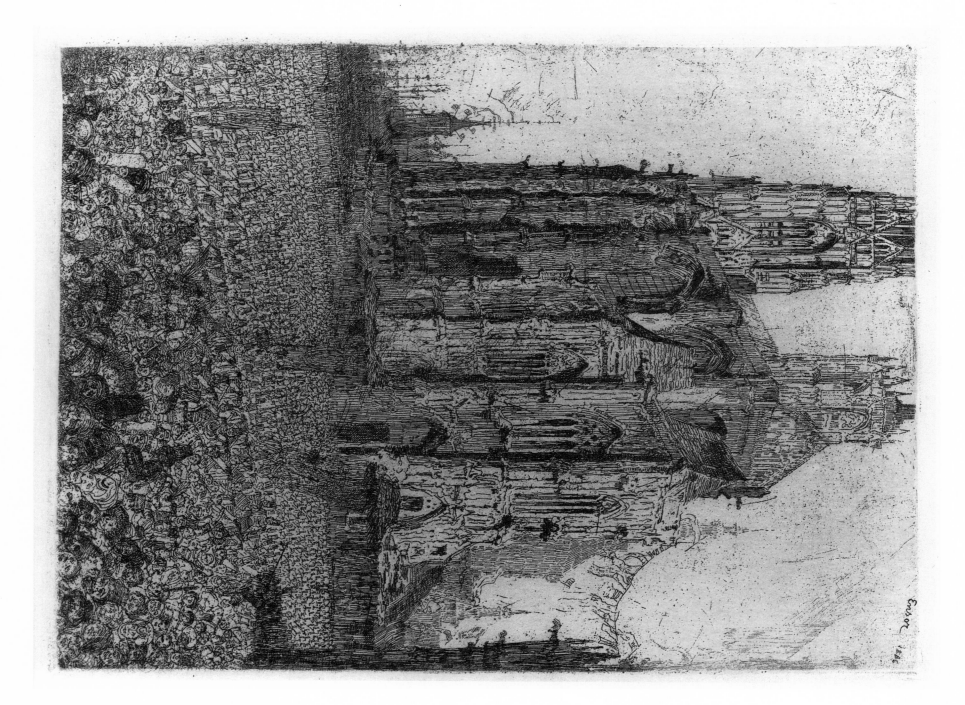

Les XX AND THE BELGIAN AVANT-GARDE

Prints, Drawings, and Books ca. 1890

Edited by Stephen H. Goddard

Essays by Jane Block, Susan M. Canning,
Donald Friedman, Stephen H. Goddard,
Sura Levine, Alexander Murphy
and Carl Strikwerda

SPENCER
MUSEUM
OF ART
The University of Kansas

Les XX and the Belgian Avant-Garde: Prints, Drawings, and Books ca. 1890

Edited by Stephen H. Goddard

Essays by Jane Block, Susan M. Canning, Donald Friedman,
Stephen H. Goddard, Sura Levine, Alexander Murphy and Carl Strikwerda

Spencer Museum of Art
The University of Kansas

Designer: Susan Alice Hyde
Managing Editor: Sally Hayden
Photographer: Jon Blumb

Publications Department, Spencer Museum of Art, Lawrence KS 66045

First Edition published 1992.
Printed in the United States of America
10 9 8 7 6 5 4 3 2 1

LIBRARY OF CONGRESS CATALOGING-IN-PUBLICATION DATA

Les XX and the Belgian avant-garde: prints drawings and books ca. 1890/edited by Stephen H. Goddard; essays by Jane Block . . . [et al.].—1st ed.
400 pp. cm.
Exhibition catalog.
Includes bibliographical references and index.
ISBN 0-913689-35-1 (soft cover)
1. XX (Artistic group)—Exhibitions. 2. Avant-garde (Aesthetics)—Belgium—History—19th century—Exhibitions. 3. Arts, Belgian—Exhibitions. 1. Goddard, Stephen H. II. Block, Jane. III. XX (Artistic group). IV. Helen Foresman Spencer Museum of Art.
NX550.A1A13 1992
700'.9493'074781965—dc20
 92-64475
 CIP

EXHIBITION ITINERARY

Exhibition organized by Stephen H. Goddard. Support for the catalogue and exhibition was provided by grants from the National Endowment for the Arts and the National Endowment for the Humanities, federal agencies.

October 31–December 12, 1992
Museum voor Schone Kunsten, Ghent, Belgium

January 24–March 21, 1993
Spencer Museum of Art, University of Kansas, Lawrence, Kansas

April 12–June 13, 1993
Sterling and Francine Clark Art Institute, Williamstown, Massachusetts

July 13–September 5, 1993
Cleveland Museum of Art, Cleveland, Ohio

Contents

5

Foreword

In January 1988, before coming to Kansas, I asked Steve Goddard what exhibition he was planning after the show of engravings by the German Little Masters that was to open the following fall. He told me he was researching the graphic work of Les XX* and explained to me something of who they were and what they did. I had never heard of Les XX, knew of only a few of the artists (James Ensor and Jan Toorop, for example), and wondered if the project was possible. Was there enough available work, could we find financing, would other museums want the exhibition?

Of course, I very quickly discovered that there are many American specialists on Les XX and its contexts, including the contributors to this catalogue, and that an exhibition of Les XX would bring to the public a significant body of fascinating and often beautiful art by a group of distinctive artists.

As a result of the extraordinary dedication, effort and enthusiasm of Professor Goddard and the members of his team of colleagues and students, *Les XX and the Belgian Avant-Garde: Prints, Drawings, and Books ca. 1890* is a reality. This exhibition introduces a large number of scholars, students, and non-professional museum viewers, and me, to the world of late nineteenth-century Belgium through the art of this important progressive group. It reaffirms that the avant-garde arose independently in many European capitals, not just in Paris. It is also an exhibition that puts James Ensor, the best known artist associated with Les XX, into clearer artistic context.

The Cleveland Museum of Art and the Clark Art Institute enthusiastically committed to show the exhibition after its opening at the Spencer Museum of Art. Both the National Endowment for the Arts and the National Endowment for the Humanities have

generously supported its organization. In addition, the Museum of Fine Arts in Ghent exhibited the European loans before they came to the United States and produced the catalogue in Flemish.

The multidisciplinary range of the exhibition is evident in this catalogue, written by scholars approaching the subject from varied points of view. The exhibition provided students with an opportunity to learn about Les XX and work on the exhibition in a seminar taught by Professor Goddard in the fall of 1990. Some of the seminar students continued their work and wrote catalogue entries in directed reading courses and as interns in the department of prints and drawings. While the exhibition is on view, Professor Goddard will teach a course on the cities of Brussels and Antwerp, using the exhibition to provide original material for study.

When the exhibition was proposed in 1988, the Spencer Museum collection had very little work by the artists associated with Les XX, only a few prints by James Ensor. Over the last few years we have acquired additional work by Ensor, as well as prints and drawings by Frantz Charlet, Henry de Groux, Alfred William Finch, Fernand Khnopff, Xavier Mellery, Constantin Meunier, Félicien Rops, Jan Toorop, Théo van Rysselberghe, and Henry van de Velde. All of these are included in the exhibition; they also provide a core of works associated with Les XX for students at the University to study in the future. The exhibition has helped us enrich our permanent collection and enlighten our students to this important society of progressive 19th-century artists.

Andrea S. Norris, Director
Spencer Museum of Art

* Les XX stands for 'les vingt,' French for 'the twenty,' and is pronounced 'lei vaⁿ.'

Preface and acknowledgments

A period of intense artistic creativity occurred in late nineteenth-century Belgium that is epitomized by the activity of a group of artists who called themselves *Les Vingt* (The Twenty) or Les XX. The most challenging Belgian artists were members of this Brussels-based organization, including James Ensor, Alfred William Finch, Fernand Khnopff, Georges Lemmen, George Minne, Félicien Rops, Henry van de Velde and Théo Van Rysselberghe. The artists of Les XX were closely aligned with progressive trends in Belgian literature and politics, and at the same time displayed artistic qualities distinct from contemporary trends in the rest of Europe.

All of the leading members of Les XX were active in printmaking or book design. Their prints, drawings, and books represent some of the most progressive and experimental creations of their time, both as art objects and as manifestations of social and political ideas. Because prints, posters and book illustrations were considerably cheaper and more portable than other art forms, they were accessible to a much larger audience than painting or sculpture and thus served a more effective social function than the other mediums. This catalogue and the accompanying exhibition focus on this graphic production by the Les XX members, to underscore that the art of Les XX was integrated into the contemporary cultural and political life of Belgium.

Work on this exhibition and catalogue began in earnest in 1990 with a National Endowment for the Humanities planning grant. This grant allowed the authors of the essays in this catalogue to meet and to consult with the curator on the themes, parameters, and key works for the exhibition. To evoke the full spectrum of the concerns of Les XX, flexible parameters were essential. For instance, though Les XX was

actually only active for the ten years the members held public exhibitions (1884–1893), anticipatory and retrospective works that bracket these years have been included.

The focus of this exhibition is the work of the members of Les XX, rather than that by the over 100 other artists who were invited to exhibit with them. However, some of the latter are included, as are works by several contemporaries of Les XX who were not members of the group or *invités*, but who are germane to understanding graphic arts in fin-de-siècle Belgium: William Degouve de Nuncques, Jean Delville, Max Elskamp, Amedée Lynen, François Maréchal, Gustave Marissiaux, Xavier Mellery, Constantin Meunier, Armand Rassenfosse, Jules van Biesbroeck, and Alfred van Neste. Finally, although Les XX was a Belgian phenomenon, their exhibitions had an international roster and their membership included several non-Belgian artists. Jan Toorop, (The Netherlands), Paul Signac (France), Darío de Regoyos (Spain), and others have been included, either because they resided in Belgium or because they were in close contact with their Belgian colleagues.

The themes of the essays in this catalogue were selected to give a historical, social and artistic context to the exhibited works of art. Alexander Murphy (Geography, University of Oregon) and Carl Strikwerda (History, University of Kansas) combined their expertise in cultural geography and political history in an introduction to the key cultural and political currents that are essential to an understanding of events in nineteenth-century Belgium. Susan Canning (Art History, College of New Rochelle) summarizes the mechanics of Les XX and its annual exhibitions, at the same time challenging some of the assumptions about their progressiveness. Sura Levine (Art

History, Hampshire College) examines the artist's involvement with social issues and socialism. Stephen Goddard (Art History and Spencer Museum of Art, University of Kansas) gives an overview of printmaking in nineteenth-century Belgium, locating Les XX's printmakers within the larger context of the graphic arts. Jane Block (Ricker Library of Architecture and Art, University of Illinois at Urbana-Champaign) describes the contributions of the Les XX artists to the art of the book. And finally, Donald Friedman (Modern Languages, Winthrop College) explicates the connection between the Les XX members and their literary colleagues, particularly the symbolist poets.

The catalogue entries summarize key thematic issues raised by the works of art. These were written by a team that includes the essayists, colleagues, and graduate students at the University of Kansas. The exhibition installation at the Spencer Museum of Art, University of Kansas, organized the works thematically, in the following sequence:

"The Politics of Contemporary Life"
 Defining Les XX and the avant-garde
 Satire and irony
 Industry and work
 Social concern, welfare, and the call to Socialism
"Landscape and the Sense of Place"
 Mood evoked by the landscape
 Sense of place evoked by tradition
 The intimate world: portraits and interiors
"Art and the Production of Culture"
 The decorative arts, design, and advertising
 Book arts
 Idealism and perversity

For convenience, the catalogue entries are arranged alphabetically by artist, and each artist's works are arranged chronologically except for closely related works that are discussed together, regardless of date.

THIS exhibition is drawn from forty-five collections and the catalogue is a collaborative effort by a team of authors. Neither the exhibition nor the catalogue would have been possible without the sponsorship of the National Endowment for the Humanities, which provided both a planning grant and a generous implementation grant. The National Endowment for the Arts also provided a major grant toward the publication of this catalogue. As exhibition organizer, I was able to spend valuable research time in Belgium through the generosity of the Franklin Murphy Travel Fund at the University of Kansas. Jane Block's research and travel was supported by the University of Illinois Campus Research Board. Sura Levine received travel support from Hampshire College.

I was fortunate to work closely with colleagues at each of the lending institutions. I thank Roger Rennenberg and Leen van Dijck at the Archief en Museum voor het Vlaamse Cultuurleven, Antwerp; Micheline Colin and André Godart at the Archives de l'art contemporain, Brussels; Suzanne McCullagh at the Art Institute of Chicago, at the Bibliothèque Royale Albert 1er, Brussels, Nicole Walch in the Cabinet des Estampes and Georges Colin and Elly Cockx at the Réserve Précieuse; David Brooke, Rafael Fernandez and Steven Kern at the Sterling and Francine Clark Art Institute, Williamstown, Massachusetts; Jane Glaubinger at the Cleveland Museum of Art; George Goldner and Lee Hendrix at The J. Paul Getty Museum; Marjorie Cohn at The Harvard University Art Museums; Charles Hack and Christine Grenning at the Hearn Family Trust; Nicole d'Huart and Bruno Fornari at the Musée d'Ixelles; Françoise Clercx Leonard-Etienne at the Cabinet des Estampes de la Ville de Liège; Tim Benson, Victor Carlson and Bruce Davis at the Los Angeles County Museum of Art; Suzanne Boorsch and Colta Ives at The Metropolitan Museum of Art; Richard Campbell at the Minneapolis Institute of Arts; Baron Serge Le Bailly de Tilleghem at the Musée des Beaux-Arts de Tournai; Guy Donnay at the Musée Royale de Mariemont; Pierre Baudson, Anne-Adriaens-Pannier and Veronique Cardon at the Musées royaux des Beaux-Arts de Belgique; Clifford Ackley and Barbara Shapiro at the Museum of Fine Arts, Boston; Robert Hoozee and Moniek Nagels at the Museum voor Schone Kunsten, Ghent; Riva Castleman, John Elderfield and Magdalene Dabrowski at the Museum of Modern Art, New York; J. Lambrechts-Douillez and Hans Nieuwdorp at the Museum Vleeshuis, Antwerp; Andrew Robison and Gregory Jecmen at the National Gallery of Art, Washington; Roberta Waddell and Robert Rainwater at the New York Public Library; Innis Shoemaker at the Philadelphia Museum of Art; Francine de Nave at the Plantin-Moretus Museum and the Stedelijk Prentenkabinet, Antwerp; Dale Roylance at the Graphic Arts Collection, Princeton University Library; Robert Johnson, Karin Breuer and Judith Eurich at the Fine Arts Museums of San Francisco, Achenbach Foundation for the Graphic Arts; Alexandra Mason and James Helyar at the Spencer Research Library; and Phillip Dennis Cate and Trudy Hansen at the Jane Voorhees Zimmerli Art Museum, Rutgers. I also thank the many private

collectors for their hospitality and their willingness to share their collections.

The staff members at the institutions where the exhibition toured were enthusiastic and patient: Robert Hoozee and Moniek Nagels at the Museum voor Schone Kunsten in Ghent, where the European loans were shown with substitutions for the works in U.S. collections; David Brooke and Rafael Fernandez at the Sterling and Francine Clark Art Institute; and Evan H. Turner and Jane Glaubinger at the Cleveland Museum of Art.

I am grateful to Andrea Murphy at the Belgian Embassy in Washington and Henk Mahieu at the Department of External Affairs in Brussels for their interest in this project and for smoothing out several of its wrinkles.

All who worked on the project are indebted to many colleagues who have shared their knowledge freely or whose friendship has been essential to the success of this work: Paul Aron, Arsène Bonafous-Murat, Susan Craig, Frans De Haes, Robert Flagothier, Barry Friedman, Fabrice van de Kerckhove, Ger Luijten, Andrew Parker, Rodolphe Rapetti, Eugène Rouir, Pascal de Sadeleer, Robert Siebelhoff, Brent Sverdloff, Sabine Taevernier, Gabriel Weisberg, G.W.C. Van Wezel. I would also like to thank my family, Diane, Emily and Erica Goddard, for their patience with me while I was away on research trips.

At the Spencer Museum of Art thanks must go first to the graduate student assistants in the Max Kade-Erich H. Markel Department of Graphic Arts who helped out in numerous ways over the past four years: Patricia Fidler, Sharyn Brooks Katzman, Midori Oka, and Bill North. These four colleagues all worked long hours on tasks ranging from research to airport runs. The success of the exhibition is in no small part

their success. Special thanks also go to Carmen Doering, graduate assistant in the Education Department, for her thoughtful work on the gallery guides and label copy. From the museum staff we thank Andrea Norris and Doug Tilghman for patience and for help with grant writing; Pat Villeneuve for overseeing educational programs; Janet Dreiling for a multitude of registrarial responsibilities; Carolyn Chinn Lewis for general trouble-shooting; Mark Roeyer and Dan Coester for the exhibition design and installation; Jon Blumb for superb photographic work; Lori Eklund for arranging programming; Kathleen McVay for stocking the bookstore with Belgicana; Barbara Becker and Gina Witt for wrestling with European invoices; Keith Barnhart for overseeing security; and Judy Wright and the Friends of the Art Museum. Sally Hayden, managing editor at the Spencer Museum of Art, Susan Hyde, graphic designer, and Monika Fischer, editorial assistant, worked tirelessly to make this catalogue a success. Heartfelt thanks to the entire team.

Those of us who were lucky enough to pursue our research in Europe are deeply indebted to our Belgian friends and hosts. Their hospitality and insights have been an essential ingredient in this exhibition: André and Nicky Bollen, Roger and Brigitte Cardon, Lode de Clercq and Nadine Tasseel, Luc and Adrienne Fontainas, Robert and Hedwig Hoozee, Roger Marijnissen, M.C. and Ada Oleff, Milt Papatheofanis, Marc Quaghebeur, Maurice Tzwern, Paul Willems, and a friend who has encouraged many American students and scholars in Belgium, Madame Paul van der Perre.

Stephen H. Goddard
Curator of Prints and Drawings
Spencer Museum of Art

Lenders

Albert Alhadeff

Anonymous Lenders

Archief en Museum voor het Vlaamse Cultuurleven,
 Antwerp

Archives de l'art contemporain en Belgique, Brussels

The Art Institute of Chicago

Bibliothèque Royale Albert 1er, Cabinet des Estampes
 and Réserve Précieuse, Brussels

Sterling and Francine Clark Art Institute,
 Williamstown, Massachusetts

The Cleveland Museum of Art

Collection of Adrienne and Luc Fontainas

The J. Paul Getty Museum, Malibu, California

The Harvard University Art Museums, Cambridge

The Hearn Family Trust

Musée d'Ixelles

Josefowitz Collection

Cabinet des Estampes de la Ville de Liège

Los Angeles County Museum of Art

The Metropolitan Museum of Art, New York

Minneapolis Institute of Arts

Musée des Beaux-Arts de Tournai

Musée Constantin Meunier, Brussels

Musée Royale de Mariemont, Morlanwelz

Musées royaux des Beaux-Arts de Belgique, Brussels

Museum of Fine Arts, Boston

Museum voor Schone Kunsten, Ghent

Museum of Modern Art, New York

Museum Vleeshuis, Antwerp

National Gallery of Art, Washington

The New York Public Library

Philadelphia Museum of Art

Plantin-Moretus Museum, Antwerp

Graphic Arts Collection, Princeton University Library

The Fine Arts Museums of San Francisco, Achenbach
 Foundation for the Graphic Arts

Dr. Richard A. Simms

Spencer Museum of Art, University of Kansas

Spencer Research Library, University of Kansas

Stedelijk Prentenkabinet, Antwerp

John and Ann Talleur

Willis Collection

Jane Voorhees Zimmerli Art Museum, Rutgers,
 The State University of New Jersey

Contributors

JANE BLOCK is the director of the Ricker Library of Architecture and Art at the University of Illinois at Urbana-Champaign. She is the author of *Les XX and Belgian Avant-Gardism 1868-1894* (University of Michigan, 1984).

SUSAN M. CANNING is associate professor of art history at the College of New Rochelle, New York. The Antwerp Museum of Fine Arts, Belgium, published her book *Henry van de Velde: Paintings and Drawings* in 1988.

Associate Professor DONALD FRIEDMAN teaches modern languages at Winthrop College, Rock Hill, South Carolina. His most recent publication is *An Anthology of Belgian Symbolist Poets.*

STEPHEN H. GODDARD is curator of prints and drawings at the Spencer Museum of Art and associate professor of art history at the University of Kansas. His last exhibition and catalogue were "The World in Miniature: Engravings by the German Little Masters, 1500–1550," 1988.

SURA LEVINE is assistant professor of art history, Hampshire College, Amherst, Massachusetts, specializing in late 19th-century Belgian sculpture. She is writing a dissertation on Constantin Meunier and working toward a doctorate at the University of Chicago.

ALEXANDER MURPHY is associate professor of geography at the University of Oregon, Eugene. In 1988 he published a study of Belgian regional language differences.

CARL STRIKWERDA is associate professor of history at the University of Kansas. He has published numerous articles on Belgian social history in *Comparative Studies in Society and History* and other journals.

Abbreviations

AM—*L'Art moderne/Modern Art*

AAC—Archives de l'art contemporain en Belgique, Brussels/Archives of Belgian Contemporary Art

AMVC —Archief en Museum voor het Vlaamse Cultuurleven/Archive and Museum of Flemish Cultural Life

BB—*Bibliographie de Belgique*

BMRBA—*Bulletin des Musées royaux des Beaux-Arts de Belgique*

BN—*Biographie Nationale*

Getty Center—Getty Center for the History of Art and the Humanities, Special Collections

IEV/CAE—Institut Emile Vandervelde, Fonds Cercle d'art et d'enseignement de la Maison du Peuple de Bruxelles

JBA—*Journal des Beaux Arts et de la Littérature*

MRBA—Musées royaux des Beaux-Arts de Belgique

POB—Parti Ouvrier Belge/Belgian Workers' Party

RGB—*La Revue Graphique Belge*

RUB—*Revue de l'Université de Bruxelles*

TN—*Les Temps nouveaux/New Times*

Authors of catalogue entries

A.A. —Albert Alhadeff
J.B. —Jane Block
S.C. —Susan M. Canning
D.F. —Donald Friedman
S.G. —Stephen H. Goddard
R.H. —Robert Hickerson
S.K. —Sharyn Brooks Katzman
S.L. —Sura Levine
B.N. —Bill North
K.P. —Kirsten H. Powell
M.S. —Maggie Stenz
C.S. —Carl Strikwerda
A.W. —Alfred Willis

Glossary of printing terms

Aquatint—An etching technique that creates different tones. Powdered resin is sprinkled on the etching plate prior to the plate's being bitten by the etching acid. The result is finely-textured tonal areas whose darkness is determined by how long the acid is in contact with the plate.

Cliché—In French, a photographic negative. However, the term is also loosely used to designate a variety of photomechanical printing processes.

Drypoint—A printing method similar to etching, except that the lines are manually scratched into the plate, without the use of acid. The hallmark of a drypoint print is a soft and often thick or bushy line, somewhat like that of an ink pen on moist paper.

Engraving—An intaglio technique; lines are carved into the plate with a burin, a chisel-like tool.

Etching—A printing technique in which lines are incised into a metal plate with acid for printing in the intaglio method. The plate is covered with an acid-resistant ground through which the artist scratches a design with a stylus or needle, revealing the bare metal. The plate is then immersed in an acid bath that cuts the drawn lines into the plate.

Foul biting—The marks etched into a plate due to flaws in the acid-resistant ground. Although usually accidental, foul biting can be caused intentionally to create random marks on the plate.

Gillotage—A relief process made by transferring a lithographic image to a metal plate that is then etched to produce a relief plate. The term is also used inaccurately to refer to varieties of photomechanical relief printing.

Heliogravure—An early form of photogravure.

Intaglio—Any of the techniques in which an image or tonal area is printed from lines or textures scratched, etched, or engraved into a metal plate: including aquatint, drypoint, engraving, etching, soft-ground. The plate is covered with ink, then the surface is wiped clean, leaving ink in the incised lines or textures that create the image. This plate is then printed in a press on moistened paper. The paper is forced down into the inked areas of the plate and the image is transferred to the paper.

Letterpress—Relief printing done by applying paper to a raised metal, inked surface, often blocks of movable type.

Lithograph—A print produced by lithography, in which the image is drawn on a flat slab of limestone (or a specially treated metal plate). The stone is chemically treated so that when ink is rolled onto the stone it adheres only to the drawn image. This inked image is then transferred to paper in a high-pressure press.

Photogravure—Printing a photographic image by the intaglio process. The photographic negative (which may be of an artist's drawing) is projected onto a sensitized gelatin emulsion or carbon

tissue that is transferred to a copper plate. After the plate is washed, areas corresponding to the image on the negative are dissolved and the plate can be bitten by acid as in etching. In hand photogravure, the most common method used to create the works of art in this catalogue, the copper plate has been prepared for aquatint etching. The end result can closely resemble a traditional linear etching or soft-ground etching.

Photomechanical relief print—By the 1880s there were many ways to transfer a black line drawing to a relief printing block by photographic means. These methods are generally known as line blocks and the images printed from them typically share many of the qualities of woodcut. The methods vary in complexity and can involve etching photosensitized plates or electrotyping light-sensitive gelatin plates.

Photomechanical reproduction—This term is used for a variety of processes that result in the transfer of a photographic image to a printing matrix, such as an etching plate, relief block, or a lithographic stone. The term is used in this text whenever it could not be ascertained what photomechanical process was used.

Platino-gravure—Trade name for a form of photogravure used sometimes by Alexandre, who worked with Fernand Khnopff. The exact technique is not known, but it may have involved a hybrid photogravure process that was intended to resemble a platinum print.

Relief print—Any print with an image that is printed from the raised portions of a carved, etched, or cast block; a simple example would be a rubber stamp. The most common relief prints are woodcuts. The term is used in this text when it is not known which kind of relief printing was used (photomechanical or hand carved, for example).

Silver print—A photographic print on paper impregnated with silver nitrate. Distinct from platinum print, for example.

Soft-ground—An etching technique that involves covering the plate with a malleable ground through which a variety of textures can be pressed, and thus etched into the plate. For example, paper laid on top of a soft-grounded plate can be drawn on with a pencil and the resulting etched image will resemble a pencil line drawn on paper. Distinguished from "hard ground," which is used for simple line etching.

Sulphur ground—In this etching technique a caustic sulphur compound is painted directly onto an etching plate or sulphur dust is applied to the plate. The resulting marks will hold ink and can be printed like an etching. The method can be compared to printing the rust marks on a steel or iron plate.

Wood engraving—A relief print carved into the end grain of a block of wood that is the same thickness as the height of a piece of movable type ("type high"). This was traditionally a commercial technique practiced by specialists and used in magazine and book illustration.

Woodcut—A relief print made from the image carved into a piece of wood, usually on the plank grain.

Zincograph—A lithograph done on a zinc plate instead of on stone. The term is inaccurately and infrequently used to designate a photo-etched relief print.

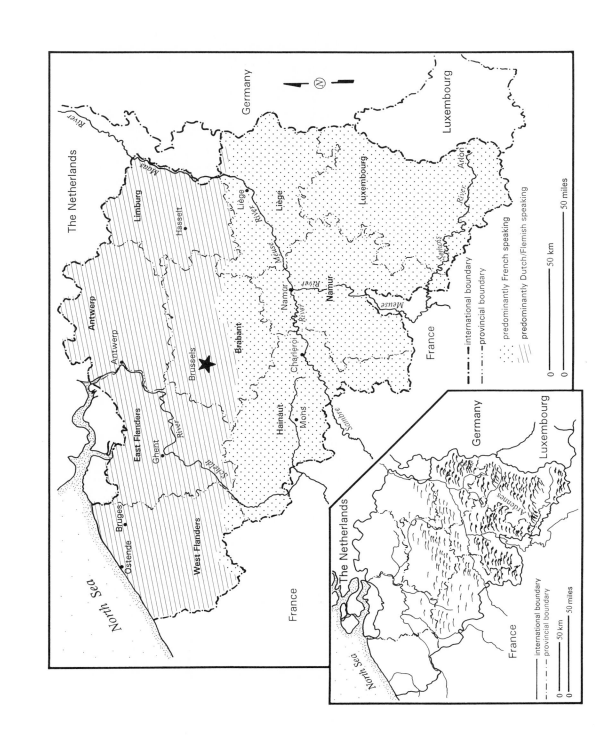

The Netherlands

Germany

Luxembourg

Maas River

Limburg

Antwerp

Antwerp

Hasselt

Liège

Liège

Liège River

Luxembourg

Arlon

Meuse River

Brussels

Brabant

Namur

Namur River

Namur

Semois River

East Flanders

Ghent

Scheldt River

Charleroi River

Hainaut

Mons

Meuse

France

Bruges

Ostende

West Flanders

Scheldt

Sambre River

North Sea

France

international boundary
provincial boundary
predominantly French speaking
predominantly Dutch/Flemish speaking

0 50 km
0 50 miles

Germany

Luxembourg

The Netherlands

Ardennes

France

North Sea

international boundary
provincial boundary

0 50 km
0 50 miles

Les XX and the Belgian Avant-Garde

Brussels and the Belgian Avant-Garde in Historical and Geographical Perspective

by Alexander Murphy and Carl Strikwerda

LES XX was part of a unique moment in modern Belgian history when a number of important changes in urban geography, politics, and international cultural relations came together. Les XX flourished during the 1880s in Brussels, a city that had recently emerged as an important banking, government, and commercial center and that, for the first time, was taking on the cultural leadership of Belgium. The 1880s were also a watershed in Belgian politics. The previously dominant Liberal party split and new anarchist and socialist movements began. In addition, activists forced the new Catholic government and public opinion to recognize Flemish demands.

In the midst of these changes, the country's artists and writers for the first time responded to the social impact of industrialization. At the same time, the members of Les XX and their contemporaries strove to receive the same level of international recognition for their art that was given to artists in Paris. In doing so, they created for Belgian artists a new set of international contacts with France, Britain, the Netherlands, and Europe as a whole.

Brussels and Belgium in the Late Nineteenth Century

In 1900 the population of the Brussels metropolitan area was only a little over 600,000, much smaller than that of Paris, London, or Vienna. Moreover, the capital cities of much larger neighboring states were dominating the European political scene. Most general accounts of the late nineteenth century do not rank Brussels among the great cities of Europe. To dismiss Brussels as a minor, undistinguished urban center, however, would be a serious mistake. The Brussels of Ensor, Finch, and van de Velde was a rapidly changing, dynamic place that nourished the development of innovative social, political, and cultural forces.

The special character of late-nineteenth-century Brussels grew out of particular geographical and historical circumstances. Founded in the tenth century around the castle of a feudal lord, Brussels rose to modest prominence in the fifteenth century as one of the seats of the Burgundian dukes who had set about to unite a number of principalities to the north and west of France. Variants of French were spoken in the southern Burgundian lands while Low German or Dutch dialects predominated in the north. Brussels itself lay just to the north of the line separating these two linguistic realms; the local dialect was Germanic with some French elements mixed in.[1]

With the collapse of the Burgundian dynasty, Brussels and the rest of the Low Countries came under the rule of the House of Hapsburg. Charles V (reigned 1515-1555) chose the city as his capital, making Brussels the primary residence of the most powerful political figure in Europe at the time. Charles' son, Philip II (1556-1598), later transferred the seat of power to Spain, and the entire Low Countries were ruled from afar. A revolt against foreign rule eventually led to independence for the northern Low Countries (the Netherlands), but the remaining territories (essentially modern Belgium and Luxembourg) remained under Spanish Hapsburg control.

From the late sixteenth century until 1830, the southern Low Countries were ruled successively by the Spanish Hapsburgs (until 1715), the Austrian Hapsburgs (1715-1794), France (1794-1815), and the Netherlands (1815-1830). Throughout this time Brussels functioned as the central administrative seat and the focus of political life. During the periods of

Spanish, Austrian, and especially French rule the French language gained a significant foothold among the upper classes in the city; the Spanish and Austrians used French as the primary language of administration and the French sought to impose their language throughout what we now call Belgium.[2] Moreover, the general prestige of French in Europe at the time prompted many of the city's elite to send their children to Paris to study. Consequently, when Belgium revolted against Dutch control in 1830 and emerged as an independent state, an influential minority of Brussels' inhabitants (some thirty percent of the city's total population) considered French their primary language.

In view of Brussels' long-standing role as an administrative center, it is not surprising that it became the capital of the newly independent Belgian state. It also emerged as the main urban center in Belgium. The population of the metropolitan area grew rapidly from 88,000 people in 1800 to 140,000 in 1830 and the city proper was rapidly expanding beyond the fourteenth-century walls that had encompassed it for so long.[3] Belgium's centralized political structure ensured that it would become the focal point of the emergent state.

Despite its small size (approximately 11,000 square miles), nineteenth-century Belgium encompassed a territory of great diversity and richness. Within the boundaries of the country lay the great medieval Flemish cities of Bruges and Ghent, the thriving port city of Antwerp, the rapidly industrializing cities of the Sambre-Meuse valley, the rugged and isolated Ardennes in the southeast, and significant rural, agricultural lands in the center and northeast [map, p.15]. Situated at the geographical center of the country, Brussels was well positioned to play a major role in the country's economic and cultural life.

The government in Brussels presided over a state divided into nine administrative provinces and hundreds of small communes, legacies of medieval agrarian village units.[4] By the late nineteenth century the city proper had expanded well beyond the commune of Brussels, but the communal system was so entrenched that only minor adjustments were made in the communal structure of the metropolitan area. Hence, for administrative purposes the city was divided into a number of discrete units (twelve at the turn of the century). The resulting political fragmentation has posed consistent difficulties in governance and has profoundly affected the ways in which social and political movements in the country have functioned.

The country was also divided in an east-west direction by the line separating Romance and

Germanic Europe. With little change from Burgundian times, this line still divided Belgium into two major language spheres: the south, called Wallonia since the late nineteenth century, where French and related dialects were in use; and the north, or Flanders, where Dutch and Flemish dialects predominated. The peoples of these two linguistic realms have come to be known as Walloons and Flemings, respectively. The nineteenth-century language line was not a barrier separating two linguistically homogeneous peoples, however. In the larger cities of northwest Belgium, especially Ghent, Antwerp, and Brussels, French had gained a foothold among a small but influential elite, and both Wallonia and Flanders, but particularly the latter, were divided by significant dialectical differences. Indeed, there was no widespread sense of ethnic or regional identity among Flemings and Walloons when Belgium gained its independence in 1830; rather, these identities were in the process of developing as the nineteenth century drew to a close.[5]

Nineteenth-century Belgium was remarkable in a number of respects. It was the first country in continental Europe to experience the industrial revolution, it saw the rise of a powerful nationalist movement in reaction to the privileged position of French in the early Belgian state, and it came to play an increasingly significant international role. Each of these circumstances had important implications for the growth and development of Brussels and, ultimately, for the social and cultural environment out of which the work of Les XX and the Belgian avant-garde emerged.

The industrial revolution began to take hold in Belgium in the early nineteenth century. The comparative tranquility of the region, the availability of capital and labor, the presence of easily extractable natural resources, and Belgium's strategic position prompted financiers to invest in Belgian industry decades before similar steps were taken in Germany.[6] Industrialization had its greatest early impact in two areas: the Flemish textile districts, especially in and around Ghent, and the metallurgical districts of the Sambre-Meuse valley between Liège and Mons. The introduction of factories in the former area revolutionized the production of textiles and transformed the economic and social character of towns and cities such as Ghent. In the Sambre-Meuse valley, large-scale resource extraction and processing industries were established, producing an industrialized landscape and fostering considerable urban growth.

The impact of the industrial revolution on Brussels was more indirect. It spurred some industrial

expansion in the western part of the city, but the major changes in Brussels at the time were not in the industrial realm. Instead, commerce and administration were the primary engines of growth in the nineteenth century.[7] This is not to suggest that the industrial revolution was of little importance for Brussels, however. The development of heavy industry and labor-saving machinery fueled the growth of commerce and administration in the Belgian capital. By the late nineteenth century the economy of Brussels revolved as much or more around governmental functions, finance, and trade as it did around industry. Indeed, the comparatively low level of dependence on manufacturing meant that the city could continue to prosper between 1873 and 1896, when Belgian industrial growth as a whole significantly slowed.

The language situation also had a strong impact on the development of nineteenth-century Belgium and Brussels. Although speakers of Dutch or related Flemish dialects were in the majority in Belgium (around 58 percent of the population), French was the language of public life. The Belgian constitution called for freedom of language use, but effectively French was the official language.[8] This position was assured by Francophone control of the economy and the government; even in the major cities of the northwest the small minority of French speakers controlled a greatly disproportionate share of the wealth.

The French language had made much greater inroads in Brussels than in any other city to the north of the language line before 1830 and the dominance of French in the city's commercial and administrative life precipitated its rapid growth thereafter. Many Walloons came to the city to fill commercial and administrative positions and local members of the Flemish-speaking middle class saw learning French as a means of social advancement. Census figures attest to the rapid growth of French during the period. Within the boundaries of present-day Brussels, those declaring French as their primary language grew from 32 percent of the population in 1846 to 48.7 percent in 1910. During the same period, those declaring Dutch as a primary language fell from 66.7 percent to 45.5 percent.[9]

The dominant position of French in Belgium's public life and its rapid growth at the expense of the local dialect in Brussels did not go unchallenged. Throughout the nineteenth century a movement opposing the privileged position of French gained ground. Born in the larger cities in the northwest, the so-called Flemish movement pointed to Brussels as an example of the threat posed to the Flemish people by

Francophone cultural and linguistic hegemony. Brussels often found itself at the center of the rapidly developing debate over language and nationalism in Belgium.

The changes brought about by industrialization and language shift in the nineteenth century were part of a reorientation of Brussels from a modest provincial center to an important European city. This reorientation is reflected in the physical growth of the city; metropolitan Brussels grew from a population of 140,000 in 1830 to more than 600,000 in 1900, despite a steep decline in births and deaths.[10] During the same period, the proportion of the Belgian population living in the metropolitan area swelled from less than three percent to almost ten percent.[11] These figures reveal that much of Brussels' growth can be attributed to immigration, a clear testimony to the city's increasing significance, at least within Belgium.

A great transformation of the physical character of Brussels complemented the population growth. The fourteenth-century walls surrounding the city were torn down between 1818 and 1871 and replaced by wide boulevards. This opened the way for the spread of the city; in the first seven decades after independence the amount of built-up land in and around Brussels more than doubled.[12] Much of the expansion was to the east and southeast, adjacent to the administrative and financial districts of the old city.

At the same time, Belgium's second king, Léopold II, who ruled from 1865 to 1909, actively sought to build the international stature of Belgium and Brussels. Inspired by the grand plans of Baron Haussmann to transform Paris into a dazzling exemplar of modernity, and aided by Jules Anspach, the mayor of Brussels in the 1860s and 1870s, Léopold II successfully pushed for large-scale urban development schemes that transformed the face of the city.[13] These included the clearing of slums to make way for wide avenues, covering the Senne river running through the center of Brussels, and the construction of massive buildings and monuments, including the Palace of Justice in the central part of the city, the Sacred Heart Basilica to the west, and the monument to Belgium's fiftieth anniversary in the Parc du Cinquantenaire to the east.

Brussels' transformation into a major city was furthered by transportation developments.[14] The first railroad passenger service in continental Europe was initiated in 1835 between Brussels and Mechelen. By 1870, Brussels had major railroad stations both to the north and to the south of the old city and roads had been widened to connect the two. Moreover, requests were already being made to unite the two stations

with a train line that would run through the center of the town, although no concrete plans were made until the early twentieth century.

Complementing the expansion of the railroad was the elaboration of an intraurban transportation system that was remarkably sophisticated for its time. Horse-drawn trams were introduced in 1869 and electrified trams came in near the end of the nineteenth century. Between 1874 and 1899 the number of tramway travellers increased four-fold.[15] The building of large avenues facilitated movement around the town in privately-owned vehicles. Thus, Brussels was a remarkably accessible city both to those who lived there and to those who lived in surrounding areas and sought employment in the city. Accessibility was often purchased at a high social cost, however, and the gleaming triumphs of Léopold's grand designs for the city sat uncomfortably next to areas of squalor and deprivation.

The Social and Political Impact of Industrialization

The artists of Les XX lived in one of the most industrialized and urbanized societies in the world, a society that simultaneously benefitted from enormous new wealth and was torn by debate over major social problems. The juxtaposition of poverty and wealth and the debate over industrialization inspired artists in Les XX to experiment with new forms of expression. The political conflict of the 1880s also encouraged observers of Les XX to see the artists as revolutionary, as sympathizers in the cultural realm with the new political currents of socialism and anarchism growing out of industrialization.

Industrialization did not bring prosperity to all of Belgian society in the nineteenth century. The initial boom of industrialization lasted from 1800 to the 1850s, with some interruptions, and slowed dramatically in the 1870s and 1880s. New competitors cut into the markets for Belgian exports and inexpensive grain from North America and Argentina undermined the position of Belgian farmers. These pressures were doubly hard because the country, especially in the poorer, agricultural area of Flanders, was probably the most densely populated country in the world.[16] Belgium survived these hard times at a heavy cost to its population. Where British or French workers laboured for nine or ten hours, Belgian workers often worked for eleven. Wages, even in the most modern industries such as coal-mining and metallurgy, were extremely low, among the lowest in northwestern Europe.[17]

Belgium also depended heavily on women's work, both in industries such as textiles and in agriculture.[18]

The economic discontent of the 1880s combined with new political currents to produce an explosive situation. The very years in which the Les XX members were active were among the most eventful of Belgian history. Industrialization had been fostered by a small upper middle class and aristocratic elite which dominated the Liberal and Catholic parties.[19] The new Belgian state of 1830 that these two allied parties helped to create was one of the most democratic in Europe, with about ten percent of the adult males having the right to vote. By the 1880s, however, this electoral system remained virtually unchanged, while Germany and France, for example, had adopted universal male suffrage. A group of left-wing Liberals, known as Progressives or Radicals, pushed the Liberal party to widen the right to vote and to bring workers and other lower class people into the political system. The establishment Liberal leaders, known as *doctrinaires*, resisted this pressure for change, as did the Catholic party which came to power in 1884.

The sense of change was heightened in the early 1880s when the Liberal party for the first time came under the control of strongly anticlerical leaders. Between 1879 and 1884, the Liberal government tried to secularize public education, a move that provoked a backlash and led to the Catholics taking power in 1884. The defeat of 1884 strengthened the feeling of the Radicals, who were strongly anticlerical, that the political system had to change to put Belgium in line with progress.

The closed political system and the hard times of the 1880s encouraged the spread of socialist and anarchist ideas. These ideas had not yet been formalized into clear programs, so that people interested in political change—such as the supporters and patrons of Les XX—could sample freely from and even mix ideas from socialism, anarchism, and radicalism. This search for new political philosophies formed part of a larger European movement away from establishment liberalism. New and more intense forms of nationalism, political Catholicism, working class parties, and modern racism all emerged during this era of turmoil.[20] This movement may have been more abrupt in Belgium simply because liberalism had been so successful earlier in spawning industrialization and ignoring its social costs.

In March 1886 the discontent with social problems felt by the working class burst open with full force. Anarchists organized a celebration of the fifteenth anniversary of the revolutionary Paris

Commune in the industrial city of Liège. The celebration disintegrated into rioting, which prompted attacks by the police. The frightened government called out the army to occupy many of the coal and steel towns in Wallonia. A wave of mass strikes, rioting, and clashes between the army and workers swept the industrial region of southern Belgium.[21] The upheaval shocked Belgium and much of Europe.

One reason the innovations of Belgian artists may have intrigued French observers in the late 1880s was because they saw Belgium as a society in ferment, a kind of laboratory for what less-industrialized France might become. Foreign observers were also intensely aware of how the upheaval of 1886 sparked an upsurge in political organizing. The Socialists, just organized as a party in 1885, grew quickly; the Radicals redoubled their efforts to push the Liberal party to the left; and even the Catholic party saw the emergence of a more progressive wing which called for suffrage reform and new social measures.

Further strikes broke out in 1887 and 1891, and, finally, a national or general strike organized by the Socialists occurred in 1893. From 1886 on there was little doubt that the political system would be changed, the only question was how radically and quickly it would be changed, and which groups—Catholics, Socialists, establishment Liberals, Anarchists, or Radicals—would influence the pace of change. Even a genuine social revolution, not just political change, seemed possible for many Belgians in the late 1880s and early 1890s.

Thus, Belgium, and to an extent Europe, was ready for an artistic movement such as Les XX which, according to its supporters, claimed to reject boldly the canons of the past and strike out in new directions. Or, to put it perhaps more accurately, it was understandable that important cultural figures would seize on Les XX and argue that it represented part of the same revolutionary spirit as did socialism, anarchism, anticlericalism, and radicalism. In a sense, political and cultural figures such as the critic Octave Maus, lawyer and journalist Edmond Picard, and poet and essayist Emile Verhaeren fashioned the connection between Les XX and contemporary history. They not only pointed out the connection to the wider public, but also convinced the members of Les XX themselves that the group was a part of a vast social and cultural shift.[22]

Such an argument was more plausible because of Les XX's ambition to create a total art. Les XX brought together prints, painting, music, poetry, and decorative arts in the belief that all these media form part of a whole. Similarly, the kind of radical social and political change which seemed possible in the 1880s promised to change all aspects of society. Just as the aristocracy and upper bourgeoisie dominated society, so undermining their control would bring about a social revolution.[23]

The waning influence of Les XX in the mid-1890s may be linked to changes in the same political and social trends that helped make the group influential. Economic conditions generally improved during the 1890s and the political situation no longer was as open as it had been. The establishment Liberals rejected the efforts of Radicals to turn the party to the left. The Socialists succeeded in absorbing many Radicals and Anarchists, and those who tried to remain independent were pushed to the margins. The Socialists themselves, as they became more organized, did not abandon their dreams of social revolution. However, the hard work of elections and building up organizations such as consumer cooperatives made the movement less visionary than it had been at first.

Most importantly, the Socialist-led general strike of 1893 succeeded in getting the Catholic government to grant universal male suffrage. The results, however, were ambiguous. Shrewdly, conservative Catholics and establishment Liberals offset the effect of universal suffrage by granting extra votes to the wealthy. This meant that the Socialists only won victories in heavily industrial areas, such as Liège, where workers' votes were not diluted by large numbers of plural votes. More striking, however, was the large increase in Catholic votes. Giving votes to the lower classes not only enfranchised workers, but also farmers and shopkeepers who voted overwhelmingly Catholic. To reach and hold the allegiance of the new voters, all parties became more bureaucratic and less free-wheeling. Thus, the political situation, which in the 1880s had seemed to be in flux with many possibilities open, had by the mid-1890s been reduced to an electoral battle between heavily organized mass parties.[24]

The Growing Significance of the Flemish Movement

Economic and political changes were not the only sources of social upheaval in late-nineteenth-century Belgium. The so-called "language problem" loomed larger. The roots of the problem lay in the dominant position of the French language in public life; with the founding of the Belgian state, French became the language of the military, the courts, the government, and higher education. In short, Belgian society, economy, and politics were dominated by Francophones.

The Flemish movement emerged in the 1830s in reaction to this state of affairs. In its early days the Flemish movement was dominated by middle-class intellectuals, primarily from Ghent and Antwerp, who were concerned about the fate of their language and culture.[25] Caught up in the romantic revival sweeping through Europe, they sought to champion the cause of the Flemish people primarily by pressing for greater linguistic rights and by promoting symbols of Flemish culture. Lack of success in gaining any significant concessions from the Francophone-dominated government led to greater politicization of the movement by the middle of the nineteenth century. Though still small in number, the champions of the Flemish movement began calling for an equal use of French and Dutch in public education in Brussels, as well as the use of Dutch in public administration, court proceedings, and the military when Flemings were involved.[26]

By the 1870s, the impact of the Flemish movement was widening as the growing Flemish middle class found themselves in a disadvantaged position within Belgium. The movement successfully backed legislation calling for the use of Dutch in criminal trials if the defendant so requested and requiring public notices and communications to be issued in both French and Dutch in northern Belgium.[27] However, these laws were pale reflections of the original bills submitted to the Belgian parliament and enforcement was often weak. Other modest legislative gains came in the 1880s and 1890s in the areas of education and judicial reform, but during the time that the members of Les XX were active the Flemish movement was struggling both for wider support among the Dutch speakers of Belgium and for meaningful change on the political front.

The late-nineteenth century also saw the first stirrings of a reactive Walloon movement. A few Walloon cultural and literary societies had been founded in the middle of the nineteenth century and some of these became vehicles for organizing opposition to the growing power of the Flemish movement.[28] Their concerns centered on the potential threat posed by the Flemish movement to the privileged position of French in Belgium. At the same time, some Walloons were unconvinced that the powerful Francophone elite in Ghent, Antwerp, and Brussels, many of whom were from "frenchified" Flemish families, would adequately protect distinctly Walloon interests. The Walloon movement was very small in the nineteenth century, but its existence foreshadowed the polarization of Belgium along language lines that was to come.

Brussels stood somewhat apart from both the Flemish and the Walloon movements. The city took a back seat to Ghent and Antwerp as a center of Flemish activism and many in the Walloon movement looked to Liège.[29] Nonetheless, Brussels was caught up in the tides of Flemish and Walloon ethnonationalism. It was the site of heated political debates surrounding the position of Dutch in Belgian public life, and some of the most active Walloon literary and cultural societies were founded by Walloon immigrants living in and around the capital. At the same time, Brussels was the undisputed center of the effort to promote Belgian nationalism. Many in the capital identified strongly with Belgium as a political/territorial unit and were concerned to elaborate and strengthen a sense of national identity in the youthful state.

The artists of Les XX are not particularly noted for their involvement in linguistic or nationalist causes. They came from diverse backgrounds and their primary concerns lay elsewhere. As we have already seen, many identified closely with the aims of the growing socialist movement, which largely sidestepped the issues of language and nationalism. For them nationalism was a distraction from more fundamental concerns, including the lack of universal male suffrage, the social disruptions associated with industrialization, and the dominant role of the Catholic church in Belgian society.

This does not mean that language and nationalism were irrelevant to Les XX. To the contrary, nationalist romanticism focused social and artistic attention on things such as folklore and landscapes, and a few members of Les XX, including Henry van de Velde, became closely identified with the cultural wing of the Flemish movement.

Although not necessarily intended as nationalist statements, the Les XX drawings depicting local traditions, buildings, and landscapes were consistent with nationalist efforts to focus attention on local history and culture. Indeed, Flemish activists were not just vocal opponents of the dominant position of French in Belgian society; they actively sought to promote a sense of Flemish ethnonational identity through the glorification of Flanders' past and of its special character as a place. Movement leaders chose the lion of Flanders, an emblem from the coat of arms of the medieval Counts of Flanders, as their symbol and they promoted works of literature, music, art, and drama that sought to capture the Flemish "national soul."[30]

Similarly, members of the small Walloon movement channeled much of their energy into cultural and artistic endeavors that celebrated the special

character of the people and places of southern Belgium, and Belgian nationalists themselves sought to draw attention to the special historical and geographical characteristics that defined Belgium as a country and that separated it from its neighbors. The Les XX drawings focusing on land, people, and history thus resonate with ethnonationalist imagery; they invite reflection on the past and present of the places they represent.

Since most of the landscapes and buildings depicted by members of Les XX are from northern Belgium, one might conclude that the group was largely sympathetic to the aims of the Flemish movement. Yet this does not necessarily follow. As an area that had not been totally transformed by industrialization and that was steeped in a splendid artistic and urban history, northwestern Belgium embodied features that were glorified by both Flemish and Belgian nationalists. Consequently, the depictions of Bruges by Fernand Khnopff [cat. 62] or James Ensor's etching of the town hall at Oudenaarde [cat. 34] could be interpreted as images in tune with either Flemish or Belgian nationalism. Since most of the members of Les XX were not strongly associated with one particular movement, most of their images should not be interpreted as explicit expressions of nationalist commitment. Instead they should be seen as reflections of the ethnic and national currents sweeping Belgium at the time.

There are, however, a few works by members of Les XX that are directly tied to the Flemish movement. One is Ensor's celebrated drawing *The Battle of the Golden Spurs* [cat. 40]. This fourteenth-century battle ended in the Flemish peasantry routing the French. It thus became an important symbol of the Flemish movement and the date on which the battle was fought became the Flemish national holiday. Ensor's decision to depict the battle had clear significance for the Flemish movement. But the satirical view projected in the etching casts doubt on whether Ensor intended it as a statement of support for the Flemish cause.

Much less ambiguous are the contributions made by Jan Toorop and van de Velde to the Flemish literary review *Van Nu en Straks* (*From Now On*) [cat. 125 and 138-140]. The dominance of French at the upper levels of artistic life in Brussels in the nineteenth century meant that most members of Les XX functioned in a Francophone world, and few seemed to question this. The primary critical voice of Les XX was the French-language periodical *L'Art moderne* (*Modern Art*); as the leading journal of art, music and literature in late-nineteenth-century Belgium, most

members of Les XX regarded it as the primary forum for discussion of their work. *Van Nu en Straks* stood as a symbol of opposition to this state of affairs.

The periodical was founded in 1893 by a group of leading Flemish literary figures. The primary force behind the review was Flemish activist August Vermeylen. The review came to be strongly identified with the Flemish movement. Van de Velde's and Toorop's willingness to design covers and end pieces for the review thus stand as clear statements of support for the Flemish movement's efforts to define and encourage a distinctly Flemish cultural identity.

The links between nationalism and the works of other members of Les XX are much less obvious. Yet in keeping with the other social changes that influenced the Belgian avant-garde, the linguistic and nationalist currents crossing Belgium challenged conventional arrangements and foreshadowed greater changes to come. The Flemish movement, in particular, focused attention both on local history and on the relationship between culture and nationalism. Its contribution to a critical examination of the status quo and its focus on local people and places are unmistakably reflected in the works of Les XX members and their associates.

The Changing International Context

The success of Les XX helped make Brussels into a genuinely international cultural center for the first time. This transformation involved the Bruxellois artists and writers in a complex set of relationships with other countries. On the one hand, British, Dutch, and Germanic influences helped the Belgians see Brussels as more than a provincial city within Francophone culture. At the same time, the Belgians joined artists and writers in Paris in forming, for a time, a cosmopolitan French-speaking movement embracing artistic innovation in both cities. This success coincided with the emergence of Brussels as by far the most important Belgian city. Thus, Brussels moved to the stature of a European cultural *center* by first moving to a position of greater importance within Belgium itself.

Unlike most European capitals, Brussels had not had a long history as a metropolis or as a center of culture. In the centuries before Belgian independence in 1830, Brussels had gradually become the administrative center of the southern Low Countries. Yet the great university of the country was in Leuven, while the archbishopric and primate of Belgium was seated in Mechelen. In the arts, the old Flemish centers of Ghent

and Antwerp claimed a stature at the level of the capital city up through the middle decades of the nineteenth century. The annual government-sponsored exhibition, for example, rotated between Antwerp, Ghent, and Brussels.[31]

During the nineteenth century, however, Brussels grew much more quickly in population and wealth than did other large Belgian cities. Between 1870 and 1880, Ghent grew 14 percent in population and Liège grew 20 percent, while Brussels grew no less than 35 percent.[32] The concentration of wealth was even more marked. Brussels was the center of the banking industry, the home of publishing houses and art galleries, and the site of the great aristocratic and upper bourgeois mansions.[33] The recessions of the 1870s and 1880s furthered Brussels' role as a center of wealth. As industrial centers such as Ghent and Liège suffered from economic hard times, Brussels prospered with the growth of foreign investment. Belgian capital was invested in other European countries and in Russia, China, and Latin America, and much of the income from this investment came to Brussels' banks and the city's wealthy elite. The Paris metro, for example, was largely built with Belgian equipment and capital.[34]

These international economic connections made Brussels a more cosmopolitan city. Substantial numbers of British, French and German businessmen lived in or traveled to the city. Representatives of the German coal cartel, for example, met with their Belgian counterparts every Wednesday in a Brussels restaurant to fix coal prices for Belgium, Luxemburg, and northeastern France.[35] In the late nineteenth century, Brussels often offered weekly or monthly English and German newspapers for the foreign colony.

Belgium had already developed numerous economic ties with other countries early in the industrial revolution, as it bought machinery and imported raw materials from British brokers and helped develop German and French industry. But the late nineteenth century saw these ties deepened. Because the Brussels capital market was more open than that of Paris, French banks loaned money through Brussels, while German businesses borrowed funds there. The Brussels financial journal *Moniteur des interets materiels* (*Monitor of Material Interests*) gained its fame by claiming to cover every major international financial transaction.

These economic ties strengthened or helped make possible a number of cultural connections. British influence had already been strong in Belgium by the mid-century. In part, this was welcomed by the Belgian elite to offset the overwhelming power of France. France had threatened to annex Belgium after the Belgian revolution of 1830 nearly failed, and Britain had helped keep the country independent and neutral. While French influence never declined, Belgium mixed British and other cultural models with those of France to create some distinct cultural patterns. Augustus Pugin, the architect of the neo-Gothic London House of Parliament, was extremely popular in Belgium. Also, the Liberals and Catholics in the Belgian Parliament prided themselves on the stable constitutional monarchy they enjoyed, as opposed to the supposedly turbulent French system, and at times they even called themselves "Whigs" and "Tories" after the British.

The new king, Léopold I, who reigned from 1831–1865, was Queen Victoria's uncle, and this started a long chain of relationships between the two countries. The great Catholic noble family of Brussels, Carton de Wiart, illustrates some of these connections. Henry Carton de Wiart, Edmund Picard's law intern during the years Picard championed Les XX, was a friend of the French writers Maurice Barrès and Paul Verlaine. One of Henry's brothers served as an officer under Lord Kitchener, another served as vicar general to the Archbishop of Westminster, while a cousin was an aide to the future King George V.[36]

The growth of German economic power and cultural reputation after 1871 added new influences. Henry Carton de Wiart studied at Bonn as well as Paris, before taking up law in Brussels, while Picard and Maus, the promoters of Les XX, were ardent Wagnerians.

Emulation of British openness to foreigners fostered Brussels' position as an international center. Like the British, the Belgians during the nineteenth century took in numerous refugees, dissidents, and exiles, though being the tiny neighbor of France and Germany made Belgium's decision to do so a much riskier challenge than in the case of Britain. As a result of this openness, Karl Marx and Friedrich Engels planned their future collaboration together when they met in Brussels. Victor Hugo, fleeing Napoléon III, and numerous refugees of the Paris Commune came to Belgium, while German Socialists evaded Bismarck's spies by moving to Brussels and Liège.

The Socialists in Belgium resembled the artists in the way they fostered these cosmopolitan connections by publishing in French and German journals and commenting on foreign developments in their own publications. The French and Spanish particularly admired how the Socialists in Belgium made their consumer cooperatives, often called Maisons du peuple (Houses of

the People), cultural as well as economic and political centers.[37] Lectures, concerts, art exhibits, libraries, and reading groups found a home in the cooperatives. Some members and supporters of Les XX participated in the Section d'Art (Art Section) of the Belgian Socialist party, which formed part of the broad cultural vision of Belgian socialism and had a great influence in France.

The cosmopolitanism for which Les XX became so famous grew up naturally in the international world of Brussels in the late nineteenth century. Two of the founding members of Les XX, James Ensor and Willy Finch, each had an English parent. Fernand Khnopff married an English woman, was deeply influenced by English art on a visit there, and became the correspondent of the British magazine *Studio*.[38] Two other founders were foreign; Périclès Pantazis was Greek and Darío de Regoyos was Spanish. The later membership in Les XX of Auguste Rodin and Paul Signac testifies to the close relationship between Paris and the Brussels group. The Dutch painter, and later Les XX member, Jan Toorop visited England with the poet Emile Verhaeren and the Socialist leader Jules Destrée. Toorop later married an Irish woman. The most important international connection represented by Les XX, of course, was the group's open-minded policy of inviting artists from all over Europe, and even some Americans working in Europe, to exhibit in Brussels. The eleven different nations represented in the exhibits demonstrate the unique role that Les XX played for a time in opening up Europe to new directions in art.

Although Les XX disbanded in 1894 and its successor group, La Libre Esthétique, had much less impact, Les XX laid a foundation for international artistic cooperation in which Belgium played a leading role. The international arts and crafts movement and the architectural styles of art nouveau which spread throughout Europe carried on the cosmopolitan spirit that the Brussels artists of Les XX had helped establish. That the activities of Les XX placed Brussels and Belgium in a different position from that which it had occupied in the 1870s was clear to many observers. Whereas in the 1870s Brussels had played only a very minor role in the plastic arts and architecture, in the era of art nouveau and the arts and crafts movement the city figured prominently in the European scene, including connecting British developments to those of the Continent.[39]

LES XX was the product of a special place and a special time. In their rebellion against the traditional salon system and their concern to make art relevant to society, the artists of Les XX produced a body of work that offers tangible expression of the profound changes sweeping Brussels and Belgium. Les XX came into being in a city that was affected by the social disruptions and hardships associated with early industrialization, as well as by the forces of nationalism and internationalism. The members of Les XX were diverse in outlook; no one social or political commitment characterizes their work. But in distinct ways they saw in the struggles of laborers and nationalists, and in the rapidly changing position of Brussels and Belgium on the European stage, social developments and challenges that demanded an artistic response. The result was a creative movement of remarkable originality, intensity, and diversity.

Notes

1. Beardsmore, *Français Régional*.

2. Deneckere, *Langue Française*.

3. Eggericks and Poulain, "Communes de la Région Bruxelloise."

4. Van der Haegen et al., "Belgium Settlement System," 251–363.

5. Murphy, *Language Differentiation in Belgium*.

6. Riley, *Belgium*.

7. De Belder, "Structures Socio-Professionnelles," 227–234.

8. Van Velthoven, "Taal en Onderwijspolitiek," 261–387.

9. McRae, *Multilingual Societies*.

10. Ledent, "Urbanisation d'une Capitale," 321–349.

11. Vandermotten and Vandewattyne, "Armatures Urbaines."

12. Deconinck, "Agglomération," 175–200.

13. Ranieri, *Leopold II*.

14. Abeels, "Communications dans et vers la Ville," 232–245.

15. Kurgan-van Hentenryk, "Economie et Transports," 216–226.

16. Mokyr, *Industrialization in the Low Countries.*

17. Taylor, "Coal Industry," 44; Burn, *History of Steel-Making,* 121–3.

18. Müller, "Frauen Arbeit in Belgien."

19. Clark, "Nobility, Bourgeoisie, and Industrial Revolution," 140–175.

20. Schorske, *Fin-de-siècle Vienna.*

21. Bruwier et al., *Wallonie née de la grève?*

22. Aron, *Ecrivains belges et le socialisme.*

23. Egbert, *Social Radicalism,* 603–18; Herbert, *Artist and Social Reform.*

24. Mommen, *De Belgische Werkliedenpartij,* 96–122; Kossmann, *The Low Countries 1780–1940,* 361–74, 473–88.

25. Zolberg, "The Making of Flemings and Walloons," 179–235.

26. See e.g., *Commission Flamande.*

27. Maroy, "L'Evolution de la Législation Linguistique Belge," 449–501.

28. See e.g., Schreurs, *Les Congrès de Rassemblement Wallon.*

29. Jennissen, *Le Mouvement Wallon.*

30. Clough, *A History of the Flemish Movement in Belgium* .

31. Block, *Les XX and Belgian Avant-Gardism,* xiii.

32. Strikwerda, "Urban Structure, Religion, and Language," 12.

33. Gepts-Buysaert, "Afterword: the Social Context of Belgian Art."

34. McKay, *Tramways and Trolleys,* 62.

35. De Leener, *Le Marche charbonnier belge,* 67–75.

36. Schmitz, "Carton de Wiart," 164–66.

37. Furlough, *The Politics of Consumption;* Brenan, *The Spanish Labyrinth,* 219.

38. North, "Khnopff and Photography."

39. On the international setting see Romein, *The Watershed of Two Eras,* 559–72.

'Soyons Nous': Les XX and the Cultural Discourse of the Belgian Avant-Garde

by Susan M. Canning

ON October 28, 1883, thirteen artists in Brussels signed their name to a folio marked with a double X, declaring the formation of Le Cercle des Vingt (The Circle of Twenty) or Les XX.[1] The original thirteen were Frantz Charlet, Jean Delvin, Paul Dubois, James Ensor, Charles Goethals, Fernand Khnopff, Périclès Pantazis, Frans Simons, Gustave Vanaise, Théo Van Rysselberghe, Guillaume Van Strydonck, Théodore Verstraete and Guillaume Vogels; Willy Finch, Darío de Regoyos, Achille Chainaye, Jef Lambeaux, Willy Schlobach, Piet Verhaert, and Rodolphe-Paul Wytsman soon added their names to the list [fig. 1].

These twenty artists proposed to hold an exhibition in Brussels each February where each member could show their own artwork alongside the work of select invited artists, both Belgian and foreign, who shared similar aesthetic concerns. Through their salons, Les XX sought to revive the local art scene, to bring contemporary art to Belgium, and to make Brussels "the center of a magnificent avant-garde movement which carries our country in all fields of art."[2]

By the time the group dissolved ten years later they had achieved their goals. They had exhibited some of the most important contemporary artists from the Continent, England and the United States, including Paul Cézanne, Walter Crane, Paul Gauguin, George Seurat, Vincent van Gogh, and James McNeill Whistler, and had successfully launched their own careers. Brussels had become an important art capital as well as a showcase for art nouveau architecture and design. In fact, the salons sponsored by Les XX became so popular and were such a financial success that by the early 1890s it was these exhibitions, rather than the official Salon, that were the preferred place for most artists to exhibit in Belgium.

The ten salons of Les XX occurred during a time of intense cultural activity in Belgium. This period from 1880 until 1895 witnessed not only the shows by Les XX and the salons of groups modeled after them, but also the publication of more than 25 new literary reviews. Appearing weekly or monthly, these journals chronicled not only the activities of a burgeoning cultural scene but also the criticism, prose, and poetry of writers such as Georges Eekhoud, Max Elskamp, Théo Hannon, Grégoire Le Roy, Georges Rodenbach, and Emile Verhaeren. Self-consciously calling themselves the Jeune Belgique (Young Belgium), these writers, as did the artists, resolved to introduce Belgium to contemporary modernist theory and to establish a national style expressive of the spirit and values of this young country.

The Cultural Politic of the Belgian Avant-Garde

As Jean Puissant and Paul Aron have shown, the formation of a cultural avant-garde in Belgium was due to a rapidly growing economy that by mid-century had enlarged the ranks of that country's middle-class.[3] When it became an independent state in 1830, Belgium was already the most industrialized country on the continent, and the availability of raw materials combined with a constitutionally-imposed policy of political neutrality and an advantageous geographical position to further economic expansion. In the southern Walloon region of Belgium factories producing iron and coal yielded the capital for this growth while the agricultural and textile base of the rural region of Flanders, to the north, provided the labor. Construction of the railroad system in the 1840s

allowed Belgium access to major markets on the Continent and in England and brought the capital city, Brussels, into close contact with the cultural centers of Paris and London. Increasingly, the middle class relocated to urban centers such as Brussels, Antwerp and Ghent and lent their support to the Liberal government's laissez-faire economic policies by concentrating their activities in trade, banking and law.

After a period of extended economic growth, the recession of 1873–1875 and the industrial downturn of 1884 resulted in a parliamentary crisis that led to the election of the conservative Catholic party and a period of increased governmental control. The diminished opportunities for employment that followed this economic crisis prompted many of the Jeune Belgique generation to turn to careers in journalism

and writing, rather than in the law profession they had studied at the university. The recession led to lowered wages and living standards for the working class and, in the 1880s, to a period of social unrest and strikes as the workers protested their plight. As the government resorted to increasingly repressive measures to put down these demonstrations, the Parti Ouvrier Belge (Belgian Workers' party) moved the workers' struggle to the political sphere by demanding universal suffrage. Within this context of economic depression, class strife, and mass demonstrations, the Jeune Belgique movement founded journals to justify their choice of a literary profession and Les XX initiated their salons to show new art in Belgium. Both groups debated the role that the visual arts and literature played within a society where only a privileged few had access to political power.

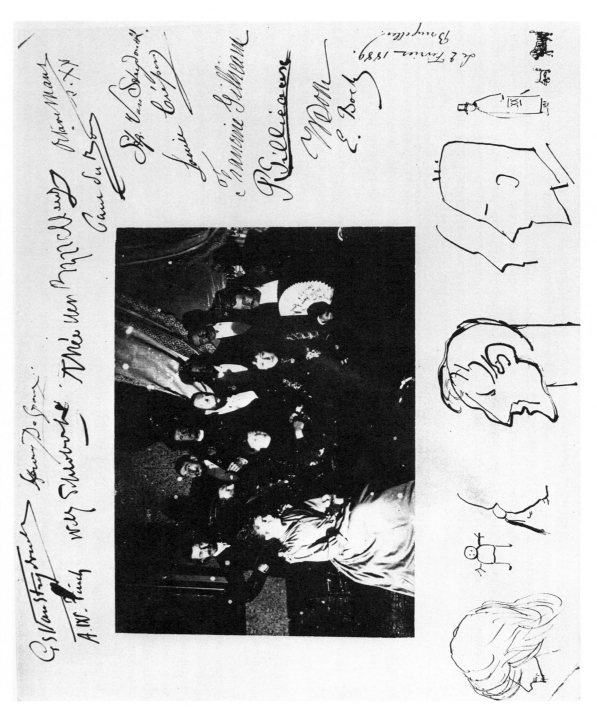

FIGURE 1. Anonymous, The Group Les XX, photograph, 1889. Courtesy, Archives de l'art contemporain en Belgique.

While the Jeune Belgique searched for the means to express their alternative ideology, the Belgian State, well aware of the role that culture played in forging a sense of national purpose and identity, actively patronized art that supported and verified its position. Beginning in the 1840s, the government actively sought to legitimize itself through sponsorship of Cercles Artistique et Littéraire (Literary and Artistic Circles) in Antwerp, Brussels and Ghent, an annual literary award, and a national Salon for the visual arts.

The celebration of the Belgian state's fiftieth anniversary of independence in 1880 intensified this official bid for cultural validity. In order to reinforce the notion of a continuous and consolidated Belgian culture, the State commissioned a bibliography of Belgian writers and financed the publications *Cinquante ans de Liberté* (*Fifty Years of Liberty*) and *Patria Belgica* (*The Belgian Fatherland*). Further signs of a distinct Belgian identity were to be found that year at an exhibition commemorating the country's achievements in fine and industrial art, displayed in a museum built especially for the occasion at the Parc du Cinquantenaire.[4] With such symbolic importance assigned to culture and especially to literature, it is little wonder that the government's refusal of a national literary award for the naturalist author Camille Lemonnier in 1883 occasioned the first gathering of the Jeune Belgique.[5]

This attempt by the government to create a sense of an officially sanctioned national identity had some unintended results. Instead of celebrating their national heritage, the Jeune Belgique generation began to question both the nature of this identity and its social definition. Asking themselves if they shared the same capitalist values as their fathers, these artists and writers sought to establish a new perspective that would express nationalism through modernist aesthetics, rather than through the government's conservative and traditional mode.

Even as they hailed Lemonnier as the father of their new movement, this young generation of artists and writers harbored a certain ambivalence toward politicizing national culture. Although their self-run journals attested to their mistrust of official patronage, these future avant-gardistes were not beyond accepting governmental largesse. For example, during the group's early years many Vingtistes showed not only at Les XX exhibitions but also at the government-sponsored artistic circles and the national Salon.[6] This ambiguity toward governmental patronage on the part of the Jeune Belgique generation was due to the shared goals of each group. Both the Jeune

Belgique and the Belgian state equated cultural expression with the desire for independence and status, both saw it as a reflection of the national soul. Yet it would be the Jeune Belgique who would succeed in creating a national style where the State would fail.

The Jeune Belgique

The origin of the Jeune Belgique movement was in the mid-nineteenth century, when reforms in higher education initiated by the Liberal party (in power between 1847 and 1884) granted access to the country's universities to a broader segment of the middle class.[7] As a result, a second generation, more educated and professionally trained but without the employment opportunities of their parents, began searching for outlets for their energy and creative ambition.

At the Catholic University in Louvain and the Free University in Brussels they formed literary societies and organized student-run presses to publish their own poetry and prose. These journals, with names such as *La Semaine des étudiants* (*The Students' Week*) and *Le Type* (*Type*), brought groups of student intellectuals into contact with one another. In addition to fostering a collaborative and collective spirit of working and publishing together, these student publications also initiated discussions of literary practice and theory, thus energizing an aesthetic debate that would continue in the literary journals of the 1880s. These theoretical debates separated writers into different literary camps, creating in the process the fertile environment and eclectic mix of styles that would come to characterize the Jeune Belgique.[8]

The journal that gave this movement its name, *La Jeune Belgique*, published its first issue in December of 1881. The staff of *La Jeune Belgique* was formed from the defunct student publications *La Semaine* and *Le Type* and a review published at the Free University, *La Jeune Revue Littéraire* (*The Young Literary Review*).[9] In its first year, the bimonthly *La Jeune Belgique* published naturalist writers and declared its admiration for the French naturalist Alphonse Daudet, but after Max Waller and his colleague Albert Giraud took control in the journal's first year, the review became the leading proponent of a formalist, "art for art's sake" aesthetic.

The principle literary rival to *La Jeune Belgique* in the 1880s was a weekly journal of art and literature, *L'Art moderne* (*Modern Art*), which published its first edition 6 March 1881. Ostensibly devoted to Belgian arts and letters without regard to style or

tendency, *L'Art moderne* rejected the formalist approach of *La Jeune Belgique*, promoting instead the social role of art that reflected the anarcho-socialist perspective of the journal's lawyer-editors, Edmond Picard, Victor Arnold, Eugène Robert and Octave Maus. "We wish to smooth the way, to facilitate the rapport between the artists and the public, so that each day Art can gain the beneficial social influence that it should obtain, so that artists also will be able to possess the important material and moral position which they are owed."[10]

Whereas *La Jeune Belgique* concentrated on literature, the essays in *L'Art moderne* focused primarily on criticism of the visual arts and reviews of cultural events. To reinforce the journal's self-proclaimed anarchist viewpoint, the articles were often unsigned, but this anonymity did little to hide each editor's interests. Picard, in particular, played a dominant role in the journal's early years, defending both the social function of art and a national style in arts and letters. The journal's advocacy role for the visual arts expanded after 1883 when Octave Maus accepted the position of secretary for Les XX. *L'Art moderne* became that group's publicity outlet and published articles on its activities and members and reviews of its shows. While maintaining its anarcho-socialist outlook, the orientation of *L'Art moderne* turned more toward symbolism after the lawyer-writer Emile Verhaeren joined the staff late in 1885.

Other journals soon joined in the critical debate initiated by *La Jeune Belgique* and *L'Art moderne*. *La Société Nouvelle* (*The New Society*), which first appeared in 1884, went one step further than *L'Art moderne* and called upon Belgium's artists to create a new society. Founded by Fernand Brouez, this journal devoted most of its monthly edition to essays and criticism. Adding an internationalist viewpoint based upon anarcho-socialist ideology to the discourse, *La Société Nouvelle* emphasized a pluralist perspective that, in Brouez's view, reflected the commonly-held beliefs of not only the artists and writers, but also the scientists and socialists of this new generation.

Initially, the symbolist perspective was supported by three journals, *La Basoche* (*The Bar Clerks*) and *L'Elan littéraire* (*The Literary Elan*), later named *La Wallonie*. *La Basoche* was formed by Charles-Henry de Tombeur and André Fontainas, former students at the Free University in Brussels, and ran from November 1884 until April 1886. In addition to discovering Belgian authors, this journal introduced the Brussels public to the symbolist poets Stéphane Mallarmé, Stuart Merrill, and René Ghil.

L'Elan, a literary society at the University of Liège, began a publication entitled *L'Elan littéraire* in 1885. Recognizing the need for a journal to report on the cultural contributions of the Walloon region, Albert Mockel, Hector Chainaye, and Charles de Tombeur took over the direction of *L'Elan littéraire* in 1886 and renamed it *La Wallonie*.[11] At first this review focused on local talent, featuring the poetry and prose of its staff and essays by Céleston Demblon and Herbert Krains, but soon *La Wallonie* became the primary vehicle for symbolist writers in both Belgium and France. Although it ceased publication in 1892, *La Wallonie* spurred the formation of the similar journals: *Floreal* (*May*) in Liège; *Le Reveil* (*The Awakening*) in Ghent; and *Stella* and *L'Art jeune* (*New Art*) in Brussels. Many of the contributors to *La Wallonie* also published in *Le Coq rouge* (*The Red Rooster*), a symbolist/socialist review created by Georges Eekhoud and former writers for *La Jeune Belgique* who had become disenchanted with that journal's stubborn allegiance to an "art for art's sake" ideology.

It was quite difficult for Flemish writers to gain recognition for their language and rich heritage because French-speaking Belgians dominated the cultural scene. Not only was French the official language of government and culture, but the Flemish were further isolated by regional dialects that set them apart by both race and class. Encouraged by the increased literary activity among the Jeune Belgique, Flemish writers founded reviews to promote their literature and art. *Het Pennoen* (*The Pennant*), founded by University of Louvain students Albrecht Rodenbach and Pol de Mont, inaugurated this revival of Flemish literature and de Mont was its leading proponent. In his next journal, *Jong Vlaanderen* (*Young Flanders*), de Mont declared his allegiance to the "art for art's sake" aesthetic while offering his readers an eclectic mix of naturalist poetry and prose and reprints of Dutch and Flemish literature.

By 1888, twenty journals dedicated to Flemish literature and art were in publication. Although most of these publications were vague on theory, all maintained an anti-dogma, anti-bourgeoisie, anti-establishment stance. As with the Jeune Belgique, divisions soon arose between writers who, like de Mont, supported a purely formalist approach and those who believed art should have social purpose. A different *Jong Vlaanderen*, which was published in Brussels by three lycée students, Huibert Langerock, Lodewijk de Raet and August Vermeylen, injected an anarcho-socialist perspective into the discussion, while in Antwerp *De Vrije Vlucht* (*Free Flight*) imitated the layout and aesthetic policy of *La Jeune Belgique*.

When the second *Jong Vlaanderen* folded, Vermeylen joined with Emmanuel De Bom and Lodewijk Krinkels to publish *Ons Tooneel* (*Our Theatre*), a weekly review dedicated to reviving Flemish theatre. Although this venture lasted only seventeen issues, Vermeylen soon launched another undertaking. Along with De Bom, Prosper van Langendonck, and Vingtiste Henry van de Velde, he founded the journal *Van Nu en Straks* (*From Now On*).[12]

In its title and prospectus *Van Nu en Straks* announced its intent to be the agent for the revolutionary avant-garde, independent of any group and consecrated to presenting art and literature of the present and the future both inside and outside of Belgium. This internationalist, modernist outlook reflected the diversity of its editors and the uniqueness of this journal, which sought from the start to balance individual creative expression within the needs of social collectivity.[13]

Numerous articles in the first series of this journal (1893–1894) were devoted to theoretical discussion of avant-garde art and anarchist theory, complemented by the symbolist layout by Vingtiste Henry van de Velde and the designs of Dutch artists Jan Toorop and Jan Thorn-Prikker. Among the editorial staff, Vermeylen, in particular was concerned with the social role of art. In the essay *"De kunst in de vrije gemeenschap"* ("Art in a Free Society") he presented a model, influenced by symbolist theory, of art as an idealistic, non-materialistic force free of all authority except the laws of nature.[14] The first series of *Van Nu en Straks* came to an end after only one year, mainly due to the excessive costs of production of its innovative typography and ornamentation.

When he revived *Van Nu en Straks* in 1896, Vermeylen took an even more radical stance. In his opening essay in the first edition of the new series he attacked the traditional and reactionary elements within the Flemish movement. Arguing that language reform was not enough, Vermeylen called for a social and economic movement whose goal began with the freedom of the individual and progressed to the linguistic and political independence of Flanders. Vermeylen would later renounce these militant views, but not before his impassioned essays, together with those of Jacques Mesnil (pseudonym of Jacques Dwelshauvers) and Fernand Domela Nieuwenhuis, provided the spark for the politicization of the Flemish movement of the 1890s.[15]

As was the case with *Van Nu en Straks*, these literary journals were more than just a place where this young generation of writers could publish their work; they were also the avenue through which they could proclaim their ideals for art and society, foster collaboration, and find a collective solidarity. A small group of publishers aided and abetted these writers by printing their journals and limited editions of their poetry and prose, establishing a network and literary infrastructure that would continue beyond the short life span of most of the Jeune Belgique publications.

While the literary journals disseminated modernist art and literature within Belgium, these publishers dispersed the aesthetics of the Jeune Belgique throughout Europe. Publishing first became a profitable business in Belgium in the 1840s, as a result of the country's relaxed censorship and flourishing trade in unauthorized editions of French novels. After this practice was banned in 1852, Belgian publishers turned to printing censored French writers such as Charles Baudelaire and Victor Hugo or political pamphlets that spread liberal ideas north to Belgium.

One of the earliest and most important of these publishers, Henry Kistemaeckers, kept his small printing house in Brussels profitable by publishing socialist pamphlets; naturalist writers such as Paul Claudel, Guy de Maupassant and J.K. Huysmans; and collections of satirical or erotic prints and prose [cat. 117]. Kistemaeckers also launched the literary career of the Belgian naturalist Camille Lemonnier by printing his *Une Mâle* (*A Man*) after it had been rejected by several French printing houses.[16]

Edmond Deman, who had been part of the editorial staff of *La Semaine des étudiants*, began publishing in 1876 with deluxe editions of Mallarmé illustrated with frontispieces by Edouard Manet, Auguste Renoir, Odilon Redon and Whistler. He later published the work of Belgian symbolist writers, including that of his former classmate Emile Verhaeren, in limited editions that attracted a loyal following among book collectors.[17] Like Deman, Paul Lacomblez, also specialized in Jeune Belgique writers, selling books by subscription. In Antwerp, Paul Buschmann printed small editions of poetry such as Max Elskamp's *Dominical* [cat. 134].[18]

Les XX

Like their literary counterparts, the visual artists of Les XX were better schooled and more professional than the generation that had preceded them. Fifteen of the twenty original members of Les XX had attended art academies in Brussels or Antwerp and seven of those who later joined the group had attended advanced courses in art.[19] At the Academy, these future Vingtistes were taught to draw and paint from

nature and to copy from modern masters as well as from antique sculptures.

In addition to their art school training, most of the Vingtistes were familiar with contemporary art and realist theory. This knowledge was gleaned from Parisian art journals, local publications such as *L'Artiste* (*The Artist*) and *L'Art moderne*, and occasional trips to Paris made convenient by Belgium's extensive train network.[20] With their appetites whetted by modernist art and aesthetics, this new generation of young artists sought access to cultural institutions as they, like the writers, aimed to legitimize their chosen profession.

At this time, the primary route to a successful art career was through exhibition at the government sponsored annual Salon. In Belgium the national Salon was triennial, moving between the major cities of Antwerp, Brussels, and Ghent. In the 1880s the national government threatened this decentralized salon system with a plan to create a single salon in Brussels. A period of intense competition ensued as Antwerp and Ghent sought to prove their cultural importance by revitalizing and reforming their own salons.[21] As a consequence of these reforms, not only were young Belgian artists able to see modernist paintings at the national Salon by artists such as Albert Bastien-Lepage and Henri Fantin-Latour (exhibiting in Brussels in 1881), and Edouard Manet (on view in Ghent in 1880 and in Antwerp in 1882), they were able to show their own work as well.[22]

Even if the Salon remained the primary place for an enterprising young artist to exhibit, other exhibition societies offered the possibility of exposure, sales, and government patronage. The State-sponsored Artistic and Literary Circles also organized shows, but only for artists who had shown at least twice at the Triennial.[23] Exhibitions sponsored by the groups L'Essor (The Flight) in Brussels and Als Ik Kan (As Best I Can) in Antwerp, though linked through patronage to the Academy, lent themselves the air of independence by eliminating entry requirements.[24] But these groups, the Salon, and the Cercles Artistique were commercially motivated. As a result, L'Essor and Als Ik Kan's exhibitions were characterized by an eclectic mix of styles with progressive and conservative artists showing together. As Jane Block has written, it was the crass commercialism of L'Essor, as well as their persistent conservatism engendered by King Léopold II's sponsorship of the group, that prompted many of its members to break away to form Les XX.[25]

The concept of a self-supporting exhibition society independent of official sponsorship and dedicated to the exhibition of modern art did not originate with Les XX but rather with the Société Libre des Beaux-Arts (The Free Society of Fine Arts) founded in 1868 [fig. 2].[26] Though they declared themselves open to all styles, the primary purpose of the Société Libre des Beaux-Arts was to promote realist style and theory. Even though they organized only a few salons in 1872, their impact on the Belgian art world was extensive, due to the publication of the bimonthly *L'Art libre* (*Free Art*), which defended and disseminated the group's ideas.[27] The Société Libre used its collective voice to fight for the representation of younger artists and new styles at the Salon. Although they paid for their aggressive tactics with exclusion or poor placement at official exhibitions, eventually their polemics paid off. As evidenced by the works by Société Libre artists on view at the 1872 Triennial Salon and by the successful exhibition of Charles Herman's socially critical *À l'Aube* (*At Dawn*) at the 1875 Salon, realist technique had become acceptable in official circles. Although Société Libre ceased to exist in the mid-1870s, the group's call for the free and individual interpretation of nature, their confrontational tactics, and their use of a journal to promote their ideas was taken up first by La Chrysalide (The Chrysalis) and later by Les XX.

Like the Société Libre, La Chrysalide, formed in 1875, was known for its aggressive and independent spirit. Their group polemic was clearly stated in an etching by Félicien Rops used as the invitation for their first exhibition [cat. 115]. In this print the group's youthful enthusiasm is symbolized by children and butterfly larvae interwoven into the letters that spell out the group's name, while their anti-Academic and anti-Salon stance is embodied by butterflies that hatch from a cocoon (the "chrysalis" of the group's name) to hover over a sarcophagus labeled "academic painting." The membership of La Chrysalide included musicians and singers in addition to artists. Its interests were defended by *L'Artiste*, whose editor, Théo Hannon, was also a member of the group.

The Société Libre and La Chrysalide were independent art circles, formed to promote realist practices and technique in alternative exhibition spaces. Although animated by the same modernist outlook as these exhibition societies and even sharing some of the same artists, Les XX's goals were more ambitious.[28] Rather than a small group of artists who all shared the same style and exhibited in a rented space, Les XX brought together divergent styles into the same rooms where the national Salon would later be seen.[29] In this fashion, Les XX interjected their salons into the public discourse of official culture, further

encouraging the Brussels populace to view their salons as the avant-garde equivalent of the Triennial.[30]

Objecting to the lottery system used by L'Essor, which commodified the work on view, Les XX substituted an entry fee. This fee and a 25 franc surcharge on each Vingtiste (returned after each salon) allowed Les XX to be self-sufficient and to present exhibitions based on quality and not on public taste. While accenting their own professionalism, Les XX appropriated L'Essor's exhibition policies: they hung each artist's work separately and organized lectures and concerts in conjunction with their salons. Yet even as they borrowed from L'Essor, Les XX intended that they be publicly perceived as an avant-garde alternative to that group. As Jane Block has written, they chose a numerical title that set them apart while simultaneously criticizing L'Essor's governing committee of twenty members.[31]

The fact that Les XX wished to remain independent of the commercial practices of L'Essor and the national Salon does not mean that they were not interested in sales or in making a profit. Indeed, the group's self-sufficiency and longevity was dependent upon their ability to attract a paying public and to promote and sell the work on view. L'Art moderne played an important role in generating publicity for the group. Before each Les XX salon the journal published the names of the exhibiting artists and afterwards, a list of works sold. The journal also reviewed the salons, publishing supportive articles on the artists on view as well as extracts of negative reviews by hostile critics. These promotional tactics all furthered the group's radical, avant-garde image in the public eye. As the Les XX exhibitions became fashionable, many Vingtistes and their invited guests sold their work.[32]

By establishing a reputation for selling work, more artists were willing to exhibit in Les XX and, in turn, the participation of the invités insured Les XX's fame and fortune.[33] As the group's salons became known as the place to see controversial avant-garde

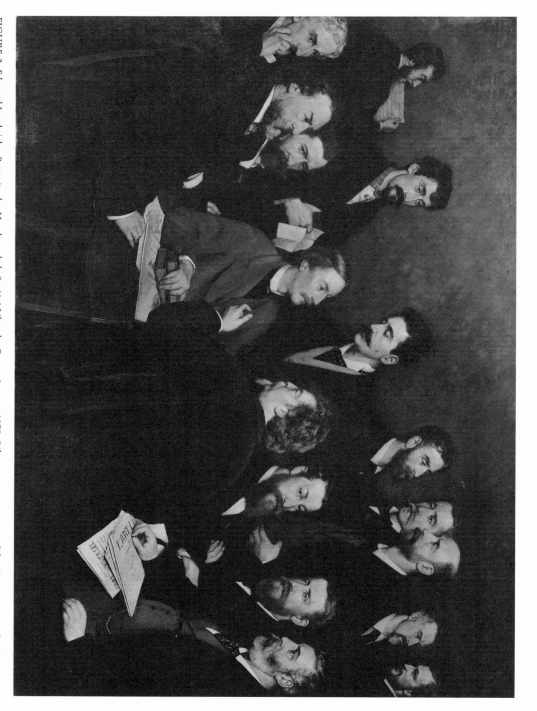

FIGURE 2. Edmond Lambrichs, Portraits des Membres de la Société Libre des Beaux-Arts, ca. 1875. Oil on canvas, courtesy of the Musées royaux des Beaux-Arts de Belgique.

art, increasing numbers of the general public (that is the middle class who could afford the fifty centime entry fee) flocked to the Les XX exhibitions.[34] Les XX's first salon made only 580.33 francs, but revenues increased steadily in each successive year until the last two. When the group dissolved in 1893 they had earned over 50,000 francs.

Les XX's openings became social events that even the official art world could not ignore. By the opening of Les XX's second salon in 1885, state ministers, members of the Senate, and numerous aristocrats were in attendance. Over fifteen hundred people attended the opening of the group's fourth salon in 1887, leading some to complain that the works on view could not be seen for the crowd. Paul Signac accompanied Georges Seurat to the opening, where the latter's *Sunday Afternoon on the Isle of the Grand Jatte* (1886, The Art Institute of Chicago) was on view. Afterwards he wrote to Camille Pissarro: "I have just left the exhibition exhausted. An enormous crowd, a terrible throng, very bourgeois and anti-artist. All in all it is a great success to us. Seurat's canvas was practically invisible, it is impossible to get near it, so dense was the crowd."[35]

One critic commented on Les XX's ability to put on a good show, "Oh! Les XX, what skill they show, as they know how to whip up their annual exhibitions with savvy announcements, as they make art to excite curiosity, to incite artistic quarrels and to intrigue the indifferent."[36] By making a profit and attracting a large following, Les XX succeeded in their goal. Where the Société Libre and La Chrysalide had provided alternatives to the national Salon, Les XX replaced it entirely.[37]

As the Les XX salons became established, the group's installations became more complex and their advertising more sophisticated. The artist-members designed posters to publicize their exhibitions and catalogues that listed the artists and works in every salon [cat. 57, 68–70 and 145]. Les XX's first catalogues were not unlike those of the national Salon, L'Essor, but as the group became more popular and profitable, the catalogues came to symbolize Les XX's aesthetic.[38] For the fifth salon, Les XX's accent on anarchist individualism was underscored both by the inclusion of a drawing or handwritten list of each artist's works reproduced on a separate page in the catalogue and by the red cover with the Les XX emblem embossed in black [cat. 1, 50, 91]. Although this use of drawings or the red cover was not new to Belgium, the presentation in a book format certainly was.[39]

In later catalogues, careful attention was paid to paper, layout, and type, all with the intent to set the exhibition catalogues and Les XX apart from the other exhibition

societies of the period. The intent of the members of Les XX to present themselves to the public as the revolutionary pioneers of the Belgian avant-garde is evident in Georges Lemmen's dramatic 1891 and 1892 covers. The first depicts a red sun labeled Les XX rising over a turbulent sea and the second shows a red banner with Les XX's emblem in front of a fruit-laden tree [cat. 68 and 69].

In addition to publicizing and documenting their salons, Les XX paid close attention to the installation of the exhibitions. The group rejected the typical salon-style floor to ceiling arrangement and instead grouped the paintings of each artist together, hung from a railing at eye level [fig. 3]. Though this organization stressed individual style, the group's unified stance was reinforced by the prominent placement of their double X emblem, designed by Fernand Khnopff, on the wall of each room.

As the Vingtistes grew more sophisticated in exhibition installation, other innovations followed. In 1885 they closed off the rotunda of the Palace of Fine Arts to provide more room for the exhibition and the year after they began to hang works by artists practicing the same stylistic approach together. Individual artists could suggest the arrangement of their works, as Whistler did in 1884 and 1886. At the 1890 and subsequent salons, the neo-impressionists in the group acknowledged their debt to Georges Seurat's theories of complimentary color by arranging their works on drapes tinted olive green.[40] The group also refused to separate fine from applied art and they combined drawings, prints, decorative art, and printed books in the same rooms with paintings and sculpture. By acknowledging the importance of installation to the presentation of their ideas, Les XX offered an experience quite different from the massive floor to ceiling display of the national Salon, one that promoted through the harmonious and decorative arrangement of their exhibitions the notion of individualism within the context of a unified and harmonious avant-garde.

Les XX's accent on individualism can be seen not only in the diversity of artists and works on view, but also in the fact that the organization was self-governing, giving each member a voice in invitations and membership. Les XX replaced L'Essor's elaborate system of rules with a more democratic process that distributed the decision making and the organization of salons among group members. They eliminated jury or selection committees and instead asked members to suggest artists to invite. A committee composed of three members was then responsible for the installation. What set Les XX apart from contemporary

groups in Belgium and France, however, was the active participation of its members and their friends in organizing the group's salons, scouting out new talent, and making contacts, first in France and then with artistic contemporaries in other countries.

Through their ties with the earlier Société Libre and La Chrysalide groups, the Vingtistes had some connections with the Parisian art scene.[41] This bond was strengthened in the 1880s when members of Les XX visited or lived in Paris and, later, when their invited guests attended the opening of the Les XX salons in Brussels.[42] The close relations between French artists and Les XX were affirmed at the end of 1887 when the Société des XXXIII (The 33 Society), which included several Vingtistes, opened their first exhibition at the George Petit gallery in Paris on 30 December 1887.[43]

Vingtiste Théo Van Rysselberghe, in particular, was an avid francophile and played a prominent role in bringing French modernism to Brussels. As his letters to the group's secretary, Octave Maus, indicate, Van Rysselberghe often travelled to Paris, where he contacted many young artists. Through his efforts

FIGURE 3. Anonymous, photograph of a Les XX salon, 1884. Archives de l'art contemporain en Belgique, Brussels.

Louis Anquetin, Gustave Caillebotte, Albert Dubois-Pillet, Paul Gauguin, Armand Guillaumin, Louis Hayet, Paul Helleu, Paul Signac, and Vincent van Gogh all received invitations to exhibit with Les XX.[44] Van Rysselberghe is particularly remembered for having discovered the work of Henri de Toulouse-Lautrec, who had never publicly exhibited before he was invited to show with Les XX in 1888.

In addition to making arrangements for these artists to exhibit at Les XX, Van Rysselberghe acted as the liaison between Maus and his fellow Vingtistes Willy Finch, Willy Schlobach, and Frantz Charlet. He often conveyed to the group's secretary their exhibition needs, titles of works for the catalogue, and opinions on group membership. Van Rysselberghe was also quite involved with the design and layout of the salons. His suggestions included employing the peristyle or the rotunda of the Palace of Fine Arts as a display area, the use of movable panels to hang paintings, and, as mentioned above, the hanging of tinted drapes to create a harmonious environment for the works on view.[45]

Van Rysselberghe was often assisted in these activities by his good friends: Emile Verhaeren, the

L'Art moderne editor and poet, neo-impressionist Paul Signac, and symbolist painter Eugène Boch. Verhaeren had been won over to neo-impressionism when he saw Georges Seurat's work at the 1886 Impressionist exhibition in Paris and recommended to Maus that Seurat be invited to the next Les XX salon.[46] In the years that followed, Verhaeren actively promoted neo-impressionist artists and defended its practitioners in his essays and art reviews. Signac, who's first contact with Les XX was when he travelled to Brussels with Seurat to attend the opening of the 1887 salon, was also well connected to the Parisian art world. Even before he was elected a member of Les XX in 1891, Signac often acted as an intermediary for the group and he provided Maus with the addresses of Lucien and Camille Pissarro, Alexandre Charpentier, Paul Gauguin, Jean Baffier and Albert Bartholomé. Moreover, Signac encouraged Charpentier to show his work at Les XX in 1890 and Jules Chéret to send his posters there the next year, and arranged for the Seurat retrospective of 1892.[47] Signac was also the president of the Society of Independent Artists and through him the Vingtistes Van Rysselberghe, Lemmen, and van de Velde were invited to exhibit with this Parisian group. Although not a Vingtiste himself, Eugène Boch (brother of Vingtiste Anna Boch) often discussed the group's affairs with his cousin Octave Maus, the Vingtiste secretary. When Maus came to Paris, he consulted with Boch on artists and events in both official and avant-garde circles. It was due to Boch's recommendations that van Gogh, Toulouse-Lautrec, Gauguin, and Emile Bernard received invitations to exhibit with Les XX.

Verhaeren and these artists expanded the group's already strong ties with France, while Willy Finch, Fernand Khnopff and Georges Lemmen provided most of the contacts with London. Although they did not meet until Finch traveled to London in 1885, he requested Whistler's invitation to the first Les XX salon and in 1886 nominated the American artist for membership. Whistler repaid Finch for his support by inviting him to show at the Society of Royal British Artists from 1886 until 1888. Finch also proposed invitations for British artists Walter Sickert and, on Whistler's advice, Waldo Story to the 1887 salon. Khnopff did not journey to England until 1891, but he began to exhibit there in 1886 and was quite familiar with the work of contemporary British artists. In his requests for invitations, Khnopff promoted Whistler and Pre-Raphaelite and Arts and Crafts artists. Like Khnopff, Georges Lemmen, who had been elected to Les XX in 1888, had a strong interest in both Whistler and the Pre-Raphaelites and he also encouraged their invitation to Les XX. Later all three of these Vingtistes became interested in the writings of John Ruskin and William Morris, and the English Arts and Crafts movement. Due to Lemmen's initiative, Walter Crane's picture books were exhibited at the 1891 Les XX salon. As a result of both Lemmen's and Finch's interest in the decorative arts, Herbert Horne and Selwyn Image (associated with the Century Guild in England) were invited to show at the 1892 salon.

The relationship between the Vingtistes and their Dutch contemporaries also appears to have been quite close. Les XX's ties with Holland and especially The Hague school were already well established in 1884, as their invitations to Louis Artan, Joseph Israëls, Willem Maris and Anton Mauve to their first salon suggest. These contacts increased with the group's continued invitations to the other Dutch artists Willem Mesdag in 1885, Isaac Israëls and George Breitner in 1886, and Willem and Matthijs Maris, Philippe Zilcken, and Marinus van der Maarel in 1887. The Dutch artist Jan Toorop, elected to Les XX at the end of 1884, lived in Holland between 1886 and 1887 and in the spring of 1890 settled at Katwijk-aan-Zee. Although it is difficult to ascertain when Toorop made his first contact with other Dutch artists, he would later be instrumental in bringing Floris Verster and Jan Thorn-Prikker to exhibit at Les XX.[48] Even more importantly, Toorop helped to introduce the art of Les XX to Holland. In 1889 he organized an exhibition of Les XX artists for the Panorama Society of Amsterdam and in 1892, along with Théo van Rysselberghe and Henry van de Velde, Toorop arranged for an exhibition of members of Les XX and the Antwerp-based Association pour l'Art at the Haagsche Kunstkring (Art Circle of The Hague) [fig. 4].[49]

While these artists were active in discovering new talent for Les XX, Henry van de Velde, who became a member in 1889, actively disseminated Les XX's ideas within Belgium. Even before he was elected to the Brussels group, van de Velde helped poet Max Elskamp form the Antwerp artist's association, L'Art Indépendant (Independent Art). Dissatisfied with the conservative nature of Antwerp's art societies, L'Art Independant modeled themselves after the Brussels group and even invited several of that group's members to exhibit at their 1887 salon.[50] Although this group was short-lived, van de Velde's second group, L'Association Pour L'Art (The Association for Art), was more successful.[51]

The person responsible for working with all of these artists and joining their art together into a cohesive salon was the group's secretary, Octave Maus. While his colleagues Picard and Verhaeren at *L'Art moderne* focused their attention on promoting Les XX

and developing the group's polemic through editorials and reviews, Maus's duties were mainly administrative. In addition to contacting artists and securing their participation, Maus arranged for shipment of artworks to and from the salon. He was also responsible for obtaining exhibition space. As a lawyer specializing in copyright law and artist's legal rights in the Brussels Appeals Court, Maus had close ties with the government and these contacts helped smooth the way for the group to exhibit in the Palace of Fine Arts.[52] As Les XX became more prominent, however, Maus' link to the government caused him to become

more cautious as to what the group exhibited. For example, in 1891 he blocked exhibition of James Ensor's satirical indictment of the Belgian legal system, *Les Bons Juges* (*The Good Judges*), stating later that he feared public outrage at the work would cause the Les XX exhibition to be closed. Apparently, Edmond Picard did not agree with Maus that Ensor's painting would cause problems and the work was shown at Les XX in 1892.

Though there can be no doubt that Maus' talent as an organizer contributed to Les XX's longevity, it also led to friction within the group. As he assumed

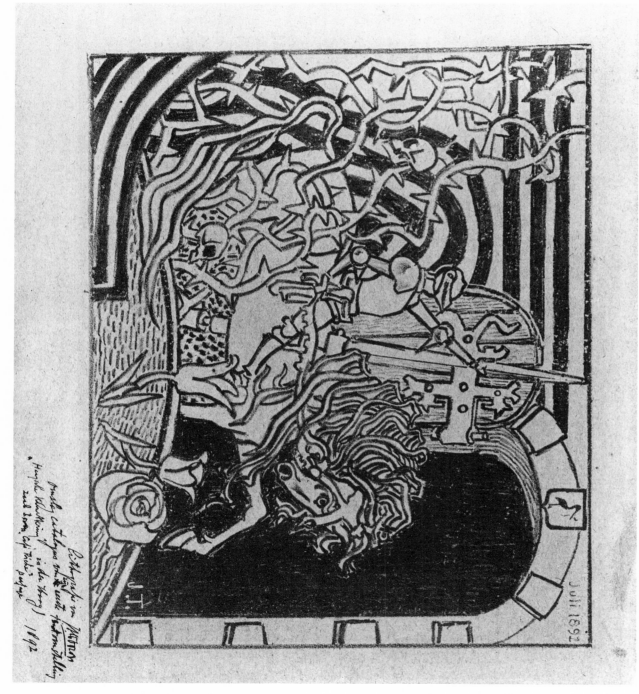

FIGURE 4. Jan Toorop, *De ridder voor de poort* [*The Knight before the Gate*], cover for *Tentoonstelling van schilderijen en teekening van eenigen uit de "XX" en uit de "Association pour l'art"* [Exhibition of paintings and drawings by some of the "XX" and the "Association pour l'art"], held at the Haagschen Kunstkring, The Hague, lithograph in blue, 1892. Collection Haags Gemeentemuseum, The Hague.

more and more control, Les XX's exhibitions took on a decidedly French alignment, such as Van Rysselberghe, found favor with Maus, while those who supported a more nationalistic, Belgian focus for the group, including Ensor, had a much more difficult time. In fact, in the waning years of the group, the antagonism between Ensor and Maus became so strong that Maus avoided informing Ensor of the group's activities and meetings.[53] Maus's dissatisfaction with the group's democratic orientation and his own desire to have more power also contributed to the dissolution of Les XX. Apparently, at the same time that he solicited votes among the membership for disbandment by suggesting that avant-garde groups should not last more than ten years, Maus already intended to form another group, La Libre Esthétique (The Free Aesthetic), that he alone would direct.[54]

In addition to the Les XX salons, Maus organized the musical evenings that accompanied each exhibition. Like the lecture series sponsored by Les XX, the idea of presenting concerts in conjunction with a salon was not new. Both the government-sponsored Cercles Artistique and quasi-independent groups such as L'Essor held regularly scheduled concerts, but at Les XX these auditions became part of the group's aesthetic.

Music in Belgium enjoyed official patronage, as did the other arts. State sponsorship included the National Conservatory of Music in Brussels, the annual *Prix de Rome* scholarship, and popular concerts devoted to educating the public on works of Belgian composers and musicians. In the 1870s, the Brussels Conservatory, under the direction of François-Auguste Gevaert, gained a reputation that rivaled similar institutions in Paris and Germany. As more and more musicians of international fame travelled to Brussels to teach or give recitals, that city became an important music center.[55]

Although the State promoted a national school of music, in general French music was favored, especially in Brussels, and composers such as Peter Benoit, who sought to develop Belgium's native Flemish heritage in music, received far less official patronage.[56] In addition to the strong French presence, many of the musicians who taught or performed at the Conservatory advanced the music and ideas of Richard Wagner in their classes and concerts. Gevaert, for example, disseminated Wagner's early works through his own highly personal adaptations. Also, the conductor Adolphe Samuel presented many of Wagner's operas and lyrical dramas in public concerts at Brussels' Royal Park. Even the royal court knew of the German composer's work, as Wagner's opera

Lohengrin was first performed at the Théâtre Royale de la Monnaie in 1870.

As a member of the Brussels Wagnerverein, Octave Maus often promoted the German composer in reviews and essays for *L'Art moderne*, but at Les XX it was not Wagner but contemporary French music that prevailed.[57] The predominance of the modern French school at Les XX reflected the influence of the French composer, Vincent d'Indy, as well as the close musical ties between Belgium and France. Beginning in 1888, d'Indy worked with Maus in organizing the Les XX concerts.[58] As a result of their collaboration, those attending Les XX's concerts heard premieres of compositions by, among others, d'Indy, Gabriel Fauré, Ernest Chausson, Charles Bordes and Emile Mathieu. Although French, d'Indy and many of these composers were also ardent admirers of the Belgian composer César Franck. Due both to d'Indy's enthusiasm and to the sensitive interpretations of Franck's compositions by the Belgian violinist Eugene Ysaye, the composer's work and legacy came to dominate the concerts of Les XX's later salons.

Even though music by Russian, Scandinavian, and Flemish composers was heard at Les XX salons, the accent on French music underscores the influence that French modernism had on Les XX. As the group embraced successive waves of artists from the south, internal conflicts that pitted nationalist interests within the group against those who saw the group as aligned with France and a more internationalist outlook became more prominent. This debate over national style, which eventually led to a falling out between Maus and Edmond Picard, was an issue not just of concern for the Vingtistes, but for all of the Jeune Belgique. Along with the modernist debate over which form artistic expression should take and what should be its role in society, the question of nationalism was central to the aesthetic discussions of this period. The ensuing debate within the Belgian avant-garde over nationalism only accentuated further the confused and often contradictory relationship between Belgian and French intellectuals at the turn of the century.

The Aesthetics of the Jeune Belgique and Les XX

Nationalism

Ever since the War of Independence in 1830, Belgium had turned to France, its southern neighbor, for critical theory and cultural validation. Belgian authors, for example, measured success by publication in France,

while artists sought exposure at the Parisian Salon. At the same time, French writers found Belgium, with its less restrictive censorship, to be a receptive haven for their gritty realist novels and paintings.

Nowhere was this conflicted relationship more apparent than at the offices of *La Jeune Belgique*. Although the chauvinistic associations of its chosen title would suggest that *La Jeune Belgique* was a nationalist call for Belgian youth to produce a native school of arts and letters, as Joseph Hanse has noted *La Jeune Belgique* took its title from the contemporaneous French journal *Jeune France* (*Young France*).[59] This French connection was also evident in the Belgian review's program and motto:

"Before everything else, We make Literature and Art. Young Belgium will not be any school. . . . We invite youth, that is to say the strong and loyal, to aid us in our work. They will show that there is a Young Belgium like there is a Young France and that with us they will take for a motto: *Soyons nous* (Be Yourself)."[60]

From *La Jeune Belgique's* point of view however, "Be yourself" did not mean "be Belgian" but rather, be an individual without ties to nationality, politics, religion or ideology. Yet even as the editors of *La Jeune Belgique* disavowed nationalism, they did not deny its importance in the formation of an individual's aesthetic vision.

Although Belgium's dominant aristocratic and bourgeois classes maintained strong nationalist beliefs, members of the lower middle and working classes were less concerned about issues of national identity or culture.[61] Despite this lack of support among the lower classes, the Socialists strongly championed the notion of a "Belgian spirit." Edmond Picard, in particular, promoted national identity because it reinforced his view of the social role of culture in society:

To see the Belgian milieu, to think in Belgian, here is what the Belgians ought to do. Yes to think in Belgian! that which, contrary to fashion, cannot be said, get rid of the flandricisms, but give way to the spirit to see and to express ideas according to the natural propensity of our habits and our race.[62]

Yet even with the call for unity and the attention Picard and other socialists paid to Belgian nationalism, there was not a joining of these two groups within the Belgian avant-garde. Instead, regionalist movements developed in both the north and the south.

Like the Jeune Belgique, Les XX took an active role in promoting Belgian arts and letters. They exhibited the work of older Belgian artists while providing an alternative exhibition space for the emerging generation of painters and sculptors. In their first four salons they sponsored lectures by Belgian writers and critics on their literary contemporaries and recitals of work by Belgian composers and musicians.[63] Despite this support of Belgian art, the issue of nationalism lead to conflicts between those members inclined toward a more internationalist perspective and those who wished the group to exhibit and champion only Belgian artists.

Les XX, as the Société Libre and La Chrysalide before them, was formed as a place to showcase artists who shared the group's aesthetic concerns. Thus theory and stylistic approach, rather than nationality, motivated their invitations. Membership in the group was another matter, however. Initially, Les XX members sought to reinforce the idea that they represented all of Belgium by including artists from every major city in the group.[64] The illusion that Les XX represented a national group of avant-garde artists did not last past their first salon, however. Two artists from Antwerp, Jef Lambeaux and Piet Verhaert, resigned during the first salon and Frans Simons and Théodore Verstraete, also from Antwerp, left in 1885. Jean Delvin and Gustave Vanaise, both from Ghent, quit the following year.[65] Although the conservative orientation of these artists obviously conflicted with the more progressive viewpoint of the majority of Les XX's members, their departure and the subsequent debates over who should become a member called into question the group's role in supporting and sustaining Belgium's national culture.

In 1886, American artist James McNeill Whistler, who had exhibited with the group in 1884 and 1886, was nominated for membership by Willy Finch. From Finch's viewpoint, Whistler's election would add an artist of substantial stature to the group, thereby advancing their international credibility. Finch's close friend, James Ensor, led the opposition with strenuous objections to Whistler's nationality and reputation.[66] Evidently the majority of the group agreed with Ensor, as they voted not to admit Whistler and to leave the vacant spots open for young Belgian artists.[67]

The controversy over Whistler's candidacy forced members of Les XX to examine their commitment to Belgian art. Although their decision to deny Whistler and elect Henry de Groux, the son of the Société Libre artist Charles de Groux, signalled the resolve of some members to promote young Belgian artists, their zeal for modernist theory would lead the group on an increasingly international course. Though they continued to add Belgians to their membership (Georges Lemmen and Henry van de Velde in 1889, Robert

Picard in 1890, and George Minne in 1891), the election of Auguste Rodin in 1889 and Paul Signac in 1891 testified to Les XX's move away from a nationalist orientation.

The Modernist Debate

The call for self-expression while simultaneously denying national identity is but one of the inconsistencies that characterize the nature of Belgian modernism. The Jeune Belgique movement, in fact, is known for the diversity of its stylistic schools, which range from naturalism to symbolism and from "art for art's sake" to "art for society's sake." Even though modernist theory is based on the notion that the individual is the primary interpreter of contemporary life and it sanctions the multiplicity of artistic practice, for some the result was an eclectic mixture lacking in originality. For others, this diversity suggested a tolerance for difference that allowed for the co-existence of many groups and the cross-fertilization of ideas.

I. Naturalism—From a twentieth-century perspective it is perhaps difficult to understand the passion that the debate over modernist practice incited in the artists and writers of the Jeune Belgique. Weaned on Romantic idealism and the cult of personality, these young Belgians defended their points of view with an intensity and fervor that is hard to comprehend from a jaded post-modern context. To our eyes, Zola's descriptive novels or Courbet's dark canvases and palette knife technique hardly appear radical, but in 1870s Belgium naturalist literature and realist art were associated with pornography, leftist politics, anarchy, and even civil war. Memories of the French Commune and its aftermath were still fresh in the minds of many, and those artists and writers who advocated an honest and direct representation of nature as interpreted by an individual's temperament were also often thought to be advocating the overthrow not only of taste but also of governmental authority.

With its accent on modern life and its rejection of tradition, naturalist aesthetics appealed to this new generation of Belgians, most of whom thought of themselves as naturalists or realists.[68] Like the French, the Belgian naturalists subscribed to a scientific model that understood the human condition to be determined by heredity and environment. Although initially inspired by Emile Zola, eventually the editors of La Jeune Belgique rejected this French

writer as didactic and overly dogmatic and they turned to the writers Alphonse Daudet and Camille Lemonnier. This disavowal of Zola became the point of departure for Belgian writers, leading them first to develop their own version of naturalism and then to reject this movement entirely.

As announced by L'Art moderne in its review of the group's first exhibition, Les XX committed themselves to the individual and social rationale of realism: "The study and direct interpretation of contemporary reality by the artist, left free to his temperament and master of a carefully studied technique."[69] At Les XX's early salons, most of the Vingtistes and their invited guests exhibited works inspired by the tactile brushstrokes of Courbet's tachist technique and realist subject matter. Yet, as their invitations to members of the Société Libre, La Chrysalide, and The Hague school also indicated, Les XX sought to represent their own social concerns and environment, thus underscoring the difference of a northern and native approach to that of the French realists.

In their first three salons, Les XX's commitment to realism could be found in their invitations to French plein air and impressionist painters as well as to artists from England, Germany, and Scandinavia who painted in an impressionist style. Yet, just as the Jeune Belgique writers moved away from their initial fascination with naturalism, so too did the Vingtistes refine and redefine the realist basis of their aesthetic theory. Indeed, even as their enthusiasm for Seurat and his divisionist color theories pointed to the group's ongoing investigation of realist theory, it also marked a growing dissatisfaction among some Vingtistes with the imprecision of impressionism and their desire to make art of a more universal and conceptual nature.

Even though Les XX and the Jeune Belgique writers eventually repudiated the tenets of naturalism, its aesthetic code authorized those that followed. Although the proponents of "art for art's sake" condemned the naturalists for not paying attention to a work of art's formal properties, they drew upon this notion of aesthetic independence to reinforce their own ideal of an autonomous art practice. Even if those who supported a social role for art felt naturalism had not gone far enough in engaging art with society, they acknowledge that this movement had set the stage by introducing leftist ideas and a social discourse into the content of art. Meanwhile, the symbolists claimed as their own naturalism's accent on originality and freedom of personal expression, while rejecting its descriptive approach as too materialistic.

II. "Art for Art's Sake" vs. Social Art—Whereas naturalism furnished the foundation for Belgian modernism, it was the debate between the adherents of "art for art's sake" and those who advocated a social role for art that sharply divided the emerging Belgian avant-garde. As championed by the editors of La Jeune Belgique, "art for art's sake" considered art an autonomous activity free from the restraints of society or politics. In their view, the content of art was self-contained, existing only for itself, its essential purpose was to perfect its form in order to promote an ideal of beauty. The artist became the primary vehicle to both visualize and express this ideal. By defining the role of the artist as purely formalist, practitioners of the "art for art's sake" aesthetic were able not only to justify their professional status but also to align themselves with the nationalist objectives of Belgian modernism.[70]

The autonomy of art promoted by this group was opposed by those who believed that art could not be divorced from the social milieu. From the anarcho-socialist perspective, art was more than the reflection of its surroundings, as the naturalists would have it, nor was it produced purely for pleasure. Indeed, the purpose of art, as stated by L'Art moderne's editor Edmond Picard, was "to arouse. Art destined for distraction ought to come only after that which has for its mission to improve, to fight, to elevate".[71] Although he championed a revolutionary role for the artist and writer ("The time has come to dip the pen in red ink"), Picard rejected the notion of art as propaganda.[72] As a writer himself and an avid art collector, Picard was sensitive to the needs of the artist and he sought a rapprochement between the politics of art and its practical application.[73]

This argument over the role of art in modern society was often rancorous and at times quite personal. The initial volley was sounded in a series of articles on the emerging literary movement in both L'Art moderne and La Jeune Belgique. It quickly escalated to insults and name calling. The war of words became so heated that finally Picard fought a duel with Albert Giraud of La Jeune Belgique. Fortunately, all that was injured in this face-off were the participant's egos, but the combative nature of this polemic would soon characterize the belligerent discourse of the Les XX salons. With the advent of Symbolism, the friction between these two journals reached an apex. Though La Jeune Belgique backed itself further into an uncompromising formalist stance that led to the desertion of most of its staff, L'Art moderne, after first criticizing this new approach, soon took on a pragmatic strategy.

Due to the group's realist orientation and Picard's influence, the salons of Les XX were noted for their commitment to the exhibition of social art without defining the form this type of art should take. In the early salons, the group's social orientation was found in the exhibited work of Jean-François Raffaëlli, Constantin Meunier, and the Vingtistes Finch, Ensor, Toorop and Goethals. Les XX's commitment to exhibit socially-oriented art continued through the 1880s, most notably in their numerous invitations to Meunier.[74] As the group became involved with neo-impressionist and symbolist theory, however, their anarcho-socialist perspective was expressed more in public education and activism than in artwork on view at the group's salons. L'Art moderne published articles on the social purpose of art by Proudhon and Kropotkin and reviews by the anarchist art critic Félix Fénéon. Among the Vingtistes, Van Rysselberghe, Signac, Rodin, and van de Velde contributed work to socialist and anarchist reviews. Van de Velde later joined with Khnopff, Maus, Picard and Verhaeren to form the Section d'art (Art Section) of the Socialist-built Maison du Peuple (House of the People) in Brussels.

III. Symbolism—Although symbolist writing could be found in the Belgian journals La Basoche and L'Elan littéraire as early as 1885, it did not have a name or coherent exegesis until Jean Moréas' 1886 manifesto, published in Paris and reprinted later in Brussels.[75] Rejecting the naturalist's pursuit of the objective realm, Moreas moved artistic expression toward an even stronger emphasis on the subjective sphere and the timeless domain of ideas.[76] In pursuit of the conceptual, the symbolists moved from description to suggestion. As a result they saw formal devices, such as structure or language in literature or color and shape in painting as only a means to an evocative end. This disavowal of formalism led the symbolists into a direct confrontation with the followers of the "art for art's sake" doctrine.

As Herman Braet has shown, the "art for art's sake" criticism of symbolism encompassed four areas: language and style, free verse, originality, and clarity.[77] In order to create an original work, symbolist writers freed their prose and poetry from the constraints of traditional grammar and syntax. Searching for new and original ways to express their ideas, the Belgian symbolist writers Max Elskamp, Charles van Lerberghe, Maurice Maeterlinck, and Emile Verhaeren emulated the simple naïveté and "primitive" manner of folk and popular art. They turned to the Middle Ages for their inspiration. To the defenders of "art for

art's sake," this medievalizing was symptomatic of the encroachment of Flemish and Germanic ideology on what they felt was the superior Latin and classical legacy of the French culture. This xenophobia is repeated in the formalist repudiation of the symbolist search for sonority. For those adherents of "art for art's sake," the symbolist's use of language as sound rather than as syntax resulted in confusion, incoherence and unintelligible sounds even as it reduced poetry to a secondary status behind music.

Literary chauvinism also underscored the debates over free verse. Followers of "art for art's sake" attacked free verse as antithetical to the spirit and tradition of the French race. The formalists also found the symbolist obsession with originality to be bizarre and banal. What the symbolists touted as individualism and the creation of a new poetic form, others saw as jargon and originality for its own sake. They spurned the emotional subjectivity and sense of mystery to which the symbolists aspired, preferring instead a discipline of order and objectivity. To the formalists, the symbolist abandonment of classical French versification for arrhythmic phrasing, uneven rhyme, individualism, 'the cult of the new' and evocative obscurity led to a provincial art without rules that was tantamount to anarchy: "If all the world set out to be original and personal, one would arrive quickly at a most complete anarchy, similar to that which reigned around the Tower of Babel. Each would have his own language, his own pronunciation and his own spelling."[78]

Although their conceptual orientation proved antithetical to the precepts sacred to the believers in "art for art's sake," the symbolists found more consensus among anarcho-socialist intellectuals and those who advocated an engaged social role for artists. By redirecting the naturalist/realist aesthetic toward a more subjective orientation, the symbolists had not rejected that movement's interest in modern life, nor had they opposed a social role for art. In fact, both the symbolists and the anarchists based their ideology on the freedom of the individual in expression and in social contract. The symbolists and the socialists had other interests in common as well; both movements maintained an empathy for the misery of the lower classes, an admiration for the humble, and an idealistic faith in social redemption.[79] Recognizing that these commonly-held principles and the potential for cultural validation of the anarcho-socialist ideology were more important than any debate over form or technique, those who advocated a social role for art overlooked the symbolist fixation on personal expression and instead advanced programs based upon

co-operation.[80] The most famous of the collaborations between the symbolist and socialist members of the Belgian avant garde was the Section d'Art. This artistic wing of the Belgian Workers' party presented lectures, concerts and discussions on contemporary art, literature, politics and music to Brussels's working class. With such idealistic premises, the Section d'Art lasted only a few years, but it was this successful collaboration between socialist and modernist theory that initiated a national school of arts and letters.[81]

Symbolist theory encouraged visual artists to freely invent from nature and to portray their fantasies and visions as real. At Les XX, the symbolist-oriented artists generally utilized one of two approaches. One group, which included the Vingtistes Fernand Khnopff, James Ensor, Henry de Groux, and the invités William Degouve de Nunques, Xavier Mellery, and Odilon Redon, chose to alter the context and thus the interpretation of their representation of reality. Khnopff, Mellery, Degouve de Nunques and Redon simplified their compositions and often utilized muted light and a soft focus to create a dreamlike, even visionary atmosphere in their artwork. Rops and de Groux made imaginary transformations of literary texts in order to realize their personal vision of the world while Ensor exaggerated and distorted his figures and masks to represent the contemporary world as hypocritical and corrupt. Other Belgian symbolists appropriated a more synthetist approach, simplifying and flattening form, exaggerating line and heightening color to create artworks expressive of their creator's ideas. George Minne drew slender gesturing figures whose expressive deformations recall the anguished yet spiritual ambiance of medieval art. Toorop's paintings and drawings accentuated surface patterns and linear arabesques and van de Velde joined Seurat's color theory with van Gogh's energetic line (van Gogh had shown with the group in 1890 and 1891) to create stylized images of peasants at work or nearly abstract seascapes [fig. 5].

Due to Les XX's support of neo-impressionist and symbolist theory and social art, their involvement with decorative art was almost inevitable. Both symbolism and neo-impressionism emphasized the artificial and arranged nature of art-making and thus the underlying decorative nature of all art. Also, Picard actively promoted decorative art in his editorials in L'Art moderne. In his view, decorative art played an essential role in society as it instructed the masses on the universal principles of beauty, thereby raising their living standards and the aesthetic values of the whole community.[82]

At Les XX's first five salons decorative art was confined to the traditional avenues of book illustration and medallion design. By 1888, however, the group expanded their exhibitions to include decorative panels, ceramics and glasswork. The group's last three salons witnessed the flowering of applied art as Les XX exhibited tapestry and book design, posters, and furniture. Intermixed freely with the paintings and sculpture on view, these decorative objects were often placed on stands to raise them to an equal standing with the other artwork.

The alliance of socialism, symbolism and decorative art privileged by the salons of Les XX placed before the Belgian public for the first time the aesthetic that would soon be called art nouveau. As symbolized by Les XX's installations, catalogues, and production of decorative art objects, this unity of social theory and modern style suggested an avant-

garde style. Yet despite the symbolic and social ideal allied with decorative art at the salons of Les XX, the art nouveau style that ensued failed to produce the social transformation that Picard had envisioned. Indeed, it was but a short time before these same avant-gardists were creating chryselephantine sculpture to glorify the government's acquisition of the Congo or designing and decorating homes for Belgian industrialists.[83] Similarly, the innovations in layout and book design instigated by the symbolists and members of the English Arts and Crafts movement never transformed the living standards of the working class but remained, instead, the property of middle class book collectors. This inability by Les XX and the Jeune Belgique to sustain its radical tenets and create a permanent revolution in art and society brings us to question both the nature of this movement's radicalism and its self-definition as avant-garde.

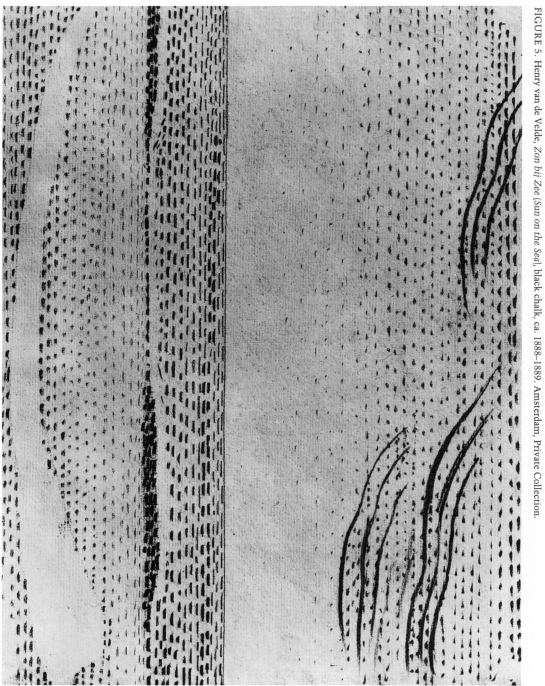

FIGURE 5. Henry van de Velde, *Zon bij Zee (Sun on the Sea)*, black chalk, ca. 1888–1889. Amsterdam, Private Collection.

Success and Failure of the Belgian Avant-Garde

In the 20th century, the avant-garde has come to be associated with youthful revolt, an aggressive and provocative attitude, the pursuit of novelty, and a messianic belief in the social benefit of personal expression.[84] These aspects describe the activity of the Belgians, but were they truly avant-garde? Were they motivated by a desire to overthrow the status quo or more personal reasons? What were their goals and did they achieve them? In other words, what was the contribution of the Jeune Belgique and Les XX to the cultural discourse of 19th-century Belgian arts and letters?

The Jeune Belgique and Les XX would fit within most profiles of the avant-garde. Their members were young, middle-class, highly educated, and professional. They knew each other and they formed a collaborative network that fostered communication and support. At events such as the banquet to commemorate Lemonnier and Les XX's salons, the Jeune Belgique positioned itself in opposition to the official culture with an aggressive stance that it maintained throughout the 1880s.

Despite their public antagonism, the Jeune Belgique, like the establishment they opposed, only desired a piece of the economic and cultural pie. In the face of an intransigent official culture, the writers established their own journals and network of publishers, managing in the process to establish their reputations both in Belgium and abroad.

From the beginning, Les XX set themselves against the national Salon ("If they are not content in their place, let them exhibit together!" was the group's motto for their second salon) but their goal was to replace one salon with another.[85] Although innovative in the way in which they exhibited artwork and in the type of work they included, they did not aim to overthrow the system, only to re-align it to their own viewpoint. Like the Triennial Salon and other official groups, Les XX planned to sell art and make a profit. Yet even as they succeeded in bringing new art to Belgium and making money, Les XX inspired few imitators and no successors.[86] Indeed, the dynamic mix of democratic individualism that characterized Les XX also made them unique. The same energy was not repeated at La Libre Esthétique, despite the inclusion of many ex-Vingtistes, as Maus alone determined who would exhibit. Likewise, groups that existed outside the Brussels support system, such as L'Art Indépendant and the Association Pour L'Art, were short-lived. Yet, even though their

impact on Belgium was limited mainly to Brussels, Les XX's provocative tactics and financial prosperity succeeded in demonstrating to their public the notion of the group as an entrenched and well-organized avant-garde, one that was certainly as interesting, if not more so, than the national Salon.

The Jeune Belgique was formed during a period of conservative politics and economic depression, and, for the writers and artists of this movement the choice of a career often arose more from economic necessity than creative ecstasy. Indeed, the desire to legitimate a non-orthodox career through avant-garde activity played a significant role in sustaining the energy of the Jeune Belgique movement. At the same time that economics encouraged their collaborative efforts, the Jeune Belgique's polemic rose out of a clash of conservative and progressive tendencies within the middle class itself.[87] Opposing the laissez-faire capitalism of their fathers, these artists and writers searched for an aesthetic experience that would counter widespread industrialization brought on by these economic policies.[88] Thus they immersed themselves in the medieval past or in the moral aims of Morris's Arts and Crafts movement, all the while preaching the renewal of society and industry through the revival of decorative art. Not only did the art nouveau movement fail to live up to the idealistic principles of the Jeune Belgique, but also, as demonstrated by the ostentatious display of objects at the 1897 international exposition at Tervuren, this style came to symbolize the cultural ideology of King Léopold II and the colonial expansionist policies of the State. Thus, though the Jeune Belgique initially positioned itself in revolt against tradition, by the time art nouveau prevailed in the mid-1890s, this movement's radicalism had been successfully undermined by its own inbred, middle-class values.

As this essay has shown, the cultural scene in Brussels was characterized by a diversity of artistic style. This stylistic variety was not founded upon difference but rather a shared modernist ideology of romantic individualism. This aesthetic, that artistic form expresses an individualized interpretation of reality, allowed advocates of "art for art's sake" to champion pure form, the symbolists to investigate its evocative possibilities, and the socialists to believe that form could contain a revolutionary idea. In other words, each group chose to construe modernist theory for their own end and to their own advantage. Therefore the formalists could use their interpretation of modernism to denounce the symbolists for destroying form or justify their fear of ideology by accusing social artists of didacticism. Meanwhile, the

symbolists and the Socialists could find a basis in modernist theory for cooperation by not insisting that form contain revolutionary content.

Although the Jeune Belgique's modernist ideology allowed for a diversity of expression, most of the styles taken up by this group were based upon French language and theory, the inevitable result, no doubt, of fifty years of privileging this cultural tradition in Belgian arts and letters. Thus, even as they called for a national style, the Belgians did not question this French cultural hegemony nor focus their avant-garde critique on the manner in which artists and writers expressed or visualized their ideas. For the most part, the social implications of truly revolutionizing the way culture was produced, or for that matter, the language in which it was created, were not discussed. Thus, even though the Jeune Belgique advocated aesthetic, linguistic, or social change they presented their ideas in a manner quite similar to their more traditional competitors. It would only be with the advent of symbolist deformation of form in both literature and art and the introduction of decorative art at Les XX that the Belgians began to experiment with language, layout, and typography and finally formed a new style. Yet even this style, art nouveau, was based upon contemporary French models. Indeed, the only true avant-garde rupture with both French language and tradition occurred not within the Jeune Belgique but in the pages of *Van Nu en Straks*. Although this journal was grounded, as were the others, in symbolist aesthetics and anarcho-socialist theory coming from France, its editors chose to embody the revolutionary rhetoric of their text within a radically new concept of layout and design.

Whereas the discourse of the Jeune Belgique movement never really broke with tradition and offered, instead, modifications and variants of the same modernist mentality, its basis in individualism accentuated authenticity and originality.[89] This quest to find the essential expressive self in a new and unique way would lead many authors to discover their own native, "Belgian" identity. Even if this "sense of place" was construed by most members of the Jeune Belgique to be less a declaration of nationalism or a sign of allegiance to the Belgian nation-state than a

reaffirmation of individualism, it would be the local color found in Verhaeren's *Les Flammands*, Georges Eekhoud's *Kermisses*, or Ensor's paintings and etchings that set these artists apart from their European counterparts, enabling them to recognize their own ethnic legacy. In turn, this acknowledgment of the Flemish heritage within the cultural renewal of the Jeune Belgique led, through *Van Nu en Straks*, to the birth of the Flemish political movement and the concurrent renewal of Flemish art and literature.

If the Jeune Belgique and Les XX were not entirely as radical or as avant-garde as their rhetoric, what can be said of their contribution to Belgian culture? Although not a break with the past and, in fact, a continuation of it, the aesthetic discourse of the Jeune Belgique did indeed lead to a flowering of French literature in Belgium. In addition, the aggressive, tenacious spirit and often rancorous critical debate incurred by this movement led to the introduction of modernist theory into Belgium. Based as it was on the spirit of individualism, this process of self-legitimization by the Jeune Belgique and Les XX also allowed for a process of experimentation and co-operation that crossed national borders and moved outside the confines of art into the social sphere. In addition, by sustaining its own interests as well as the careers of its members and by fostering ties with like-minded groups in France, England, and Holland, Les XX served as a dynamic demonstration of the international potential for an active avant-garde.

Yet, even as Les XX and the Jeune Belgique movement put Belgium on the cultural map and moved its artists and writers away from provincialism to a more international viewpoint, it also unleashed the forces of regionalism that lead eventually to the fragmentation of a national Belgian culture. It is not without irony that August Vermeylen, the editor of *Van Nu en Straks*, wrote, "In order to be something, we became Flemish. We wished to be Flemish (*'Soyons nous'*) in order to become Europeans," for that call—*Soyons Nous*—sparked the cultural discourse of the Belgian avant-garde that led to a new school of Belgian arts and letters, but one which was Flemish, rather than French, in origin.[90]

Notes

Research for this essay was made possible by a Faculty Summer Research Grant from the College of New Rochelle and a Travel to Collections Grant from the National Endowment for the Humanities.

1. For more on Les XX see Maus, *Trente Années*; Legrand, *Groupe des XX*; Canning, "Salons of 'Les Vingt'"; Brooklyn Museum, *Belgian Art*; Block, *Les XX and Belgian Avant-Gardism*.

2. "Le centre du magnifique mouvement en avant garde qui dans toutes les domaines de l'art, emporte notre pays," "Petite Chronique," *AM* 3 (7 October 1888): 321.

3. Puissant, "Naturalisme en Belgique," 109–118; Aron, *Ecrivains Belges et le Socialisme*, 142–150.

4. On the relationship between nationalism and culture, see Aron, *Ecrivains Belges*, 137-38; Klinkenberg, "Littérature nationale".

5. The banquet, organized by Max Waller, was held May 27, 1883, at the Grand Hotel, near the Academy, in Brussels. After Georges Rodenbach spoke, Edmond Picard gave a speech and Emile Verhaeren read a poem. Lemonnier warmly thanked the assembled crowd of more than two hundred artists, writers, politicians, journalists, musicians, lawyers, and doctors. Nine future Vingtistes and twelve of their future invited guests attended, as well as the entire staffs of *L'Art moderne* and *La Jeune Belgique*. The entire text of the proceedings were published in *AM* 3 (3 June 1883): 173–180, and a list of those who attended the banquet in "Manifestation Lemonnier," *AM* 3 (10 June 1883): 192.

6. The critics were quick to note this discrepancy between the anti-establishment posture of the members of Les XX and their acceptance of governmental largesse. In his review for the group's first salon, for example, Gustave Lagye listed the Vingtistes Verstraete, Simons, Verhaert, Lambeaux, Schlobach, Wystman, Van Rysselberghe, Charlet, and Khnopff as artists who had exhibited at earlier government-sponsored salons in Ghent, Antwerp, and Brussels. As he also noted, Charlet, Delvin, Lambeaux, Vanaise, Verhaert, and Verstraete had all won medals at these exhibitions: Lagye, "L'Art jeune," 147. In a later article Lagye charged Picard with duplicity for sponsoring Les XX while maintaining his position as vice-president of the Cercle Artistique in Brussels: Lagye, "Fleurs de Rhetorique," 163.

Before he joined Les XX, Théo Van Rysselberghe enjoyed the fruits of state patronage. After exhibiting at the Triennial in Ghent in 1881 he was awarded a grant from the government to travel to Spain and Morocco. He later showed the results of this trip at an exhibition at the Palace of Fine Arts in Ghent and the Cercle Artistique in Brussels. Even after becoming a Vingtiste, Van Rysselberghe continued to receive government support. In 1885 *L'Art moderne* announced that the artist sold the painting *Le Conteur arabe* (*The Arabian Storyteller*) to the State for 3,500 francs; the government had actually purchased Van Rysselberghe's still unfinished *La Fantasia arabe* (*Arabian Fantasy*). *Le Conteur arabe* was sold on the condition that it would be exchanged, along with an additional 1,500 francs, for the other painting when it was finished. The exchange never took place and *Le Conteur arabe* was placed in storage at the Namur Museum, where it was destroyed during a bombing raid in World War II. *La Fantasia arabe* was later acquired by the State at a public sale and is now at the Museum of Fine Arts in Brussels.

7. The Liberal Party established its own university (Université Libre) in Brussels in 1836. During the party's long reign of parliamentary power they passed education laws that re-established a system of free public education and removed the Catholic Church's control over schools. Though these educational reforms would eventually reach the working class, in the second half of the century it would be the middle class who benefited the most from these reforms. Between 1864 and 1884 the number of students receiving secondary and university education doubled in proportion to the population. The majority of the university graduates received professional degrees in engineering, teaching or law.

8. The collaborators for *La Semaine* included Emile Verhaeren, the future publisher Edmond Deman, Albert Gilkin, Albert Giraud, Georges Bauwens, Joseph Neve, Hector van Dorselaar, Emile van Arenbergh, and the Flemish writers Albrecht Rodenbach and Florimonf Heuvelmans. *Le Type* was directed by Max Waller and F. Verlant. Although both journals advocated literary autonomy, they disagreed over naturalist theory. An intense rivalry soon developed between the two reviews and the discourse degenerated to accusations of Catholic or Liberal allegiances within each group. The university authorities stepped in and suspended both journals, but not before Giraud and Waller decided to work together.

9. *La Jeune Revue littéraire* grew out of an earlier publication, *La Chrysalide*. Directed by Alfred Bauwens, this journal was open to all styles but emphasized naturalism. Max Waller's father soon bought the journal and it was retitled *La Jeune Belgique*, with Waller as editor and Emile Verhaeren, Albert Giraud and Charles van Arenberghe on the staff.

10. "Nous voulons aplanir les voies, faciliter les rapports entre les artistes et le public, afin que l'Art acquière chaque jour davantage la bienfaisante influence sociale que doit lui appartenir, afin aussi que les artistes occupent matériellement et moralement la situation importante dont ils sont dignes"; "Notre programme," *AM* 1 (6 March 1881): 2.

11. On *La Wallonie* see Mathews, *La Wallonie*.

12. On this influential journal see Lemaire, "August Vermeylen en van de Velde"; Lissens, "Van Nu en Straks"; van Dijck et al., *Van Nu en Straks*; Musschoot, "Van Nu en Straks: A Flemish Art Nouveau Periodical".

13. Poet and critic Prosper Van Langendonck was a fervent Christian, while Cyriel Buysse was a naturalist writer known for his pragmatic approach. August Vermeylen, Emmanuel de Bom, and Henry van de Velde were committed anarchists.

14. Musschoot, "Van Nu en Straks," 47–49, interprets Vermeylen's essay to be a reply and rebuttal of Walter Crane's essay *The Claims of Decorative Art* as adapted by the Dutch artist and critic Jan Veth in his *Kunst en samenleving* (*Art and Society*) published in 1893. Rejecting Crane and Veth's materialism and their principle of utilitarian practicality, Vermeylen promoted an anarchist concept of society formed in symbolist idealism. In Musschoot's view, it was Vermeylen's article, reprinted in the Dutch periodical *Architectura*, and not the exhibitions organized by Les XX in Holland that initiated art nouveau in Holland.

15. For a discussion of anarchism in relation to *Van Nu en Straks* see Moulaert, *Anarchisme*.

16. Known chiefly as an art critic, Lemonnier could not find a publisher for his first novel, *Une Mâle*. After being turned down by all the Parisian editors, he turned to Kistemaeckers and it was published in 1880. Kistemaeckers also collaborated with etcher and Vingtiste Félicien Rops, whose work included an etching for *Le Pendu dans la forge* [cat. 117], illustrations for Théo Hannon's licentious *Rimes de joie*, and the vignette for Kistemaeckers publishing house. On Kistemaeckers see Baudet, *Kistemaeckers*.

17. Deman often printed these editions on the presses of Vve. Monnom, a Brussels based firm that also published *L'Art moderne* and *La Jeune Belgique*. In 1889, Théo van Rysselberghe married widow Sylvie Monnom's daughter, Marie, and was soon collaborating with Deman on the design and layout for limited editions of Verhaeren's poems (see Block essay).

18. In 1870, brothers Paul and Gustave Buschmann took over the printing firm founded by their father Joseph-Ernest. According to the memoirs of both Paul Buschmann's nephew and Elskamp, though Elskamp learned the principles of layout and typography from Buschmann, the production of *Dominical* was a collaboration; the poet decided on the format and page justification and the printer chose the typeset. On the production of this book see Baudin, "Typographiques de van de Velde".

19. Of the founding members, Frantz Charlet, Paul Dubois, James Ensor, Willy Finch, Charles Goethals, Fernand Khnopff, Darío de Regoyos, Willy Schlobach, Théo van Rysselberghe, Guillaume van Strydonck, Guillaume Vogels, and Rodolphe Wystman studied at the Brussels Academy. Jef Lambeaux, Piet Verhaert and Théodore Verstraete attended the Antwerp Academy. Among those who joined the group, Guillaume Charlier, Henry de Groux, Jan Toorop and Isidore Verheyden followed courses at the academy in Brussels, Henry van de Velde studied at Antwerp and George Minne in Ghent. Georges Lemmen, elected to the group in 1889, attended the Academy of Fine Arts at Saint-Josse-ten-Noode, a school founded in 1864 by the painter Henri Hendricks to train students in the techniques of painting and the decorative arts.

20. *L'Artiste*, formed in 1875 and edited by the poet and painter Théo Hannon from 1877 until 1880, was a continuation of three earlier naturalist journals. The first of these reviews, *L'Art libre*, a bi-monthly founded in 1871, was the organ of the *Société Libre* and was linked through its editorial staff to the satirical revue *L'Uylenspiegel*. *L'Art libre*'s staff included the future Vingtiste Félicien Rops and the artists and members of Société Libre Camille Van Camp, Louis Artan, and Louis Dubois. After this review ceased publication in 1872, one of its contributors, Camille Lemonnier, founded *L'Art universel*. *L'Art universel* sought to broaden the appeal of naturalism by expanding coverage to include literature and music. In addition to reviews and essays, *L'Art universel* offered its readership editions of etchings or musical compositions as part of their subscription. The bimonthly appeared for three years and experienced a modest success, even opening a Paris office briefly in 1875, thus solidifying liaisons between numerous French and Belgian writers. When *L'Art universel* stopped publication in June 1876, Lemmonier, who worked tirelessly to bring artists, writers, and musicians together under this journal's banner, reassembled much of its staff into *L'Actualité* [*The Present Day*]. Less specialized than its antecedent, this weekly focused more on literature but continued to offer its patrons photographic reproductions of works by Belgian artists. Although originally it took on itself a family publication, *L'Actualité* very quickly took on the allure of an avant-garde journal and began publishing the leading naturalist writers of day, including J.-K. Huysmans, Emile Zola and Theo Hannon. *L'Actualité* ceased to exist after a year, but most of its staff were reassembled under Hannon to publish *L'Artiste*. *L'Artiste* laid claim to the avant-garde tradition of these earlier journals and continued to defend literary and artistic modernism under its motto "Naturalism, Modernity." *L'Art moderne* took over *L'Artiste*'s subscription list and audience when it began publication in 1881. For a history of these journals see Vanwelkenhuyzen, "De l'Uylenspiegel à la Jeune Belgique"; Delsemme, "Mouvement naturaliste."

21. In his introduction to the exhibition *Antwerpen 1900*, Jean F. Buyck describes in detail the intense rivalry between Antwerp, the self-proclaimed "metropolis of the arts" and Brussels, the political capital. After Brussels mounted the retrospective honoring Belgium's fiftieth anniversary to challenge Antwerp's cultural hegemony, that city replied with its 1882 Triennial, which included almost 1600 works by 940 artists. For a discussion of the evolution of Belgium's Triennial Salons see Bienenstock "Gari Melchers and the Belgian Art World."

22. Between 1879 and 1884, the following Vingtistes exhibited at the national Salon:

Antwerp, 1879: G. Charlier, J. Delvin, C. Goethals,
P. Pantazis, F. Simons, G. Vanaise, I. Verheyden,
P. Verhaert, T. Verstraete, G. Vogels.
Ghent, 1880: P. Pantazis, T. Van Rysselberghe, P. Verhaert,
I. Verheyden, T. Verstraete, G. Vogels, R. Wystman.
Brussels, 1881: F. Charlet, J. Ensor, F. Khnopff, P. Pantazis,
F. Simons, G. Vanaise, T. Van Rysselberghe, P. Verhaert,
I. Verheyden, T. Verstraete, G. Vogels, R. Wystman.
Antwerp, 1882: A. Boch, A. Chainaye, F. Charlet, J. Ensor,
F. Khnopff, G. Lemmen, P. Pantazis, F. Simons,
T. van Rysselberghe, G. van Strydonck, P. Verhaert,
I. Verheyden, G. Vogels, R. Wystman.
Ghent, 1883: A. Chainaye, F. Charlet, J. Delvin,
D. de Regoyos, J. Ensor, C. Goethals, F. Khnopff,
G. Lemmen, P. Pantazis, W. Schllobach, F. Simons,
T. Van Rysselberghe, G. Van Strydonck, P. Verhaert,
I. Verheyden, T. Verstraete, G. Vogels, R. Wystman.
(Although Henry van de Velde's name is listed, apparent-
ly his work was not at the salon.)
Brussels, 1884: A. Boch, F. Charlet, F. Khnopff,
W. Schlobach, J. Toorop, G. Vanaise, H. van de Velde,
T. Van Rysselberghe, G.. van Strydonck, I. Verheyden,
T. Verstraete, R. Wystman.

23. The French sculptor Auguste Rodin, who joined the group in 1889, showed at the 1880 Salon in Ghent and the 1882 Salon in Antwerp.

A reaction to the more progressive orientation of these Salons occurred with the 1884 Brussels Salon, when even the conservative critics thought the jury was particularly harsh. Works submitted by James Ensor and Willy Finch were rejected and those by Anna Boch, Isodore Verheyden, and Fernand Khnopff were poorly placed. A protest "Salon des Réfuses," organized by Xavier Mellery, was held at the Palace of Industry in October, 1884.

24. The Artistic Circles were formed to promote literature and science in addition to art and, as stated by the group founded in Antwerp in 1852, "d'établir des relations plus frequentes et plus intimes entres ceux qui cultivent les sciences et les arts et ceux qui sont a même de les proteger (to establish fre-quent and intimate relations between those who cultivate the arts and sciences and those who protect them)": "Cercle Artistique, Littéraire et Scientifique." The organization of these circles included honorary members and representatives of the military in addition to the members. The membership was aligned to four sections: the plastic arts, music, French and Dutch literature, and science. In addition to regular meetings, the Circle offered its membership scientific and literary lectures, concerts, exhibition and dinners.

The Vingtiste Isodore Verheyden exhibited regularly at the Brussels Cercle Artistique (1876–1880, 1883, 1886, 1889, 1892), as did Guillaume Vogels (1876–1880, 1882, 1883, 1885). Other Vingtistes who showed at the Cercle Artistique included Anna Boch (1877, 1880, 1882), Guillaume Charlier (1888, 1891, 1894), James Ensor (1882), Charles Goethals (1888, 1891), Fernand Khnopff (1882, 1883, 1891), Périclès Pantazis (1873–1880, 1882, 1883), Auguste Rodin (1874), and Félicien Rops (1873). Rodolphe-Paul Wytsman and Gustave Vanaise exhibited at these salons after they left Les XX.

Originally L'Essor was named Le Cercle d'Eleves et Anciens Eleves des Academies des Beaux-Arts. To distance them-selves somewhat from the Academy, the group changed their name to L'Essor in November 1879. They held their first exhibition in December 1876 at the Lucas Huis in Brussels. They had no salon in 1877 and only one salon from 1879 until 1882. The increased success of the group from 1882 until 1885 can be measured by both their numerous group and individual exhibitions and the location of their salons at the Palace of Fine Arts, the same place where Les XX exhib-ited and the Brussels Salon was held. In 1882 L'Essor had three exhibits and in 1884 they held four, including a group show by the soon-to-be-Vingtistes Théo van Rysselberghe, Frantz Charlet and Dario de Regoyos of their drawings from Spain. In 1884 L'Essor exhibited in Antwerp, followed by two exhibitions in Brussels the following year. After no exhibi-tions in 1886, they showed annually in Brussels (and once in 1889 in London) until the group dissolved in 1891.

Als Ik Kan was founded on October 25, 1883, only a few weeks after the announcement in L'Art moderne of the forma-tion of Les XX. Like L'Essor, the membership of Als Ik Kan were former students of the Antwerp Academy and the paint-ing professor Charles Verlat. Although their name (taken from the motto of the painter Jan van Eyck) reflected the group's ties with Flemish tradition, their incentive was more commer-cial than chauvinistic, as they wanted the opportunity to sell their work outside of the restrictive regulations of the official salon. On Als Ik Kan see Buyck, "Kunstkring Als Ik Kan."

25. At its first exhibition in 1877, Léopold visited the show and bought five works. The following year he bought nine works and he continued his support in later years with the purchase of lottery tickets. Other patrons of L'Essor included the English ambassador to Belgium and the Count of Flanders: Block, Les XX, 5-6.

26. Before the formation of the Société Libre, there were two private studios associated with the Academy that were allied with progressive tendencies in Belgium. The Academy of St. Luke was formed in 1846, lasted until 1850, and was revived from 1853 until 1863. Among its members were Charles Hermans, Félicien Rops, Louis Dubois, and Louis Artan, all of whom were later members of the Société Libre and would be invited to show with Les XX. The other studio was orga-nized by the painter and academy member Jean Portaels to encourage individual expression.

For an in depth study on the Société Libre see Roelandts, "Société Libre des Beaux-Arts."

27. Each edition of L'Art libre was accompanied by the group's manifesto: "On voulait bousculer les jurys, forcer les portes des grandes expositions et introduire ce qu'on appelaient L'Art Libre. L'Art Libre, cela signifiat: libré de la convention, libré d'exprimer une impression personnelle, mais non point libré de l'effort et du respect de la nature. Notre idée domi-nante, c'est celle d'affranchissement. Nous representons l'art nouveau, avec sa liberté absolue d'allures et tendances, avec ses caracteres de modernité. . . Ce que nous voulons, c'est lutter avec énergie contre tout ce qui arrété, détourné ou ralentit. (We wish to overthrow the juries, to force open the doors of the great exhibitions and introduce that which we call Free Art. Free Art, that signifies: free of convention, free to express a personal impression, but no longer free of the effort and of the respect for nature. Our prevailing idea is independence. We represent new art, with its absolute free-dom of aspect and tendencies with its modern character-istics. . . . We wish to fight with all our energy against all that stops, detours, or slow downs.)": as quoted in Lagye, "L'Art Jeune."

28. Périclès Pantazis, a founding member of Les XX, was associ-ated with both the Société Libre and La Chrysalide, as was Félicien Rops, who was elected to Les XX in 1885. Artists who showed at La Chrysalide and later became Vingtistes included James Ensor, Willy Finch, Jef Lambeaux, Guillaume

29. Vogels and Gustave Vanaise, Théodore Baron, Constantin Meunier, Louis Artan and Charles van der Stappen, all of whom exhibited at the Société Libre and La Chrysalide, were also invited to show with Les XX.

Most of the exhibitions of the Société Libre were held in rented rooms. Their first salon was held in Brussels at 5 Galerie du Roi. Later salons benefited indigent children of Minimes and victims of the Chicago fire. The first exhibition of La Chrysalide was held at the tavern Le Ballon on the rue Cantersteen and was open every night from 7:00 until 9:00 p.m. The second exhibition took place in a private room above the Le Petit Louvain and again was open in the evenings. The group's final exhibition was held in the rented Salle Janssens, 9 rue de l'Écuyer. L'Essor's exhibitions were also open at night. Their first salon was held at the Lucas-Huys on the rue Ducale and their next exhibition was at the Salle Marugg on the rue du Bois Sauvage. With King Léopold II's patronage, L'Essor gained access to a more official venue at the Palace of Fine Arts. Like L'Essor, Les XX's exhibitions were held at the Palace of Fine Arts, but they were only open during the day. In 1888 and subsequent years, Les XX showed at the Museum of Art in Brussels.

30. In her recent article on the Impressionist exhibitions in Paris, "Impressionist Installations," Martha Ward points out the role that public and private spaces played in shaping the aesthetic discourse of modernism and in defining the public's reception of an art group's professionalism and stability. Not only was Les XX aware of the prominence and public attention that exhibiting at the Palace of Fine Arts brought to the group, they used this fact to their advantage. In addition to staging elaborate openings guaranteed to garner press coverage, the group constantly promoted itself as the true salon of Belgium. Holding their exhibitions in February, the month before the official Salon, and showing them in the same place made comparisons inevitable. Eventually, with the group's continued success publicized by L'Art moderne, the Brussels public gained the impression that Les XX was a secure and durable group. An example of the extent to which Les XX usurped the Triennial through their use of a public exhibition space can be found in Max Waller's review of their 1888 salon. For this critic, the official Salon was full of mediocrity and one had to search for quality among the vast number of artworks while at Les XX one could find "une réunion d'oeuvre choisies, limitées comme nombre, hardies comme facture, intéressantes en tous cas (a reunion of choice works, limited in number, bold in treatment and always interesting)," leading Waller to conclude, "Le Salon des XX est une vrai salon (the Salon of the XX is a true salon)": Waller, "Chronique bruxelloise," 11.

31. Block, "Origins of 'Les XX'".

32. Paul Cézanne, Paul Gauguin, Odilon Redon, Giovanni Segantini, Georges Seurat, Paul Signac, Henri de Toulouse-Lautrec, Vincent van Gogh, and others sold their artwork at Les XX exhibitions. The only painting van Gogh sold while he was alive, La Vigne Rouge (The Red Vineyard) of 1888 (now in Moscow at the Pushkin Museum of Fine Arts), was bought by Vingtiste Anna Boch for 400 Belgian francs.

33. Paul Cézanne first turned down the invitation to exhibit with Les XX in 1890. Rewald, in Post-Impressionism, 342, has suggested that Cézanne had not heard of the group, but as the symbolist writer Téodor de Wyzewa noted in a letter to Maus (MRBA, AAC 5356), Cézanne's insecurity about the public's acceptance of his work made it difficult to secure his participation. Maus persisted, however. He sent Cézanne a list of the other invited artists and implied that the French artist was disdainfully isolating himself. Apparently Maus's tactic worked, as Cézanne, flattered to be included with artists such as Renoir, Segantini and van Gogh, agreed to send three paintings to Les XX: letter to Maus, dated 27 October 1889 (MRBA, AAC, 5273). Although he did not receive good reviews, Cézanne remained on favorable terms with the group and requested a catalogue after the salon had closed.

34. The fee was 50 centimes during the week, but was raised to 2 francs when there was a lecture or concert. Those attending the opening were charged 5 francs unless, as a member of the group, a friend, an invited artist, a critic, or a writer, they received a free invitation. In order to entice more of the Brussels public to attend, Les XX began selling passes to the salons in 1886. These passes, which cost 10 francs, entitled the bearer to free admission at any time and, from 1888 on, a reserved seat at the lectures and concerts. The cost of the pass was raised to 15 francs in 1891.

35. Rewald, Post-Impressionism, 104.

36. "Oh! Les XX, quelle habileté ils deploient, comme ils savent faire mousser leur annuelle exposition par de savants communiqués, comme ils ont l'art d'exciter la curiosité, d'inciter les querelles artistiques et de passionner les indifférents": Mauprat, "L'Exposition des XX."

37. In fact, the national Salon was influenced by the success of Les XX. As Jennifer Bienenstock noted in "Gari Melchers," 80, the 1887 and 1890 Triennials showed an increased tolerance for plein air and modern life subjects due to the success and popularity of the Les XX salons and the election of Edmond Picard, the group's chief polemicist, to the national Salon's organizing committee. According to Block, Les XX, 44, attendance at the Brussels Triennial declined forty-three percent between 1884 and 1890, while attendance at Les XX during the same period rose forty-five percent.

38. Khnopff's 1890 catalogue cover in a Japanese style suggested the group's growing interest in decorative art; George Lemmen's 1893 cover with its curving, organic flower represented the flowering of decorative arts and art nouveau style at Les XX.

39. Both L'Essor and Als Ik Kan incorporated drawings into their catalogues and the Jeune Belgique had printed a red cover for its issue on Lemonnier's commemorative banquet in 1883. Mecoenas (Théo Hannon) complained that the catalogue was too fragile and meant more as a collector's item than as documentation of the works on view: Mecoenas, "Les Apporteurs de Neuf," 2.

40. This attempt by Les XX to create a tasteful and harmonious environment for the work on view was not always well received. The elaborate nature of their display, which by 1890 had come to include ushers and a vestiary, potted plants, velvet drapes and marble bases for the sculpture, led neo-impressionist Paul Signac to complain that the setting distracted from the proper viewing of the pointillist works on vie: "Catalogue de l'exposition des XX."

41. These connections were mainly through Félicien Rops, a member of both the Société Libre and La Chrysalide, who, after exhibiting with Les XX in 1884, was elected a member of the group in 1886. The French sculptor Auguste Rodin was also quite familiar to Belgian artists, having exhibited in the 1872, 1874, and 1875 Salons. He also received several commissions for sculptures at the Royal Conservatory, the

42. Guillaume van Strydonck lived in Paris in 1885 and again in 1887 and 1888. Fernand Khnopff visited Paris from May until June 1884 and was there again in 1887. Darío de Regoyos and Willy Schlobach also made several trips to Paris in the 1880s. Every year Les XX held a banquet in conjunction with the opening of their salon. The invited artists were often in attendance in addition to the Vingtistes. Although more artists surely came, documentation confirms that the following artists were in Brussels for the Les XX salons: Raffaelli (1885), Seurat and Signac (1887), Signac (1890), Segantini (1889), Toulouse-Lautrec (1890, 892), and Chéret (1891).

43. Formed at the initiative of Louis Roll, Albert Besnard, and Guillaume van Strydonck, the Société des XXXIII included Van Strydonck and the Vingtistes Fernand Khnopff, Théodore Verstraete, Félicien Rops, Guillaume Charlier, and Théo van Rysselberghe among its members. Darío de Regoyos, who attended the opening, wrote to Maus that Van Strydonck and Khnopff were well received, but that he found the quality inferior to the Les XX salons: letter from Darío de Regoyos to Octave Maus, 31 December 1887 (A.A.C.5057).
In its reporting of the group, *L'Art moderne* played up the Vingtiste connection, calling it at first mention the Association des Trentistes Parisiens (Association of the Parisian Thirty), and noting that they had modeled themselves after Les XX: "Le placement se fera, selon le mode nouveau inauguré par Les XX, par panneaux, en reunissant les oeuvres des membres du Cercle et celles des invités (The placement will be made, according to the new style inaugurated by *Les XX*, by panels, and joining together the works of the members of the Circle and that of their invited guests)"; "Pêtite Chronique," *AM* (27 November 1887) 383. *L'Art moderne* continued to link this Parisian group with Les XX, asserting that they were only following the path established by the Belgian group and that, like them, they had no president; "Pêtite Chronique," *AM* (16 January 1887): 23. Finally in April, this journal announced that thirty-three artists had signed a contract with Durand-Ruel to have a show in January of each year and listed the members along with its president (Moreau-Nelaton) and secretary (Ary Renan) without further allusion to this group as a spin-off of Les XX; "Pêtite Chronique," *AM* (22 April 1887): 134.

44. Chartrain-Hebbelinck, "Lettres de Théo Van Rysselberghe", 59-75. This discussion of Van Rysselberghe's contributions is based upon his comments in these letters and in unpublished correspondence with Maus in the Archives de l'Art Contemporaine en Belgique of the Royal Museum in Brussels.

45. Van Rysselberghe derived his ideas from a number of sources, including Whistler's installations and contemporaneous salons of impressionist and neo-impressionist art circles. See Ward's descriptions of these installations in "Impressionist Installations," 605-613, 618-622.

46. After the Les XX salon, Verhaeren acquired Seurat's *Coin d'un bassin [Honfleur]* (1886, Otterlo, Rijksmuseum Kroller-Muller) and *Le l'hospice et le phare d'Honfleur* (1886, Washington, D.C., National Gallery of Art) for his collection.

47. Many of Signac's activities can be found in the letters he wrote to Maus. These are reproduced in Chartrain-Hebbelinck, "Lettres de Paul Signac," 59-75.

48. Although undocumented, Toorop's acquaintance with artists of The Hague school is likely, given the fact that he exhibited in the same Vingtiste salons with Willem Mesdag in 1885 and Willem and Matthijs Maris and Philippe Zilcken in 1887. Zilcken, who later become The Hague correspondent for *L'Art moderne*, even wrote an article on Toorop for *Elsevier's Geillustreerd Maandschrift*. After his move to Katwijk aan Zee, Toorop met the poet Alfred Verwey and through him, Jan Veth and R.N. Roland Holst. Veth, a founding member of De Nederlandsche Etsclub (The Etching Club of Holland), invited Toorop to exhibit with this group in 1893.

49. Included in the Panorama exhibition, 26 May–23 June 1889, were works by Boch, de Groux, De Regoyos, Dubois, Finch, Lemmen, Rops, Schlobach, Toorop, Van Rysselberghe, Van Strydonck and Vogels.
Toorop had been elected president of Panorama in 1891, giving him the position to act as the intermediary between this group and the Belgians.
The exhibition held in June and July 1892 included works by Van Rysselberghe, Toorop, and van de Velde. On this exhibition see Siebelhoff, "The Hague Exhibition of 1892," and Joosten, "Van de Velde en Nederland."

50. L'Art Indépendant was six artists: Léon Abry, Floris Crabeels, Maurice Hagemans, Alexandre Marcette, Isidore Meyers and van de Velde, and the secretary, Elskamp. The group's only show included artwork by Vingtistes Ensor, Khnopff, Rops, Van Rysselberghe, and Vogels alongside their own. On this group see Cardon, "L'Art Indépendant."

51. The 1887 exhibition of L'Art Indépendant was the subject of much negative criticism by the Antwerp press. Calling Félicien Rops's *Pornocrates* pornographic, the Society of the Palace of Industry demanded the work's removal [cat. 121]. L'Art Indépendant refused and the following year when they applied for an exhibition space permission was denied by the mayor. Without a place to exhibit, the group dissolved.
Like Les XX, L'Association Pour L'Art invited artists from several countries to exhibit with members of the group. They also aligned their work singly on panels, showed decorative art alongside fine art, and organized a lecture series and musical concerts. Vingtistes Finch, Lemmen, Boch, van de Velde, Signac, van Rysselberghe, Minne, and Toorop were all invited to participate in the association's 1892 salon. Although this first salon was quite successful and made a profit of 2,300 francs, the group's second exhibition was less popular and the group disbanded shortly after the second salon closed.

52. All unofficial groups had to petition the government for exhibition space. In 1885 the Minister of Fine Arts, Auguste Beernaert, rejected Maus's request for rooms 11 and 12 at the Palace. After printing Beernaert's letter and his own reply in *L'Art moderne*, the minister apparently reconsidered the request and permission was granted. In fact, not only did Les XX receive official approval but also they were granted more space than they had previously requested. No doubt due to Maus' and Edmond Picard's political and social contacts, the group had no problem obtaining exhibition space for subsequent salons. For further discussion of Les XX's ties with official culture, see Block, *Les XX*, 42.

53. See Ensor's letters to Maus between December 1889 and November 1893, as reproduced in Legrand, "Lettres de Ensor à Maus."

54. In his letter proposing dissolution, Maus wrote, "Plusieurs membres de l'Association des XX estimant que les cercles d'avant-garde ne doivent pas durer trop longtemps sous pein de déchoir ou de reculer, et trouvent que le terme de dix années que nous avons victorieusement atteint est un maximum qu'il ne faut pas depasser, ont proposé la dissolution de la Société. . .(Several members of the Association of Les XX estimating that avant-garde circles ought not to last too long under pain of losing honor or moving backward, and finding that the term of ten years that we have attained victory is a maximum that can not be passed, have proposed the dissolution of the Society)": letter [MRBA, AAC 6303], as quoted in Maus, *Trente années*, 145. Théo van Rysselberghe, responding to Maus's suggestion to be part of the organizing committee of the Le Libre Esthétique, alluded to the problems incurred by Les XX's democratic organization, "L'idée d'un 'comité' dans lequel aucun de nous (XX) n'aurait plus rien à dire de direct—dans lequel il n'y aurant pas de peintres, pas de musiciens, pas de sculpteurs, qui organiserait des expositions et auditions et y inviterait des artistes choisis par lui, me semble excellente. Cela simplifierait énormément et serait au moins une très réelle innovation. . . . Les artistes sont, je crois, peu faits pour s'associer et monter des 'affaires' (The idea of a 'committee' within which none of us (XX) would have anything direct to say—within which there would not be painters, musicians, sculptors, who organize the exhibitions and concerts and would invite there the artists chosen by him, seems to me excellent. This will enormously simplify things and will be at least a very real innovation. . . . Artists are, I believe, poorly made for partnerships and for setting up 'business')": letter from Van Rysselberghe to Maus [MRBA, AAC 6332], as reproduced in Chartrain-Hebbelinck, "Lettres de Théo van Rysselberghe," 77.

55. For an overview of Belgian music during this period see Closson and Van den Borren, ed., *La Musique en Belgique*, 247-84.

56. Peter Benoit (b.1834) devoted his life's work to creating Flemish music formed from the idioms of popular songs and melodies. He played an active role in education, publishing a series of essays on the subject of Flemish music between 1867 and 1884, and in promoting native music through his own compositions. In 1867 he established the Royal Flemish Conservatory, which he directed until his death in 1901.

57. Maus had first been introduced to music by his cousin Anna Boch, herself a pianist as well as a painter. Later he studied piano with Louis Brassin, who introduced him to the music of Richard Wagner and contemporary French composers.

58. On the relationship between D'Indy and Maus see van Linden, "Maus et la Vie Musicale."

59. Hanse, *Littérature belge*, 343-44.

60. "Nous faisons de la Littérature et de l'Art avant tout. *La Jeune Belgique* ne sera d'aucune école...Nous invitons les jeunes,c'est-à-dire les vigoureux et les fidèles, à nous aider dans notre oeuvre. Qu'ils montrent qu'il y a une Jeune Belgique comme il y a une Jeune France, et qu'avec nous ils prennent pour devise: *Soyons nous*": *La Jeune Belgique* (1 December 1881): 1.

61. Puissant, "Le naturalisme en Belgique," 111.

62. "Voir le milieu Belge, penser en Belge, voilà ce qu'il faut à ces Belges. Oui penser en Belge! Ce qui ne veut pas dire être incorrect, évacuer des flandricismes, mais laisser aller son esprit à voir et à exprimer ses conceptions selon la pente naturelle à nos moeurs et à notre race": "Jeune Belgique d'Autrefois," 371. Picard's call here to eliminate the Flemish aspects of language owed much to his own bicultural identity that encouraged him to define Belgian identity as both Flemish and Walloon.

63. At the first salon in 1884 there were lectures by Edmond Picard on contemporary Belgian art, Georges Rodenbach on the Jeune Belgique, and Albert Giraud on literary reviews. The composer Gustave Kefer gave a concert with the Instrumental Union and Emile Agniez and Arthur Degreef presented their own compositions. There were no concerts for the second exhibition, the lectures focused on Flaubert and the naturalist aesthetics of contemporary French painting. The third lecture series was divided between theatre (Mlle. Thénard of the Comedie Francaise presented a performance) and literature, with Edmond Haraucourt reading from his novel and Georges Rodenbach returning to give a lecture on Camille Lemonnier. There was only one concert that year, a piano recital given by Mlle. Derscheid. At the fourth Vingtiste salon, Edmond Picard spoke on his book *Le Juré* and there were two concerts devoted exclusively to Belgian music that included works by Benoit, Blockx, Mathieu, Degreef and Kefer.

64. The nationality of the group's non-Belgian members, the Greek Périclès Pantazis and the Spaniard Dario de Regoyos, was overlooked because they practiced a realist/impressionist approach in their paintings as did most of the original Vingtistes. Similarly, the Dutchman Jan Toorop, elected in 1884, was easily integrated into the group because, like them, he had studied at the Academy, exhibited at the Salon and L'Essor and painted in an impressionist manner.

65. In his letter to Maus dated 25 February 1884 (MRBA, AAC 4626], Lambeaux did not give an explanation for his resignation. Although *L'Art moderne* suggested that he may have been intimidated by the avant-garde nature of the group, the Vingtiste Rodolph-Paul Wytsman suggested in a letter to Verhaeren that Lambeaux may have quit because of his ego. Piet Verhaert had received several negative reviews in the press, and this reception in addition to Lambeaux's resignation more than likely prompted his own departure. Simons and Verstraete received much negative criticism at the first two Les XX salons and the prominent critics Jacques Dur and Lucien Solvay called for their resignations. In a letter to *L'Etoile belge*, 6 March 1885, Verstraete announced his departure, citing as his reason the failure of Les XX to defend him against these critical attacks. With the resignations of Verstraete, Simons, Lambeaux, and Verhaert, there were no longer any Antwerp members in Les XX. That city would not be represented again until Henry van de Velde's election in 1889. Delvin was forced out early in 1886 when Maus called a emergency meeting to decide whether or not to admit all of the work Delvin had submitted for the salon. When one of the paintings was refused admission, Delvin removed his work from the salon and retired from the group. Vanaise resigned the next day, complaining that a singular aesthetic policy was being imposed on Les XX. On these resignations see Block, *Les XX*, 45-47.

66. In a letter to Maus, Ensor offered his view of Whistler's election, "Pourquoi admettre des étrangers? N'y a-t-il plus des jeunes en Belgique? Sommes nous les derniers jeunes? Je ne le pense pas. . . . Pourquoi admettre Whistler? Sa peinture sent déjà le moisi et le renfermé, il est connu et reconnu, quel art et principe nouveaux peut-il apporter chez nous? Si vous croyez au bon effet pour le public, n'oubliez pas que la

réputation de Whistler est, comme nôtre, detestable dans l'épicerie. On le trouvé toqué, timbré, grognon, plein de suffisance et pourri de fausse distinction. Vous voyez que son admission ne peut rien ajouter à notre situation devant le public. . . . Cherchons les jeunes, ne vieillissons que le plus tard possible. Place a ceux qui cherchent et non à ceux qui ont trouvé (Why admit strangers? Are there no longer young [artists] in Belgium? Are we the last young ones? I think not. . . . Why admit Whistler? His painting seems already moldy and stuffy, he is known and recognized, what art and new principle can he bring us? If you believe in a good result for the public, do not forget that Whistler's reputation, as ours, is detestable in the grocery shop. One finds him crazy, crack-brained, peevish, full of conceit and carrying false distinction. You see that his admission can add nothing to our situation before the public. . . . Let's seek out the young, and only grow old as late as possible. Make way for those who seek—not for those who have arrived)": letter dated November 1866 (AAC 4784), as reproduced in Legrand, "Les Lettres de Ensor à Maus," 25-26.

67. Ensor's friend Guillaume Vogels and Rodolphe-Paul Wytsman also preferred a Belgian candidate. The views of the other Vingtistes are not known, although Anna Boch and Félicien Rops also voted against Whistler.

68. Due to the interconnection between naturalism and nationalism, the distinction between naturalism and realism was of critical importance to the Belgians when they first began discussing naturalism in the mid-1870s in *L'Artiste* and later in *L'Actualité*. Eventually, however, both realists and naturalists were joined under the banner of modernism, as Lemonnier clarified in his article on Courbet first published in 1878: "Le naturalisme est le réalisme agrandi de l'étude des milieux, échappée à la circonstance et inquiet des contingences. . . . Le naturalisme en art est la recherche du caractère par le style, de la condition par le caractère, de la vie entière par la condition: il procède de l'individu au type et de l'unité à la collectivité (Naturalism is realism made larger by the study of the milieu, freed from circumstance and troubled by continence. . . . Naturalism in art is the research of character by style, of the condition by character, of the entire life by the condition: one proceeds from the individual to the type and from the unity to the collectivity)": Lemonnier, "Courbet et son oeuvre," 23–24. On the Belgian reaction to naturalism see Gergely, "Naturalisme en Belgique," 89–108.

69. "L'Exposition des XX," 49.

70. For a discussion of the "art for art's sake" movement in Belgium see Gilsoul, "Théorie de l'Art pour l'Art," and Aron, *Les Écrivains belges*, 132–135, 154–161.

71. "L'art n'est pas fait seulement pour amuser, il est surtout fait pour émouvoir. L'art destiné à distraire ne doit venir qu'après celui qui a pour mission d'améliorer. L'art destiné à distraire ne doit venir qu'après celui qui a pour mission d'améliorer, de combattre, d'ennoblir": Picard, "Le jeune mouvement littéraire," 222.

72. "L'Heure est venue de tremper la plume dans l'encre rouge": Picard, "L'Art et La Revolution," 225.

73. Picard did not insist on revolutionary content, asking instead that artists maintain a moral imperative and social responsibility no matter what form their artwork. Aron, *Les Écrivains belges*, 36.

74. Meunier showed with the group in 1885, 1887, 1889, and 1892. Les XX asked him to join the group, but Meunier refused, preferring to remain independent.

75. "Le Symbolisme," *Le Figaro* (18 September 1886). Both *La Jeune Belgique* and *L'Art moderne* published excerpts of Moréas' manifesto. *La jeune Belgique* proceeded Moréas' text with a commentary that linked his approach with the Decadent school of writers, adding: "On y verra un singulier cas d'aberration artistique, le mépris de la langue, la déformation du verbe, une tendance au charabia dont le simple bon sens fait raison (One will see here a singular instance of artistic aberration, the contempt of language, the distortion of speech, a tendency towards jargon in the place of good sense)." "Chronique littéraire," 435. *L'Art moderne* divided Moréas' essay into two sections and presented its own comments before and after. Edmond Picard, the author of the unsigned essay, agreed with Moréas' critique of the lack of originality, pastiche of styles, and tyranny of academicism in contemporary literature, but he found the French writer's declarations vague and his ideas incomprehensible; "Le Symbolisme," 314.

76. Moréas gave the best description of symbolism in his manifesto: "Ennemie de l'enseignement, de la déclamation, de la fausse sensibilité, de la description objective, la poésie symbolique cherche à vêtir l'Idée d'une forme sensible qui, neanmoins, ne serait pas son but à elle-même, mais qui, tout en servant à exprimer l'Idée à son tour,...car le caractère essentiel de l'art symbolique consiste a ne jamais aller jusqu'à la conception de l'Idée en soi (Enemy of teaching, of statement, of false sensibilities, of objective description, symbolic poetry endeavors to cloth the Idea in a sensitive form which, nevertheless, would not be an end in itself, but would be subordinate to the Idea while serving to express it . . . The Idea, on the other hand, should not make its appearance deprived of the sumptuous trappings of external analogies, for the essential character of symbolist art consists of never going straight to the conception of the Idea itself)." Moréas, *Le Figaro*.

77. *L'accueil fait ausymbolisme en Belgique.* This discussion of the critical debate between the "art for art's sake" followers and the symbolists is a summary of Braet's essay.

78. "Si tout le monde se mettait à être original et personnel, on en arriverait bientôt à l'anarchie la plus complète, semblable à celle qui régna jadis sur la Tour de Babel. Chacun aurait sa langue à soi, sa prononciation à soi et son orthographe à soi.": Gille, "Lettre à Albert Giraud," 42.

79. Aron, "Le Symbolisme Belge," 316.

80. After initially criticizing symbolism as "pathological," Edmond Picard came to believe that the creative orientation of an artist would not impede their participation in the social sphere. Picard's understanding of symbolist theory underwent a transformation due, in part, to his personal friendships with Pierre-Marie Olin, co-director of *La Wallonie*, and Emile Verhaeren, who joined the staff of *L'Art moderne* at the end of 1885. Aron, *Les Écrivains belges*, 157, suggests that, due to the fact that they were also trained as lawyers, many of the symbolists tolerated Picard's didactic personality.

81. Aron, *Les Écrivains belges*, 65–125. As this author so ably demonstrates, despite the rapprochement between ideology and culture at the Section d'Art, the practical application of

these ideas was not always so smooth. See also Aron's article "Le Symbolisme Belge," 307-317.

82. "Les arts décoratifs exercent à leur tour sur le peuple leur grand influence sociale, éveillent et affinent le sentiment du beau, épurent les moeurs en y melant ce subtil parfum qui les preserve de la bestialité (the decorative arts exercise in turn a great social influence on the people, awakening and refining a sense of beauty, purifying their morals and placing there a subtle perfume which preserves them from bestiality)." AM 3 (12 August 1883): 253.

83. Levine, "Art Nouveau Sculpture," 72. Chryselephantine is metalwork combined with ivory.

84. Poggioli, Theory of the Avant-Garde.

85. "S'ils ne sont pas contents de leur place, qu'ils exposent chez eux!" This maxim, attributed to a critic commenting on the Brussels Salon of 1884, was placed on the front of the 1885 Les XX catalogue.

86. L'Art moderne claimed that numerous groups were formed upon the same principles as Les XX. But though modeled after Les XX, the French Société des XXXIII and L'Art Indépendant and the Association pour l'Art in Antwerp

existed only for short periods and thus they could hardly be seen as perpetuating the Vingtiste spirit. L'Art moderne reported the formation of the group Cercle des X (The Circle of Ten) in 1885, "Petite Chronique," AM 5 (19 April 1885): 127; of Le Cercle des Peintistes (The Painter's Circle) in 1886, "Petite Chronique," AM 6 (11 July 1886): 210, of Les XIII (The Thirteen) in 1891, "Salon des XIII," AM 11 (8 March 1891): 79; and of Die XI (The Eleven), a Berlin group, in 1893, "Petite Chronique," AM 13 (29 October 1893): 351. Yet once L'Art moderne proclaimed Les XX's paternity, it made few further references to the activities or membership of these groups, suggesting that these spin-offs were either short-lived or not quite as progressive as the Vingtistes may have liked. On groups patterned after Les XX see also Block, Les XX, 54-58.

87. Weisgerber, "La Jeune Belgique," 221.

88. Vervliet, "Lever de rideau," 87.

89. Ibid., 86.

90. "pour être quelque chose, nous devons être Flamands. Nous voulons être Flamands (Soyons Nous) pour devinir Européens," as quoted by Vervliet, 89.

Politics and the Graphic Arts of the Belgian Avant-Garde

by Sura Levine

I appeal to artists: be part of your century. It behooves you to be the historians of your time; and to relate it the way you see it, to express it the way you feel it, from every aspect, in all its guises and manifestations, through all its vicissitudes and greatness.

—*Camille Lemonnier*[1]

The Worker entered into Art and was recognized as the equal of the ancient gods.

—*Jules Destrée*[2]

THE growing alliance between art and labor politics in fin-de-siècle Belgium is reflected in the abundance of representations of the Belgian working class in this exhibition. During the final decades of the nineteenth century, radical artists and critics alike called for an art that had a social function. Beginning in the early 1870s, pleas from Camille Lemonnier and other writers for artists to be "historians of their time" encouraged the creation of *l'art social*, or art with a social message. To these artists, modernity implied a specific relationship between art and labor and class struggles. A number of the artists and critics associated with the Belgian avant-garde—including James Ensor, Fernand Khnopff, Georges Lemmen, Gustave Marissiaux, François Maréchal, Constantin Meunier, Armand Rassenfosse, Félicien Rops, Paul Signac, Jan Toorop, Théo van Rysselberghe, Henry van de Velde, Jules Destrée, Edmond Picard and Emile Verhaeren— sought to ally their avant-gardism with the social reforms of the Parti Ouvrier Belge (POB/Belgian Workers party). Their level of involvement was as diverse as the artists who produced the work.

L'art social, in this sense, was not limited to a single style as has usually been assumed.[3] It was, instead, part of a general movement to create an art that provided more than a purely aesthetic experience. Some Belgian artists produced a body of work representing labor as a noble and worthy subject, while others created posters or placards and participated in exhibitions developed at the Maison du peuple (People's House) in Brussels. Still others gave lectures at Les XX and at the Section d'art (Art Section) of the Maison du peuple or wrote articles on the political nature of contemporary art for *L'Art moderne* (*Modern Art*) and other journals. These artists examined the political circumstances around them and were inspired to portray the modern world.

The development of social art coincided with the artists' growing awareness of and concern for the working class, the largest segment of the Belgian population. The working class became a focal point, both in representation and in the discourses on the arts and political and economic theory, particularly during the two decades following the devastating labor strikes of 1886. Although the artists associated with Les XX were not the first in Belgium to be concerned with the working class and working-class imagery was not the primary or exclusive focus of the Les XX exhibitions, many of these artists made class a central issue in their work.[4]

If modernity in the arts in general concerned the representation of contemporary life, the Belgian avant-garde interpreted contemporary life quite specifically as a consequence of industrialization. The nature and extent of the alliance between art and labor politics within avant-garde circles forms the subject of this essay. Many artists based their work on class issues and sought to involve themselves in

political change. These artists not only created images of labor; many of their works were also intended for consumption by the working class.

In commenting about the effects of modern life, Belgian avant-garde artists often employed the female figure as a characteristic and sustaining subject. Some artists, including Fernand Khnopff, imagined the ideal woman as a hermetic figure; others personified her as a prostitute, whose trade brought together sex and death. Representations of the female laborer were almost equally divided between depictions of the noble, industrial female worker and the urban, working class woman whose morals were deemed analogous to that of the prostitute. These latter two types—the female laborer and the prostitute—are the focus of the final portion of this essay: gender complicated the depiction of class and labor imagery since the kind of labor associated with the female figure determined the audience's response.

Historical and Political Context

Belgium had become the most highly industrialized country on the European continent by the mid-nineteenth century and was under the leadership of a Liberal Parliament until 1884. The last glimmers of this economic prosperity were in the "boom" years following the Franco-Prussian War. Between 1870 and 1914 the Belgian economy wavered between great expansion and long-term depression. This expansion reached a climax in 1873 and a downward trend began, creating depressed conditions that would last almost continuously until 1895.[5] Though there was a brief respite from economic depression coinciding with the celebration of the fiftieth anniversary of Belgian independence in 1880, the bad winters of 1883–84 and 1885–86 relegated much of the Belgian agricultural and industrial population to near-starvation.[6] In response to the continuing neglect of the population by the Liberal and Catholic Parties, the POB formulated its political platforms based on labor issues.

Reformist in nature, the POB initially rejected the more inflammatory term "socialist" as part of its name. This is not to say that socialists remained outside of the organization; many of the early leaders were socialists. But in rejecting the term, this new political party attracted a large group of disenfranchised progressive liberals, many of them lawyers, who might not have joined otherwise.[7] Although a labor movement had existed in Belgium since the First International (1864–65), the Belgian working class had little governmental representation until the

final decade of the nineteenth century. Until 1893 voting rights were based on an ability to pay a poll tax that few in the working class could afford. The right to vote became the primary platform of the POB between 1889 and 1893. At its first Congress (18 August 1885, at the Hotel du Cygne on the Grand' Place, Brussels) the POB demanded increased salaries, shorter work days, universal male suffrage, mandatory free education, and subsidized housing for low-income families.[8]

In the aftermath of sporadic strikes in the Borinage industrial region during 1885, the Party planned a series of large demonstrations throughout Belgium, scheduled for the following Pentecost.[9] By spring 1886, the POB's economic and suffrage demands, echoed by people from the industrial sectors around Liège and Charleroi, remained unheeded in the Parliament Chamber. Spurred on by the publication and rapid diffusion of over 260,000 copies of socialist Alfred Defuisseaux's pamphlet *Catéchisme du Peuple*, workers from various industrial locations decided to strike.[10]

On 18 March, a group of Liège anarchists organized a demonstration to commemorate the fifteenth anniversary of the Paris Commune. The local police took immediate and decisive action against this small, yet vocal manifestation of unrest. Within a matter of hours seventeen protesters were wounded and fifty arrested, while 104 buildings were looted.[11] The crackdown did not end the protests and within twenty-four hours a general strike was mounted throughout the industrial sectors of Belgium. By 25 March, the strikers had gained control of the Charleroi Basin and other industrial regions, with scattered incidents in Brussels and Antwerp. Despite pleas from the leaders of the POB, asking the strikers to act with restraint, the POB was blamed for the continuing violence.[12]

The 1886 strikes provoked a number of positive results, among them a series of labor reforms and a closer alliance between the arts and the POB. Once the violence had subsided, King Léopold called for a Commission du travail (Labor Commission) to examine the situation of the working class. Their findings were published a year later.[13] Among the recommendations were laws restricting the labor of women and children in heavy industry, including not allowing women or children under the age of 12 to work in the mine veins, and a mandatory four-week maternity leave.[14]

As the POB and its constituents learned the efficacy of the general strike as a means of attaining political gains, strikes and other forms of job action

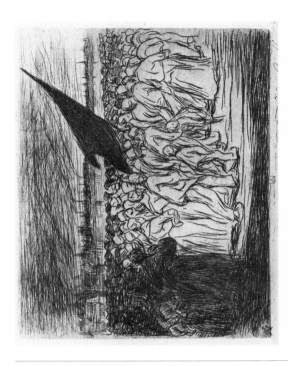

FIGURE 6. Eugène Laermans, *La Grève* (*The Strike*), drypoint, ca. 1895. © Bibliothèque Royale Albert 1er.

continued through the turn-of-the-century.[15] The 1893 socialist-backed strike for universal male suffrage was the farthest reaching of the general strikes that followed. The *censitaire* (poll tax) finally was abolished. Universal male suffrage was established but, in order for the Liberal or Catholic parties to maintain control, plural votes were granted to the wealthy.[16] In the elections held the following year, some 346,000 citizens voted POB, electing 28 deputies to the Parliament.[17]

Edmond Picard, Jules Destrée, Emile Vandervelde, and Max Hallet were among the new POB deputies. Their presence in the Parliament was important in many ways, not the least of which was their interest and involvement in the arts. Picard had written articles for and served on the editorial staff of *L'Art moderne* almost from its inception in 1881. During its early years, the journal's articles reflected Picard's socialist perspective. (In addition to Picard, the editorial board included Octave Maus, later secretary of Les XX, Eugène Robert, and Victor Arnould. From 1883 on *L'Art moderne* was viewed as the official organ of Les XX. Emile Verhaeren joined the board in 1885 and the journal's orientation became more symbolist and less overtly political in orientation.)

One of Picard's articles for *L'Art moderne* was "L'Art et la Révolution," an appraisal of the anarchist and socialist theories in Peter Kropotkin's *Paroles d'un Révolté* and Jules Vallès' *L'Insurgé*.[18] Exhorting poets that "the hour has come to dip [your] pen into red ink," Picard argued that artists of all kinds should turn to the contemporary world of labor for their inspiration.[19] He felt that by depicting this aspect of modern life the artist would dissolve the barriers between the different segments of society and form a state of harmony. For Picard, art criticism and contemporary art contained an explicitly political potential.

The increased visibility of the POB following the 1886 strike convinced even more progressives to join its ranks. Among those who joined at this time was Jules Destrée, later the Minister of Fine Arts. In addition, the strikes formed a recurrent subject for many Belgian artists. Constantin Meunier [cat. 97], François Maréchal [cat. 86], James Ensor, Eugène Laermans [fig. 6], and Félicien Rops [cat. 116] each depicted these events at least once.[20]

the development of the Section d'art brought avant-garde culture to "the people." Established by the Cercle des étudiants et anciens étudiants socialistes (Circle of socialist students and former students) in 1891, the Section d'art was a subsection of the POB's larger cultural and educational wing.[21] It was founded "to contribute to the aesthetic and scientific education of the proletariat" and provided its membership with lecture series, exhibitions and concerts.[22] In keeping with the idea that cultural events should not be prohibitively expensive for the membership, entrance fees for the events were limited to 10 centimes.

In order to entice the largest possible number of artists, composers and writers to its cause, the Section d'art ruled that membership in the POB was not required for participation in its cultural activities.[23] It was assumed, though, that speakers and participants would at least be fully sympathetic to the working class:

It was decided that no artist, in his involvement with the Art Section, need adopt the political program of the Workers Party. Those poets, painters, musicians, who have and will reach out to the people, pulled by their sympathy for them or by their studies, certainly give them all of their ardor and enthusiasm, but remain free. Individually, they can participate in our struggles, but the Section d'art remains distinct and independent of anything other than art.[24]

Beginning with its first year, the Section d'art underwrote annual tours of the exhibitions of Les XX and La Libre Esthétique, as well as installations of works by individual artists. On occasion, Vingtistes also gave tours of the museums and of their personal exhibitions.

Section d'art

Although contributors to *L'Art moderne* and other journals of culture had written about the alliance between art and labor politics since the early 1880s,

Although much of the documentary information has disappeared, it is clear that the Vingtistes had a special relationship with the cultural wing of the POB.[25] The editors of *L'Art moderne* reported regularly on the activities of the Section d'art. Khnopff was a member of the section's organizing committee and created the device for the association's letterhead, which subsequently was reproduced on the cover of the cultural group's 1893 *Annuaire* [cat. 59].[26] Echoing the device Khnopff had created for the Les XX stationery eight years earlier, his insignia for the Section d'art is a woman before a sunrise, crowning herself with "Art." Together with the representation of the olive branch Khnopff designed for the back cover of *Annuaire*, the insignia establishes an alliance of art with politics that was meant, as Jeffrey Howe has suggested, to herald a new age.[27]

It is not known whether Khnopff ever contributed to any of the exhibitions organized by the Section d'art. Nevertheless, he identified himself as a member of the organization in a letter addressed to the group's secretary, Paul Deutscher, in 1901:

I have just learned of the program of the exhibition to which you invited me. Unfortunately, I have nothing which fits the program.

Soon, I hope, I will find for the House [Maison du peuple], a souvenir from this member of the Section d'art.[28]

Max Elskamp, Octave Maus, Edmond Picard, and Emile Verhaeren all joined Khnopff as *membres souscripteurs* (subscribing members) of the Section d'art. Each wrote articles for the 1893 *Annuaire* and, over the next twenty years, gave lectures and/or courses on art, politics and literature at the Maison du peuple.[29]

Many other artists exhibited or participated in varying degrees at the Section d'art.[30] These included Vingtistes Willy Finch, Guillaume van Strydonck, Anna Boch, Paul Signac, Georges Lemmen, Henry van de Velde and other artists associated with, but not members of Les XX, among them Constantin Meunier and Eugène Laermans.[31] Of the Les XX members, the contributions of Lemmen and van de Velde were the most extensive. As Susan Canning has pointed out, van de Velde gave a series of lectures to its members, including "Les Arts et d'industrie et d'ornementation populaire" in 1894, and "William Morris, artisan et socialiste" in 1897, each time making explicit the relationship between radical forms of art and the concerns of the working class.[32] Van de Velde provided other assistance to the Section d'art, including designs for publicity materials.

He composed the program flyer for Pierre d'Alheim's "Moussorgski & le Peuple" [fig. 7], a lecture and concert that took place 1 February 1898.[33] Taking the politics of this assignment very seriously, van de Velde wrote to Deutscher, "You can print my drawing in *red* (or in color)."[34]

Lemmen's contributions also were crucial, and equally ephemeral in character. On at least two occasions, he created objects for groups associated with the Brussels Maison du peuple. One was a poster announcing May Day celebrations for 1892, the other a design for a membership card for the POB [cat. 72 and 74].

The first of May was set aside as an international celebration of labor beginning in 1890.[35] For the third celebration, Lemmen designed a May Day poster for the short-lived POB journal *Le Mouvement Social*.[36] This poster incorporates symbolic and art nouveau strategies similar to those Lemmen had employed for his Les XX catalogue covers for 1891 and 1892 [cat. 68 and 69]. The poster combines the symbols of a rising sun and tree—symbols that by 1892 were already

FIGURE 7. Henry van de Velde, *Cover for the February 1, 1898, conference and performance* "*Moussorgski & le Peuple*" *at the Brussels Section d'art*, relief print with letterpress, 1898. Courtesy of the Archives Henry van de Velde, Abbaye de la Cambre, Brussels.

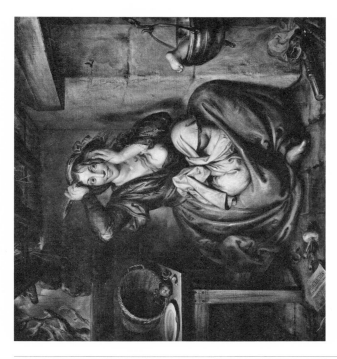

FIGURE 8. Antoine Wiertz, *Faim, Folie et Crime* (*Hunger, Madness and Crime*), oil on canvas, 1854. Musée Wiertz, Brussels.

associated with the radicalism of Les XX. Seen in concert with the images of a bird, a shovel and the text "Liberty, Work, Fraternity," these details suggest that the strong roots found in an association of labor politics, with the collective spirit of the labor movement, would form the basis for a new social order. Printed in red, the color used for banners of striking workers throughout Europe, Lemmen's poster makes explicit the alliance between art nouveau and the Workers' Party.

In 1897 Lemmen drew at least three versions of his *La Famille des travailleurs* (*Family of Workers*). Because of its similarities to a recently rediscovered drawing inscribed "Maison du peuple/*Carte de membre Effectif de Bruxelles Société du/ Personnel/De la Maison du peuple De/Bruxelles/Fondée en 1886* [sic]," it is thought to be a design for a membership card for the Maison du peuple.[37] This work was not put into circulation, however. Although it is not known who might have been responsible for this commission, or if Lemmen chose to work on it independently, this drawing is one of the few instances in which Lemmen depicted laborers. Since the drawing exhibited here is squared for transfer, it appears to have been the definitive design for the membership card.

Relationships between the avant-garde artists and the POB were not always harmonious, however. A case in point is Paul Signac's attempt to sell his monumental painting *Au temps d'harmonie*, exhibited at the 1896 Libre Esthétique, to the Maison du peuple in the closing years of the nineteenth century. Signac, a member of Les XX since 1890 and a well-known adherent of anarcho-socialism, had hoped to find a home for his painting at the Brussels Maison du peuple. The painting, like the lithograph version originally designed for inclusion in a print portfolio for the anarchist journal *Les Temps nouveaux* (*New Times*), depicts a scene from a new social order based on a union of labor and leisure [cat. 123]. Just prior to the inauguration of the new Maison du peuple in 1899, the artist began negotiations with the POB to sell the painting for installation in their headquarter's reception room, the *Salle Matteotti*.[38] However, it was too large for the intended space (measuring 4m x 3m) and the POB decided instead to purchase Antoine Wiertz's painting of Christ preaching (present location unknown).[39] Though this might seem an odd choice, given the traditional animosity between socialism and Christianity, the latter painting had been created by a Brussels-based artist who was known for his depictions of the economic sufferings of the Belgian working class [fig. 8].[40] It may have been that the Brussels group preferred to hang works by Belgian

artists, rather than purchasing works by artists from other countries.[41] It is likely that Signac's painting fell victim to his own dictum, "Justice in sociology, harmony in art: [they are] the same thing . . . An anarchist painter is not one who creates anarchist paintings, but one who, without care for money, without desire for recompense, fights with all of his individuality against bourgeois conventions and officials."[42]

The Section d'art brought culture to the people in a variety of ways. By organizing exhibitions, concerts, and courses and occasionally calling upon artists to provide art for its activities, the organization encouraged artists to put their work in the service of the Party's cause. The POB also supported avant-gardism in architecture and in the fine and graphic arts.

Palaces for the People

In the 1890s the POB commissioned new headquarters in Brussels, Ghent, and Antwerp. Of these, the most important in terms of architectural history is the Brussels Maison du peuple designed by Victor Horta [fig. 9]. Horta is best remembered as the premier architect of art nouveau homes for the wealthy in late nineteenth-century Brussels, yet his Maison du peuple—arguably his most important edifice—was built as a kind of "palace" for the working class. Horta's building also was seen, by supporters and detractors alike, as the most explicit expression of a reciprocal relation between art and politics.

The sudden prominence of the POB in national politics after 1893 necessitated a new building to serve as the headquarters for the increasingly active political party. The new building was needed to replace the cramped quarters the POB had used since the 1880s in a former synagogue on the rue de Bavière. Furthermore, the new Brussels Maison du peuple was to be a visible reflection of the differences between the Catholic and Liberal parties who sought to represent the interests of the status quo and the party of the "future," the POB.

Horta's building fulfilled these requisites as it broke radically from the norms of traditional architectural styles. It can be viewed as a harbinger of the new cooperative society envisioned by the POB. Even the materials from which the building was constructed—primarily glass, iron and steel—were significant. To Horta they symbolized the light and air that long had been denied laborers in their own homes.[43] The glass and metals of the building linked its design to two labor groups, glassblowers and miners, that had been instrumental in the formation of the POB in

FIGURE 9. Victor Horta, Maison du peuple, 1896–1899. Demolished 1965–66.

1885. Horta's building, iconographically and physically, paid homage not only to the industrial materials favored by art nouveau architects in general, but to the industries that created those materials.[44]

The Brussels Maison du peuple was inaugurated on "Red Easter" 1899, transforming the holiest of Christian holidays into a two-day celebration of socialism. To commemorate the event, the Ghent-based socialist artist Jules van Biesbroeck was commissioned to design the official poster, which depicts a young worker proudly holding the red banner associated with the POB in one hand and pointing to the events scheduled for the inauguration with the other [cat. 132]. Like the building it celebrates, this poster stylistically reflects the union of art nouveau with labor politics. Though the building is not depicted in the poster, its presence is alluded to in two details. The undulating typographic design reflects the sgraffito on the Maison du peuple while the organically-based column reproduces those Horta designed for the edifice. Using an advanced art nouveau style similar to that of the Maison du peuple, this poster accords

with van Biesbroeck's artistic philosophy that an art for the people need not be "populist" in style but should raise the awareness of its audience.[45]

To align itself more closely with the cooperative ventures of the Brussels Maison du peuple, Antwerp's Help U Zelve (Help Yourself) or Liberal party also designed its headquarters in the art nouveau style.[46] The Antwerp leaders commissioned two designers who, like Horta, were politically and architecturally progressive. Emile van Averbeke and Jan van Asperen designed the new Antwerp Volkshuis (People's House), commissioned in 1899 and completed in 1901 [cat. 143].[47] Like the Brussels Maison du peuple, it housed cooperative stores, meeting rooms and chambers for other Party functions. By commission-ing architects who had politically-progressive pedi-grees and who worked with the newest architectural vocabularies, the People's Houses in Brussels and Antwerp fostered the association of labor politics with avant-gardism.

Representing Class

Representations of the Belgian working class did not originate with the avant-gardists of the 1880s and 1890s, but had grown more frequent three decades earlier. Within two years of Gustave Courbet's instal-lation of *The Stonebreakers* at the 1851 Salon in Brussels, a group of artists in Brussels began working in a similar realist style. Led by Charles de Groux (1825–1870), a student of François-Joseph Navez (1787–1869), this realist school, like its counterpart in France, presented an important challenge to academic art and patronage.[48] As was the case in France, real-ism in Belgium constituted an alternative to official art not only through its anti-academic style, but through its representation of peasants and laborers as worthy subjects of art. For these reasons the style was scorned initially by critics and the public.

The Belgian realist artists eventually banded together as a group and formed an exhibiting society, the Société Libre des Beaux-Arts (Free Art Society) in March 1868. The group wanted to undermine official painting, such as the still-popular Neoclassicism and Romanticism, by representing scenes of contemporary life rendered without allegorical or symbolic props.[49] The subjects painted and sculpted were as diverse as the artists involved, yet all of their works fall under the general rubric of the realist or naturalist aesthetic, which aimed at giving a truthful, objective and impar-tial representation of the material world. Some, including Louis Artan (1837–1890) and Camille van

Camp (1834–1891), were plein air landscape painters who followed Corot and the Barbizon artists. Others, such as Alfred Verwée (1838–1895), painted animals as a means of commenting on the stratification of socio-economic classes in contemporary Belgian society, while still others, including Eugène Smits (1826–1912), Félicien Rops, Constantin Meunier and de Groux, began to paint and etch scenes from Belgian working class life.[50] Little is known about the actual functioning of this circle, which had ceased to exist by the middle of the 1870s. By 1875, official opposition to realism had waned, and some artists, such as Meunier and Rops, later became famous and truly popular at the Triennial and the avant-gardist salons.[51]

The members of the group did not exhibit their works simply for personal gain; on several occasions the profits from their shows went to various charities. One of their exhibitions was held as a benefit for the *écoles gardiennes*, schools for impoverished children, in the Minimes neighborhood of Brussels and in the same year they organized a subscription for the victims of the Chicago fire.[52] As Jane Block has suggested, the philanthropic activities of this first Belgian avant-garde group may have reflected the organization's belief that, as oppressed artists, they shared a common bond with the working class.[53] This consciousness of the social obligations of art remained with these painters and continued to be important for many of the artists later associated with avant-gardism.

De Groux became the spiritual leader of Belgian social realism as early as 1853, when he exhibited *L'Ivrogne* (*The Drunkard*, fig. 10) at the Salon. This painting, representing sickness among the underprivi-leged population in Belgium and the effects of alco-holism on working-class family life, became emblematic of social realism in Belgium.[54] De Groux's works were often discussed in terms of the ways they elicited pity for the vicissitudes of life for the urban and rural Belgian poor. None of his paint-ings offers consolation, but only an utterly pessimistic and straightforward view of the miseries associated with poverty, particularly his devastating *Le Moulin à Café* (*The Coffee Grinder*, fig. 11).

After de Groux's untimely death in 1870, artists Constantin Meunier (1831–1905), Charles Hermans (1839–1924) and Félicien Rops (1833–1898) emerged as portrayers of the working class.[55] Though their work took different paths, the various ways they rep-resented the working class influenced a generation of younger artists. Meunier trained as a sculptor at the Académie Royale des Beaux-Arts de Bruxelles during the late 1840s and early 1850s and is best known today for his sculptures of industrial laborers. His first

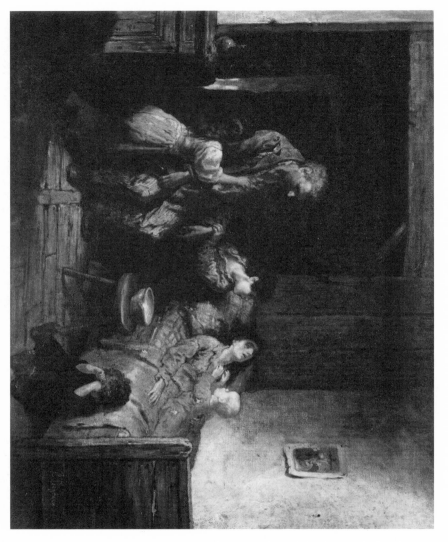

FIGURE 10. Charles de Groux, *L'Ivrogne* (*The Drunkard*), oil on canvas, 1853. Courtesy of the Musées Rroyaux des Beaux-Arts de Belgique, Brussels.

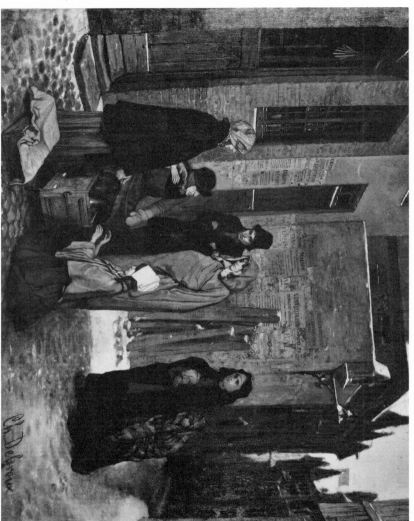

FIGURE 11. Charles de Groux, *Le Moulin à Café* (*The Coffee Grinder*), oil on canvas, ca. 1857. Courtesy of the Museum voor Schone Kunsten, Antwerp.

mature works were paintings on historical and religious themes, yet even in his decision to paint such "noble" subjects, his sympathy for the less fortunate was already evident.[56] A now-destroyed painting of *The Sisters of Charity, The Hospital of Saint Roch* (1857) presented nuns washing the feet of a destitute woman who had just died. Most of his depictions of Trappist monks similarly focused on monastic labors rather than religious practices. Meunier's *Peasant Revolt of 1798* (exhibited at the Brussels Salon in 1875) is indicative of his growing interest in representing moments when workers saw themselves as historic agents.[57] From the late 1870s until the end of his career, however, Meunier turned his attention to the contemporary Belgian working class as his major source of inspiration. He later acknowledged his debt to de Groux and other predecessors who enabled the depiction of the working class:

If de Groux emboldened me to treat the working class as a subject, the taste for not painting well-known and stiff subjects pre-existed in me and was the common patrimony of a whole generation . . . As well, this was a period which called for an individual type of painting less devoted to the unities [of art] or to princes and more concerned with the masses, the people.[58]

By shifting to contemporary industrial labor from historical or religious subjects, Meunier clearly responded to Lemonnier's entreaty that artists should become "historians of their time." Indeed, Meunier's works from 1880 forward appear to be almost a point-by-point illustration of J.K. Huysman's comments that modern art should depict "all of the kinds of work men do in the mills and in the factories, all of the

modern fever that presents the activities of industry, all of the magnificence of machines. All of this is still to be painted and will be painted."[59] His interest in the "magnificence of machines" and "all of the kinds of work men do" was reflected in the first images he painted of the industrial regions of Belgium.[60] Meunier first visited the *Pays noir* (Black Country) in 1878 or 1879 at the invitations of Baron Sadoine, director of the Cockerill factory in Seraing, and of M. Depret, director of the glass works factory of Val St. Lambert.[61] The paintings that resulted from this trip—*Dans l'usine* (*In the Factory*) and *La Chaudronnerie* (*usine Cockerill*) (*Boilerworks, Cockerill Factory*)—were exhibited to great acclaim at the 1880 Ghent Salon. Meunier also exhibited *Métallurgie: La Font de l'acier* (*Metallurgy: Steel Foundry*) at the Belgian art retrospective exhibition in Brussels the same year.[62] When asked later why he chose labor and working class figures as his subjects, he responded "I sculpted these men simply because I liked them."[63]

Throughout his career, Meunier identified himself more as a laborer of art than as an artist.[64] Although he seldom represented specific historical events such as strikes or mining accidents, these subjects do exist in his oeuvre [cat. 96 and 97], but the vast majority of his works are more concerned with labor practices of all types. Meunier was dubbed "the artist of the Flemish collieries," but his work includes depictions of agricultural labor, glassworkers, dockworkers and the port industry.[65] In addition, he produced images of industrial architecture [cat. 99], life in the *corons* (miners' dwellings), and, above all else, the faces and bodies of the laborers themselves, young and old, male and female.

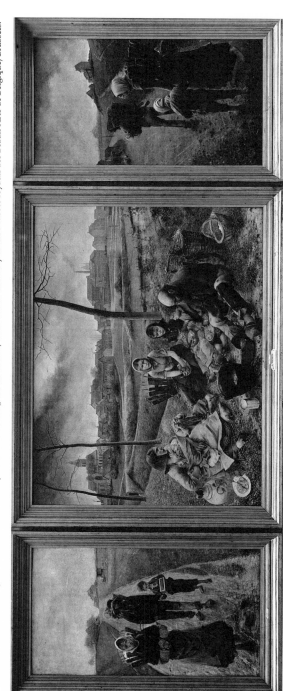

FIGURE 12. Léon Frédéric, *Les Marchands de Craie* (*The Chalk Sellers*), oil on canvas, 1882–1883. Courtesy of the Musées royaux des Beaux-Arts de Belgique, Brussels.

Meunier's increasing renown for representing the working class was further strengthened by his frequent participation in exhibitions throughout Europe, his intimate friendships with Picard and Destrée, who promoted his work in the socialist press, and his collaborations with such literary figures as Camille Lemonnier, leader of Belgian naturalism. An early collaboration was *La Belgique* (1884), Lemonnier's volume detailing the characteristics of contemporary life throughout Belgium. In addition to Meunier's numerous illustrations of factories and peasants from the Hainaut and Liège regions, the volume included images by Xavier Mellery, Emile Claus, Théodore Verstraete, and others.[66] Meunier worked with

Lemonnier on at least two other occasions, providing illustrations for Lemonnier's novella *Le Mort* (*The Dead Man*, c. 1882, cat. 95] and initiating the *Au Pays noir* project around 1896, a deluxe portfolio of etchings based on his drawings of that industrial region.[67] Meunier's images also were published in a variety of other authors' texts. These include a strike scene, etched by his son Karl [cat. 97], that served as the frontispiece of Louis Delmer's *Le Fils du Gréviste* (The Striker's Son), a story describing the general strike of 1886.

From the early 1880s onward, artists of very different political persuasions turned to the working class for their inspiration. Léon Frédéric (1856–1940) is best

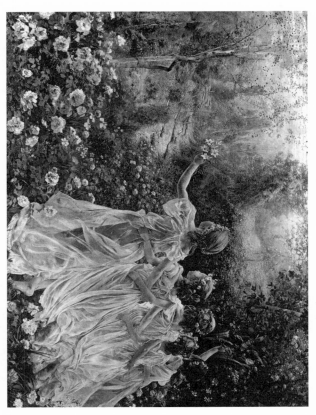

FIGURE 13–a,b,c (clockwise from upper left). Léon Frédéric, *Le Peuple verra un jour le lever du soleil* (*One Day the People Will See the Sunrise*), oil on canvas, 1891. Brussels, Communauté Française.

13–a

13–b

13–c

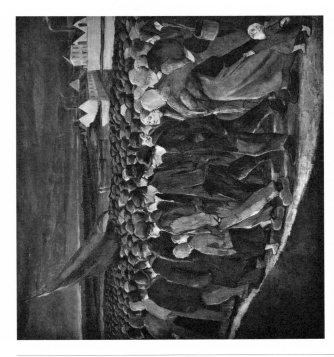

FIGURE 14. Eugène Laermans, *Un Soir de grève* (*The Night of the Strike*), oil on canvas, 1898. Courtesy of the Musées royaux des Beaux-Arts de Belgique, Brussels.

known today for his genre paintings and religious subjects, yet he also produced a number of important images of working-class life. The development of Frédéric's labor-inspired imagery recently has been characterized as marking a shift from a kind of photographic realism to a "symbolist socialism."[68] His monumental 1882–83 triptych of *Les Marchands de Craie* (*The Chalk Sellers*, MRBA) provides a visual narrative of a day in the life of itinerant laborers [fig. 12]. On the side panels, Frédéric depicts their grueling trek to and from the chalk mines; the central panel presents the family taking a short break from their travails in order to eat a paltry lunch.

The obvious pessimism of the *Chalk Sellers* is transformed into hope in *Le Peuple verra un jour le lever du soleil* (*One Day the People Will See the Sunrise*, 1891, figs. 13a–c).[69] The left panel presents three nude and bleeding young girls making their way through a thorn field. It is telling that they are journeying away from Brussels' cathedral, the Church of Saint Gudule, that is depicted in the background. This panel signifies, in the words of a critic at the time, "the people who, tired of religions, go on, alone, through all of the difficulties of life, in search of happiness."[70] The central panel depicts a group of doomed figures attempting to climb out of a turbulent landscape toward a better life presented in the right panel. Set in a radiant spring landscape, five young girls, all dressed in diaphanous robes, traverse a garden strewn with roses. Their salvation and that of the Belgian people is the Palais de Justice (Law Courts) of Brussels, barely discernible in the distance in the brilliantly-lit, clearing sky. This painting was exhibited with great success at the 1891 Antwerp triennial salon.[71]

The labor strikes became important and compelling subjects for many of Belgium's avant-garde artists during the final quarter of the nineteenth century. Rops' *La Grève* (*The Strike*) is the earliest of these modernist images [cat. 116]. Rops created this etching in 1876 while visiting the collieries at Frameries, six years before the first Les XX exhibition. Although this print had been published in the December 1885 issue of *L'Artiste*, Rops also chose to include it among his submissions for the final exhibition of Les XX in 1893—when it would have greater political relevance, given the recent history of strikes throughout Belgium.

La Grève seems to be unique among these depictions of the labor strikes in its focus on the female figure. In a counterpoint to the more typical images of large groups of predominantly male workers forming processions in a clearly articulated industrial

landscape, such as those by Eugène Laermans [fig. 14], Constantin Meunier [cat. 97] and François Maréchal [cat. 86], Rops' etching recalls the fact that *grève* is a feminine noun.

In contrast to the realistic images of labor unrest, Maréchal's drawing utilizes an exuberant graphic touch and a sense of the paper itself as an active textural agent, typical of the pastels associated with such neo-impressionist and symbolist artists as Georges Seurat and Fernand Khnopff [cat. 56 and 62]. Maréchal, from Liège, was a chronicler of the working class. In such works as his masterful drawing *On Lécheu d'baie* (*A Toady at the Railing*) he depicted the effects of unemployment in the coal-mining regions [cat. 84]. As a major industrial center, Liège and its surroundings suffered more than other parts of the country in the wake of numerous strikes and mine closings. In presenting various consequences of economic recession, Maréchal evoked the fatalistic attitude of a man who has no work and no hope of work. The figure in *On Lécheu d'baie* sits, hands folded on his thighs, staring sightlessly, as if he had been in this same spot throughout the day and would remain there through the night.

This interest in all aspects of industrial labor was shared by another Liège artist, Gustave Marissiaux, dubbed "the Constantin Meunier of photography."[72] Marissiaux's monumental series, *La Houillère* (*The Coal Mine*, 1905), of over three hundred photographs is an extraordinary project both in terms of the history of documentary photography and in the way it

reflected the commercial viability of labor imagery in Belgium. Commissioned by the Liège coal syndicates to create, for publicity, a photographic survey of the technical accomplishments of the Belgian coal industry, Marissiaux catalogued all aspects of the coal-mining industry in the early years of this century.[73] *La Houillère* was first presented as a slide lecture at the Liège chapter of the Belgian Association of Photography, in 1905.[74] Working in a straightforward documentary mode, Marissiaux's series contains both panoramic views of the belching towers typical of the industrial landscape and details of the back-breaking work done by men, women and children above and below ground [fig. 15 and 16]. Many of his images recall the same poses and scenes that Meunier and other artists had used since the early 1880s. Marissiaux presented a second, more intimate view of the Belgian working class in the portfolio of thirty photogravures, *Visions d'artiste*, he published three years later. Where *La Houillère* portrays the more "official," work-day aspect of the coal mines, *Visions d'artiste* depicts domestic interiors along with scenes of labor.

Representing Gender

Though Rops' *La Grève* was unusual in its depiction of a *female* striker, this etching is typical of many late nineteenth-century images that reveal a preoccupation with women and their class standing. These works offer both moralizing critiques and sympathetic views of the situation of women in the modern world. They also point to the ways that class position helped determine notions of femininity. Three types of women appear frequently in these modernist renderings—the hermetic or domestic bourgeois woman, the female industrial laborer, and the prostitute; only the latter two will be discussed here as they crystallize, most clearly, attitudes to both gender and class.[75]

Women constituted a crucial presence in each aspect of Belgium's industrial and agricultural production. They worked alongside men in the fields and in the mines, and dominated the service and fine textile industries. Thus it is hardly surprising that artists concerned with Belgium's working class turned to women laborers as an important subject. In representations of lace making—a cottage industry—artists often presented a lone female laborer seated by a window in the more intimate environment of home. Such depictions were accurate insofar as they documented the location of such work, but they fail to do justice to the quality of the domestic space itself.

Throughout the second half of the nineteenth century, social theorists were concerned with the impoverished environments in which the Belgian working class lived and regularly commented on the extreme youth of the women who worked in textiles.[76] However, in the vast majority of paintings of seamstresses and lace makers all allusions to the adverse conditions of women's and child labor are completely absent. These images often present fairly

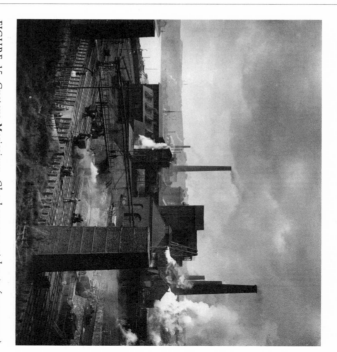

FIGURE 15. Gustave Marissiaux, *Charbonnages et hauts fourneaux à Ougrée, Bois d'Avroy* (*Coal mine and furnaces at Ougrée, Bois d'Avroy*), photograph, 1904. Courtesy of the Musée de la Vie Wallonne, Liège.

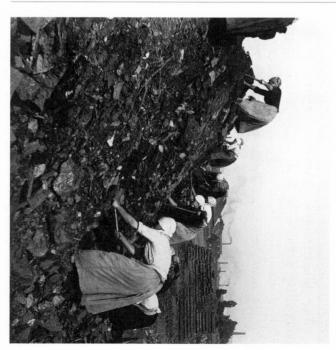

FIGURE 16. Gustave Marissiaux, *Le Terril* (*The Slag Heap*), photograph, ca. 1904. Courtesy of the Musée de la Vie Wallonne, Liège.

cozy and well-lit, even picturesque spaces; in many of these depictions the textile worker is a women at least in her twenties (sometimes older), neatly dressed and peacefully at work in spotless surroundings. Artists as diverse as Henri De Braekeleer, Léon Frédéric and Georges Le Brun all created lyricizing views of the *travailleurs à domicile* (home industrial laborers).[77] The laborers they depict might, in fact, be mistaken for women of the leisure class who were also portrayed, on occasion, pursuing such domestic tasks as sewing.

The potential confusions of class status in these domestic images, however, are completely absent in depictions of women at work in the coal mines. Where knitters, lace makers and seamstresses were represented as primly feminine, depictions of *hiercheuses* (haulage women) and *glaneuses* (coal gleaners) at work emphasized their physical strength rather than their gender [fig. 17]. Marissiaux's *Retour au "Coron" (Return to the Miners' Dwellings)* for example, portrays a group of women straining, almost like beasts of burden, under their coal sacks [cat. 89]. Their individuality, like their femininity, has been

effaced. At leisure, however, the *hiercheuse* was often rendered as a participant in and purveyor of sexual license. Rassenfosse's 1905 *Hiercheuse* [cat. 110], *Le Baiser du Poiron/L'Amour au Pays noir* [cat. 109], and Maréchal's *Premier Mai* [cat. 85] all comment on the activities of *hiercheuses* at moments of repose. In the first, the young women sits coquettishly on what appears to be a slag heap and boldly confronts her audience, in the others the female figure loses herself in sexual abandon. Although Meunier, Douard, Marissiaux and other artists portrayed *hiercheuses* in an elevated, ennobled style [fig. 18], Rassenfosse and Maréchal—perhaps reflecting governmental discussions of sexual license among the female labor population—depicted these women as promiscuous.[78] Thus, haulage women would come to be viewed as the counterpart of urban prostitutes.

The figure of the prostitute as emblematic of urban working class women was an ubiquitous subject through the turn of the century for artists interested in exploring the nature of modernity. This fascination with prostitution is already evident, for example, in Charles Hermans' monumental 1875 *À L'Aube (At*

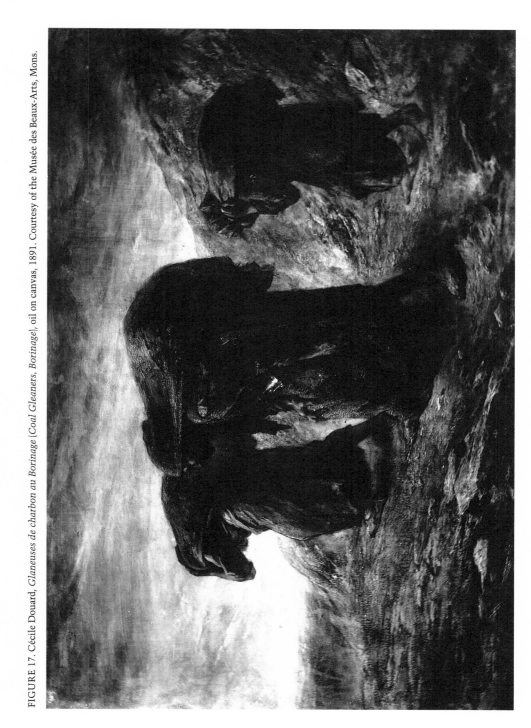

FIGURE 17. Cécile Douard, *Glaneuses de charbon au Borinage (Coal Gleaners, Borinage)*, oil on canvas, 1891. Courtesy of the Musée des Beaux-Arts, Mons.

Dawn, fig. 19); it reached its greatest expression in the works of Félicien Rops. *À L'Aube*, exhibited at the 1875 Salon, combines a social realist concern for representing the working class with the painterly innovations of the French Impressionists, especially in the break-up of color and brushwork.[79] David Stark has argued that this work is "a far cry from the increasingly remote, detached objective viewpoints of the French impressionists," for Hermans "presents the spectator with a moralizing anecdote."[80] The focal point of the painting is a drunken gentleman, in tails and top hat, who has just exited from a cabaret in the early hours of a work day. He hesitates between two fashionably attired prostitutes, one of whom points with her fan to a waiting carriage while the other embraces him in an attempt to convince him to stay with her.[81] Behind them, another courtesan crosses the threshold with her client. In the left corner, by contrast, is a group of laborers on their way to work, including a modestly-dressed, drab woman, who turn their attention, in varying degrees of embarrassment and fascination, to this scene of debauchery.

By incorporating a series of contrasts—rich and poor, leisure and work, drunk and sober, and debauched and noble—Hermans' painting critiques the extremes of modern life. Although this painting presents working-class subject matter, attention is focused on the fashionably dressed coquettes in the foreground. The painting's favorable reception in 1875 can be attributed, in part, to the way it presents the ultra-feminine figure of the prostitute as a contrast to the desexualized female laborer, their confrontation thereby suggesting wholly antithetical social roles.

Though Rops was fascinated with all manner of contemporary women (he even designed women's clothing with the sisters Duluc), he focused on the *demi-mondaine* and the streetwalker as typifying the modern, urban working-class woman. But where Hermans represented modern prostitutes as pretty and sensuously plump, Rops rarely idealized these figures. Instead, as he wrote in an 1878 letter to one of his patrons, "one must never draw a classical nude but the nude of today. One must not draw the bosom of the Venus de Milo but rather the bosom of Tata which is less beautiful but which is the bosom of the day."[82] And where Hermans' portrayal of prostitutes omitted any allusions to venereal disease, Rops often concentrated on precisely this latter issue.

Typical of Rops' depictions of prostitutes is *Mors Syphilitica* (*Syphilitic Death*, cat. 114), produced in the same year as Hermans' *À L'Aube*. This etching was created when new laws were being enacted to regulate

both the types of prostitution and cleanliness among sex-workers in Belgium and France. Set in a doorway with her face partially cast in shadow, Rops' prostitute at first glance seems quite attractive; she wears a slinky dress that hugs her curves and reveals her breasts. Rops added pink highlights to her nipples, lips, cheeks, and the flower in her hair. Yet she seems already infected with a sexually-transmitted disease as her face is skeletal; her association with the "grim reaper" is evoked by the scythe placed in the shadows behind her.

Although "real" prostitutes were linked to the spread of disease, idealized prostitutes could still inspire art. Rops' fascination with the exceptional increase of prostitution in France and Belgium found

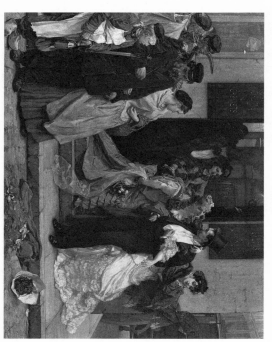

FIGURE 18. Gustave Marissiaux, *Hiercheuse* (*Haulage Woman*), photograph, 1904. Courtesy of the Musée de la Vie Wallonne, Liège.

FIGURE 19. Charles Hermans, *À L'Aube* (*At Dawn*), oil on canvas, 1875. Courtesy of the Musées royaux des Beaux-Arts de Belgique, Brussels.

its most scandalous expression in 1878 in *Pornokratès* [cat. 121]. In the watercolor on which the present print is based, Rops transformed the modern streetwalker into a goddess. Although it had been rendered nearly a decade before it was exhibited at the 1886 Les XX installation, it was one of the most frequently mentioned of all the works shown that year.[83] Like Edouard Manet's *Olympia* (1863), which shocked the Parisian Salon audience when it was exhibited, *Pornokratès* challenged the current norms of painting in its transformed conception of the undressed female form.[84] Like her pampered French ancestor, Rops' subject is naked rather than nude, realistically rendered rather than cloaked as a Venus, sexually insolent rather than demurely sensuous. Blindfolded and placed atop a parapet, she haughtily walks a pig, an emblem of filth and temptation.[85] Were it not for her brazen nakedness, she might be mistaken for a proper middle-class woman walking her well-bred dog. Adorned with the accoutrements of her trade (the black hose, gloves, hat and jewelry), she parades not on the boulevards that were the streetwalkers' domain at this time, but above the weeping personifications of the arts—as if suggesting that the modern prostitute is truly the new muse of the arts.[86] She was, for Rops, modernity itself: prostitution in general remained low, prostitution swelled as a consequence of industrialization and the growing bourgeoisie now having increased leisure time and money to spend.[87]

ALTHOUGH many in the avant-garde discovered in the working class a noble subject for their art, all clearly responded to the call that artists should paint "lovingly and honestly" the world they saw around them. Where some, including Meunier and Marrissiaux, rendered all aspects of labor practices, others, including Lemmen and Signac, united labor with leisure in the interest of depicting a new social order. Rarely were these images simply documentary in character. Indeed, rather than passively reflecting the world, Belgian artists *created* history in the ways they framed the working class. In portraying the effects of industrialization—whether through posters, placards and membership cards for the POB, or through images of the industrial basin or of the modern streets of the city—all of these artists understood their work to have more than a narrowly aesthetic purpose.

This social art thus exceeded its ambition to create a realistic depiction of the working class. More than the sum total of objects hanging on the walls of exhibitions, these paintings, sculptures and graphic works precipitated a wider debate on the meaning and purpose of art itself. Working alongside political activists, the Belgian avant-gardistes took an active role in political as well as cultural discourse. If, as Jules Destrée suggested, "the Worker entered Art and was recognized as the equal of the ancient gods," these gods were laid to rest with the emergence of *l'art social*.

Notes

1. "Je dis aux artistes: Soyez de votre siècle. Il vous appartient d'être les historiens de votre temps, de le raconter tel que vous le voyez, de l'exprimer tel que vous le sentez, sous toutes ses faces, sous toutes ses formes, dans toutes ses manifestations, à travers toutes ses vicissitudes et toutes ses grandeurs." Lemonnier, "Salon de 1872," 241.

2. "Et l'Ouvrier entra dans l'Art et fut reconnu comme l'égal des anciens dieux." Jules Destrée, untitled discussion of Constantin Meunier, from the fifth section of a special number of *La Plume*/Meunier issue, 78.

3. Two exhibitions—Berlin, Neue Gesellschaft für Bildende Kunst, *Arbeit und Alltag* and Charleroi, Palais des Beaux-arts, *Art et Société en Belgique*—reopened the discussion of social art in Belgium, but the majority of each catalogue is devoted to realist artists.

4. Ensor's drawings of *Christ Entering the City of Jerusalem* [cat. 21 and 22] make explicit connections between striking workers and the avant-gardism of Les XX by juxtaposing a series of banners related to each. These drawings, like the painted and etched versions of *Christ Entering the City of Brussels* [J. Paul Getty Museum, Malibu], were never exhibited at Les XX, even though the painting was scheduled to be exhibited at the 1889 show [catalogue 45 is a print after this painting].

5. Puissant, "La Belgique de 1830 à 1914," 18.

6. Miners, in particular, became the victims of this surplus market, since no limits were set on the amount of ore that could be mined. On average, male miners' salaries declined from 1,013 FB between 1871 and 1880 to 918 FB between 1881 and 1890. For a more extensive analysis of the down-

turn in the economic situation of laborers during this period, see Waxweiler, "Travail et salaire"; Defourney, "Esprit Nouveau"; Rowntree, *Land and Labour Lessons*, 392–405 and 467–500.

7. The POB's name was officially changed to the Parti Socialiste / Socialistische Partij in the early twentieth century.

8. Even though two legislative proposals already were being considered—"la loi Janson" of January 1890 and Louis Bertrand's 1895 proposal to cap the industrial work day at ten hours—the majority of Belgian industrial laborers continued to work ten or more hours a day. The 1896 census reveals that half of the labor force in heavy industry still worked more than ten hours and an additional twenty per cent worked eleven or more. This census also notes that miners earned approximately 3.50FB a day, a barely subsistence-level salary. A small percentage of the working class continued to work up to thirteen hours a day through the period of World War 1, according to Neuville, "Condition ouvrière."

9. On 19 March 1886 *Le Peuple* published the announcement for this proposed national demonstration: "Debout citoyens! Que de 13 juin, 1886, jour de Pentecôte, nous trouve tous à Bruxelles acclamant l'ère de liberté nouvelle! Reprenons aux censitaire le mandat qu'ils nous ont surpris et qu'ils ont indignement trahi! Qu'en même cri d'honneur et de loyauté nous rassembli: Vive le Peuple! Vive le suffrage universel!" See also Vandervelde, *Parti Ouvrier Belge*, 37.

10. Published simultaneously in French and Flemish, Defuisseaux's *Catéchisme du peuple* was written to educate factory laborers about the importance of gaining universal suffrage. In the form of a catechism, it describes the ways that employees were enslaved by their political disenfran-chisement. The pamphlet begins with a section entitled "De la Condition du peuple et son esclavage": 1. Qui es-tu? R. Je suis un esclave. 2. Tu n'es donc pas un homme? R. Au point de vue de l'humanité, je suis un homme, mais par rapport à la société je suis un esclave. 3. Qu'est-ce qu'un esclave? R. C'est un être auquel on ne reconnaît qu'un seul devoir, celui de travailler et de souffrir pour les autres. 4. L'esclave a-t-il des droits? R. Non. 7. A quoi reconnaissez-vous en Belgique l'homme libre de l'esclave? R. En Belgique, l'homme libre est riche, l'esclave est pauvre. . . 9. Que faut-il donc faire d'un esclave un homme libre? R. Il faut lui donner le droit de voter, c'est-à-dire établir le suffrage universel. ("On the Condition of the People and Their Enslavement" 1. Who are you? R. I am a slave. 2. Then you are not a man? R. From the point of view of humanity I am a man, but in the eyes of society, I am a slave. 3. What is a slave? R. It is a being who has a single function, to work and to suffer for others. 4. Does a slave have rights? R. No . . . 7. How do you distin-guish a free man in Belgium from a slave? R. In Belgium, a free man is rich, a slave is poor. . . 9. What then must be done to make a slave a free man? R. He must be given the right to vote, he must be given universal suffrage.) as cited in Chlepner, *Histoire sociale*, 52n1.

11. Jan Toorop's painting, *Après la grève*, (1886–87, Rijksmuseum Kröller-Muller, Otterlo), as Eugène Laermans was to do some twenty years later, in *Le Mort* (1904, MRBA), depicts a victim of the violent repression in the spring of 1886 being carried

The illustrated press provided daily depictions of the events of the general strikes throughout Belgium. See, for example, *Le Globe Illustré*, "Les Désordres ouvriers à Liège" (4 April 1886) and "Les Grévistes à la verrerie Monson à Roux" (11 April 1886).

by two men and followed by his grieving widow and their child. For analyses of the 1886 strikes, see Bruwier et al, *Wallonie née de la grève*.

12. The Ghent-based POB newspaper *Vooruit* was explicit in describing its political differences from the anarchist activi-ties: "you, workers from Ghent, stay calm, stay away from these anarchist troubles. We are socialists, we are absolutely separate [from them]," *Vooruit*, 20 March 1886, Jean Volders similarly pleaded with the readership of *Le Peuple* to avoid violence, "Notre ligne de conduite reste la même. Nous devons continuer notre oeuvre d'émancipation sans recourir à la violence (Our path remains the same. We must continue our work for emancipation without resorting to violence)"; *Le Peuple*, 1 April 1886.

13. A team of doctors, legal experts and others analyzed all aspects of working class lives, from diet and working condi-tions to salaries and health problems. The results were pub-lished in the multi-volumed *Commission du travail*.

14. Out of a total population of 1,000,000 in 1868, some 13,254 women worked in the mines. Of the 8,752 who worked sub-terraneously, 3,692 were young girls and almost 100 were eight years old. Because of their size, children were hired in the coal mines to open and close the air shafts, to light extin-guished lamps, and to work as *hiercheurs* or haulers. The sit-uation for child workers in home-based work, such as ribbon works and agriculture, was far worse, as they often entered the work force at age 8 or 9. For more information on women and child workers, see Neuville, "Condition ouvrière," 30–31 and *Documents relatifs au travail*.

15. The total number of strikes between 1896 and 1905 was well over 1,200; general strikes occured again in 1887, 1891, 1893 and 1902.

16. Thus it was only in the industrial areas of Belgium that repre-sentation from the POB was introduced.

17. The Liberals received 530,000 votes while the Catholic Party retained its immense lead with 927,000 votes.

18. Written in praise of these two authors, this three-part article was designed to inspire artists as well as writers. The install-ments were published in *L'Art moderne* on 18 and 25 July and 1 August 1886.

19. "L'heure est venu de tremper la plume dans l'encre rouge."

20. Ensor's works referred to the strikes in Belgium in a number of cases, although the strikes themselves were not the prima-ry subjects. For example, in *Christ Entering the City of Jerusalem* [cat. 21], *Christ Entering the City of Brussels* [cat. 45], and *La Belgique aux XIXe siècle* [cat. 37], Ensor depicted socialist banners alongside those referring to Les XX.

21. The Section d'art et d'enseignement provided members with a large variety of practical courses, from typing and history to economics, in addition to lectures, concerts and exhibitions. Though the classes were often small and sometimes poorly attended, a number of classes, including De Brouckère's 1892 "Catéchisme Socialiste," enrolled over 60 children.

22. "désireux de contribuer à l'éducation esthétique et scien-tifique du prolétariat," Vandervelde, "Introduction," *Annuaire de la Section d'art*, 2.

23. Vandervelde, *Annuaire*, p. 2. Ultimately, the Section d'art was less interested in creating new socialist works than in disseminating to the working class the best of existing culture, regardless of political position. This position was made explicit in a rather heated exchange in the Parliament chambers, July 3 or 4 1895, between Destrée and Woeste, a more conservative deputy:

"où l'on applaudit des oeuvres comme celles de Bach, de Brahms, de Wagner, de Beethoven, de Chopin . . ."

"M. Woeste: Tous socialistes!"

"M. Destrée: Comment! nous ne pourrions admirer que les socialistes, et vous voudriez garder pour vous et pour la bourgeoisie Bach et Wagner? Ce serait trop joli, par exemple! Nous prétendons apprécier ces oeuvres comme vous, et nous voulons encore et surtout faire partager par les masses ouvrières ces trésors immenses de satisfaction . . On fait de l'art à la section d'art, et non de politique."

("Where we applauded the works of Bach, Brahms, Wagner, Beethoven, Chopin . . ."

"M. Woeste: All socialists!"

"M. Destrée: What? Can we only admire socialists and while you would like to hold onto Bach and Wagner for yourselves and the bourgeoisie? That would be too rich! We affirm that we appreciate these works as you do, but we want to share with the working class masses these great treasures which give us such pleasure. We make art not politics at the Art Section."); Destrée, *Discours Parlementaires* (Brussels: Lamertin, 1914) 526, as cited by Aron, *Ecrivains belges et le socialisme*, 77.

24. "Il a été décidé qu'aucun artiste, en adhérant à la Section d'art, ne s'engagerait à adopter le programme politique du parti ouvrier. Ceux des poètes, peintres, musiciens, qui sont venus et viendront vers le peuple, attirés par leurs sympathies pour lui ou par leurs études, lui donneront certes toute leur ardeur et leur enthousiasme, mais resteront libres. Ils peuvent individuellement se mêler intimement à nos luttes, mais la Section d'art reste distinct et indépendant de toute tendance autre que l'art." *Le Peuple*, 13 November 1891.

25. Much of the archival material of the early years of the cultural wing of the POB and the membership rolls disappeared during World War II. What remains was catalogued in 1974 by Robert Abs, former librarian and archivist at the Institut Emile Vandervelde, as "Fonds Cercle d'art et d'enseignement de la Maison du Peuple de Bruxelles," hereafter IEV/CAE. Recently, five additional letters written by Meunier, Khnopff, Lambeaux, and Jacob Smits to Paul Deutscher resurfaced; they are in the MRBA/AAC.

26. For the 1893 *Annuaire*, Khnopff wrote the brief essay "L'Art anglais." In 1893, the artist spoke to the Section's audience on Netherlandish painters. For a listing of lectures given at the Section d'art from 1891 to 1914, see Aron, *Ecrivains belges*, 253–262.

27. See Howe, *Symbolist Art of Khnopff*, esp. 63, 68.

28. Now owned by the MRBA/AAC (64,621), the complete letter of January 1901:

Cher Monsieur Deutscher:

Je vien [sic] d'avoir connaissance par les affiches, du programme de l'exposition à laquelle vous m'aviez invité; mais, je n'ai aucune oeuvre qui corresponde à ce programme.

Bientôt, je l'espère, je vous trouverai pour la Maison un 'souvenir' de membre de la Section d'art.

Veuillez, cher Monsieur Deutscher, recevoir l'expression de mes sentiments distingués.

Fernand Khnopff

29. During the first season alone, Picard gave a number of lectures on art and literature; these included "l'Art et le mouvement social," given in conjunction with a visit to an exhibition of Meunier's paintings and "*Le Mouvement littéraire belge*," part of a larger series that included talks by Emile Vandervelde, Verhaeren and Destrée. Max Elskamp published a poem in the 1893 *Annuaire*. Maus organized many of the musical concerts from 1891 to 1901 at the Section d'art. He also provided guided tours of the Les XX and La Libre Esthétique exhibitions to the members.

30. Constantin Meunier exhibited on several occasions, including the 1901 exhibition, at the Maison du peuple. In a letter dated December 1900, Meunier wrote, "Je participerai volontiers à votre petit salon d'oeuvres d'art à la Maison du Peuple," (MRBA, AAC 64,623). On another occasion, he wrote that he would send his *Femme du Peuple* to an exhibition at the Maison du peuple (IEV/CAE 216 bis).

When invited to the same exhibition in December 1900, Mellery declined, pleading that "[m]on travail en ce moment a pour but une oeuvre homogène d'ensemble." (IEV/CAE 216).

31. Although no letters from Finch exist in the archives of the Section d'art, it is clear that he was contacted on several occasions.

In a letter dated "24 Xbre 1900," van Strydonck accepted Deutscher's invitation to exhibit at the Maison du peuple (IEV/CAE/290).

In a letter, circa 1901, Boch writes that she would send "avec plaisir un tableau pour l'exposition de la Maison du Peuple" (IEV/CAE/18).

For Signac's contribution to the Maison du peuple, see notes 37, 38 and 40, as well as the catalogue entry for his *Au temps d'harmonie*.

32. Van de Velde's lecture on Morris was published in the following year; Canning, *van de Velde*, 46 and n46. For a more in-depth discussion of van de Velde's involvement with the POB, see Tibbe, *Art Nouveau en Socialisme*, esp. 40–60.

33. For documents pertaining to d'Alheim's lecture, see IEV/CAE 2.

34. "Tu fais imprimer en *rouge*, mon dessin (ou couleur)," IEV/CAE 289.

35. Following the Haymarket riots of 1 May 1886 in Chicago, the 1889 participants of the Second International (1889–1914) moved to designate May Day as an international celebration of labor. The first official celebration of May Day took place in 1890. In the months leading up to these celebrations, both the *Vooruit* and *Le Peuple* announced the plan to their readers. The *Vooruit* announced that May Day would not be a strike, but a celebration of labor, "Geene werkstaking maar een Feestdag van den Arbeid moet het zijn op donderdag 1 mei," *Vooruit*, 4 December 1889. These sentiments were echoed by the statement in *Le Peuple* that the May Day celebrations should be "éclatante et pacifique (loud yet peaceful)," *Le Peuple*, 16 April 1890. For histories of the Haymarket riot and the development of Labor Day, see Dommanget, *Premier mai*; Foner, *May Day*; van Goethem, *De Roos op de Revers*.

36. This poster is inscribed "Supplément au No. 4 du Mouvement social," indicating that it reached all of the journal's readers.

37. The related drawing was sold as lot 180 at Galerie Campo, Antwerp on 25 October 1988; Cardon, *Lemmen*, 173–174.

38. Chartrain-Hebbelinck, "Lettres de Paul Signac," 83n2, cites an undated letter from Signac to Henry van de Velde concerning his continuing negotiations with the POB.

39. The painting was exhibited in "Trente ans d'art indépendant 1884–1914" at the Paris Salon des Indépendants in 1926 under the title "Au temps d'harmonie, décoration pour une Maison du peuple." The painting eventually was purchased by the Mairie de Montreuil in 1938. For a discussion of the POB's decision not to buy Signac's painting, see Aron, Écrivains belges et le socialisme, 76, and Chartrain-Hebbelinck, "Lettres de Paul Signac."

40. Wiertz is best known today for this 1854 painting Faim, Folie et Crime [fig. 8], depicting a poor, hungry women who, unable even to pay her taxes, has cut off her infant's leg for food.

41. Since none of Signac's correspondence with the Maison du peuple seems to exist, it is impossible to determine the exact reason why his painting was declined.

42. "Justice en sociologie, harmonie en art: même chose . . . Le peintre anarchiste n'est pas celui qui représentera des tableaux anarchistes, mais celui qui, sans souci de lucre, sans désir de récompense, luttera de tout son individualité contre les conventions bourgeoises et officielles par un apport personel."

43. Horta understood that he needed to "construire un palais qui ne serait pas un palais, mais une 'maison' où l'air et la lumière seraient la luxe si longtemps exclu des taudis ouvriers (construct a palace, which wouldn't be a palace but a 'house' where air and light, too long excluded from workers' hovels, would be the luxuries)", as cited in Dulière, Horta Mémoires, 48.

44. The actual construction of the building may be viewed as yet another cooperativist venture prized by the POB: the socialist cooperative of laborers provided much of the funds to purchase the site; the foremen were from Party ranks; the carpenters' union gave forty of its workers to the project for a year and a half to make the furnishings and other wooden details; the painters' union provided its services; and the metal and glass works were provided by their respective unions.

45. Two letters from 1900 written by van Biesbroeck to Paul Deutscher, then secretary of the Section d'art, enunciate these views, IEV/CAE 154 and IEV/CAE 279.

46. The building's facade is reproduced in Maisons du Peuple, 40.

47. The Liberal Party in Antwerp took positions similar to the POB in Brussels regarding cooperatives and syndicalist movements; the Antwerp socialists, by contrast, concentrated almost exclusively on issues of class struggle and for this reason the Help U Zelve building was dubbed a Volkshuis. For more information on Antwerp's Liberal Party, see catalogue 143.

48. Navez was a student of the French painter Jacques-Louis David. The Belgian was director of the Brussels Academy from 1833 to 1859 and was the recognized leader of Belgian neoclassicism. For more information on Navez's impact on the history of Belgian neoclassicism, see Moerman, "François-Joseph Navez."

49. Typical of the rallying cries for Belgium realism was Léon Dommartin's definition of this new art: "Faire amoureusement et honnêtement ce qu'on voit—telle est la devise de la peinture moderne [Paint lovingly and honestly what you see—this is the motto of modern painting]." Dommartin, in L'Art libre 1 (15 December 1871).

50. Two Rops lithographs La Buveuse d'absinthe (c. 1869) and L'Enterrement wallon (c. 1872) are typical of the kinds of imagery the artist developed while associated with the Société Libre.

51. Throughout his later career, Meunier received awards and other forms of official approval from the art establishment. Although Rops remained somewhat of an outsider, his art likewise received critical, though not always wholly positive, acclaim.

52. The idea of joining art exhibitions with philanthropic concerns was not unique to the Société Libre; the Belgian Association of Photographers and other arts organizations often also donated their proceeds to charities. The profits from Gustave Marissiaux's illustrated lecture on his photographic series La Houillère, for example, raised 700 FB each for chauffoirs publics (public warming rooms) and for orphanages in the Liège region.

53. Block, Les XX and Belgian Avant-Gardism, 2.

54. De Groux's sympathy for the working class remained constant throughout his career. See Stark, Charles de Groux.

55. De Groux died unexpectedly from a chronic pulmonary ailment in 1870.

56. After his debut as a sculptor (with what many considered a student work) at the 1851 Brussels Salon, Meunier did not exhibit sculptures again until 1884. His early envois (submissions) to the Triennial Salons included Les Funerailles d'un trappiste (exhibited 1857), Le Repos éternel, couvent à la Trappe (1862), Trappistes laboureurs in collaboration with Alfred Verwée (1863), and St. Etienne, martyre (1866).

57. During the period represented in this painting, the Catholic Church in Belgium had come under increasing attack from the anti-clerical movement of the French, who, at that time, governed Flanders and Brabant. In September 1796 the French abolished most of the religious orders and confiscated their properties. Similarly asked to take a vow of loyalty to the French government and Napoleonic law, the peasant population revolted in November 1798. Thousands of peasants lost their lives in this revolt, their moderate behavior contrasting sharply with the severity with which the French dealt with them.

58. "Si de Groux a pu m'enhardir à traiter les sujets du peuple, le goût de ne pas traiter des sujets archiconnus et compassés préexistait chez moi et était le patrimoine commun de toute la génération . . . De même que c'est l'époque où le désir d'une peinture individuelle moins vouée aux unités, aux princes, et plus consacrée aux masses, aux peuples," Thiery and van Dievoet, Constantin Meunier, 24.

59. "tout le travail de l'homme tâchant dans les manufactures, dans les fabriques; toute cette fièvre moderne qui présente l'activité de l'industrie; toute la magnificence des machines, cela est encore à peindre et sera peint," Huysmans, "L'Exposition des Indépendants."

60. He later wrote, "Puis le hasard me mène dans le pays noir, le pays industriel. Je suis frappé par cette beauté tragique et farouche. Je sens en moi comme une révélation d'une oeuvre de vie à créer. Une immense pitié me prend. Je ne pensais pas encore à la sculpture. J'avais 50 ans et je sentais en moi des forces inconnus, comme une nouvelle jeunesse, et bravement je me mis à l'oeuvre. C'était hardi, car hélas! j'avais une famille nombreuse (Then chance led me to the black country, the industrial region. I was astonished by its tragic and ferocious beauty. I felt in me a revelation of a life's work still to be made. I gave in to an immense pity. I didn't yet think of returning to sculpture. I was fifty years old and I felt in me unknown forces, like a new youth, and bravely I put myself to work. It was bold, because, alas, I already had a large family)." Treu, *Constantin Meunier*, 23.

61. There is some confusion about the exact dates of Meunier's trip to the area.

62. By 1880 Meunier's preeminence as an artist of industry was manifested in his receiving a commission to create a "chariot of industry" for the large parade devoted to Belgian commerce, held in conjunction with the fiftieth anniversary celebrations of Belgian independence.

63. "'j'ai sculpté ces hommes, tout simplement parce que je les aimais," Fierens-Gevaert, "Bonté de Meunier," 2.

64. He is reported to have said to his good friend and collaborator, the naturalist writer Camille Lemonnier, "Je ne suis plus qu'un ouvrier vivant au jour le jour (I am nothing more than a worker living from day to day)", as cited in "Constantin Meunier," *La Revue de Bruxelles*. His art work derived from this humanitarian viewpoint rather than a purely socialist politics. Although on several occasions he decried that he was identified as a socialist artist in the left-wing press, several of his unpublished letters indicate that he was quite sympathetic to the politics of the POB.

65. Sparrow, "Constantin Meunier."

66. Some of these illustrations were based on drawings and paintings Meunier already had exhibited, while others were made specifically for the book.
 In addition to several illustrations of Beguines and peasants, Mellery also provided images from the industrial centers.

67. Karl Meunier (1864–1894) followed his uncle, Jean-Baptiste Meunier, in becoming a graphic artist. From the early 1890s until Karl died all of the etchings published after Constantin Meunier's images were made by his son. The text for *Au Pays noir* was by Camille Lemonnier. A series of letters from Constantin to Lemonnier concerning this project are at the Maison Camille Lemonnier in Brussels.

68. Aron, "Arts et les lettres," 161.

69. Collection of the Ministère de la Communauté Française.

70. "le peuple qui, fatigué de religions, s'en va seul à travers toutes les difficultés de la vie, à la recherche du bonheur," Champal, critic for *La Réforme*, as cited in Royer, *Plaidoirie de Royer*.

71. Three years later the painting was introduced by the defense team pleading the case of Jules Moineau, an anarchist lawyer, accused of bombing the house of a Liège city councilman. Royer, *Plaidoirie de Royer*.

72. "le Constantin Meunier de la photographie," Casier, "Fête d'Art," 161.

73. Indeed, some three quarters of the photographs in this series referred directly to the commercial potential of the coal-mining industry; Moreau, "Photographique de Gustave Marissiaux," 26.

74. As was the case with most of the profits gained from its lecture series, the profits from Marissiaux's slide lecture went to the public heating houses and to a society for abandoned children.
 La Houillère also was exhibited at the 1905 Liège Exposition, where Marissiaux was awarded the grand prize in photography, and at the Photo Club in Paris during the same year. In subsequent years, the series was presented to great acclaim in Courtrai, Berlin, Brussels, and Antwerp.

75. Although this figure type falls outside the scope of this essay, it is important to note that the hermetic character was also developed as a response to industrialization, in that she is represented as "protected" from the outside, modern world.

76. Dumont and Walgrave cite an anonymous member of the Bruges Chamber of Commerce who describes having seen girls as young as six working in the lace industry and that these girls worked exceedingly long hours, "courbés, littéralement courbés, pliés en deux, sur le carreau à dentelles, et ils n'ont, pendant toute la journée, que quelques instants se livrer à l'exercice (bent over, literally bent over, folded in two, over the lace pad, and they're given, during the course of the day, only a few moments to exercise their bodies)." Dumont and Walgrave, "La Femme belge," 65.

77. See Henri de Braekeleer's *La Cathédral* (1872) and Léon Frédéric's *Flemish Lacemaker* (1907), reproduced in *Arbeit und Alltag*, 231; Georges Le Brun's *La Vieille Tricoteuse* (1903), *La Fileuse* (1903), and *La Tricoteuse* (1903), reproduced in *Art et Société*, 162, 186–187; and Rops' *La Lyre* [cat. 122].

78. According to a report on the situation of the Belgian working class in 1886, a Dr. Boëns noted that, "la plupart des jeunes filles se sont pas pubères qu'elles ont cessé d'être vierges . . . Pendant le retour au crépuscule, bien souvent la fille des houillères s'écarte un peu de la bande pour se livrer sans honte ni pudeur, presque sous les yeux des ses compagnons de travail (the majority of young girls have ceased to remain virgins once they have reached puberty . . . During the return [from work] in the evening, a young girl from the coal mines often separates herself a bit from the group and gives herself up, without shame or modesty, almost within eyesight of her working companions)." See Dumont and Walgrave, "La Femme belge," 63.

79. Measuring 248 x 317 cm, this painting's dimensions far exceeded those of any other Belgian realist or impressionist painter.

80. Stark, *Charles de Groux and Social Realism*, 297.

81. Hollis Clayson has demonstrated that this emphasis on the fashionably-dressed *cocotte* in images of prostitutes also caused quite a bit of confusion in Parisian society, as bourgeois women bought the same kinds of clothes. Clayson, *Painted Love*, esp. 56–112.

82. "Il ne faut pas faire le sein de la Vénus de Milo mais bien le sein de Tata qui est moins beau mais qui est le sein du jour," Félicien Rops, as quoted in *La Plume littéraire, artistique et sociale*, in a special number devoted to his career, 172 (June 1896): 190-191. The double entendre of the final phrase, no doubt, was intended, as Rops was a masterful writer.

83. Regardless of political persuasion, almost every Belgian critic writing on the exhibition commented on this work.

84. For an analysis of the reasons Manet's painting was so problematic for the Parisian public, see Clark, *Painting of Modern Life*.

85. Rops was not the only artist of his generation to pair a prostitute with an animal. Manet's *Olympia* included a black cat at the figure's feet and Georges Seurat later depicted a prostitute walking a leashed monkey in his *Sunday Afternoon on the Island of the Grande Jatte* (1884-86, exhibited in 1887 at Les XX, The Art Institute of Chicago).

86. Many French and Belgian guidebooks from this period indicated where prostitutes could be found in the evening. A typical text is the anonymous *Paris After Dark: Night Guide for Gentlemen* circa 1870, that reads: "Nowhere are the nymphs of the pavé to be seen in greater force than on the boulevards. As soon as the lamps are lit, they come pouring through the passages, and the adjacent rues, an uninterrupted stream, until past midnight," as translated in Clayson, *Painted Love*, 93.

87. As Jean Claes suggested in the pages of *Le Peuple*, "Une des causes de la démoralisation, un des grands pourvoyeurs de la prostitution, c'est l'insuffisence de la rémuneration du travail de la femme. On l'a dit avec raison, le trafic de la femme, qui se pratique ouvertement partout, est un mal social . . . Si le salaire de l'homme est mince, celui de la femme est dérisoire. Cela ne suffit pas encore (One of the principal causes for the demoralization, one of the greatest reasons behind prostitution, is the insufficiency of remuneration for women's work. It has been said with good reason that the traffic in women, which is practiced openly everywhere, is a social evil . . . If men's salaries are small, those for women are laughable. They just aren't enough)," Claes, "Le Travail de la femme."

Print Culture in Nineteenth-Century Belgium

by Stephen H. Goddard

Printmaking before the Etching Societies

The arts in nineteenth-century Belgium were frequently given to a grandiose vision that celebrated the youthful nation. For example, Antoine Wiertz's oil sketch *The Apotheosis of the Queen* of 1856 was planned as a 150-foot-tall painting to be erected in front of the Royal Palace in Brussels, and Jozef Poelaert's Palais de Justice (1866–1883), also in Brussels, is often considered the world's largest nineteenth-century building.[1] It is against this imposing vision that the origins of Belgian printmaking, by nature a medium of modest format, must be considered.

In 1852 the writer and art historian Adolphe Siret published an article on the status of Belgian printmaking and its future. For Siret, printmaking in Belgium was "more dead than alive," having fallen into a period of decadence ever since the departure of the Antwerp-born engraver Gerard Edelinck to Paris in 1665.[2] When Siret was writing, Belgium was barely twenty years old, and there was a premium placed upon defining the young nation and its culture in ways that would distinguish it from France. With Belgium's independence in mind, Siret was looking for a way to get back to the glorious days of Flemish printmaking prior to French domination in the arts. He favored a state that would encourage the production and extensive distribution of prints of an immense format that would astonish the public and that would copy "our immortal Flemish canvasses."[3]

Although Siret lamented that "the public does not like serious printmaking because it is an art that demands some time; these days one likes quick pleasure, as if a cataclysm will strike tomorrow," he did much to promote printmaking in his capacity as director of the conservative periodical *Le Journal des*

Beaux-Arts et de la Littérature.[4] Under his direction this journal published prints from 1859 until Siret's death in 1883, including twelve annual albums of ten prints each that appeared between 1870 and 1883.[5] An idea of what was considered to be the best of this traditional sort of production can be seen in Edouard De Vigne's *La Forêt* (*The Forest*, fig. 20), which was singled out in an 1886 list of the journal's prints as "rare, large and superb."[6]

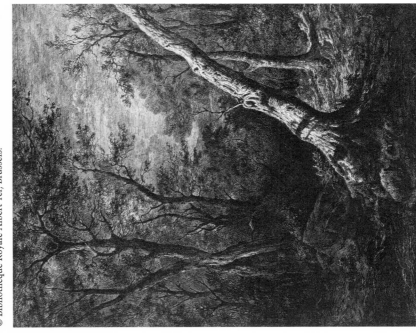

FIGURE 20. Edouard De Vigne, *La Forêt* (*The Forest*), etching, ca. 1859–69. © Bibliothèque Royale Albert 1er, Brussels.

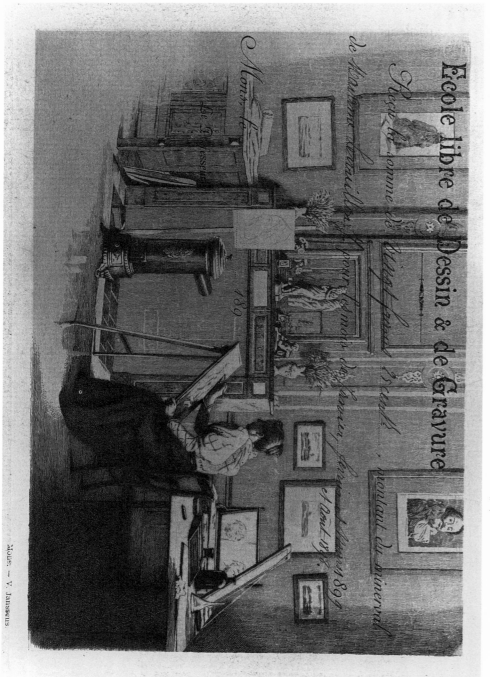

FIGURE 21. Receipt from a school of printmaking and drawing in Mons (probably etched by Auguste or Louise Danse), by 1900. Private collection.

Siret's efforts are only one factor contributing to a thriving print culture that by the end of the century included printmaking classes, three etching societies, exhibition venues, and coverage in a number of artistic journals. The instruction of printmaking in the first half of the nineteenth century is well documented. Even prior to Belgian independence the new art of lithography was introduced in Brussels. Charles Senefelder, brother of the inventor of lithography, Alois Senefelder, settled in Brussels in 1817 and taught courses in the technique.[7] Classes in printmaking were offered at the Antwerp Academy by Erin Cor after 1832, and in Brussels by Luigi Calamatta, professor at the Ecole de gravure (School of Printmaking) that had been created by the state in 1836.[8] However, with Calamatta's departure for a new post in Milan, together with the Brussels Academy's failure to maintain a class in printmaking and a shortage of professional print publishers in Belgium, the promising beginnings were losing momentum by mid-century.[9] Classes in printmaking were still offered at the end of the cen-

tury, though on a relatively modest scale. For example, Auguste Danse, a student of Calamatta, offered printmaking courses in Mons, and Auguste Numans offered a printmaking course several times at the Cercle des aquarellistes et aquafortistes (Brussels Watercolorists' and Etchers' Union).[10] The nineteenth-century etched receipt from a school of printmaking and drawing in Mons may be from the school founded by Auguste Danse (who lived until 1919), and may have been etched by Auguste or Louise Danse [fig. 21].

Just as printmaking in Brussels seemed to be losing ground in the third quarter of the century, two Antwerp painters, Henri Leys (1815–1869) and his nephew, Henri De Braekeleer (1840–1888), found considerable success as printmakers independently from the efforts taking place in the capital. Leys' father had been a copper-plate printer who sold devotional prints in his Antwerp shop.[11] Both De Braekeler and Leys saw printmaking as an aside to their painting careers, although both achieved wonderful results with their graphic works. According to

Loys Delteil, De Braekeleer produced no fewer than eighty etchings, which he printed himself.[12] These are typically scenes in and around the old quarters of Antwerp [fig. 22]. Leys, who specialized in scenes of Flanders' historical past [fig. 23], called his etchings an amusement which he shared with friends whom, he modestly claimed, he knew would excuse his lack of experience.[13] Neither of them seem to have made an effort to sell their etchings, preferring to use them as gifts and as embellishments to their painting careers, as did members of Les XX at the end of the century.[14]

Belgium's three etching societies evolved long after most of the printmaking activity of Leys and de Braekeleer.[15] These societies were largely composed of amateurs and enthusiasts who sought official sanction and recognition for printmaking. Although the members of Les XX created their group independently and avoided official support, several of them (including Félicien Rops, James Ensor, Théo Van Rysselberghe, and Fernand Khnopff) contributed prints to the portfolios assembled by the etching societies; Rops was actively involved in the organization of these societies. Most importantly, the etching societies in Belgium nurtured a tireless group of specialists (such as professional printers and publishers) who helped to create a receptive environment for printmaking, so that when the members of Les XX did take up printmaking the necessary materials and resources where already at hand.

"Long Live Grounds and Mordants!" Belgium's Three Etching Societies

Three etching societies were founded in Belgium by the 1880s, each of which involved the Countess of Flanders (1845–1912), an etcher from the royal household, in their operations [fig. 24].[16] In 1869, at the age of twenty-four, she sponsored the short-lived Société Internationale des Aquafortistes (International Etching Society), which operated under the presidency of Félicien Rops (later a member of Les XX).[17] Rops' ambitions for the society are made clear in a letter of 1870. He wrote that his "good Belgian soul was touched by the piteous state of etching in Belgium," and

I dream of all kinds of noble, patriotic and grotesque things: the renewal of etching in Belgium, the creation of a national collection of etchings, and I get it into my head to turn this little Belgium, so well placed between England, France and Germany, into a publishing centre like Leipzig.[18]

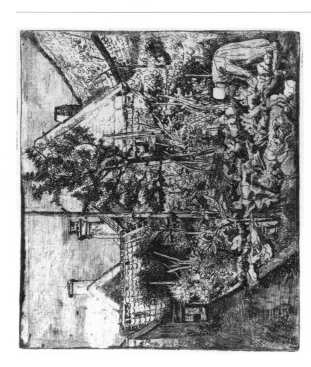

FIGURE 22. Henri De Braekeleer, *La Coupeuse de choux (The Cabbage Cutter)* or *Le Jardin (The Garden)*, etching, by 1874. Private collection.

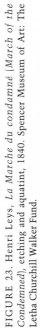

FIGURE 23. Henri Leys, *La Marche du condamné (March of the Condemned)*, etching and aquatint, 1840. Spencer Museum of Art: The Letha Churchill Walker Fund.

Like all etching societies, the primary goal of the group was stated as the encouragement of a taste for etching, but unlike the two etching societies that followed in Belgium, the Société Internationale specifically militated against the kind of reproductive printmaking advocated by Siret.[19] The statutes of the society give many details about the group's exhibitions and lotteries, and they mention a communal workshop, located next to the society's printing shop, with etching tools and acid baths available for use by the members.[20] The actual printing was left to a professional plate printer, François Nys (a Belgian whom Rops had lured away from his job with the distinguished Parisian print publisher Auguste Delâtre), but the statutes state that when the plates were editioned, a member of the committee or a delegate was to assist in the printing.[21]

Rops designed the frontispiece for the Society's portfolios [fig. 25], which shows a griffon scratching an etching plate with its bared claws and includes the inscription "*unguibus et morsu vives* (long live grounds and mordants)!" Only two portfolios were

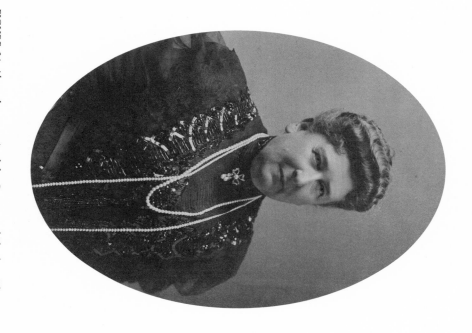

FIGURE 24. Alexandre, portrait of the Countess of Flanders. Silver print. Private collection.

issued by this etching society, in January and June of 1875. Among the prints issued were an early print by Constantin Meunier of armed peasants in the peasants' war and etchings by Josef Israëls, Jules Goethals, Auguste Danse, Storm van's-Gravesande, Rops and the Countess of Flanders.

In 1880 the Vereeniging der Antwerpsche Etsers/Association des Aquafortistes Anversois (Antwerp Etching Society) was founded under the patronage of the Verbond van Kunsten, Letteren en Wetenschappen / Cercle Artistique, Littéraire et Scientifique (Union of Art, Literature, and Science of Antwerp).[22] This society remained active until 1891, and served as a model for the Amsterdam-based De Nederlandsche Etsclub (Dutch Etching Club), founded in 1885.[23]

Although essentially a civic organization, the Antwerp Etchers were careful to include the Countess of Flanders in their society. Her etchings are found in several of their annual albums of twelve prints; the report included in the Album of 1881–82 contains a brief biography of the Countess and a list of thirteen of her major etchings.[24]

FIGURE 25. Félicien Rops, detail of frontispiece for Société internationale des aquafortistes, etching and letterpress, January 1875. © Bibliothèque Royale Albert 1er, Brussels.

The Société des Aquafortistes Belges (Society of Belgian Etchers) was founded in 1886.[27] This group named the Countess of Flanders as its Honorary President and was subsidized by the state.[28] Although Les XX members Fernand Khnopff (who was on the administrative committee of the society), Théo van Rysselberghe, and James Ensor were to contribute prints to the Société des Aquafortistes Belges (cat. 61 and 44], this group was generally no less conservative than the Antwerp etching society that it sought to rival.[29] However, the Société des Aquafortistes did serve as an active voice promoting printmaking. In 1890, for example, they responded to a charge by the Royal Academy concerning the decadence of print-making in Belgium. To better the situation they suggested 1) creating a workshop and printing shop at the Academie des Beaux-Artes de Bruxelles (Brussels Academy of Fine Arts), 2) vigorous encouragement of etching societies, 3) prizes for prints, and 4) annexing a room at the Musée royale de Bruxelles (Royal Museum in Brussels) consecrated to printmaking.[30]

The need for a public venue to encourage the study of prints may seem surprising, given that the *cabinet des estampes* (printroom) at the Royal Library in Brussels was opened to the public in April 1858.[31] A letter of 1900 from Théo van Rysselberghe to Octave Maus, while establishing that the Royal Library was a desirable repository for prints by contemporary artists, also makes it clear that Van Rysselberghe had little or no direct personal experience with the printroom.[32] In fact, it seems to have been relatively unknown to the general public, and was the subject of a satirical article by Emile de Munck, "Le Tombeau des Estampes" ("The Print Tomb").[33] De Munck, founder and publications director for the Société des Aquafortistes Belges, probably authored the four-point proposal cited above. De Munck, incidently, was most intimately involved with the book arts. He and his colleague Xavier Havermans, in part due to the influence of the English Arts and Crafts Movement, favored a return to the elegant fonts and printed ornaments of six-teenth-century Flanders.[34]

Despite the outcry for official sanction for the display and study of printmaking, it is clear that there were a number of established venues for the display of prints. The etching societies sponsored exhibitions of work by their members, and as early as 1855 there is evidence of a series of old master print exhibitions focusing on Flemish and Netherlandish artists at the Cercle artistique et littéraire de Bruxelles (Artistic and Literary Union of Brussels).[35] Contemporary print and drawing exhibitions were

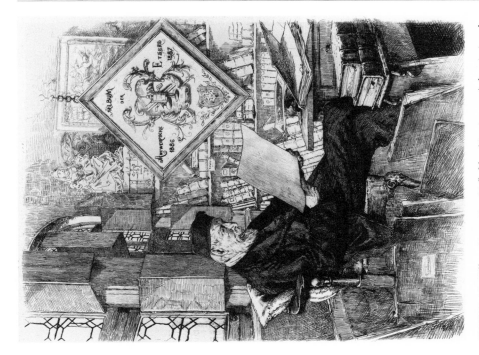

FIGURE 26. Willem Geets, *Een Liefhebber (An Amateur)*, frontispiece for the 1886–87 *Album des aquafortistes anversois*, etching. © Bibliothèque Royale Albert 1er.

By and large, the production of the Antwerp Etchers was well-crafted but provincial, in the same self-satisfied way as the nostalgic images produced by the Als Ik Kan (As Best I Can) group of Antwerp artists.[25] Willem Geets' frontispiece for the 1886–87 album, *Een Liefhebber (An Amateur)*, embodies this picturesque but cloying evocation of Antwerp as the Capitol of the Arts [fig. 26]. An old gentleman sits in a shuttered room that could be a chamber in the sixteenth-century Plantin-Moretus residence (now a museum of Antwerp printing) surrounded by portfolios and books of prints, two of which are labeled "Rembrandt." The title of the portfolio appears as a coat of arms of the type used in the pageants of the sixteenth-century chambers of rhetoric. Also visible are an allegorical image of a nautical theme (perhaps the river Scheldt) and a statue of the Virgin and Child with Saint Anne. One gets the impression from Geets' frontispiece that this society imagined itself as producing etchings for a sixteenth-century audience; indeed, there is evidence that many nineteenth-century middle class and patrician families in Belgium actively reenacted their historical past.[26]

loosely announced as *Black and White* exhibitions (both *"noir et blanc"* and *"blanc et noir"*). These were sponsored by a variety of artists' groups, including *L'Essor*, and later by the Société des Aquafortistes Belges.[36] Unfortunately, exactly whose work was exhibited in these exhibitions remains obscure. By the end of the century the book arts (still under the rubric of *"blanc et noir"*) and Japanese prints were also given their own exhibitions.[37]

Although they never formed an etching society, several artists in Liège were prolific printmakers, in particular, Armand Rassenfosse, François Maréchal, Adrien de Witte, Emile Berchmans, and Auguste Donnay.[38] In addition to their activity in Liège, several of these artists exhibited with the Société des Aquafortistes Belges.

The overall impact of the etching societies was relatively modest. This may be due in part to the increasingly prominent production and collection of posters.[39] The poster arts and photography had their own journals in Belgium; articles on printmaking appeared in journals dedicated to the fine arts in general and in commercial trade journals.[40] Relative to these more modern mediums, the routine prints of the etching societies seem to have been tinged with the nostalgic aura of historicism. However, were it not for the etching societies, the printers and publishers who were also to serve progressive and independent artists might not have been able to keep their doors open.

"For My Collaborator" The Determining Role of the Printers

Among the many dedications written by Van Rysselberghe on his prints is one of 1897 inscribed to his printer, *"exemplaire pour mon collabo Van Campenhout* (copy for my collaborator Van Campenhout)" and the year before Ensor had inscribed his portfolio of twelve etchings to his *"camarade* (friend)", the printer Charles Vos.[41] In these dedications, the artists testify to the essential role of the copper plate printer. After the etching process was complete, it was the job of the plate printer to arrive at an inking and printing of the plate that met the approval of the artist. This could mean that the printer took over a certain amount of responsibility in choosing papers and colors to propose to the artist. In short, the plate printer was a collaborator in the true sense of the word. It is the printer, not the artist, who is giving a look of approval at a fresh impression of a print in Henri De Braekeleer's painting in the Antwerp Museum [fig. 27].

In writing to Maus about a proposed exhibition of color prints, Van Rysselberghe testified to the degree to which a plate printer might call the shots, "I've never done color prints. I don't count that little bit of red that my printer rubbed onto the jacket of the little old walker on the etching that you know."[42] "The little old walker" is Emile Verhaeren strolling along the beach in his inevitable red coat (cat. 153). In all the impressions that the author has seen, the plate has been printed "à la poupée," that is, the plate has been carefully inked with two colors (brown and reddish brown), instead of using a separate plate for each color. Thus Van Campenhout has taken Van Rysselberghe's finished plate and made a color etching out of it, apparently with the artist's approval.

Certain characteristics of Ensor's prints were due to the different printing habits of his three main printers: Evely, Charles Vos, and Van Campenhout.[43] The most sumptuous impressions of Ensor's prints are associated with his first printer, Evely. Evely, who also worked with Redon, Rops, Rassenfosse, and Toorop, had a predilection for delicate printing and the use of rare and unusual papers. The exhibited impressions of Ensor's *Hôtel de Ville de Oudenaarde* (printed on a page out of an old ledger, cat. 34) and *La Cathédrale* on fine Japan paper (cat. 24), may have been printed by Evely.[44] After Evely, both Charles Vos and the firm of Van Campenhout printed Ensor's prints on Japan or the more common "simile-Japon" paper. These include many reprintings of Ensor's plates, which were sometimes steel-faced, on simile-Japon.[45] We do not know how many impressions were taken from Ensor's plates. Sabine Bown-Taevernier, in her essay on Ensor's prints, cites a letter of 1931 from Ensor to Albert Croquez in which Ensor wrote:

I don't know if I numbered my etchings for it is of no importance in my opinion. In any event I haven't printed heaps of them, they are far from reaching the hundredth, and 100 impressions doesn't amount to a hill of beans in this world.[46]

Lemmen also had Van Campenhout print his etchings, and he had his lithographs printed by the firm of Monnom.[47] Regrettably, very little is known about the firm of "Vve. Monnom" ("Widow Monnom," actually Sylvie Monnom).[48] Monnom was the lithographic printer of choice for the artists of Les XX. This firm printed the group's posters and catalogues, as well as the artist's lithographs. Théo Van Rysselberghe married Sylvie's daughter, Maria Monnom, in 1889. In his recent monograph on Georges Lemmen, Roger Cardon has published a few additional details about the Monnom printing house.

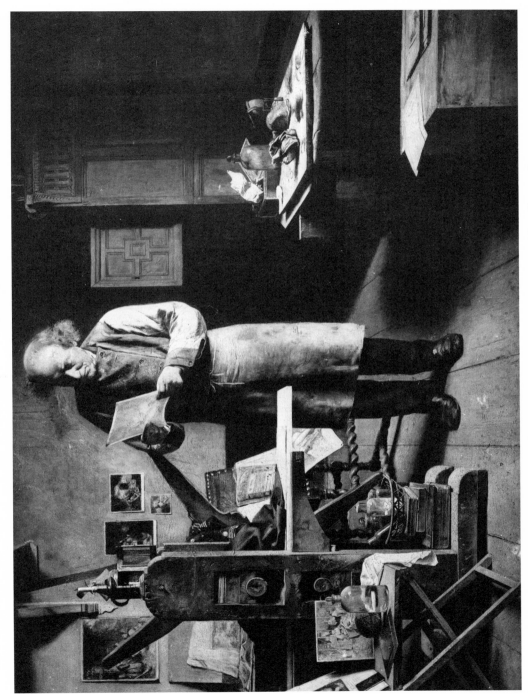

FIGURE 27. Henri De Braekeleer, *De Plaatdrukker* [*The Plate Printer*], oil on canvas, 1875. Museum voor Schone Kunsten, Antwerp.

Most important of these is a letter from Lemmen to George Morren in which Lemmen praises the Monnom shop for the quality of their printing, and for allowing the artist to witness the final printing, to make corrections on the spot, and to instruct the printer personally.[49]

Veteran Printmakers: Rops, de Groux and Ensor—Fame, Fortune, and Immortality

Three members of Les XX, Rops, de Groux and Ensor, may be singled out for their relatively sustained immersion in various problems of printmaking, and for the professionalism with which they actively cultivated the sale and collection of their graphic art. The incentive for involvement with printmaking, however, differed somewhat for each of these artists. The economic factor is an obvious

one, and one that the artists approached in a perfectly straightforward manner. For de Groux, who always seems to have been struggling to get by, the economic consideration may have been tantamount. In 1896, for example, he wrote from Brussels to his friend Léon Bloy in Paris, "I have made some lithographs with which I hope to make some money in Paris."[50] This passage also suggests that Brussels was not a likely place to find a market for lithographs. The special issue of *La Plume* dedicated to de Groux lists sixty-nine lithographs by the artist, giving their prices (or values for those out of print), and the nineteen lithographs available for purchase through *La Plume* are clearly indicated. This degree of specificity was not granted to Ensor or Rops in their *La Plume* special issues.[51]

For Rops, at least early in his career, this economic motivation was combined with a means to promote his career as an artist outside of Belgium. Believing that "whatever one does in Brussels does

not count towards a European reputation,"[52] Rops wrote to his father in 1863:

> I believe and maintain that the *publication* of prints or of illustrated books is the best means for a young artist to become known and to earn money; while a painting is unique, books and prints are published by the thousand and can make your name known.[53]

Both Rops and de Groux ultimately came to spend a significant proportion of their careers in Paris, in part because of the more favorable atmosphere for making and selling prints.

The effectiveness of prints as a means of promoting an artistic career is in part reflected by the fact that Rops, Ensor, and de Groux were almost unique among Belgian artists featured in the book-length special monographic issues of the Parisian periodical *La Plume* (the only other was Meunier, whose sculptural works might be construed as multiples). These three also tended to print in large, or at times even open-ended editions, while most other members of Les XX printed very small editions.[54]

In addition to the unique aesthetic qualities of etching, Ensor saw in prints a power in numbers, a means to hedge against the role of fate in determining his artistic legacy. In short, Ensor saw in printmaking a means toward artistic immortality (for an ironic twist on this theme see his *Mon portrait en 1960*, cat. 31). In a well known letter of 1934 he wrote to Albert Croquez about his turning to etching in 1886, at the age of twenty-six:

> Pictorial materials still worry me (in 1886). I dread the fragility of painting, exposed to the crimes of the restorer, to insufficiency, to the slander of reproductions. I want to survive, to speak to the people of tomorrow for a long time yet. I think of solid copper plates, of unalterable inks, of easy reproductions, of faithful printing, and I am adopting etching as a means of expression.[55]

In addition to the creative possibilities inherent to printmaking, each of these artists also recognized the importance of the status of the print as a multiple. Unlike unique works of art, the print was easily marketable, it could help broadcast a new career, and it could serve as a sort of artistic insurance.

Rops and the Magic of Making Multiples

Although several Belgian artists involved with woodcut book illustration, notably Max Elskamp, carved their own blocks and printed them, Rops was unusual for his time in that, after mastering lithography, he became involved with every aspect of the etching process: applying grounds to the plate, drawing on the plate, biting the plate with acid, and the final printing process. Of all the members of Les XX who made etchings, Rops was apparently unique in owning his own press.[56]

Rops cultivated a romantic image of himself as an artist totally immersed in printmaking activity. Unlike De Braekeleer's plate printer [fig. 27], in Paul Mathey's painting of Rops at his press (here illustrated by the wood engraving by Baude after the painting, fig. 28] it is now the artist himself who passes muster on a print that he has just run through the press.[57] Rops received more debonair treatment than De Braekeleer's anonymous printer; the former's cigarette smolders on the edge of the press bed and a swatch of fabric (actually used to diffuse light while etching) hangs across the top of the image as if to make the shop into a stage.

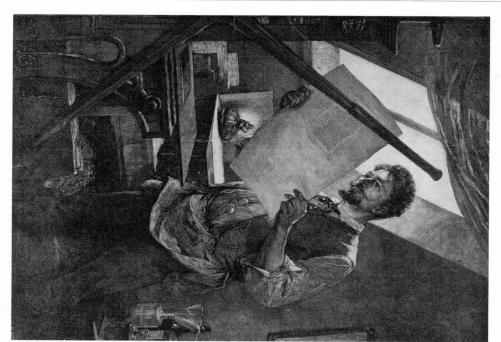

FIGURE 28. Baude after Paul Mathey, *Portrait of Rops in the Studio at Work*, wood engraving, ca. 1875. Los Angeles County Museum of Art: Gift of Michael G. Wilson.

Rops' activity as an experimental printmaker is evident in his use of a variety of materials as printing plates (including ivory), and his fascinating pedagogical plates—plates that may have been used as scratch pads to show his students different etching tools, etching grounds, and mordants (see cat. 111 and 112).[58] These plates tend to be small enough to be held in the hand, and they generally have no right-side-up, since the artist turned them about in his hand while drawing. In addition to the images scratched into these plates there are frequent patches where he has tried out a few drops of an acid on a given aquatint or soft-ground.

Rops kept a remarkable record of his experiments with various recipes and techniques that he titled *Omnia artistique*.[59] This manuscript book, which was not intended for publication (it reads like a combined diary and laboratory manual), contains seventy pages that are almost completely filled with Rops' observations. The main part of the text was written in July 1888, but it includes many earlier observations and discoveries, and it contains additions as late as 1894. The common strand running through this text is a search for a perfect soft-ground, an etching technique for which Rops was, and still is, famous. The distinctive quality of soft-ground is that it makes possible a variety of subtle tonal or textured effects like the various effects of a pencil on different papers. Armand Rassenfosse participated in some of these technical explorations with Rops, and the etching ground that was the result of their collaborative investigations was dubbed "Ropsenfosse."

This issue of Rops' soft-ground experiments bears directly upon his use of another technique, photogravure (or its earlier form, heliogravure). Heliogravure is a means of printing a continuous-tone image, resembling a photograph and making use of a photographic negative, from an etching plate. From the mid 1870s, Rops used heliogravure as a means of transferring a drawing to a plate that could then be brought to completion with traditional etching techniques.[60] Pure heliogravures were also made of Rops' drawings, with little or no added etching. Many of these have been innocently treated as soft-ground etchings until recently.[61] Soft-ground etching, with its ability to create a rich spectrum of grays and textural passages, can work very well in combination with heliogravure. According to Rassenfosse, much of Rops' experimentation was toward developing a transparent soft-ground through which he could see the photographically produced image on the etching plate in order to accurately rework it:

In all honesty, the processes that Rops and I tried to perfect (namely soft-ground and aquatint) were secondary processes—to satisfy the magician in him—and were practical means to complete at will, and in a manner resembling pencil, the photogravures that he felt rendered his drawings imperfectly and which he therefore wished to retouch.

When I went to see him for the first time in 1886 he directed me immediately to search for a transparent soft-ground.[62]

It was Rassenfosse who discovered that by substituting rubber solvent used in patching bicycle tires ("it was the bicycle's flourishing era") for the solvent terebinthine, the soft-ground could be rendered somewhat transparent.[63]

In general, heliogravures were produced for the artist by a specialist in the technique. Late in Rops' career Albert Bertrand produced heliogravures after his drawings.[64] It was also Bertrand who produced numerous posthumous heliogravures after Rops' prints and drawings, once the reproduction rights to the artists' estate had passed into the hands of a publisher, Gustave Pellet.[65] The technique of heliogravure had become so popular by the end of the century that Jules Adeline, author of *Les Arts de Reproduction Vulgarisés* (*The Reproductive Arts Vulgarized*) lamented that there were no longer artists capable of using engraving tools, they having been replaced by a new breed of artisan, the heliogravure retouchers.[66] It is important to note that Rops had no qualms about signing reworked photogravures (or photogravures touched up with colored pencil, see cat. 121). Heliogravure was simply another etching tool that Rops made use of in translating his drawings to metal plates in order to multiply them. As Rassenfosse put it in defense of Rops, one should not get too fetishistic about printmaking techniques.[67]

De Groux and the Heft of Lithography

In describing de Groux's Parisian studio, Louis Gillet was impressed not only by the walls painted in red and the approximately twenty unfinished canvasses and numerous sketches scattered around, but also by "three or four lithographic stones as big as carving stones, giving the impression of some enormous undertaking."[68]

This description is in keeping with de Groux's affinity for the grandiose and for cataclysmic subjects. Contemporary critics compared him to Rubens and Delacroix, artists whom he clearly admired.[69] His themes were often based on scenes of political turmoil,

Wagner's operas, or Napoleon's campaigns; themes that permitted de Groux's penchant for surging masses of humanity. His most important painting *Le Christ aux outrages* (*The Mocking of Christ*), which caused a great sensation in both Brussels and Paris, became the subject of a lithograph (cat. 10) and is typical of his chaotic compositions. He also made lithographic portraits of figures he admired: Baudelaire, Balzac, Napoleon, Rops, Rubens, Wagner, Zola, and his father Charles.

De Groux's commitment to printmaking is indicated by his working on unwieldy lithographic stones in his studio, rather than exclusively in the printer's shop. In fact, de Groux seems to have been at odds with his printers who, in the words of Emile Baumann, "burned his stones with acid that was too strong and, under the pretext of rendering his drawings more 'lithographic,' they betrayed and deformed them."[70] At times de Groux was so involved with lithography that it became an impediment to travel. In late 1896, for example, he wrote twice from Brussels to his close friend, the writer Léon Bloy in Grand Montrouge:

Another thing, I want to have several lithographs printed in Paris, but for this it will be necessary to get a room to do the retouching in, and, if necessary, have the stone transported. I would happily come to Montrouge, but this will be difficult with lithographic stones weighing eighty kilograms. [December 23]

I believe Grand-Montrouge is too far from Paris, and I have cause to fear the danger and the cost of shipping such delicate and complete work, and the difficulties of the necessary transport from the printing house to the studio, when the proof does not at once give the desired result. [December 25][71]

De Groux's work qualifies as an early form of expressionism, in part because of the urgency of his drawing style, a style that lends itself much more to the immediacy of drawing on the lithographic stone than to the delicate and more protracted work of etching. It is possible that the sheer weight of the lithograph as a drawing medium appealed to de Groux, who seems to have savored struggle, and who was given to all variety of visual impact, including outsized frames and formats, and grandiose subjects.[72]

Ensor and the Problem of Printed Light

Ensor was not an innovator in printmaking in the same sense as Rops. He did not own a printing press or apply the ground to his own plates, and, as we have seen, the special impressions of his etchings were produced by professional plate printers.[73] Although it has generally been assumed that Ensor had little to do with the printing process, he claims to have personally inked his plates and assisted in the printing process for some proofs of *L'Entrée du Christ à Bruxelles* (cat. 45).[74] In general, however, it may be said that Ensor was not seduced by the broad spectrum of technical possibilities available to the intaglio artist. Perhaps he was distinguishing himself from Rops when he wrote in 1890, "I can't yield to those tricks, secrets and trifles of biting the plate."[75] With the exception of a few experiments with sulphur ground (in which the corrosive is applied directly to the plate, see cat. 32), and a few attempts at soft ground etching and lithography, he preferred to limit his technical vocabulary to traditional etching and drypoint. For the most part, Ensor kept his technical options close to those available to Rembrandt and Goya, both of whom he admired. More than half of his total output of 133 etchings was produced between 1886 and 1891 (86 have been counted), and Ensor was to write fondly of this period, in a letter to his friend Emma Lambotte:

I am so pleased that you think well of my etchings. I have signed and dated them for your pleasure. In looking at the dates you can see that 1888 was an especially fecund, happy period of walks in the open air, punctuated with the delicious work of the etcher. Nature seemed beautiful and kind.[76]

The prints that Ensor produced in this critical period were integral to his creative process, and it has been summarized that he considered them as "independent works, exhibiting them with his paintings and drawings."[77] Although Ensor bothered little with the details of etching, he may be considered an innovative printmaker in his frenetic use of the etched line to evoke his overriding artistic concerns. At the peak of his career, when, as Bown-Taevernier has pointed out, Ensor had just begun to experiment with printmaking, these concerns were with the penetration into the essence of light.

Ensor's investigation of light culminated with his series of five remarkable drawings, *Les Auréoles du Christ ou les sensibilités de la lumière* (*The Haloes of Christ or the Sensibilities of Light*), which he exhibited with Les XX in 1887. It is clear that Ensor's investigation of light concerned its physical, particulate nature, as well as its fertile application as metaphor, rather than with the transitory effects of visible light explored by the impressionists. In fact, Ensor distanced himself from the treatment of light by the impressionists, whom he called "superficial daubers suffused with traditional recipes," as well as

the pointillists, about whom he said, "in their correct and frigid lines they achieve only one of the aspects of light, that of vibration."[78] Jacques Janssens has reported that "to anyone who congratulated him on his choice of subjects, Ensor would reply without hesitation, 'They are not subjects, they are lights.'"[79] Although late in his career, it is significant that Ensor wrote with great admiration to Albert Einstein shortly after they met in 1933, referring to him as the "splendid launcher of penetrating rays" and "the man of light," and expounding:

Yes, the celestial bodies irradiate the paradises of rotarian relativity, lighting up the closed field of our table where glasses, bowls, crystals, vials, reflecting the spangles and the cries of silk and of joy of the merry young stars, where explosive charges, candles, rockets inflame our senses and burn the spirit of our thoughts.[80]

This visionary world suffused with a scintillating, particulate light is in many ways analogous, at least in sensory terms, to Ensor's other great love, the briny, granular atmosphere permeated with smells

that he knew from his home on the coast of Belgium, and about which he wrote with such passion:

The Flemish sea gives me all its nacreous fires, and I embrace it every morning, noon, and night. Ah, the wonderful kisses of my beloved sea, sublimated kisses, sandy, perfumed with foam, refreshingly pungent.[81]

These twin concerns with the quanta of light and of atmosphere (in terms of climate, not ambience) are beautifully evoked through Ensor's delicate, tremulous handling of the etching needle (fig. 29). More importantly, in the critical years of the late 1880s, Ensor accomplished with etching and drypoint what he could not accomplish in other media. While his drawings can initiate one into the full intricacy of his vision, and his paintings can seem to dazzle with the full shock of the electromagnetic spectrum, his bundled, fibrillating lines scratched with a drypoint needle or etched with acid, and his loosely controlled use of foul-biting, sulphur ground, and light passages of aquatint, result in a remarkably tactile quality appropriate to his concern with "the sensibilities of light" and with what Georges Lemmen called the "most vaporous and most fluid effects of the atmosphere."[82]

"Prints from a Portfolio" and Prints for Sale

In the course of its ten years of existence, about twenty-five artists exhibited prints with Les XX.[83] These included Félix Bracquemond, Mary Cassatt, Odilon Redon, Max Klinger, Lucien and Camille Pissarro, Henri de Toulouse-Lautrec, and James McNeill Whistler. Judging by the Les XX exhibition catalogues, only four members of Les XX (Ensor, Finch, Lemmen, and Rops) exhibited their prints with the group. Although the catalogues may be misleading (Rops, for example, is known to have exhibited more prints with the group than the catalogues indicate), de Groux, Khnopff, Toorop, and Van Rysselberghe seem never to have exhibited their prints with Les XX.[84] This would imply that for many members of Les XX, printmaking lay outside of the arena of important artistic endeavor. However, even if we admit that Khnopff's prints were relatively minor achievements, this would be a false conclusion. De Groux had been ousted from the group before he began printmaking in earnest, and other members of Les XX did exhibit their prints in other European capitols.[85] Most importantly, exhibitions cannot be taken as the only gauge of seriousness of artistic purpose. Prints often enjoyed

FIGURE 29. James Ensor, detail of *La Cathédrale*, etching, 1886. Spencer Museum of Art: Gift of John and Ann Talleur in Loving Memory of Raymond Cerf.

an important intimate life that was independent of exhibitions, and took the form of portfolios, display in galleries, and the practice of giving prints as gifts.

The considerable energies expended by Van Rysselberghe, Finch, and Lemmen in printmaking appear to have been motivated primarily by the pleasure of "the delicious work of the etcher," to use Ensor's phrase. One senses that these artists were infatuated with printmaking, and that they approached it out of familiarity, but not out of intellectual or economic urgency. On January 25, 1899, for example, Van Rysselberghe wrote to Pol De Mont, who had asked to see examples of Van Rysselberghe's prints for an article on the artist that he was writing:

I would like to have included a collection of my etchings, but they were printed in very small numbers and are out of print (the best possible collection of them is now being exhibited in Vienna) . . . I have made a few posters, those for the exhibition of the L[ibre] E[sthétique] in 1896 and 1897, and one for the frame maker N. Lembrée in Brussels in 1897 [cat. 152]. To tell the truth, I consider these works of little importance; my real concern is with painting on which henceforth I spend all my time; I continue my attempts at etching because this technique seduces me a great deal, and I am at home with it.[86]

Roger Cardon's recent study reveals that Lemmen's sustained efforts in lithography (thirty-three prints) and etching (eighteen prints) were usually realized in only a few impressions.[87] Perhaps Lemmen's and Van Rysselberghe's small print editions found compensation through their involvement with book ornament and poster design, both graphic mediums that are usually printed in large numbers. In a letter of 1904 to Octave Maus about Maus' "mischievous" idea of featuring color prints at the next La Libre Esthétique exhibition, Van Rysselberghe touched on current attitudes about what he termed "fine art prints:"

you must be careful to distinguish fine art prints—one says from a portfolio (although this classification is idiotic)—from industrial work, work that is simply kitsch, or bad work.[88]

In indicating that the phrase "prints from a portfolio" is what "one says," Van Rysselberghe gives us a key to the way in which "fine art prints" were perceived in the late nineteenth century.[89] That he calls the term idiotic may indicate that he is not entirely comfortable with a clear distinction between artistic and industrial production.

However, if, as Van Rysselberghe indicates, "prints from a portfolio" was an established term, it is useful to look at the phenomenon a little more closely.

Opened only at the time of viewing, the portfolio allowed for intimate perusal, and it was often associated with a cultivated and intellectual environment. The most compelling indications of this come from France. For example, in Bracquemond's famous etched portrait of Edmond de Goncourt, a portfolio appears in a special stand for prints (often called an "X" due to their X-shaped legs, see fig. 30 and cat. 152), along with other trappings of learning and good taste.[90] An extravagantly carved bookcase by François-Rupert Carabin of 1890 (Paris, Musée d'Orsay) incorporates book shelves and a special built-in compartment for prints.[91] Finally, the penultimate esthète, Des Esseintes of J.K. Huysmans' À Rebours, in order to "distract his attention and kill the interminable hours . . . had recourse to his portfolios of prints and sorted his Goyas."[92] Des Esseintes also had portfolios of Rembrandt prints, "which he would examine now and again on the sly," so as to protect them from the polluting gaze of the rabble and uncritical connoisseurs.[93]

The "print from a portfolio" doubtless retained something of the exclusive and precious aura so relentlessly ascribed to it by Huysmans. Although Van Rysselberghe evidently tried to distance himself from this "idiotic" designation, he and several other artists of Les XX (de Groux, Ensor, Finch, and de Regoyos) nonetheless produced portfolios, and many of the artists contributed to group portfolios that were published in France and Germany.[94] For the artists, the assembly of a portfolio served an important function; it was a primary means of imposing a conceptual order upon several years' print production. Like Marcel Duchamps' later Boîte-en-valise (Studio in a Suitcase) the portfolio was a useful way to encapsulate an artistic career, or an episode of one.

Bookstores, Publishers, and Frame Shops

Whether or not they relied upon printmaking for income, all of the artists of Les XX who made prints used them as a form of gift for important patrons and colleagues. This is evident from the large number of prints bearing dedicatory inscriptions (see cat. 61 and 80), and, in a few cases, from their provenance (cat. 157, previously owned by Willy Finch). The print as a gift, then, was used as a greeting among friends, and as a means of maintaining good favor with dealers, critics, publishers, and collectors.[95]

FIGURE 30. Armand Rassenfosse, *Les Affiches étrangères illustrées* (*Foreign Posters Illustrated*), lithograph, 1896. Museum of Fine Arts, Boston.

The prints were, of course, also available for sale, but reconstructing exactly where is a difficult task.

Prints were available through frame shops, such as the firm of N. Lembrée (cat. 152) and those bookstores and publishing houses that were closely affiliated with the arts. The large number of prints by Ensor and de Groux, and photographs after works by Khnopff, listed in the *Bibliographie de Belgique* indicates that they were available for sale in bookstores.[96] It is very difficult to find documentation or information about the display of prints in such informal settings. However, we know that in 1891 Ensor's etchings were exhibited at gallery Dietrich in Brussels; Dietrich being the firm that published the beautiful *Almanach* by Verhaeren and Van Rysselberghe (cat. 149 and 150), as well as numerous prints by Ensor and Finch.[97] "Maison Dietrich" also sold photographs (platinum prints) and reproductive prints of works by the Pre-Raphaelites, as well as books illustrated by Walter Crane and books

published by William Morris' Kelmscott Press.[98] When Finch completed his 1892 album of ten etchings it was made available for sale at the publishing house of Veuve Monnom (cat. 51–54).[99] It is likely that other publishing firms that specialized in the arts, such as J.E. Buschmann in Antwerp (publisher of the second series of *Van Nu en Straks*) also sold prints.[100] We know that a number of impressions of certain etchings by Lemmen were among the archives of the etching printer Van Campenhout, although whether or not they were available for sale through this firm is not certain.[101]

The publisher who was most intimately involved with the artists of Les XX was certainly Edmond Deman and there is some evidence that he had prints available in his shop. We learn about this through Camille Mauclair in his description of his first encounter with the art of James Ensor in 1893. Mauclair described how, having just perused etchings by Rops at the Brussels shop of Edmond Deman with

Verhaeren, he encountered Ensor's etching *La Cathédrale* [cat. 24] in a nearby shop window amidst a confusion of colorful posters. From this it is clear that Deman had prints by Rops in his shop, but unfortunately we do not know the name of the shop with the Ensor in the window.[102]

Enthusiasts of Japanese prints, however, looked to Paris for their source. For example, in the late 1880s, when van de Velde was studying Japanese prints at his studio in Calmthout, Théo Van Rysselberghe wrote to Eugène Boch [brother of Les XX artist Anna Boch]:

> when you go to Paris, stop in for a moment at the little Kimoura [at Wakai's shop] to see if he has anything new and please ask him not to forget me, and when he has something new he may send me a packet of plates—I will return those that I don't wish to keep with payment for those that I do.[103]

This request almost certainly concerned packets of Japanese prints, for Wakai was one of Paris' leading importers and dealers of Japanese arts.[104] In any event, we know that Van Rysselberghe had a collection of Japanese prints since he, like Georges Lemmen, loaned Japanese prints to an exhibition held in Brussels in 1892.[105]

"A Closed House" and the Attorneys
A Probable Source of Patronage

The artists of Les XX were intimately involved with the Belgian Workers' Party and with political reform. They incorporated political statements and aspects of social criticism into their art, and they offered their compositions for use in the publications and promotional material of the Section d'Art (the artistic wing of the Belgian Workers' Party, see cat. 59 and 74), and there is no evidence that the prints of Les XX experienced any kind of popular distribution. In fact, quite the opposite seems to have been the case.

Specific instances in which prints by Les XX can be identified in private collections are rare, but two very wealthy collectors, Henri Van Cutsem (whose collection forms the core of the collection of late nineteenth-century works at the Tournai museum), and Charles Dohmen in Liège, owned Finch's portfolio of ten etchings (cat. 51-54).[106]

In all probability, the collectors of "portfolio prints" (to use Van Rysselberghe's phrase) were wealthy enthusiasts and members of the intellectual circle that surrounded the editors of *L'Art moderne*: Octave Maus and Edmond Picard. Maus, of course,

was also the secretary of Les XX and of La Libre Esthétique, but it is Picard more than he who energized this enlightened but elite public.

There were two specific arenas of artistic activity animated by Picard, a private gallery called La Maison d'Art (The House of Art), and a professional organization for members of the bar, Le Jeune Barreau (The Young Bar), that sponsored a number of cultural events. La Maison d'Art operated from 1894–1900 and was "adorned with modern things":

> books, paintings, sculptures, trinkets, prints, fabric, utensils—here they hang on the wall, there on easels, on shelves, tables and buffets . . . to hold and admire as freely as the owner.[107]

In the second of eight booklets published by La Maison d'Art we are told "La Maison d'Art is not open to the public. It is a closed house."[108] This gallery (ultimately given over more to the display of art than to its sale), which also hosted musical events and lectures, was in Picard's home at 56 Avenue de la Toison d'Or.[109] The Belgian poet Iwan Gilkin referred to it as "the most ardent intellectual foyer that has ever existed in our country."[110] Although there is no inventory to tell us exactly what prints were on display at La Maison d'Art, other than some of the posters that were periodically exhibited, there is no reason to doubt that among them were the works by Les XX, and La Libre Esthétique.[111]

Picard was a highly influential lawyer who championed socialism and progressive art with equal fervor. It is in part due to his efforts that Le Jeune Barreau of Brussels, and to a degree that of Antwerp, was intimately involved with the arts. In nineteenth-century Belgium law school was the standard embellishment to a young man's academic career. Many of the artists, writers, and patrons discussed in this catalogue had studied to be lawyers (Combaz, Demolder, Destrée, Elskamp, Khnopff, Maeterlinck, Maus, Picard, Rops, Van Cutsem, and Verhaeren). The young members of the bar were highly literate, and they were closely involved with the cultural affairs of their young nation.

In 1891 the writer and critique Eugène Demolder [see cat. 41], and another prominent member of the bar, Octave Maus, organized a special fiftieth anniversary exhibition for Le Jeune Barreau, with the exhibited items drawn extensively from the collections of the members of the Barreau.[112] The exhibition included nine sections, one of which was given over entirely to works of art (the others treated manuscripts, diplomas, books, medals, portraits, souvenirs of famous

orchestra pit Les XX member Anna Boch played second violin, and the composer and pianist Vincent d'Indy, in a *zwans* gesture (see cat. 82), played the kettledrum.[116]

The association of the bar and the arts was not limited to Brussels. The Antwerp Jeune Barreau sponsored a number of exhibitions.[117] The group's journal, *Le Jeune Barreau,* included many articles by and about Picard, and it regularly published advertisements for *L'Art moderne.* In one exceptional instance this journal published a letter by Maurice Maeterlinck that, while aping his own symbolist poetry, argues in support of his cousin, Albert Maeterlinck, who was seeking admission to the bar in Antwerp after moving from Ghent. It is taken for granted that the audience will understand a reference to the defence of Whistler, and enjoy Maeterlinck's tongue in cheek exercise in self-parody.[118]

In addition to bookstores and publishers that specialized in the arts, these two exclusive arenas (the "House of Art" and the bar) were likely promoters of the prints of the artists of Les XX. Picard himself was an avid collector. The auction of his estate in 1904 included a section with eighty-seven "watercolors, drawings, etchings, and lithographs," including work by Courbet, Danse, Daumier, Ensor, Khnopff, Lemmen, Mellery, Meunier, Redon, Rops, Toorop, and Van Rysselberghe.[119] Maus, of course, had a similar collection, much of which is now at the Musée d'Ixelles. It can only be assumed that other members of the "Young Bar" similarly patronized contemporary Belgian printmaking.

FIGURE 31. Théo Van Rysselberghe, frontispiece for the Conférence du Jeune Barreau, *Fête Jubilaire, Omnia Fraternè!,* lithograph, 1891. © Bibliothèque Royale Albert 1er, Brussels.

cases and of famous banquets, and miscellaneous). The fifty-seven works displayed in the arts section ("paintings, drawings, sculptures, prints, photographs, etc.") included works by Khnopff, Mellery, Meunier, Redon, Rops, Toorop, and Van Rysselberghe.[113] The group continued its jubilee celebrations by writing and performing a light-hearted play, *Omnia Fraternè!,* that was published with a cover designed by Van Rysselberghe (fig. 31).[114] The cast and orchestra included prominent artists, poets, musicians and critics, including Octave Maus (playing a leading role), Georges Picard (eldest son of Edmond and administrator of *La Maison d'Art*) serving as stage manager, and the lawyer of the Belgian Workers' Party and patron of Victor Horta, Max Hallet, serving as a second stage manager. Les XX member Guillaume Van Strydonck provided whistles, his wife played two roles, and the critic H. Carton de Wiart played three roles.[115] In the

"I See in Flemish and I Write in French"
Toward a Conclusion

A review of the 1889 Les XX exhibition published in *L'Art moderne* began, "It is necessary to lower oneself to some of Mr. James Ensor's etchings in order to discover who the artist really is."[120] The author of this review (possibly Verhaeren) insists, in an ironic voice, that one must confront Ensor's prints in order to come to grips with the artist in his totality. It is not certain which prints were on view at the exhibition; the 1889 catalogue includes only "drawings and etchings" as the fourteenth of eighteen entries under Ensor's name. However, it must have included a sampling of Ensor's etchings of 1888, among the most important of his career.

Although the reviewer for *L'Art moderne* apparently recognized that prints can open certain avenues of understanding and offer access to an artist's more

difficult subjects, Les XX was never to focus special attention on the arts of printmaking. Octave Maus, the secretary of Les XX and the editor of *L'Art moderne*, (whose eyes seem to have focused on Paris as much as Brussels) only came to the idea of a print exhibition in 1904 (for La Libre Esthétique); this was more than fifteen years after Ensor's most prolific period of etching, nearly a decade after the colorful success of the Parisian print portfolios, *L'Estampe Original* (*The Original Print*), and four years after the German periodical *Die Graphischen Künste* (*The Graphic Arts*) initiated a double issue dedicated to contemporary Belgian printmaking.[121] In 1904, when Maus did discuss a print exhibition with Van Rysselberghe, it was to be a color print exhibition. It is no wonder that Van Rysselberghe responded to this idea as "mischievous," for, except for their activity making posters, Belgian artists had made very few color prints.[122]

Unlike paintings and large, colorful posters, prints failed to gain the attention of much of the Belgian public. But given the observation (or axiom) that in printmaking an artist's most challenging and unsettling ideas often find expression, it is surprising that the medium did not find a wider appreciation within the Belgian avant-garde; it is surprising that Les XX never sponsored an exhibition "blanc et noir."[123] However, as we have seen, the prints by members of Les XX sometimes went beyond the scope of the group and found an alternative audience in bookstores, publishing houses, and frame shops; through the publications of the Section d'Art and charitable institutions; through the habit of giving prints as gifts; and perhaps through a network of patrons animated by the Young Bar. The prints by members of Les XX, which were often tangential to their activity as a group, were part of an independent print culture at the end of the century.

The historicizing and nostalgic prints and books discussed above (Siret's proposal to copy "our immortal Flemish canvasses," Geets's sentimental depiction of a print collector steeped in the past, Leys' prints of Flemish historical themes, De Braekeleer's etchings of daily life in the old quarters of Antwerp, and de Munck's and Havermans' turning to handmade papers and Renaissance fonts in their book designs) contributed to a preoccupation with Flemish heritage that was continued in the prints and books made by progressive Belgian artists at the end of the nineteenth century. These progressive artists often combined Flemish lore or aspects of contemporary life in Belgium with current international artistic trends. As the writer, woodcut artist, and eventual

folklorist Max Elskamp once wrote, "I see in Flemish and I write in French."[124] In this simple statement, Elskamp, whose artistic activity was limited to print mediums, suggests that his visual world is the world of popular expression, and of regional, historical, and geographical associations [fig. 32], while his literary world, although still steeped in Flemish lore, found expression in the international realm of French letters. It is risky to attempt an analogy, but it may be said in general that the Belgian artists of Les XX, while still seeking a broader European identity, also tended to "see in Flemish." This is especially evident in the prints of several of the Vingtistes, such as Ensor, Finch and Rops, and perhaps in the Rubinist works of de Groux.

A similar duality is manifest in the artists' activities in both the populist and elitist arenas, as in their work for the artistic wing, Section d'Art, of the Belgian Workers' Party and for Picard's exclusive exhibition society Les XX provided the artists with

FIGURE 32. Max Elskamp, *Notre Dame du horlogiers* (*Our Lady of the Clockmakers*), from the series *Notre Dame des plus belles métiers*, woodcut, 1903–1905. Spencer Museum of Art: gift of the Friends of the Art Museum.

their international foothold and stature, while their activity in the more intimate mediums of printmaking, which, as we have seen, existed independently of Les XX's corporate identity, allowed them an arena to explore artistic possibilities on a more intuitive and personal level than in their paintings. As the reviewer

for *L'Art moderne* suggests, to understand Ensor and (we may add) his contemporaries, we must come to terms with their prints. This is especially true if we are to understand what Elskamp might have called the artists' Flemish perspective, as distinct from their international perspective.

Notes

1. For Wiertz see Lesko, *James Ensor*, 59–64.

2. Siret, *Gravure en Belgique*, 4, 41. For Edelinck see Hind, *Engraving & Etching*, 146–48.

3. Siret, 41; "Que l'Etat fasse faire par les jeunes graveurs des oeuvres sérieuses, telles que la copie de nos immortelles toiles flamandes, sur une vaste échelle, dans des proportions qui étonnent le public et que ces travaux soient convenablement répandus dans les masses."

4. Siret, 7; "Le public n'aime pas la gravure sérieuse, parce que c'est un art qui demande du temps et qu'à notre époque on aime à jouir vite, comme si un cataclysm devait arriver demain." Siret is best known for his *Dictionnaire des peintres* and his work as director of *JBA*. See Bergmans, "Siret."

5. Hymans, "Oeuvres," 144, 492. A list of the 136 prints still available for sale is listed in *JBA* 28 no. 1 (15 January 1886): 8.

6. See note 5 for the list, it is the only print listed with a description, and is by far the most expensive print listed (20 francs). De Vigne's etching was printed by Delâtre in Paris.

7. Hymans, 420–58; Rooses, *Art in Flanders*, 324. For an introduction to nineteenth-century printmaking in Belgium see Rouir, *150 Ans*, 7–14; see page 7 for Charles Senefelder.

8. Hymans, 125–28, 400–07. Corr succeeded De Meulemeester in Antwerp, who is succinctly described by Rooses, *Art in Flanders*, 322–23, as having "conceived a fervent and almost exclusive passion for the Loggia of Raphael, which he began to engrave, but never finished." Hymans (400) lists the major students of Corr: Verswyvel, Bal, J. Linnig, Collette, Durand, J.-B. Michiels, J. Nauwens, Van Reeth, Wilders, and Degraux; and of Calamatta: Joseph Franck, Joseph-Arnold Demannez, Jean-Baptiste Meunier, Flameng, Delboîte, Gust. Biot, David Desvachez, J. Thévenin, Lelli, Mariano Morelli.

9. The École de gravure was briefly annexed with the Brussels Academy (1848–1862), but ceased to exist after 1862. Alvin's attempts to convince the government to establish a calcographic institute similar to the *Gesellschaft für Vervielfältigende Kunst* in Vienna were fruitless. Hymans, 128–29; 407–09. For the shortage of print publishers see Hymans, 405

10. Hymans, 410. For Danse see Sand, "Graveurs Wallons." Numans, *Cours d'Aqua-forte*, 6; "ce cours est la reproduction écrit de celui que nous donnons depuis bientôt deux ans au Cercle des Aquarellistes et Aqua-fortistes."

11. Burty, "Henri Leys," 468. Rooses, "Leys," col. 65.

12. Delteil, *Le Peintre Graveur* 19.

13. Burty, 470–71; "Ces travaux faits uniquement comme amusement pour moi, écrivait récemment M. Leys en les offrant à un hereux amateur, je les réservais à des amis dont la bienveillance pouvent me faire pardonner le manque d'expérience, et n'y rechercher que ce qu'elles peuvent contenir d'intéressant."

14. Wellens, "De Braekeler," col. 149; "Toutfois, c'est dans cette technique [non destinée à la vente, et permettant de ce fair une plus libre expression] que De Braekeler parvient plus rapidment qu'avec les pinceaux à cette liberté de trait et à l'effet luminuex désiré."

15. Delteil gives two periods of printmaking activity for de Braekeler, 1860–61 and 1874–77. Leys died in 1869. De Braekeler was invited to join the International Etching Society in 1875 when Baron Goethals saw his work at the firm of Nys (Nijs), the society's printer; see Tralbaut, "De Braekeleriana – III," 163. His last etchings were made around 1876.

16. The Countess of Flanders (Marie-Louise-Alexandrine-Caroline de Hohenzollern) was born in Sigmaringen, the daughter of Charles Antoine, Prince of Hohenzollern-Sigmaringen. She married Prince Philippe, Count of Flanders, the youngest son of King Léopold I of Belgium, in 1867 in Berlin.

17. *Société Internationale des Aquafortistes sous la patronage de S.A.R. la Comtesse de Flandre, Statuts*, Brussels (J.H. Briard), 1870. The statutes are dated 4 December 1869.

18. As translated by Arwas, "Félicien Rops;"; Arwas's source was an article in *AM* 3 July 1881, "Félicien Rops et l'Ecole de Gravure en Belgique," 141; "Ma bonne âme de Belge s'émeut de l'état piteux dans lequels se trouve la gravure en Belgique; je rêve toutes sortes de choses nobles, patriotiques et grotesques: la renovation de l'eau-forte en Belgique, la création d'une Calcographie, et je me fourre dans la tête de faire de cette petite Belgique, si bien placée entre

19. *Société Internationale des Aquafortistes, Statuts*; article 1, "Il est fondé à Bruxelles une société pour répandre et développer le goût de la gravure à l'eau-forte"; article 17, "Les eaux-fortes présentés pour la publication dans l'Album ne peuvent être des copies, le cas—excepté où l'artiste aurait gravé d'après lui-même."

20. *Société Internationale des Aquafortistes, Statuts*, Article 40; "Un atelier avec outillage commun pour le travail et la morsure des planches, annexé à la disposition de ses membres, à partir du 15 février 1870."

21. Arwas, "Felicien Rops," 4–5.

22. The group's statutes were published 1 September 1880. Several of the officials were presiding members of the Cercle Artistique or the Antwerp Academy, but the secretary was Max Rooses, director of the Plantin-Moretus Museum.

23. Giltay, "Nederlandsche Etsclub," 92.

24. Bouillon, *Paysages et Villegiature pour une princesse*, 25, lists the Countess's etchings published by the Antwerp Etchers. The annual album appeared in two gatherings of six.

25. "Als Ik Kan" refers to the signature of the famous fifteenth-century Flemish painter Jan van Eyck, "As best I can." For the group, see Buyck, *Antwerpen 1900*, passim; Buyck, "Problem of Provincialism," 71–80. They distinguished themselves from the artists of the Cercle Artistique, which was more closely tied to the official salons.

26. In the 1894 Oud Antwerpen (Old Antwerp) exhibition in Antwerp, for example, Max Rooses and his family dressed up in historical Flemish costume; see the photograph published in Voet, "Max Rooses," 75. I thank Lode De Clercq for bringing this article to my attention, and for sharing photographs of anonymous nineteenth-century Belgian citizens in historical costume in their Flemish Renaissance Revival homes. See also the early catalogue and the discussion of Oud Antwerpen, the renactments of the pageants of the Antwerp guild of rhetoric, De Violieren, and similar manifestations in Willis, *Flemish Renaissance Revival*, 187–90, plates 117–120.

27. The statutes were published in 1886, in *JBA* 28 no. 18 (30 September 1886): 143. The group was based in Brussels.

28. Hymans, 495.

29. Khnopff, *Un Geste d'offrand*, 1900, Ensor, *Le Triomphe de la Mort*, 1896, Van Rysselberghe, *Le Tub*, 1897. The Belgian group's decision to issue fifteen portfolios a year, not twelve like the Antwerp group, may be one product of this rivalry. Antwerp traditionally called itself the Belgian center of art and commerce, but the predominantly francophone capitol did not wish to be outdone by Antwerp.

30. "Société des Aquafortistes belges," 206–08. Also reported in *L'Imprimerie Belge de la Typographie, Papetrie, Librairie et de toutes des branches qui s'y rattachent* 9 no. 4 (20 February 1891). These journals contain primarily technical articles on such innovations as perfumed inks and varieties of photo-relief printing, but other topical items concerning printing appear also, such as the issues involved in pornographic publications.

31. Under the direction of M. Alvin, Hymans, 62, see also 68–74.

32. AAC 11.998, 4 October 1900; "j'ai 'placé' il y a 4 ou 5 ans, au cabinet des estampes (Bruxelles) ma première série d'eaux-fortes. Cette opération se fit par l'entremise d'une (je crois) 'Société belge de bibliophilie' (?) laquelle me prit 25% sur le prix de vente-pour la peine. J'ai fait, depuis, d'autres planches et j'en mets encore 4 ou 5 jour en ce momment, cela me fera une nouvelle série de 10 à 12 planches dont je serais . . . 'placer' encor . . . res chez ledit . . . d'estampes. Mais je ne sais plus: ni le nom, ni l'adresse du bonze qui se chargea de ce trafic, ni, exactement, quelles sont les planches contenues dans l'album. Mais n'es tu pas un père, n'est-ce pas l'octave-du-Bon-Secours à qui on peut tout demander? Tu vas donc, comme un vrai brave, envoyer ton commis au cabinet de la Place du musée, un jour qu'il s'embêtera très fort; il demandera à voir l'album d'eaux fortes de T.V.R: il constatera s'il y a les planches que je crois s'y trouver et dont ci joint la liste"

33. De Munck, "Le Tombeau des Estampes," 49, the article begins; "Titre étrange, je le veux bien, mais n'est-ce pas un tombeau que ce Cabinet mystérieux, presque impénétrable, ignoré du public, où gisent, dans les ténèbres de cases hermétiquement fermées, les oeuvres de nos maîtres lithographes et graveurs morts?" For de Munck see Breuer, *Nos contemporains*, 241–242.

34. De Munck, *Arts Graphiques en Belgique*. The notice practices what it preaches; it is printed on Belgian handmade paper (made by De Meurs Freres & Soeurs at Rhode St-Genèse) and its ornaments, printed from photomechanical reliefs, were drawn by de Munck and Desaircourt in emulation of German and Flemish Renaissance designs.

35. This was apparently part of a series of small exhibitions of Dutch and Flemish etchings, several of which were monographs, treating Rembrandt, Van Ostade, Cornelis Bega, Teniers, Thomas Wyck, and Jan Both. See Alvin, *Exhibition d'eaux-fortes*.

36. *AM* 2 no. 30 (23 July 1882): 238; "Exposition de Noir et Blanc à *L'Essor*." *JBA* 28:18 (30 September 1886): 143 article 3; "Elle peut également organiser des expositions 'blanc et noir' et de tout ce qui rattache à l'art de la gravure." A letter from Rassenfosse in Liège to the printer Nys in 1884 or 1889 concerned an exhibition "*Blanc et Noir*," that was to include Walloon drawings (Getty Center no. 900250).

37. For Japanese prints, see endnote 105. Havermans, "Blanc et Noir," 71–2, Havermans proposes a "Black and White Salon" exclusively for exhibiting illustrations, which would include, as well as Belgian artists, foreign contributions by artists such as Steinlin, Forain, Willette, Nicholson, Beardsley, Sattler, and Stuck.

38. Drion, *Graveurs Liégeois*. De Croës and Clercx-Léonard-Etienne, *François Maréchal*.

39. This point has been emphasized by Block in "The Art Poster in Belgium."

40. *Bulletin, Association Belge de Photographie*, from 1873; *L'affiche artistique*, N.S. from 1901. Relevant trade journals include *La revue graphique belge*, from 1898, and *L'art de l'imprimerie et de toutes les professions qui s'y rattachent*, from 1888. See Block, "The Art Poster in Belgium," 8–21.

41. The inscription appears on an impression of Van Rysselberghe's portrait of Francois-Auguste Gevaert at the Gallerie Derom, Brussels. Ensor dedicated the portfolio [no. 1 of the edition], "A mon excellent camarade Charles Vos. En témoinage de ma haute estime. James Ensor. Bruxelles 20 Mars 1896." Although published by Van Campenhout, Vos may have been involved with the printing of the portfolio, as Tricot has proposed in *Ensoriana*, 38–42.

42. See endnote 88. "Moi, non, je n'ai jamais fait d'estampe en couleurs; je ne compte pas comme telle le peu de rouge que mon imprimeur a frotté sur la vestons du petit vieux déambulant — dans l'eau forte que tu connais."

43. Van de Perre, "L'oeuvre gravé de James Ensor," 22–32. Van Campenhout was a family firm, as Mme. van der Perre has clarified in a letter to the author; the firm was originally called Imprimerie Bouwens, located in 1892 at rue du Champ de Mars. This became Imprimerie J.-B. Van Campenhout, and operated under this name from 1 May 1892–10 May 1927. It was located in Brussels on the Chaussée de Wavre until 1906, and thereafter at rue de Conseil 23. From 1927 until 1954, the firm passed to a son who had worked with his father since 1919, taking the name Imprimerie Adolphe Van Campenhout. Finally, from 1954 to 1969 the firm was run by Adolphe's widow as Imprimerie Veuve Adolphe Van Campenhout.

The address on the Chaussée de Wavre was 163, as given on numerous prints published for the Société des Aquafortistes Belges.

44. Van der Perre; Bown-Taevernier, 188.Van der Perre, 26, counts five impressions of prints by Ensor printed on vellum by Evely, and van der Perre notes that Evely often mixed a little bister or red into the black ink, or printed in sanguine or blue. See also Hefting, *Toorop*, n.p.

45. Van der Perre, 27.

46. Bown-Taevernier, 188, letter of 29 October 1931, Ostende Musée des Beaux-Arts; "Je ne sais pas si j'ai numéroté mes eaux-fortes or cela ne veut rien dire à mon avis, d'abord je n'ai pas tiré des tas d'épreuves de mes eaux-fortes, elles sont loin de friser la centaine et cent épreuves ne signifient rien dans le monde, une paille."

47. Roger Cardon, *Georges Lemmen*, 354–355.

48. R. Cardon, 122 n8, for Vve. Monnom, whose maiden name was Sylvie Marie Thérèse Descamps.

49. R. Cardon, 355, citing AAC 47949, February/March 1910; "Pour l'impression tu ne pourrais trouver mieux que Monnom où l'on te permettra d'aller toi-même à l'atelier surveiller le tirage, corriger toi-même les pierres, s'il y a lieu, et conseiller le tireur. Ce dernier, Edmond, est le meilleur imprimeur lithographe que tu puisses trouver en Belgique."

50. Bloy, *Correspondance Bloy et de Groux*, 259–61 (18 July 1896); "J'achève certaines lithographies par lesquelles j'espère faire de l'argent à Paris." De Groux is known to have made some of his pastels in Parisian bars to earn drinking money (this was kindly related to me by Arsène Bonafous-Murat).

51. The Rops issue does include a listing of all his prints, but no values or prices are indicated.

52. Lemmonnier, *Félicien Rops*, 51, as translated in Arwas, "Félicien Rops," 4.

53. Delevoy et al., *Félicien Rops*, 83; "Je crois et je maintiens que la publication soit d'estampes, soit de livres illustrés, est le meilleur moyen pour un jeune artiste de se faire connaître et de gagner de l'argent: le tableau n'est tiré qu'à un exemplaire; le livre."

54. For Lemmen's editions, see endnote 87; for Van Rysselberghes' see endnote 88; for Ensor's see endnote 46. De Groux's editions were usually at least 25.

55. Based in part on the translation by Lesko, *Ensor*, 43, whose source was Juin, *Histoires étranges*, 14. For the original passage see Croquiz, *James Ensor*, 8: "La matière picturale m'inquiète alors (en 1886). Je redoute la fragilité de la peinture, exposée aux méfaits du restaurateur, à l'insuffisance, aux calumnies des reproductions. . . . Je veux survivre, parler longtemps encore aux hommes de demain. Je songe aux cuivres solides, aux encres inaltérables, aux reproductions faciles, aux tirages fidèles et j'adopte l'eau-forte comme moyen d'expression. . . . Ensuite je reprends ma palette avec un bel aplomb et la couleur, fraîche et pure, à nouveau, me domine."

56. R. Cardon, 354, for Lemmen's lack of a press. For Ensor, see endnote 73. Toorop does appear to have owned a lithographic press, see Spaanstra-Polak, *Jan Toorop*, 11; Hefting, 113.

57. Mathey's painting is at the Musée national du Château de Versailles, MV6146.

58. Arwas, *Rops*, 9. Rops used "copper, zinc, steel, various soft metals, glass, and even once engraved on ivory, managing to get two proofs before the plate cracked." For the pedagogical plates see Rouir, *Rops, Les techniques*, 17–18.

59. Reproduced in its entirety and transcribed in Guyaux, "Omnia artistique."

60. Rouir, *Rops, Les techniques*, 19–26. Rouir considers *La Vieille Masken* [cat. 113] to be the first reworked photogravure by Rops. Later in the century, Georges Rouault, working for the publisher Ambroise Vollard, produced an enormous body of etchings that were reworked photogravures of his drawings.

61. Rouir, *Rops, Les techniques*, 19–26; also Rouir, *Rops; catalogue raisonné*.

62. Armand Rassenfosse, in a letter of July 1933 to Louis Lebeer, curator of the printroom at the Royal Library, Brussels, in Brussels, MRBA, *Félicien Rops*, 174–75 (from *Le Livre et l'Estampe* 1 March 1934); "Disons donc bien sincèrement que les procédés que Rops et moi avons essayé de perfectionner (je parle du vernis mou et de l'aquatinte) sont des procédés secondaires et ce qu'il a cherché avec lui et pour contenter le charmeur qu'il était, sont des moyens pratiques de compléter à son gré, dans le genre du crayon, les photogravures qu'il jugeait rendre son dessin imparfaitement et qu'il voulait pouvoir retoucher à sa manière."

"Quand je suis allé le voir pour la première fois en 1886, c'est tout de suite vers la recherche du vernis mou transparent qu'il m' dirgea."

63. Brussels, MRBA, *Félicien Rops*, 174; "C'était l'époque florissant de la bicyclette, on avait toujours sous la main un

64. Delevoy et. al., *Rops*, 229, 236, 239.

65. Arwas, 10.

66. Adeline, *Arts de Reproduction Vulgarisés*, 239–40; "On con-state également qu'il ne restera bientôt plus un seul artiste capable de donner de bonnes estampes au burin, et cela au moment où deviennent de plus en plus nombreux les hommes de métier, aussi adroits à varier les grains d'aquat-inte qu'à manier le roulette et tous les outils du graveur en taille-douce.

Cette corporation nouvelle s'apelle les retoucheurs, et elle forme avec l'heliogravure en creux, qui lui a donné nais-sance et qui la fait vivre, des éléments d'illustration artis-tique en parfait accord avec les conditions de la vie actuelle."

67. Rassenfosse cited in Brussels, MRBA, *Félicien Rops*, 175; "Peut-être serait-ce cependant pousser trop loin le fétichisme que de ne vouloir retrouver dans une photogravure retouchée par l'artiste lui-même, les caractéristiques fondamentales de son art, l'essence de sa personnalité."

68. Gillet "Henry de Groux," 267; "Trois ou quatre pierres litho-graphiques, larges comme des pierres de taille, donnent l'idée d'une oeuvre énorme en construction."

69. De Groux copied Rubens' *Hercules Defeating Hydra* in the form of a lithograph, illustrated in *La Plume*/de Groux issue, 198.

70. Baumann, *Henry de Groux*, 109; "Mais il devait batailler sans cesse contre les imprimeurs qui brûlaient ses pierres avec des acides trop violents et, sous prétexte de rendre plus 'lithographiques' ses dessins, les trahissaient, les défor-maient."

71. Bloy and de Groux, *Correspondance*, 310, 23 December 1896; "Autre chose encore: J'ai l'intention de faire tirer à Paris plusieurs lithographies, mais il faudrait pour cela que je puisse disposer d'une chambre où je puisse les retoucher et, au besoin, faire transporter une pierre.—Je viendrais bien à Montrouge, mais avec des pierres lithographiques pesant 80 Kgs, c'est fort difficile"; 315, 25 December 1896; "Quant aux lithographies. . . . je croyais le Grand-Montrouge plus éloigne de Paris et j'avis lieu de redouter, pour des travaux si délicats et achevés, les dangers et les frais de camionnage, les diffi-cultés dans les transports nécessaires de l'imprimerie à l'ate-lier, quand l'épreuve ne donne pas d'emblée ce qu'on espère."

72. *La Plume*/de Groux issue, 267; "Une vingtaine de toiles en train et des dizaines d'ébauches encombrent les chevalets, pendent aux murs, s'appuient aux tables, dansent dans des cadres trop larges, ou sont inclinées l'une sur l'autre comme des briques."

73. Hoozee et al., *Ensor, Dessins et Estampes*, 188; Ensor claimed in 1907 not to have a press, nor did he own his own plates. His printing was done in Brussels.

74. Getty Center no. 860504, letter of 20 December 1898 from Ensor to Deschamps; Ensor spoke of "une nouvelle eux-forte: L'entrée du Christ à Bruxelles le mardi-gras en 1889." Ensor hoped to include this new work in the special number of *La Plume*, and asked if Deschamps would be patient enough to wait until Ensor had time to proof the print, "je suis aller a Bruxelles me charger des cuivres, assister au tirage, etc. etc."

75. Hoozee et al., *Ensor, Dessins et Estampes*, citing J. Warmoes, "Valère-Gille et la jeune Belgique, autographes provenant de sa bibliothèque," *Le livre et l'estampe* 20 (1974): 202; "Moi je ne connais pas du tout le métier d'aqua-fortiste. Je sais dessiner et graver proprement et après c'est le hasard qui décide. Je ne peux me plier devant toutes les ficelles, trucs et minuties, aussi j'ai abimé de nombreuses planches et me suis crevé les yeux inutilment."

76. Hoozee et al., *Ensor, Dessins et Estampes*, 190, letter (AAC inv 9734) dated 26 September 1904; "Combien je suis heureux du bien que vous pensez de mes eaux-fortes. Je les ai signées et datées pour vous être agréable. En consultant les dates, vous verrez que l'année 1888 a été surtout féconde, heureuse époque de promenades en plein air, agrémentées du delicieux travail de l'aquafortiste. La nature semblait tou-jours belle et bienfaisante."

Although many of Ensor's etchings after this initial peri-od are essentially recapitulations of ideas worked out first as drawings or paintings, Croquiz has pointed out that during the 1880s and the early 1890s Ensor's ideas could find their first expression in any of the media in which he was active, including etching, only to be reworked in other media later in his career; see Croquiz, 17. The examples Croquiz cites in which compositions found their first expression as etchings are: "le *Christ apaisant la tempête*, gravé en 1886, se retrou-ve dans les tableaux, de différentes dimensions, datés de 1890 et 1891. L'*Assassinat*, gravé en 1888, devients peinture en 1891. L'Eau-forte les *Barques échouées*, de 1888, devient en 1900 avec des variantes, une toile très haute en couleurs. On trouve *Les Joueur graves* en 1895 et peints en 1902."

77. Hoozee et al., *Ensor, Dessins et Estampes*, 187; "Il consid-érait ses eaux-fortes comme des compositions à part entière et les exposa, ainsi que ses dessins et ses tableaux, chez Les XX."

78. Chipp, *Theories of Modern Art*, 110.

79. Janssens, *James Ensor*, 38.

80. Ensor, *Mes Ecrits*, 177; "Oui, les corps célestes irradient les paradis des relativité rotariennes, allument le champ clos de notre table où verres, coupes, cristaux, flacons, reflètent les paillettes et les cris de soie et de joie de jeunes étoiles en goguette, où pétards, bougies, fusées incendient nos sens et brûlent l'esprit de nos pensées."

81. Chipp, 112.

82. Lemmen, "James Ensor," 697; "Il y a dans cette nombreuse série de paysages et de marines des pièces d'une délicatesse merveilleuses, et depuis Rembrandt et Whistler, je ne con-nais chez nul artiste pareille aptitude à fixer en quelques traits légers les effets les plus vaporeux ou les plus fluides de l'atmosphère, à dégager des choses le charme poétique." The irony of comparing Ensor with Whistler (whom Ensor had actively kept out of Les XX) was certainly not lost on Lemmen.

83. The exact number of prints exhibited with Les XX is not certain, since the medium of exhibited works is not always indicated in catalogue.

84. Delevoy et. al., *Rops*, 192; Rops is only listed as exhibiting a very few of his etchings (and only those used as frontispieces or book illustrations). Prints were sometimes omitted from the catalogues altogether, as in 1889 when Rops exhibited the series *Les Diaboliques* with Les XX, which is not mentioned in the Les XX exhibition catalogue.

85. Van Rysselberghe exhibited prints in Vienna; see endnote 86. Toorop organized an exhibition in The Hague in 1892 with work by members of Les XX and L'Association pour l'Art (*Haagschen Kunstkring, Tentoonstelling van schilderijen en teekeningen van eenigen uit de "XX" en uit de "Association pour l'Art"*). A letter from Van Rysselberghe to Toorop reveals that Van Rysselberghe and Dario de Regoyos planned to send prints to this exhibition; (AAC 20.701), "J'enverrais volontiers ques eaux fortes—peut être aussi un peu de peinture. . . . Dario m'a remis dernièrement à Paris des eaux fortes pour les faire exposer à la Haye. Est-ce au KunstKring? Si oui je les enverrais en même temps." However, there is no evidence that the prints were actually exhibited at this exhibition.

86. AMVC 149957, 25 January 1899, Van Rysselberghe to Pol de Mont, written from Paris;

 J'eusse aimé y joindre une collection de mes eaux-fortes: mais elles ont été tirées à fort petit nombre et sont épuisées. (L'ultime collection que ce possible est actuellement exposée a Vienne). Pour ce qui est des illustrations je n'en fis guère qu'une fois: pour le livre d'Edmond Picard: "Al mogreb al Aksa"—relations d'un voyage que nous fîmes, en 1887, au Maroc.

 J'ornai parfois de titres, culs de lamps & des volumes edités par le librairie Edm. Deman (notamment la serie des poémes d'Em. Verhaeren, et les "Histoires Souveraines" de villiers, actuellement sous presse.

 L'éditeur Dietrich publia en 1895 un "Almanach" poésies de Verhaeren et dessins de moi.

 Je fais peu d'affiches: celles pour les expositions de la L.E. de 1896 et de 97—et une pour l'encadreur N. Lembrée de Bruxelles. (97)

 A vrai dire, je considère tous ces essais comme de peu d'importance; mon grand souci demeure la peinture à laquelle je consacré dornévant tout mon temps; je continuerai mes essais d'eaux forte parce que ce moyen me seduit beaucoup et qu'il est de mon domaine—

87. Lemmen's editions usually numbered from a few to a few dozen; see R. Cardon 357, and 351–438 passim.

88. AAC 12.010, from a letter of 1904 from Van Rysselberghe to Maus. The letter is worth quoting from extensively:

 Excellente et très maligne, ton idée d'une exposition de l'Estampe en couleurs pour la prochaine LE. Excellente, à condition que tu sois aussi circonspect dans le choix de tes invités que tu l'es généralement. Il ne suffit pas que tu montres des estampes en couleurs—il les faut d'autant plus choisies que très souvent cet art se mercantilise et que presque tous les peintres, bons et mauvais, ont taté, au moins une fois en leur vie, de ce genre. Et très peu ont fait de l'estampe vraiment intéressante et originale.

 Je ne connais pas la constitution de la Sté. française des graveurs en couleurs; il doit y avoir pourtant du

déchet Müller a fait des planches pas mal du tout—et Vuillard, Denis, Bonnard & Co ont fait jadis de très jolies, pour Vollard, qui les édita (je te cite ces noms, au hasard, puisque tu m'en demandes)—Nicholson, mais je crois foutre bien qu'il faut l'inviter!

 En Belgique . . . Evenepoel . . . et Meunier ont fait de l'affiche, pas mal, et Lynen qques illustrations de livres; je ne connais rien — que de très nul — des autres (en tant qu'estampe en couleurs). Ce sera du reste là où il faudra que tu fasses attention: de séparer ce qui est de l'estampe d'art — disons de portefeuille (quoique le classement soit idiot) — de ce qui en est industriel ou simplement coco, ou mauvais. Bref, en triant avec grand soin, tu trouveras certainement à réunir une collection d'estampes en couleurs tout ce qu'il y a de plus intéressant; ne te dissimule pas que cela te donnera autant (si pas plus) de mal que de sélectionner des invités peintres ou autres "plastiques"—mais ce sera un excellent biais, pour éviter les chichis bêtes, et cel ne ruinera pas a qui fut la caisse de la LE (ce qui est à considérer).

 Moi, non, je n'ai jamais fait d'estampe en couleurs; je ne compte pas comme telle le peu de rouge que mon imprimeur a frotté sur le veston du Petit vieux déambulant—dans l'eau forte que tu connais. Cross, Luce et Signac en firent jadis pour l'éditeur Pellet (actuellement rue le Peletier). en Allemagne, je ne connais personne—van de Velde pourrait te tuyauter? Khnopff doit, En effet savoir qui tu pourais prendre pour l'Autriche. En Angleterre, Shannon, sûrement. Lucien Pissarro (bois et lithos) et d'autres que j'ignore, mais qui sont, certainement.

 Enfin, tu en sauras plus long que moi en te remuant si pue que ce soit.

 Sais tu que Degroux a été retrouvé par mourey, à Marseille? Parfaitement sain de corps et . . . d'esprit, prétend-on. Pauvre diable!

89. Only rarely is there evidence of private collectors around 1900 framing their prints. In an anonymous article, "Conservation des Estampes," *La Revue Graphique Belge* 6 no. 6 (March 1903): 62–63, there is a suggestion that more valuable prints (presumably "Old Master" prints) be equipped with "frames with shutters like old triptychs," to protect them from the light; "On pourrait construire, pour les estampes de haut prix, des cadres à vantaux, dans le genre des anciens triptychs."

90. The portfolio contains a series of etchings by the author's brother, Jules de Goncourt.

91. Illustrated in Paris, Musée d'Orsay, 47.

92. Huysmans, *Against the Grain*, 95–96.

93. Huysmans, 96; for Des Esseintes taste for rare and specially commissioned papers see 132.

94. The portfolios included: De Groux, "Les Vendanges" (incomplete, see cat. 9); Van Rysselberghe, "Eaux-Fortes de Théo Van Rysselberghe, Bruxelles, 1894" (Van Rysselberghe considered issuing a second portfolio in 1900 with work done subsequent to his 1894 portfolio, see endnote 32); Dario de Regoyos (two series, titles and dates uncertain); Finch, "Det Gamla Borga etsningar af A-W-Finch tryckt a Aktiebolaget-F. Tilgmanns bok=oth stentryckeri samt kemgrafi" published in December 1902, Finch, "Eaux-Fortes par A.W. Finch—Bruxelles Dietrich & Cie." published in 1892 or 1893, (Finch seems to have

issued a second series from Finland, "Helsingfors," in 1906, see R. Cardon, 355); Karl Meunier after Constantin Meunier, "Au Pays Noir," c.1896; Ensor, "Douze eaux-fortes," 1896. For the latter portfolio and a listing of Ensor's prints that appeared in albums, books, and periodicals, see Tricot, *Ensoriana*, 38–48. De Groux, Meunier, Rops, and Van Rysselberghe contributed to various print portfolios, such as *L'estampe originale*, *Les temps nouveaux*, *Germinal*, and *L'Epreuve*.

95. The author has seen numerous dedicated prints by de Groux, Ensor, Khnopff, Rops, Van Rysselberghe, and Lemmen.

96. For Ensor and Finch see end note 97. For de Groux's lithographs see *BB* 22 no. 22 (1896): 412 (*Les Hiboux*), 24 nos. 16–18 (1898): 509–10 (*Charles Baudelaire, Emile Zola*), 24 no. 14–15 (1898): 271 (*Le Christ aux outrages*); and for a photographic reproduction after de Groux, see 15 no. 12 (1889): 390 (*Procession de la fête patronale des archers à Machelen*). Works by Rassenfosse, Rops and Mellery also appear in the *BB*. For Khnopff, see cat. 60.

97. Hoozee et al., *Ensor, Dessins et Estampes*, 12. In 1892 Dietrich published portfolios of etchings by Ensor and Finch, *BB* 8 no. 7 (1892): 195. Ensor's *Les Sacripants* and *Les Lutteurs* were published by Dietrich in 1897, *BB* 23 no. 15–16 (1897): 291, as was *Hop Frog* in 1898, *BB* 24 no. 9 (1898): 158.

98. These are listed in an eight-page advertising section at the end of Destrée, *Préraphaélites*. I thank Fabrice van de Kerckhove for bringing this to my attention.

99. *AM* 13 no. 11 (12 March 1893): 87. I thank Maurice Tzwern for bringing this to my attention.

100. For Buschmann, see Antwerp, Museum Plantin-Moretus, J.E. Buschmann. The firm published van de Velde's beautiful 1893 poster for the Association pour l'Art and other posters for artists' groups, periodicals, and exhibitions; see Antwerp, Hessenhuis, *Culturele Affiches te Antwerpen*, nos. 7, 21, 27, 54, and 60, to mention only those prior to 1900.

101. R. Cardon, 355; whose source was the testimony of a descendent of the Van Campenhout family.

102. *La Plume*/Ensor issue, 675.

103. AAC 3.862, letter from Van Rysselberghe in Heyst to Boch in Morêt, 11 October 1887; "quand tu iras à Paris, vas un peu voir chez le petit kimoura (de chez Wakai) s'il n'a rien de neuf, et dis lui s.t.p. de ma part que je lui prie de ne pas m'oublier quand il recevra du neuf—Il peut m'envoyer un paquet de planches—je lui renverrai celles que je ne prends pas—et le montant de l'emplette."

104. I thank Gabriel Weisberg for providing information on the firm of Wakai Kenzaburo.

105. R. Cardon, 105–106 n15; a list of early exhibitions of Japanese prints in Belgium is given. The first Cardon cites is the 1889 Exposition de peinture et d'estampe japonaises at the Cercle artistique et littéraire in Brussels, where 108 prints were shown. Cardon also discusses the role of the musician Edmond Michotte in propagating interest in Japanese prints in Belgium.

106. For Van Cutsem see Pion, "Cutsem." Van Cutsem appointed Victor Horta to build the museum to house his collection in

Tournai. His collection includes the drawing by Chartier for the 1888 Les XX catalogue and a *Liber Amicorum* with contributions by many artists. The inventory of the Dohmen collection is housed at the Getty Center (890081), among the over 100 prints by old and modern masters are many by members of Belgian etching societies (Nunans, Rops, Baes, Rassenfosse, Danse, Linnig, den Duyts, Maréchal).

107. Brussels, Galerie d'Exposition, *Une Maison d'Art*, 2; "Et ce musée, et cette maison garnis de choses modernes, intimes et proches comme tout ce qui éclot sous nos yeux avec des murmures et des bruissements qui tintent à nos oreilles. Les livres, les tableaux, les sculptures, les bibelots, les estampes, les étoffes, les ustensiles [sic] ici appendus aux murs, là sur des chevalets, des étagères, des tables, des buffets, des crédences, à portée de la main, à portée du regard, se livrant au toucher, maniés et admirés en une caresse aussi libre que celle du propriétaire, anticipant sur l'achat par l'essai et chassant à l'avance toute déception par l'objet vu et savouré sous la lumière où il baignera dans notre propre intérieur." See Block, "La Maison d'Art."

108. Brussels, Galerie d'Exposition, "A la Toison d'Or," 5; "La Maison d'Art n'est pas ouverte au public. Elle est une maison fermée."

109. R. Cardon, 40–41, for La Maison d'Art.

110. E. Herbert, *Artist and Social Reform*, 158.

111. La Maison d'Art sponsored an exhibition of Belgian and French posters in 1896 (May 14–June 2), see Block, "La Maison d'Art," 58.

112. Breuer, *Nos contemporains*, 259–61.

113. *Conférence du jeune Barreau de Bruxelles*. The section "Souvenirs de banquets professionnels" includes (item 313); "Epreuve sur Japon, grandes marges, avant la lettre, du menu dessiné par M. Théo Van Rysselberghe pour le banquet de la Conférence du jeune Barreau (1890)." At the turn of the century Gisbert Combaz designed posters for both the Brussels and Antwerp bar, see Block, in Block and Hansen, *The Art of Belgian Posters*, cat. 16.

114. I thank Jane Block for confirming that this title page is by Van Rysselberghe; see *Le Palais*, 156.

115. I thank Sura Levine for confirming that "G-S Van Strydonck" is Guillaume Van Strydonck, whose middle name was Séraphim.

116. *Conférence du Jeune Barreau, Fête Jubilaire*, 11.

117. *Exposition du Souvenir; Conférence de jeune barreau d'anvers*, 1904; *Conférence de jeune barreau d'anver*, 1911. In 1900 the group sponsored an exhibition of Ex-libris (bookplates). Although the 1893 exhibition had very little to do with the arts, the 1904 exhibition included works by Ensor (nos. 396–402), Laermans (no. 725), and Rops (nos. 923–925). The 1911 exhibition included works by Khnopff (no. 760), Ensor (nos. 828–833), and an extensive section of Folk Art (nos. 944–993), probably due to the influence of Max Elskamp, member of the Antwerp bar.

118. Maeterlinck, "Me Albert Maeterlinck," 77–78. The flavor of the letter can be gleaned form the last few lines:

 Il fut sécretaire de l'Association libérale. Il est l'un des piliers de la Revue de Droit maritime d'Autran. Il est docteur en philosophie. Il a défendu Whistler.

 Dites-moi à votre tour si Albert aime les jeunes de votre Barreau. Ils sont actifs, chercheurs, ils aiment la profession . . . et ils sont de ceux qui regardent du côté du soleil!

 Il n'arrive peut-être pas d'évenements inutiles. Telle, cette lettre, cette lettre, cette lettre

 Oh! Oh!

 Votre
 Maurice Maeterlinck

119. Brussels, Gallery Le Roy, *Collection de Edmond Picard*. Henry de Groux was represented by two paintings.

120. *AM* 9 no. 8 (24 February 1889): 57; "Il faut se rabattre sur certaines eaux-fortes de M. James Ensor pour découvrir l'artiste vraie qu'il est."

121. De Mont, "Graphischen Künste."

122. See note 88. Van Rysselberghe's uneasiness about color lithography is revealed in a letter to André Marty in which he speaks of his plans to make a color lithograph, and hopes, while travelling to London to get some good council on technique from Lautrec; Getty Center no. 870525, photocopy.

123. It may be that the directorship of Les XX, faced with the task of maintaining some modicum of respectability in order to guarantee an annual exhibition space in the Palais des beaux-arts [Musée Ancien] or the Musée Moderne (after 1887), had little patience for the tougher images produced by the group, such as the unabridged etchings of Ensor and Rops.

124. "Je vois en flamand et j'écris en français," writing to Albert Mockel; see Davignon, *L'Amitié de Max Elskamp et d'Albert Mockel*, 15. Elskamp went on to write, "J'ai bien souvent pensé à cela et je crois que si j'avias pu écrire en flamand, j'aurais trouvé la vraie 'formulation' (c'est danois mais exact) de ma pensée."

125. See, for example, E. Herbert; R. Cardon, 21–47.

Book Design among the Vingtistes: The Work of Lemmen, van de Velde and Van Rysselberghe at the Fin-de-siècle

by Jane Block

AN artistic revolution redefined the boundaries of the visual arts during the last decades of the nineteenth century. Artists marching to the banners of socialism and the English Arts and Crafts Movement, or reacting to the perceived failures of the Industrial Revolution turned their attention to every aspect of human invention. Students of painting and sculpture began to design a range of decorative objects, including rugs, silverware and jardinières. With this expanded interest in the design of everyday articles came a transformation in book design.

The aesthetic movement of the 1880s produced the first major visual change in book design. James McNeill Whistler (American, 1834–1903) began to design his own books and catalogues in 1878, in reaction to the excesses of book production of the previous decade. He shunned the overloaded decoration and eclectic mix of typefaces common in book design and his work was characterized by an overall simplicity and unified appearance, a restrained use of ornament, wide margins, and asymmetrical title pages.

Since his books were printed commercially, Whistler was less interested in the manner of their production. It was left to William Morris (English, 1834–1896) to create the fine-art book and the corresponding private press to produce it. Rebelling against shoddy, mass-produced work, Morris denounced the inferior state of book design typified by mechanical production and an overall disregard for appropriate typeface, ornament, paper, and bindings. He took matters into his own hands by designing three typefaces, creating woodcut decorations, and, in 1891, establishing the Kelmscott Press.

Inspired by Morris, artists and publishers in Europe and America attempted similar experiments in reforming the book arts. Three Belgian publishers were

particularly receptive to the renewed interest in book design: Paul Lacomblez (born 1855), Edmond Deman (1857–1918), and Sylvie Monnom (1836–1921).[1] This receptivity was not expressed in imitating Morris, but in reforming the art of the book on their own terms. Unlike Morris, these publishers did not make their book papers by hand or commission new typefaces, and their decorations were rarely printed from wooden blocks. (Lemmen, the only new Belgian face of this period, was designed for a German publisher and cut in Germany.) Instead, they worked within established means to elevate the standards of commercial printing.

The new interest in book production in Belgium coincided with a resurgence of prominent national writers. As an article in *L'Art moderne* (*Modern Art*) poetically observed about this burgeoning trend, "a great and magnificent flowering has burst forth. One has only to extend a hand to pick a delicate rose, perfumed jasmines, or rougher and more powerful blossoms."[2] Lacomblez, Deman and Monnom were responsible for publishing much of the new Belgian literature of the time, including significant works by Jules Destrée, Georges Eekhoud, Max Elskamp, Iwan Gilkin, Charles Van Lerberghe, Maurice Maeterlinck, Edmond Picard, and Emile Verhaeren.[3] So fervent was Paul Lacomblez's effort in this literary and artistic renaissance that he sought the assistance of the Mayor of Brussels, Charles Buls. Lacomblez suggested to Buls that the State consider subscribing to literary publications, arguing that even "an insignificant outlay" would be invaluable for both publisher and author and would benefit "the national patrimony."[4]

With this literary awakening came a Belgian renaissance in the visual arts, supported by a proliferation of new journals and exhibition societies whose

shared goal was to set before their audiences the most challenging international artistic endeavors. Three periodicals—*La Jeune Belgique*, *La Wallonie*, and *L'Art moderne*—recorded the key cultural events within Belgium and informed their public of progressive developments abroad. Foreign periodicals available in Belgium, such as *The Hobby Horse*, *The Studio*, *L'Art décoratif*, and *Dekorative Kunst*, featured columns on international exhibitions, decorative arts, book design and graphics.

The dynamic exhibition societies Les XX (1884–1893) and its successor La Libre Esthétique (1894–1914) not only were responsible for exhibiting local avant-gardistes, but introduced into Belgium the leading foreign artists, writers, and composers of the day.[5] In addition to exhibiting work by an international array of Impressionists, Neo-Impressionists and Symbolists, Les XX imported the works of many graphic artists, including Jules Chéret, Henri de Toulouse-Lautrec, Walter Crane, Selwyn Image and Edward Horne. Many Vingtistes regularly traveled to London and Paris to keep abreast of the latest currents in the arts.

Several prominent figures in this Belgian renaissance wrote for foreign journals. Octave Maus, the secretary of Les XX, contributed to the French periodicals *La Cravache*, *La Plume*, *Art et Décoration*, and *La Revue Indépendante*. Vingtiste Fernand Khnopff was the Belgian correspondent for the prestigious *The Studio* in Britain. Conversely, French art critic Félix Fénéon and poet Gustave Kahn were frequent contributors to the Belgian *L'Art moderne*. *La Wallonie*, founded in Liège, Belgium, in 1886, was a true collaborative effort between the French and Belgian Symbolists. They published the works of both the great Belgian authors Emile Verhaeren, Georges Rodenbach and Maurice Maeterlinck, and renowned French writers Francis Viélé-Griffin, Stéphane Mallarmé and André Gide.

An international artistic platform was disseminated that included not only the traditional beaux-arts categories of painting, sculpture and architecture, but expanded the realm of the artist to include the decorative arts. The former distinction between artist and craftsman was eradicated. Household objects—rugs, china, table settings, light fixtures, even locks and keys—became objects worthy of the artist's scrutiny. In this milieu of an overall desire to design every aspect of daily life, graphic arts and book design flourished in Brussels.

The arena in which *les apporteurs de neuf* [bearers of the new], as *L'Art moderne* called the Vingtistes, could test their mettle was the exhibition forums of

Les XX and La Libre Esthétique. From its inception Les XX produced a well-designed annual exhibition catalogue. The group's logo, designed by Fernand Khnopff, was emblazoned on each of its catalogues and paper and inks were of more than ordinary quality. The generous margins and avoidance of clutter reflected the chief concerns of book designers of the English Aesthetic Movement. Vingtistes followed artistic events in England through their *invités*, including James McNeill Whistler, and fellow members Alfred William (Willy) Finch, a devoted Whistlerian, and Georges Lemmen, who was particularly drawn to the work of Walter Crane.[6]

Book design was of growing interest at Les XX by the late 1880s. For the 1888 catalogue, each artist created his or her own page of entries, which was reproduced and printed from photomechanical plates [cat. 1, 50, 91 and fig. c]. Although the experiment was not repeated, it suggests the extent to which the group and its leader, Octave Maus, were dissatisfied with contemporary typography and wished to expand the range of printing possibilities.

In the 1890s the catalogue designs achieved international significance when Georges Lemmen created the 1891, 1892, and 1893 Les XX covers [cat. 68, 69 and 70]. Maus rightly understood their significance; in June 1896 he sent the catalogues to an exhibition on the modern book at l'Art Nouveau, Siegfried Bing's gallery in Paris.[7] This interest in design continued with the La Libre Esthétique catalogues, for which Théo van Rysselberghe's cyclamen design became the standard decoration.

Both Les XX and La Libre Esthétique courted book designers as *invités*. In 1891 more than a dozen of Walter Crane's *Picture Books*, lent from Lemmen's personal collection, were displayed. This was followed in subsequent years by entries from Herbert Horne, William Morris, Lucien Pissarro, and T. J. Cobden-Sanderson. Also exhibited were group showings by the Société Danoise du Livre [Danish Book Society]; the latest titles from the "Librairie d'Art" of Dietrich & Company, the premier art bookstore in Brussels; and contemporary foreign graphics, including the first issues of the journals *Die Jugend*, *The Pageant*, and *Ver Sacrum*. A 1894 review in *L'Art moderne* remarked that La Libre Esthétique "exhibits some of the most characteristic and most original productions of the modern book trade."[8]

The printing houses of Lacomblez, Deman and the *Veuve* (Widow) Monnom selected artists who were members of the Belgian avant-garde. Unlike Edward Burne-Jones and William Morris, the principal designers for Morris's Kelmscott Press, these artists did not turn

to the Middle Ages or the Renaissance for visual inspiration. The three artists who were most strongly allied to these three distinguished Belgian printing houses were important artists of Les XX: Georges Lemmen, Henry van de Velde and Théo Van Rysselberghe.

These men began their respective careers not as graphic artists, but as landscape and portrait painters. As members of Les XX, they had been mesmerized by Seurat's canvases when they were shown in Brussels and they, in turn, painted powerful pointillist canvases of their own. At the same time, each was drawn to the English Arts and Crafts movement and to creating decorative objects. Each of the three Belgians had a serious and long career as a book illustrator. The names of Lemmen, van de Velde and Van Rysselberghe were soon linked in the minds of critics throughout England and the Continent as exemplars of modern book-art production.9

Lemmen's first attempts at book design, though expressive, only foreshadowed his later importance. At the 1889 Les XX exhibition he showed a drawing for the cover of Georges Eekhoud's *La Nouvelle Carthage* (*The New Carthage*), depicting the port of Antwerp [fig. 33]. According to Lemmen, the image was not a literal depiction, but was meant to convey the atmosphere of the port. The sans serif lettering boldly proclaims the title and author. This drawing had not been commissioned for the book; Lemmen explained to Eekhoud his hope that this drawing could be used for a new, second edition of the novel, but it was never used.10

Two years later, in 1891, Lemmen designed the masthead for the tenth anniversary issue of the weekly periodical, *L'Art moderne* [fig. 34]. The symbolic image depicts a thorny, rocky road where a naked figure attempts to harvest a crop: the seeds of progress are being planted wherever *L'Art moderne* spreads its gospel. Here, against all odds, the arts will prosper under its fortifying and nurturing influence. By this time Lemmen was studying seriously the work of A.H. Mackmurdo, Selwyn Image, and Walter Crane. The image reflects Lemmen's interest in English art, to be sure, but more directly responds to the work of Vingtiste George Minne, whose expressive illustrations for Maurice Maeterlinck's *Serres chaudes* had appeared in 1889 [cat. 102].11 For the cover, Lemmen has taken Minne's vanquished figure, crawling along the earth without the will to harvest, and has rendered it vigorous, nearly robust. The central motif of the life-giving power of the sun further suggests the force and power of the new art championed by *L'Art moderne*. The letter forms seem experimental, as if Lemmen were groping for a new, energized, expressive vocabulary.

With his next projects, Lemmen suddenly stood at the forefront of European graphic design. For the covers for the 1891 and 1892 Les XX exhibition catalogues [cat. 68 and 69], Lemmen began with his favored English images, including the motifs of suns, tree, and spear from Selwyn Image's *Hobby Horse* graphics of 1886 [figs. 35 and 36]. These he melded with both the abstraction he had learned from Seurat and the vegetal forms with which several Brussels architects were experimenting, to create something

FIGURE 33. Georges Lemmen, cover for Georges Eekhoud's *La Nouvelle Carthage* (*The New Carthage*), conte crayon and chalk, 1889. © Bibliothèque Royale Albert Ier.

FIGURE 34. Georges Lemmen, masthead for *L'Art moderne*, Jan. 4, 1891. Photomechanical reproduction. © Bibliothèque Royale Albert Ier.

VOLUME I.

1886.

FIGURE 35. Selwyn Image, cover for *The Hobby Horse*, photomechanical reproduction, 1886. University of Illinois at Urbana/Champaign, Rare Book and Special Collections.

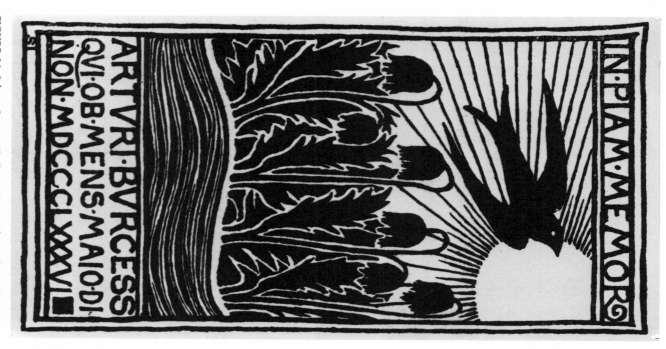

mermaid, the band of dolphins is nothing more than a pattern of repetitive dots and swirls [fig. 38].[12] The snails on the vase's mouth are presented alternately as light and dark forms. Although Crane did not develop this further into an abstract decorative style, such designs clearly comprise a prescient basis for Lemmen's art nouveau forms.

In 1892, Henry van de Velde produced his first book design, a woodcut for the cover of *Dominical* [cat. 134], written by his childhood friend Max Elskamp (1862–1931). Van de Velde was surely influenced by Minne's illustrations—whether woodcuts or not—for Maeterlinck's *Serres chaudes*, as well as by Lemmen's photomechanical relief for the masthead of *L'Art moderne* [fig. 34]. But Lemmen's 1891 Les XX cover stands as the direct prototype for

FIGURE 37. Georges Lemmen, cover for H. Carton de Wiart's *Contes hétéroclites* (*Anomalous Tales*) photomechanical reproduction, 1892. © Bibliothèque Royale Albert 1er.

entirely new. A new forceful line—explosive, swirling, and telegraphic—delivers Lemmen's message that Les XX will be the life-giving power of the artistic scene in Belgium. Lemmen's cover for Henry Carton de Wiart's (1869–1951) *Contes hétéroclites* (*Anomalous Tales*, fig. 37) shows his continued use of this fluid line, soon to be labeled "art nouveau." The thick lettering of the title is enmeshed in bulging and swaying vegetation.

Of seminal importance to Lemmen's mature style was the work of Walter Crane. On a vase by Walter Crane of 1888–89, although we can clearly decipher a

FIGURE 36. Selwyn Image, "*In Piam Memor*" from *The Hobby Horse,* photomechanical reproduction, 1886. University of Illinois at Urbana/Champaign, Rare Book and Special Collections.

FIGURE 39. Max Elskamp, letter to Henry van de Velde, bound in with *Dominical*. © Bibliothèque Royale Albert 1er, Reserve Précieuse.

FIGURE 38. Walter Crane, Mermaid Vase, ceramic, 1888. Victoria & Albert Museum.

Dominical. Although based upon nature—we can decipher the sun, sea and sand—it reveals van de Velde's drive toward developing an ornamentation free of representation.

The design of *Dominical* was very much the product of its author, Max Elskamp. In an undated letter of 1892 to van de Velde, Elskamp explained that he wanted *Dominical* to resemble Albert Mockel's *Chantefable un peu naïve* (*A Somewhat Innocent Ballad*), published in 1891 in Liège. He also asked for an illustration that was taller than it was wide, but finally accepted his collaborator's now famous image. Elskamp further indicated that the title page would read "*propitiatoirement orné* (harmoniously decorated)" as opposed to "*avec vignette* (with vignette)," which he claimed was a wornout phrase [fig. 39].[13] Writing to Elskamp, Lemmen applauded van de Velde's "*très beau dessin* (very beautiful drawing)" for *Dominical*.[14]

Van de Velde's next book design, for *Salutations dont d'angéliques* (*Salutations, Some Angelic*, cat. 136), also by Elskamp, was even more abstract and lyrical than *Dominical*. Again, van de Velde was only responsible for the cover illustration and design; Elskamp and the printer, J.E. Buschmann, chose the layout and design of the entire book. The eager artist sent an unsolicited drawing to accompany the poem "*Tour d'ivoire*" ("The Ivory Tower"), but it reached Elskamp after the printing was completed. Elskamp graciously suggested that van de Velde supply a colored cover for *Salutations* "since you really want to."[15]

Although Van Rysselberghe was the first of the three artists to become involved with book illustration, his style did not mature until 1893, several years after Lemmen's and van de Velde's. In 1884, at age twenty-two, he contributed a frontispiece to *Contes de minuit* (*Midnight Tales*, cat. 144), by his friend Emile Verhaeren. Van Rysselberghe rather literally translated a passage from the tale in which the hero, Ernest Vinckx, returns home to find that panels in his parlor, based on Teniers' *Kermesse*, have come to life. In the illustration, the giant nudes literally drip their flesh onto the book and furniture in sympathetic response to Vinckx's newly acquired Gothic painting of the Crucifixion. Similarly, Van Rysselberghe's drawings from 1889 for Edmond Picard's *El Moghreb-Al-Aska* are illustrations in a literal sense. They record Picard's travels in the company of the Belgian minister to Tangiers to visit the Sultan of Morocco.[16]

103

By 1891 Van Rysselberghe's style had changed dramatically with his ornamentation of Pierre Olin's *Les Légendes puériles* (*Puerile Legends*).[17] The vignettes that accompany each poem are interwoven with the hand-drawn titles and gracefully melded to the set type. This integration of image with title stands symbolically for the more complete commitment of the artist to the text. For instance, the poem title "*au bord de la mer*" ("The Seaside") pluckily rides the crest of the wave [fig.40]. The placement of the letters themselves give a sense of movement, while the seafoam forms a delicate border framing the title.

Within two years Van Rysselberghe had found his own "modern" idiom for book ornamentation with Verhaeren's *Les Campagnes hallucinées* ("Hallucinated Countrysides," fig. 41). Printed by Edmond Deman, it heralded a close association between design-er, author and publisher. This led to Van Rysselberghe producing the decorations for fourteen books by Verhaeren between 1893 and 1911.[18] *Les Campagnes hallucinées* of 1893, the first in a trilogy, was followed

in 1895 by *Les Villes tentaculaires* ("Tentacled Cities," i.e. urban sprawl, fig. 42) and in 1898 by *Les Aubes* ("Dawns," fig. 43). On each of the covers the central decoration is framed by a rectangular border. The most restrained is the earliest, in which a bat flies beneath van Rysselberghe's calligraphic lettering. In *Les Villes tentaculaires*, the "tentacles" of the modern city are expressed in organic, swirling forms that become the tentacles of a nautilus, menacing both the viewer and the book's cover. In the final volume, *Les Aubes*, the old order is destroyed. The smoke from the fire of this destruction rises and curls over the frame's edge; the orange sun and lettering of the new order are superimposed over the flames.

Concurrent with Belgian architect Victor Horta's creation of a new style of architecture in the land-mark Tassel House, Lemmen, van de Velde and Van Rysselberghe had forged a new Belgian style in the graphic arts. In 1892 van de Velde was offered a pro-ject that brought the three of them together as collab-orators for the Flemish journal *Van Nu en Straks*

au bord de la Mer

*Deux tout petits en-
fants jouaient sur la
plage, au bas des du-
nes solitaires, bien loin, bien loin…
Ils jouaient & pour ne pas gâter leurs beaux habits*

(*From Now On*). Van de Velde was approached by August Vermeylen at the 1892 Les XX exhibition to help produce a journal that would be dedicated to Flemish poets and artists, after the model of such journals as *The Hobby Horse* [fig. 44].[19] Van de Velde was to be in charge of the review's layout and ornamentation and was given free rein to commission artists. He chose Belgians James Ensor, George Minne, Georges Morren, Georges Lemmen, Théo Van Rysselberghe, Xavier Mellery and Willy Finch; Dutchmen Thorn Prikker and Jan Toorop; Englishman Charles Ricketts; and Lucien Pissarro, a Frenchman living in England.

The cover designed by van de Velde for *Van Nu en Straks* [cat. 138] is very similar to *Salutations*. Indeed, van de Velde probably worked on them at the same time; the first issue of the periodical appeared in April 1893 and *Salutations* was published the following month. Lettering and image are here more closely

FIGURE 41. Théo Van Rysselberghe, cover for Emile Verhaeren's *Les Campagnes hallucinées*, photomechanical reproduction, 1893. ©Bibliothèque Royale Albert 1er.

FIGURE 42. Théo Van Rysselberghe, cover for Emile Verhaeren's *Les Villes tentaculaires*, photomechanical reproduction, 1895. © Bibliothèque Royale Albert 1er.

related than they appeared in *Dominical*. The words "Van" and "Nu" begin to spill out over the frame and onto the page, much as Van Rysselberghe's lettering and image for *Les Villes tentaculaires* would do several years later. Virtually divorced from representation, except for the sun in the upper right-hand corner, the image embodies the vigor and force of the avant-garde artists and writers that the journal represented.

Van de Velde and Vermeylen also looked to England for visual inspiration. *Van Nu en Straks* employs wide margins, headpieces and tailpieces, a legibility of text, and full-page illustrations that recall *The Hobby Horse*. Van de Velde later recounted the excitement he felt when Vermeylen unveiled William Blake's *Book of Los* and proclaimed it the best example of English typography.[20]

English precedent was also uppermost in the minds of Lemmen and Van Rysselberghe when they contributed to *Van Nu en Straks*.[21] A comparison of headpieces drawn by the three reveals their different approaches to ornamentation. Van Rysselberghe's design [fig. 45], which accompanies the poem "*Van*

FIGURE 43. Théo van Rysselberghe, cover for Emile Verhaeren's *Les Aubes*, photomechanical reproduction, 1898. © Bibliothèque Royale Albert 1er.

Hoogmoed" ("About Pride") by Prosper Van Langendonck, repeats the rectangular frame of van de Velde's cover. Yet Van Rysselberghe's image is contained within the boundaries of the frame and the lettering is relaxed and graceful. On the other hand, van de Velde's headpiece, for the article "*Rythmus*" ("Rythm") by Alfred Hegenscheidt, is a pictorial equivalent of its title [fig. 46]. The repetition of three abstract shapes within a rectangular box sets up a steady pattern that pulsates within the confines of its boundaries. Once again, comparison with the *Hobby Horse* is revealing [fig. 47]. Here Mackmurdo's vignette, although retaining ties with the naturalistic world, is composed of abstracted floral motifs. Lemmen set his headpiece, "*De Kunst in de vrije Gemeenschap*" ("Art in Free Community," fig. 48), free from any rectangular boundary; its distinctly floral form slowly uncoils across the top of the page. Lemmen's design is robust and relies on a remembered representation, whereas van de Velde uses aggressively abstract form to convey meaning. Van Rysselberghe's images typically are more elegant and lyrical than the other two.

Each of the three Belgians continued to develop their personal styles. Lemmen's work progressed in two separate ways: in an abstracted, calligraphic manner and as a combination of naturalistic forms and botanical ornament. In 1893, he created a new cover for the periodical *L'Art moderne* in the former style [cat. 71]. He presented text and image as equally important, entwining the title in the floral motifs and integrating it into the composition. Although the fluidity of the freely-drawn lettering suggests that Lemmen wished to create new letter forms, his

F RESTRAINING SELF-DENIAL IN ART.

The Dorian flutes, heard through the mysterious defiles of Olympos, haunted by the legends of the Vision of God, taught their hearers, in those ancient, genuine strains of Hellas, this truth above all others that there is no Art but the Art of Life. For the Dorian flute itself was a striking product of the instinct of this unique people, themselves the ground-spring of Culture to Greece and to the world, which taught them to seek after an advance in Culture in the security of a patient reserve. For the severity of the three-stringed Lyre having yielded, by pressure of irresistible melody, to the seven-stringed lute, the ceaseless watchfulness of the guardians of the State decided that the dividing line was reached, and he who lasciviously introduced and played upon a lute with nine or fourteen strings, was incontinently and solemnly put to death, as one who would delude and draw away the people from the life of measured and ideal Art; and, somewhere about this time, these same severe guardians admitted, doubtless after much and weighty thought, the most startling innovation of flute music, and by this wise concession attained, in conjunction with the seven-stringed lute, to the most perfect music that the world, pending the discovery of the Violin—the vibration of string with string—was to know and hear.

This, the first music of Culture—the Dorian Harmony—was distinguished throughout the ancient world as possessing an unique, high-sounding and solemn strain, befitting a people who saw life as a whole, and allowed no one Art to absorb or to deteriorate the rest of life.

"Give us that which is good and beautiful" was the Dorian's prayer: and He, who, through all the changes of the world's story, left Himself not without a witness, taught them, amid the myrtle dingles and the many-sided, oak-covered slopes of the great hills, by the worship of Ἀπέλλων[1]—the averter and defender, the son of God who slew the Python—born of the slime and filth of earth—and descended into Hell that he might redeem and restore all men to a life

3

[1] Ἀπέλλων, not Ἀπόλλων, appears to have been the ancient Doric-Æolian form.—C. O. Müller. Dorians, p. 323, ed. 1830.

FIGURE 44. Herbert Horne, initial letter from the *Hobby Horse*, photomechanical reproduction, 1888. University of Illinois at Urbana/Champaign, Rare Book and Special Collections.

FIGURE 45. Théo Van Rysselberghe, headpiece for *Van Nu en Straks*, photomechanical reproduction, 1893. Private collection.

FIGURE 48. Georges Lemmen, headpiece for "De Kunst in de vrije Gemeenschap" in Van Nu en Straks (first series no. 8-10), photomechanical reproduction, 1894. Private collection.

FIGURE 47. A.H. Mackmurdo, headpiece for "On the Representation of the Nude" in The Hobby Horse, vol. 1, photomechanical reproduction, 1886. University of Illinois at Urbana/Champaign, Rare Book and Special Collections.

FIGURE 46. Henry van de Velde, headpiece for "Rythmus" in Van Nu en Straks (first series no. 8-10), relief print, 1894. Private collection.

thoughts clearly had not turned to composing a consistent alphabet that could be cast in type and used in subsequent projects.

One year later, for the periodical *Le Réveil* (1892–1896), Lemmen designed a cover in his second manner, showing a nude in a landscape [fig. 49]. Both this cover and that of *L'Art moderne* are framed by decorative motifs that separate and accentuate the central image. The nude, whose long tresses end in waves, is anchored by a tree trunk (recalling the 1892 Les XX catalogue), while the sun, visible at the right, recreates Lemmen's cover for the 1891 exhibition. An unpublished preparatory drawing, dated 20 December 1893, shows the artist's initial concept [fig. 50]. The waterfall was a later addition, as was the central, monumental placement of the nude. The entire format was changed from a horizontal to a vertical configuration to conform to the magazine's dimensions.

Van Rysselberghe's most complete foray into book design was in 1895 for *Almanach*, a calendar book with

poems by Verhaeren [cat. 149 and 150]. Van Rysselberghe supplied initial letters, headpieces and tailpieces for each month, and four full-page illustrations of the seasons. Of the thousand copies printed on *papier Ingres*, 250 were printed in each of four colors: mauve, orange, blue, and green. The well-known title page is even more energetically curvilinear than Van Rysselberghe's earlier designs. The floral tendrils

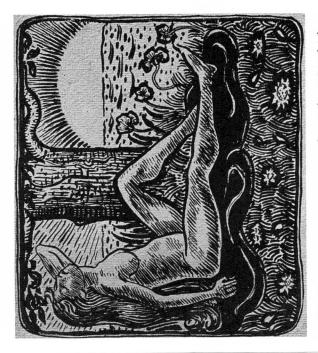

FIGURE 50. Georges Lemmen, preparatory drawing for *Le Réveil*, ink on paper, December 20, 1893. Previously Elisabeth Thevenin Collection.

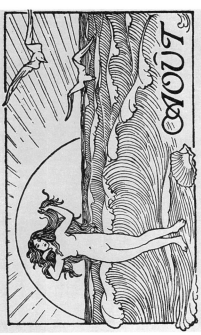

FIGURE 51. Théo Van Rysselberghe, *"Août"* ("August") from Emile Verhaeren's *Almanach*, photomechanical reproduction, 1895. © Bibliothèque Royale Albert 1er.

*Dans le matin qui s'ouvre et s'ébroue,
c'est le soleil qui fait la roue
comme un grand paon d'or et d'argent.*

*Son luxe inouï de lumières,
ardentes fleurs, clartés trémières,
d'après un rythme foudroyant
descend.*

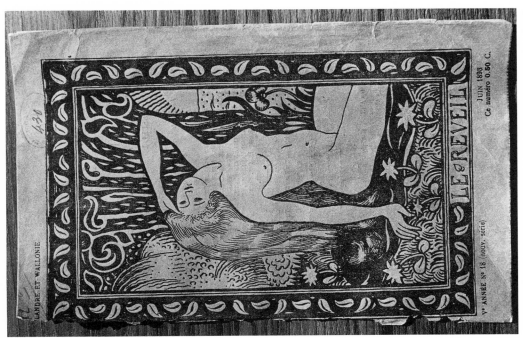

FIGURE 49. Georges Lemmen, cover for *Le Réveil*, photomechanical reproduction, June 1895.

interlace the frame and their swaying movements balance the strong, individualistic lettering. The gentle, lyrical rhythms are reinforced by the pale ink colors. Each vignette charmingly captures the spirit and flavor of the month or season it represents, so that we convincingly feel the warmth and sexual presence of August [fig. 51] and the mysterious and symbolic chill of autumn [fig. 52]. Yet the images represent Van Rysselberghe's personal interpretations and merely suggest the poems they illustrate. Thus, "Août" ("August") presents a Venus displaying her beautiful crop of hair; we feel the radiance and heat of the sun. Similarly with "L'Automne" ("Fall") we smell the perfume of melancholy and we feel a sense of gloom, perhaps foreboding, in the lonely presence of the ravens and the statues of the Virgin and Child in the woods. Verhaeren encouraged Van Rysselberghe to create his own visual correspondences to the poems, instructing him to "decorate the calendar completely the way you wish to. When one is half involved in a thing, it never goes as well as when one takes care of it completely alone."22

Almanach was a great critical success. The Belgian critic for Le Petit Bleu said that though Van Rysselberghe had kept his intensely personal ornamental style, at the same time "never had there been a more faithful adaption of a text more dependent upon the word of the writer." He hailed Van Rysselberghe as "a master of the decoration of the book that no one in Belgium will ever equal."23 Upon receiving a copy, Camille Pissarro (father to Lucien) felt a "great artistic joy" and rejoiced in the "illustrations of Rysselberghe, so fine, and so full of art, and typography, paper, format and color so successful." He concluded that "Verhaeren is a great poet and you, Théo, have been spoiled by a fairy."24 The critic for The Studio found an English flavor to the book and predicted that "it will probably find many purchasers here, and be examined critically as evidence of English ideals set forth in the idiom of a country that has for centuries remained in friendly relations with our own."25 Walter Crane recognized in Almanach "a sympathetic response to English feeling."26

If the four complete calendar pages, with their floral borders, readily bring to mind William Morris's complicated botanical motifs, the illustrations for each month recall the work of Lucien Pissarro. Indeed, Van Rysselberghe had sought the advice of Lucien Pissarro, his good friend. Pissarro's first portfolio of prints (some featuring the months), Twelve Woodcuts in Black and Colours was published by Charles Ricketts and Charles Shannon in 1891.27 Pissarro published the first of his own books in 1894, Margaret Rust's Queen of the Fishes.28

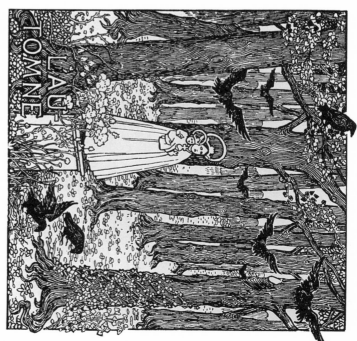

FIGURE 52. Théo Van Rysselberghe, "L'Automne" ("Autumn") from Emile Verhaeren's Almanach, photomechanical reproduction, 1895. © Bibliothèque Royale Albert 1er.

FIGURE 53. Théo Van Rysselberghe, cover for Emile Verhaeren's Les Heures claires, photomechanical reproduction, 1896. © Bibliothèque Royale Albert 1er.

The Studio certified the result of Van Rysselberghe and Verhaeren's collaboration, declaring that "the clever designer, . . . while evidently influenced by English work, has . . . adapted nature in obedience to the convention which distinguished the early woodcut . . . from the laboured engravings of later years."29 Finally, *Almanach* provided a prototype for Félix Vallotton and Peter Behrens in their calendar books for 1897 and 1899, respectively.

Van Rysselberghe and Verhaeren continued to collaborate. They produced two notable works in 1896, *Les Heures claires* (*Sunlit Hours*) and *Pour les amis du poète* (*For the Poet's Friends*), both published by Edmond Deman. *Les Heures claires* [fig. 53] is refreshing in its novel decorations, including such delights as a floral motif that resembles a pair of gloved hands.30 The cover, stippled light yellow-green, shows three fluttering butterflies. The fluid lettering and flame-like "V" of Verhaeren, printed in orange, reinforce the sense of gentle movement.

Pour les amis du poète was a tribute to Verhaeren on the occasion of a banquet held in his honor. Organized by the periodical *L'Art Jeune*, it was held at the Metropole hotel on 24 February 1896. A portrait of Verhaeren by Van Rysselberghe was used as the frontispiece; most of the ornamentation derived from earlier sources.31 Motifs reused from *Van Nu en Straks* and *Les Campagnes hallucinées* were intermingled with those by Fernand Khnopff. (Deman, with the permission of the artists themselves, frequently repeated motifs previously used in his books.)32

If Verhaeren gave Van Rysselberghe free rein to make artistic decisions about his books, Max Elskamp and van de Velde had a markedly more complex collaborative arrangement. Having already provided woodcuts for *Dominical* and *Salutations*, van de Velde supplied the cover design for a third Elskamp work, *En Symbole vers l'Apostolat* (*A Sign toward the Apostolate*, fig. 54). Elskamp explained to van de Velde that he considered the group as part of a series, "I see the three books, side by side one another, mauve for *Dominical*, blue for *Salutations*, and for this one—not at all pink." The words on the cover *were* printed in reddish-brown; a gold-brown was selected for the background designs. In contrast to the dripping, flowing quality of the designs for *Dominical* and *Salutations*, the forms of *En Symbole vers l'Apostolat* are ordered and tamed. Elskamp suggested that van de Velde use "the ends of a bishop's crozier for the ornamentation of the cover."33

The poems chant praises of angels, incense and a bell tower, all in the voice of a child in a natural state of innocence and wonder. Reviewing the book in 1895, Eugène Demolder explained that "Elskamp

invents an apostolic pantheism in which the sea and the horizon, as well as the sheep in the orchard, or masts of small skiffs, participate."34

Although van de Velde created no designs for Elskamp's next book, he actually played a more significant role in determining the appearance of an Elskamp work in this book. *Six chansons de pauvre homme pour célébrer la semaine de Flandre* (*Six Songs of a Poor Man to Celebrate Flanders Week*, cat. 16), with woodcut designs by Elskamp, was printed in 1895 by Maria and Henry van de Velde on their hand press, which Elskamp had baptized "*La Joyeuse*" (The Joyous One). Elskamp offered his advice as well. As he explained to his cousin, Henri Damiens, he learned the printing trade from Paul Buschmann, Sr., director of the printing house J. E. Buschmann, in Antwerp, that produced *Dominical, Salutations dont d'Angéliques and En symbole vers l'Apostolat.* Elskamp claimed that here he had

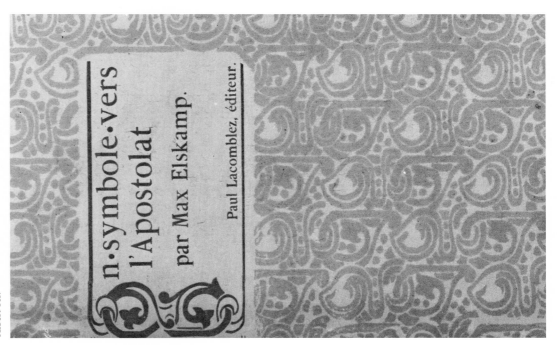

FIGURE 54. Henry van de Velde, cover for Max Elskamp's *En Symbole vers l'Apostolat*, photomechanical reproduction, 1895. © Bibliothèque Royale Albert 1er.

learned about setting type, wetting paper, pulling copies, and that he knew "all the secrets."35 Now he added woodcut illustrations to his previous skills.

Letters exchanged between Elskamp and van de Velde for *Six chansons* [fig. 55] reveal the close contact between Elskamp and Henry and Maria—his "colla-bos," as he called them. Planning the book, Elskamp wondered whether van de Velde had received the 150 sheets of paper he supplied, and suggested that two pressruns would be needed for the cover. The Caslon type was selected by van de Velde, however, and the layout was solely his. Elskamp approved of both, graciously remarking to his friend that "your typeface is superb . . . your format is exquisite."36

The decoration of *Six chansons* was done by Elskamp. Elskamp was an admirer of popular Flemish woodcuts and songs, which he sought to emulate in a modern version of his own verse with woodcuts. For example, the motifs of the beekeeper and the upside-down man whose feet emerge from a beehive are naive depictions of faith. *L'Art moderne* found Elskamp's drawings to be "of such a delectable naivety, so perfect for the text and so cleverly puerile, that we can't imagine any professional who could have dealt with them so well."37 As Christian Berg noted seventy-five years after the book was printed, "there is a close correlation between the woodcuts and the verses of *Six chansons* that accounts for the impression of harmony and unity that emerges from this small book."38

Elskamp's next work was created without the assistance of van de Velde, who was now living in Germany. *L'Alphabet de Notre Dame La Vièrge* (*The Alphabet of Our Lady*, cat. 17), printed in 1901 by J. E. Buschmann, is a tour de force of text and woodcuts. Also based on Elskamp's admiration for popular culture, the images are meant to recall Flemish folk-art traditions.39 However, Elskamp's designs combine these forms with the more elegant line of art nouveau. The vitality and tendency towards abstraction of the images recall van de Velde's previous work for Elskamp. Although Elskamp continued to illustrate his own books into the 1920s, he came the closest to merging these two seemingly disparate styles in *L'Alphabet*.

Lemmen, like Van Rysselberghe, usually enjoyed complete freedom in the design of his decorative motifs. His work for *Van Nu en Straks* and *Le Réveil* prepared him for the graphic commissions he received from several art galleries in the mid-1890s. Lemmen designed publicity announcements for La Maison d'art, Edmond Picard's eclectic Brussels gallery. Picard, one of the founders of *L'Art moderne* and a champion of Les XX, in 1894 turned his home at 56

FIGURE 55. Max Elskamp, letter to Henry van de Velde concerning *Six chansons de pauvre homme pour celebrer la semaine de Flandre*, undated. © Bibliothèque Royale Albert 1er.

FIGURE 56. Georges Lemmen, letterhead for La Maison d'Art (letter from William Picard to Georges Eekhoud, January 29, 1897). Archives et musée de la Littérature. © Nicole Hellyn, Bibliothèque Royale Albert 1er.

avenue de la Toison d'Or into a semi-private version of Les XX and La Libre Esthétique.[40] Lemmen also created the covers for eight brochures in which Picard outlined the goals of this undertaking. The last pages of both brochures seven and eight bear a stylized flower that was used in a reduced and redrawn version for the gallery's letterhead [fig. 56].

Similarly, Lemmen was commissioned by Siegfried Bing to provide designs for his Parisian gallery, Le Salon de l'Art Nouveau. The conception of Bing's gallery was greatly influenced by a visit he made to La Maison d'art. Lemmen designed publicity announcements, posters, letterhead, and endpapers for Bing and created a stained glass mosaic, stencilled frieze and rug that graced one of van de Velde's three rooms installed at the gallery.[41]

In 1897 Lemmen's most complete book design was published, Gustave Kahn's *Limbes de lumières* (*Flickerings of Light*, cat. 75).[42] Lemmen supervised the layout and typography of the whole project, and designed the cover, title page and over sixty large (*Book of Images*, fig. 57, no. 4–6, 8 & 9 from the left).[43] ornamental vignettes, all printed in pale ochre.

Kahn reworked the poems that finally appeared in this work over a period of years. As early as 1892 this work was prematurely announced in the fall of 1895 in *Le Réveil*.[44] In an unpublished letter to Kahn dated 11 February 1896, Lemmen explained that Deman's illness had delayed the preparation of the proofs for the typeface.[45] Lemmen reassured Kahn that Deman soon would be forwarding a page of proofs for his approval. Lemmen had apparently suggested that Deman hire Auguste Bénard of Liège as the printer,

but Deman instead chose to have *Limbes de lumières* printed in Brussels by Alexandre Berqueman. Unsure about the exact title, Lemmen queried Kahn whether it was "Limbes de (of) Lumières" or "Limbes et (and) Lumières."[46] Kahn replied that the "de" was very significant. He further wished to make certain that Lemmen understood that the "flickerings of light" referred "not to daybreak but, on the contrary, to the indecisive hour where light disappears."[47] Kahn described this in the first poem as "the ambiguous hour of gas sparks in indistinct suburbs."[48] Lemmen clearly understood. The muted ochre color of the ornamentation captures this transitional state between fading daylight and artificial light. The tonal proximity of the white paper and the pale ink causes the designs themselves to flicker on the page.

Le Réveil was ecstatic about the edition, "Each piece of the ornamentation by Mr. Georges Lemmen is arresting. They are all as decorative as they can be and of a very personal arrangement."[49] Many of the headpieces and tailpieces are purely abstract. Even the representational designs, such as the frog, birds, and flowers, are drawn with an economy of means. Particularly effective is the framing device Lemmen used to encapsulate the name of the author and title of the book. The critic Julius Meier-Graefe, soon to be a champion of Lemmen's art, found the cover to be the most excellent part of the design.[50]

Shortly after this, Van Rysselberghe created his most complete art nouveau works: the decorations for twelve songs composed by his friend Georges Flé (1862–1937), *Poésies mises en musique par Georges Flé pour chant et piano* (*Poetry Set to Music by Georges Flé for Song and Piano*), 1898, and a posthumous collection of tales by Auguste Villiers de l'Isle-Adam (1838–1889), *Histoires souveraines* (*Superlative Tales*),

FIGURE 57. Anonymous, *L'Association pour l'art exhibition* (Antwerp), photograph, 1892. © Bibliothèque Royale, Musée de la Littérature, Brussels.

1899.[51] For Flé's work Van Rysselberghe created some of the most unusual vignettes of his career to decorate the verses of Victor Hugo, Paul Verlaine, Théophile Gautier and an assortment of other poets. Lute strings, lyres, a cello neck and pipes of pan alternate with floral and abstract motifs. The headpieces and tailpieces are printed in light green ink in contrast to the orange for the titles of the poems. The music printed in brown ink holds its own against this elaboration, producing a perfect combination of decoration and text. Many of the pieces recall Van Rysselberghe's earlier successes. For example, the illustration for "Les Papillons" ("The Butterflies") by Gautier [fig. 58] suggests the ornamentation for Les Heures claires. Poésies mises en musique [fig. 59 and cat. 154] is a pivotal book in Van Rysselberghe's career; the ease and grace of many of its ornaments forecast his next work, Histoires souveraines [fig. 60], yet some of the ornaments herald a more rectilinear, severe style that was soon to follow.

FIGURE 58. Théo Van Rysselberghe, headpiece for "Les Papillons" by Théophile Gautier (from Georges Flé, Poésies mises en musique), photomechanical reproduction, 1898. Private collection.

Histoires souveraines is a memorial selection of twenty stories written by Villiers de l'Isle-Adam. Through an open referendum, Deman sought the advice of artists and writers to assist him in selecting the stories.[52] In fact, as Luc and Adrienne Fontainas have revealed, the history of this edition dates back to 1 September 1891 and originally the book was to bear a frontispiece by Felicien Rops.[53] Nearly five years later, in March 1896, Van Rysselberghe was preparing drawings to ornament the book.[54]

The result is a consummate piece of book decoration. The sheer profusion of its forty, large, decorated headpieces and tailpieces reveals the inventive wealth at Van Rysselberghe's creative disposal. Each chapter ornament is printed in pale green, contrasted by the deep green of the hand-lettered titles. Peacock feathers, floral patterns and swans leisurely flow across the pages, in contrast to the rather unfortunately pedestrian typeface selected. As Van Rysselberghe's most

FIGURE 59. Théo Van Rysselberghe, tailpiece for "Nuit d'etoiles" (from Georges Flé, Poésies mises en musique), photomechanical reproduction, 1898. Private collection.

complete book, *Histoires souveraines* bears comparison with *Limbes de lumières*. Again, the former's vignettes are characterized by grace, smoothness and gentle rhythms. In Lemmen's designs there is a tension, a sense of compression and a nervous quality foreign to Van Rysselberghe's aristocratic elegance.

Van Rysselberghe's undated drawing for an advertisement for *Histoires souveraines* [fig. 61] is in a markedly different style.[55] The border is regularized, with a geometric pattern of repeating quadrats. Even the lettering, when compared to the fluid writing of the headpiece for "Le Tueur de Cygnes" ("Killer of Swans," fig. 62), is now more blocky, sober and solid. Van Rysselberghe developed this manner more fully in the next several years, abandoning his art nouveau style after 1899.[56]

The cover for Stephan Zweig's German translation of Verhaeren's poetry, issued in 1904 as *Ausgewählte Gedichte* (*Selected Poems*, fig. 63), reveals a full blown development of the quadrat motif Van Rysselberghe

FIGURE 62. Théo Van Rysselberghe, headpiece for *"Le Tueur de Cygnes"* from Villiers de l'Isle Adam's *Histoires souveraines*, photomechanical reproduction, 1899. © Bibliothèque Royale Albert 1er.

FIGURE 60. Théo Van Rysselberghe, cover for Auguste Villiers de l'Isle Adam's *Histoires souveraines*, photomechanical reproduction, 1899. ©Bibliothèque Royale Albert 1er.

FIGURE 61. Théo Van Rysselberghe, advertisement for *Histoires souveraines*, ink drawing, 1899. Musées royaux des Beaux-Arts de Belgique, archives de l'art contemporain.

used in his advertisement for *Histoires souveraines*. Here typography and image are fully contained and ordered. His cover ornamentation for Verhaeren's *Les Heures d'après midi* (*The Afternoon Hours*, fig. 64), issued in 1905, reveals another example. A garland of roses encircles the title, written in a hand that is restrained when compared to his freer calligraphic work of a decade before.[57]

It is tempting to see in these later works the artist's response to his own growing popularity in Germany and Austria. Van Rysselberghe was among the first foreign artists invited to exhibit at the Vienna Secession. In 1899, twenty of his paintings, drawings and lithographs appeared in *Ver Sacrum*, the official organ of the Secession. By then he had already prepared graphic designs for German galleries and publishers.

Lemmen also benefited from German patrons, who afforded him the opportunity to experiment with a

seemingly endless variety of freehand letters. His work for Julius Meier-Graefe's periodical *Dekorative Kunst*, founded in 1897 in Munich, and its French counterpart *L'Art décoratif*, which began publication a year later, led him to create two posters, letterhead and advertisements for the two reviews.[58] For their German commissions, both Lemmen and Van Rysselberghe began to combine their characteristic lettering with references to German fonts such as "Fraktur."

The same German art connoisseurs spurred van de Velde's commercial career to great fame. Van de Velde created the cover for the first issue of *L'Art décoratif* [fig. 65], which was devoted entirely to his work. Included in the issue were van de Velde's furnishings for Meier-Graefe's editorial office of *L'Art décoratif*, complete with Lemmen's poster for *Dekorative Kunst* over the doorway. But Van Rysselberghe had prepared the initial cover for *Dekorative Kunst* the year before.

FIGURE 63. Théo Van Rysselberghe, cover for Emile Verhaeren's *Ausgewählte Gedichte* (translated by Stefan Zweig), photomechanical reproduction, 1904. © Bibliothèque Royale Albert 1er.

FIGURE 64. Théo Van Rysselberghe, cover for Emile Verhaeren's *Les Heures d'après-midi*; photomechanical reproduction, 1905. © Bibliothèque Royale Albert 1er.

The interest of Elskamp, van de Velde, Lemmen and Van Rysselberghe in new lettering was part of the revival of calligraphy in the 1890s, based in part on William Morris's new type designs. In addition, innovations in lithography led artists to experiment with the blending of image and text directly on the lithographic stone. The omnipresent poster popularized this calligraphic approach and encouraged type designers to invent faces that emulated it. Similarly, the new technology of photoengraving made it possible to print the most individualistic calligraphic demonstrations without the laborious tasks of woodcut or hand engraving. By 1895, *The Studio* could proclaim that "no subject is more important to the decorative artist than the right placing and consistent choice of lettering."[62]

The culmination of this international interest in artistic lettering was Rudolf von Larisch's publication *Beispiele Künstlerischer Schrift* (*Examples of Artistic Lettering*, fig. 67), issued in three series, beginning in 1900.[63] Larisch's first series contained work by Lemmen (whose first name was erroneously listed as Gustave) and Théo Van Rysselberghe.[64] Also included among the twenty-two examples were works by Lemmen's idol, Walter Crane, Otto Eckmann, Joseph Olbrich, and Joseph Plenik.

FIGURE 66. Théo Van Rysselberghe, *Fürst Lichtenarm*, photomechanical reproduction, ca. 1899. University of Illinois at Urbana/Champaign.

FIGURE 65. Henry van de Velde, cover for *L'Art décoratif*, relief print, October 1898.

Contemporaries found it confusing at times to distinguish between the styles of the three Belgians. For example, Friedrich Deneken, the director of the Kaiser Wilhelm Museum in Krefeld, approached van de Velde with a commission to design a local newspaper's masthead on the strength of what he presumed to be van de Velde's cover for *Dekorative Kunst*. Van de Velde confessed to Deneken that he had not designed the admired issue. He answered that "I confess that at first glance the attribution is possible," and neglected to name Van Rysselberghe as the designer.[59] Then he recommended Lemmen as the artist best able to satisfy the needs of the *Krefelder Verkehrszeitung*, and Lemmen was hired.

Another commission for Meier-Graefe also has caused confusion as to the identity of the designer. The cover of his *Fürst Lichtenarm* has been incorrectly attributed, this time by a modern scholar, to van de Velde [fig. 66].[60] It is by Van Rysselberghe and stylistically is very close to the contemporary *Histoires souveraines*.[61] Indeed, the large floral motif under the title was copied almost exactly as a tailpiece for one of the stories.

FIGURE 67. Rudolf von Larisch, *Beispiele Künstlerischer Schrift (Examples of Artistic Lettering)*, photomechanical reproduction, 1900. Private collection.

BEISPIELE·KÜNSTLERISCHER·SCHRIFT
HERAUSGEGEBEN·VON·RUDOLF·v·LARISCH
·MIT·ORIGINALBEITRÄGEN·VON·

RUDOLF·BERNT· WIEN ALOIS·LUDWIG· DÜSSELDORF
PAUL·BÜRK· DARMSTADT RUDOLF·MELICHAR· WIEN
WALTER·CRANE· LONDON THEO·MOLKENBOER·AMSTERDAM
OTTO·ECKMANN· BERLIN COLOMAN·MOSER· WIEN
ADALBERT·CARL·FISCHL·WIEN ALPHONS·MUCHA· PARIS
OTTO·HUPP· MÜNCHEN JOSEPH·OLBRICH· DARMSTADT
MARCEL·KAMMERER· WIEN JOSEPH·PLEČNIK· WIEN
RAPHAEL·KIRCHNER· DRESDEN ALFRED·ROLLER· WIEN
JAN·KOTĚRA· PRAG THEO·V·RYSSELBERGHE·PARIS
MELCHIOR·LECHTER·BERLIN EMIL·RUD·WEISS·KARLSRUHE
GUSTAVE·LEMMEN·BRÜSSEL BERNH·WENIG·BERCHTESGADEN

·VERLAG·:·ANTON·SCHROLL&Cᵒ·WIEN·MCM·

FIGURE 68. Georges Lemmen, alphabet in Rudolf von Larisch's *Beispiele Künstlerischer Schrift*, photomechanical reproduction, 1900. Private collection.

Despite their classicizing forms, Lemmen's characters in *Beispiele Künstlerischer Schrift* retain vestiges of his curvilinear style, especially the "A's" and "R's" [fig. 68]. They have a consistency unlike the decorative contortions of his earlier lettering, as seen in, for example, *Contes hétéroclites* [fig. 37]. It is as though Lemmen were thinking not merely about hand-lettering but about the cutting of a typeface. The lettering is legible and compact. The Van Rysselberghe example is at once more elongated and static, and lacks the fluidity of the Lemmen.[65]

By this time Lemmen *had* designed a typeface. Like the artists Eugène Grasset, Georges Auriol, Peter Behrens and Otto Eckmann—but unlike Elskamp, van de Velde or Van Rysselberghe—Lemmen turned his interest in typography toward the much more difficult task of creating a set of usable, individual letters. Commissioned in 1898 for a deluxe, monumental edition of Friedrich Nietzsche's *Also Sprach Zarathustra* (*Thus Spake Zarathustra*) the characters were cut and cast in Leipzig, Germany.[66] This *Prachtausgabe* (deluxe edition) was the product of the enlightened

patronage of the German art collector Harry Kessler (1868–1937). But it was also very much a Belgian enterprise; in addition to employing Lemmen's typeface, it was designed and decorated by van de Velde, who provided chapter headings, tailpieces, paragraph

CIVILISATION ⸱ PRIX ⸱
TABIATURE ⸱ MORT ⸱
JARGON ⸱ FLUIDITÉ
COLLE ⸱ PASTORALE
MYRMIDON ⸱ ZÉLIA

dividers, and a stunning title page [cat. 79]. The book finally appeared in 1908, ten years after its conception. It was issued by the Insel Verlag of Leipzig and printed there by W. Drugulin in an edition of 530 copies.

The book as originally conceived in 1897 was very different from the final version. It was to be printed in red and black from an English typeface, its decorations cut from wooden blocks. The Kelmscott Press *Chaucer* clearly provided the model. A new contract drawn up in December 1898 and signed in June 1899 between Kessler, van de Velde, Frau Elizabeth Förster-Nietzsche (Nietzsche's sister and literary executrix), and the Berlin publisher Samuel Fischer included the more "modern" idea of having Lemmen create an original typface.

Count Kessler, an avid amateur printer, corresponded with Lemmen on every aspect of the alphabet now under preparation. The two already had an amiable working relationship; Lemmen had designed a book for Kessler, *Notizen über Mexico* (*Notes on Mexico*), and his ex libris (bookplate), and had provided ex libris for many of Kessler's friends as well.[67] Now Kessler wanted nothing short of the complete renovation of nineteenth-century Gothic *"Fraktur"* and the adoption of modern typography in Germany. He sent Lemmen samples of typefaces he admired, including William Morris's, and the Caslon type of Ricketts's *Hero and Leander* of 1894. Lemmen expressed his desire to remove his art nouveau exuberance from the letters, "I have gotten rid of all caprice and excess ornamentation, and have preserved a purely classical look to my typeface, while attempting to give it pleasing proportions as well."[68] The result [fig. 69] is a Roman face inspired by

Morris's first typeface, Golden, combined with residual art nouveau curves, most notable in the R, P, and C.

On 26 April 1899, while Lemmen was still hard at work on the typeface, van de Velde expressed his doubts about such an immense undertaking to his friend and patron Eberhard von Bodenhausen, "I am going to tell you in all frankness that from the moment Count Kessler spoke to me of this edition I feared this commission."[69] After confessing his shame at having been gripped by such an emotion, van de Velde explained how the *Zarathustra* could be ornamented. Van de Velde felt that because some of the chapters were *"concrets* (concrete)" and others *"abstraits* (abstract)," he could not allow himself to mix abstract and more representational ornaments. Instead, he would provide an ornamental initial letter for each chapter and a tailpiece, if space permitted. Through Julius Meier-Graefe he had already seen proofs of "the handsome new typeface by Lemmen."[70]

By the end of 1899 Lemmen was nearing completion of the daunting task. On 11 December Kessler informed

FIGURE 70. Georges Lemmen, alphabet in Julius Hoffmann's *Schriftenatlas*, photomechanical reproduction, ca. 1903. University of Illinois at Urbana/Champaign.

FIGURE 69. Georges Lemmen, specimen sheet of Lemmen typeface, letterpress, 1899. Count Harry Kessler Papers, The Newberry Library, Chicago.

van de Velde that "Lemmen finally sent the letter designs, or at least most of them, and promises to finish the rest soon; thus, we will be able to cut the punches in January."[71] Van de Velde expressed impatience to Kessler, demanding "that he must absolutely make either Fisher or Lemmen, or both of them together, hurry up. Temperaments that can bear to *wait* for the realization of their plans are simply inexplicable to me!"[72] By 29 January 1900, Kessler could report to van de Velde that he had received "dessins complets de Lemmen (the complete designs by Lemmen)."[73] Unfortunately, no further progress was made for another seven years. Though Lemmen completed the typeface by 1900, he was constrained from exhibiting the proof sheets due to lengthy legal battles involving copyright. Only when these legal issues were resolved did van de Velde wish to bring this project to fruition.

It is a mark of the high esteem in which Lemmen's graphic art was held that he was asked to contribute to

ENTWÜRFE VON GEORGES LEMMEN

FIGURE 7.1a (left) and 7.1b (right). Georges Lemmen, advertisements in Julius Hoffmann's *Schriftenatlas*, photomechanical reproduction, ca. 1903. University of Illinois at Urbana/Champaign.

Julius Hoffmann's *Schriftenatlas* (*Lettering Atlas*), published about 1903.[74] The goal of Hoffmann's gazetteer was to present the best new alphabets and typefaces available from England, France, Austria, Germany, and the United States. The volume devotes considerable space to designs for commercial purposes. For example, in addition to his alphabet [fig. 70], Lemmen provided two pages of advertisements [fig. 7.1a and 7.1b]. His lettering is considerably less classical than the typeface for *Zarathustra*, and in some ways is a return to his earlier, energetic art nouveau style.

An exhibition was held in Antwerp in 1904 to celebrate the "*Livre moderne*" (The Modern Book).[75] It was hosted, appropriately enough, by the Plantin-Moretus Museum, the bastion of fine-art printing during the Renaissance. Though the catalogue paid homage to England for its important role in this resurgence of book arts, Belgium was well represented among its exhibitors. Ironically, the exhibition also

served as the swan song of the artistic flowering of art nouveau graphics. Indeed, by the time *Also Sprach Zarathustra* (*Thus Spoke Zarathustra*) was published in 1908, the typeface and its decoration almost seemed an anachronism.

Zarathustra marks the high point of Lemmen's and van de Velde's production in the book arts. Van de Velde's second Nietzsche volume, *Ecce Homo*, which also appeared in 1908, is yet another powerfully expressed manifestation of his ideals of abstract ornamentation and line, but in some ways it is an anticlimax after *Zarathustra*. Although Lemmen produced more than a dozen additional books between 1906 and 1914, including the illustration of sixty-four tales by his good friend Louis Delattre in 1908, his major work was complete with the *Zarathustra* typeface.[76]

Van Rysselberghe continued to illustrate covers for books published by Deman, until 1911.[77] Yet his career in the book arts had changed course around 1900, as we have seen, and it was never as vital a part of his oeuvre after that time.

The sheer quality and quantity of ornamentation produced by Lemmen, van de Velde and Van Rysselberghe is proof of the vitality of the book arts in Belgium at the fin de siècle. In some instances their respective styles are so close as to make attribution difficult. Typically, however, they retained three distinct graphic styles that allow us to distinguish hands. For nearly two decades their designs graced the most significant Belgian literary productions. Together they created a "modern" style of ornamentation that they hoped would be recognized as an integral part of their work, and not be seen merely as a dalliance or diversion from the rigors of the Fine Arts. As Lemmen wrote, "to embellish all of life, to disseminate beauty everywhere, this is the function of the artist in the rebirth that we hope for."[78] Their multi-faceted careers as designers of books, furnishings, paintings, and, in van de Velde's case, buildings revealed their adoption of Morris's and Crane's redefinition of the artist as a sanctifier of life and as a reformer of society. In viewing the book designs of Lemmen, van de Velde and Van Rysselberghe, we do not merely experience the expressive power and beauty of their ornamentation, but are witness to their affirmation of the artist as a powerful and vigorous agent for societal change.

Notes

1. The most significant work to date on the book arts in late 19th-century Belgium is by Fernand Baudin, see "Books in Belgium" and "Le dessein du caractère." See also Liebrecht, *Histoire du Livre*, sixth and last part. The exhibition catalogue *The Turn of the Century* includes a section devoted to Belgium; the dealer's catalogue produced by Warrack & Perkins is subtitled "Books illustrated by artists associated with the groups Les XX and La Libre Esthétique in Brussels, together with contemporary documents and periodicals, 1884–1914."

2. "Le Livre Belge," *AM*, 242: "Toute une floraison magnifique a surgi. Il n'y a qu'à tendre la main pour cueillir des roses délicates, des jasmins parfumés, ou des fleurs plus âpres ou plus puissantes."

3. A review of the section devoted to L'Imprimerie et Industries du Livre (book printers and manufacturers) at the 1897 World's Fair in Brussels provides a good overview of the printers, lithographers, photoengravers, founders, and bookbinders practicing in Belgium; see "A l'Exposition de Bruxelles," 67–71. A list of prizes awarded at the exhibition was published in *RGB* 1 (October 1897): 61.

4. Lacomblez to Buls, 15 December 1891. Similarly, *AM* recommended government support for authors, "Il faut que les commandes de livres soient égales aux commandes de tableaux et de statues," 12 (30 July 1893): 242. For Lacomblez, see Deschamps, "La Renaissance Belge," and "Paul Lacomblez."

5. For Les XX, see Block, *Les XX*, and Canning, *Le Cercle des XX*.

6. In 1886 Finch proposed Whistler's name for membership in Les XX. Whistler was denied membership in order to reserve a place for a young Belgian artist.
 Lemmen's knowledge of English developments led to a two-part article in *AM* on Walter Crane, published in March 1891; he enthusiastically praised Crane, William Morris and the English Arts and Crafts Movement; see Lemmen, "Walter Crane."

7. The catalogues were listed under the heading "Les Livres imprimés non illustrés." It is difficult to determine which of the Les XX or La Libre Esthétique catalogues were shown, since only the general heading "*Catalogues des expositions* #542" is used. The catalogue *Exposition internationale du Livre moderne à l'art nouveau* was ornamented by Félix

Vallotton. The organizing committee included Octave Uzanne, founder and president of "Bibliophiles contemporains et des Bibliophiles indépendants," and the art critic Julius Meier-Graefe.

8. L.D.L., "Le Salon de la Libre Esthétique: Les Livres."

9. Loubier, "Die Kunst im Buchdruck," 486; Rudolf Kautsch quoting Meier-Graefe, *Die neue Buchkunst*, 87; *Ausstellung von Werken*, unpaginated, on Display Case 17, "Belgien, wo van de Velde, Lemmen und Van Rysselberghe neue Ornamentik zuerst im Buchschmuck entwickelten." For information on van de Velde and the book arts, see Baudin's two-part article, "Henry van de Velde." For Lemmen, see Cardon, *Georges Lemmen*; this excellent work reproduces many of Lemmen's illustrations; pages 489–497 contain a list of Lemmen's work for books, periodicals, exhibition catalogues, print portfolios and assorted graphic projects. Van Rysselberghe's book projects for Deman are included in the exhaustive catalogue by the Fontainas, *Edmond Deman*. All three artists are treated in Riegger-Baurmann's "Schrift im Jugendstil."

10. Lemmen to Eekhoud, 20 April 1889. It has been assumed that Lemmen showed this same work again at the Association pour l'art of 1892 in Antwerp and again at Les XX in 1893. However, a documentary photo of the former exhibition [fig. 57] shows a new drawing for Eekhoud's work; it also was never published by the author.

11. The common assertion that Minne produced woodcuts for *Serres chaudes* is questioned in Baas & Field, *Revival of the Woodcut*, 70–72. For more on Minne, see Alhadeff, "Minne: Fin de Siècle Drawing and Sculpture." and "Minne: Maeterlinck's Fin de Siècle Illustrator."

12. Crane designed seven of these pots for Maw & Co.; they were exhibited in 1889 at the Arts & Crafts Society. See Spencer, *Walter Crane*, 194n33.

13. Elskamp to van de Velde, undated letter; bound in with copy of *Dominical* in the Bibliothèque Royale, Réserve Precieuse, L.P. 2918A.

14. Lemmen to Elskamp, 30 March [1892]. Van de Velde held *Dominical* in high regard. In February 1898 he inscribed a copy to the connoisseur of fine art printing, Count Harry Kessler, also his good friend and patron. "J'inscris avec émotion votre nom sur le livre de celui dont l'amitié m'est un si précieux bien que ne crois pouvoir placer mieux notre liaison que dans tel délicats et fortéfiantes auspices." This copy, numbered 2, is in the Newberry Library, Chicago.

15. My thanks to Roger Cardon for supplying the relevant passage from this undated letter [1893] from Elskamp to van de Velde; "Je reçois ton dessin pour tour d'ivoire trop tard malheureusement, la première feuille est tirée. Fais-moi donc puisque tu le veux bien une couverture en couleurs."

16. *El Moghreb-Al-Aska* was published by Fernand Larcier, Brussels, June 1889; the frontispiece was designed by Odilon Redon. Portions of the book were reprinted in *AM*, July 15, July 29, August 26, September 9 and September 30, 1889. Van Rysselberghe traveled with Picard; this was his third trip to Morocco.

17. The colophon of *Légendes puériles* reveals that its publisher was none other than the *Veuve Monnom*, also Van Rysselberghe's mother-in-law. Van Rysselberghe married Maria Monnom in September 1889. The *Veuve Monnom*'s press published the periodicals *L'Art moderne*, *La Jeune Belgique*, and *La Société nouvelle*, the annual catalogues for Les XX and La Libre Esthétique, and posters designed for the latter by Van Rysselberghe and Lemmen.

18. These are *Les Campagnes hallucinées*, 1893; *Les Villes tentaculaires*, 1895; *Pour les amis du poète*, 1896, dedicated to Verhaeren, with ornamentation also by Fernand Khnopff; *Les Heures claires*, 1896; *Les Aubes*, 1896; *Les Visages de la Vie*, 1899; *Le Cloître*, 1900; *Petites légendes*, 1900; *Toute la Flandre: Les Tendresses premières*, 1904, *Toute la Flandre: Les Héros d'après-midi*, 1905; *Toute la Flandre: La Guirlande des Dunes*, 1907; *Toute la Flandre: Les Héros*, 1908; *Toute la Flandre: Les Villes à pignons*, 1910, and *Toute la Flandre: Les Plaines*, 1911. Deman's entire oeuvre is the subject of the two-part catalogue by the Fontainas.

19. The first series appeared from April 1893–October 1894. A second series, published from 1896–1901, had a more literary and sociological emphasis. One of the main sources on the journal is Musschoot, *Van Nu en Straks 1893–1901*. See also Lemaire, "August Vermeylen en Henry van de Velde" and Ghent, CKC, *Van Nu en Straks*.

20. This is cited by Curjel as *The Book of Job* but this mistake is corrected in van de Velde, *Récit de ma Vie*, 187n2.

21. Among van de Velde's circle of Vingtiste friends, Lemmen, Finch, Khnopff, Willy Schlobach and Toorop had already traveled to London. Lemmen specifically noted in "Walter Crane" that he had studied English entries at the Triennial Salon of Antwerp of 1885 and that of the Exposition Universelle of Paris, 1889.

22. Cited by Warmoes, in "Une amitié," 2; "Ornemente le calendrier absolument comme tu le trouves bon. Quand on se mêle à demi d'une chose elle ne va jamais aussi bien que si on s'arrange seul"

23. Jacquelin, "Le Livre Illustrée"; "il faut saluer en Van Rysselberghe un maître de la décoration du Livre que personne chez nous n'égala jamais."

24. C. Pissarro to Van Rysselberghe, 11 December 1894; "grande joie artistique...illustrations de Rysselberghe, si fin, si plein d'art, typographie, papier, format, couleurs si réussis... et vous Théo, vous avez été gâté par une fée." See also Bailly-Herzberg, *Correspondance de C. Pissarro*, 20. L. Pissarro did not share his father's favorable opinion. In a letter dated 27 December 1894, Camille Pissarro writes "Tu n'aimes pas les illustrations de Théo, il faut voir cela comme une chose sans conséquence ou plutôt une chose commerciale, c'est bien fait, proprement rendu; dans ce genre, c'est bien"; Bailly-Herzberg, 527.

25. "New Publications," XXXIII.

26. Crane, *Decorative Illustration*, 254; Van Rysselberghe is referred to as Rysselburgher. Crane obviously thought highly of *Almanach* since he chose to include the plate "*Août*" in his book, 266. The only other Belgian artist mentioned in Crane's text is Khnopff, 254.

27. One of these woodcuts was published in issue 8–10 of *Van Nu en Straks*; the proofs were exhibited at La Libre

28. Esthétique in 1895. The *Almanach* was displayed at Bing's Exposition internationale du Livre moderne held at his gallery, Art Nouveau, in June 1896, listed under the rubric "Les Livres imprimés illustrés par des procédés mécaniques." Van Rysselberghe also responded to apt criticism from L. Pissarro on 3 January 1895 regarding his woodcut for *Almanach*. Apparently, in the mechanical process the use of the *clichés* had reduced the drawings too far and altered the entire proportional ratio of word and image. Van Rysselberghe vowed to Pissarro that these miscalculations would be remedied in the final product.

28. L. Pissarro exhibited at Les XX and at La Libre Esthétique, contributed to *Van Nu en Straks* and was in correspondence with Van Rysselberghe from 1892 until 1926, the year of Van Rysselberghe's death.

29. "New Publications," 32.

30. This whimsical tailpiece appears on page 28.

31. See Fontainas, *Bulletin du bibliophile*, 495, for a complete list of ornamentation by Van Rysselberghe and Khnopff.

32. Unable to complete all the ornaments for *Petites Légendes* (1900), Van Rysselberghe wrote to Deman, "Mais tu pourras, soit en répéter un, ou en prendre un qui te paraîtra convenir, dans ta petite réserve [But you may repeat one of them or take one that appears to fit from your small reserve]," Fontainas, 530.

33. Elskamp to van de Velde, 9 May [1894]; "La plus grande diffi culté sera de trouver la couleur de la couverture car en mes yeux, je vois les trois bouquins à côté l'un de l'autre—mauve bleu Dominical, bleu Salutations et pas du tout rose celui-ci . . . Un grand usage pourrait être fait des bouts de crosses d'évêque sous forme de visages etc."

34. Demolder, "Chronique Littéraire," 54; "Elskamp invente un panthéisme apostolique, auquel participent la mer et l'horizon, aussi bien que les moutons des vergers ou les mâts des barquettes."

35. Gaspar, "Max Elskamp," 66.

36. "Ton caractère est superbe," cited in Berg, "Lettres de Max Elskamp," 165; "ton format est exquis," Berg, 164.

37. "Un Livre," 11; "Les dessins . . . sont d'une naïveté savoureuse et si adéquate au texte et si artistement puérils q'on n'imag ine aucun professionnel qui les eût pu traiter ainsi."

38. Berg, 155, "Il existe une étroite corrélation entre les bois et les vers des *Six chansons*, ce qui explique l'impression d'harmonie et d'unité qui se dégage de ce petit livre."

39. Elskamp was a student of popular folk art and folk songs. He collected these and objects from the material culture such as tools, keepsakes, etc. He donated his collection to the Conservatoire de la tradition populaire, Antwerp, which became the Musée du Folklore and opened to the public on 18 August 1907. See Guiette, *Max Elskamp*, 60.

40. For the history of the Maison d'Art, see Block, "Picard's Asylum of Beauty."

41. For Lemmen and van de Velde's collaborative efforts see Block, "A Neglected Collaboration."

42. The genesis of the poems in the published version of *Limbes de lumières* is the 1891 publication of some of them in *La Jeune Belgique* under the title, "Extraits d'un livre d'image." Kahn published additional poems that ultimately appeared in "Limbes de lumières" in *La Jeune Belgique* in 1892 and in *La Société Nouvelle* of 1895. Kahn's poem "Lied" appeared in *Le Réveil* in February/March 1895, 76. For the chronology of the poems see Ireson, *L'Oeuvre de Kahn*, 232–233.

43. These drawings, seen here at the Association pour l'art in Antwerp in 1892, were displayed again at Les XX in 1893. In a letter to Elskamp, 13 May 1892, Lemmen informed Elskamp that Kahn would lend his work by Seurat to the Association's exhibition and that Kahn had agreed to recite his verse there on 12 June. A Kahn collection with the title *Livre d'Images* was finally published in Paris by La Mercure de France on 6 October 1897 without Lemmen's contribution.

44. Guequier, "Tablettes," 234.

45. Lemmen to Kahn, 11 February 1896.

46. *Ibid.*, "Enfin!..Deman qui a été un mois malade me donne des nouvelles. Il vous enverra aux premiers jours de la semaine prochaine une page d'épreuves et vous verrez si le caractère vous plaît. Ce n'est pas celui dont je vous ai parlé, Deman ne s'étant pas entendu avec l'imprimeur Bénard, de Liège."

47. "Le livre s'appellera *Limbes de Lumière* [sic], entendons-nous bien sur le sens des mots, ce n'est pas d'aurore qu'il s'agit, mais au contraire de l'heure indécise où la lumière disparaît," quoted in part in Fontainas, "Edmond Deman," 4: 503. The reply to Lemmen is the undated letter bound in with copy 1 on Japan paper.

48. "C'est à l'heure ambiguï du gaz en flammèches par les faubourgs confus."

49. Arnay, "Chronique littéraire," 321; "Des ornementations de M. George [sic] Lemmen arrêtent à chaque pièce. Elles sont aussi décoratives qu'il se peut et d'une ordonnance très personnelle."

50. Meier-Graefe, "Die moderne Illustrationskunst," 511; "Das gelungenste an dem Buch ist der Umschlag."

51. Georges and Laure Flé were good friends of the Van Rysselberghes. The interpretation of four of Verlaine's poems by Georges, a composer, was performed at the 1897 Libre Esthétique. G. Flé organized a performance of popular music at the Section d'art of the Maison du Peuple in 1896. His wife, Laure, a professional singer, performed at the Libre Esthétique in 1907. Van Rysselberghe did several oils and drawings of Madame Flé. The Flé's villa at Ambleteuse was built circa 1893–94 by their friend, the architect Louis Bonnier. It was here that Van Rysselberghe came to paint some of his most beautiful marineseapes, such as *Promenade*, 1901.

52. Perinet, "Picorée," *Coq Rouge* 2 (June 1896): 142. The results of the referendum were published by Perinet, "Picorée," *Coq Rouge* 2 (July 1896): 191. Thirteen of the twenty suggestions were published.

53. Fontainas, 4: 516–520.

54. Van Rysselberghe to L. Pissarro, 26 March 1896, "et je prépare des dessins pour orner un volume de Villiers, que publiera Deman à la fin de l'année."

55. Van Rysselberghe's cover for the 1899 edition of Deman's *Poésies de Stéphane Mallarmé* also shows this geometric border. See Fontainas, 4: 511 for an illustration.

56. Among Van Rysselberghe's final forays in his earlier manner are the exuberant cover for de Souza's *Modulations sur la Mer & La Nuit*; and his more restrained design for Signac's edition of *Eugène Delacroix au Néo-Impressionisme.*

57. Yet many of the ornaments used as headpieces and tailpieces were reused from earlier texts executed in his more robust art nouveau style. Some of the ornaments are by Khnopff and taken from *Les Débâcles*, *Les Flambeaux noirs*, and *Les Soirs.*

58. The first issue of *Dekorative Kunst* was published in October 1897 by H. Bruckmann. The first issue of *L'Art décoratif* first issue appeared October 1898 at Meier-Graefe's headquarters, 37 rue Pegolèse, Paris.

59. Van de Velde to Deneken, undated, no. 102, Kaiser Wilhelm Museum, Krefeld.

60. Delevoy, "Les Arts appliqués à la vie quotidienne," 32.

61. Even though the stylistic evidence makes the attribution certain, it is gratifying to have the printed proof, found at the back of Meier-Graefe's book, *Die Keuschen! Das Liebesleben im neunzehnten Jahrhundert*. The advertisement bears the words, "*Fürst Lichtenarm: Die Keuschen*, Teil I, 'Mit Umschlagszeichnung von H. van Rysselberghe.' "The Van Rysselberghe designs was used again for Teil II, *Die Keuschen: Der Prinz*. Curiously, the well-known French bibliophile Octave Uzanne reproduced it with the caption "anonyme" in his article "Couvertures Illustrées de Publications Etrangères," *Art et Décoration* 5 (January/June 1899): 38.

62. "The Editor's Room," XVII. The author was reviewing E. F. Strange's book *Alphabets* (London: George Bell and Sons, 1902). Strange's book included alphabets designed by Selwyn Image and Charles Voysey, among others.

63. Larisch was born 1 April 1856 in Verona, Italy. He taught at the Kunstgewerbeschule, the Graphische Lehr-und Versuchsanstalt and the Akademie der bildenden Künste. The *Beispiele künstlerischer Schrift* was issued in a series of three volumes, 1900, 1903, and 1906 and published by Anton Scholl and Co, Vienna. Larisch's other writings on calligraphy include *Über Leserlichkeit von ornamentalen Schriften* (1904) and *Unterricht in ornamentaler Schrift* (1905). Larisch died in Vienna on 24 March 1934.

64. Brown, *Letters & Lettering*, 75, reproduces Lemmen's lettering from Larisch without decorative frame, as an example of "Modern German Capitals."

65. For reviews of Larisch's book see W.F.-D., "Art Centres," 208–209; "R. Von Larisch-Wien," 53–64; and Scholermann, "Beispiele künstlerischer Schrift," 467–472.

66. For the complete story of the genesis and history of *Also Sprach Zarathustra*, see Block's, "The Insel-Verlag 'Zarathustra,' " 129–137.

67. Lemmen designed ex libris for Kessler's friends: Curt von Mutzenbecher, Cornelie Richter, Reinhold Richter and Karl Emich Count zu Leiningen Westerburg. The latter had a personal collection of over 20,000 book plates and wrote *German Book Plates, an Illustrated Edition of German and Austrian Ex-Libris*, trans. G. Ravenscroft Dennis (London: G. Bell and Sons, 1901). Lemmen also designed ex libris for Octave Maus, Louis Delattre, Julius Meier-Graefe and Dr. C. Baudoux. For an interesting article on ex libris see Anne Rouzet, "Les Ex-libris art nouveau en Belgique," 87–92.

68. Lemmen to Kessler, 17 March 1899: "J'ai banni cette fois toute fantaisie, tous enjolivements, et suis resté—dans la forme purement classique tout en essayant de donner à mes caractères des proportions agréables."

69. Van de Velde to Bodenhausen, 26 April 1899: "Je vais vous dire en toute franchise que dès que le Cte Kessler m'a parlé de cette édition j'ai eu peur de ce travail." I am indebted to Dr. Catherine Krahmer, Paris, who is authoring a biography of Meier-Graefe, for supplying me with a photocopy of this document.

70. Ibid., "le beau caractère nouveau de Lemmen." In two letters to Kessler, 21 April 1899 and 1 November 1899, Meier-Graefe writes of the "Fischer-Sache." Apparently, Meier-Graefe wished to contribute financially to *Zarathustra*, but by 21 April 1899 his funds were tied up and he was no longer in a position to be able to do so. Meier-Graefe confesses that he was extremely pleased with the typeface, "Mir gefällt die Schrift *ausgezeichnet*"; I am grateful to Catherine Krahmer for supplying me with the relevant passages from these letters.

71. Kessler to van de Velde, 11 December 1899: "Lemmen a enfin envoyé les caractères, c'est à dire la plus grande partie, et il promet de les finir très prochainement, nous pourrons donc commencer à graver les poinçons en janvier."

72. Van de Velde to Kessler, January 1900: "il faut absolument obtenir soit de Fisher, soit de Lemmen—soit de tous les deux qu'ils fassent hâte. Quels inexplicables témperaments—pour moi—que ceux qui peuvent aussi *attendre* la réalisation de leurs projets."

73. Kessler to Van de Velde, 29 January 1900: Lemmen also worked on a supplementary alphabet of initial letters that were not used for *Zarathustra*.

74. This book was issued around 1903 in Stuttgart by Hoffmann, the publisher of *Dekorative Vorbilder*. It was edited by Ludwig Petzendorfer and published originally in 18 parts.

75. It was at this exhibition, Exposition Du Livre Moderne; that Lemmen's wish to unveil his typeface for *Zarathustra* was denied by the publisher, Schuster and Loeffler. An exhibition held two years later, July–September 1906, in Ostend the Musée du Livre pays homage to the writers of these works, as opposed to the publishers or book designers; see *Liste Sommaire d'Oeuvres Littéraires*. Eugene Demolder dreamed of such an exhibition that would be sponsored by the Ligue pour le Libre belge, which was finally constituted in 1900. His plea for "Une exposition du livre belge," can be read in *AM* 20 (19 August 1900): 261–263.

76. This was *Le Jeu des petites gens en 64 contes sots*. Delattre (1870–1938) was a medical doctor who wrote charming, humorous tales as a hobby. Lemmen illustrated Delattre's *Avril* (1907), *Le Roman du Chien et de L'Enfant* (1907), *Le Pays Wallon* (1910) and *Les Carnets d'un médecin de village* (1910). He also designed for Delattre and his wife, Louise, the cover to their *Jardin de la sorcière* (1906) and *Le Prince Grenouille* (1908).

77. In addition, Van Rysselberghe supplied a portrait of André Gide for the frontispiece of Gide's *L'Immoraliste*, published in Paris by Georges Crès et Cie., 1917.

78. Lemmen, "Chronique d'Art," 178; "Embellir toute la vie, par tout répandre la Beauté, telle semblerait la fonction de l'Artiste dans un renouveau qu'on espère."

Belgian Symbolism and a Poetics of Place

by Donald Friedman

THE efflorescence of symbolist literature in Belgium paralleled the decade of activity of the members of Les XX and the vigor and originality with which this international literary movement was grafted in Belgium infused the work of many visual artists of the period. The 1880s mark the beginning of an extraordinary outpouring of symbolist literature in Belgium that continued into the 1920s. Ardent writers who sought to cultivate their individuality and artistic integrity as well as their national identity created Belgium symbolism. From the vantage point of our own fin-de-siècle, we are now able to fully appreciate the artistic explorations and innovations of these Belgian symbolists, whose writing retains a fresh and avant-garde caste a century after its creation. Within the vast scaffolding of the international symbolist movement, we are able to distinguish Belgian thematics, sources of fascination, and stylistic techniques that underlie the work of diverse authors sharing by chance a geographical determination that was transformed by choice into a source of artistic inspiration.

Symbolism and Belgian Symbolism: An Overview

Belgian symbolism shares the essence of the international movement that originated in France and swept Europe at the end of the nineteenth century. In its broadest definition, symbolism is a style and a mystique unconcerned with description or mimetic representation of objects and events in their historical reality, focusing instead on evocation and distillation of mood.[1] The thrust of the movement was to suggest through indirect discourse the secrets of interiority, thereby creating an enduring zone of aesthetic experience distanced from the banality and materialism of society. The general aura of symbolism is elusive and evanescent, the disappearance of the lyric self, masked by the personae of myth and legend. Within this aura, Belgian symbolism has its own particular nuance and characteristics that encompass the highly varied and individualistic creation of many writers, who found artistic renewal in giving enigmatic expression to the mysterious and uncharted depths of interiority.

In the January 1894 *Le Réveil*, Victor Remouchamps wrote of the 'interior world', "We have everything within us. The mind is an ocean of sensations, a universe of visions; but it is necessary to know how to explore it."[2] Paradoxically, the key to this exploration for the Belgian Symbolists was highly concrete imagery, culled from the exterior world, as a transparent screen and mirror allowing access to inner states. Concrete imagery may dilate or expand in meaning to encompass abstract states of mind. Stéphane Mallarmé had distinguished two types of symbolic usage, either to gradually evoke an object in order to demonstrate a mood or, conversely, to start with an object and, through deciphering, disengage a mood from it.[4] The second usage typifies Belgian poetry of the turn of the century, in which exterior landscape serves as the designation of the interior. The lineaments of the known may suggest the artist's hidden response to it; subjective deformation of a familiar environment may transform it into an inner realm of poetic experience.

Belgian symbolism is a poetry of strangeness and hallucination precisely because of being rooted in a sense of geographical place, much more so than

Emile Verhaeren summarized the essential form and distinction of Belgian symbolism in an 1887 article in *L'Art moderne*, "One begins with things seen, heard, felt, tasted in order to give rise to evocation."[3]

French Symbolism. Though the endless artificial dreamscapes evoked by the French Symbolists, such as somnolent, enchanted gardens inhabited by swans and princesses, are also present in Belgian symbolism to a lesser extent, the strongest of the Belgian poets sought the dreamlike aspects of their own northern environment in order to demonstrate the subtle, ambiguous influence of atmosphere upon those who absorb it.

Spatial paradigms for the inner world are recurrent throughout Belgian Symbolism. They frequently take the form of actual cities, no longer sites of communi-ty, but explored as realms of solitude, the poet's pri-vate sphere of introspection. Bruges and Ghent, canal cities of mirroring water, are Georges Rodenbach's spaces of poetry and delving. A black and labyrinthine London serves Verhaeren as a manifestation of spiri-tual dejection and madness, as do wintry planes and villages of Flanders. The polyglot port of Antwerp is the pivot of Max Elskamp's poetry, serving as entry-way to many other spaces, often spaces within spaces as in a play of Chinese boxes. In number 7 of the *Chanson de la Rue Saint-Paul*, Elskamp's native street leads to a harbor brothel and, within it, to two engravings, *Vesuvius* and the suspended *Brooklyn Bridge*, emblems of the fire and waiting that are the essence of the place. Spatial paradigms are used to suggest moods of disjunction, isolation, and suffocat-ing disharmony in the poetry of Maurice Maeterlinck. Hothouses, bell-glasses, diving bells, spaces of protec-tion and imprisonment, are models of interiority. Brief notations of aspects of asylums, hospital wards, canal cities enter into uncanny conjunctions in Maeterlinck's world of confusion, a private theater where "rien n'y est à sa place," nothing is in its place.[5] Charles Van Lerberghe, who wrote *La Chanson d'Eve* from a pastoral retreat in the Ardennes, evokes a series of Edens, distinct spaces that reflect the shifting moods of the poet-figure, Eve, who enters a state of symbiosis with the world she is the first to perceive, transforming it in her image.

This marked primacy of place and the centrality of spatial paradigms for the inner world that define Belgian symbolism may be attributed to feelings of nascent national pride. In 1880 Belgium was a fifty-year-old nation state and by 1885 symbolism was the first wide-spread, multi-national literary movement in which Belgians played a determinant role. Though sharing a common language with France and a com-mon impetus to deny the contingencies of the mun-dane world in their art, the Belgian writers could mitigate the force of French cultural imperialism and establish a Belgian presence in the literary world,

distinct from their neighbor's, through cultivation of image repertoires of places, objects and Flemish or Walloon experiences; by exploring their own geogra-phy and rendering it expressive.

Symbolism as a style has largely and incorrectly become associated with abstraction and purposeful obfuscation that denies entrance into the poem to all but the initiated. This is not the case with Belgian Symbolism. With its emphasis on concrete imagery and extraction of mood from the visible world, the language of Belgian symbolism is lucid. Simple lan-guage allows the reader to enter the sphere of the sug-gestive and equivocal. For example, Georges Rodenbach's poems are often structured around a cen-tral conceit reinforced by many subsidiary metaphors. The accumulation of sensory impressions, compar-isons and uncanny personifications of the inanimate world, rather than the difficult syntactical distortions of other symbolist poetry, contribute to an atmos-phere of uncertainty. In Maeterlinck's verse individ-ual lines are simple and direct, often oracular pronouncements of vision; it is the untoward juxtapo-sitions of objects and uncertain links between the pronouncements that suffuse Maeterlinck's poetry with proto-surrealist ambiguity. Verhaeren and Elskamp practice syntactical distortion in their verse, but their innovations are made for simplification. Verhaeren's truncated lines, obsessive repetitions and unfamiliar use of adverbs perfectly convey halting thought and inner torment. Such calculations as ellipses, absent articles and extremely short lines of 5-7 syllables endow Elskamp's verse with a willed naive, folkloric quality and emphasize individual moments of vision that together form a panorama of mood. In *La Chanson d'Eve*, Van Lerberghe orches-trates a fluid, malleable language of variable meter and often muted or absent end rhymes intended to convey the unspoiled vision of the first being.

There is a correlation between the enduring, respected tradition of Flemish painting, at once mys-tical in orientation and based upon close, precise observation of the world, and the visual and visionary qualities of language prevalent in Belgian Symbolism. The writers consciously turned to the painterly past for inspiration. The works of Jan van Eyck and Hans Memling figure prominently in the prose of Georges Rodenbach; the fifteenth century St. Ursula Reliquary painted by Memling, dream-like yet precise in detail, is a central source of metaphorical construction in his 1892 *Bruges-la-Morte* [cat. 58].[6] Verhaeren was also interested in the visual arts and an astute critic who wrote both about the Flemish past and contemporary idealist painters. Verhaeren's first collection of

poetry, *Les Flamandes*, was inspired by sixteenth century genre painting, just as Maeterlinck's most disturbing reflection on the human condition, *The Blind*, received its impetus from Pieter Bruegel. Gregoire Le Roy and Jean Delville were symbolist poets and painters, in quest in both media of the enigmatic that lurks beneath appearance.

As a visionary poetry, Belgian symbolism influenced many artists of the turn of the century. These included Xavier Mellery, Fernand Khnopff and William Degouve de Nuncques, who derived much of their inspiration from contemporary literature and sought in their work to portray objects and places in a manner that suggests their mystery and ambiguity, rather than their definitiveness. Among the techniques used by Belgian visual artists of the turn of the century to depict images congruent with symbolist poetry are uncommonly compressed or expanded compositions, idiosyncratic use of color, muted or absent color suggestive of silence, and emphasis of stasis and suspended animation.

In this literature of northern voice, at once more oriented toward the proximate world than French Symbolism, yet surrounded with a spectral frisson of unreality, there is an idiosyncratic repertoire of figures that also are present in the visual arts. The figures of Greek myth are largely absent from Belgian poetry, though the presence of Narcissus is constantly implied but unnamed in Rodenbach's canal city of reflection. Rodenbach's world is haunted by Ophelia, suggestive of drowning entrance into an amniotic state of dream. Ophelia is also present in Verhaeren's work, but as a figure of madness, the "corpse of reason" that trails across the Thames toward the engulfing abyss. Madmen are recurrent in Verhaeren's *Les Campagnes hallucinées* (*Hallucinated Countrysides*) and are analogous of the poet engaged in subjective deformation of the perceived world. Convalescents and invalids are omnipresent in the poetry of Rodenbach, Verhaeren, and Maeterlinck. In Rodenbach's verse, the invalid is a privileged being of silence and introspection, cloistered from the tumult of the world. In Verhaeren's poetry, there are the "skeptical ill," raging against their condition and tormented by disbelief. Maeterlinck presents the feverish invalid, weak, helpless, and lost in hallucination. The veiled and virginal nun is another multivalent figure in Belgian literature. Engaged in lace-making or the singing of canticles, Rodenbach's nun suggests the pure and sacrosanct nature of artistic creation. Conversely, the nun in Maeterlinck's world is associated with hospitals, sickbeds, and premonitions of death. In general, Catholicism is an important source

of decor and imagery in Belgian Symbolism. Albert Giraud's commedia hero in *Pierrot Lunaire* becomes a priest and offers his heart as the Eucharist. Iwan Gilken adapts the rosary and litany forms of the church to convey decadent erotic experience. Litanies and orisons, hypnotic in their repetitions, are also forms favored by Maeterlinck and Elskamp. Decaying, dank churches and all they contain become sources of imagery in the verse of Rodenbach and Verhaeren, who use fallen religious edifices as metaphors for spiritual malaise and the general ruination of a world in entropy. Except in the *Chanson d'Eve*, the pagan, liberated climate of Mallarmé's artist-faun is excluded from the imaginary universe of Belgian Symbolism, where even the gleaming, joyous isles of Van Lerberghe's Eden alternate with crepuscular spaces of death and disincarnation.

The last fin-de-siècle produced symbolism, the most death-haunted of literary movements, in which a sense of modernity and artistic renewal paradoxically coexists with a disdainful repudiation of the banality of the modern world, and a fear of the unknown with a twilight nostalgia for the legendary, the passing and irrevocably past. The enduring fascination of symbolism is its morbidity and thanatopsis, its heightened cognizance of the void that surrounds the transitory manifestations of existence, its preference for states of imagined non-being, states of suspension rather than motion, silence rather than speech, and its emphasis of the nebulous rather than the fulsome and solidly permanent. Within this poetics of detachment from life the Belgian symbolists created their own worlds suffused with mystery. With their fusions of the exterior and the interior and literary fulcrums between the seen and the unseen, the Belgian poets of the turn of the century evoked lasting zones and magnets of the poetic imagination.

Psychic Terrain in Belgian Symbolism

1. The City in Suspended Animation—The Belgian symbolists applied a life-subtracting hallucination to the sites of their homeland. Rooted in the prevailing fin-de-siècle reception of Schopenhauer's philosophy, with its insistence on the extinction of the ego and the peace of non-consciousness as a release from life's vain struggle, the symbolists conceived the world as an illusory fabric woven from myriad subjective perceptions, a weightless phantasmagoria doomed to vanish with the disappearance of its percipient. These twin themes, annihilation of the self and concomitant effacement of the phenomenal, were given expression

by the Belgian symbolists in the dead city imagery that became obsessively recurrent in poetry, prose, and the visual arts and was rapidly internationalized.[7]

Expressive of an impetus to transmute the tangible into the ideal and to effect literary imbrications of psychic states and exterior environment, the Belgian symbolist "dead" cities—Bruges, Ghent, Furnes, Malines and others—were actually urban loci remote from the rapid shift and flow of the commercial metropolis. These sites were most often canal cities of mirage that call stability into question, ambiguous Atlantides, hovering in a half-state both aqueous and terrestrial. The Belgian symbolists found in the canal city a landscape profoundly suggestive of visionary experience. The watery depths and blindly meandering passageways of the canal city provide a structural metaphor for the unconscious mind. Parallels may be drawn between a voyage in the canal city as a severance from the world, a symbolic disincarnation and descent into the underworld, and as an exploration of the tenebrous depths of the unconscious. The geographical cities were transformed into literary cities of the soul and "other worlds" by means of imagery of *estompe*, or atmospheric conditions such as incessant rain and mist that blur and enshroud the real and negate its substantial qualities, and by imagery of *attente*, arrested time. Lethargic cities of still water served the symbolists as an ideal of an interior space of stillness in which futurition halts. Progress, the obsession of the modern age, is countered by the suspended animation of a city-museum in which the present is forever fused with a legendary past or devolves into a state of lingering decline.

Georges Rodenbach (1855-1898) was a pivotal figure in Belgian letters and the first to adapt symbolist poetics of inwardness and indeterminacy to this theme, firmly rooted in experience of his native Flanders. The writer turned to Bruges not because he wished to revive the pageantry, energy, and purposefulness of the city during the days of its hegemony but because, for the Symbolist, Bruges is outside time; it belongs neither to the past, present, nor future. The medieval landmarks of Bruges linger in Rodenbach's writing as a decor of silence. The merchant's homes along the Quai de Rosaire are skeletal, the windows closed and secretive. The churches of Saint Sauveur and Notre Dame are empty, damp, and haunted with an odor of stale incense. Noiseless nuns wander the enclosures like swans, while carillon bells toll lost hours, accenting the lifelessness that is Bruges. Rodenbach's dead city is a silent city, evoked in terms of muted or absent sound, suggestive of being in its most hushed state, diminished and reduced to the threshold of non-

being. Rodenbach's literary cityscape is an experiment in the negation of life. The symbolist artist is a reverse Pygmalion, draining the city of animation.

According to symbolist convention, the atmosphere of the canal city is lethal, leading personae and reader to the breathless realms of Thanatos. The moods engendered by the dead city may be broadly categorized into two types, expressive of dichotomous attitudes toward inertia and solitude and related to experience traditionally associated with an afterlife. In its inertia, the canal city may suggest an inferno, a landscape of transfixed pain, rife with awareness of petrification, dull incarceration, and the futility of living:

Deceased are the patrician mansions,
And eternally enfolded in silence,
Lost in the frozen quarters of ancient cities,
Where the pinions caught in a motionless night,
Mourn their lost treasures in diaphanous evenings,
Which descend upon them from the fading sunlight,
Thus to adorn the tears of these ancient dwellings,
Which are like the dismal souls of vanished things,
At the quarter hour, the carillon bell languidly strews,
Its heavy flowers of iron upon the void of the streets.

—Rodenbach, from *The Reign of Silence*, 1891[8]

In its infernal mode, the dead city is a linguistic construction of suffering. Like the graphic artist Xavier Mellery, who explored *l'ame des choses*, the soul of things, Rodenbach attributes sentience to the inanimate cityscape and correlates it with his fearful mood. As typifies symbolist indirect discourse, emotive response is transposed and implicit in the admonitory object contemplated. In the following example, instead of offering the luminescence of hope, of a lighted and certain pathway, the flickering streetlamps of the canal city, assailed by wind, bespeak threatened extinction, ever-renewed and unredemptive suffering:

The Night is alone, like a beggar.
The streetlamps offer
Their yellow flame
As alms.

The Night is as quiet as a locked church.
The melancholy streetlamps
Open their rose flame,
Bright bouquets of light,
Bouquets under glass, the holy relics
That fill the Night with plenary Indulgence.

The Night endures pain!
The streetlamps in a chorus,
Dart their red and sulphurous flame,
Like votive images,
And Sacred Hearts,

with cold knives.
The Night grows inflamed!
The streetlamps in a row
Unfurl their blue flame,
Along the outskirts,
Like souls stopping for rest,
Souls of the day's dead, treading the roadways,
Who dream of return to their locked houses,
As they linger, a long time, at the city gates.

—Rodenbach, from *The Mirror of the Native Sky*, 1898

An undefined existential torment subjectively deforms the canal city into a place of expiation and a paradigm of fall without regeneration.

Conversely, the inertia of the canal city may suggest the suavity of the faded and the supernanuated. Decline is, in many symbolist contexts, the essential attribute of beauty. Throughout symbolist poetry, there is a delectation of objects and places more precious in their slow disagregation than in their original vitality. Beauty is inherent precisely in late epochs and times of day, a hovering resplendence before final annihilation. The beauty of the ancient canal city is thus valued at its most ephemeral, shadowed with mortality. Solitude in this paradisiacal context of the dead city is not fearsome, but soothing, associated with creative inwardness and a mood of narcoticized disincarnation. In Rodenbach's Bruges pleasure is not derived from existence, but from imagined absolution from existence, a convalescent repose in which harsh brightness and wounding noise are banished:

The victorious mist, against the pale depth of air,
Has diluted even the accustomed towers,
Whose grey thoughts are now gone forever,
Like some vague dream, or a geometry of vapour.

—from *The Mirror of the Native Sky*

O snow, the sweet sound, who lulls the nights,
So gentle, you, the most pensive sister of silence,
The immaculate balance in a cloak of indolence,
Preserving your pallor throughout the vespers.
Sweet! you smother and enfeeble
All of the tumult, shapes, uproar;
Wavering snow, you seem to vanish,
Far, most far away, in the haze of the streets!
And you die the death for which we have prayed,
A white end, thoughtful, pious, serene,
A pardoned death, which slowly tells
A Chaplet of wadding, a rosary of flakes,
And the end draws near: beneath its somber veils,
The sky has passed away; see how it crumbles in flakes;
The sky collapses and my heart filled with astral light,
Becomes a vast cemetery of stars.

—from *Reign of Silence*

Sweet is the room, a gentle, secluded harbour,
Where weary of stretching its sails to the wind,
My dream has come to rest in the mirror, pale and
 still.

Tired! Without longing for new headways of stars,
Departures for islands, my dream is sound asleep
In the deep mirror, as if in a silent canal;
And why hope for some sudden gust of wind to drive
To high seas, this soul anchored in the looking-glass?

—from *Reign of Silence*

Silence: it is the voice that trails, wearily,
Of the lady of my Silence, with very gentle step,
Shedding the white lilies of her complexion in the
 mirror;

Barely convalescent, she watches everything in the
 distance,

The trees, a passerby, the bridges, a stream,
Where wander the great clouds of daylight,
But who, still too feeble, is suddenly struck
With the tedium of living and a feeling of loathing,
And more subtle, being ill and half-exhausted,
She says: "The noise hurts me; have the windows
 closed."

—from *Reign of Silence*

Snow transforms the "dead city" into a void of quiescence, silencing and freezing life, reducing conceptual reality to a state of blank virtuality. Pronounced delectation of non-being is expressed in this imagery of softness, melting, as well as in the feminine personification of snow as a nun lost in a caressingly gentle death. In the paradisal context, the dead city is haunted by the veiled and virginal women, sisters of silence lost in contemplation, and the city becomes a maternal entity, in which the labyrinthine form and the ubiquitous presence of water suggest a uterine structure, a place of protective withdrawal and gestation of more pure and profound being. Exoneration from active life and its strife was embodied in a figure of will-less quiescence, the Schopenhauerian rather than the Christian nun.

Both visual artists and writers were drawn to the metaphorical possibilities inherent in the *béguinage*, the walled community of convents, a replica city enclosed within the remote city, itself enclosed within a network of canals - thus, the ultimate locus of severance and introversion. According to the symbolist stance, claustration is associated with cessation of desire and striving, with cultivation of stillness and inwardness. Rather than participation in life, remoteness from life may lead to the repletion of self-communion or the peace of self-forgetfulness:

Certainly, the cloistered dead city is a realm of speculative suicide, imagined suppression of sound and activity, conducive to reveries of metaphoric drowning and dissolution as a non-violent renunciation, a gentle effluence from the shores of life. The mirror world and the mirror world of the canal city serve the symbolists as a pre-Freudian paradigm of the unconscious. In symbolist literature, reflected images appear to rise to the surface of the "slumbering water," the *"eau dormante,"* like dream-formations coaxed to the borderline of consciousness. Recurrent imagery of submergence in water, the vertiginous depths of the canal and the mirror, implies the floating thought of a mind liberated from temporal and spatial limitations, a sleep with open eyes, lost in the unconscious processes of creativity.

The Belgian dead city thematic is an experiment in imagined suppression of purposeful waking consciousness and an examination of the oneiric landscape that results from that suppression. Whether paradisal or infernal, figuring a chrysalis, a protective space of disembodiment, or the airless closure of the tomb, the Belgian dead city is a landscape of metaphoric construction. All landscape art is necessarily subjective, infused with and revealing the mood of its creator. The uniqueness of the fin-de-siècle literary topos of the canal city is its negation of time and dematerialization of the substantial, in order to express states of symbolic non-being. Geographical cities, the most noble and prestigious of the Flemish past, are transformed into mysterious zones of solitude, an amalgamation of the material and the spiritual, a multi-faced literary space of creation and non-being.

II. The Far Reaches of Madness—Emile Verhaeren's poetic period of 1887–1895, coinciding with the exhibitions of Les XX, is steeped in decadent morbidity and reveals most emphatically the dejection of the symbolist psyche. Landscapes that are projections of spiritual inertia, hysterical anxiety, and dementia are especially prominent in Verhaeren's black trilogy, *Les Soirs* (*The Evenings,* 1887), *Les Débâcles* (*The Debacles,* 1888), and *Les Flambeaux noirs* (*The Black Torches,* 1891). Verhaeren's essential purpose in this trilogy was to suggest psychic disintegration in outsized and dissonant imagery, "hallucinating," isolating and exaggerating aspects of a given reality to the point of unreality. Verhaeren's poetry represents a pronounced expressionist tendency of Belgian symbolism. In an essay on northern painting in *L'Art moderne,* Verhaeren detailed his admiration for Matthias Grünewald's Isenheim crucifixion, its violent distortions conveying an overwhelming suffering. Verhaeren writes that

"the color of the painting seems to be made of the vinegar which soaked the henchman's sponge: it grates and screams."[9] Verhaeren conceived of the scream as central to his own artistic creation. Like Grünewald, Verhaeren manipulates startling imagery to express the darkness of the world. In his "Poet's Confession," Verhaeren defined an art of laceration, rooted in a constant recoiling from the concepts of balance and restraint:

I love the absurd, the useless, the impossible, the excessive, the intense because they provoke me, because I feel them like thorns in me and because I wish not to be afraid of their touch

I would have an art that grated and screamed life . . . and not the life of all—as the naturalists would have it—but subjective life, personal, special—scream of joy, scream of hate, what does it matter—but a scream which always comes from the depths of the being, even if the heart must burst from it, like an overheated cauldron.[10]

Ernst Cassiner has discussed this intense excitement as the mythopoeic state of mind, when external reality is not simply observed, "but overcomes the mind in sheer immediacy with emotions of fear and hope, terror or wish-fulfillment, then the sparks somehow jump across, the tension finds release, as the subjective excitement becomes objectified and confronts the mind as a god or daeman."[11] Verhaeren's art of the scream is animistic, captivated by an overpowering external reality invested with spirit. Verhaeren's verse constitutes a wandering, a voyage, a panoramic exploration of a poetic geography which concretizes alienation, estrangement from society and reality, the world as a fluctuating representation of a fearful consciousness.

Madness is elevated in Verhaeren's poetry as a liberation from the constraining bonds of rational thought and as a possibility of fabricating private worlds, congruent with the artist's subjective reconstruction of the world in the art work:

I wish to wander towards madness and its suns,
The white suns of moonlight, at high noon, bizarre.

—from "Fatal Flower," *Les Soirs,* 1887

For the surrealists, this conjunction of opposites, the possibility of the mind to conceive "white suns of moonlight at high noon" would signal a proliferation of imagery that could ultimately transform the world. In Verhaeren's writing, however, the idiosyncratic illumination of madness remains "bizarre," at once alluring and threatening, associated with a yearning for self-abolition. Thus, Verhaeren's "skeptical invalids" dream of departure for the "far reaches of hysteria," a site of orgiastic dismemberment of self and the world it perceives:

> Beyond, in the far reaches of hysteria and flame,
> And of livid froth and raucous frenzy,
> There we could ferociously rend and abolish the soul,
> Ferociously joyous, the soul and the heart.
>
> —from "The Ill," *Les Soirs*

The nihilistic impetus of this auto-cannibalism, the desire to rend the mind as an escape from the prison of reason, is amplified in a variety of spatial paradigms. "The Revolt" evokes a city disintegrating in pandemonium, at once an imaginative reconstruction of the plundering and burning of factories by the Belgian unemployed in the mid-1880s, a reminiscence of the Reign of Terror and the legendary rampage of the Dulle Griete, and a menacing prophecy of cataclysm to come. Infusing these disparate aspects of fearful destruction, the city of "The Revolt" is an exteriorization of anarchic insanity:

> Toward some remote city of riot and outcry,
> Where the guillotine flashes its shining steel,
> With a sudden, insane desire, my heart sets forth.
>
> The muffled drumbeats of many wasted days,
> Of silenced rage and suppressed storm,
> Sound, in the mind, an impetuous attack.
>
> From the black belfry, the old clock face
> Hurls its wrathful disk in the depth of the evening
> Against a stunned heaven, splattered red with stars.
>
> Tolling knells of thudding footsteps resound,
> As immense conflagrations, raging on rooftops,
> Deface all of the capitals. . .
>
> —from "The Revolt," *Les Flambeaux noirs*, 1891

Visual and auditory imagery combine to convey the incendiary upheaval. Chaos becomes eternal and time nullified in an uncanny serial metamorphosis, the clock first transformed into a furious face, then into an explosive detonation, shattering the heavens and staining them red.

As in the city of revolt, violence and distress are the emotions coalesced by Verhaeren's suffocating

London, his chosen landscape of madness, evoked as a dangerous labyrinth, always nocturnal and always without a guide. London becomes the poet's model for spiritual abandonment, the condition of a soul lost in the exitless recesses of its own involution:

> In this London of cast-iron and bronze, my soul,
> Where slabs of iron clack within shanties,
> Where sails depart without our Lady,
> Without stars, through a tepid web of chances.
>
> —from "London," *Les Soirs*

In "The Corpse," the voyage through the London soulscape is formed by the chance drifting of personified madness, "the corpse of my reason," across a stygian Thames, each stanza constituting a halt, a station of the cross of pain:

> There reigns a sadness of rock,
> Houses of brick, black turrets,
> Where the windows, mournful eyelids,
> Open to the mists of evenings.
> These are the great stockyards of panic,
> Full of dismantled ships
> And splintered masts,
> Splayed against a sky of crucifixion.
>
> —from "The Corpse," *Les Débâcles*, 1888

The conjunction of the concrete and abstract, "stockyards of panic," welds the exterior vision and the inner state of mind. The broken, splintered forms of the ships, emblems of non-voyage and paralysis, are suggestive of foundered hopes, shattered nerves and dreams. The primacy and crescendo of vision is emphasized as an implied eye moves upward in three lines, scanning ship, mast, and "sky of crucifixion." This livid twilight has many analogues in Verhaeren's apocalyptic and sanguinary Flemish sunsets, evoked in imagery of virulent disease:

> An evening overflowing with purples and red rivers
> Grows rotten far above the dwarfed planes,
>
> —from "To Die," *Les Soirs*

> Over marshes of gangrene and bile,
> Hearts of pierced stars pour blood from the depth of the sky.
> Vast black forests and black horizon
> And clouds of despair
>
> As they circle in futile voyages through the air,
> From north to south, in the closed precincts of sorrow.
>
> —from "An Evening," *Les Flambeaux noirs*

The poet's spiritual wound is manifest in the festering purulence of the horizon, stagnant marsh and sky forming mutual mirrors of pain, echoed by the pointless back and forth drifting of clouds, the landscape suggesting a world transformed into an expiatory prison. The monotonous flattened space of the Flemish planes, though seemingly limitless, is far from liberating. Like Verhaeren's London, the planes are conducive to sensations of being lost in black immensity, repetitive wandering through emptiness.

This dark Flanders is bound in an inertia that is not simply a suspension of time, but as Verhaeren's jarringly graphic imagery of corrosion indicates, a condition of mephitic stagnation. Unlike Rodenbach's evanescent interior Bruges, space of nostalgia and melancholy, Verhaeren's moribund Flanders is not a ghost of its past greatness, but a corpse in decay. As a model of universal devolution, Verhaeren evokes a cursed realm, beyond hope of redemption, where even the rain, rather than cleansing or fecundating the countryside, is relentless, punitive, and miring:

The streams through their rotten dikes,
Discharge their burden upon the meadows,
Where drowned hay drifts in the distance;
The wind slaps elder and nut trees;
Frightfully, sunk waist high in the flood,
Huge, black oxen bellow at the twisted sky.
Evening draws close, with all of its shadows,
Obstructing the planes and the copse,
While forever, it goes on, the rain,
The long rain,
Fine and dense, sodden, like soot.

—from "The Rain," *The Illusory Villages*, 1895

Aspects of this landscape that represent its observer's state of mind are not only its monotony, but its dampened, weighted abulia, the defeat of all energy, signalled by the hopelessly bellowing oxen, uncomprehending like man and their brute strength useless when faced with triumphant destructive processes.

Verhaeren confronts his reader with visions of places that are tortured or contorted to reveal the hell borne within. Anguish manifest in startling, often grotesque, imagery forms his signature:

Like severed
Hands
The leaves drift upon the pathways,
The fields and the copse.

—from "The Old Woman," *The Illusory Villages*

This vignette of autumn leaves as a shower of dismembered hands is simple and arresting. The highly visual

image, conveyed in so few words, imprints itself in the reader's mind as both uncanny and a truth—leaves do resemble hands—and the visionary dimension of leading the reader to conceive a floating myriad of mutilated hands, an unsettling valediction of autumn, is fascinating and cruel. Verhaeren shocks the reader into seeing and accepting new worlds filtered through poetic approximations of derangement. His truculent verse demonstrates that for the innovative artist, beauty is not inherent in subject matter, but in subjective ordering of vision, the orchestration of sound and image complexes, the interplay of the concrete image and the abstract states it evokes. Verhaeren was a pioneer in the modernist exploration of the excessive, a seer elaborating for his reader strange, exaggerated, and menacing territory of despair.

III. An Architecture of the Soul: Windows, Thresholds, Glass Enclosures—As a poet, dramatist, and essayist, Maurice Maeterlinck explored the ineffable. In 1889 he wrote both a collection of poetry, *Serres chaudes* (*Hothouses*), and a play, *La Princesse Maleine*. The latter created a symbolist drama and revolutionized the theater. Maeterlinck's early plays of the 1890s, *L'Intruse* (*The Intruder*), *Les Aveugles* (*The Blind*), *Pelléas et Melisande*, and *La Mort de Tintagiles* (*The Death of Tintagiles*), turn from the societal and mimetic to the interior and existential. These plays subvert the theatrical aesthetic of action with a dominant mood of anguish. The plays are characterized by silence, somnambulistic waiting and terrified awareness of death as an omnipresent and insinuative force. In the place of the sequential dialogue of conventional drama, Maeterlinck created a modernist, disarticulate language of fear and incomprehension—ellipses and uncanny repetitions of simple words and short phrases, the hesitant stammerings with which lost souls confront the shadows of death and express the ineffectuality of being.

The poems in *Serres chaudes* are also truncated utterances rife with tension between the spoken and unspeakable. In his verse, Maeterlinck accumulates, brief, highly visual pronouncements, momentary and kaleidoscopic flashes of drama, in order to evoke a mood of disorientation. Maeterlinck's longer poems are catalogues of displaced objects and conjunctions of opposites, a substitute universe of incoherence, rupture, and spiritual uncertainty.

O hothouse lost among the trees,
With your doors forever closed!
As the dead voice, whispering under your dome
Calls forth the lost days of my soul.

The thoughts of a princess, fainting with hunger,
The distress of a sailor, dreaming of waves in the
 desert,
Copper music at the windows of those who are slowly
 dying.

—from "Serres chaude," *Serres chaudes*

In their brevity, Maeterlinck's apostrophes are suggestive and open-ended. The ambiguous link between the succession of disconnected images in "Hospital"—an implied invalid's feverish desire for the coolness of fountain marble, forest, and glacier—contributes to an atmosphere of strangeness. Throughout *Hothouses*, Maeterlinck reifies the infirm soul in serial spatializations, alternating visions of hospitals, prisons and battlefields; places where being is dragged to a pained, disconsolate end:

A fountain rises in the middle of the room!
A group of little girls parts the door a crack!
I see lambs on an island of meadows!
And beautiful plants on a glacier!
And lilies in a marble hall!
There is a feast in a virgin forest!
And oriental vegetation in an ice-cave!

—from "Hospital," *Serres chaudes*

Once, there was a pitiful little holiday on the outskirts
 of my soul!
They harvested hemlock there one Sunday morning,
And all of the convent virgins watched the ships
 passing on the canal one day of fasting and
 sunshine.
While the swans suffered under a venomous bridge;
They were chopping down trees around the prison,
They were bringing medicine one June afternoon,
And meals for the sick expand over all the horizons!

—from "Soul," *Serres chaudes*

Interspersed with these poems that guide the reader through disconnected visual scenes, are more succinct poems, prayers addressed to a hidden or absent God. Teeming, mephitic visions and dejected lethargy are the modalities of the Hothouses that convey the state of a soul lost in the dark night of spiritual abandonment:

Today, my soul languishes,
Ill with distress and absence,
Diseased with darkness and silence,
And my eyes flash without horizons.

—from "Weary Hunts," *Serres chaudes*

You have seen my distress through the dark nights!
Now you know me, my Lord;

And I will carry wretched flowers from the ground
To scatter on a young corpse beneath the sunlight.

—from "Serres chaude," *Serres chaudes*

You also know my lassitude,
The dimmed moon, the black dawn,
Enrich, oh Lord, my barren solitude,
Watering it with your divine glory.

Open your pathway for me, Lord,
And light it for my weary soul,
Because the sadness of my joy
Resembles new life beneath the frozen ground,

—from "Prayer," *Serres chaudes*

Sunlight warms my pillow,
As the same hours always toll,
And my gazes will heap flower-petals,
Upon dying women who reap in the fields. . .

—from "Afternoon," *Serres chaudes*

It is the mute misery of "dying women who reap in fields" that inspired George Minne's consummate illustrations for Hothouses—fierce sun, wheat transformed into flames, figures bent like withered, failing plants, drawn downward by an overwhelming gravity to a hard, encrusted, inhospitable ground.

The dimness and solitude of the forsaken soul, its severance from the absolute, is figured by structures enclosed in glass, hothouses, bell-glasses, diving bells, crystal palaces, various transparent membranes used by Maeterlinck to define a private mental world. With its vegetation guarded by invisible yet infrangible walls, the hothouse becomes a model for the hidden, inner realm of dreams and the unconscious, which may be glimpsed but only imperfectly explored

O bells of glass!
Uncanny plants forever sheltered!
While outside the partitions, the wind stirs my senses!
An entire valley of the soul, forever motionless!
And so much mildness shut in toward midday!
And the strange images perceived through the crystal
 panes!

—from "Bell-Glasses," *Serres chaudes*

The fragile barrier of glass paradoxically defines a state of exposure and isolation; the partitions that establish a special, protective climate and prevent the incursion of the outer world upon the private realm also construct a prison. Maeterlinck's glass enclosures define a state of spiritual claustrophobia, the soul's impulse to break free of constraints, to liberate itself from the barricade of individuality and definitude and lose itself in the unknown:

Sealed within the windows of crystal
And weary melancholy,
My vague, abolished distress
Hovers in the air and slowly grows.

Vegetations of symbols,
Dismal water-lilies of past pleasures,
Sluggish palm-trees of desires,
Cold moss and slack vines.

Solitary in their midst,
A pale and rigid lily feebly
Raises its motionless ascent
Over the woeful foliage.

And in the steps of its light,
Like the moon, little by little,
Lifts up to the closed window,
A mystic, white prayer against the blue.

—from "Foliage of the Heart," *Serres chaudes*

Although defining a space of exclusion, shut off and apart, the glass-house is, nonetheless, a prison formed of a pure substance. As an architecture encasing the soul, the very immateriality and tenuousness of the crystalline scaffold constitutes a hope. The carapace may be broken; the diver may be released from his bell and feel the flow of currents. The soul may overcome hard separateness and merge in mystic marriage with eternal being.[12] The desire for abolition of individuality and absorption in the infinite is expressed in the Hothouses with imagery of purifying coolness and submersion, an assuagement of the soul's burning thirst:

I await your pure fingers upon my face,
The caresses of angels of ice,
I wait for them to bring me the ring,
I await their coolness upon my face,
Like a treasure sunk in warm water.

—from "Soul of Night," *Serres chaudes*

I await your nights, at last to see
My desire washing its face,
And my dreams in the evening bath,
Dying in a palace of ice.

—from "Amen," *Serres chaudes*

The faint hope offered the arid soul in *Serres chaudes* is denied elsewhere in Maeterlinck's work. His interior or architecture is more confining, impenetrable, and suffocating in *Fifteen Songs*, brief and folkloric verse taking the form of alternating voices, reminiscent of harvest and spinning chants. The songs are simple yet highly ambiguous in their reiteration of a spiritual search that remains always undefined, always unfulfilled, and always continued:

—You have lit the lamps,
—Oh! the sunlight in the garden!
You have lit the lamps,
I see sunshine through the chinks,
Open the doors to the garden!

—The keys to the doors are lost,
We must wait, we must wait,
The keys have fallen from the tower,
We must wait, we must wait,
We must wait other days . . .

—Other days will open the doors,
The forest guards their locks,
The forest around is ablaze,
It is the brightness of dead leaves
Which blazes on all the door sills.

—Other days are already weary,
Other days are also afraid,
Other days will never come,
Other days will also die,
And we will die here also.

—no. 12 of *Fifteen Songs*, 1900

Throughout the songs, imagery of benightedness, (blindfolded eyes, caverns, extinguished torches), imprisonment (locked doors, lost keys), and sacrifice of the meek resumes in miniature the atmosphere of debility that pervades Maeterlinck's theater. In his puppet-plays, *Princess Maleine*, *The Seven Princesses*, and *The Death of Tintagiles*, the fairy-tale paradigm of regeneration, triumphant life-force, and restoration of social order is reversed. Spaces of incarceration serve as visual metaphors for human powerlessness to overcome a dark and random fatality. Act I of *Princess Maleine* concludes in a windowless tower where a girl and her nurse have been immured, the latter prying away a stone to admit blinding light and visions of a razed city. The Grimm brothers' Maleen is a patient Griselda, who endures tests and humiliations in order to finally marry her Hjalmar. Maeterlinck's Maleine is a fragile and lost being, a martyr too pure for the world, and she is murdered by Hjalmar's father in a locked room. Spaces that allow neither entrance nor exit determine Maeterlinck's puppet dramas. In *The Seven Princesses*, an infirm king and queen and a young prince watch the deathly sleep of maidens locked in a glass room, a miasmic atmosphere in which they are barely visible in a clouded mirror. Six princesses awaken and lift, in ritual gesture, the youngest and most beautiful, dead and rigid. Countering Perrault's fairy-tale of the sleeping beauty with its celebration of sexual awakening and quickening of the world, the force of death and inertia triumphs in Maeterlinck's dramatic

reinterpretation. In *The Death of Tintagiles*, Ygraine stands at a threshold, pleading and battering an iron door, behind which her innocent brother is being sacrificed to an invisible monarch. Release from suffering in the world is impossible. Immobile yet persuasive, the puppet, rather than the actor, is Maeterlinck's chosen representative of the paralyzed human condition, an anguished fairy-tale played out in a closed theater in which effort is unavailing and destruction of the chained beings inevitable.

Three diverse artistic temperaments engaged in the literary resurgence of Belgian Symbolism, Rodenbach, Verhaeren, and Maeterlinck each cultivated a hallucinated poetics, demonstrating the permeability of inner and outer worlds. Georges Rodenbach mythicized the city of Bruges, transforming it into an underworld in suspended animation. Evoked in language suggestive of blurring and dissolution, the geographical Bruges becomes the "grey city," a wavering dream. Emile Verhaeren's inner panic scream reverberates in literary distortions of northern cities and the Flemish countryside, transformed into empty vastitudes lit with the incendiary light of frenzy. Maurice Maeterlinck's glass structures, blue and green-tinged spaces of delving and narrowing, of peering in and peering out, are alembics of visions that deny the certitude of a world subject to vertiginous transformation. Five lines may suggest five disconnected, yet synchronous worlds:

They were giving alms on a sunny day,
People harvested at the bottom of the crypt,
There was the music of mountebanks all around the
 prison,
There were wax figures in a summer forest,
Elsewhere, the moon mowed down an entire oasis.

—from "Touches," *Serres chaudes*

The Belgian symbolist poems are vessels of passage to visionary realms, interweavings of mood and place. It is, therefore, not surprising that boats figure emblematically in the works of the three writers. The quiet and introversion of Rodenbach's Bruges is exemplified in his image of the anchored boat, lulled, purposeless, forever at rest in the mirror space of the canal. An anguished solipsism is evident in Verhaeren's imagery of damaged ships, splintered masts blazoned as crucifixes against the sky, signs of emotional tension and defeat. Displaced ships, warships on ponds, ocean-liners on canals, designate the doubtful world of Maeterlinck's Hothouses. The Belgian Symbolists, mystics divorced from traditional religiosity, were engaged in a quest for a new mystery, the non-determinism of the mind. They sought to enlarge our experience with images, the means of descending into the depths of the mind where reality is infinitely malleable and an infinitude of worlds are possible.

Notes

1. The discussion of the stylistics of Belgian symbolism in this section is based on the introduction to Friedman, *Belgian Symbolist Poets*.

2. Remouchamps, "Le Monde Intérieur," 25.

3. Verhaeren, "Le Symbolisme," 115-118.

4. Mallarmé, "Réponses á des Enquêtes," 869.

5. Maeterlinck, "Serres chaudes."

6. Rodenbach's evocation of the Ursula reliquary serves as an "art poétique" on the modality of subjective landscape. The martyrs' calm acceptance of death spills over into the vernal landscape, formed by their inner joy; "Voila pourquoi la paix, qui régnait déjà en elles, se propageait jusqu'an paysage, l'emplissait de leur âme comme projété," Rodenbach, *Bruges-la-Morte*, 80.

7. For discussion of the international repercussions of the Belgian dead city thematic see Friedman, symbolist *Dead City*.

8. All translations are from *Anthology of Belgian Symbolist Poets*. For recent editions of the poetry of Rodenbach, Verhaeren and Maeterlinck see: Rodenbach, *Oeuvres*; Verhaeren, *Les Villages Illusoires*; Maeterlinck, *Oeuvres*.

9. Verhaeren, "Les Gothiques Allemandes," 259.

10. Verhaeren, "Confession de Poite," 9–16.

11. Cassirer, *Language and Myth*, 331.

12. While conceiving the *Serres chaudes* poems, Maeterlinck was engrossed in the works of the 14th-century Flemish mystic Ruysbroeck and translated his *Ornament of the Spiritual Espousals*. Ruysbroeck discusses the stages and experiences of the mystic union of the soul with God, including the trial of spiritual abandonment that he details in imagery of withering heat, evil visions, physical illness, and lethargy; this union is recurrent in Maeterlinck's poem cycle. Maeterlinck's translation and introduction have been recently re-edited: *L'Ornement des Noces Spirituelles de Ruysbroeck L'Admirable*. For cogent discussion of unificative mysticism and the phase of spiritual aridity, see Underhill, *Mysticism*. Experiences of being shut off, encased in glass, things seeming out of focus and unreal are reported in Guntrip, *Schizoid Phenomena*.

Color Plates

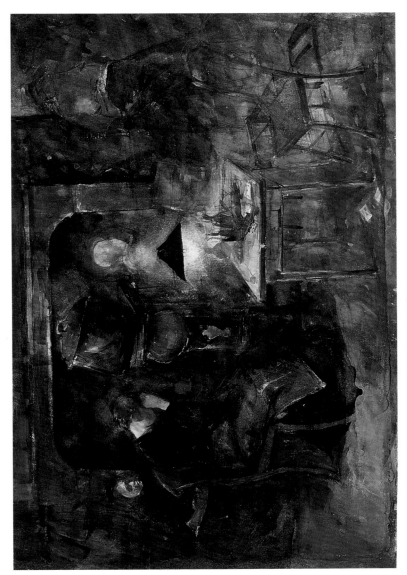

PLATE 1. Jan Toorop, *Interior*, ca. 1885 [catalogue 124].

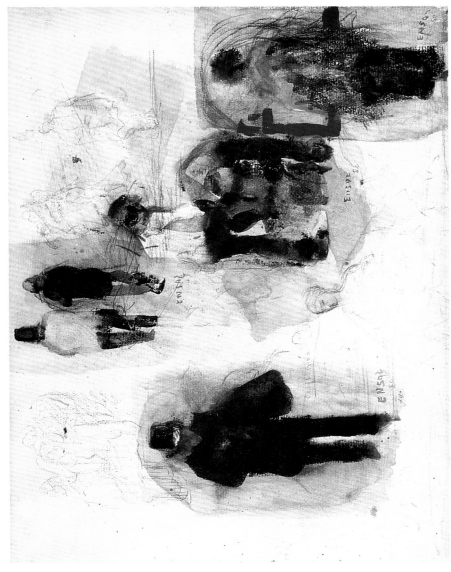

PLATE 2. James Ensor, *Silhouetten (Silhouettes)*, 1880 [catalogue 18].

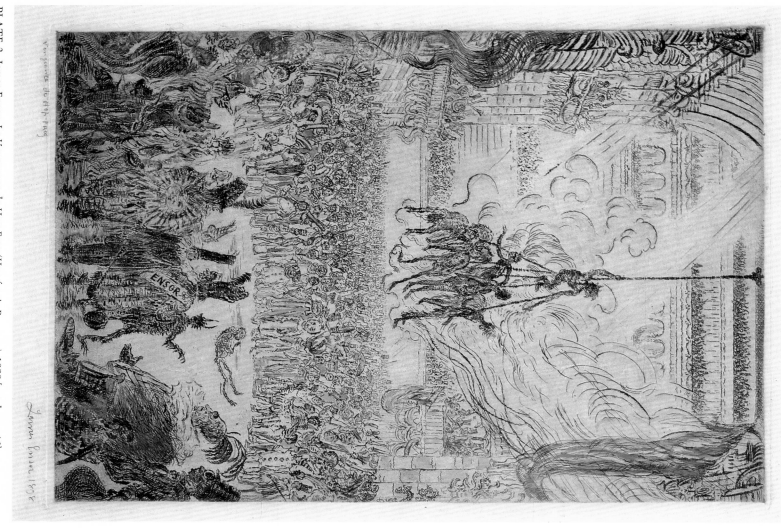

PLATE 3. James Ensor, *La Vengeance de Hop-Frog (Hop-frog's Revenge)*, 1898 [catalogue 46].

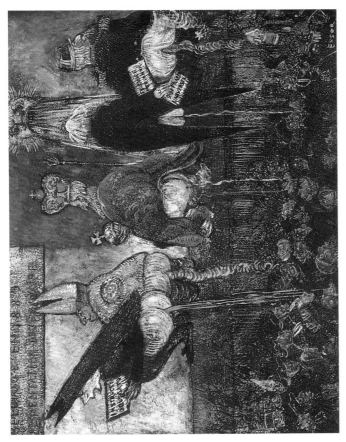

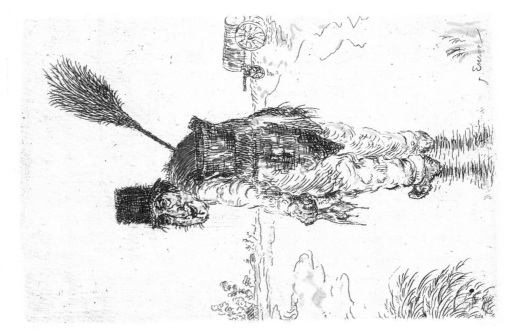

PLATE 4. James Ensor, *Alimentation doctrinaire (Doctrinal Nourishment)*, 1895 [catalogue 38].

PLATE 5. James Ensor, *Le Vidangeur (The Scavenger)*, 1896 [catalogue 43].

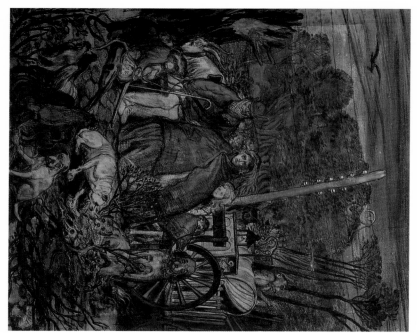

PLATE 7. Henry de Groux, *Les Errants* (The Wanderers) or *Les Gitanos* (Gypsies), ca. 1889 [catalogue 5].

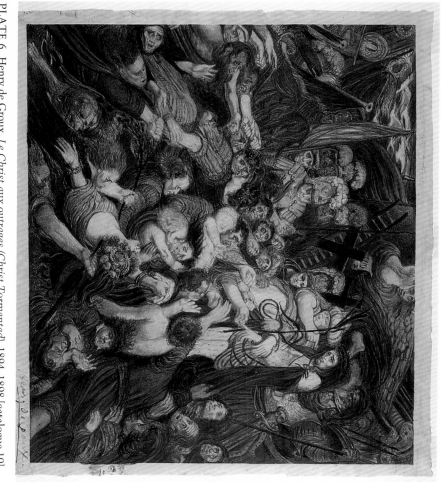

PLATE 6. Henry de Groux, *Le Christ aux outrages* (Christ Tormented), 1894–1898 [catalogue 10].

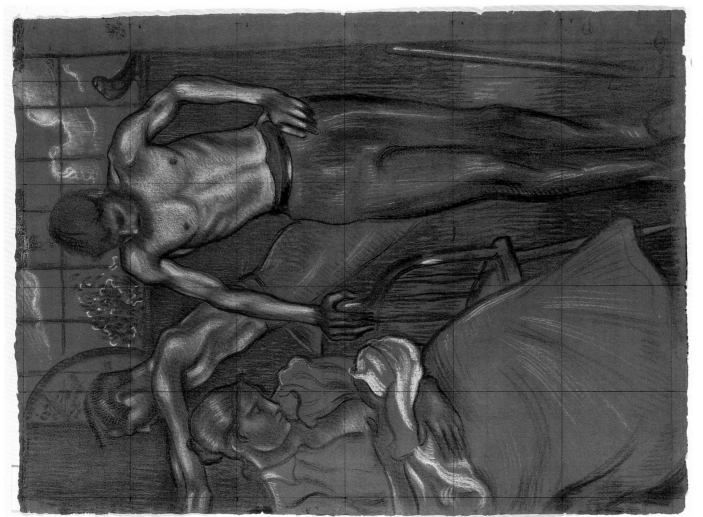

PLATE 8. Georges Lemmen, *La Famille des travailleurs* (*Family of Workers*), 1897 [catalogue 74].

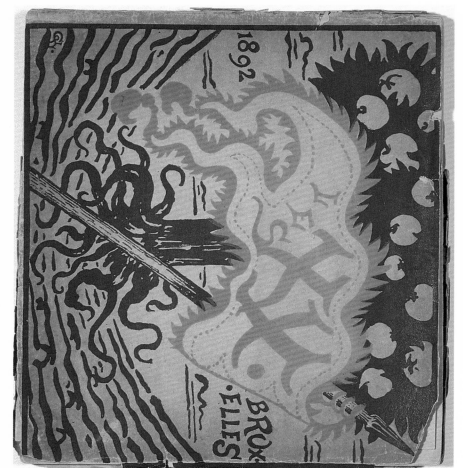

PLATE 10. Georges Lemmen, 1892 Les XX catalogue cover [catalogue 69].

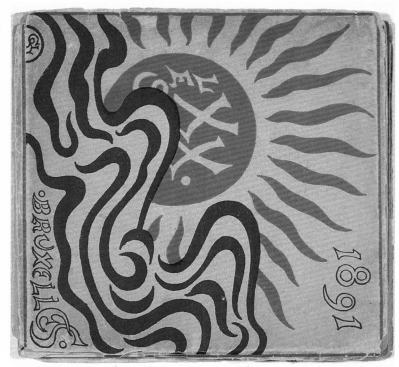

PLATE 9. Georges Lemmen, 1891 Les XX catalogue cover [catalogue 68].

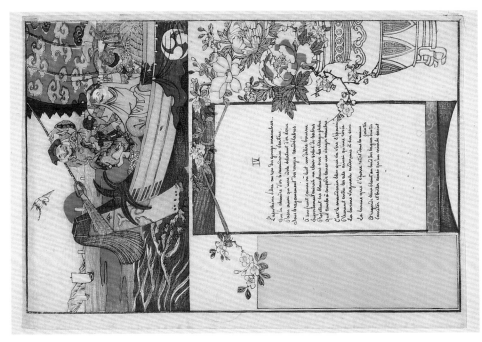

PLATE 12. Max Elskamp, fourth poem from *L'Éventail japonais* (*The Japanese Fan*), 1886 [catalogue 15].

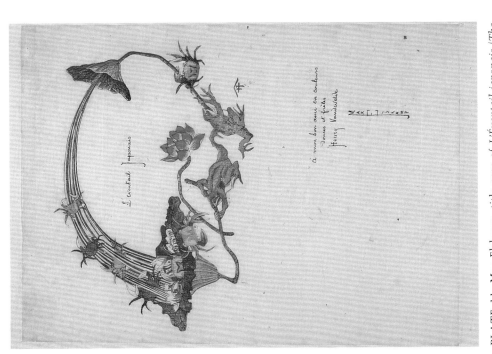

PLATE 11. Max Elskamp, title page of *L'Éventail japonais* (*The Japanese Fan*), 1886 [catalogue 14].

PLATE 13. William Degouve de Nuncques, *Effet de nuit* (*Sensation of Night*), 1896 [catalogue 4].

PLATE 14. Fernand Khnopff, *Souvenir de Bruges. L'Entrée du béguinage* (*Memory of Bruges. The Entry to the Béguinage*), 1904 [catalogue 62]

PLATE 16. Fernand Khnopff, *Avec Grégoire Le Roy. Mon coeur pleure d'autrefois* (*With Grégoire Le Roy. My Heart Longs for Other Times*), 1889 [catalogue 56].

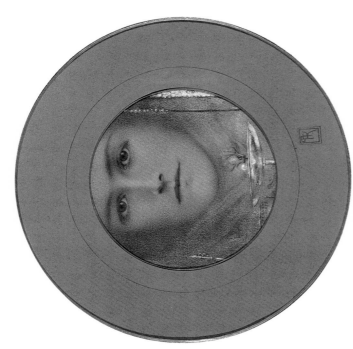

PLATE 15. Fernand Khnopff, *Les Yeux bruns et une fleur bleue* (*Brown Eyes and a Blue Flower*), 1905 [catalogue 63].

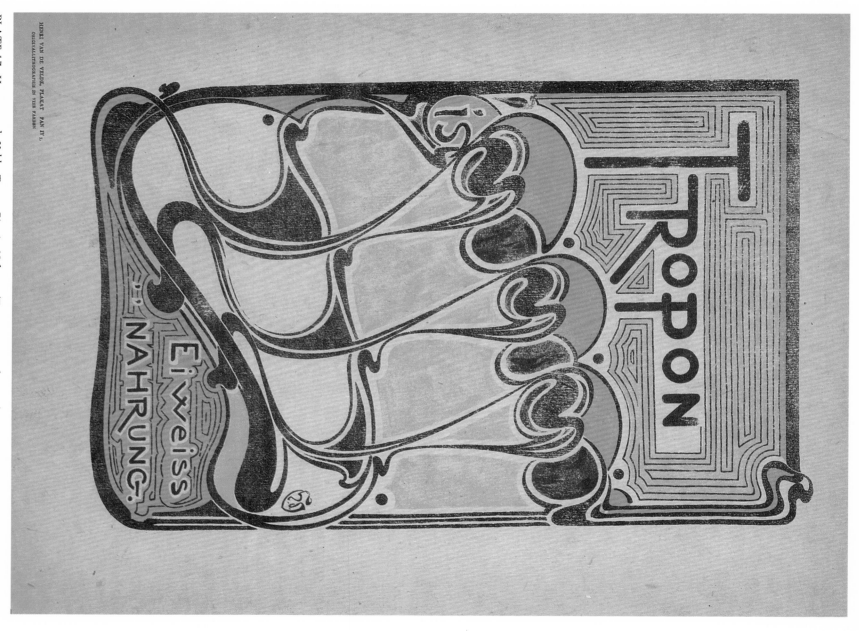

PLATE 17. Henry van de Velde, *Tropon Eiweiss Nahrung* (Tropon, Nourishment from Eggwhite), 1898 [catalogue 141].

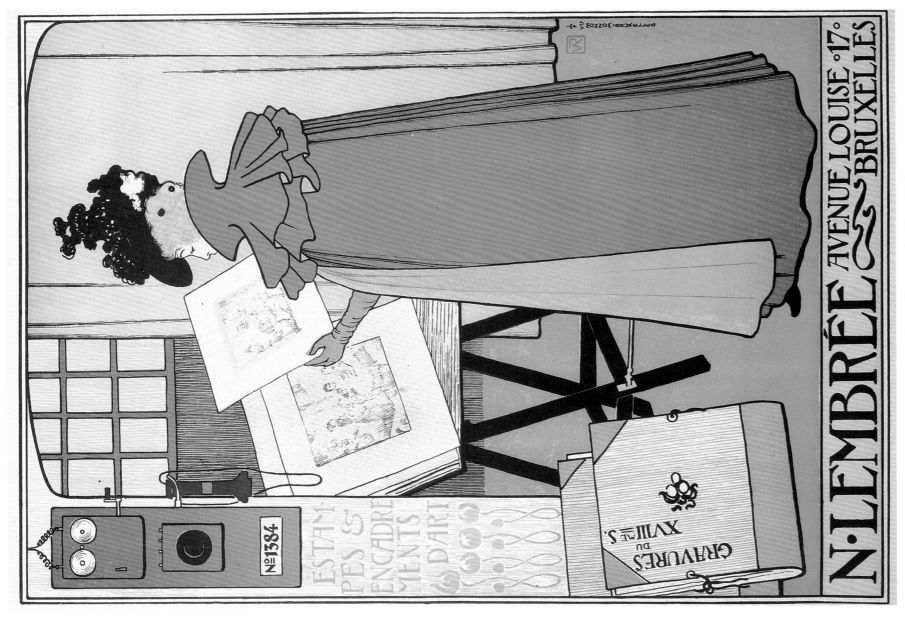

PLATE 18. Théo Van Rysselberghe, poster for the Lembrée Gallery, 1897 [catalogue 152].

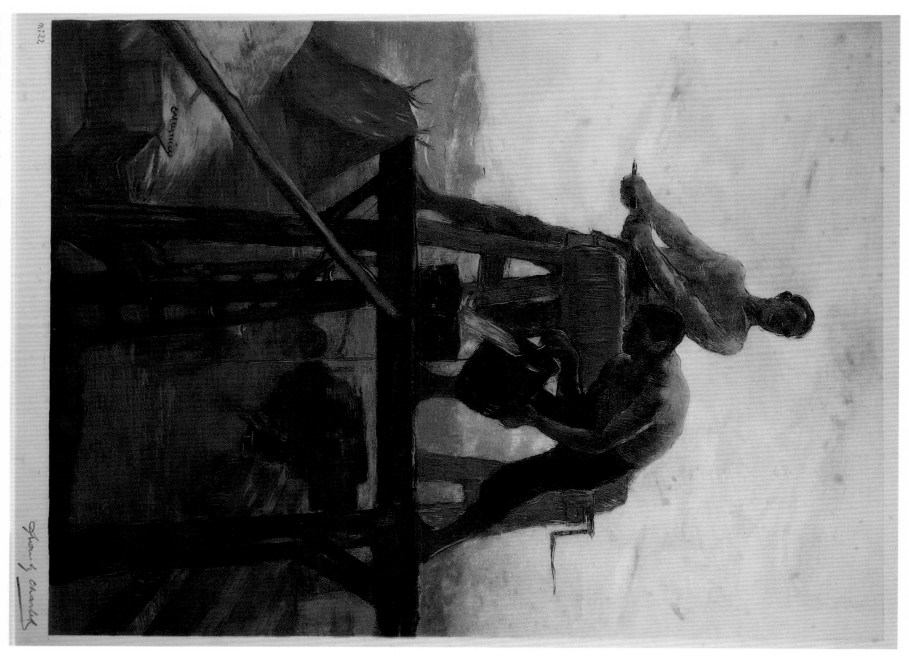

PLATE 19. Frantz Charlet, after pastel by Constantin Meunier, *Le Puits, briqueterie* (*The Shaft, Brickfields*), after 1885 [catalogue 3].

Catalogue

Measurements are given in millimeters, height before width. Dimensions given with prints, drawings and photographs are the size of the image; those with etchings are the plate size; full sheet size is given for posters, and page size for books.

Catalogue raisonnés are cited in shortened form (Cardon; Delevoy, De Croës, Ollinger-Zinque; Exteens; Ferniot; Kornfeld & Wick; Rouir; Taevernier; Spaanstra-Polak) and the endnotes contain short titles; complete information is provided in the bibliography.

1

Anna Boch
Drawing for 1888 Les XX Catalogue, ca. 1888
Pen and ink on paper
190 x 135
Private Collection, Madrid

THE 1888 catalogue for the annual Les XX exhibition was a pamphlet of modest scale that, nonetheless, was soon recognized as startlingly innovative. The red cover was unusual and bore only the group's monogram, designed by Fernand Khnopff, in the upper left-hand corner.[1] Each artist supplied one page to be reproduced in the catalogue. Many of the artists, including Anna Boch, supplied an address, a list of exhibited works, and a drawing [see also cat. 50 and 91]. The secretary of Les XX, Octave Maus, wrote a brief essay on the search for light in painting; it also was reproduced from his handwritten text. The manuscript materials were printed by photomechanical relief or 'line block'.

The drawing submitted by Vingtiste Anna Boch shows a scruffy figure standing at what could be a street corner in the working class *Marolles* section of Brussels, reading a list of Boch's paintings as if it were a poster with public information.[2] On the one hand this gesture puts art in the streets, as espoused by the Section d'art of the Belgian Workers' Party. On the other hand, her posted address, No. 1, Avenue de la Toison d'Or (Avenue of the Golden Fleece) is a quintessentially upper-class location. Edmond Picard's exclusive gallery, La Maison d'art, was also located in his house on the Toison d'Or. This apparent lack of contradiction between populist motives and patrician identity is a common element that ran through much of the Belgian avant-garde.

—S.G.

1. Madeleine Octave Maus, writing in 1926, noted that the "*catalogue à couverture rouge*" was especially sought after by collectors: *Trente Années*, 68.

2. Boch was a prolific painter, but she was not a printmaker, and examples of her graphic art are uncommon. For Boch, see especially Faider-Thomas, "Anna Boch" and Saarland-Museum, *Anna Boch und Eugène Boch*. See also La Louvière, Musée des Arts et Métiers, *Anna & Eugène Boch*; La Louvière, Salle Communale des Expositions, *Boch*; de Heusch, *L'Impressionnisme et le Fauvisme en Belgique*, 108.

2

Frantz Charlet
Pêcheur (Fisherman), 1885
Black chalk on paper
Musée d'Ixelles, Octave Maus no. 207
535 x 400

INSCRIBED: A mon cher Maus/XX jours de retard [m]ais avec/XX fois plus de Coeur/Frantz Charlet 85 Knocke (To my dear Maus/XX days too late but with/XX times more heart/Frantz Charlet 85 Knocke).

Like many of his fellow Vingtistes, Frantz Charlet was trained in the realist tradition that emphasized direct observation and attention to descriptive detail. Charlet had studied with Jean-François Portaels at the Brussels Academy and then in Paris at the private studios of Jules Lefèvre, Carlos Duran and Léon Gérôme. In the early 1880s Charlet made trips to Spain, Morocco, and Holland, where he executed numerous paintings notable for their lighting effect and subtle color harmonies. During these travels Charlet also made numerous drawings that he exhibited along with his paintings at the Cercles Artistique in Ghent and Brussels and with Les XX.

This sketch is typical of Charlet's drawing technique. Using deft, quick strokes Charlet renders his model, a fisherman from Knokke, in a modeled chiaroscuro. Charlet's figure is isolated on the paper, free from any anecdotal context. The fisherman appears lost in thought, legs apart, one hand resting on his belt, the other holding a smoking pipe. To the right the artist has drawn a smaller study of the man's head. Both drawings appear to be quick sketches, perhaps in preparation for a painting.

Charlet played an important role in the founding of Les XX. He accepted the position of secretary when the group formed, but soon realized that this responsibility would take too much time away from his artistic career and so he resigned; the position was then given to Octave Maus. Charlet pays homage to Maus in this drawing by incorporating the double X emblem of Les XX within his dedication. —S.C.

3 [Plate 19]

Frantz Charlet, after pastel by Constantin Meunier
Le Puits, briqueterie (*The Shaft, Brickfields*), after 1885
Color etching and aquatint
Spencer Museum of Art, Gift of Maurice Tzwern and Philippe Aisinber, 91.41
714 x 556

IN 1885, Octave Maus invited Constantin Meunier, already well-known to many Vingtistes, to join the group.[1] Meunier declined the honor, stating that while he preferred to maintain his independence, he would be supportive of Les XX and would exhibit with them on a regular basis.[2] Several of the members then suggested the artist be approached to exhibit as an *invité*.[3] In his first installation at a Les XX salon, Meunier exhibited his pastel *Le Puits, briqueterie* and eleven other works, including the first of his labor-inspired sculptures.[4]

The pastel and the color etching and aquatint Charlet later produced from Meunier's image depict two workers drawing water from a well in order to mix it with the clay. Set almost against the picture plane and nude to the waist in poses that enunciate their straining muscles, the brickmakers are silhouetted against a drab skyline.[5] In the background a pile of finished bricks lies on one side and on the other are the make-shift huts used for the drying and firing necessary in the brickmaking process.

The sketchy style and subtle coloration, typical of many of Meunier's pastels (see cats. 96 and 99), as well as the monumental proportions of the drawing, were captured exactly in Charlet's color etching and aquatint. The blood-red area edged in green pastel enlivens the foreground, while the yellowy ochre of the huts is balanced by the blues and darker hues of the laborers' pants.

The homage Charlet paid to Meunier in this etching appears to be unique. Its existence raises more questions than it answers. It is not known when Charlet made this print, what its purpose was, or even why he chose this particular pastel, except, perhaps, to document Meunier's first exhibition with Les XX. Its large format suggests, however, that it was produced for print collectors.[6] Since neither Charlet nor Meunier were printmakers, this etching thus remains enigmatic.

—S.L.

1. Meunier was commissioned in 1883 to copy *Descent from the Cross* by Pieter Kempeneers (1503-1580) in Seville, Spain. During the nearly ten months he spent in Spain Meunier was visited by and traveled with Darío de Regoyos, Frantz Charlet, and Théo van Rysselberghe.

2. MRBA, AAC #4684 Les XX, dossier 1885: Meunier wrote to "refuse d'être membre des XX, mais expose avec empressement comme invité." Meunier exhibited with Les XX in 1887, 1889, 1892 and with La Libre Esthétique each year from 1894 through 1903. Meunier's stature in the Vingtiste circle was acknowledged in detail by Madeleine Octave Maus, who wrote a lengthy discussion of him in her synopsis for the 1885 exhibition; see Maus, *Trente Années*, 32-34.

3. MRBA, AAC, dossier 1885, letters #4680 and #4684: Following Meunier's refusal to become a member, Jean Delvin and James Ensor were among the artists who wrote to Maus asking that Meunier become an invited participant.

4. The pastel is now housed in the Musée Constantin Meunier, Brussels. In addition to the works listed in the catalogue for the 1885 installation of Les XX, Meunier installed *Le Gardien de feu*. See Brussels, Centre International pour l'Etude du XIXe Siècle, *Dix expositions annuelles*, 55.

5. For an analysis of heroic nudity in sculptural representations of the working class in late nineteenth-century art, see John Hunisak's crucial article "Images of Workers," 52-59.

6. During the course of his career, Meunier was commissioned on a number of occasions to provide drawings for illustrations for books. Among the most notable of these are the more than twenty illustrations he created for Camille Lemonnier's books *La Belgique* (1884), *Le Mort* (c. 1882) [see cat. 95], and *Au Pays noir* (c. 1896). For this latter project, Meunier's son Karl transformed a series of eight drawings into etchings. Karl Meunier's etchings were exhibited at the final Les XX exhibition. Meunier also provided a drawing to Jean Grave's anarchist journal *Les Temps nouveaux*. This drawing, *Mineurs, borinage*, subsequently was published as the thirteenth print in that journal's print portfolio [see cat. 98].

4 [Plate 13]
William Degouve de Nuncques
Effet de nuit (Sensation of Night), 1896
Pastel
Musée d'Ixelles, Octave Maus 44
492 x 667

DEGOUVE'S art is one of simplicity and suggestion, emphasizing intuition and sensation rather than delineation of form, and creating an intensification of mystery with intimate scale. As in Whistler's more extroverted nocturnes where gradations of selected monochromes merge in indeterminate, musical effects, in this meditative pastel Degouve achieved luminously melting harmonies of chill blue and dimmed green.

An essential aspect of the symbolist aesthetic is the denial of concreteness, considered inimical to mystery. Rather than realistically depicting the scattered houses and trees, Deguouve blurs and dissolves their material presence, inducing sensations of disembodiment in the viewer, penetrated by the yielding, dream-laden atmosphere of the scene. Intangible and elusive, glowing yet subdued, the moonlit landscape has a distant, seraphic quality, as if glimpsed through a window during a voyage. Like Fernand Khnopff's monochrome pastels of Fosset in the Ardennes, Degouve's landscape is the embodiment of mood, the juncture of a fleeting atmospheric condition and the vague melancholy it evokes. Degouve's nocturnal "effet" reveals the evanescence of the world. —D.F.

5 [Plate 7]

Henry de Groux

Les Errants (*The Wanderers*) or *Les Gitanos* (*Gypsies*), ca. 1889

Chalk, ink, and gouache, laid down on cardboard

Musées royaux des Beaux-Arts de Belgique, 6302

873 x 725

LEADING up to his discussion of de Groux's *Les Ventanges* [cat. 9], Léon Souguenet mused, "Here is the exodus of people pursued by misery. For a long time de Groux has seen them wandering desperately from misfortune to misfortune, the *Tribus errantes* who will find no permanent place to rest."[1] Migrant families, wanderers, the displaced, immigrants, and Gypsies were not an uncommon sight following the first wave of industrialization at the end of the nineteenth century. De Groux very probably did witness wandering homeless families at first hand, although their most intense period of mobilization in Belgium appeared after the general strikes of 1893 [see cat. 151], well after *Les Errants* was drawn.[2]

De Groux was well known for his pastels, and this one in particular has generally been recognized as one of his major works in the medium. It is surprising, therefore, that in the list of his oeuvre published in the special 1899 de Groux issue of *La Plume* there is no work titled *Les Errants*. Several works from this list of 82 pastels appear to be of similar subjects, however:

Caravane au désert (Desert Caravan), *Les Emigrants* (The Immigrants), *L'Exode* (Exodus), and *Les Gitanos* (Gypsies). It is possible that, as the wandering homeless was a popular theme for literary and pictorial works of art, *Les Errants* was simply adapted as a convenient title for the uninscribed work.[3] Given that the attributes of the family include a violin, a gas lamp hanging from an elegant wrought iron console, a covered wagon, dogs and trained monkeys, this pastel is presumably de Groux's *Les Gitanos*.[4] If so, one would expect some indication that this is not an isolated family, but part of a caravan, and in the background near the blasted tree to the left there is another horse-drawn wagon passing by.

As Danielle Derrey-Capon has recently noted, the snagged kite seems to be an analogy to the evident freedom of the wanderers who nonetheless face daily pitfalls.[5] It is also appropriate that the kite is snagged in a telegraph line, whose prominence in the landscape evokes the encroachment of industry upon the countryside, the ownership of which the Gypsies do not acknowledge.

—S.G.

1. *La Plume*/de Groux, 220: "Voici l'exode des peuples pourchassés par la misère. Il y a longtemps que de Groux les voit pérégriner, désespérées, de malheur en malheur, les *Tribus errantes* qui ne découvriront nulle part le lieu du définitif repos."

2. Busine, "Jules Destrée et Henry de Groux," 77, dates the drawing to 1889 on the basis of a nearly identical composition in a sketchbook of de Groux's of this date (Musée Destrée, Charleroi).

3. The earliest use of the title *Les Errants* for this work, so far as I know, is in Schmitz, M, *Henry de Groux*, plate 7.

4. In a letter to the author, Rodolphe Rapetti has concurred with the identification of the pastel as *Les Gitanos*. Rapetti added that it was exhibited in de Groux's studio in 1890.

5. Lambrechts, *Fin de Siècle*, 108.

6

Henry de Groux
Le Monstre ploutocratique (The Plutocratic Monster), ca. 1890
Lithograph
Bibliothèque Royale Albert 1er, Cabinet des Estampes
Plano SIII 106326
237 x 325
Ferniot 48

DE GROUX made two lithographs on the theme of plutocracy or political rule by the rich. The first, simply titled *Ploutocratie (Plutocracy)*, is generally considered a study for the second.[1] It shows a fat, crowned lion (symbolic of kingship) curled up on a pile of coins. In the second version, *Le Monstre ploutcratique*, the animal has metamorphosed into a swine-snouted lion. Two torches emblematic of truth, and perhaps leadership, have been added; they lie dangerously on the ground among the coins. The crown now resembles a papal tiara surmounted by a cross, and decorated with a fleur-de-lis, emblem of French royalty.[2] Whether this image was inspired by specific events, such as the return of royalist sympathizers to power after the Paris commune of 1871 or the Dreyfus affair, is difficult to say. However, the symbols de Groux used remain general enough to give this allegory a universal relevance to the theme of oppression by greedy temporal and spiritual authorities.

—S.G.

1. Illustrated in *La Plume*/de Groux, 204, and in Estrada, *Salon de la Plume*, fig. 93 (discussion, 181).

2. Baumann, *Henry de Groux*, 108, incorrectly identifies the beast as a pig-snouted dog. The fleur-de-lis, which is difficult to discern, is on the front of the crown toward the top. The emblem on the very top could be either another fleur-de-lis or a cross, but close examination suggests the latter. Estrada, 181, has also noted the resemblance of the crown to a papal tiara. The crown in the first version of the composition resembles a priest's biretta.

7

Henry de Groux
Une Séance à l'Académie—Pégase chez l'équarrisseur
(*A Meeting of the Academy—Pegasus at the Glue Factory*), ca. 1892–3
Lithograph
M 3533
178 x 187
Ferniot 46
Fogg Art Musuem, Harvard University Art Museums, Gift of Paul J. Sachs,

IN Greek mythology the winged horse Pegasus once scratched the ground with his hoof, creating a spring that became sacred to the muses. For this reason, Pegasus is often closely associated with the arts. Under the title of "A Meeting of the Academy" de Groux parodies the myth to vent his wrath at officialdom. The print shows an emaciated and dying Pegasus tethered in the bone yard of a knacker (someone who sells the hides and flesh of animals). De Groux's image refers to the wasting away of the arts when they are under the control of the Academy. In the upper left a lyre hangs from the shed like a signboard, perhaps referring to Orpheus who charmed the animals with his playing of this instrument.

According to Rodolphe Rapetti, the conception of this image goes back to 1888, when de Groux wrote to William Degouve de Nuncques about his plans to make a lithograph, *Pégase sous le joug* (*Pegasus under the Yoke*), after Schiller's similarly titled poem, "Pegasus in der Dienstbarkeit."[1]

Rapetti also cites a page from de Groux's journal, February 12 1892:

Conception of a *Pégase chez l'équarrisseur*: a poor thoroughbred, completely exhausted, terrified to be without his blinders, and walking, panic stricken, on the bloody tiles . . . A poor beast, broken kneed, a sagging spine, skin eroded by contusions . . . A sort of dreadful evocation of poetry insulted.[2]

To the right of Pegasus is a sign inscribed "KOPPE Sr / GREART / ECARRIZEUR." The first two are intentionally mangled spellings ("ecarrizeur" is also intentionally misspelled) of the names of the literary figures François Coppée and Octave Gréard. As Rapetti has pointed out, both of these figures were bureaucratic functionaries, and the "Sr" is presumably an abbreviation for "Successeur," meaning "Coppée, successor of Gréard."[3] Indeed, Octave Gréard was appointed vice rector of the Paris Academy in 1879, and Coppée was elected a member of the Academy in 1884.[4]

—S.G.

1. Rapetti, "Bloy et de Groux," 379. Schiller, *Schillers Werke,* 1:230-32.

2. Rapetti, 379: "Conception d'un *Pégase chez l'équarrisseur*: une pauvre bête de race absolument fourbue, épouvantée d'être dépourvue de ses oeillères, et promenant sur le carreau sanglant une terreur panique . . . Une pauvre bête, aux genoux couronnés, à l'échine fléchissante, au poil raréfié par les contusions . . . Une sorte de terrible évocation de la *Poésie outragée.*"

3. Rapetti, 379, and in a letter to the author. Rapetti also suggests that this inscription was of Bloy's design, since de Groux rarely included such specific references in his work. There are two references to Gréard and over sixty to Coppée in Bloy's collected works, see Bloy, *Oeuvres,* 360, 372.

4. Rapetti, 379, and in a letter to the author.

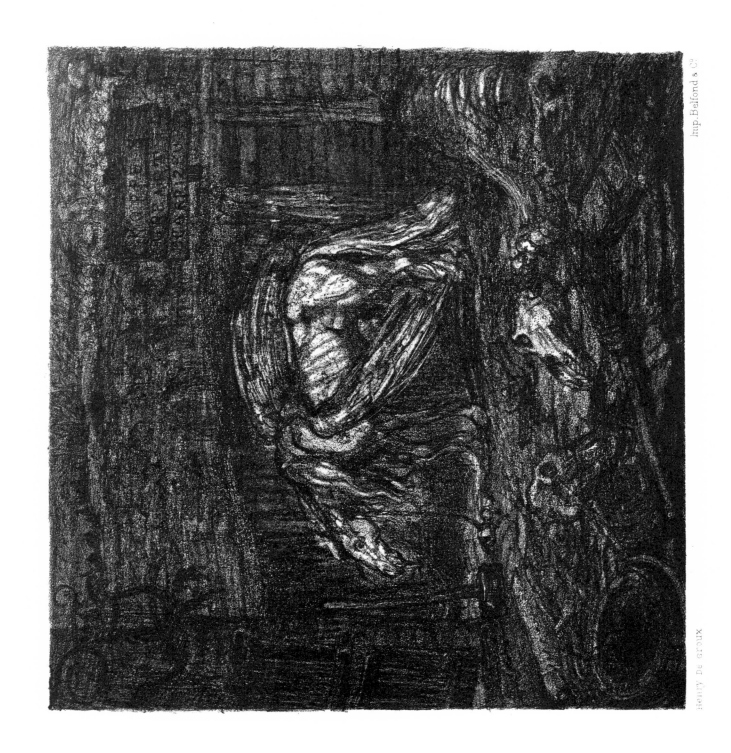

Imp. Belfond & C°

Henry de GROUX

8

Henry de Groux
Quand les bourgeois dorment dans leurs lits (When the Bourgeois Sleep in their Beds),
ca. 1893
Lithograph
171 x 206
Ferniot 50
The Metropolitan Museum of Art, Harris Brisbane Dick Fund, 26.92.14

"YOU don't know what a battlefield it is—the night—while the bourgeois sleep in their beds. It is something, sir, about which Dante never spoke."[1] So begins the narrative of Léon Bloy's short story "Le Fossoyeur des vivants (The Burier of the Living)," in which a poor soul lives out a nightmare in streets that are littered with the carnage of a battle in which the living and the dead intermingle. This story appeared in Bloy's collection of stories based on the Franco-Prussian war, *Sueur de Sang (Sweat of Blood)*, published in 1893. De Groux supplied several lithographs to illustrate these stories, including this one, though only the center of the composition was printed in the book.[2]

It is significant that de Groux used the beginning of this passage, "while the bourgeois sleep in their beds," which has political connotations, as the title of his lithograph. In the book, however, the title for the image is taken from the end of the passage, "It is something, sir, about which Dante never spoke," which effectively neutralizes a political reading.[3] This aggravated de Groux, who wrote to Bloy that the printer had "taken it upon himself to have the inscription of 'the Burier,' 'while the bourgeois sleep in their beds' deleted, leaving only the chapter's title and number!"[4]

—S.G.

1. "Le Fossoyeur des vivants," *Sueur de Sang*, 146: "Vous ne savez pas ce que c'est qu'un champ de bataille, la nuit, quant les bourgeois dorment dans leurs lits. C'est une chose, monsieur, dont le Dante n'a point parlé."

2. Bloy and de Groux, *Correspondance*, 86, 31 August 1893: "cliché de mon portrait et les 3 cuivres: portrait, *Salamandre* et *Fossoyeur* (photographic negative of my portrait and the three copper plates: portrait, *Salamandre et Fossoyeur*)" that were with the printer Delâtre. This would suggest that the book illustrations were photogravures made after the lithographs, or simply metal-plate lithographs.

 See also 77, 18 August 1893. In this context "agrandissement" would appear to refer to a re-working of the image, not to a photographic enlargement.

 Marcel Schmitz, lavishing excessive praise on de Groux, singled out this lithograph as one of the artist's best, claiming that in its horror it surpassed all other prints, with the exception of those by Goya: Schmitz, M., *De Groux*, 21.

3. The inscription reads, in full: "C'est une chose, Monsieur, dont le Dante n'a point parlé/ Le Fossoyeur des vivants ch. XIII."

4. Bloy and de Groux, *Correspondance*, 29, 22 August 1893: "Delâtre est allé ce matin trouver Ory pour lui montrer les épreuves de la Salamandre et du Fossoyeur et il se trouve qu'il a pris sur lui de faire supprimer la légende du Fossoyeur 'Quand les bourgeois dorment dans leurs lits,' en ne laissant que le titre et le numero du chapitre!"

 The title as it appears in the book is also used in the text of the special *La Plume*/de Groux edition, 244, but the list of lithographs in the journal names this as an error and gives the true title as *Quand les bourgeois dorment dans leurs lits*, 287; De Groux presumably pointed out this error, 244, 287.

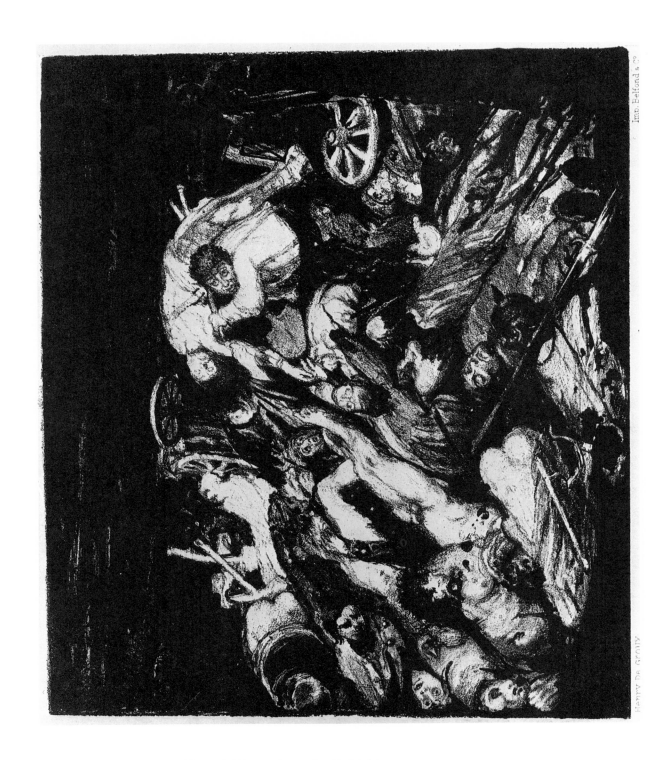

Imp. Belfond & C⁰

Henry De Groux

9

Henry de Groux
En route (*On the Way*), ca. 1894
Lithograph on Chine collé
Bibliothèque Royale Albert 1er, Cabinet des Estampes, Plano SII 87227
228 x 331
Ferniot 18

EN ROUTE is one of several lithographs that derive from parts of the painting *Les Vendanges* (*The Vintages*), begun by de Groux as he was preparing to leave Brussels for Paris.[1] These lithographs were meant to be part of a series of portfolios, also called *Les Vendanges*, each of which would feature a text by Léon Bloy and a lithograph by de Groux. Emile Baumann described de Groux's apocalyptic painting:

Before an immense facade of a burning palace—smokey flames curving like the trunks of fantastic palms—the victims line up in their shirts (kings, queens, bishops, priests), all representing legitimate rule; in the middle impaled figures and victims of hangings are bound together upon a pyre; and before is the epileptic populace, women brandishing swords or waving heads on the tips of pikes, carts heaped with broken furniture, cadavers stretched out among casks near a great crucifix laid down on the ground, all variety of ignoble disorder, sadism, demoniacal rage and the horror of revolutions.[2]

Only one issue of *Les Vendanges* was printed, "La Vigne abandonné" ("The Abandoned Vine"). (The text of Bloy's poem in this issue appears in his diary on 8 March 1894.[3]) This was accompanied by de Groux's lithograph of the Crucifixion amidst a swarming crowd of beasts and people illuminated by a beacon of light from the Eiffel Tower, emphasizing the timelessness, or perhaps the modernity, of human suffering [fig. A].[4] De Groux struggled over several states of a first version of the composition before abandoning it, in February 1894, in favor of the version with the Eiffel Tower.[5] This first issue included a cover with a lithograph by de Groux of a winged chimera, the lithograph *La Vigne abandonée*, and, at least in some instances, another lithograph, *Coin de campagne dévastée* (*Devastated Countryside*).[6]

It is not easy to identify precisely the other lithographs intended for the unfinished project; they can only be conjectured. Rodolphe Rapetti has asked if Bloy's texts were to be in response to already existing lithographs by de Groux.[7] In addition to *La Vigne abandonée*, the lithographs associated with the portfolio include *Le Cortège de la fiancée* (*The Procession of the Betrothed*), *Le Vent du carnage* (*The Wind of the Carnage*, alternately titled *The Enthusiasm of Carnage*, a scene of full-pitched battle in the streets), *La Lisière du bois* (*The Edge of the Woods*, depiction of a hanging), *Le Charmbardement* (a recapitulation of the painting *Les Vendanges*), and *En route*.[8] Several other de Groux lithographs are taken from the theme of *Les Vendanges*, but were not necessarily intended for the collaborative work with Bloy.[9]

In *En Route*, de Groux depicts a mass of mobilized citizens who plod along the cobblestone streets to the beat of a drum, pulling and pushing their possessions in carts, carrying flags and brandishing swords. Scrawled on the wagons and on placards are a number of inscriptions that clearly identify the group's anarchistic and socialist goals: "*Mort aux Bourgeois*" ("death to the bourgeois"), "*International!*" ("International"—a socialist organization), "*A Bas Charognes!*" ("down with pigs!"), "*Mort aux Vaches*" ("death to swine"), and "*[Fr]anco [P]russe.*" The latter sign refers to the Franco-Prussian War of 1870-71, in which Napoléan III was deposed after a revolution in the streets of Paris and the reformist government, the Commune of 1871, briefly was set up. This revolutionary government ended with the execution of over 17,000 men, women and children. This image, seen in its larger context as a fragment of *Les Vendanges*, would have doubtless found a good compliment in a text by Bloy, who, like de Groux, mixed his Catholicism with his anarchism and a concern for social reform.

—S.G.

FIGURE A (right). Henry de Groux, *La Vigne abandonée*, from *Les Vendanges*, lithograph, ca. 1894. © Bibliothèque Royale Albert 1er.

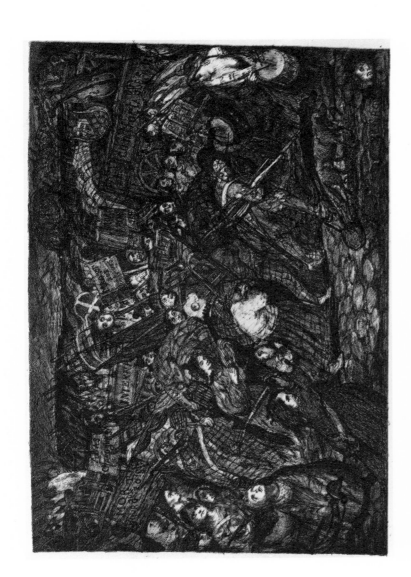

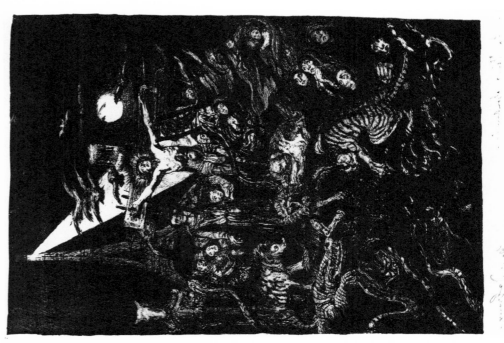

1. Bloy made several references to the painting in January 1892, *AM* 12 no. 2 (10 January 1892): 15, and *La Plume* (January 1892); see Rapetti, 380; Legrand, 70. See Rapetti, 380 and 383n33 for de Groux's work on the canvas in Brussels and Paris.

2. Baumann 109: "Devant la façade immense, interminable d'un palais qui flambe, sous les flammes fumeuses, incurvées comme les tiges d'un palmier fantastique, les victimes en chemise sont alignées, rois et reines, évêques et prêtres, tout ce qui représenta la souveraineté légitime; au centre, des empalés, des pendus, liés en grappe sur un bûcher; et, devant, la populace épileptique, femmes brandissant des sabres ou agitant des têtes au bout des piques, chariots où s'entassent des meubles brisés, cadavres étendus parmi des tonneaux, près d'un grand crucifix couché à terre, tout le désordre ignoble, le sadisme, la furie démoniaque et l'épouvante des révolutions."

3. For the text, see Bloy, *Mendiant ingrat*, I, 210–215. The text of the second poem in *Les Vendanges*, "Le Cortège de la fiancée," is in volume II, 14–18.

4. Cabinet des Estampes, Bibliothèque Royale Albert 1er, Plano SII 80069. The published version of *La Vigne abandonée*, showing the Eiffel tower, appeared in a portfolio of *Les Vendanges* on the art market "L'Art Ancien Zürich" (1978 no. 35, New York Public Library clipping file), dated 1894. Also included in this copy was another lithograph, *Coin de campagne dévastée (Série des Vendanges)*.

5. The Getty Center has photocopies of two letters from de Groux about the printing of *Les Vendanges*. In the letter of 12 February 1894 (870525, photocopies), addressed to André Marty, the publisher of *L'Estampe Original*, de Groux states that he has abandoned his stone with total dissatisfaction, but that he has made a second.

The Cabinet des Estampes, Bibliothèque Royale Albert 1er, houses several versions of the abandoned composition: Plano SIII 106321, 106322 and 106323.

6. For the portfolio, see Bibliothèque Royale Albert 1er, Plano SII 80068, accompanied by the inscription "Les Vendanges / chimera bombicinans in deserto (Rabelais) / Lithographiés des Henry de Groux / Texte de Léon Bloy / Édité par l'Estampe orininale; 17, rue de Rome."

7. Rapetti, "Bloy et de Groux," 381.

8. Two versions of *Le Cortège de la fiancée* were executed, see *La Plume/de Groux*, 201, 268.

9. Baumann, 109; "*Nocturne, Oiseaux de proie, la lisière du bois, et autres fragments des sinistres Vendanges.*"

10 [Plate 6]

Henry de Groux
Le Christ aux outrages (*Christ Tormented*), 1894–1898
Lithograph with pastel
Spencer Museum of Art, 90.94
510 x 600
Ferniot 9

HENRY DE GROUX began work on his celebrated painting, *Le Christ aux outrages*, at the age of 21 while he was sharing a studio in Brussels with his friend, William Degouve de Nuncques.[1] De Groux wrote fondly of this studio with its large garden, surrounded by acacias, lilacs, and poplars, where he worked intensively while grieving the death of his mother in 1889.[2] In this peaceful setting de Groux composed his cataclysmic commentary on human grief.

When it was exhibited for the first time, at the 1890 triennial Salon in Brussels, the King of Belgium was so impressed by the enormous canvas that he asked to speak to the artist. Their conversation, as recorded by Charles Buet, is remarkable in that when the artist was asked to explain the ugliness of his figures, especially that of Christ, he responded in terms that anticipate an understanding of expressionism. In explaining his work to Léopold II, de Groux said of the figures, "I thought that the emotions that they express do not have to beautify them," and of Christ, "I thought that Christ, being God in human form in order to take on all human sorrow and grief, could not be beautiful, at least not in the common sense of the word, and in this circumstance, he had to endure physical fear and the outward appearance of guilt."[3]

Léopold was so enthusiastic about the work of this young Belgian artist that he agreed to pay for shipping the canvas to Paris for the Salon du Champ-de-Mars. Although the work was refused for this salon, it was exhibited in 1892 in a shed on rue Alain-Chartier, and then at the Salon des arts libéraux.[4] *Le Christ aux outrages* generated considerable critical reaction in Belgian and French artistic journals, evoking frequent comparisons to Rubens, Goya, and Delacroix.[5]

At the same time that de Groux was beginning work on *Le Christ aux outrages* (late 1887), Ensor was probably already at work on his monumental painting, *The Entry of Christ into Brussels* (dated 1888, cat. 45). Although the two artists were acquaintances, it is difficult to say if either was aware of the other's work.

The similarities between these two paintings go beyond their status as the key works in either artist's career, their enormous scale, or their use of a Christian theme as a point of departure. More importantly, both compositions make use of episodes from the life of Christ in which Christ is set off against a teeming throng. In either case this may be interpreted as an analogy for the alienation of the artist by contemporary society. Finally, either painting might be seen as a response (at least in scale) to Seurat's *Sunday Afternoon on the Island of La Grande-Jatte*, exhibited at the Les XX salon in 1887.

It is not surprising that de Groux eventually set out to render his key work as a print (as did Ensor). The beginning of the lithograph can be traced to around 2 December 1894, when he thanked his close friend, the writer Léon Bloy, for sending a photograph to him of *Le Christ aux outrages*.[6] On 8 December he wrote Bloy again, stating that he was continuing to work on his lithograph of *Le Christ aux outrages*, and that he was taking his time so as to achieve an excellent result.[7] Indeed, the lithograph was not finished until 1898, on Good Friday.[8] The lithograph reverses the composition as seen in the painting.

The completion of the lithograph corresponds with the culmination of the Dreyfus Affair. De Groux sided with the pro-Dreyfus faction, and he found a heroic figure in Dreyfus' outspoken supporter, Emile Zola.[9] In fact, de Groux decided to do a painting of Zola assailed by the "hideous crowd" upon emerging from the Palais de Justice after his trial for his letter "J'accuse," written in support of Dreyfus. Although this was only achieved as a pastel, the composition is clearly based upon the throng from *Le Christ aux outrages*, and it was dubbed "Zola aux outrages," again evoking the notion of the artist pitted against society.[10]

The special issue of *La Plume* dedicated to de Groux includes a comprehensive list of the artist's paintings, pastels, and lithographs. The lithograph of *Le Christ aux outrages* (described simply as "the

artist's masterpiece, that upon which his reputation rests") was available in several forms.[11] For fifty francs, one of ninety impressions printed on "vieux japon" ("Japanese" paper) was available; seventy-five francs would buy one of six printed on thin "chine" ("Chinese") paper; and for 150 francs, one could purchase one of the twelve that were hand-colored by the artist with pastel.[12] The exhibited impression is one of these twelve, each of which was colored differently.[13]

—S.G.

1. Degouve de Nuncques posed for the scythe-wielding figure in the lower right of the painting [lower left of the lithograph, to the left of the snarling dog], see Baumann, *De Groux*, 51. The painting measures 2.93 x 3.53 meters and is now at the Palais du Roure, Avignon (Fondation Flandressy-Esperandieu).

2. Baumann, *De Groux*, 43n1, from de Groux's journal: "J'avais alors vingt et un ans. Je venais de perdre ma mère dont la mort avait été pour moi l'occasion du plus grand désespoir que j'eusse connu. Pour la première fois, j'allais pouvoir travailler régulièrement en me consacrant exclusivement à une seule oeuvre de mon choix. Nous avions trouvé, William de Gouve et moi, un atelier dans une rue de Bruxelles, immémoriale-ment habitée par des peintres, rue des Côtes, 210 . . . Un grand jardin, limité au fond par la voie ferrée, élargissait autour de notre demeure un cadre assez attrayant d'acacias, de lilas, de hauts peupliers surplombant des frondaisons charmantes jusqu'à la haute grille de la porte d'entrée." Baumann, 53, dates the death of de Groux's mother to April 1889, but there is a discrepancy in the dates, for de Groux would have been 21 in November 1887 [he was born on 16 November 1866, see Brussels, MRBA, *Académie Royale*, 153-155n1]. From the above passage, it would appear that *Le Christ aux outrages* was begun late in 1887.

3. Buet, "Le Christ aux Outrages," 248-250, 250 reprinted from *Magasin Littéraire* [Ghent], 15 July 1892

— Monsieur de Groux, dit le roi, je connaissais déjà l'oeuvre de votre père. C'est le premier ouvrage de vous que je vois. Vous avez fait là une chose bien *étrange*, mais c'est une page très remarquable. Je voudrais vous adresser quelques questions.

—J'ai la certitude, Sire, d'avoir fait, en effet, une chose fort étrange et assurément intolérable pour le 'philistin.' Aussi suis-je heureux qu'elle ait la fortune de vous plaire.

—Oui, mais pourquoi *les* avez-vous faits tous se obstinément laids?

—Sire, j'ai pensé que les sentiments qu'*ils* exprimaient ne devaient pas les embellir.

—Mais le Christ lui-même, pourquoi est-il laid? pourquoi exprime-t-il l'effroi, l'épouvante? La tradition le représente beau et plein d'espérance.

—J'ai pensé que le Christ étant Dieu qui s'est fait homme pour assumer toutes les douleurs et toutes les misères humaines, il ne pouvait être beau, au moins de la beauté vulgaire, et que dans cette circonstance, il avait dû assumer la peur physique, et même l'apparence, l'aspect de la culpabilité.

—Ce que vous dites est intéressant, mais très audacieux! . . . Peut-être, car Henri de Groux n'est pas plus hétérodoxe en peignant Jésus laid que les primitifs qui l'ont toujours représenté ainsi, d'apres un texte de Tertullien, du traité *De Carne Christi*, d'apres aussi la parole du Psalmist: *Ego sum vermis et non homo, opprobrium hominum et abjectio plebis* [David, XXI, 7].

Le Roi disant à l'artiste: "Monsieur Henry de Groux, votre père était un grand peintre" et Henry de Groux, en s'inclinant de répondre: "Oui, Sire, et Léopold 1er était un grand roi." See also, Schmitz 23.

For de Groux and expressionism see Estrada, *Salon de la Plume*, 49-50.

4. Brussels, MRBA, *Académie Royale*, 154.

5. Much of the special issue of *La Plume* dedicated to de Groux is an anthology of these critical reactions to *Le Christ aux outrages*. See Estrada, 48-54, for a review of the critical response to the painting.

6. Bloy and de Groux, *Correspondance*, 150. This may be the photograph that de Groux gave to Bloy, and by which the author first learned of the painting. See Rapetti, *Bloy et de Groux*, 383n15.

7. Bloy and de Groux, *Correspondance*, 159: "Je continue à travailler au *Christ aux outrages* en lithographie. Ce sera encore assez long. Je veux la pousser aussi loin que possible et je suis certain d'arriver à un résultat tout à fait excellent."

8. Baumann, *La Vie Terrible*, 145: "8 avril. Aujourd'hui, Vendredi-Saint, je termine chez Chaix la lithographie du *Christ aux outrages*. Je ferai en sorte d'aller voir à Notre-Dame les Saintes reliques, et je veux faire mes Pâques en bon catholique."

9. Ibid, 140-43.

10. Baumann, *De Groux*, 143. *La Plume/de Groux*, 208: the work *Zola et la foule à la sortie du Palais de Justice* is illustrated. See Estrada, 181, for "Zola aux Outrages."

11. *La Plume/de Groux*, 287: "Cette pièce est l'oeuvre maîtresse de l'artiste, celle qui lui a valu sa réputation." Jules Destrée, who had written an appreciative article about *Le Christ aux outrages* on its 1890 exhibition [reprinted in *La Plume/de Groux*, 227-32], was given a dedicated trial proof of the litho-graph by the artist; Busine, *Autour de Jules Destrée*, 74.

12. *La Plume/de Groux*, 287.

13. The impression in the Spencer Museum of Art shows addition-al drawings in the margin of the lithograph, on the lower left is the grail, and at the lower right is a frontal head of Christ.

11

Henry de Groux
Mort de Siegfried (*The Death of Siegfried*), ca. 1895
Lithograph
Spencer Museum of Art, Letha Churchill Walker Memorial Art Fund, 89.47
320 x 460
Ferniot 40

T HE operas and aesthetic theories of the German composer Richard Wagner received a great deal of attention following his death in 1883, just prior to the organization of Les XX. *L'Art moderne*, for example, published numerous articles on Wagner throughout the year of his death. French poet Catulle Mendès gave a lecture on Wagner in conjunction with the first Les XX exhibition, 1884.[1]

Along with Zola and Napoleon, Wagner became one of de Groux's modern heroes. Prior to his forced

departure from Les XX, de Groux exhibited many Napoleonic themes, but, as Madeleine Octave Maus observed, when he returned to exhibit with La Libre Esthétique in 1895 he was under the spell of Wagner.[2] De Groux's lithograph *Mort de Siegfried* is more fluid than usual and is clearly indebted to the Wagnerian lithographs of Henri Fantin-Latour, one of which, *Parsifal*, had been exhibited with Les XX in 1885.[3]

The story of Siegfried is based on the Germanic myth of the Nibelungen family. The myth was set

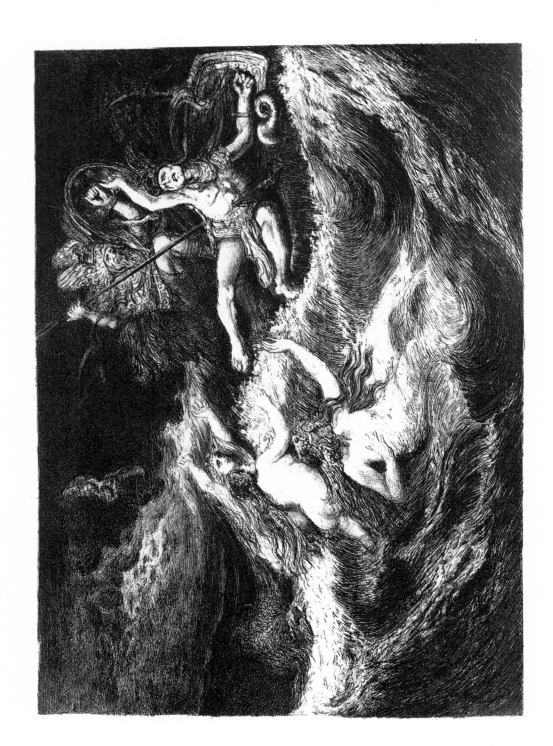

down as an epic in the thirteenth century in the form of the *Nibelungenlied* (*Song of the Nibelungen*) and ultimately became one of many literary tributaries that found expression in Wagner's series of four operas, *Der Ring des Nibelungen*. As related by Wagner, the warrior Siegfried wins the treasure of the Nibelungen and, after drinking a potion that causes him to forget his own love for Brünhilde, he kidnaps her that she might become the bride of his wife's brother, King Gunther. Unaware of the potion, Brünhilde plots the murder of Siegfried.

De Groux's composition shows the death of Siegfried as it occurs in act III of Wagner's fourth opera from *The Ring*, *Götterdämmerung* (*Twilight of the Gods*). The three Rhine maidens that Siegfreid encoun-ters while hunting are visible in the frothy waters of the Rhine in the foreground. They had tried to win the Ring from Siegfried by offering to exchange it for the bear he was pursuing. The large dog-like bear is visible in the water to the left of the maidens. The murder of Siegfried is shown on the banks of the Rhine, where the rest of the hunting party has caught up with him. Siegfried, after drinking the potion from his drinking horn to restore his memory, has sung the story of his love for Brünhilde. In feigned support of the enraged Gunther (to whom Brünhilde is betrothed), Hagen drives his spear through Siegfried's only vulnerable area, his back. De Groux has even shown the two ravens who warned Siegfried of revenge moments before Hagen thrusts his spear into Siegfreid's back. —S.G.

1. AM 3 (1883), 2, 12, 17, 33, 37, 41, 49, 52, 59, 117, 288, 295: Mendès was one of four lecturers; the others were Edmond Picard, "L'Art jeune," Georges Rodenbach, "Les Jeunes Belgique," and Albert Giraud, "La Petite Presse en Belgique."
 Further evidence that Wagner was in vogue at the turn of the century is found in the photograph of Maria van de Velde in a room with items of contemporary taste, including sheet music by Wagner on the piano [cat. 146].

2. Maus, *Trente Années*, 194: "Degroux reparaît, hanté par Wagner (Montsalvat) comme il l'a été par Napoléon."

3. Brussels, Centre International pour l'Etude du XIXe Siècle, *Dix expositions annuelles Bruxelles*, 49.

12

Jean Delville
Tristan et Yseult (Tristan and Isolde), 1887
Pencil, black chalk, charcoal
Musées royaux des Beaux-Arts de Belgique, 9727
443 x 754

J EAN DELVILLE, both as a visual artist and a poet,
animated the cultural life of Brussels. Delville was
drawn to the hermetic philosophy of Villiers de l'Isle-
Adam and the occultism of Joséphin Péladan, who
was a practitioner of magic and founded the Salon
Rose+Croix for the exhibition of idealist art. In 1892
Delville opened the Salon pour l'art in Brussels,
which became an important exhibition space for sym-
bolist artists. Rodin, Gallé and Puvis de Chauvannes
were among the exhibitors. Delville then opened the
Salon de l'art idéaliste in 1896 and continued to
exhibit art with an occultist orientation. Delville
later succeeded McIntosh as the director of the
Glasgow Academy of Fine Arts and was professor at
the Brussels Academy from 1905–1937.

A cosmic light bathes Delville's Tristan and
Isolde, primal lovers moved to the ultimate denial of
life and the separation it imposes.[1] Delville, inspired
by the final scene of Wagner's opera with its evocation
of nirvana as an engulfing tide sweeping the lovers
into eternity, depicts Isolde as a phosphorescent,
undulant wave flowing over and merging with an inert
Tristan. The dark-haired figure of Tristan resembles
the artist and contrasts with his blonde soul mate who
surrenders herself to oblivion. The apex of the triangu-
lar composition is the cup of love potion that bound
the pair in life, poured out and transformed into a
resplendent grail, its flood of light signalling the
lovers' exoneration from the stain of being. Delville's
work, like Péladan's *Androgyne*, is peopled with

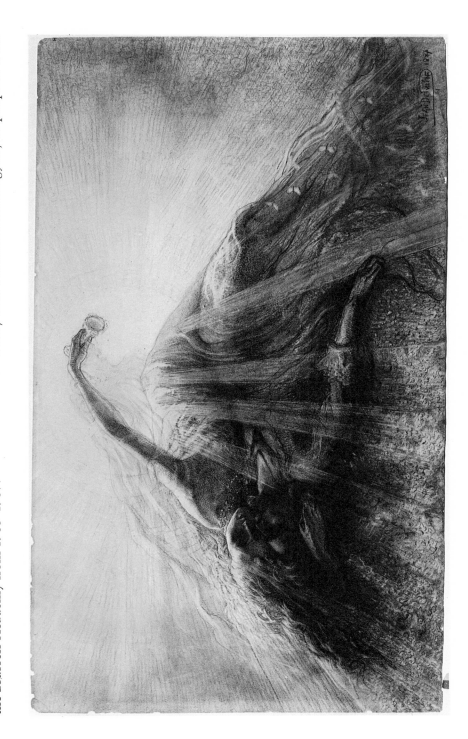

seraphic beings who have transcended earthly dichotomies. United in the apotheosis of their love–death, Delville's interwoven Tristan and Isolde suggest the fusion of masculine and feminine, the essence of divinity to fin-de-siècle occultists. The play of butterflies in the lower right corner of the drawing hints at the lovers' passage through death as a transformation, a chrysalis state leading to joyous release.

Delville's drawing can also be viewed as an illustration of the final scenes of Villiers de l'Isle-Adam's *Axël*. The French writer was a proponent of the occultist revival and a father figure for the symbolists. In the story, Princess Sara de Maupers is adorned with diamonds like the woman in Delville's drawing and, having decided that life is sacrilege, drinks poi-

son with Axël. Axël drinks the poison first and falls, "Sara inclines toward him, trembles, and there they lie, stretched out in death, intertwined upon the sand of their funereal pathway, exhaling their last breaths upon each others' lips."[2] Sunlight from an upper window floods the crypt where Sara and Axël lie; their sepulchre is radiant with golden treasure, emblematic of the inner resources that set the couple apart from those trapped in the commonplaces of daily life. Certainly the pose, the lighting and all the elements of the conclusion of Villier's novel, including the suggestion of treasure upon which the lovers lie, are in Delville's drawing. It is an amalgamation of the love-deaths of both the German composer and the French writer.

—D.F.

1. Maria Luisa Frangia interprets Delville's drawing as an interpretation of Wagner's opera in Il *Simbolismo di Jean Delville*, 24–28.

2. *Axël* was first conceived and serialized in 1872, then expanded and reworked in 1880–1884. A definitive edition was published after Villiers' death in 1889.

13

Darío de Regoyos
Une Rue à Tolède (Street in Toledo), 1882
Pen and ink on paper
Private collection, Madrid
525 x 345

THE members of Les XX adopted as one of their own the Spanish artist Darío de Regoyos y Valdés, whose "swarthy, smiling, shaggy, spirited, half-wild appearance, and his guitar" enlivened their gatherings and who became a popular subject for their own art.[1] In 1879 some Spanish musician friends studying at the Brussels Conservatory invited de Regoyos to visit— "an eight-day trip that lasted several years."[2] The affable Spaniard attended the daily gatherings of musicians, writers and artists at Edmond Picard's home, socializing with many of the Belgian avant-garde. He studied for a year at the Academy, where he became close friends with Théo Van Rysselberghe who introduced him to the people who later formed Les XX.[3]

De Regoyos returned briefly to Spain in April 1882 and the next month went to Toledo to make sketches of the distinctive architecture and narrow streets of that city. In July, at L'Essor's first *Noir et Blanc (Black and White)* exhibition (only drawings, engravings, etchings, lithographs, and drypoints were shown), de Regoyos displayed four pen and inks in a single frame.[4]

Une Rue à Tolède is one of two street scenes in Toledo reproduced from these original four in the book *L'Art Espagnol* by de Regoyos' friend, critic Lucien Solvay in 1887.[5] The drawing appears to have been drawn rapidly to maintain its expressive force. Steep vertical house facades line a rough street in Toledo, whose furrowed surface leads us to the small figure of a woman. Framed by the dark doorway of a balconied house, she bends over a laden table, but the artist appears more interested in the character of the street and buildings than in the human activity.

The Belgian poet and critic Emile Verhaeren became de Regoyos' closest friend and traveling companion. To comfort Verhaeren after the death of his father in 1888, de Regoyos invited him to travel throughout Spain with him. Verhaeren published his impressions of these travels in *L'Art Moderne,* dedicating them to de Regoyos. Extracts from the

articles were translated into Castilian by de Regoyos, combined with his sketches, including this one, and published in the Spanish magazine *Luz* in 1898. In addition, Verhaeren's melodramatic narration and de Regoyos' spontaneous drawings of everyday Spanish life, religious ceremonies, and festivals formed the basis for the illustrated travel book *España Negra,* first published in Barcelona in 1899.[6] This gave the sketch a wide audience. In the black and white lines of de Regoyos' sketch Verhaeren saw the dark grey-browns and stony hues

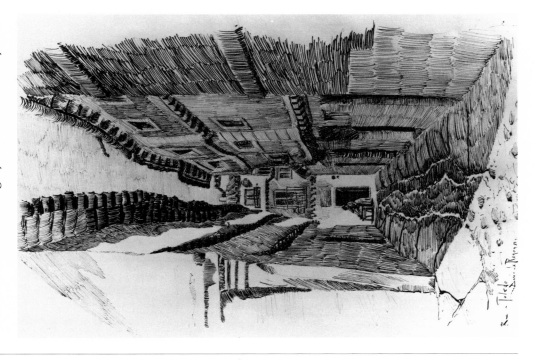

that lead to pensive thoughts of death so popular with fin-de siècle poets and artists.[7]

The original drawing was executed on Thon paper, ideally suited for translation into wood engraving.[8] De Regoyos' "limited mastery of the medium accentuated its old-fashioned quality," which became "a kind of personal creative stamp."[9] At a time when photomechanical methods were dominant over reproductive wood engravings for their ability to translate the illusion of half-tones, de Regoyos may have

chosen wood engraving for *España Negra* for its quality of roughness and simplicity which better captured the essence of his street scenes.[10]

De Regoyos is best known in Spain for introducing the techniques of impressionism that he learned in Belgium. In the quiet scene of *Rue à Tolède*, de Regoyos displays another skill which he may have honed during his long visits to Belgium—the ability to feel and reflect the spirit of a place, giving weight both to its artistic and psychological value.[11]

—S.K.

1. "la physionomie noiraude, souriante, poilue, vive, à demi-sauvage, et la guitare": "Rysselberghe–Charlet–de Regoyos," *AM* (8 April 1883): 112, quoted in Brussels, MRBA, *Académie Royale*, 245–246.

 Constantin Meunier and James Ensor painted portraits of the artist in 1884. Van Rysselberghe painted de Regoyos in 1882 and 1895 and did lithographs and drawings of him in 1887 and 1889.

2. "Un viaje de ocho días que duró varios años," Juan San Nicolás quotes the artist in Madrid, Fundación Caja de Pensiones, *de Regoyos*, "Biografía," 303. De Regoyos was the first foreign member of L'Essor (1880) and became a member of Les XX in 1883.

3. When twenty-year-old Van Rysselberghe won a purse to study abroad in 1882, he chose Spain rather than Italy under the blandishments of de Regoyos: San Nicolás in Madrid, Fundación Caja de Pensiones, *de Regoyos*, 34.

4. Ibid.

5. See *L'Art Espagnol*, a volume in the *Bibliothèque Internationale de L'Art* series, introduction by Solvay, 27 and 29. The book is a compilation of seventy-two photogravures based on drawings and other original works on Spain by Goya, Meunier, Sargent, and other artists. De Regoyos' drawing was subtitled *Une Rue à Tolède*, by which it is popularly known.

6. Serraller, "Darío de Regoyos," in Madrid, Fundación Caja de Pensiones, *de Regoyos*, 17.

7. "Si se quiere pensar en la muerte, nada mas a propósito que esos pueblos castellano. . . el pardo unas veces, otras en tonos huesosos. (If one wishes to meditate on death, nothing is more appropriate than these Castilian towns . . . grey-brown sometimes, others in bone-colored tones)": Verhaeren, "Conclusion," in Verhaeren and de Regoyos, *España Negra*, 75.

8. Fontbona, "Regoyos en Cataluña," in Madrid, Fundación Caja de Pensiones, *de Regoyos*, 28.

9. "su limitado dominio del medio acentúa el arcaísmo . . . una especie de sello personal," Ibid.

10. "By the end of the 1880s, wood engraving was all but extinct as a viable commercial medium," existing primarily for limited-edition illustrated books: Baas, "Introduction," in Baas and Field, *Revival of the Woodcut*, 17.

11. Noted by de la Encina, "Nuestro Pintor Franciscano," in Madrid, Fundación Caja de Pensiones, *de Regoyos*, 49; first published in *España* 43 (18 November 1915): 48–50.

14 [Plate 11]
Max Elskamp
L'Éventail japonais (The Japanese Fan),
title page, 1886
Woodcut and relief print?
Private collection, Brasschaat
424 x 330

15 [Plate 12]
Max Elskamp
L'Éventail japonais (The Japanese Fan),
fourth poem, 1886
Woodcut and relief print?
Private collection, Brasschaat
424 x 330

MAX ELSKAMP wrote the six sonnets in *L'Éventail japonais* in 1884. In 1886 he combined them under this title, intending to print them in a small edition of fifty.[1] The title page (dedicated to artist and Vingtiste Henry van de Velde, a friend of Elskamp) and the fourth sonnet were printed in a similar format and technique; the poet's handwritten script was printed onto a page illustrated with a Japanese woodblock print. Elskamp was very interested in Japanese art and collected Japanese prints. While the text of the sonnets reflects Elskamp's enthusiasm for the "art for art's sake" aesthetic, his dedication to van de Velde ("my good friend in colors") and numerous references in the poems imply that he was also interested in impressionism.

Although the title page alludes to the friendship and possibly to collaboration between Elskamp and van de Velde, *L'Éventail japonais* was solely the work of Elskamp. The poet embodied his writing with a Japanese sensibility by selecting generic Japanese woodcuts to accompany his poems.[2] Although the process for printing the text (according to de Sadeleer, "pâte à polycopier") and the images Elskamp selected proved expensive, he felt the result was both pleasing and compatible with his Parnassian aesthetic. In a letter to van de Velde, Elskamp wrote, "I had to work like a crazy man with a printer to write in reverse in the wax, but I wished to be more fashionable by writing it all myself. It will cost more, but that's also chic. This will ruin me for a time, but who cares."[3]

For *L'Éventail japonais* Elskamp chose images that allowed him to integrate his text with the pictures to form a cohesive whole. He achieved this in a variety of ways. While on some of the prints the image is at the top of the page with the text below, on other pages, including sonnet IV, the image surrounds the text. At the time *L'Éventail japonais* was created, the idea of combining image and script was innovative, as even William Morris and his Kelmscott Press had yet to take this approach in book design. —S.C.

1. The edition of fifty was never completed, twelve to fifteen copies were actually printed: de Sadeleer, "Bibliothèque Littéraire d'un Amateur" no. 11, n.p.

2. The woodcuts bear the marks of two Japanese printers: Sato on the cover and the house of Yomasa for the dedication page and sonnets IV and VI: de Sadeleer, "Bibliothèque Littéraire d'un Amateur" no. 11.

3. Letter discovered and reproduced by Pascal de Sadeleer in his remarks for a sales catalogue for the Librairie Simonson, "Bibliothèque Littéraire d'un Amateur" no. 11.

16

Max Elskamp
Six Chansons de pauvre homme pour célébrer la semaine de Flandre
(*Six Songs by a Poor Man to Celebrate the Flemish Week*), 1895
Woodcut
172 x 128
Private collection, Brasschaat

THIS collection of poems honoring the days of the week was designed by Henry van de Velde but decorated with woodcuts by the author, Max Elskamp. Van de Velde selected the Caslon typeface and laid out the pages. It was printed in an edition of 154 in yellow-ochre by van de Velde and his wife, Maria, on their press nicknamed "La Joyeuse," and completed on 15 December 1895.

Van de Velde's press has been hailed as the "first private press in Belgium."[1] As a confirmed follower of William Morris, van de Velde inevitably wished to experiment with printing books as well as decorating them and for this work was content to relinquish the illustrations to his friend.

Elskamp's decorations derive from the popular Flemish woodcuts that he loved and collected, including the charming cover vignette, showing an upside-down figure's feet protruding from a beehive.[2] For the sixth day of the week, "Celle du Samedi," Elskamp included a self-portrait before a window. Elskamp's volume concludes with the ode to Sunday, showing on the left the image of the humble apiarist and on the right the Dove of the Holy Spirit. In Christian iconography the beekeeper is the symbol of eternal hope, tending to his industrious bees, who live in a unified community. The reduction of the beekeeper's outline accords with the simplicity and sweetness of the verse.[3]

—J.B.

A présent c'est encor Dimanche,
et le soleil, et le matin,
et les oiseaux dans les jardins,
à présent c'est encor Dimanche,

et les enfants en robes blanches,
et les villes dans les lointains,
et, sous les arbres des chemins,
Flandre et la mer entre les branches.

1. de Sadeleer, "Max Elskamp et la presse privée," 22.

2. For more on this, see de Sadeleer, *Poète et graveur*; de Sadeleer, "Max Elskamp et la presse privée"; Berg, "Dix-Neuf lettres de Max Elskamp."

3. The image of the beekeeper was reproduced by Meier-Graefe in his column "Neue Bücher," in *Deutsche Kunst und Dekoration* 2 [1898]: 131.

17

Max Elskamp
L'Alphabet de Notre Dame La Vierge (The Alphabet of Our Lady the Virgin), 1901
Woodcut and photomechanical relief
Spencer Museum of Art, Elmer F. Pierson Fund, 89.60
265 x 210

THIS is the only book by Elskamp in the exhibition in which Henry van de Velde played no role. Elskamp based the imagery, as he had for his *Six Chansons*, on Flemish popular culture. In fact, the publisher is listed as "Édition du Conservatoire de la Tradition Populaire" (Edition of the Folk Tradition Conservancy). Like the French popular woodcuts of "Images d'Epinal" (Elskamp called them his "mannekensblaren"), these works have an immediacy and freshness that are meant to evoke the purity of childhood.[1] The pink and blue colors suggest the transparency of

watercolor (a yellow and blue edition and a black one also exist). *L'Alphabet*, printed by J.E. Buschmann, was issued 2 October 1901 in an edition of 215.

In the colophon Elskamp referred to himself as an "imagier," which means "a maker of colored prints." This emphasis upon the manual aspect recalls William Morris's ideal of the craftsman capable of producing a refined and elegant art. Elskamp had used hearts in *Six Chansons* to illustrate "Celle du Jeudi"; here he made them a central decorative motif. On each double-page, matching borders of intertwined

hearts frame letters of the alphabet on the left-hand leaf and surround the accompanying vignette on the opposite leaf. Above and below the text and vignette are sprays of flowers.

The images are a curious combination of light and airy borders and a striking pictograph. If the former reveal the simplicity and naiveté of Flemish woodcuts so dear to Elskamp, many of the latter resemble then contemporary art nouveau graphics, recalling Elskamp's previous collaboration with van de Velde. Each vignette actually has a second,

religious meaning. For example, for the letter 'N', a "Nef de sécurité (Vessel of Protection)" sails along, abetted by wind and wave. The Vessel of Protection, of course, is also the Nave of the Church, which protects and shelters the soul.

Belgian poet Charles van Lerberghe, overwhelmed by this simple book, wrote to Elskamp, "With what admirable fervor you have respected these words or have created new ones—a miracle! And, as a great artist, you have drawn symbols! Some of these images are simply beyond description."[2]—J.B.

1. In two autographed copies of *L'Alphabet de Notre Dame La Vierge*, Elskamp refers to these images, to Pol de Mont, "mannekensblaren suivant Flandre, en tentative d'un renouveau de notre vielle imagerie," and to his friend Henry Van de Putte, "mannekensblaren pour ses gosses,"; quoted in de Sadeleer, *Max Elskamp: Poète et graveur*, no. 24.3 "Ornamentation des mannekensblaren."

2. "Avec quelle admirable ferveur vous avez redit ces paroles ou en avez crée de nouvelles,—miraculeusement!—et avez dessiné en grande artiste des symboles! Certaines de ces images sont ineffables": letter from Van Lerberghe to Elskamp, Bibliothèque Royale, Musée de la littérature, F.S. XII 154/458, 6 March [1902]. A longer excerpt from the letter is reprinted in de Sadeleer, *Elskamp*, no. 24.4.

18 [Plate 2]

James Ensor
Silhouetten (Silhouettes), 1880
Colored pencil, black chalk, brown ink
Museum voor Schone Kunsten, Ghent
252 x 337

THE group of earth-tone figure sketches by Ensor from ca. 1880-85 (sometimes known as Ensor's "somber period") are usually referred to as his *Silhouettes*; this is the title that Ensor gave them in a 1929 retrospective at the Brussels *Palais des Beaux-Arts*.[1] He signed his name (and sometimes gave the date) beneath each figure, possibly fearing they would be cut up and sold separately.[2]

The exhibited *Silhouettes* depict four figure groups: a man in black walking forward, carrying a bag in his left hand; a figure in profile with his left foot propped on a box or cart of some kind; a figure standing facing away, possibly at a bookstall; and two figures who seem to be talking with each other as they walk away.[3]

The *Silhouettes* were drawn soon after Ensor spent three years at the Académie Royale des Beaux-Arts de Bruxelles. He quit his studies in the summer of 1880 and returned to Ostend to live at his parents' house, on the corner of the Rue de Flandre and the Boulevard Van Iseghem; his studio was on the third floor attic.[4] During this period in Ostend Ensor spent much of his time sketching his immediate surroundings, including these scenes from his studio window.

The quick, spontaneous strokes of the *Silhouettes* effectively capture the activity of the street and, quite appropriately, they are said to "illustrate the most impressionist moments in Ensor's works."[5]

—M.S.

1. Brussels: Palais des Beaux-Arts, *James Ensor*, no. 67–72, 74–79.

2. Suggested by Robert Hoozee in a 1991 lecture at the University of Kansas.

3. A black chalk drawing, *Libraire, Figures* (private collection), from this period depicts figures at street bookstalls: see Hoozee et. al., *Moi James Ensor*, 54 no.14.

4. Hoozee et. al, *Moi James Ensor*, 11.

5. "illustrant les moments les plus impressionistes de l'ouevre d'Ensor": L.D.M., *James Ensor*, 105 no. 27.

19

James Ensor
Lamp à huile et 'floche' de rideau (Oil Lamp and Gathering of Drapery),
1880–1885
Black chalk on paper
Private collection
226 x 175

EMILE VERHAEREN said of Ensor's drawings, "If for Ensor some furniture is haunted, then all the objects shudder, stir, and feel. . . . Nothing is dead, completely."[1] The "haunted" aspect of Ensor's drawings, made famous by the artist's use of masks and skeletons, only appeared after 1885. Yet his earlier drawings, including this one, do seem to shudder and stir with a brooding restlessness.

Ensor, who turned 20 in 1880, had just returned from several years spent studying art at the Brussels Academy, where he achieved no particular distinction. Re-ensconced in his family's bourgeois home in Ostend, he drew local figures, street scenes, silhouettes [cat. 18], members of his family, and the elaborate bric-a-brac that decorated his parents home.[2] *Lamp à huile et 'floche' de rideau*, actually two separate drawings that have been mounted together, is a beautiful example of this latter group of interior studies.

Robert Hoozee has characterized Ensor's drawings of 1880–1885 as "receptive" in nature, in opposition to the artist's later, "expressive" drawings.[3] Indeed, in drawings such as *Lamp à huile et 'floche' de rideau* Ensor seems to be mastering, perhaps cynically, a plump, baroque vocabulary of materialism that he will later make perverse use of in his fantastic and satirical images.

—S.G.

1. Verhaeren, *James Ensor*, 51: "Si pour James Ensor certains meubles sont hantés, tous les objets frissonnent, bougent, sentent. . . . Rien n'est mort, complètement."

2. Hoozee et. al., *Ensor, Dessins et Estampes*, 43–44, characterizes Ensor's activity during 1880–1885 as that of a draftsman.

3. Hoozee et. al., 44.

20

James Ensor
Personnages of Goya (Adaptations of Goya's etching, plate 51 from Los Caprichos),
ca. 1885
Pencil on paper
Art Institute of Chicago
1965.1184
157 x 226

INSCRIBED: après Goya C'est un si grand inconvenient d'avoir les ongles trop longs que cela est defendu même dans la sorcellerie[1]

Ensor had little taste for the curriculum at the Brussels Academy, where he and many other future members of Les XX studied.[2] Drawing lessons consisted of renderings of plaster casts of antique sculpture, anatomy studies, and studies of the male nude. Ensor called the Academy a "box of myopics" and stated that he never understood the "confusion of his profes-

sors when faced with his restless investigations." He even wrote a short satirical play about the Academy.[3] It is hard to see in the Academy a foothold for Ensor's training as an artist and, in fact, there is abundant evidence that he honed his drawing skills by faithfully copying works by artists whom he admired.[4] These artists included Callot, Constable, Daumier, Delacroix, Doré, Dürer, Gillray, Goya, Manet, Michelangelo, Millet, Rembrandt, Rowlandson, Steen, Stevens, Turner, and Verwee. These remarkable studies began about the time the Ensor was at the

Academy and continued into the mid-1880s. His source material was primarily culled from art magazines, such as the *Gazette des Beaux-Arts, L'Art,* and *The Studio,* and, less frequently, from art books.[5]

From the list of artists copied by Ensor it is clear that he felt considerable kinship with the historical community of satirical graphic artists. Furthermore, Ensor started making these copies just as he was beginning to become familiar with his own cynicism and finding novel ways of expressing it in the arts. From all this it should come as little surprise that Ensor found his way to Francisco Goya's series of eighty etchings and aquatints, *Los Caprichos,* probably the most celebrated satirical prints.

Goya's title for plate 51 of *Los Caprichos* was *Se repulen* (*They Spruce Themselves Up,* fig. B). Eleanor Sayre has summed up the theme, "The witches in the foreground 'spruce themselves up' to hypocritically disguise their nature, protected by a third witch who conceals their transformation."[6] The so-called "Ayala manuscript," which has brief explanations of *Los Caprichos* that are often considered to have come from a source very close to Goya, says of this print, "Crooks excuse and cover up for each other." Another manuscript which vies for authority, the "Prado manuscript," says, "This business of having long nails is so pernicious that even in witchcraft, they are prohibited."[7] Whatever Ensor's source may have been, it evidently included the caption from the "Prado manuscript," for he wrote at the bottom of his drawings, "after Goya; it is such an inconvenience to have nails that are too long that it is even prohibited in witchcraft."

—S.G.

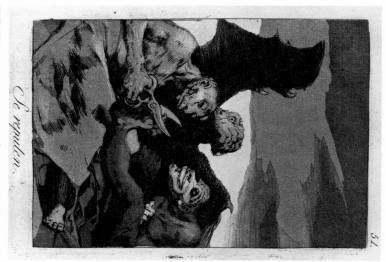

Se repulen.

FIGURE B. Francisco José de Goya y Lucientes, *Se Repulen,* plate 51 from *Los Caprichos,* etching and aquatint, published 1799. The Art Institute of Chicago, Clarence Buckingham Collection, 1948, 110/51.

1. As given in Farmer, *Ensor,* 39 no. 69.

2. Ensor attended the Academy from 1877 until 1880. Vingtistes Charlet, de Groux, Finch, Khnopff, Minne, Van Rysselberghe and Toorop all studied at the Brussels Academy at some point in their careers; Mellery and Meunier (not actually members of Les XX) also studied at the Academy.

3. Ensor, *Mes ecrits,* 95: "je n'ai jamais compris le désarroi de mes professeurs devant mes recherches inquiètes." See also Brussels, MRBA, *Académie Royale,* 165.

 The play, "Trois semaines a l'académie," is given in Ensor, *Mes ecrits,* 39-41. The moral of the play is that "the student leaves the Academy and becomes a member of Les XX" and the student's work is rejected by the salon.

4. Elesch, *James Ensor,* 56, noted, "It is not surprising that Ensor would turn to these particular artists for inspiration: who but the masters of social commentary would be better teachers?"

5. See Schoonbaert, "'Gazette des Beaux-Arts' en 'The Studio'" 205-21; Delevoy, *Ensor,* 241-51, has a section dedicated to the subject, "Des modèles culturels"; Schoonbaert in Zürich 1983 154-60 or (essentially the same essay) Antwerp 1983, 104-27; Eisenman, "Allegory and Anarchism in James Ensor's *Apparition,* 2-17; Hoozee et. al., *Ensor, Dessins et Estampes,* 61-63.

6. Sayre, *Prints by Goya,* 106-07.

7. Sayre, 107. The original in the López de Ayala manuscript is "Los empleados ladrones se disculpan y tapan unos à otros." The original in the Prado manuscript, which was previously given more authority than the Ayala manuscript, is also given by Sayre, "Esto de tener las uñas largas es tan perjudicial que aun en la Bruxeria esta prohivido." For the issue of the manuscripts see also Iannone, *Goya.*

21

James Ensor
The Entry of Christ into Jerusalem, 1885
Graphite and conté crayon
J. Paul Getty Museum, 89.GD.42
255 x 166

E NSOR exhibited a series of large drawings at the 1887 Les XX salon, *Les Auréoles du Christ ou les sensibilités de la lumière* (*The Halos of Christ or the Sensibilities of Light*). This is an 1885 study for the third drawing in the series, the monumental *Lively and Radiant: The Entry into Jerusalem* (2060 x 1503).

In this smaller version, Ensor has sketched out the theme and basic compositional arrangement. The subject, a parade down a boulevard in an urban milieu alludes to both popular and religious festivals—the annual carnival, the reenactment of medieval joyous

entries, or the Palm Sunday procession—and to the Socialist marches that had occurred in Brussels the year of this sketch.[1] Ensor uses a bird's eye perspective to create a vast expanse of space from the foreground back to the horizon nearly at the top of the page. This compositional device evokes the density and size of the crowd in addition to positioning the viewer as a spectator.

In the right foreground is a balcony on which several figures stand, waving to the crowd below them. The arrangement of this group is most likely based on

an etching by Rembrandt, *Christ before Pilate* (Bartsch 77), in which there is a similar grouping of large figures in the foreground and a repoussoir figure who turns to wave to the crowd.[2]

Above the crowd are banners with proclamations; these banners, with different texts, are also in the larger drawing and in the painting *Entry of Christ into Brussels in 1889* [cat. 45]. The differing texts provide insight into the artist's shifting interests and concerns. In the study sketch the banners' proclamations underscore the social context of the scene. The top banner reads "Salut Jesus, Roi des Juifs (Salute Jesus, King of the Jews)," the one below it "Egalité, Fraternité (Equality, Fraternity)," and the lowest "Vive la Sociale (Long Live the Social)." Ensor also includes "Les XX" on a banner on the building at the left.

In the middle of the vast crowd of military, musicians, and Belgium's middle and lower classes, Christ

rides a donkey while greeting the crowd. In the anarchist circles that Ensor frequented, Christ was viewed as a revolutionary individual whose heroic sacrifice had transformed and saved society. (Ensor linked himself with the figure of Christ in several instances, beginning with his 1886 *Calvary*.)

On the verso of this drawing are two sketches of Christ carrying the cross and another of a seated mother and child. Adriaen van Ostade's etching of 1647, *The Family*, is the source for the mother and child. Ensor made a more complete reference to van Ostade's composition in his contribution to the 1888 Les XX exhibition catalogue [fig. C].

The drawing *Entry of Christ* provides evidence of Ensor's sustained interest in scenes of the Passion and the "Halos of Light," and in 17th-century Netherlandish artists, as well as his ongoing work on the *Entry of Christ into Brussels.*

—S.C. and S.G.

1. Hoozee et. al., *Ensor, Dessins et Estampes*, 112.

2. Ibid. 113.

FIGURE C: James Ensor, 1888 Les XX catalogue entry, photomechanical relief. Spencer Museum of Art, 89.109.

22

James Ensor
Christ Presented to the People and the Entry of Christ into Jerusalem, 1887
Black chalk
Museum voor Schone Kunsten, Ghent, 1985–M
175 x 200

T HIS drawing forms the transition between Ensor's 1885–1886 series of drawings, *Les Auréoles du Christ ou les sensibilités de la lumière* (*The Halos of Christ or the Sensibilities of Light*) and his large canvas *The Entry of Christ into Brussels in 1889*. The loose rendering and sketchy layout show the artist in the process of working out his ideas of joining two scenes from the halo series.[1] The picture retains the figures and composition of the scenes, but the artist has transformed the verticle layout into the extended horizontal that he later employed in *The Entry of Christ into Brussels in 1889*.

—S.C.

1. Hoozee et. al., *Ensor, Dessins et Estampes*, 119.

23

James Ensor
Le Christ apaisant la tempête (Christ Calming the Storm), 1886
Drypoint
Private collection
153 x 230
Taevernier 5 i/iii

ENSOR'S *Le Christ apaisant la tempête* is based on the biblical passage Matthew 8:23–27, which tells how the Apostles, fearing for their lives after a great storm had overcome their boat, woke Christ and "he rose and rebuked the winds and the sea; and there was a great calm."[1] This drypoint (later reworked as an etching) was done during the same year as Ensor's series of drawings, *Les Auréoles du Christ ou les sensibilités de la lumière* (*The Halos of Christ or the Sensibilities of Light*, see cat. 21 and 22), that are central to his investigation of light.[2] Most of the composition is dedicated to depicting the effects of light permeating the briny atmosphere. Given Ensor's frequent identification with the figure of Christ, this scene amounts to a self-portrait of the artist as a source of light and of calm.

This print inspired two later painted versions of the theme. It has been pointed out that these paintings owe much to the turbulent paintings of William Turner.[3] However, it is difficult to find in Turner's pallete or brushwork an analogue for Ensor's use of drypoint line. Describing light and atmospheric effects by filling the sky with linear patterns is an act of daring. It is likely that Ensor knew of Rembrandt's various successes in describing changeable weather with etching and drypoint, such as his *Three Trees*, prior to Ensor's own drypoint rendering of *Le Christ apaisant la tempête*. Identifying a source for Ensor's composition is not as important as realizing that in seeking a means to convey the essence of light he was able to put both art historical precedent and a variety of mediums at his disposal.

—S.G.

1. *The New Oxford Annotated Bible* (N.Y.: Oxford University Press, 1973), 1180.

2. Hoozee et. al., *Ensor, Dessins et Estampes*, 213.

3. Ibid, and Hostyn in Paris: Petit Palais, *James Ensor*, 205.

Morel, "Ensor et la France" in Paris: Petit Palais, *James Ensor*, 67–73 ; she takes issue with Elesch's claim that the image was inspired by Balzac's *Jésus-Christ en Flandre*.

24

James Ensor
La Cathédrale (The Cathedral), 1886
Etching
Spencer Museum of Art, Gift of John and Ann Talleur in loving memory of Raymond Cerf,
91.278
234 x 177
Taevernier 7 iii/iii

L*A CATHÉDRALE* is one of the eight etchings and drypoints that Ensor completed during 1886, his first year as a printmaker; he was 26. This work is often singled out as the quintessential Ensor etching—a superb achievement that heralds his most productive period as a printmaker. It also made a considerable impression on Ensor's contemporaries. The French critic Camille Mauclair recalled his first encounter with the art of Ensor, "I had just thumbed through a collection of work by Rops, in the company of Emile Verhaeren at the shop of the editor Edmond Deman, then on the rue d'Arenberg in Brussels, when we headed toward Sainte-Gudule and a print in a shop window caught my attention." This print was an impression of *La Cathédrale*, "lost among other prints and a jumble of colorful posters."[1] The etching was eagerly reproduced in the avant-garde press in Belgium: as the frontispiece for *La Jeune Belgique* in 1891 and on the pages of the Belgian avant-garde periodicals *Van nu en straks* (1894) and *Le Spectateur catholique* (1897)[2].

The image remains enigmatic—though recent scholarship has identified the source for the structure as Aachen Cathedral, a convincing relationship has been made with Ensor's *Entry of Christ into Jerusalem* (and therefore ultimately with his *Entry of Christ into Brussels*, cat. 45) and Balzac's *Jésus-Christ en Flandre* (Jesus Christ in Flanders) has been proposed as a literary source.[3] At the time the etching was made there was open competition between the Catholic church and the Liberal party over a variety of contemporary issues, yet it is difficult to find the expression of a partisan view in *La Cathédrale* (though the form inhabiting the uppermost window of the right tower in the first version of the etching somewhat resembles the rampant Lion of Flanders).[4] The choice of Aachen Cathedral as a prototype may be relevant, for it contains the coronation hall of the emperors, and has been the site of at least 32 coronations of kings and emperors. This site, perhaps more than any other, articulates the historic intermingling and competition of secular and ecclesiastical powers.

Two of the earliest descriptions of the print are particularly authoritative, since they were written by Ensor's literary friends Eugène Demolder and Emile Verhaeren. Demolder wrote in 1892:

The most beautiful [of Ensor's etchings] is the *cathédrale* that served as the frontispiece for *La Jeune Belgique* in 1891. It is an old, very old cathedral that has been eaten away by time and whose stones appear wrinkled. It is 'clothed in the centuries,' its ogives grieve, its two large square towers have dreamed under the skies of historical epochs. Loaded with reliefs, sculptures, and gargoyles like a precious reliquary, it appears alone in an enormous town square, a gigantic and precious fragment of an ardent tower of Babel embraced by heaven. It is like the symbol of all gothic cathedrals and sums up the antiquity of the magnificent ogival windows with panes shadowed in gold through which passes the chants and rays of light from venerable high masses and episcopal ceremony.

At the foot of this temple a swarming crowd masses together: in the background rows of soldiers wearing shakos, and in the foreground carnival figures in crazy hats are crushed together. A festive feeling emanates from the people and animates the banners spread out above the town square, right up to the distant belltowers, where flags have been hoisted.[5]

In 1906 Verhaeren evoked a similar image:

La Cathédrale(1886). A tight, compact, and teeming multitude advances; less with its legs, arms, and bodies, than with its faces; towards one knows not what goal. It shifts as a whole, not individually, with a massive unified motion, as if all of humanity were set into motion. In its midst is a church with its great towers, with the ecstasy of its ogives, with its roofs and its pinnacles—a light, ethereal and triumphant church that dominates in its fixed position. In the distance other buildings are perceptible, with rising spires and poles with huge flags. One thinks of a colossal secular festival, of a prodigeous anniversary. It is an epochal spectacle.

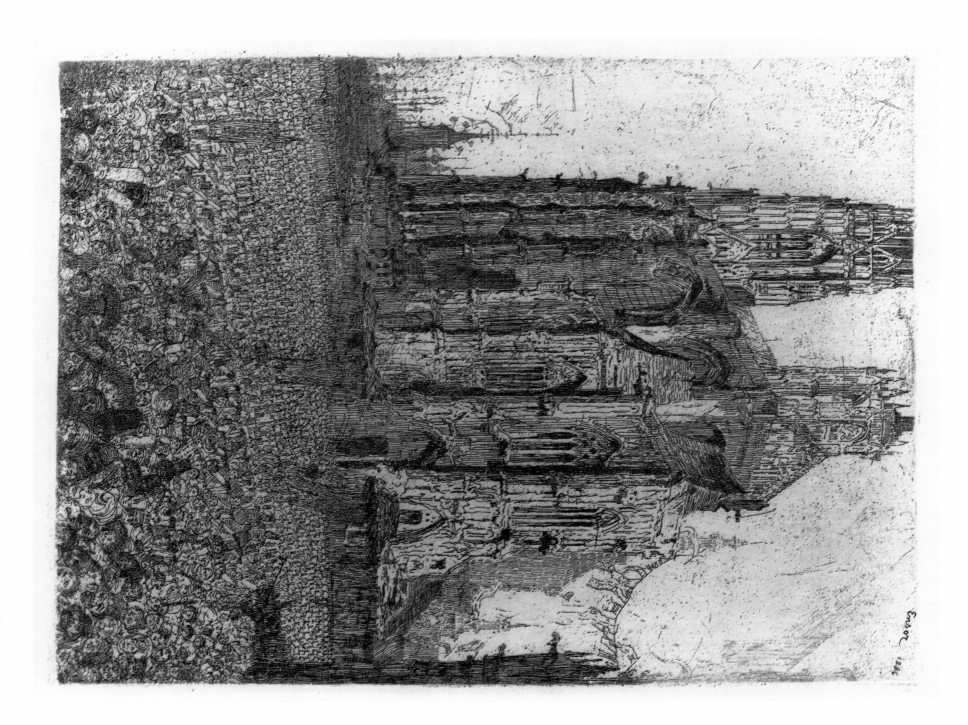

And this impression is not given forcefully, but with a light and delicate touch. The prickly etching needle has scratched everywhere, but its point never becomes harsh or relentless. One might call it the work of a family of flies or of a swarm of insects. A happy atmosphere, transparent, delicate, and light, bathes the entire page; and if the word 'masterpiece' slips past the lips of one who looks at it, the word is well placed, just as each shadowy passage and each illuminated surface is perfectly placed on the copper plate.[6]

For Demolder and Verhaeren, *La Cathédrale* summoned many themes (the tower of Babel, the Gothic cathedral as a symbol, humanity in its totality, religious ceremony, and secular festivals) without being limited to any one of them. In mentioning the tower of Babel, Demolder was doubtless thinking of the sixteenth-century satirical painter Pieter Bruegel the Elder, who painted some of the best-known versions of the theme, and to whom Ensor is often compared. Like so many of Bruegel's works, Ensor's *La Cathédrale* is laden with potential meaning, but in its universality it denies specific readings. In *La Cathédrale* Ensor puts humanity and its institutions—or perhaps the nuance should be unruly humanity and its lofty aspirations—in the balance.

After the original plate was damaged, Ensor etched a nearly perfect copy of *La Cathédrale* in 1896, although it was bitten somewhat longer and tends to be darker. The exhibited impression of *La Cathédrale* is from the first plate of 1886 and is one of the rare unsigned impressions of Ensor's etchings that were printed on a fine Japanese paper, presumably by Ensor's first printer, Evely.[7]

—S.G.

1. *La Plume/Ensor*, 675. "Je revenais de feuilleter, en compagnie d'Emile Verhaeren, une collection de Rops dans la magasin de l'éditeur Edmond Deman, qui se trouvait alors rue d'Arenberg, à Bruxelles, et nous remontions vers Sainte-Gudule, lorsqu'une gravure, à une vitrine, retint mon regard. Perdue parmi des estampes et un pêle-mêle d'affiches bariolées, elle n'eût point attiré l'attention si précisément sa discrète tonalité d'ombre pâle, sa transparence singulière ne lui eussent conféré ce quelque chose d'indéfinissable qui arrête de loin l'amateur et l'assure qu'une oeuvre d'artiste est toute proche de lui. ... C'était une eau-forte représentant une cathédrale, au pied de laquelle se pressait une foule grimaçante et houleuse, repoussée par le défile de régiments en parade."

2. *Van nu en straks* 1 no. 8–10 (1894): 41; *Le Spectateur Catholique* 2[July–December 1897]: 93.

3. Lesko, *Ensor, the Creative Years*, 86–91, summarizes much of the literature. See also Hoozee et. al., *Ensor, Dessins et Estampes*, 219, for the relationship to Aachen Cathedral, and McGough, "Ensor's 'Entry of Christ into Brussels,'" 124–25, for the relationship to Ensor's *The Entry into Jerusalem* and *Christ Driving the Money Changers from the Temple*. The relevant passage in Balzac is given by Elesh, *Ensor*, 68: "All of a sudden I saw in the background thousands of cathedrals, resembling those I had just left, but ornamental with paintings and frescoes: I heard marvelous concerts. Around these cathedrals crowded thousands of people, crowded together like ants in their anthill." Elesh gives the source as Honoré de Balzac, "Jésus Christ en Flandre," *La Comédie Humaine*, 9 (Paris: Bibliothèque de la Pléiade, 1965), 266.

4. McGough, 62–63, summarized the issues: "(1) unrest among the laboring classes over working conditions and pay, (2) the call for universal suffrage, (3) the 'School War' ... (4) 'Personal Service' ... and (5) the Flemish Movement."

5. Demolder, *James Ensor*, 21:
La plus belle est cette *Cathédrale* qui a servi de frontispice à *La Jeune Belgique* de 1891. C'est une vieille, très vieille cathédrale qui est rongée par le temps et dont les pierres paraissent ridées. Elle est 'vêtue de siècles', ses ogives se chagrinent, ses deux larges tours carrées ont rêvé sous les cieux d'époques historiques. Chargée, comme une châsse précieuse, de reliefs, de sculptures, de gargouilles, elle paraît, seule sur une grande place immense, quelque tronçon gigantesque et précieux d'une tour de

Babel fervente adoptée par le ciel. Elle est comme le symbole de toutes les cathédrales gothiques et résume l'ancienneté des magnifiques fenêtres à ogives et à vitres pénombrées d'or par où des grand'messes séculaires et des pompes épiscopales ont laissé passer leurs chants et leurs rayons.

Au pied du temple une foule énorme grouille et se masse: dans le fond, des rangées de soldats coiffés de shakos, et à l'avant-plan des figures de carnaval serrées, avec des coiffures drôles. Un sentiment de fête émane du peuple et anime les bannières déployées au-dessus de la grand'place, et jusqu'aux clochers lointains, où l'on a arboré des drapeaux.

The Art Institute of Chicago owns an impression of *La Cathédrale* dedicated by Ensor to Demolder and dated 1891 (ill. in Janssens, *Ensor*, 19).

6. Emile Verhaeren, *James Ensor*, 58:
La Cathédrale (1886). Serrée, compacte, myriadaire, une multitude s'avance moins avec ses jambes, ses bras, son corps qu'avec ses visages, vers on ne sait quel but. Elle bouge non pas individuellement, mais totalement, d'un énorme mouvement d'ensemble et c'est comme si la masse humaine entière s'ébranlait. Au meilleur d'elle, une église avec ses grandes tours, avec l'élancement de ses ogives, avec ses toits et ses clochetons, une église légère, triomphante, aérienne est plantée et domine. Au loin se devinent d'autres architectures, des surgissements de flèches, des hampes géantes et des drapeaux. On songe à une colossale fête séculaire, à quelque anniversaire prodigieux. Le spectacle est épique.

Et cette impression est donnée non pas avec force, mais avec légèreté et délicatesse. Le burin fourmillant a creusé partout mais jamais sa pointe ne fut rude ni acharnée. On dirait le travail d'un clan de mouches ou d'une ruche d'insectes. Une atmosphère joyeuse, transparente, fine, légère, baigne la page entière et si le mot-chef-d'oeuvre vole sur les lèvres de celui qui la regarde, ce mot y semblera bien à sa place comme est à sa place sur le cuivre chaque trait d'ombre et chaque surface de lumière.

7. These unsigned impressions on special papers are generally the impressions that Ensor kept for himself, see Hoozee et.al., *Ensor, Dessins et Estampes*, 189. For Evely, see Goddard essay in this catalogue, p. 75.

25

James Ensor
Grande vue de Mariakerke (Large View of Mariakerke), 1887
Etching
National Gallery of Art, Washington, Rosenwald Collection, 1964.8.8
218 x 269
Taevernier 13 i/ii

THE countryside and villages around Ostend were a frequent source of inspiration for the young Ensor. On several occasions he depicted the village of Mariakerke, 3 km southwest of Ostend, including in a painting of 1876 (*Vue de Mariakerke*, Antwerp, private collection) and five etchings from 1886–1900.[1]

In Ensor's time Mariakerke was a seaside resort with a bathing place north of town toward Ostend. The village itself was at the end of a popular promenade starting from the bathing area. After a walk along the beach or in the dunes a stroller could rest in one of several cafés located near the picturesque fourteenth-century church of Notre-Dames-des-Dunes, the focus of this composition.[2] Ensor was buried in the church's cemetery in 1949. *Grande Vue de Mariakerke* reveals Ensor's preoccupation with the effects of light and atmosphere. His loose and informal lines effectively capture the shifting sunlight in a cloudy sky and the warm sea breeze which ruffles through the tall grass in the foreground.

—M.S.

1. These are: *The Orchard*, 1866 [Taevernier 2], the church steeple is not the Church of Notre-Dames-des-Dunes; *Little View of Mariakerke*, 1887 [Taevernier 16], a view of the church from the back; *Little Houses at Mariakerke*, 1888 [Taevernier 54]; *Windmill at Mariakerke*, 1889 [Taevernier 71], with the church tower faintly visible in the distance; and *Small View of Mariakerke*, 1900 [Taevernier 117].

2. The tower was damaged in World War I and repaired in 1930–31. See Hoozee et. al., *Moi James Ensor*, 191; Hoozee et. al., *Ik James Ensor*, 103, for a recent photograph of the church.

26

James Ensor
Rue de Bon-Secours à Bruxelles, 1887
Drypoint
Private collection
130 x 90
Taevernier 17 only state

rue du Bon-Secours James Ensor 1887

THIS drypoint, like the Ensor's *Portrait of Ernest Rousseau* [cat. 28], is a record of the artist's residence in Brussels in 1877–80. "During the winter 1887/88, Ensor lived in a room at 123, Boulevard Anspach in Brussels. From his studio, he had a view of the large building at 154-156 Boulevard Anspach, and of the rue de Bons-Secours."[1] This large building on the boulevard Anspach is the subject of another drypoint (Taevernier 20). The view Ensor gives here looks over the busy Boulevard (named after Jules-Victor Anspach, Mayor of Brussels from 1863–1879, remembered for modernizing parts of Brussels) and down the older rue de Bon-Secours, named for the seventeenth-century chapel, Notre-Dame de Bon-Secours. The view is stopped by the gabled façades of the rue Marché au Charbon (Coal Market Street).[2] In the distance is the dome of Notre-Dame de Bon-Secours, although it would not be so clearly in view from Ensor's vantage point. Ensor compels us to look beyond the new, straight boulevard and into the heart of an old quarter of Brussels, where the artist has posted his name on a signboard.

—S.G.

1. Hoozee et. al., *Ensor, Dessins et Estampes*, 200: "Pendant l'hiver 1887/88, Ensor occupe une chambre au 123 boulevard Anspach à Bruxelles. De son atelier, il avait bur sur l'édifice monumental du boulevard Anspach 154-156 et sur la rue de Bons-Secours."

2. A related drawing is discussed in Hoozee et. al., *Ensor, Dessins et Estampes*, 98.

27

James Ensor
Le Pisseur (The Pisser), 1887
Etching
Philadelphia Museum of Art, Gift of the Print Club of Philadelphia, 54–40–25
149 x 108
Taevernier 12 only state

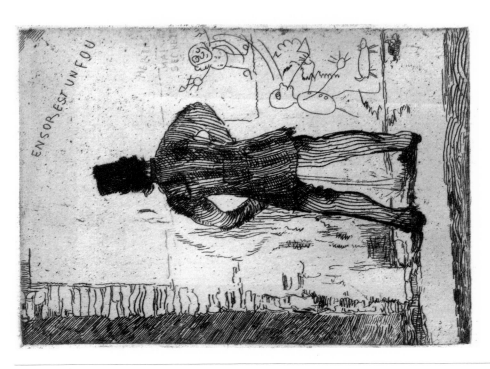

THE PISSER, one of Ensor's earliest etchings, clearly links the artist to the earthy, scatological tradition of northern European art. In the print a member of the middle class—recognizable by his top hat, long jacket and pin-striped pants—relieves himself against a wall. Although the man's back is turned, obscuring his identity, the prominently displayed moustache, which is found in numerous self-portraits of this period, suggests that the pissing man is Ensor. "Ensor est un Fou (Ensor is a fool)" is written on the wall above the man and beside him are two figures drawn in a child-like scrawl, one smoking and the other holding a pipe. A pile of manure rests in front of the wall, next to the man.

The image of the pissing man is reminiscent of a drawing by Jacques Callot of the same title (Florence, Uffizi), but Ensor's immediate source is an illustration by Amédée Lynen for the title page of Théo Hannon's 1883 book, *Au Pays de Mannekin-Pis* [fig. D].[2] As opposed to Callot's jester or Lynen's worker, Ensor's character is obviously a member of the bourgeoisie (though the patches on his coat indicate that he is a marginal member).

The man's act of urination also connects him to the legend of Manneken-Pis, the story of a young urchin who used his urine to put out a fire that threatened Brussels, and to Tyl Ulenspiegel, the hero of a book by Charles de Coster, who shows his disdain for authority by pissing on his enemies.

The scatological markers of urination and defecation, the graffiti and the drawings in Ensor's etching all refer to behavior abhorrent to civilized society. Though the graffiti refers to Ensor as a fool, the artist is celebrating the tradition of the natural fool often found in northern art and literature. In this tradition, as elucidated in Erasmus's *In Praise of Folly*, the fool's behavior accents the commonality of the human condition and critiques social pretentiousness. The awkward naiveté of the figures scratched on the wall advocates having a child's vision. By combining these images with that of a man urinating, Ensor gives primacy to his Belgian legacy and to the northern heritage that utilizes the conventions of satire and folly to comment upon human nature. By joining his own image to this tradition, Ensor proclaims his own artistic position as the fool whose marginal and scatological activity will prove beneficial to all.

—S.C.

FIGURE D. Amédée Lynen, cover for Théo Hannon's *Au Pays de Mannekin-Pis*, photomechanical reproduction, 1883. Copyright Bibliothèque Royale Albert 1er.

1. These include *Self-Portrait with Flowered Hat* (1883, Ostend: Museum of Fine Art), *My Portrait* (1884, Brussels: Royal Museum of Fine Arts), *Self-Portrait with Sketchbook* (1885, Karlsruhe: State Museum of Art) and an 1888 photograph of the artist published in Lesko, *Ensor: The Creative Years*, 29 fig. 25.

2. I thank Steve Goddard for bringing to my attention the connection with the Lynen illustration. Libby Tannenbaum was the first to remark on the similarities between Ensor's print and Callot's drawing: Tannenbaum, *Ensor*, 64. Callot's *Le Pisseur* was reproduced in Vachon, *Callot*, and in *L'Art* (1878, 12:93). Ensor's print reverses Callot's composition but retains a wall. Dominique Morel suggests that Ensor only dressed the figure in middle-class clothing to modernize him: Morel in Paris: Petit Palais, *Ensor*, 70.

28

James Ensor
Portrait d'Ernest Rousseau, 1887
Drypoint
Private collection
228 x 168
Taevernier 11 iii/iv

D URING his years in Brussels (1877–80), Ensor formed close relationships with the members of the progressive Rousseau family. Even after he established his permanent residence in Ostend in 1880, he returned to Brussels frequently as a guest of the Rousseaus. He was introduced to them by Théo Hannon, a classmate of Ensor's at the Brussels Academy. Hannon's sister, Mariette Rousseau, an intellectual and emancipated woman, was a botonist and mycologist.[1] She and her husband, Ernest Rousseau (a professor of natural history), and their son Ernest Rousseau Junior, quickly befriended the young Ensor. Mariette in particular encouraged Ensor's artistic activity.[2] Her husband, noted for his "universal culture, wed to a stout peasant good-heartedness," seems to have been universally liked.[3] In 1887 his students at the University of Brussels gave him a portrait bust of himself by Jef Lambeaux (member of Les XX in 1884). Ensor's drypoint portrait of Rousseau is a close re-working (in reverse) of a drawing that, it has recently been shown, appears to be a study of Lambeaux's sculpture, and not a portrait taken from life.[4] The artists that associated with the Rousseau family at their home at 20 rue Vautier also left a testimonial of friendship in the form of an album, to which Ensor contributed a drawing.[5]

Ensor's portrait of Ernest Rousseau was done in pure drypoint, in which the artist simply scratches directly on the metal plate with a sharp tool, without the need to etch with acid. This technique is associated with small editions (drypoint lines break down quickly) and rich, bushy lines that are created by the

metal bur that naturally results from scratching on the plate. Rousseau's bushy moustache and corpulent presence are wonderfully conveyed in this tour-de-force trial of pure drypoint.
—S.G.

1. Hostyn in Paris:Petit Palais,*Ensor*, 171 no. 116.

2. For Mariette see Wodon, "Hannon-Rousseau," cols. 405–10.

3. Hoozee et. al., *Ensor, Dessins et Estampes*, 207, quoting Haesaerts, *Ensor*, 75, describes Rousseau, "corpulent, à moustache touffue et tombante . . . inspire la sympathie à quiconque l'approche. Tolérant et frondeur, d'une bonté rayonnante, il allie une culture universelle à une solide bonhomie paysanne." Also cited by de Hureaux, in Paris: Petit Palais, *Ensor*, 171 no. 117.

4. Hoozee et. al., *Ensor, Dessins et Estampes*, 78.

5. Todts in Paris:Petit Palais, Ensor, 114, no. 44.

29

James Ensor
Petits figures bizarres —Mes amis animalisés. Les Rousseau et Ensor (*Small Bizarre Figures—My Friends Animalized. The Rousseaus and Ensor*), 1888
Etching, hand-colored
The Fine Arts Museums of San Francisco, Achenbach Foundation for the Graphic Arts, Victor & Lorraine Honig Collection, 1964.152.7
137 x 98
Taevernier 53 ii/ii

ENSOR was fascinated by insects, an interest he shared with Mariette (Hannon) Rousseau, a biologist at the Royal Institute of Natural Science. In several etchings he joined animals or insects with human forms. In this print, Mme. Rousseau has the body of a butterfly, her husband, Ernest, that of a beetle and their son, Ernest, Jr., is a lightning bug. The woman with a caterpillar larvae body in the center of the composition is Ensor's maternal grandmother. To the left of these figures stands Ensor, apparently consorting with the devil. All of the faces look out without expression, suggesting that Ensor drew the portraits from photographs. The taxonomic layout suggests a biological chart. By including himself and the devil, Ensor evokes his own fanciful, even devilish amusement as he imagines his friends and family pinioned and on display like a bug collection.

—S.C.

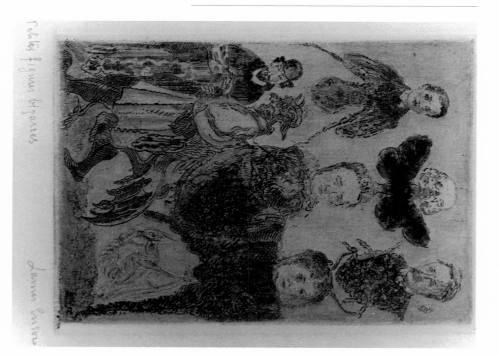

30

James Ensor
Squelettes musiciens (Skeleton Musicians), 1888
Black and brown chalk on paper, laid down on panel
Private collection
210 x 160

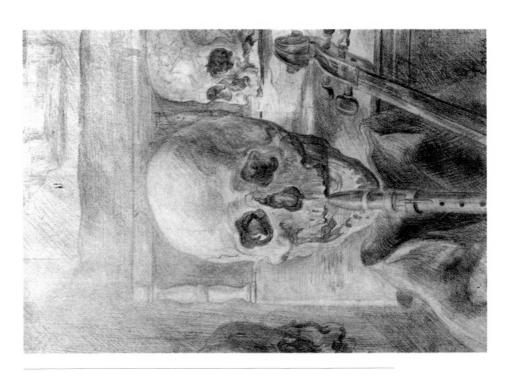

ENSOR listed "Fantasies and Grotesques" among his entries in the 1887 Les XX exhibition. In the 1889 Les XX catalogue, the most likely year that his *Squelettes musiciens* would have been exhibited, this bizarre company had grown to include drawings designated as "Fantasies, grotesques, diableries, grimaces et incohérences (Fantasies, grotesques, devilries, grimaces, and incoherences)."[1] This highly charged image would have been at home in any of these catagories, although we do not know if it was ever exhibited by Les XX.

By this time in Ensor's career (1888–1889) the artist had a practise of rendering himself skeletal in his self-portraits [see cat. 31], and by habit we see Ensor as the front musician in *Squelettes musiciens* (for Ensor's flute playing see cat. 41). If we look past Ensor's witty cynicism, the composition invites myriad associations with themes of *vanitas* (the emptiness of earthly possessions) and *memento mori* (a reminder that we must die).[2] In *Squelettes musiciens*, however, the artist has asserted the ability of art (music, in this instance) to triumph over mortality.[3]

—S.G.

1. Brussels: Centre International, *Dix expositions annuelles*, 183.

2. For *vanitas* and *memento mori* see Hall, *Dictionary*, 291.

3. For a similar conclusion see Hoozee et. al., *Ensor, Dessins et Estampes*, 132.

31

James Ensor
Mon portrait en 1960 (My Portrait in 1960), 1888
Etching
Spencer Museum of Art, anonymous gift, 70.37
64 x 113
Taevernier 34 ii/ii

WITH the exception of the portrait of his dead father, *Mon Père Mort* (Taevernier 35, after a drawing of 1887), Ensor's portraits in etching and drypoint done in 1888 depict transformations of the subjects. For example, he transformed himself and some friends into hybrid insects in both *Petits figures bizarres* [cat. 29] and *Insectes singuliers* (Taevernier 46). In this etching, he transported himself to the year 1960, when he would be 100 years old, and imagined himself as a skeleton in advanced decay. A large spider seems to be leaving the cadaver, as if there is nothing left to suck from it, while three snails mill around the skeleton's feet. Ensor shows himself, as he

did his father on his deathbed, with his head propped up against a pillow, and as has been recently observed, what remains of the artist still wears a pair of slippers.[1] The often macabre themes of *vanitas* and *memento mori* appealed to the symbolists and other artists of their generation, as Herwig Todts has noted in discussing this print.[2] For Ensor, the obsession with mortality extended beyond his choice of subject matter, for he once stated that he hoped to find permanence by taking up the medium of etching.[3] Indeed, as Carrie Brewster has put it, "it's as if he is speaking to us across time, affirming the common link of death that will unite us all."[4]

—S.G.

1. Hoozee et. al., *Ensor, Dessins et Estampes*, 203.

2. Todts, in Paris: Petit Palais, *James Ensor*, 180.

3. See Goddard essay in this catalogue, p. 82.

4. Brewster, *Ensor, Self Portrait in Prints*, 2.

32

James Ensor
Les Étoiles au cimetière (Starry Night at the Cemetery), 1888
Sulphur ground etching
Museum of Modern Art, New York, Gift of Abby Aldrich Rockefeller, 112.52
140 x 180
Taevernier 56 only state

A LTHOUGH Ensor was not given to experimental printmaking, he did embellish several of his plates through a method of creating tonal passages called sulphur ground etching. This technique, in which sulphur is applied as a corrosive agent directly on the etching plate, is very difficult to control and the results can be hard to predict.

In *Les Étoiles au cimetière* Ensor applied a sulphur ground over an entire plate that, according to a recent scholarship, previously had an image of burlesque figures etched on it. When the heavily bitten plate printed an image resembling a starry night Ensor decided to add the tombstones with drypoint in the foreground.[1] This would indeed seem to be the likely sequence of events. The startling modernity of Ensor's use of chance has not gone unnoticed, nor has the fact that this print predated Van Gogh's painting *Starry Night* by one year.[2] In truth, however, Ensor's plate should be seen as a salvage job, albeit a particularly successful one. Through simply establishing a horizon line, he was able to turn the impression of a random smattering of light created by the nearly ruined plate into the flickering randomness of the night sky.

—S.G.

1. Hoozee et. al., *Ensor, Dessins et Estampes*, 187. She reports that a lightly inked impression at the Gementemuseum in The Hague reveals the image of the burlesque figures.

2. Schaar and Rüter, *Graphik aus sechs Jahrhunderten*, 138, go so far as to call this the first non-objective work of graphic art, prior to Ensor's adjusting the image and adding the title. See also Adams, "Ensor as a 1980s Artist," 11; Lesko, *Ensor*, 131-32.

33

James Ensor
Les Barques echouées (*Boats at Low Tide*), 1888
Etching on laid paper
Spencer Museum of Art, Gift of Richard Hollander, 79.5
176 x 237
Taevernier 49 only state (third of three intermediary stages)

In addition to etching many views of the environs of Ostend [see cat. 35] around 1888, Ensor etched numerous views of the boats, docks, and canals of Nieuwpoort and Ostend.[1] *Les barques echouées* is usually considered Ensor's most successful marine subject. This remarkable evocation of sand, light, mist, and salty air is simply unsurpassed in the medium of etching. Ensor's friend, poet Emile Verhaeren, wrote of this print:

In the second [*Les Barques echouées*], the depth of the landscape is wonderfully rendered due to the oblique position of the two principal lines, that of the distant shore, and that of the boats on the bank; while the broad, ample volute of the cloud unrolls its burden in the same direction as the shore at the right and the boats at the left, contributing to the illusion of expansiveness. Often, the subtle play of lines doesn't fare well in the compositions of James Ensor, but here the

most malevolent of critics have nothing to grasp onto; the work is irreproachable.[2]

Elemental scenes of land, sea, and air inevitably conjure up myriad associations, especially when passage is implied, as with Ensor's empty, beached boats. Significantly, similar symbolically laden recipes were also exploited by other fin-de-siècle artists who shared a strong subjective bent, including Vincent van Gogh (*Fishing Boats at Saintes-Maries-de-la-Mer*, June 1888, Amsterdam: Vincent Van Gogh Foundation), and Edvard Munch (woodcuts of figures staring into the distance from the shore). It may be that Ensor's *Les barques echouées* is essentially a study taken from his beloved port city, but its confluence with symbolist imagery is probably why this, of all of Ensor's marines, is singled out as his most essential.

—S.G.

1. See Hoozee et. al., *Ensor, Dessins et Estampes*, 197-99. Ensor etched nine scenes of Ostend, seven in or before 1888. (Taevernier 14, 30, 39, 40, 44, 45, 49, 64, 89.)

2. Verhaeren, *Ensor*, 59: "dans la seconde, grâce à la disposition oblique des deux lignes principales, celle du rivage lointain et celle des bateaux sur le quai, l'approfondissement du paysage est admirablement rendu, tandis que la volute large et ample du nuage, déroulant sa portée dans la même direction que le rivage de droite et les barques de gauche, concourt à cette même illusion d'étendue. Souvent, le jeu subtil des lignes ne fut guère favorable aux compositions de James Ensor, mais ici les plus malveillantes critiques ne peuvent avoir de prise et son oeuvre est irreprochable."

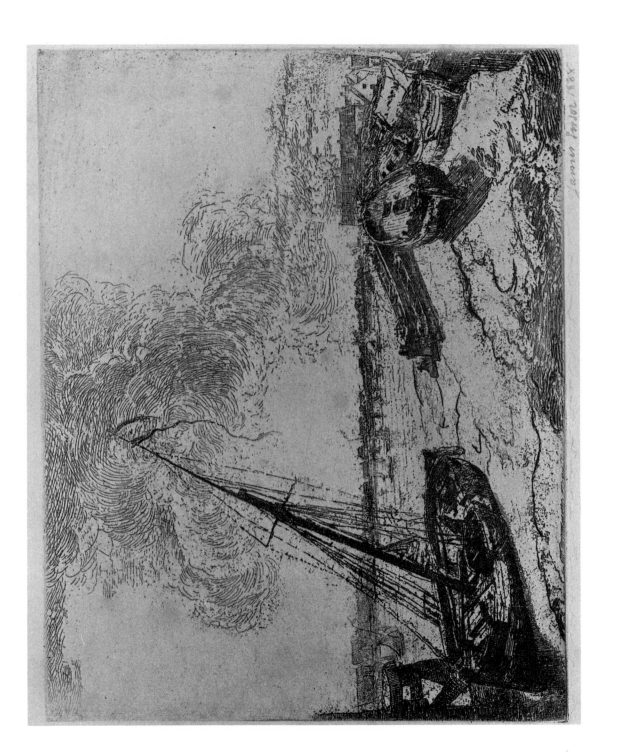

34

James Ensor
Hôtel de ville de Oudenaarde (*Oudenaarde Town Hall*), 1888
Etching, on old ledger paper
National Gallery of Art, Washington, Rosenwald Collection, 1980.45.488
159 x 119
Taevernier 28 iii/iii

OUDENAARDE is a Flemish city with many historical associations and Ensor uses an old Flemish spelling "Audenaerde" (literally "old earth") for his etching of the town hall.[1] Oudenaarde, the hometown of Adrien Brouwer (one of the greatest 17th-century painters of peasant life), is situated south of Ghent on the river Scheldt. The town is particularly famous for its beautiful town hall in flamboyant Gothic style—"a Marvel of refined luxury," to quote Max Rooses.[2] Ensor has etched this extremely ornate structure with a granular line that seems to define detail just beyond our limits of optical resolution. Ensor, who was intrigued by mob scenes and carnival behavior, may have known the legend that this building rests on the

foundations of an earlier town hall that was destroyed by fire in 1525 by a mob celebrating carnival.

This impression is printed on old ledger paper, turned sideways; the ruling lines for tabulating figures are clearly visible. Papers from the 16th–18th centuries were prized for their quality and, by Ensor's time, sheets such as this one were carefully collected for special printings. This impression of the etching was presumably printed by Ensor's first printer, Evely, who is associated with special inkings and impressions on unusual papers.

Ensor's orthography, and also his materials in this impression of the etching, seem to have been carefully aligned with his historical subject matter, a quintessentially Flemish 16th-century town hall.

—S.G.

1. De Seyn, *Dictionnaire Historique et Geographique I*, 65, gives various historical spellings for the town, including a use of "Audenaerde" in 1817 though "Oudenarde" and "Oudenaarde" were used in the 13th, 16th, 17th and 18th centuries.

2. Rooses, *Art in Flanders*, 25.

35

James Ensor

Chaumières (à Slykens, près d'Ostende) (*Thatched Cottages in Slykens near Ostend*),

1888

Etching

Cleveland Museum of Art, Dudley P. Allen Fund, 82.161

119 x 80

Taevernier 50 only state

I N Ensor's day the small community of Slykens lay on the outskirts of Ostend on the Bruges Canal. Before being subsumed by Ostend, it served as the first stop for the tram that travelled along the Belgian coast from Ostend northward to the resort of Blankenberghe.[1] *Chaumières* is one of the thirty etchings that Ensor produced between 1886 and 1904 of Ostend and its environs.[2] Most were done before 1890, apparently on day trips in and around Ensor's beloved home town. Consciously or not, these are much in the spirit of Rembrandt's landscapes, which often incorporate elements observed from his walks in the vicinity of Amsterdam.

The tile roofs, thatched cottages, wattled fence, and the figure who seems to be slogging his way through a blustery autumn wind all suggest a northern European setting. The tall masts and the pole with a weather vane on the right help to set the scene as Slykens along the Bruges canal.

—S.G.

1. Baedeker, *Belgium and Holland*, 18.

2. 1886: *Le Verger*, 1887: *La grande vue de Mariakerke, L'estacade à Ostende, Petite vue de Mariakerke*, 1888: *La lisière du petit bois, Le chenal de Nieuport, Vue du port d'Ostende, Vue d'Ostende à l'est, Boquet d'arbres, Ferme Flamande, Les chaloupes, Le grande bassin d'Ostende, Les barques échouées, Chaumières, Maisonnettes à Mariakerke*, 1889: *Bateaux à vapeur, Le boulevard van Iseghem à Ostende, Ferme à Leffinghe, Le pont du Bois, Le moulin de Mariakerke, La kermesse au Moulin ?, La mare aux peupliers, Le pont rustique*, 1890: *Musique rue de Flandre*, 1891: *Le moulin de Slykens*, 1894: *Les petites Barques*, 1899: *Les Bains à Ostende*, 1900: *Petite vue de Mariakerke* 1903: *Les toits à Ostende*, 1904: *La Plage de la Panne*.

36

James Ensor
La Kermesse au moulin (The Kermis at the Mill), 1889
Etching
Cleveland Museum of Art, Gift of Mr. and Mrs. Robert D. Milne
in memory of Lillian Steinberg, 88.116
140 x 178
Taevernier 72 only state

CROQUEZ describes this print as a pastiche in the manner of Claude Lorrain; the windmill is in the town of Oudenburg.[1] In addition to the windmill, which was still standing when Croquez was writing in 1947, Oudenburg had a ruined Benedictine abbey, an old church, and was described in 1910 as being situated "in the midst of productive gardens which supply Ostend with fruit and vegetables."[2] Ensor also etched one of the Oudenburg orchards in 1886. Like *Chaumières (à Slykens, près d'Ostende)* [cat. 35], *La Kermesse au moulin* not only describes the environs of Ostend, but incorporates elements of Flemish folklore.

A kermis is an outdoor festival celebrated in the Low Countries since the Middle Ages. Though derived from the Flemish word for church mass and associated with religious holidays, kermisses were notoriously secular celebrations. They formed a new subject matter for many leading Flemish painters of the Renaissance and Baroque, including Pieter Bruegel, Adriaen Brouwer, and David Teniers. In this print Ensor shows himself to be steeped in Flemish tradition, both in terms of folklore and art history. Elements in this etching, such as the banner jutting from a tavern window (probably announcing a saint's day), figures eating and drinking at an outdoor table, festive dancers, and a silhouetted figure urinating against a building, were all stock elements in 16th- and 17th-century depictions of village fairs. Looming above this rollicking activity is the windmill, a rallying emblem in the Low Countries that could announce both periods of festivity and of mourning.[3]

—S.G.

1. Croquez, *L'Ouvre Gravé de Ensor*, no. 72.

2. Baedeker, *Belgium and Holland*, 2.

3. In some communities, blades of the windmill were removed in periods of mourning and decorated with garlands for a Kermiss or with other decorations for other festivities; there was also a children's game called mill-play: see ter Laan, *Folkloristisch Woordenboek*, 246–47.
 In a hand-colored version of this print (illustrated in Janssens, *Ensor*, 42) Ensor gave the blades of the windmill red stripes. The mill also figures in numerous Dutch proverbs: see, for example, ter Laan, *Nederlandse Spreekwoorden*, 241–42.

37

James Ensor
La Belgique au XIX siècle (*Belgium in the Nineteenth Century*), 1889
Etching
Private collection
172 x 233
Taevernier 81 i/ii

ENSOR, like many of his Les XX colleagues, was interested in politics and current events and he played an active role in the social and political discourse of his time. This is reflected in *La Belgique au XIX siècle*. This print, a copy in reverse of a drawing in the Royal Library in Brussels, makes overt reference to Socialist demonstrations that called for universal suffrage and educational and military reform. Using the same crowd motif of his monumental painting *L'Entrée du Christ à Bruxelles*, finished in the same year [cat.45], Ensor visually links the harsh actions of the soldiers attacking the marchers to the apathetic conceit of King Léopold II.

As he did in numerous drawings and prints executed during this time, Ensor uses text to directly address the viewer. The banner bearing the words "Belgium in the 19th century" on either side of King Léopold II's head established the social context of the scene. The king is placed hierarchically in the center of the composition and appears oblivious to the violence beneath him. In a semi-circle beneath him are his words to the crowd: "Que voulez-vous? N'êtes-vous pas contents? Un peu de patience, pas de violence. Je vois bien quelque chose mais je ne sais pour quelle cause je ne distingue pas très bien (What do you want? Are you not happy? A little patience, no violence. I do see something but I don't know why I

can't distinguish it very well)." The last sentence refers to the fable "The Monkey and the Magical Lanter" by Florian. In this tale, the monkey invites his friends to a slide show but does not really project anything. The turkey, however, says he sees something, though not very well. Ensor implies that King Léopold II, squinting through a lorgnette on the scene below, only sees what he wants to see.

One thing the king refuses to see is a flag thrust at him, but turned and printed so that the Belgian public who saw the drawing at the 1891 Les XX salon could read it. The flag proclaims the socialist platform of the POB—Personal Service, Obligatory Instruction, Universal Suffrage—labeling the demonstrators as Socialists in opposition to the king and the Catholic party that was in power.[2]

In contrast to the remote king, the crowd presses toward the viewer, the foreground, and even the edge of the frame. These changes in scale that visually set apart the aloof and haughty position of the king from the populist cause of the demonstrators, together with the texts that express their antithetical purposes, express Ensor's antagonism to the repressive policies of the Belgian state. At the same time he implicates the viewer, that is the middle-class patrons of the Les XX salons, in the massacre of the demonstrators in the foreground.

—S.C.

1. Proof of the connection between the king and Florian's turkey is found in the artist's inscription, "The Turkey King," on the back of a proof of this print; first pointed out in Hoozee et. al., Ensor, *Dessins et Estampes*, 155.

2. For explanation of these phrases, see cat. 38.

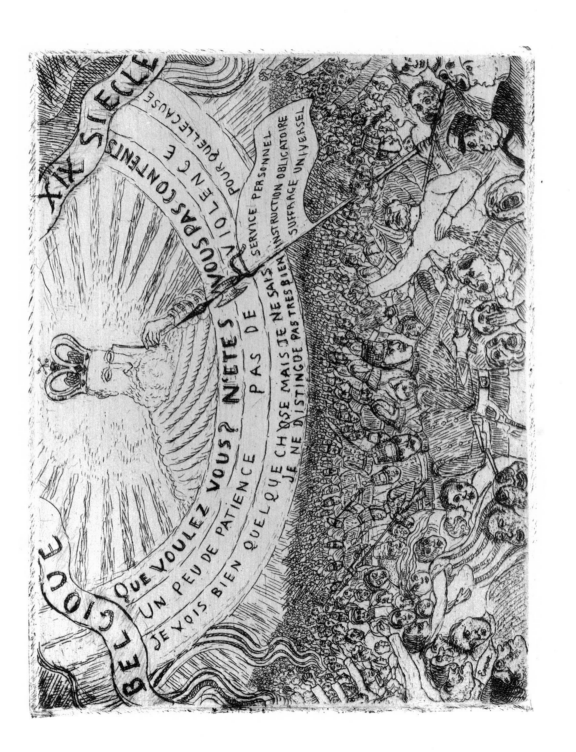

38 [Plate 4]

James Ensor
Alimentation doctrinaire (Doctrinal Nourishment), 1895
Etching, hand-colored
Private collection
180 x 230
Taevernier 79 only state

IN the 1880s Ensor made numerous prints and drawings that challenged the central authority of the Belgian state; *Alimentation doctrinaire* is perhaps the most direct and confrontational of these. Ensor clearly intended to offend the sensibilities of the Belgian middle class, who would have seen this print at the 1891 Les XX salon.

Ensor assembles representatives of the political status quo, subtitled "Belgium in 1889." Each figure holds a card that refers to an issue prominent in the parliamentary debates of the 1880s. On the far right sits a general holding a sign that reads "personal service." This refers to the common practice of wealthy families paying men from the lower class to serve out their male members' mandatory military service. Both the Liberal and Catholic parties supported this: the Liberals feared a loss of support from the propertied class (the only ones eligible to vote) while the Catholics saw it as a way to subsidize the poor. Seated next to the general is a member of parliament under a shining sun that spews fluid from its mouth, an image often found in anarchist publications. This balding legislator clutches a sign that reads "Universal Suffrage," referring to the limited franchise granted only to property owners. Extending the vote to the lower classes was a central platform of the Socialist party, the POB, who agitated and demonstrated for this cause throughout the late 1880s. The Catholics controlled Parliament during this period and opposed extending the vote on the grounds that a larger electorate would undermine the Church's authority and strengthen the Socialists' power. The Liberals were also against universal suffrage as it would give too much economic and political power to the lower classes. The Catholic church is represented by a bishop and a rector on the left side of the print. The rector holds a sign which translates as "Obligatory Instruction," a reference to the on-going struggle between the Catholic and Liberal parties for control over public education. In the center of these figures sits King Léopold II holding the scepter of his power. Each figure squats on the edge of a bowl, expelling the waste product of their political position into the open mouths of their disciples below.

The offensive and clearly scatological references in Ensor's attack link this image to anarcho-communist theory. Ensor first came in contact with anarchism as a student at the Brussels Academy. Through his friend Théo Hannon, Ensor met Victor and Mariette Rousseau, who in turn introduced him to the writings of Pierre Kropotkin and Elisée Reclus. The role of the free individual in undermining the centralized authority of the state was central to the anarchist ideology of both of these theorists. By bearing the buttocks of the political, military and religious leaders of the Belgian state, with text to make sure his audience gets the point, Ensor makes fun of the mindless conformity of the masses who willingly gobble up whatever drivel their masters serve them. Ensor draws upon a the rich satirical tradition that stretches from Bruegel to Rowlandson, while asserting through the radical and offensive tactic of scatological humor the revolutionary potential of individual action. Interestingly, when Ensor was made a baron by King Albert in 1929 he tried to buy up all extant copies of this print.

The print on view is Ensor's first version of this subject. Because the artist reworked the plate with aquatint, its imagery is nearly illegible. Although he added colored pencil and pastel to enhance the image, Ensor decided later that same year to make a second version in which he duplicates the first plate. In this second version, the figures are in reverse order from the first plate, the texts are the same, and, in this more linear treatment, clearer and easier to read. —S.C.

39

James Ensor
Le Christ descendant aux enfers (The Descent of Christ into Hell), 1895
Etching, hand-colored with pencils
90 x 141
Spencer Museum of Art, 69.39
Taevernier 103 ii/ii

LIKE several other prints by Ensor in this exhibition, this image originated as a drawing. The drawing portraying Christ's visit to purgatory after his death by crucifixion was finished in 1891. Christ descended to purgatory to save the unbaptized souls left there after the fall of Adam. The drawing and the subsequent 1895 etching seen here were not Ensor's first treatment of this theme. In 1886 he drew another version in which Christ in silhouette is accompanied to Hell by two devils (*The Devils Dzitts and*

Hihahox commanded by Crazon mount a furious cat and conduct Christ to Hell, 1886, Brussels: Museum of Fine Arts). This early drawing deemphasized the salvation aspect of the story, unlike this print in which Ensor underscored the transcendent nature of Christ who rises above and dominates the crowd assembled around him. Curvilinear arabesques form into banners and flames suggesting both the celebratory nature of the scene and its hellish location.

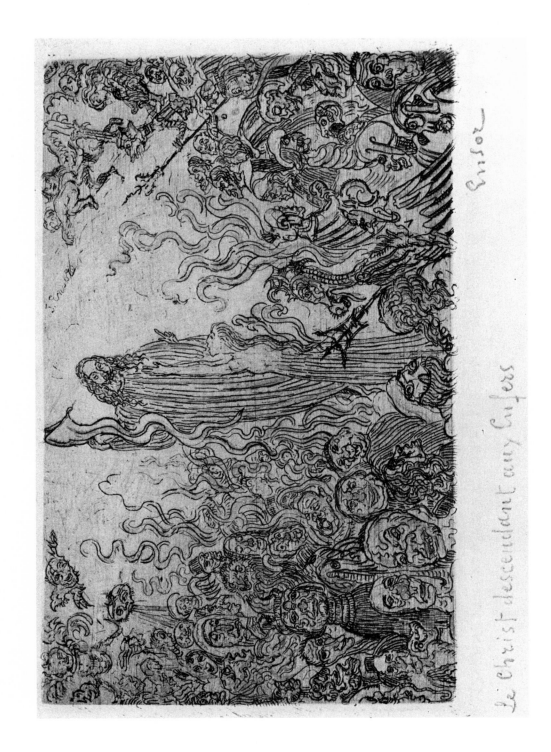

Le Christ descendant aux Enfers

As in many of his other works, Ensor resorts to exaggeration. The inhabitants appear to be caricatures of monks, soldiers and the bourgeoisie, distorted by the flames that consume them. As Christ looks down, a young woman raises her arms in supplication. Other figures in the crowd, however, seem unaware of Christ's presence and, like the crowds in so many of Ensor's paintings and drawings of this period, caught up in their own activities.

With its emphatic rhythms and undulating curvilinear forms, the style of this print suggests the emerging art nouveau line found also in Lemmen's covers for the Les XX catalogue [cat. 68–70] and in Henry van de Velde's drawings for tapestry designs.

—S.C.

40

James Ensor
Bataille des éperons d'or (Battle of the Golden Spurs), 1895
Etching
Collection of John and Ann Talleur
280 x 241

THIS etching is based on a drawing dated 1891. Both recount the story of the rout of the French army by the Flemish civil guard in the Battle of Courtrai in 1302. Although the French had superior numbers, they were defeated by the ingenuity and tenacity of their Flemish opponents who used their knowledge of the terrain to lure the French army into a swamp. Dressed in their golden spurs for a battle on horse-back, the French soon became bogged down in the mire and the Flemish were able to overwhelm and defeat them.

In both the print and the drawing, Ensor depicts the scene from the omnipresent bird's eye perspective typical to fifteenth-century prints. This perspective creates a view similar to looking through a microscope. Indeed, the many figures appear at first glance

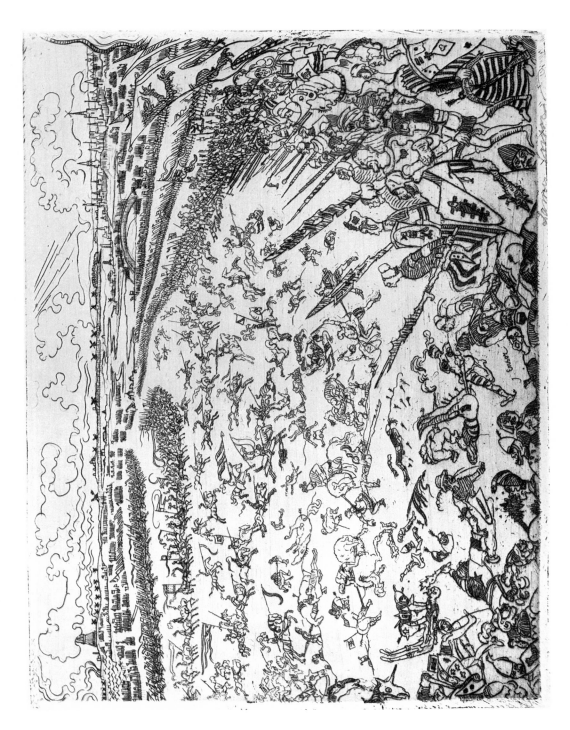

to resemble a teeming world of competing insects. The vast, flat topography stretches across the plane of vision until it reaches the horizon line. The windmills on the horizon locate the scene in the North. In the background plane Ensor has rendered line after line of the French army, their banners and flags waving as they prepare for battle. In the right foreground the motley array of Flemish peasants and soldiers has assembled, a civil guard with little armour and only a few shields and spears to defend them. Here and there are banners with a standing lion, the emblem of the Count of Flanders and of the Flemish land to be defended. In the center of the composition is the quagmire where both man and horse have fallen, only to be pounced upon by the waiting Flemish. All sorts of torture and dismemberment abound as the artist

imaginatively explores the grotesque elements of the story's narrative. The moment Ensor chooses to depict leaves the outcome undetermined, but it is clear that the artist has little empathy for the French whose bodies and horses litter the battlefield.

Through this print Ensor states his allegiance with his native Flemish heritage. More than likely the story of the French invasion of Flanders bore affinities with the artist's own situation at Les XX. There, after initially being proclaimed a leader of the group, Ensor grew increasingly isolated as Les XX grew more enthusiastic for French modernism. No doubt this story of indomitable will, creativity, and ingenuity championing over superior technology and numbers appealed to the artist's sardonic sense of humor.

—S.C.

41

James Ensor
Fridolin et Gragapança d'Yperdamme (Fridolin and Gragapança of Yperdamme),
1895
Etching
Art Institute of Chicago, 1967.21
103 x 140
Taevernier 95 only state

INSCRIBED: Fridolin et Gragapança d'Yperdamme ou amis Ensor et Demolder

Ensor's etching is at once autobiographical and closely allied to the tales about the fictitious town of Yperdamme spun by the artist's close friend, Eugène Demolder.[1] Ypres and Damme are Flemish cities, but there is no Yperdamme. In his third book of stories about Yperdamme, Demolder described Saint Fridolin:

Fridolin was a thin saint, whose large moustache and goatee made him resemble a fencer from the past. His hair was curly, the color of ebony, and he walked about in a long yellow coat.

This bizarre saint always had a flute in his coat pocket, and the Lord no doubt called him to paradise not on account of his good Christian life, but for this instrument from which he obtained the most delicious sounds, and also for the way that he painted masks.[2] This account, published in 1896, goes on to describe Fridolin as a painter and etcher of cathedrals, marches, demonic events and windmills; it also describes a trip to Zeeland by Fridolin and the Count of Yperdamme. In Ensor's etching of 1895 there is no mistaking the flute-playing Fridolin as the artist himself and the dancing Gragapança as the portly Demolder.[3] In fact, Ensor identified them in an inscription on the exhibited impression of the print.

Ensor and Demolder took a trip to Zeeland in 1895, which Ensor described to his friend Emma Lambotte in a letter:

A delightful region where the gracious little peasants dance to the sound of my flute. Sometimes we danced around like the possessed with no concern for rips [tearing our clothes?] before the good, amazed Zeelanders.[4]

Another literal aspect of the etching is the review in Fridolin's pocket, *La Libre Critique*, a reference to the issue of 6 January 1895, which contained Demolder's article on Ensor as a painter and musician.[5] (1895 was an eventful year for Demolder as he gave up his career in law in order to write full-time and married Claire Rops, daughter of Félicien.)

Demolder's use of the imaginary has been called "essentially visual," annexed to the genre scenes of Dutch and Flemish art."[6] Due in part to his love of drink and good times, he also has been called a direct descendent of Brueghel and Teniers.[7] It is possible that in concocting Saint Fridolin, the French-speaking Demolder tipped his hat to Flemish author Jan Bruylants, who wrote the farcical "folks-drama," *Fridolien*, in 1864.[8] *Fridolien* is significant because it was unusual for a play, or any literary work, to be published in Flemish in Belgium so early in the nineteenth century. It was still being performed at the end of the century, and it is possible that it was an important antecedent to the Flemish Movement.[9] In this light, Herwig Todts' suggestion that Ensor's print may make reference to the Flemish saying "Naar iemands pijpen dansen (to dance to someone's flute, meaning to be led by the nose)" is also significant.[10] In the final analysis, *Fridolin et Gragapança d'Yperdamme* is a picaresque fantasy about the Flemish heritage of the two francophone artists who, like Brueghel [reputed to have masqueraded as a Flemish peasant], made an actual pilgrimage to the land of "the gracious little peasants." It is, of course, also significant that in Ensor's version of the tale it is the critic who dances to the tune of the artist. —S.G.

1. Demolder published the first monograph on Ensor three years before this etching; see Demolder, *James Ensor*.

2. The first two Yperdamme books by Demolder are *Contes d'Yperdamme* and *La Légende d'Yperdamme*. The second included three vignettes by Rops.

 Demolder, *Le Royaume authentique du Grand saint Nicolas*, 67:

 Fridolin était un saint maigre, dont la large moustache et la barbiche le faisaient ressembler à quelque escrimeur du temps passé. Il portait des cheveux bouclés, couleur d'ébène, et marchait vêtu d'un long manteau jaune.

 Ce saint bizarre avait toujours une flûte dans la poche de son habit, et l'on assure que le Seigneur l'avait appelé au paradis non pas à cause de sa vie bien chrétienne, mais pour cet instrument, dont il tirait des sons délicieux, et aussi pour la façon dont il peignait les masques.

3. There are two preparatory drawings for this etching; see Ollinger-Zinque, *Ensor*, 125. A Callot etching of two dancing figures (Lieure 246/460) makes a compelling comparison to Ensor's composition: see Hoozee et. al., *Ensor, Dessins et Estampes*, 209; Tannenbaum, *James Ensor*, 71. Less convincing is Elesh's proposal that an English caricature served as Ensor's source: see Elesh, *Commentary*, 33-35, citing G. M. Woodward's *Dandies*.

 Demolder's tale is clearly evoked in a drawing by William Degouve de Nuncques of Ensor playing a flute; Ensor plays for an angel and Saint Nicholas and Ensor's crook is strung with masks (illustrated in Stavelot: Musée de l'Ancienne Abbaye, *William Degouve de Nuncques*, 18 no. 37, "Ensor jouant de la flûte, 23 x 17, Coll. Etat - Musée Stavelot").

4. Hoozee et. al., *Ensor, Dessins et Estampes*, 209 (citing AAC inv. no. 9752): "Pays ravissant où de gracieuses petites paysannes dansèrent au son de ma flûte. Parfois nous gambadions comme des possédés sans souci des accrocs devant les braves Zélandaises émerveillées."

5. Ibid.

6. Aron, discussion in *BN*, suppl. XVI, col. 400: "Il y déploie plus librement un imaginaire essentiellement visuel, médiatisé par les 'scènes de genre' de l'art flamand et hollandais, ou, dans un registre plus contemporain, par les oeuvres de Rops, d'Ensor, et des impressionnistes."

7. De Seyn, *Dictionnaire des Ecrivains Belges*, 543-44. For Demolder's drinking prowess see also Aron discussion in *BN*, suppl. XVI, col. 396-402, particularly col. 397.

8. Bruylants, *Fridolien, Volksdrama*. Fridolien is the heroine of the drama. Bruylant [1834-76] was editor in chief of the Antwerp newspaper *De Koophandel*. He wrote nearly a dozen theatrical pieces and an historical work on the Netherlands during the rule of Philip II. He also collaborated on a nationalistic, historical drama ("vaderlandsch geschiedkundig drama"), *Burgemeester van Stralen*. See De Seyn, *Dictionnaire Historique et Géographique* I, 165.

9. *De Violier* 2, no. 23 (November 1896) announced a performance of *Fridolien*, apparently performed by members of *De Violier* (Antwerp's leading chamber of rhetoric since the late fifteenth-century).

 The premiere of a short comic opera *Fridolin* by M. Courtier, music by Emile Agniez was announced in *AM* 6, no. 5 (31 January 1886): 39.

10. Todts, in Paris: Petit Palais, *James Ensor*, 221-22.

42

James Ensor
Les Cuisiniers dangereux (*The Dangerous Cooks*), 1896
Chalk and pencil
Plantin-Moretus Museum
244 x 330

THIS drawing, executed three years after the last salon of Les XX, reflects Ensor's disaffection with his milieu. By the time Ensor was a founding member of Les XX, he was already a well known artist, having shown at the national Salon and at L'Essor. He had many admirers among the Vingtistes and was considered by critics to be a leader of the group. But due to the influence of Octave Maus and other members, by 1887 Les XX became an enthusiastic supporter of contemporary French art, especially the neo-impressionism of Georges Seurat. Ensor did not share this

enthusiasm and even as he continued to show with the group, he felt isolated from his colleagues. Moreover, Ensor felt that his deeply personal paintings and drawings were often misunderstood by the critics, some of whom dismissed his work as confusing or bizarre.

In this drawing, Ensor alludes to the role that Maus and Edmond Picard played in shaping the Les XX aesthetic by portraying them as cooks preparing a meal of the body parts of several members of the group. On the left, Picard fries the head of Guillaume

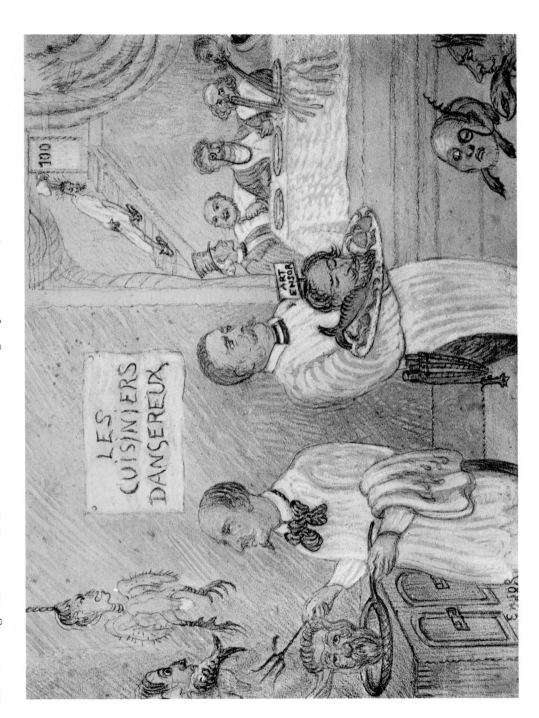

Vogels while above on a shelf are the heads of Georges Lemmen and Théo van Rysselberghe with a fishtail. Anna Boch's head on a chicken carcass hangs in the background. Maus prepares to serve Ensor to the critics assembled at a table in the back room—Ensor's head alongside a fish is marked "Art Ensor," a pun on the popular dish "hareng saur" (smoked red herring). On the floor to the right is Charles vander Stappen with the body of a pig and Henry de Groux attached to a lobster.

In a room to the rear, several critics await their meal while reveling and vomiting in a manner reminiscent of 16th century Flemish prints. Ensor has drawn them to be recognized: Edouard Fetis with his flowing white hair and top hat, the round face and rotund body of Eugène Demolder, Camille Lemonnier with spectacles and moustache, the balding crown of Max Sulzberger, and Emile Verhaeren's flowing, exuberant moustache. Behind these seated men Théo Hannon, beset by an attack of diarrhea, rushes up the stairs only to discover an overturned chamberpot.[1]

Using conventions of Dutch and Flemish printmakers—a room looking into another room, the feast and excessive behavior—Ensor cues the viewer to his satiric intent. The artist makes visible his own disaffection with a wicked sense of humor. Obviously, Ensor sees himself and his colleagues at Les XX as ingredients in Picard and Maus's recipe for critical success. Yet even if the critics devour the meal of freshly cooked "Art Ensor," their depicted regurgitation suggests that the result of their critical efforts is little more than waste product. Even as Ensor makes fun of his contemporaries his critique is blunted, for he includes both his supporters and detractors in the scene. Ensor's antagonism toward Maus is well documented, but Picard was one of the artist's strongest defenders and patrons. Though the conservative critics Fetis and Sulzberger generally dismissed Ensor's work in their reviews, Demolder, Lemonnier, Verhaeren and Hannon were among his most ardent backers; both Demolder and Verhaeren wrote monographs on the artist and Demolder organized Ensor's first one person show in Brussels. Along with Lemonnier, these four writers would also contribute to the 1896 Ensor issue of La Plume. Hannon had been Ensor's closest friend in the 1880s, but by the time this drawing was executed they had become estranged.

By placing his head on a platter like John the Baptist, Ensor envisions himself as a martyr for modern art and his own spiritual cause. Drawing on the image of Modernity, an 1883 etching by fellow Vingtiste Félicien Rops in which a woman carries the head of an academic painter on a platter, Ensor represents his belief in his own centrality to Belgian modernism alongside the foolish behavior of his contemporaries who have failed to recognize his importance and his sacrifice.[2]

—S.C.

1. These figures are identified in Haesserts, Ensor, 38.

2. Hoffman, "Iconography of Rops," 209–210.

43 [Plate 5]

James Ensor
Le Vidangeur (The Scavenger), 1896
Etching and drypoint, hand-colored
Collection of Dr. Richard A. Simms
114 x 77
Taevernier 106 only state

THIS is an example of Ensor's preference for representing the marginal characters who live on the fringes of civilized society. With his basket strapped to his back and carrying a broom, wearing baggy clothes and a top hat that accentuates a disproportionately large head, Ensor's scavenger sets out on his daily rounds. Obviously the artist intends to make this man as unsavory as possible, with his mangy beard and peeling skin and the smell implied by his grasp of some slimy object. Yet, despite this, Ensor's figure is not unapproachable. His head turned toward the observer, the scavenger's face wears a friendly grin. Moreover, by isolating the figure and setting him against the skyline, Ensor monumentalizes and ennobles the man's lowly but important role.

Scavengers were familiar figures in Belgium in Ensor's time. They served the important function of collecting and selling garbage and manure. Belgium played a leading role in the 19th century in initiating sanitation programs that included the laying of sewer pipes and instituting large scale recycling programs whereby the poor could gather and sell excrement. The scavenger is one such entrepreneur who benefitted from collecting the waste products of the upper and middle classes. That Ensor sees the irony at play in this man's lowly but important position is evidenced both in his humorous yet sympathetic treatment and by the inclusion of the top hat that satirically suggests that this man could be viewed as Belgium's newest capitalist entrepreneur. —S.C.

44

James Ensor
La Mort poursuivant le troupeau des humains (Death Pursuing a Flock of Mortals),
1896
Etching and drypoint
Spencer Museum of Art, Letha Churchill Walker Memorial Art Fund, 88.65
232 x 175
Taevernier 104 ii/iii

IN this etching Ensor joins the crowd motif that figured prominently in his work after *The Entry into Jerusalem* with the moralizing tale of the grim reaper that is often found in northern art. In Ensor's rendition, Death, personified by a large, web-footed skeleton carrying a large sickle, hovers over a narrow street. Behind him billowing clouds spew forth more skeletons, while on the right several figures, including two monks, are consumed by flames. Beneath the skeleton, a massive crowd fills the passageway, reaching far into the background and pressing forward toward the foreground plane. Interspersed among the crowd are more sickle-bearing skeletons marshalling the masses forward toward their doom.

Although the crowd scene was based upon the massive Socialist demonstrations held in Brussels and witnessed by Ensor in 1885 and 1886, the artist has included all classes of society to say that death comes to all. Thus we see top-hatted bourgeoisie, military men with their medals and barristers in their robes alongside working class men and women. As the crowd rushes forward, some looking back in horror while others pray or open their mouths to scream, a half naked woman tries to save her child. Next to her a man holds his wounded head, apparently the victim of another man who holds aloft his knife. All of these details combine to invoke in an almost visceral manner the claustrophobic effect of a rioting crowd filled with panic and terror. Perhaps to give some relief to the apocalyptic vision of the last judgement, Ensor includes a comic brothel scene at the middle right where an open window reveals a party going on in the midst of all this mass hysteria.

This etching is based upon a drawing Ensor executed in 1887 (Antwerp: Royal Museum of Fine Arts). Although the print basically is a copy in reverse of this drawing, Ensor has made some notable changes. He has eliminated a kissing couple who had stood on the balcony at the left along with a man who defecated on the crowd and replaced them with a skeleton who appears to scale the wall toward the people in a window above him. Ensor also sharpens and increases the perspective depth of the crowd, further augmenting the forward crush of the fleeing and terrified masses and heightening the overall claustrophobic temper of the scene.

The drawing for *Death Pursuing a Flock of Mortals* was one of Ensor's first uses of a skeleton. Death was definitely on his mind in 1887; that year both his father and grandfather died and he had experienced a prolonged illness. In an 1887 letter to Octave Maus, Ensor depicts himself as an emaciated, silhouetted being led from his bed by a skeleton in a top hat. In the drawing *Death Pursuing a Flock of Mortals* and this later print however, Ensor extends his personal meditation on death to a broader social sphere. Ensor acknowledges his own northern heritage while suggesting that, rather than the mass demonstrations for social justice upon which this scene is based, our common mortality is the great social equalizer.

—S.C.

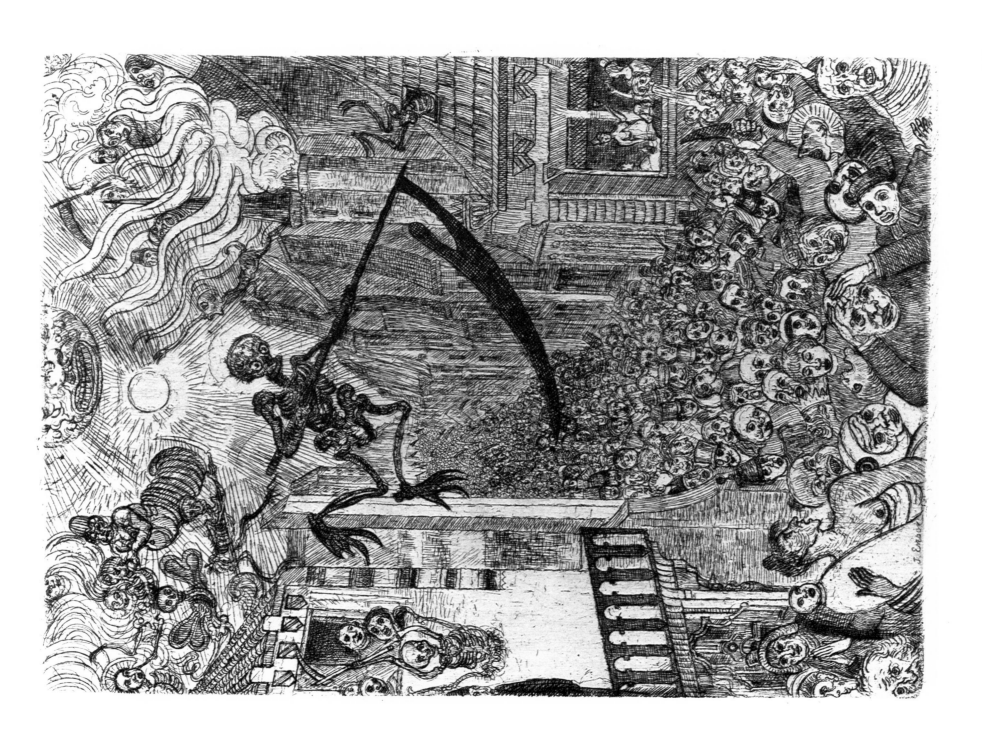

45

James Ensor

L'Entrée du Christ à Bruxelles (*The Entry of Christ into Brussels*), 1898

Etching

Sterling and Francine Clark Art Institute, 1962.56

250 x 356

Taevernier 114 iii/iii

THERE is little doubt that the 1888 monumental painting *The Entry of Christ into Brussels* (Malibu: J. Paul Getty Museum) is the most important painting of Ensor's career. It has often been seen as Ensor's answer to Seurat's *La Grande Jatte*, which had been exhibited the previous year with Les XX. Ensor's anxiety about the increasing prominence of French-inspired art in the ranks of Les XX is echoed in the French tricolor that flutters above the crowd.[1]

Ensor began reproducing his major drawings and paintings as etchings in the 1890s and he eventually created an etched version of this key work. However, the painting was not exhibited until 1929 and so the image was first accessible through the etching.[2]

In *The Entry of Christ into Brussels* the streets are bursting with a carnivalesque, masked crowd bearing signs and banners that announce a broad spectrum of contemporary social, commercial, political, and artistic concerns. Ensor referred to the print as "The Entry of Christ into Brussels, Mardi Gras, 1889."[3] The figure of Christ is a portrait of the artist; Ensor portrayed himself as the Savior many more times immediately following *The Entry of Christ into Brussels*.[4] As concluded by Stephen McGough:

For Ensor the Entry was also an allegory of his career as an artist in provincial Ostend attempting to gain acceptance in the capital city. . . . The mocking gestures and buffoonery which greet Christ as he comes into Brussels are the equivalent to the incomprehension and derision which Ensor saw himself face each year when he exhibited his works at Les XX in Brussels.[5]

In a related drawing, Ensor's 1885 *The Entry of Christ into Jerusalem* (Ghent: Museum voor Schone Kunsten), a portrait of Emile Littré (closely based on a photograph by Nadar) appears in the lower right. Littré was an important French positivist who helped pave the way for a contemporary perception of Christ as a revolutionary figure.[6] In the painting and in the print, the figure of Littré has been replaced by a bloated figure in a bishop's miter at the bottom center.

The slogans are much more specific in the print than in the painted version of *The Entry of Christ into Brussels*. They are:[7]

VIVE JESUS ET LES REFORMES (Long live Jesus and the reforms)

COLMAN'S MUSTART (Colman's mustard)

VIVE DENBIJN (Long live Denbijn)

MOUVEMENT FLAMAND (Flemish Movement)

LES VIVISECTEURS BELGES INSENSIBLES LES XX (The insensitive Belgian vivisectionists Les XX)

VIVE LA SOCIALE (Long live the Sociale or Long live welfare)

FANFARES DOCTRINAIRES TOUJOUR REUSSI (Doctrinaire fanfares always succeed)[8]

LES CHARCHUTIERS DE JERUSALEM (The butchers of Jerusalem)

PHALANGE WAGNER FRACASSANT (Sensational Wagnerian Phalanx)

SALUT JESUS ROI DE BRUXELLES (Greetings to Jesus, King of Brussels)

LA SAMARIE RECONNAISSANTE (The grateful Samaritan)

VIVE ANSEELE ET JESUS (Long Live Anseele and Jesus)[9]

Christ/Ensor appears amidst this mob seething with contemporary opinion on such issues as the role of Christ as a revolutionary figure, the Flemish movement, Les XX, socialism, conservative politics, anti-Semitism, and enthusiasm for Wagner's aesthetic theories. The juxtaposition of the these slogans and an advertisement for Colman's Mustard suggests Ensor's distrust of all forms of dogmatism. Though McGough has argued that Ensor was influenced by the composition of a socialist march in Brussels in 1886, a carnivalesque atmosphere is also strongly present.[10] By 1896 carnival processions in Ostend, which

Ensor certainly witnessed, specifically prohibited any allusion to contemporary political figures, but this regulation only testifies that this had become a problem for the authorities.[11] It may be the similarities of these two mass phenomena that appealed to Ensor. As in the 1889 painting and subsequent lithograph, *Christ Tormented*, by Ensor's friend Henry de Groux [cat. 10], Christ represents the persecuted creator/artist. In Ensor's image, however, paranoia has not taken over and a radiant Christ/Ensor blesses the masked crowds assembled around him as if to indicate the true path to his artistic compatriots. —S.G.

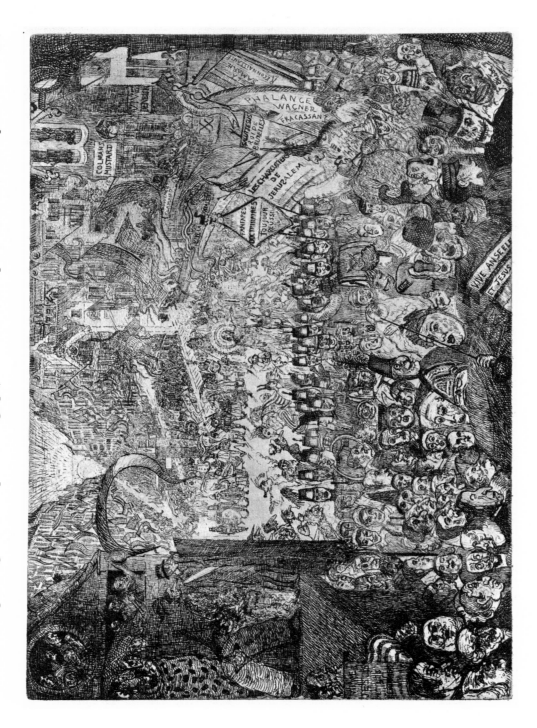

1. McGough, *Ensor's "Entry of Christ into Brussels,"* 162.

2. McGough, 1, recapitulates the situation in which *The Entry of Christ into Brussels* was listed in the 1889 *Les XX* exhibition catalogue but was not exhibited (exactly why is still not certain).

3. In a letter of 20 December 1898 to Deschamps, Ensor spoke of "une nouvelle eux-forte: *L'entrée du Christ* à Bruxelles le mardi-gras en 1889.": Getty letter 860504. Ensor hoped to include this new work in the special number of *La plume*, and asked if Deschamps would be patient enough to wait until Ensor had time to proof the print, "je suis aller a Bruxelles me charger des cuivres, assister au tirage."

4. McGough, 116–135, concerning Ensor's images of Christ, he specifies 1889–1891 as the period that "Ensor portrayed himself directly as Christ."

5. McGough, 10–11.

6. Hoozee et. al., *Ensor, Dessins et Estampes,* 107 and 114; McGough, 156–57; Lesko, *Ensor, the Creative Years,* 132–34.

7. McGough, 207–213. This transcription essentially follows that of Farmer, *Ensor,* 46.

8. For the meaning of "doctrinal" in nineteenth-century Belgium, see cat. 38.

9. McGough, 153, summarizes, "Edward Anseele, who, under the white banner of Ghent, led the 15 August 1886 socialist march."

10. McGough, 152 and 229n260.

11. The Ostend newspaper *Le Carillon* (1er année, no. 13, 12 February 1896 [pp. 2–3, though not paginated]), in an article on the various competitions associated with Carnival, stated "comme pour la cavalcade du 16, toute allusion politique est interdite dans n'importe quel concours (as in the cavalcade of the 16th, any political allusion is prohibited in any competition)."

46 [Plate 3]

James Ensor
La Vengeance de Hop-Frog (Hopfrog's Revenge), 1898
Etching, hand-watercolored
Sterling and Francine Clark Art Institute, 1962.55
360 x 250
Taevernier 112 ii/ii

THIS etching is based on a story by Edgar Allen Poe. Ensor made three versions of this image: an 1886 lithograph, an 1896 painting and this etching of 1898.[1] Ensor admired Poe's writing and made several drawings and prints after his stories.[2] In "Hopfrog's Revenge," the court jester Hop Frog organized a masked ball to get back at the king and his court who had laughed at him and insulted his girlfriend, Tripetta. At the height of the festivities Hop Frog tied up the king and his companions, covered them with oil, and set them on fire. In this print Ensor represents the climax of the story, Hop Frog's triumphant revenge, when the smoldering king and his ministers, disguised as apes, are hoisted on a chandelier by the Hop Frog for all the revelers to see.

The vast ornate, multi-tiered room where Ensor stages this scene of revenge bears a resemblance to a court scene represented in the Callot print *First Intermission*, 1617. Like Callot, Ensor places figures in the foreground and it is over these backs that the viewer gazes upon the scene. Unlike Callot, however, Ensor creates a direct view, as if the observer is seated on a balcony opposite the chandelier. In this fashion the artist creates a deep stage-like space that is made even more monumental by the addition of balconies and an immense crowd in the background.

Ensor deliberately underlines the grotesqueness of Poe's tale. In the handcolored version seen here, the artist underscores the contrast between the grotesqueness of the narrative and the festivity of the ball by coloring the costumes in red, blue and green and by using red to emphasize the blistering bodies of the king and his cronies. The artist intends for the public to be part of this spectacle by his inclusion of an opening next to the two figures in the right foreground. To the left of this opening, another spectator wears a sash bearing Ensor's name and the date of the print.

More than likely, Ensor identified with Poe's court jester. Ensor felt he had been abused and laughed at by the Belgian art world and the press. When the lithograph of this print was offered for sale by the literary magazine *La Jeune Belgique* in 1891, Ensor suggested in a letter to editor Valère Gille that the best advertisement for the print would be a quote from Poe's story. The quote he choose reveals the affinity Ensor felt with Hop Frog, who, like the artist, lived in a social milieu where his unique abilities where misunderstood and laughed at: "Nothing is better than to cite here the song of Poe. Perhaps: 'The crowd fell back again for an instant, then silence', or 'The work of vengeance was accomplished. The eight bodies swung on the chains, a confused mass, fetid, sooty, hideous' or better: 'This was my last buffoonery.' If you wish a notice I believe that this last is the best."[3] For Ensor this scene that pictures Hop Frog's detractors as a swinging pile of charred flesh was indeed the artist's best revenge. Using the pretense of Poe's story to create a fantastic and perverse image of his own artistic triumph, Ensor was able to have the last laugh on his contemporaries.

—S.C.

1. Rouir, "Ensor: La Vengeance de Hop Frog," 211–14, dates the lithograph in the collection of the Print Cabinet of the Royal Library, Brussels, to 1885.

2. Ensor later wrote of his admiration for Poe and his *Histoires extraordinaires*. Ensor works inspired by Poe include *King Pest* (1880, Brussels, private collection), *The Black Cat* (1886–88, Karlsruhe, Staatliche Kunsthalle), *The Devil in the Belfry* (1888, Hamburg, collection Klaus Hegewisch) and *The Domain of Arnheim* (1890, private collection). For a discussion of Poe's influence on Ensor, see Lesko, *Ensor: The Creative Years*, 94–96.

3. Letter from Ensor to Gille, 27 April 1891, as reproduced in Warmoes, *Gille et la Jeune Belgique*, 21.

47

James Ensor
Peste dessous, peste dessus, peste partout (Plague here, Plague there, Plague everywhere), 1904
Etching on wove paper
Print Collection, Miriam and Ira D. Wallach Division of Art, Prints, and Photographs;
New York Public Library, Astor, Lenox and Tilden Foundations
192 x 291
Taevernier 127 only state

THIS is a copy in reverse of an 1888 drawing in colored pencil now in the collection of the Royal Museum in Antwerp. The arrangement of the central figures is taken from a photograph of Ensor with several friends and his sister, Mitche, on a trip to Bruges. In the etching, the Rousseaus, Willy Finch, and Mitche sit on a bench on a seaside boardwalk.[1] Ensor's friends are the epitome of middle-class propriety in their fashionable clothing. Their refinement is humorously contrasted to the tattered rags and smelly odors of the lower class figures surrounding them.

Bilious clouds rise up from the fishermen, the mother and child, and the puddles of urine and manure beneath the bench. The proper bourgeoisie seem engaged in their discussion and oblivious to both the stench and the wretched condition of the poor people around them. Ensor's sardonic humor is revealed in the title above the scene, which could refer to either the smelly figures or to the couples on the bench. By leaving the significance of the title unclear Ensor allows the audience to determine which of the groups is the true pest.

—S.C.

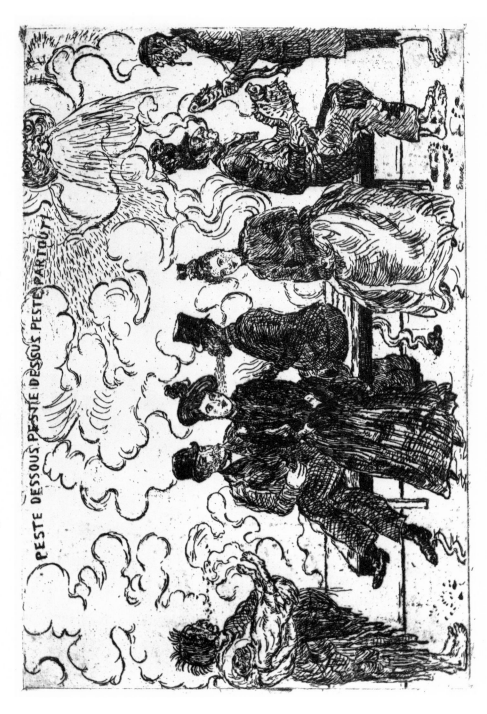

1. Discussed and illustrated in Hoozee et. al., *Ensor, Dessins et Estampes*, 81.

48

Alfred William Finch
Sheet of sketches, ca. 1878–1883
Charcoal and black chalk
Musée des Beaux-Arts de Tournai, d.616
224 x 174

LIKE his friend James Ensor, whose drawn fragments of furniture and decorative accessories appear frequently in studies, Finch had a passion for observing and sketching the details of daily life.[1] Everyday objects as much as literature and music inspired the two companions. Drawing upon a domestic environment of heavily-carved buffets, armoires, tables and chairs, Finch created intimate studies imbued with imagination and life.[2]

The baluster of a buffet or mantle, a horse and cab, and the knob or finial of a piece of furniture—perhaps a stone carving if the lines below represent a church window—cover a sheet of paper notated and signed by Finch. The horse and cab are less weighty and worked; Finch probably sketched the patient animal on his drawing pad out-of-doors.[3] The somewhat more deliberately drawn animal-head baluster and crouching figure atop the post emerge mysteriously from the shadows. But unlike the ghosts that Ensor inserted into earlier sketches of furniture, Finch's objects are unhaunted.

Filled with the improvisation and immediacy of a sketched study, the objects are neither dreamlike, visionary, nor imaginary as symbolist works. No sense of independent life in the inanimate carvings, the "soul of things" to which Xavier Mellery referred, seems to threaten the viewer. Finch's vivid drawings, free of obsessive detail, celebrate the comfortable materiality of bourgeois Belgian life.

—S.K.

1. Examples abound of Ensor's drawings of furniture details; see cat. 19, for example. Masks and apparitions appeared later as additions to the original works.

2. As seen in their paintings, prints and drawings, Finch and Ensor's middle-class family homes were richly decorated and had a somewhat somber atmosphere. Sketches proved a valuable tool to experiment with a combination of effects and plastic expression when antique statues or living models were neither available nor desired.

3. The weary, blindered horse is similar to the ones in *Fiacres en stationnement* [cat. 54].

49

Alfred William Finch
Portrait of James Ensor, ca. 1879–1883
Charcoal
Musée des Beaux-Arts de Tournai, d.626
224 x 174

ENSOR and Finch were often in one another's company in the early 1880s in Ostend. A comparison of their sketches made during this period reveals their similar choices in technical approaches to rendering still lives [cat. 19 and 48]. The two friends also posed for one another frequently at this time. Finch appears in several of Ensor's drawings and, perhaps most promi-

nently, in Ensor's painting, *La musique russe (Russian Music,* 1881, MRBA).[1] In Finch's sketch of his friend painting we see Ensor holding his palette in his left hand, poised in concentration. The verso of the drawing shows a number of quicker studies, among them details of an artist's hand (presumably Ensor) holding a palette and a right hand holding a brush.[2] —S.G.

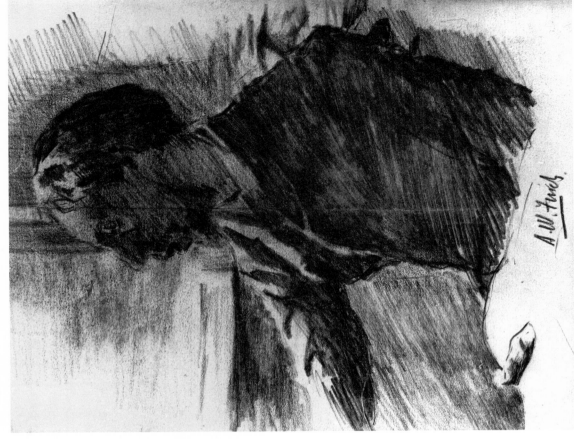

1. See Roberts-Jones, "Willy Finch, une Maitre de l'art en Belgique," 13-15, for the artists' mutual friendship and further examples of drawings and paintings of one another.

2. Illustrated in Brussels: MRBA, *A.W. Finch,* cat. 68b.

50

Alfred William Finch
1888 Les XX catalogue entry
Photomechanical relief
Spencer Museum of Art, 89.109
208 x 140

P ERHAPS the greatest influence on Finch was the February 1887 Les XX salon to which Camille Pissarro and Georges Seurat were *invités*. Seurat's pointillist masterpiece, *La Grand Jatte*, had an electrifying effect on Finch. At the 1888 show Finch offered his first neo-impressionist works, five divisionist landscapes that included scenes of Suffolk, England, and its environs. Finch introduced these works in the catalogue with this charming sketch. The scene, probably an English harbor view, originally in pen and ink, is executed in the familiar dotted patterns of pointillism.

Finch probably anticipated the arrival of the *invités'* neo-impressionist paintings and had a sense of their importance. In three articles for the journal *L'Art*

Moderne during 1886–1887 the critic Félix Fénéon discussed the second Independent exhibition in Paris and Seurat and other pioneers of pointillism. The June 1886 review of the eighth Impressionist show discussed the principles of color theory and optical mixing in *La Grand Jatte*. The concepts of aesthetics and color theory of Rood, Chevreul and Henry were familiar to Finch. He entered into a correspondence with Paul Signac and other theorists and further developed an interest in color, light and atmospheric effect.

Finch's airy and atmospheric marine sketch, while perhaps commonplace to modern eyes, must have been refreshing and startlingly adventurous to those unfamiliar with the latest experiments in art. —S.K.

51

Alfred William Finch
Champs (Fields), ca. 1888
Etching
Spencer Museum of Art, Spencer Fund, 89.78
95 x 165

52

Alfred William Finch
Étude de verger (Study of an Orchard), ca. 1888
Etching
Spencer Museum of Art, Spencer Fund, 89.79
120 x 163

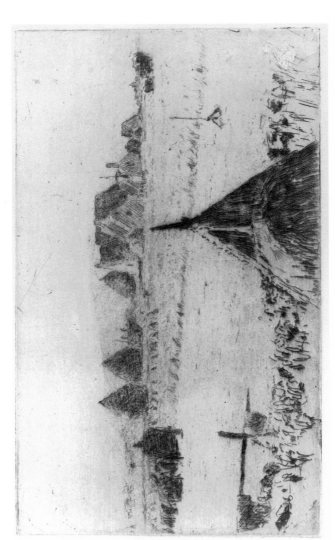

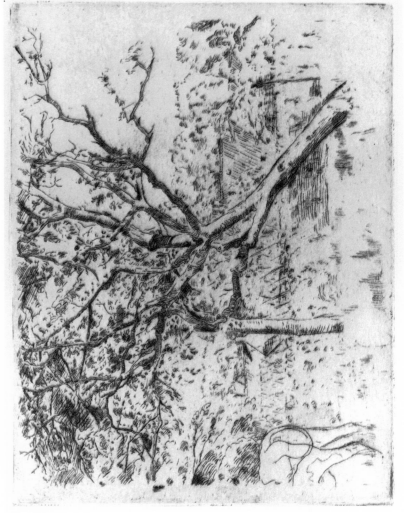

53

Alfred William Finch
Couseuse vue de profil gauche (Woman Sewing Seen from the Left), ca. 1888
Etching
Spencer Museum of Art, Spencer Fund, 89.73
130 x 162

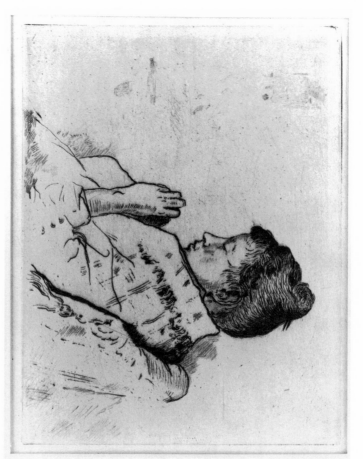

54

Alfred William Finch
Fiacres en stationnement à la Porte de Namur (Carriages Waiting at the Porte de Namur), ca. 1888
Etching
Spencer Museum of Art, Spencer Fund, 89.76
158 x 174

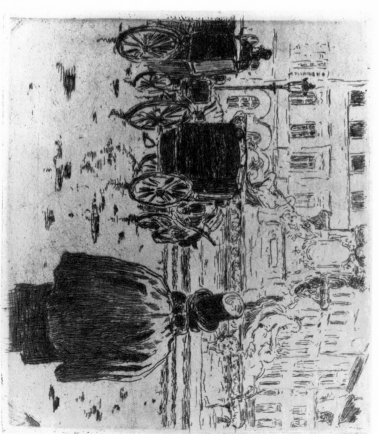

FINCH is best known as an innovative art nouveau ceramicist and designer and as a founder of modern art in Finland. However, his early years were spent as an important player in Belgium's progressive art circle. He was a founder of *Les XX* and one of its staunchest supporters and most revolutionary members.[1] Finch exhibited yearly at *Les XX* salons, except for 1889. His exhibited etchings are not overtly revolutionary in technique or content, yet they reverberate with a love and appreciation for Belgian life and place, as well as with the concerns of the Belgian avant-garde during the closing decades of the nineteenth century.

Finch's English familial and social connections opened the British art world to him, and through him, to Belgian artists. Visits to England resulted in friendship with the Anglo-American artist James Whistler, whose etchings and engravings affected Finch's taste, as did those of James Ensor.[2] Finch's frequent trips to Britain introduced him to Pre-Raphaelite paintings and to John Ruskin's ideals that espoused art as a moral force through its fidelity to nature. Finch was influenced by and championed the ideas of William Morris and Walter Crane, whose Arts and Crafts movement emphasized function and simplicity in design.

As vignettes of rural and urban life, the series of ten etchings from which these works may come represent almost half of the etchings done during Finch's years in Belgium.[3] While there is some continuity in subject or mood among a number of the prints, they were probably not conceived or etched at the same time. Finch introduced five etchings at the 1887 *Les XX* salon and three more the following year, by which time he was a member of the Société des Aquafortistes Belges. The artist offered both pastels and watercolors at the 1893 show, and two publishers tendered editions of etchings in 1892 and 1893.[4] By 1899 Finch's friend, Georges Lemmen, remarked upon the rarity of the 1893 collection of ten plates to which some of these " powerfully evocative" etchings may belong.[5]

Champs and *Étude de verger* offer pleasant, evocative glimpses of the Belgian countryside. They also deal with issues of time and change, people and their land. The wheat harvest is underway in *Champs*; loaded wagons follow farm laborers as they form hayricks.[6] Finch's compositional design underlines the unity of land and people.[7]

Finch's etchings of seasonal agricultural activity draw on themes current in both avant-garde and traditional art. Finch was familiar with Millet's series, *The Seasons* (1868-1874), and he also may have been familiar with Pissarro's series, *The Four Seasons* (1872-

1873).[8] As Brettell has noted, "The truest and most convenient expression of the seasonal changes in nature was agriculture, and the cycle of planting, blooming, tilling, and harvest became emblematic of natural or seasonal time."[9] The rhythm of seasons, the sense of natural order, the association between peasant and nature—all are implied by the depiction of the cyclical ritual of the harvest. Finch's artistic heritage was rooted deep within the rich northern-European tradition of agriculture and countryside and had predecessors in pastoral poetry, in Breughel's bacchanalian harvest scenes, and in seventeenth-century pastoral scenes.

Étude de verger contains a humorous vignette—tail swishing, the rear end of a cow occupies the lower left corner.[10] During the Renaissance in the Low Countries the image of the cow became emblematic of bucolic virtues and of the land itself, and Finch combines the delight of this direct view with its traditional resonance.[11]

In general, Finch emphasizes the human/land connection and pride of place in his pastoral etchings; technological innovations are generally not in evidence. Neither the nineteenth-century Belgian context of agricultural recessions and rural poverty nor the inroads of modernization and industrialization are permitted to impinge on these ideal views. Just as the French impressionists who portrayed agriculture in its pre-modern and traditional forms were commenting upon modernization, so, too, Finch may have been both evoking the past and marking the rapidly-passing present.[12] During the agricultural revolution industry triumphed, ending bucolic isolation.[13] Finch and Henry van de Velde, with whom he painted in the countryside, believed that the depiction of "rural life . . .[was a] primitive respite from modern industrialized society."[14] These etchings are affectionately nostalgic emblems of Belgian history.

A different mood is suggested by *Fiacres en stationnenement à la Porte de Namur*. Hackney drivers and cabs await customers around the Fontaine de Brouckère at the Porte de Namur. Still a main entry into Brussels from the southeast, the Porte de Namur is a remnant of one of the seven gates to the medieval walled city of Brussels. Finch is no less observant of the urban landscape than of the countryside around Brussels. The grayness after rain, the puddles of standing water reflected on the damp pavement, the northern light and atmosphere are caught by Finch without heavy plate tone or aquatint.

The fountain in the center of the square was completed in 1866 to honor Charles de Brouckère, burgomaster of Brussels from 1848-1860. Finch presents us with a simplified version of the fountain.[15] He fluidly

sketches the double basin flanked by statues of Neptune and Amphitrite relaxing on dolphins. For Belgians, certainly for inhabitants of Brussels, the fountain was a familiar sight, honoring the virtues of civic and national duty. In a typically subtle fashion, Finch imbues this print, too, with a sense of pride in Belgium and the virtues of her people.

The final print is one in a long line of works portraying somber and contemplative northern European women concentrating on their lacemaking or sewing.[16] Many of the Vingtistes used their wives, mothers and sisters, engrossed in domestic chores, as models. Catherine Eliza Pelling, whom Finch married

in 1885, is the probable model for this etching. Grounded in Flemish realism and with a somewhat tighter technique than the exterior views, Finch's spontaneity is still apparent. In the mid- to upper-left corner random lines mark the plate. Without clearly defining a background, Finch has succeeded in suggesting a cozy Belgian interior and the peaceful atmosphere of his home.

Although specific, the vignette and all the prints in the series respond generally to the particularities of Belgian life. Once again, Finch grounds his images in the everyday and mundane, while evoking the grand themes of his time and the artistic legacy of Belgium. —S.B.K.

1. According to Georges Lemmen, Finch and Ensor were "inseparable" during Finch's year of study at the Academie des Beaux-Arts in 1878–79, and even then had reputations as dangerous revolutionaries. I am grateful to Robert Hoozee for providing a copy of Lemmen, "A. W. Finch," which contains this observation.

2. Impressed by Whistler's work, Finch arranged his invitation to the first Les XX salon. Whistler reciprocated with invitations for Finch to show at the Royal Society of British Artists' exhibitions in 1886–1887 and 1887–1888. Finch proposed Whistler for membership in Les XX in 1886, but Ensor's enmity defeated the motion. Finch was perhaps inspired to produce a series of Belgian scenes by Whistler's English series.

3. Derrey-Capon, in Brussels: MRBA, A.W. Finch, surmises that Finch's Belgian print production totaled only twenty-five, 45; she hypothesizes that Finch was too busy with his divisionist experimentation and ceramic production from 1888 to 1892 to work on etchings, 46.

4. See Brussels, Centre International pour l'Etude du XIXe Siècle, Dix expositions annuelles, 111, 147, 290. By August 1892 Dietrich & Cie. published a portfolio of 10 etchings by Finch for 125 Belgian francs. See no. 33 on the annual list of published books and prints: BB 1892, 195. In 1893 Veuve Monnom offered for sale a signed and numbered edition of 10 plates printed on Japan paper. I am grateful to Maurice Tzwern for discovering this advertisement in AM 13, no. 11 (12 March 12 1893): 87.

5. "Un recueil de dix planches, aujourd'hui rarissime, fut publié en 1893: figures, paysages belges et londoniens; la Tamise à Londres, surtout, y est puissamment évoquée": Lemmen, "A.W. Finch," 232.

6. Derrey-Capon, A.W. Finch, gives this work the title Champ de blé en Belgique (Wheatfield in Belgium) and the narrower dates ca. 1888–1890, 197; she cites another example of this image as no. 21 in an 1893 portfolio, Eaux-fortes par A.W. Finch, no publisher given.

7. The Flemish tradition of the peasant integrated into the land-scape is a long one and in 1891 van de Velde gave a lecture on the peasant as a theme in art, "Le Paysan en Peinture," which was excerpted in AM, 22 February 1891.

8. Pissarro was an invité to the 1887 Salon des XX.

9. Richard Brettell, "The Fields of France," 247.

10. Derrey–Capon, A.W. Finch, gives the dates ca. 1886–1888. The example in her catalogue is no. 4 in the 1892 portfolio Eaux-fortes d'A.W. Finch, published by Dietrich & Cie, Brussels.

11. The cow, whole and cropped, appears in Lucas van Leyden's Milkmaid of 1510, one of the earliest genre subjects in northern art and a predecessor of numerous prints and paintings by seventeenth-century artists such as Albert Cuyp, Paulus Potter, and Adriaen and Jan van de Velde. Albrecht Dürer's The Prodigal Son Amid the Swine, 1476, may be an earlier source. Lemmen submitted his painting, Etudes de vaches, for the 1890 Les XX salon, so contemporaneous interest in the subject does not seem to have flagged.

12. For example, Monet's mythic grainstack series now is seen not only as an essay on Impressionist light and color theory, but as emblematic of the issues facing modernization and industrialization of the French countryside.

13. Gepts-Buysaert, "The Social Context of Belgian Art," 175.

14. Canning, "Henry van de Velde," 53.

15. In reality, the cartouche backed a white marble bust of Brouckère. The rectangle sketched below identified the statue. Finch has chosen not to show the three infants raising wreaths which surmount the ensemble of sea gods, nor the other side of the fountain which bears a marble tablet listing the burgomaster's offices and honors.

16. Derrey-Capon, A.W. Finch, titles and dates this image Femme cousant, ca. 1887–1888; she locates it in an 1893 portfolio by an unnamed publisher, 100, illus197.

55

Fernand Khnopff
Trademark for Edmond Deman, ca. 1887
India ink on paper
170 x 155
De Croës, Delevoy, Ollinger-Zinque 104

T HE tradition of ex libris, or book plates, dates back to at least the fifteenth century. Many artists of the late nineteenth century, including a number of those associated with Les XX, found designing ex libris a legitimate form of artistic expression.[1]

Edmond Deman was a pivotal figure in the history of Belgian art and literature of the late nineteenth century. Between 1888–1912 Deman's firm was responsible for the publication of many limited edition books. Among the authors published by Deman

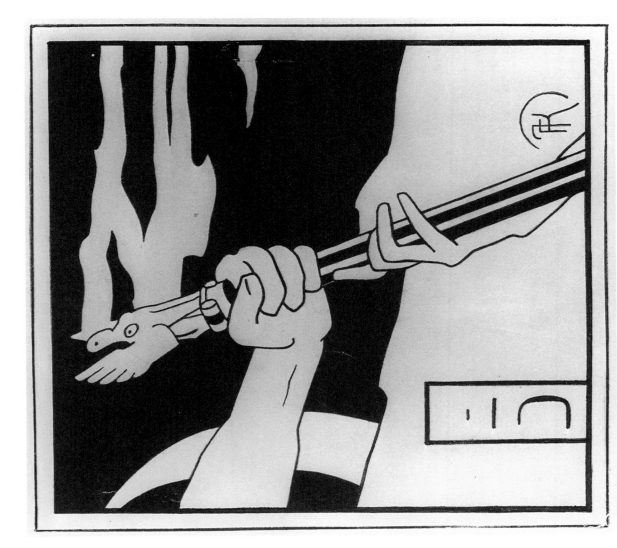

were symbolists Maurice Maeterlinck, Stéphane Mallarmé and Emile Verhaeren. These were often illustrated by artists associated with Les XX, including Khnopff, Georges Lemmen, George Minne, Félicien Rops, and Théo Van Rhysselberghe.[2]

Khnopff's design testifies to his interest in esoteric Egyptian texts and images. It is similar to another design for an ex libris for Deman from the same time period.[3] Both of these ex libris designs are related to Le sablier (The Hourglass) by Khnopff, ca. 1892, apparently a study for a series of works in enamel.[4] All three of these designs have several common elements. First, in each is an ionic column surmounted by a winged sphinx that bisects the composition. As Jeffery Howe has noted, the source of inspiration for this is likely an ancient Greek pictorial tradition in which the Sphinx is depicted sitting atop an ionic column while questioning Oedipus.[5] In both of the designs for Deman the column has been transformed into a staff grasped by two opposing hands. Another element common to all three designs is the range of mountains that occupies the lower portion of the composition.[6] In Le sablier and the second ex libris design for Deman, Khnopff depicted the sun setting behind these mountains. In this exhibited design the sun has been replaced with what appears to be a crescent moon. The overall treatment of this design is much more abstract than the other two designs.

In the lower left of the ex libris is a cryptogram that can be read as the initials of Edmond Deman. Knopff's inspiration for this is probably the pseudo-hieroglyphs of Athanasius Kircher (see cat. 57).[7] —B.N.

1. Khnopff's ex libri for Deman was exhibited in 1894 at the Nederlandsche Etsclub, The Hague, Pulchri Studio, number 45. For information on ex libris designed by Khnopff see Tielmans, "Les Ex-libris Dessinés par Fernand Khnopff." For information on ex libris designed by Belgian artists see Khnopff, "Belgian Book-plates"; Dirick, Ex-Libris Belges; and Rouzet, "Les Ex-Libris Art Nouveau en Belgique."

2. Fontainas, "Biographie et bibliographie d'Edmond Deman."

3. See Delevoy et. al., Khnopff, 420, number 104 bis.

4. See Delevoy et. al., Khnopff,, 278, number 217. For a brief discussion of Le sablier see Howe, "Egyptian Motifs in the Work of Fernand Khnopff," 162.

5. Howe, "Egyptian Motifs in Khnopff," 162.

6. Howe notes the appearance of this staff in Khnopff's design for Deman, however, he fails to mention the relationship between the design for Deman and Le sablier, "Egyptian Motifs in Khnopff," 166-67.

7. Howe, "Egyptian Motifs in Khnopff," 167.

56 [Plate 16]

Fernand Khnopff
Avec Grégoire Le Roy. Mon coeur pleure d'autrefois
(With Grégoire Le Roy. My Heart Longs for Other Times), 1889
Pastel and white chalk
The Hearn Family Trust
248 x 142
De Croës, Delevoy, Ollinger-Zinque 127 bis

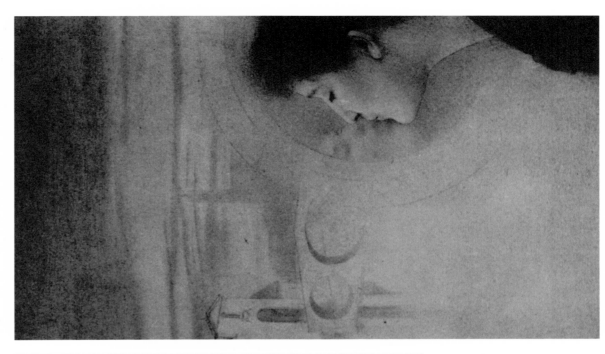

FIGURE E. Fernand Khnopff, *Mon coeur pleure d'autrefois*, 1889. Title page from Grégoire Le Roy book. Heliogravure. Private collection. 252 x 187.

FERNAND KHNOPFF'S frontispieces for works of contemporary literature serve less as illustrations of specific texts than as emblems of the creative process (see also cat. 58). The theme of Grégoire Le Roy's 1889 collection of poems is nostalgia, not for any definite lost past, but for the veiled life of the unconscious:

> Do you hear, over there, over there, in my thoughts,
> the grandmothers, as they recount fabulous tales?
> Like the mute passage of the spirits through the shadows,
> or the silence of a wing as it brushes a branch.

This image of an entranced narcissistic kiss with which Khnopff introduces Le Roy's verse suggests drawing the gaze inward to the source of being. For the symbolists, narcissism represents a form of askesis, a turning from the world to the soul. Contemplation is the way of both mystic and artist. Khnopff depicts the Béguinage Ste. Elisabeth on the left, signalling the reclusion necessary in the quest for inner beauty. The nexus of imagery in Khnopff's drawing of the mirror, the convent, and the merging of self and soul in a kiss of peace depicts a state of blissful self-possession and attainment of the infinite within.

—D.F.

57

Fernand Khnopff
1890 Les XX catalogue cover
Photomechanical relief
Private collection, Brasschaat
124 x 165
De Croës, Delevoy, Ollinger-Zinque 102

COMMENTING on the catalogue of the 1890 Les XX exhibition, Paul Cézanne said, "Permit me to address all of my congratulations for the picturesque and very successful aspect that you have given to this charming booklet."[1] This remark was influenced, no doubt, by Khnopff's design for the cover, which summarizes some of his artistic concerns.

Khnopff's design for the 1890 catalogue cover is based on his 1883 design for the Les XX monogram. It is possible that Khnopff's monogram design, which incorporates a pair of interlacing Xs, was inspired by Xavier Mellery's monogram. Mellery, Khnopff's first teacher, often signed his paintings with an interlacing X and M (see cat. 90). Khnopff's 1890 catalogue cover design has a curvilinear element not present in the original 1883 design for the monogram. This use of line is manifested in two distinct styles, each with a different source.

First, the tendril-like treatment of the word "Les" and the date "1890" are typical of the emerging art nouveau. In this regard, Khnopff's design anticipates his design for a poster advertising the 1891 exhibition of Les Vingt. In the 1891 poster design, which again utilizes the basic configuration of the 1883 monogram, Khnopff further develops the tendril motif. Writing about Khnopff's 1891 poster design, Robert Koch states, "it is a forerunner of the Art Nouveau style, and it establishes an early contact between Belgium and the English Arts and Crafts movement."[2] In both the 1890 catalogue cover and the 1891 poster design, Khnopff contains the organic form of the word "Les" within a rectilinear form.[3]

The second manifestation of curvilinear elements in Khnopff's design is in the treatment of the word "Brussels." A possible source for this may be the pseudo-hieroglyphs of Athanasius Kircher in his book *Oedipus Aegyptiacus* (Lyons, 1652–54).[4] As Jeffery Howe has demonstrated, Khnopff appropriated the pseudo-hieroglyphs of Kircher for use in his own work. When comparing the hieroglyphs in paintings by Khnopff such as *Un ange*, 1889, and *Des caresses*, 1896, with the word "Brussels" in Khnopff's 1890 catalogue cover, the stylistic similarities become apparent.[5] As Howe has noted, Kircher was part of "the Renaissance tradition of interpreting Egyptian hieroglyphs as Neoplatonic symbols containing hidden divine truths."[6] Khnopff's interest in Kircher is further strengthened by a consideration of the three-leaf clover in the upper right corner of his design. Kircher mistakenly believed that hieroglyphic writing was the invention of Hermes Trismegistus, who was thought to be an incarnation of the Greek god Hermes (Thrice Blessed).[7] Khnopff may have included the three-leaf clover as a veiled reference to Hermes Trismegistus, and possibly even the Trinity.

—B.N.

1. Maus, *Trente Années*, 108: "Permettez-moi de vous adresser toutes mes félicitations pour l'aspect pittoresque et très réussi que vous avez donné à ce charmant livret."

2. Koch, "Poster by Khnopff," 72.

3. For a discussion of Khnopff's preference for the rectilinear over the curvilinear vis-à-vis art nouveau, see Howe, 145–46.

4. For a brief discussion of Khnopff's interest in Kircher's book and Kircher's concept of the hieroglyphic tradition see Howe, *Symbolist Art of Khnopff*, 43–45; for a fuller discussion see Howe, "Egyptian Motifs in Khnopff."

5. See Delevoy et. al., no. 122 and 275.

6. Howe, *Symbolist Art of Khnopff*, 43–45.

7. Howe, *Symbolist Art of Khnopff*, 44.

58

Fernand Khnopff
Cover for Georges Rodenbach's *Bruges-la-morte* (*Bruges the Dead*), 1892
Wood engraving
188 x 120
Private collection, Brasschaat
De Croës, Delevoy, Ollinger-Zinque 200

METAPHYSICAL narcissism infuses Khnopff's frontispiece for Georges Rodenbach's 1892 psychological novel *Bruges-la-Morte*, in which widower Hugues Viane wanders the underworld of Bruges, searching for his dead wife. A failed Orpheus, he worships her in the guise of a double, whom he finally murders. Khnopff ignores the events of the novel as well as Rodenbach's descriptions of the blonde wife and mistress. Khnopff presents a pristine image of a dead woman, outstretched parallel to the beguinage. Her pallour defined by dark hair, her mouth down-turned, she is a sort of breathing funerary sculpture. She is caught in a state between sleep and death, suggestive of absolute self-communion and exclusion of the exterior world. The stasis of Khnopff's figure has to do with physical death, but also with trance, an abandonment of consciousness that may be the source of significant dreams. The presence of the convent entranceway in Khnopff's depiction of a woman lost in everlasting sleep underscores the desire to attain access to the closed, hidden recesses of being. —D.F.

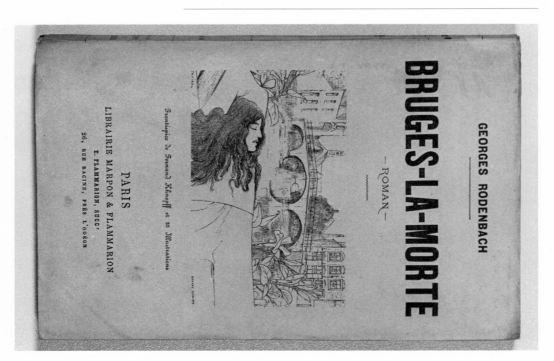

59

Fernand Khnopff
Annuaire de la Section d'Art, 1893
Photomechanical relief print
Private collection
240 x 159
De Croës, Delevoy, Ollinger-Zinque 225

FORMED in 1891 to bring art and education to the masses, the Section d'Art et d'Enseignement of the Parti Ouvrier Belge (Belgian Workers' party) sponsored a program of lectures, presentations, and performances by contemporary writers, poets, musicians, and artists.[1] Emile Vandervelde, official spokesman for the POB, evaluated the success of the meetings on art in the introduction to the 1893 *Annuaire*:

"we have, thanks to the devotion of our best artists, Beethoven sonatas, Brahms quartets or Wagner transcriptions.

—You will not be understood, they said.—Experience demonstrated the opposite. The room was full for all the meetings; several times they had to turn some people away. . . .The number of people who

regularly attended the functions was evaluated at 800. And all the artists who came to the *Maison du Peuple* declared, enviously, that they had never encountered listeners more attentive, more respectful of their work, and, at the same time, more enthusiastic."[2]

Although the Section d'Art continued for at least a decade, the *Annuaire* was only published once. No doubt intended as a printed souvenir of the year's pro- grams as well as an explanation of the section's goals and achievements, the *Annuaire* included a diverse selection of poetry, prose, and essays on art and socialism contributed by Khnopff, Vandervelde, Jules Destrée, Eugène Demolder, Paul Janssens, Maurice Maeterlinck, and Emile Verhaeren.

Khnopff's cover design not only represents the beliefs held by the leaders of the Section d'Art, but also illustrates the artist's own aesthetic theories. The design depicts a woman placing on her head a tiara decorated with the word ART. The sun's rays seem to emanate from her, as if to suggest her enlightenment by art itself. She seems transformed, no longer a mere mortal. An olive branch, a tradition- al symbol for peace, decorates the back cover of the *Annuaire*. Together these images symbolize Khnopff's belief in the power of art to create a better world, that those who experience art will be raised to a higher plain of existence, overcoming, spiritually if not phys- ically, the deficiencies of life.[3]

Khnopff also served on the guiding committee of the Section d'Art, contributed an essay on English art for the *Annuaire*, and lectured on the "Gothic" painters Jan van Eyck, Hans Memling, and Quentin Metsys (in 1893-94), Walter Crane (in 1894), and William Morris (in 1896).[4] His socialist leanings are also evident in his illustrations for Edmond Picard's book *La Forge Roussel*, and in his art criticism for *The Studio*.[5] —M.S.

1. The most authoritative souce on the Section d'Art is Destrée and Vandervelde, *Le Socialisme en belgique*, 395–402. For a summary, see Herbert, *Artist and Social Reform*, 31–34.

2. "nous apportions, grâce au dévouement de nos meilleurs artistes, de sonates de Beethoven, des quatuors de Brahms ou des tran- scriptions de wagner.
 —Vous ne serez pas compris, disait-on.—L'expérience démontré le contraire. Toutes les soirées la salle était comble; à plusieurs réprises il fallut réfuser du monde. A la dernière séance, on dut se transporter dans un autre local. On peut évaluer à huit cents le nombre de ceux qui ont assisté régulièrement aux auditions.
 Et, tous les artists qui sont venus à la *Maison du Peuple* déclarent, à l'envi, qu'ils n'ont jamias rencontre d'auditeurs plus attentifs, plus réspectueux des uvres, et, en même temps, plus enthousiastes." Vandervelde, "Introduction," in *Annuaire*, 7–8.

3. For a discussion of the apparent disparity between Khnopff's symbolist art and his social involvement in light of the philos- ophy of Arthur Schopenhauer, see Heller, "The Art Work as a Symbol," 10 and 14.

4. Khnopff in "L'Art anglais," in *Annuaire*, 30, compares English and French art. He believes that English art is directly and immediately connected to life, while in France government control of the arts is useless and encumbering. That art must be related to the people is a belief that Khnopff shared with William Morris and Walter Crane, both of whom he greatly admired.
 Howe, *Symbolist Art of Khnopff*, 27. Although art histori- ans today would catagorize Van Eyck, Memling and Matsys as Northern Renaissance artists, in the 19th century they were connected to the gothic revival, and thus to nationalist senti- ments. See 23–29 for Howe's discussion of Khnopff's interest in the art of Belgium's past and its link to the growth of the Socialist movement.

5. Howe, *Symbolist Art of Khnopff*, 26–69, particularly 62. *La Forge Roussel* is a novel that presents Picard's philosophy of law and legal systems in the character of a retired attorney general.

60

Fernand Khnopff
Un Masque (A Mask), 1897
Platinogravure, tinted blue, gold and red
Bibliothèque Royale Albert 1er, Cabinet des Estampes, SII 84250
261 x 185
De Croës, Delevoy, Ollinger-Zinque 300

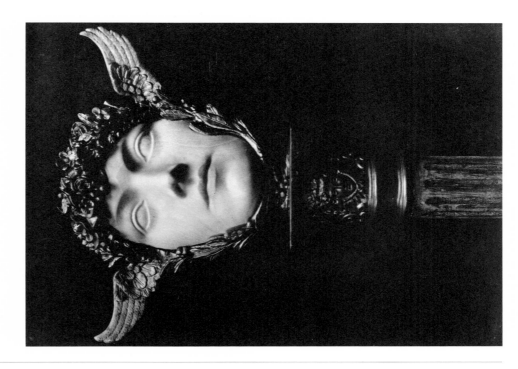

UN MASQUE is the result of a collaboration between Khnopff and Belgian photographer Alexandre.[1] The subject is an ivory, bronze, and enamel sculpture of the head of Hermes made by Khnopff in 1897. Khnopff's sister, Marguerite, may have been the model for the face.

Khnopff's use of photography can be divided into two main classifications: photographs used as studies for paintings or graphic works, and photographs of paintings or sculpture by Khnopff that have been touched up by the artist. Those works in the former category, such as *Un Geste d'offrande* [cat. 61], span much of Khnopff's career as an artist. However, those in the latter category, such as *Un Masque*, were produced only between 1888 and 1898 and were the result of a collaboration between Khnopff and Alexandre. In 1899, Khnopff participated in the symposium "Is Photography Among the Fine Arts?" The proceedings were published in five monthly parts in *The Magazine of Art*.[2] In Khnopff's contribution, which is essentially a rebuttal of Robert De La Sizeranne's essay, he denies photography a position among the fine arts, allowing for the use of photography in order to "facilitate the mere notation of facts for the artist."[3] However, in reviews in *The Studio* in 1896 of the exhibitions at the Photographic Salon at the Cercle Artistique in Brussels and of the Belgian Association of Photography, Khnopff seems to acknowledge photography's worthiness as a means of artistic expression.[4] This position seems consistent with Khnopff's collaboration with Alexandre from 1888–1898 in producing photographic images, such as *Un Masque*, that go beyond the "mere notation of facts."[5] However, Khnopff's motivation for producing these images may not have been entirely artistic; records indicate that Khnopff sold hand-colored photographs from his collaboration with Alexandre.[6]

Most of these photographs appeared as illustrations in English art periodicals such as *The Studio* and *The Magazine of Art*.[7] It is likely that the retouched photographs were available from booksellers who also sold the periodicals.[8] Khnopff thus was able to translate the art-viewing public's familiarity with his images into a commercial venture.

—B.N.

1. Alexandre, whose real name was Albert Edouard Drains (1855–1925), was active in Brussels during 1875–1922. He introduced pictorial photography in Belgium and was one of a small group of Belgian photographers that seceded from the Association Belge de Photographie in 1900 to form the Cercle d'Art Photographie. Others in this secession included Hector Colard and Maurice Brémard. The three men were the only Belgian photographers admitted to the Linked Ring, the British brotherhood of photographers dedicated to art photography; see Harker, *Linked Ring*, 67 and 171n7.

2. Khnopff, "Is Photography Among the Fine Arts?" Khnopff addressed the Académie Royale on 8 June 1916, the speech was essentially a reading of this article with opening and concluding remarks. For a transcript of the speech see Khnopff, "À propos de la photographie dite d'art."

3. Sizeranne, "Is Photography Among the Fine Arts?"102–105; Khnopff, "Is Photography Among the Fine Arts?" 157.

4. In a review of the Photographic Salon at the Brussels Cercle Artistique, Khnopff refers to a ruling by the Aix Court of Appeals in favor of photography as art. Khnopff says that the court's decision, "seems to be strongly enforced by the very interesting exhibition just mentioned": Khnopff, "Studio-Talk: Brussels," *The Studio* 6, 1896, 249. This position seems to align with that taken by the author of a review of the Photographic Salon in *AM* 1 December 1895—quoting passages from a brochure published by Colard, the author supports the court decision: "Le Salon photographique," 380–381. In another review Khnopff called the exhibition of the Belgian Association of Photography at the Brussels Museum, "a laudable attempt to turn the attention of photographers, both amateur and professional, toward the artistic side of their work.": Khnopff, "Studio-Talk: Brussels," *The Studio* 7, 1896, 246.

5. The circumstances of the dissolution of the collaboration with Alexandre are not known to this author. However, it is interesting that it appears to coincide with Khnopff's philosophic shift regarding photography's position among the fine arts. It is most likely related to Alexandre's 1900 secession from the Association belge de Photographie.

6. See *BB* 24 no. 9, 15 May 1898, 158. Entry 41 describes *Un Masque*, priced at 25 francs, as a platinum print by Alexandre that has been retouched, tinted, and signed by Khnopff: "Khnopff—Masque d'ivoire. Platinotypie retouchée, teintée et signée par M. Khnopff, artiste peintre et dessinateur à Bruxelles; phototype Alexandre, 1898. H. Om263. L. Om185. Montée sur carton fort. (25 fr.)." Ensor's *Hop-Frog* [cat. 46], entry 38 on the same page, was 50 francs. Photographs of Ensor's *Les Cuisiniers dangereux* [cat. 42], signed by Ensor, sold for 10 francs as 95 in *BB* 23 no. 9, 15 May 1897, 155.

 Some of Khnopff's hand-colored platinum prints and prices: (70) *L'encens*, 50 fr., *BB* 24 no. 12, 30 June 1898, 219; (71) *Une aile bleue*, 30 fr., *BB* 24 no. 12, 30 June 1898, 220; (34)*L'offence*, 35 fr., *Masque* (face) 27.5 fr., *Masque* (profil), 27.5 fr., *Diffidence*, 18 fr., *Ange*, 30 fr., *BB* 22 no. 9, 15 May 1896, 155; (43) *Solitude*, 30 fr., *Un arum Lily*, 35 fr., *Sibyl*, 40 fr., *BB* 22 no. 11, 15 June 1896, 191.

7. For a bibliography of the periodicals in which the photographs appeared, see Delevoy et. al., *Khnopff*.

8. See Goddard essay, p. 75 this volume.

61

Fernand Khnopff
Un Geste d'offrande (A Gesture of Offering), 1900
Drypoint
Spencer Museum of Art, Letha Churchill Walker Memorial Art Fund, 90.13
201 x 148
De Croës, Delevoy, Ollinger-Zinque 355

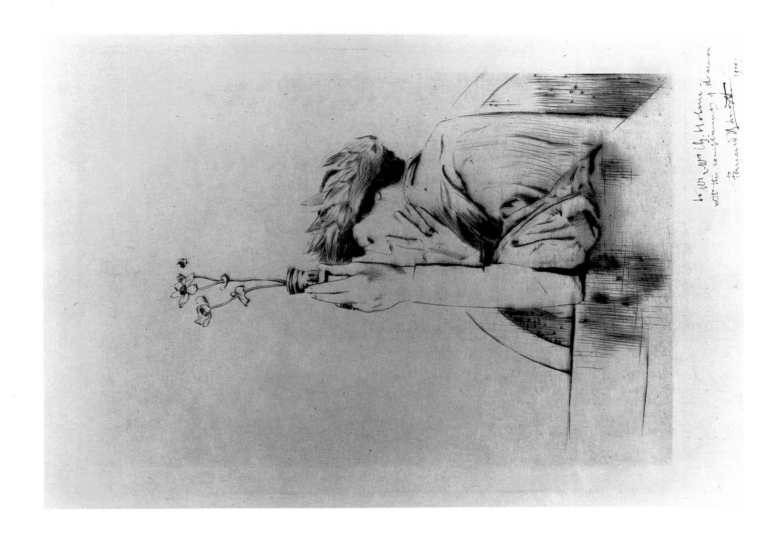

I NSCRIBED at lower right:

To Mr. & Mrs. Ch. Holme / with compliments of the season Fernand Khnopff/1900

This is one of Khnopff's relatively few explorations of printmaking. The majority of Khnopff's graphic works, including *Un geste d'offrande*, were executed in drypoint, which Khnopff preferred for its simplicity of execution and its delicate line.[1] *Un geste d'offrande* was produced for an album published by the Société des Aquafortistes belges (Belgian Etching Society) on the society's fifteenth anniversary in 1901.[2] This print exists in two states. The exhibited impression is a hand-press proof on Japan paper of the second state, pulled before the edition published by the SAB.[3]

This impression was dedicated to Mr. and Mrs. Charles Holme. Charles Holme was an East India merchant from London who, with C. Lewis Hind, founded *The Studio*, one of the most influential art journals of the late nineteenth century. Khnopff's dedication of this print to Holme and his wife is not surprising given his relationship with *The Studio*. He wrote eighteen articles for the magazine, most of which dealt with Belgian subjects, from 1894 to 1919 and served as the Brussels correspondent for the magazine's "Studio-Talk" column from 1895 to 1919.[4] In 1902 Holme edited the book *Modern Etching and Engraving*, which includes a chapter by Khnopff, "Modern Etching and Engraving in Belgium."[5] The chapter is illustrated with *Un geste d'offrande* (titled *Un geste de respect*) and an etching, *Village Politicians*, by Eugène Laermans. It is possible that the exhibited impression is the same one reproduced in Holme's book.

Khnopff's younger sister, Marguerite, was the model for a photographic study for *Un Geste d'offrande* (see also cat. 63).[6] The drypoint remains basically true to the photograph except that it is a mirror image.

—B.N.

1. Khnopff, "L'eau-forte et la Pointe-sèche," in *AM* is a transcript of his lecture on etching and drypoint delivered 3 May 1901 at the salon of the SAB.

2. The album is announced in "Concours," *AM*, 1901, 5. The SAB also held an exhibition to mark the 15th anniversary and it is likely that *Un Geste d'offrande* was shown, but conclusive evidence has not been found. The exhibition is reviewed in Maus, "Deux Expositions."

3. The first state of *Un Geste d'offrande* is reproduced as 355 in Delevoy et. al., *Khnopff*, 324–325.

4. For a bibliography of Khnopff's writing for *The Studio* see Howe, *Khnopff*, 243–247.

5. Holme, *Modern Etching and Engraving*, 1–4.

6. The photographic study was first published in De Maeyer, "Khnopff et ses modèles." See also Ollinger-Zinque, "Khnopff et la photographie."

62 [Plate 14]

Fernand Khnopff
*Souvenir de Bruges. L'Entrée du beguinage
(Memory of Bruges. The Entry to the Beguinage)*, 1904
Pastel
The Hearn Family Trust
270 x 435
Delevoy, De Croës, Ollinger-Zinque 398

KHNOPFF'S Brugescapes, like Mellery's, conform to the model of the symbolist "dead city" that transposes locale into a domain of legend and private subjectivity, emphasizing abandonment, fading of the present, and suspended animation. In turn-of-the-century literature devoted to Bruges, the Béguinage Ste. Elisabeth (the walled community of convents), the ultimate space of purity and repose, is the spiritual axis of the city. Khnopff emphasizes the ineffable stillness of the surroundings in his 1904 depiction of the entranceway to the béguinage. The arched bridge, focal point of the drawing, leads inevitably to the unknown sacred space.

Khnopff has reversed the romantic "Fernweh" of Caspar David Friedrich's drawings in which figures in protected interiors gaze from open windows toward vast landscapes, longing for flight and absorption in the overwhelming force of nature. In this pastel, an absent viewer gazes toward the portal, protective threshold of mystery, and a facade of muslin-veiled windows. The viewer is lured by the hidden space of the interior. Khnopff has truncated the buildings and eliminated the sky to emphasize their reflection in the Lac d'Amour. An intimate space of depth replaces the seas, torrents, and mountain ranges of the romantics. The serenity and concentration of the water and the diffusely radiant lighting convey a mood of tranquil detachment, an experience of both reclusion and of spiritual pilgrimage to the canal city, site of withdrawal from the world.

—D.F.

63 [Plate 15]

Fernand Khnopff
Les Yeux bruns et une fleur bleue (Brown Eyes and a Blue Flower), 1905
Pastel and gouache
Museum voor Schone Kunsten, Ghent, 1955-G
Diameter 160
Delevoy, De Croës, Ollinger-Zinque 415

THIS is a format often favored by Khnopff—a female face, truncated at the forehead and placed close to the picture plane. The work is characteristic of many of Khnopff's depictions of women and embodies several of the themes central to his art. The woman's face in this drawing is based on Khnopff's sister Marguerite. This feminine type, which appears in much of Khnopff's work, can be understood as representing Khnopff's ideal of the virgin-sister. Although based on his sister, we can trace this type back to the dreamy women of Edward Burne-Jones, the second generation Pre-Raphaelite painter. Khnopff's depictions of women might best be described with the words he used to describe those by Burne-Jones:

> virgin forms of delicate and pensive gesture, with light, soft hair, pure and gracious and sweet of aspect, the exquisite curve of innocence on their lips, and deep loving-kindness in their limpid gaze.[1]

These androgynous women can be seen as visual expressions of Joséphin Péladan's theories of androgyny, found in his first novel, *Le Vice Supreme*, as well as in his teachings surrounding the salons of the Rose+Croix. Imbued with an ambiguous quality, Khnopff's women represent a conflation of the ideal virgin and femme fatale. Although Khnopff's depictions of women are not as misogynistic as some of those of his contemporaries, in images such as *Les yeux brun et une fleur bleue*, he denies women's intellectual capability by truncating the forehead.

Khnopff places the figure close to the picture plane and uses a tondo format, setting the image within a mirror-like frame. Khnopff's use of mirror symbolism has been well documented.[2] As Howe suggests, "Khnopff's narcissism found its perfect reflection in his sister."[3] Khnopff's use of the androgyne, embodied in Marguerite, in combination with his mirror symbolism can be seen as his "own inner wish to attain this ideal state."[4]

Most of Khnopff's paintings have multiple layers of meaning. In this work, for example, there can be varying interpretations of the blue cyclamen and the pearl in the center of the dish-like vessel in front of Marguerite's face. The name Marguerite and its anglicized form, Margaret, derive from the Greek word "margarites," which means pearl. But in addition to being a veiled reference to Khnopff's sister, the pearl can also be understood as an allusion to St. Margaret of Antioch, the Christian virgin and martyr. Margaret, the daughter of a pagan priest of Antioch, was sent to the countryside in infancy to be nursed by a Christian woman. As she grew she embraced the Christian faith she was raised in. One day Olybrius, the prefect of Antioch, saw Margaret, a striking beauty, tending sheep. Taken by her beauty, Olybrius tried in vain to make Margaret his wife. Margaret was thrown into a dungeon for resisting his advances; there she was swallowed by Satan in the form of a dragon. The cross that Margaret held in her hand when she was swallowed caused the dragon's stomach to burst open, releasing her. After a series of tortures Margaret was finally beheaded, but not before praying that all women in labor should invoke her name in memory of her suffering. Thus, Margaret became the patron saint of women in childbirth. This allusion to St. Margaret is further strengthened by the cyclamen. Though traditionally a symbol of diffidence, one of the alleged medicinal qualities of cyclamen is easing childbirth.[5]

Howe has remarked that Khnopff's portrayals of his sister "take on a sacred quality as she becomes his personification of the ideal virgin-sister, pure and cerebral."[6] Khnopff literally worshipped Marguerite, setting up an altar devoted to her in his studio. In *Les yeux brun et une fleur bleue* Khnopff may have intended an incarnation of his sister as St. Margaret.

—B.N.

Coincidentally, Jan Toorop produced a portrait in 1896 in black and colored chalk and pencil, *Marguérite*, in which the subject, Marguérite Hallman, is framed by a cyclamen plant; it is reproduced in Hefting, *Toorop*, 89, no. 56. The cyclamen is also the motif of Théo Van Rysselberghe's 1908 cover for the catalogue of La Libre Esthétique's Salon Jubilaire.

6. Howe, *Symbolist Art of Khnopff*, 122.

1. Khnopff, "Edward Burne-Jones," 524.

2. Howe, "Mirror Symbolism in Khnopff."

3. Howe, *Symbolist Art of Khnopff*, 94.

4. Ibid., 142.

5. Coats, *Flowers and Their Histories*, 65: Coats writes of cyclamen, "the great value of the of the plant was to assist in childbirth, for which it was considered so potent that Turner warns us 'it is perillous for weomen with chylde to go over this roote.'"

64

Georges Lemmen
Self-portrait, 1884
Charcoal on paper
275 x 253
Private collection, Brasschaat

THIS self-portrait by nineteen-year-old Georges Lemmen shows an intense, spectacled young man. The precocious artist began entering his paintings in local exhibitions at the age of nine.[1] When he drew this self-portrait on 22 December 1884, Lemmen had re-enrolled at the Academy of Saint-Josse-ten-Noode in Brussels, where he had received artistic instruction since 1879. In 1884 he was also a member of the art exhibition society, *L'Essor*, predecessor of Les XX.

The drawing reveals Lemmen's desire to delve beneath the surface of his human subjects, a goal that was fully realized in his later portraits of *Berthe Serruys* [cat. 73] and his wife, *Mademoiselle Maréchal* [cat. 66]. Much of Lemmen's work during the mid-1880s prior to his election to membership in Les XX (November 1888) reveals his close ties to Fernand Khnopff and the art of the Pre-Raphaelites.

—J.B.

1. Cardon, R., *Lemmen*, 52.

65

Georges Lemmen
Farmhouses in Flanders, 1890
Black charcoal on buff laid paper
The Museum of Modern Art, New York, Abby Aldrich Rockefeller Fund, 157.76a
571 x 480

LEMMEN has imbued this nocturnal scene with calm and quiet. His works on paper from 1890–91, whether portraits or landscapes, are characterized by their emphasis on mood. Here he chose as his theme the contrast between artificial light and darkness. A similar exploration can be found in *La Lampe*, which shows members of his family gathered around a table reading, and in the lithograph *Vue de ville la nuit tombante*.[1] These works reveal the influence of Georges Seurat's conté crayon drawings, whose mood of mystery tinged with melancholy is close to Lemmen's. Lemmen owned Seurat's *La lune à Courbevoie: Usines sous la lune* of 1882–83, a nocturnal view of a factory lit by moonlight that was shown at the 1886 Paris Indépendants and exhibited at the Les XX Seurat retrospective in 1892.[2] Two of Lemmen's contemporaries, François Maréchal and Xavier Mellery, produced notable drawings that also emphasized the evocation of a place and time.
—J.B.

1. See Cardon, R., *Lemmen*, 86 and 369.

2. For the provenance of this work, see Herbert, *Seurat*, 89.

66

Georges Lemmen
Mademoiselle Maréchal, 1891–1892
Lithograph
Bibliothèque Royale Albert 1er, Cabinet des Estampes, Folio SIII 5523
318 x 278
Cardon 6

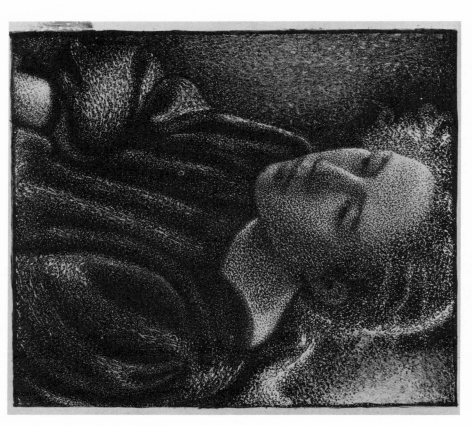

GEORGES LEMMEN was one the most talented of the neo-impressionist painters. His work at Les XX in 1887, 1889, and 1891, as well as the pointillist paintings of Paul Signac and Camille Pissarro, inspired a group of Belgian followers second to none. Although Lemmen applied the pointillist technique to seascapes and landscapes, his greatest contribution lay in the field of portraiture. His pointillist portraits, such as this lithograph of his fiancée, were almost exclusively of his family and friends. Aline Maréchal (1868–1938) and Lemmen were married in August 1893; the artist featured his wife in many of his finest works. Two of the best portraits of Aline are contemporary with this work: *Mlle. Maréchal* (Paris: Musée d'Orsay) and a conté crayon and charcoal drawing, *La Tasse de thé* (Brussels: Musées royaux des Beaux-Arts de Belgique).

Lemmen's portraits are distinguished not only by a physical exactitude, but by a psychological probing of the interior state of the individual.[1] This concern with an inner life produces an enigmatic, mysterious quality that links his pointillist portraits with the symbolist movement. Roger Cardon, Lemmen's modern biographer, has noted that this lithograph "seems to be the only neo-impressionist portrait in the entire history of the print."[2]

—J.B.

1. For a discussion of Lemmen's portraits see Block, "Belgian Neo-Impressionist Portraiture," 36–51.

2. "cette lithographie semble être le seul portrait néo-impressionniste de toute l'histoire de l'estampe": Cardon, R., *Lemmen*, 377.

67

Georges Lemmen
Portrait of Emile Verhaeren, ca. 1891
Watercolor
Private collection
220 x 185

I N this watercolor study for an oil painting, Lemmen has depicted his friend, symbolist poet and art critic, Emile Verhaeren (1855–1916), with head bent as if reading or meditating. Verhaeren wrote to his fiancée, Marthe Massin, of his sitting for his portrait on 6 July 1891 and of his return "chez Lemmen" on the following day.[1] The pointillist canvas, which has an interior pointillist frame and a larger outer frame, was completed in 1891 and now hangs in the Musée Plantin-Moretus, Antwerp.[2] It was exhibited at Les XX and at the Association pour l'art, Antwerp, in 1892.

In this study Lemmen determined the basic composition as well as the pose for Verhaeren that he used in the oil. The poet is seated in a three-quarter pose, with head and chest visible, in a minimal setting. The darker area around Verhaeren's head, rendered in a long outlining stroke and a broken touch, is meant to approximte the halo effect of the final oil panel. This creates a sense of spatial relief separating the figure from the background. The focus of the composition is Verhaeren's magnificent head and his intense powers of concentration.

This work shares with two other Lemmen portraits in the exhibition, his lithograph of *Mlle. Maréchal* [cat. 66] and his conté crayon of *Berthe Serruys* [cat. 73], a fascination with the world that lies behind external appearances. It is this interest in the psychological that ties Lemmen to the symbolist movement and gives life to his creations.　　—J.B.

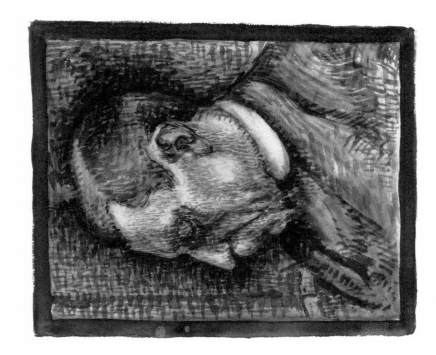

1.　Verhaeren, *À Marthe Verhaeren*, 371–372.

2.　For an illustration, see Cardon, R., *Lemmen*, 91.

68 [Plate 9]

Georges Lemmen
1891 Les XX catalogue cover
Photomechanical reproduction
Private collection, Brasschaat
147 x 145

LEMMEN designed this cover for the eighth annual Les XX exhibition in 1891. Printed in reddish-orange and black, the pulsating line of the waves and the vibrant energy of the sun's rays symbolize the vitality of Les XX's commitment and contribution to the arts. Related in its bold and dynamic configuration of line to English graphic works by Arthur Mackmurdo, Walter Crane, and Selwyn Image, this design heralded the arrival of the art nouveau style in Belgium; it served as the model for innumerable graphic works, including Van de Velde's cover for *Dominical* the next year [cat. 135].

The catalogue within this explosive cover records the significant achievement at Les XX in 1891. Not only pointillist works by Georges Seurat, Camille Pissarro, Paul Signac, Van Rysselberghe, Van de Velde, Lemmen, but decorative works by Willy Finch, posters by Jules Chéret, the book arts of Walter Crane, pottery and bas-reliefs by Paul Gauguin, a small retrospective devoted to van Gogh, a large contingent of works by maverick member James Ensor, and the symbolist contributions of Fernand Khnopff and Georges Minne were displayed.

—J.B.

69 [Plate 10]

Georges Lemmen
1892 Les XX catalogue cover
Photomechanical reproduction
Private collection, Brasschaat
164 x 188

LEMMEN'S cover depicts the banner of Les XX victoriously unfurled before a tree whose roots symbolize not only the strength of its artistic mission but its diversity. Printed in strong colors of orange and black, its graphics recall Selwyn Image's cover for the British periodical *Hobby Horse*. It also reveals Lemmen's admiration for Walter Crane, who had shown watercolors of Flora and Pegasus, as well as a dozen children's books lent by Lemmen, at Les XX. Lemmen praised Crane in a two-part article published in *L'Art Moderne*. His commentary on Crane could easily apply to his own graphic work of the 1890's: "Walter Crane is above all a *decorator*, an artist solely preoccupied with forms, arabesques, and lines."[1]

A larger portion of the 1892 Les XX exhibition was given over to printmaking, book illustration, and decorative arts than in preceding years. Mary Cassatt's series of 10 drypoints, Herbert Horne's samples of decorations for the printed book, nine of the twelve woodcuts from Lucien Pissarro's first portfolio, and Toulouse-Lautrec's posters were shown with pottery by Auguste Delaherche, ceramic tiles by Willy Finch, decorative designs by Selwyn Image and the project for a tapestry by Henry Van de Velde.

Lemmen's entries to the 1892 catalogue reveal he was was not only interested in graphic design, but also fully involved in the pointillist movement. Among the works he exhibited were portraits of his fiancée, *Mlle Maréchal* [cat. 66] and *Emile Verhaeren* [cat. 67].

—J.B.

1. "Walter Crane est donc surtout un *décorateur*, un artiste préoccupé uniquement de formes, d'arabesques, de lignes . . .": Lemmen, "Walter Crane." *AM* 11 (1 March 1891), 68.

70

Georges Lemmen
1893 Les XX catalogue cover
Photomechanical reproduction
Private collection, Brasschaat
162 x 124

LEMMEN'S third and last cover for Les XX reveals a gentler, more lyrical side to the artist, perhaps closer to Van Rysselberghe of these years. Though the floral origins of the cover design are unmistakable, the design has been abstracted and reduced from nature.

Lemmen held his catalogue covers in high regard; he exhibited them at the Association pour l'art in Antwerp in 1892 and at Les XX in 1893.[1] A rare documentary photo of the Antwerp installation [illus. 57]

shows the drawings for the 1891 cover (third from left) and the 1892 cover (11th from left).[2] Even though the photo is fuzzy, we can discern the drawing for what would become the 1893 cover (fourth from left). This drawing was listed in the catalogue as part of a series of drawings for Gustave Kahn's *Livre d'images*. A book with this title by Kahn was published several years later without Lemmen's graphics, but Lemmen apparently liked the image enough to adapt it for his 1893 Les XX cover.

—J.B.

1. Meier-Graefe wrote of Lemmen's catalogue covers in his seminal article on the book arts in Belgium, "Die moderne Illustrationkunst in Belgium," 511.

2. R. Cardon refers to this photo in *Lemmen*, 120n1; it is now catalogued at the Bibliothèque Royale, Musée de la Littérature, F.S. XII 157/7.

71

Georges Lemmen
L'Art Moderne (Modern Art), ca. 1892
Ink on paper
Musée d'Ixelles, Octave Maus 122
265 x 226

ALTHOUGH LEMMEN exhibited this drawing for the cover of the Brussels review *L'Art Moderne* at the last Les XX exhibition in February 1893, it first appeared on the issue of 7 January 1894. *L'Art Moderne* was founded on 6 March 1881 by four lawyers—Victor Arnould, Edmond Picard, Octave Maus and Eugène Robert—and ran for more than thirty years, ceasing publication in August 1914. The review was the principal mouthpiece of Les XX and La Libre Esthétique and carried important columns about new international artistic endeavours in art, music and literature. In 1891 Lemmen supplied the masthead for the review, a symbolic figure plowing a field, drawn in a realist vein [fig. 34]. This 1894 cover employs swirling abstracted floral motifs that intertwine image and word in a style that was greatly influenced by Lemmen's work and that would soon be described as art nouveau.

This is one of Lemmen's first drawings to contain his favorite decorative device: a floral border that serves as an inner frame. Perhaps his drawings for silk embroidery influenced the appearance of such a device.[1] In any case, it reappears in various rug designs and in the cover for *Le Réveil*, two 1894 projects. —J.B.

1. Referred to in a letter from Elskamp to van de Velde, quoted in Cardon, R., *Lemmen*, 116. See also the watercolor Au Jardin in Cardon, 117.

72

Georges Lemmen
Fête du 1er Mai (May Day Festival), 1892
Poster [lithograph]
Musée d'Ixelles, Octave Maus 123
205 x 148
Cardon 52

INSCRIBED in bottom margin:

Dessin de Georges Lemmen/destiné au programme de la Fête du 1er Mai au Parc Léopold (Drawing by Georges Lemmen for the program for the May Day celebration at Parc Léopold)

At Lemmen's suggestion, Walter Crane, a British adherent of the Arts and Crafts movement, was invited to exhibit a collection of his books at the 1891 XX exhibition. Many of these publications were provided by Lemmen.[1] An avowed socialist, Crane often put his art at the service of progressive politics. Although this was the only time Crane exhibited with Les XX, his ideological and aesthetic impact on Lemmen was instrumental in the latter's developing interest in creating a decorative art form that might have a more broadly-based audience.

By this time Lemmen already was viewed as one of the major figures in the renaissance of the graphic arts in Belgium. In addition to his more "fine art" prints, Lemmen's reproducible works include the 1891, 1892, and 1893 covers for the Les XX catalogues [cat. 68–70], the title page design for the 4 January 1891 issue of *L'Art moderne*, the 1894 cover of the same journal [cat. 71], and the letterhead for La Libre Esthétique's stationery (ca. 1894). Each of these projects demonstrates Lemmen translation of both Crane's and his own art nouveau style. In addition to ephemeral designs, Lemmen was a major practitioner of typographic and book design. A fine example of

this is his work for Nietszche's *Also sprach Zarathustra* (1899–1908, cat. 79), created in collaboration with fellow Vingtiste Henry van de Velde.[2]

Lemmen designed his first poster during the spring of 1892. Created for the POB's short-lived journal *Le Mouvement social*, this poster announces the May Day (Labor Day) celebrations taking place in the Parc Léopold.[3] The poster incorporates symbolic strategies Lemmen used for his 1891 and 1892 Les XX catalogue covers. It combines the symbols of a rising sun and a tree—symbols that by 1892 already signified a new world made possible through progressive politics in Belgium and France. Seen in concert with the images of a bird (perhaps a dove), a shovel, and the text "Liberty, Work, Fraternity," they suggest that the strong roots found in an association of labor politics with the collective spirit of the labor movement ("Fraternity") would form the basis for a new social order.[4]

The poster's symbolic meaning works on several other levels. Printed in red, it is the color of the banners used by the demonstrating members of the POB. This single color in concert with Lemmen's version of art nouveau relates the poster to the progressive, anarchist styles and politics of Les XX.[5] Although Lemmen would later write on several occasions that he was not a practitioner of the more realist style that he was not interested in leftist politics and linked with *l'art social*, his name and a schematic version of this style can be associated with the Maison du peuple on at least two other occasions.[6]

—S.L.

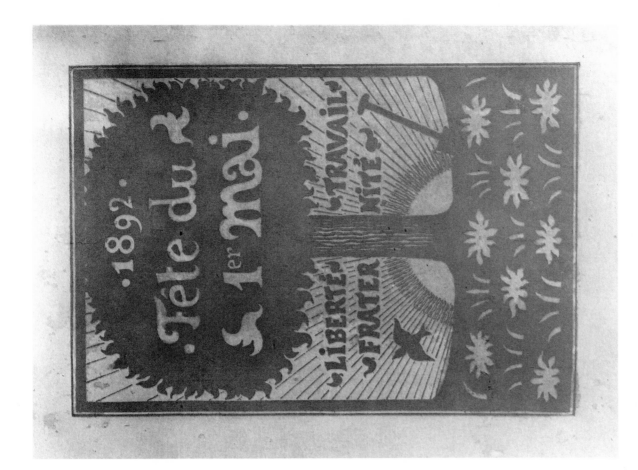

1. In conjunction with this installation at Les XX, Lemmen wrote two articles on Crane for 1 and 15 March 1891 issues of *AM*.

2. See Jane Block's essay in this volume (p. 98) for a rich discussion of Lemmen's book arts.

3. The first issue of *Le Mouvement social* appeared on 10 March 1892. A card from the novelist Georges Eekhoud to Sander Pierron, socialist art critic and member of the journal's editorial board, indicates that by mid-June of the same year publication had ceased: postcard dated 15 June 1892, Antwerp: Archief en Museum voor het Vlaamse Cultuurleven, E. 147. In addition to Eekhoud, Camille Lemonnier, Emile Verhaeren, Emile Vandervelde, Victor Arnould, and Louis de Brouckere all agreed to write for the journal: Cardon, R.,*Lemmen*, 440.

4. The phrase similarly echoes the rallying cry of the French Revolution, "Liberté, Egalité, Fraternité." The rising sun and abundant floribunda were incorporated in images associated with labor and radical politics with abandon in prints during the 1890s. Signac's *Aux temps d'harmonie* [cat. 123] provides a more complicated allegorical version of the new order.

5. There are several instances where the color red and the term anarchist are combined in relation to the Vingtiste project of being the *apporteurs de neuf.* These include Maus's letter to Verheyden upon his election to the group ("On t'acclame membre de la société anarchiste": MRBA/AAC #7248) and Picard's proscription on the relationships between politics and art ("the hour has arrived to dip one's pen into red ink": Picard, "L'Art et la Révolution," *AM* 18 July 1886). This anarchist label referred both to Les XX's avant-garde styles of painting and to the group's political and social philosophies. For more on this and related issues, see Levine in this volume (p. 55) and Block, *XX and Belgian Avant-Gardism,* 37-40.

6. A post card dated 8 November 1895 (IEV/CAE/22), from the sculptor Paul du Bois to Paul Deutscher, then the director of the Section d'art, provides Lemmen's address but gives no indication of the reason for the request.

73

Georges Lemmen
Portrait of Berthe Serruys, 1895
Conté crayon
Art Institute of Chicago, Margaret Maw Blettner Memorial Collection, 1982.1487
370 x 290

THIS drawing is a study for Lemmen's stunning neo-impressionist double-portrait of Berthe and her younger sister, Jenny.[1] Berthe, shown in strict profile, recalls the classical and monumental prototype of Northern Renaissance tradition. By stripping away the environment, Lemmen is able better to capture both the physiognomy of the sitter and the essence of Berthe's personality. Her three dimensional, plastic presence is unlike Seurat's more decorative, two-dimensional conté crayon portraits. However, Lemmen's sharply contrasted areas of dark and light around Jenny's face produce a halo effect that approximates Seurat's use of "successive contrast."

Lemmen was a personal friend of the Serruys family and had given art lessons to the eldest daughter, Yvonne, who ultimately achieved success as a sculptor.

—J.B.

1. For a discussion of this portrait, see Block, "Belgian Neo-Impressionist Portraiture"; the names of Berthe and Jenny were inadvertently exchanged in the essay. See also Lee, *Aura of Neo-Impressionism*, 44–47.

74 [Plate 8]

Georges Lemmen
La Famille des travailleurs (Family of Workers), 1897
Conté crayon and chalk on grey paper
Musées royaux des Beaux-Arts de Belgique, 7227
625 x 478

ALREADY well known for his scenes of domestic life and portraits, Lemmen turned his attention to the representation of laborers during June 1897 for his scene of the *Famille des travailleurs*. Though many of Lemmen's figurative works from the 1890s are drawn in the pointillist technique, an idiosyncratic realism permeates this series.[1] The work depicts two men and a nursing mother in an interior. This drawing is one of three known versions of this image and is not a preparatory sketch for a painting but is

thought to have been produced as a design for the membership card of the Brussels Maison du Peuple in Brussels.[2]

The drawing is squared off, suggesting that it was Lemmen's definitive design. It is not known whether the artist was commissioned by the Maison du Peuple or if he initiated this project, but Lemmen was careful to inscribe the date on this drawing. There is also no evidence that this design was used on a membership card.

—S.L.

1. Like many of his fellow Vingtistes, Lemmen became captivated by the neo-impressionist pointillist technique following Georges Seurat's exhibiting with Les XX in 1887, 1889, and the memorial exhibition in 1891.

2. A related drawing, dated 19 June 1897, recently was sold at auction (Antwerp: Galerie Campo, sale of 25 October 1988, lot 180). It also depicts the four figures and is inscribed "Maison du Peuple/Carte de membre Effectif de Bruxelles Société du/Personnel/De la *Maison du Peuple* De/Bruxelles/Fondée en 1886 [sic]." A third version, a watercolor, is reproduced in *L'Art Décoratif* 12, September 1898: 254 and in *Dekorative Kunst* II. Jahrgang, IV, number 12, September 1899: 234. For an analysis of these works see Cardon, R., *Lemmen*, 173–174.

75

Georges Lemmen
Cover for Gustav Kahn's Limbes de lumière (Flickerings of Light), 1897
Photomechanical ornaments
A. & L. Fontainas Collection
227 x 165

THE decoration of Gustave Kahn's book *Limbes de Lumières* was one of Lemmen's most ambitious graphic undertakings thus far. For this collection of thirty-six poems the artist created over sixty head and tailpieces, as well as a decorated title page and cover. The book was issued in an edition of 525. It was printed by Alex. Berqueman for publisher Edmond Deman and was completed, according to the colophon, on 20 November 1896.

The cover vignette is printed in green on dark beige paper. Swirls of vegetative art nouveau forms surround the handlettering. The page ornaments are printed in a pale ochre and are a mixture of abstract and representational forms: birds, peacocks, flowers, and butterflies are interspersed with energized organic forms. Only occasionally do they seem to relate directly to the poetic text. However, the pale ochre color itself, like the twilight fading of natural light and its replacement by artificial gas light, responds to the central motif of the poetic cycle. By the interplay of the yellow ink on the white page—positive and negative space—Lemmen has added a flickering quality to the overall effect of a muted but pale glow.

Lemmen reinterpreted the elaborate framing device on the cover for a variety of graphic designs, including advertisements for the Berlin art dealers Keller und Reiner in 1898 and the many designs for the periodical *Die Insel* the following year.

French poet Gustave Kahn (1859–1936) was well-known in Belgian circles as early as 1887, when his free-verse poems, *Palais Nomades*, appeared. Prior to Kahn's move to Brussels in 1890, he was associated with several French periodicals of importance to Lemmen: he served as editor of *La Vogue* and *Le Symboliste* and in 1888 wrote for *La Revue Indépendante*. Lemmen and Kahn probably met in 1891 when Kahn lectured at Les XX on "Le Vers Libre." Attracted to the symbolist qualities in the work of Georges Seurat, the founder of neo-impressionism, Kahn naturally also was drawn to the work of Lemmen, one of the most talented Belgian disciples of Seurat.[1] Responding in kind, Lemmen offered Kahn some of his most imaginative graphic designs. —J.B.

1. Kahn wrote the obituary for Seurat in *AM*, 5 April 1891, 107–110.

76

Georges Lemmen
Dekorative Kunst (Decorative Art), 1898
Poster (lithograph) 1898
Museum Vleeshuis, AV 38.5.10 548/637
570 x 690
Cardon 56

LEMMEN created two posters for Julius Meier-Graefe's new review, *Dekorative Kunst*, which was devoted to the regeneration of the applied arts in Europe.[1] Its first issue appeared in Munich in October 1897; the French edition, *L'Art Décoratif*, began publication the following October in Paris. Meier-Graefe promoted the work of Lemmen and Van de Velde, hiring the latter to remodel his Parisian editorial offices on rue Pergolèse, and the former to create stationery, magazine vignettes, and these posters. Meier-Graefe

featured the work of Lemmen and Van de Velde in his two reviews.[2]

This hand-drawn poster was issued in yellow and blue, printed by the Imprimerie Veuve Monnom, printer for the catalogues for Les XX and La Libre Esthétique. The abstracted floral ornamentation recalls Lemmen's art nouveau style of *Limbes de Lumières*. However, the calligraphy, with its sharper and crisper edges, suggests German "Fraktur," presumably alluding to the Germanic origins of his client. —J.B.

1. The second poster appears over the doorway of Meier-Graefe's editorial office in a photograph in *L'Art Décoratif* 1 (October 1898):25.

2. The first major article on Lemmen's decorative arts appeared in the third issue of Dekorative Kunst, see Destrée, "Georges Lemmen"; see also Lemmen, "Modern Teppiche." The premiere issue of L'Art Décoratif (October 1898) was devoted to Van de Velde and the twelfth (September 1899) to the work of Lemmen, van de Velde, and Willy Finch.

77

Georges Lemmen
Decorative paper, 1899
Lithograph in beige
Private collection
240 x 275

78

Georges Lemmen
Decorative paper, 1899
Lithograph in green
Private collection
270 x 425

LEMMEN created numerous designs for book endpapers that also could be used as a decorative cover. Each is a continuous pattern of art nouveau forms that create horizontal or diagonal rows. Lemmen's popular endpapers were available from Siegfried Bing's Galerie de l'Art Nouveau and Meier-Graefe's La Maison Moderne.

Lemmen apparently first used this abstracted floral pattern as an endpaper for the new German periodical, *Die Insel*, published in Berlin by Schuster and Loeffler, 1899–1901. Lemmen was commissioned to design and decorate the first quarter (three issues), October–December 1899. The same design was available in different colors.[1]

Many of Lemmen's decorative designs for fabric, wallpaper, and ceramic tiles were first published in *Dekorative Kunst* and its French counterpart, *L'Art Décoratif*. Both of these patterns appeared in the latter as fabric designs.[2]

—J.B.

1. See Cardon, R., *Lemmen*, 347–348, for other works incorporating these endpapers.

2. *L'Art Décoratif* 2 (September 1899): 239 and 244.

79

Georges Lemmen with Henry van de Velde
Also Sprach Zarathustra (Thus Spake Zarathustra), 1899–1908
Letterpress and relief print
Graphic Arts Collection, Princeton University Library
370 x 260

THIS deluxe edition of Nietzsche's *Also Sprach Zarathustra* was a collaborative effort of Georges Lemmen, Henry van de Velde, and art patron Count Harry Kessler (1868–1937).[1] The book was issued in 1908 by Insel Verlag of Leipzig, for whom Lemmen had already designed the first three issues of their new review, *Die Insel*, in 1899; it was printed by W.

Drugulin, Leipzig, in an edition of 530. The Princeton copy is numbered 489. The book is a large format and was printed in gold, burgundy and black. Van de Velde, who was in charge of the overall decoration, designed undecorated initial letters and chapter titles. In its complexity and beauty, *Zarathustra* recalls two other masterpieces of the private press

OVERLEAF: Page spread from *Also Sprach Zarathustra.*

tanzen, noch stille stehn. Zur kleinen Tugend möchten sie mich locken und loben; zum Tiktak des kleinen Glücks möchten sie meinen Fuß überreden.

Ich gehe durch dieß Volk und halte die Augen offen: sie sind kleiner geworden und werden immer kleiner: – das aber macht ihre Lehre von Glück und Tugend.

Sie sind nämlich auch in der Tugend bescheiden, – denn sie wollen Behagen. Mit Behagen aber verträgt sich nur die bescheidene Tugend.

Wohl lernen auch sie auf ihre Art Schreiten und Vorwärts-Schreiten: das heiße ich ihr Humpeln –. Damit werden sie jedem zum Anstoß, der Eile hat.

Und Mancher von ihnen geht vorwärts und blickt dabei zurück, mit versteiftem Nacken: Dem renne ich gern wider den Leib.

Fuß und Augen sollen nicht lügen, noch sich einander Lügen strafen. Aber es ist viel Lügnerei bei den kleinen Leuten.

Einige von ihnen wollen, aber die Meisten werden nur gewollt. Einige von ihnen sind echt, aber die Meisten sind schlechte Schauspieler.

Es giebt Schauspieler wider Wissen unter ihnen und Schauspieler wider Willen –, die Echten sind immer selten, sonderlich die echten Schauspieler.

Des Mannes ist hier wenig: darum vermännlichen sich ihre Weiber. Denn nur wer Mannes genug ist, wird im Weibe das Weib – erlösen.

Und diese Heuchelei fand ich unter ihnen am schlimmsten: daß auch Die, welche befehlen, die Tugenden Derer heucheln, welche dienen.

„Ich diene, du dienst, wir dienen" – so betet hier auch die Heuchelei der Herrschenden, – und wehe, wenn der erste Herr nur der erste Diener ist!

Ach, auch in ihre Heucheleien verflog sich wohl meines Auges Neugier; und gut errieth ich all ihr Fliegen-Glück und ihr Summen um besonnte Fensterscheiben.

Soviel Güte, soviel Schwäche sehe ich. Soviel Gerechtigkeit und Mitleiden, soviel Schwäche.

Rund, rechtlich und gütig sind sie mit einander, wie rund, rechtlich und gütig mit Sandkörnchen Sandkörnchen sind.

Bescheiden ein kleines Glück umarmen – das heißen sie „Ergebung"! und dabei schielen sie bescheiden schon nach einem neuen kleinen Glücke aus.

Sie wollen im Grunde einfältiglich Eins am meisten: daß ihnen Niemand wehe thue. So kommen sie jedermann zuvor und thun ihm wohl.

Dieß aber ist Feigheit: ob es schon „Tugend" heißt. –

Und wenn sie einmal rauh reden, diese kleinen Leute: ich höre darin nur ihre Heiserkeit, – jeder Windzug nämlich macht sie heiser.

Klug sind sie, ihre Tugenden haben kluge Finger. Aber ihnen fehlen die Fäuste, ihre Finger wissen nicht, sich hinter Fäuste zu verkriechen.

Tugend ist ihnen Das, was bescheiden und zahm macht: damit machten sie den Wolf zum Hunde und den Menschen selber zu des Menschen bestem Hausthiere.

„Wir setzten unsern Stuhl in die Mitte" – das sagt mir ihr Schmunzeln – „und ebenso weit weg von sterbenden Fechtern wie von vergnügten Säuen."

Dieß aber ist – Mittelmäßigkeit: ob es schon Mäßigkeit heißt. –

3.

Ich gehe durch dieß Volk und lasse manches Wort fallen: aber sie wissen weder zu nehmen noch zu behalten.

Sie wundern sich, daß ich nicht kam, auf Lüste und Laster zu lästern; und wahrlich, ich kam auch nicht, daß ich vor Taschendieben warnte!

Sie wundern sich, daß ich nicht bereit bin, ihre Klugheit noch zu witzigen und zu spitzigen: als ob sie noch nicht genug der Klüglinge hätten, deren Stimme mir gleich Schieferstiften kritzelt!

Und wenn ich rufe: „Flucht allen feigen Teufeln in euch, die gerne winseln und Hände falten und anbeten möchten": so rufen sie: „Zarathustra ist gottlos".

Und sonderlich rufen es ihre Lehrer der Ergebung – ; aber gerade ihnen liebe ich's, in das Ohr zu schrein: Ja! Ich bin Zarathustra, der Gottlose!

Diese Lehrer der Ergebung! Überall hin, wo es klein und krank und grindig ist, kriechen sie, gleich Läusen; und nur mein Ekel hindert mich,

sie zu knacken. Wohlan! Dieß ist meine Predigt für ihre Ohren: ich bin Zarathustra, der Gottlose, der da spricht „wer ist gottloser denn ich, daß ich mich seiner Unterweisung freue?" Ich bin Zarathustra, der Gottlose: wo finde ich Meines-Gleichen? Und alle Die sind Meines-Gleichen, die sich selber ihren Willen geben und alle Ergebung von sich abthun. Ich bin Zarathustra, der Gottlose: ich koche mir noch jeden Zufall in meinem Topfe. Und erst, wenn er da gar gekocht ist, heiße ich ihn willkommen, als meine Speise.

Und wahrlich, mancher Zufall kam herrisch zu mir: aber herrischer noch sprach zu ihm mein Wille, — da lag er schon bittend auf den Knieen — bittend, daß er Herberge finde und Herz bei mir, und schmeichlerisch zuredend: „sieh doch, oh Zarathustra, wie nur Freund zu Freunde kommt!" —

Doch was rede ich, wo Niemand meine Ohren hat! Und so will ich es hinaus in alle Winde rufen: Ihr werdet immer kleiner, ihr kleinen Leute! Ihr bröckelt ab, ihr Behaglichen! Ihr geht mir noch zu Grunde — an euren vielen kleinen Tugenden, an eurem vielen kleinen Unterlassen, an eurer vielen kleinen Ergebung! Zu viel schonend, zu viel nachgebend: so ist euer Erdreich! Aber daß ein Baum groß werde, dazu will er um harte Felsen harte Wurzeln schlagen! Auch was ihr unterlaßt, webt am Gewebe aller Menschen-Zukunft; auch euer Nichts ist ein Spinnennetz und eine Spinne, die von der Zukunft Blute lebt. Und wenn ihr nehmt, so ist es wie Stehlen, ihr kleinen Tugendhaften; aber noch unter Schelmen spricht die Ehre: „man soll nur stehlen, wo man nicht rauben kann." „Es giebt sich" — das ist auch eine Lehre der Ergebung. Aber ich sage euch, ihr Behaglichen: es nimmt sich und wird immer mehr noch von euch nehmen! Ach, daß ihr alles halbe Wollen von euch abthätet und entschlossen würdet zur Trägheit wie zur That! — Ach, daß ihr mein Wort verstündet: „thut immerhin, was ihr wollt, — aber seid erst Solche, die wollen können!" „Liebt immerhin euren Nächsten gleich euch, — aber seid mir erst Solche, die sich selber lieben — — mit der großen Liebe lieben, mit der großen Verachtung lieben!" Also spricht Zarathustra, der Gottlose. —

Doch was rede ich, wo Niemand meine Ohren hat! Es ist hier noch eine Stunde zu früh für mich. Mein eigner Vorläufer bin ich unter diesem Volke, mein eigner Hahnen-Ruf durch dunkle Gassen. Aber ihre Stunde kommt! Und es kommt auch die meine! Stündlich werden sie kleiner, ärmer, unfruchtbarer, — armes Kraut! armes Erdreich! Und bald sollen sie mir dastehn wie dürres Gras und Steppe, und wahrlich! ihrer selber müde — und mehr, als nach Wasser, nach Feuer lechzend! — Laufende Feuer will ich einst noch aus ihnen machen und Verkünder mit Flammen-Zungen: — verkünden sollen sie einst noch mit Flammen-Zungen: Er kommt, er ist nahe, der große Mittag!

ALSO SPRACH ZARATHUSTRA.

AUF DEM ÖLBERGE

DER Winter, ein schlimmer Gast, sitzt bei mir zu Hause; blau sind meine Hände von seiner Freundschaft Händedruck. Ich ehre ihn, diesen schlimmen Gast, aber lasse gerne ihn allein sitzen. Gerne laufe ich ihm davon; und, läuft man gut, so entläuft man ihm! Mit warmen Füßen und warmen Gedanken laufe ich dorthin, wo der Wind stille steht, — zum Sonnen-Winkel meines Ölbergs. Da lache ich meines gestrengen Gastes und bin ihm noch gut, daß er zu Hause mir die Fliegen wegfängt und vielen kleinen Lärm stille macht. Er leidet es nämlich nicht, wenn eine Mücke singen will, oder gar zwei; noch die Gasse macht er einsam, daß der Mondschein

movement, the Kelmscott *Chaucer* and the Doves *Bible*. Lemmen was commissioned to create a new typeface for the book. Count Kessler had long been interested in typography and counseled Lemmen on each character in his wish to surpass in excellence even the books designed by William Morris and Charles Ricketts. Kessler wrote to Nietzsche's sister, Frau Elizabeth Förster-Nietzsche, "there can be no doubt that it should be the most beautiful book produced for a century."[2]

Lemmen completed the typeface by January 1900. He was subsequently commissioned to execute a sup-plementary alphabet of initial letters, but they were not used. Production of the book was constrained by legal problems concerning the copyright. Once these were resolved, van de Velde designed the ornaments for each of the major portions of the book and the double and title pages. This ornamentation is abstract and harmonizes with Lemmen's "modern" typeface. The finished product owes much to the Arts and Crafts ideals of William Morris, but the length of time between the completion of the typeface and of the final book designs shows that new developments in book design influenced the appearance of *Zarathustra*. —J.B.

1. For the genesis of this edition see Block, "The Insel-Verlag 'Zarathustra.'"

2. Letter from Kessler to Förster-Nietzsche, 11 April 1898, Weimar: Nationale Forschungs-und gedenkstätten de Klassischen Deutschen Literatur, no. 393.

80

Georges Lemmen
Garçonnet jouant (Boy at Play), 1900
Lithograph in grey-green on greyish "Chinese" paper
Museum of Fine Arts, Boston, Gift of Benjamin A. and Julia M. Trustman, 1988.393
328 x 358
Cardon 24

INSCRIBED: à Albert Verweij, cordialement. Lemmen

This genre scene is a double portrait of the artist's wife and their five-year-old son, Pierre. Such scenes of domestic life, particularly Madame Lemmen tending to the children, are among the most frequent subjects in Lemmen's oeuvre. The softness, grace and elegance of the composition is also typical of these works. The feathery touch of Lemmen's crayon sets a mood of quiet, shared intimacy between the pair. Peacock and floral motifs add a playful, lyrical quality to the balanced triangle of mother, child and toys.[1] This lithograph is similar in style and feeling to nine other lithographs executed around this time—all of them characterized by a mood of reverie.[2]

This particular copy, no. 6, is inscribed to Albert Verwey (1865–1937), a Dutch poet and critic who was responsible for the revival of literature in the Netherlands at the turn of the century. Lemmen met Verwey through Vingtiste Jan Toorop, when Lemmen exhibited this work in 1901 at the First International Exhibition at The Hague. Toorop was one of the exhibition organizers and Lemmen traveled to Holland for the event.[3] Lemmen entrusted this lithograph to Toorop for safe delivery to the poet.[4]

—J.B.

1. The peacock curtain is in two other lithographs of the series of ten, *Étude de Fillete* and *Fillette et sa Poupée*; in a 1903 watercolor, *La Modiste*, see Cardon, R., *Lemmen*, 232; and in an oil, *Nude Smelling Flowers*, Christie's New York, 16 May 1985, no. 326.

2. R. Cardon sees these lithographs as "Formant une seule et même série," *Lemmen*, 401; for illustrations see 404–15.

3. Lemmen's visit to Holland is recorded on a Lemmen drawing of Toorop reading that is inscribed "à Jan Toorop, 12 Mai 1901, Katwijk" (Toorop lived in Katwijk). Presumably, Lemmen attended the exhibition opening 9 May.

4. Letter from Toorop to Verwey, 23 May 1901, published Nijland-Verwey, *Kunstenaarslevens*, 183: "Lemmen heeft voor hij wegging een mooie lithografie aan je cadeau gedaan. De litho is hier of zal ik je die zenden."

81

Georges Lemmen
Three postcards, 1906
Watercolor and ink
The Fine Arts Museums of San Francisco, Achenbach Foundation for Graphic Arts
Purchases, 1987.2.33, 34, 35
140 x 190 ea.

THESE three cards were written by Lemmen to his close friends, sculptor Paul Dubois and his wife Alice. Paul was one of the original members of Les XX and he and Lemmen opened a course of instruction for young students in the fall of 1892.[1] Dubois was a witness at Lemmen's marriage to Aline Maréchal the following year.[2]

The first two cards, postmarked 4–5 June 1906, deal with the return of the painter Alfred William (Willy) Finch to Brussels.[3] Finch had moved to Finland in 1897 under the patronage of Count Louis Sparre to run the ceramic division of the "Iris" factory at Borgå. In 1902 Finch moved to Helsinki, where he taught at the School of Fine Arts and the School of Industrial Arts. Finch and Lemmen kept in touch through an extensive correspondence beginning in 1897.[4] In his characteristically humorous vein,

Lemmen signed the second postcard with the initials A.W.F., pretending that the card was from Finch. Written in Lemmen's unmistakable calligraphic hand, Lemmen (acting as Finch) informs Dubois and his wife that Finch is passing through Brussels and then invites himself and Finch to dine at the Dubois home. Lemmen even suggests the proposed menu to his hosts, indicating that they would be happy to dine on "boustrink" with a Madeira sauce.[5]

The third card, postmarked 4–5 May 1908, expresses Lemmen's regrets to Madame Dubois for not making an engagement. Lemmen informs his correspondent that he is departing immediately for Paris, leaving behind him a teary-eyed wife and children.[6] To indicate his great haste, Lemmen draws the train that will whisk him off to Paris. His signature is a scrawl that trails off into the steam of the train's engine.

—J.B.

1. "Petite Chronique," *L'Art moderne* 12 (25 September 1892):311.

2. Cardon, R., *Lemmen*, 336.

3. For more on Finch, see Brussels: MRBA, *Finch.*

4. Lemmen promoted Finch's career, including an essay on Finch's contribution to painting and decorative arts for *L'Art Decoratif*; see Lemmen, "Finch."

5. 'Boustrink' is red herring; I am indebted to Jean-Luc de Paepe for unearthing this translation in Quievrex, Dialecte Bruxellois, 34, where it is spelled 'boestrink.' 'Rokkestow' is a grilled slice of bread topped with meat or jam.

6. Lemmen presumably was going to Paris to make arrangements for his exhibition at the Galerie Druet 25 May–6 June 1908.

The Fine Arts Museums of San Francisco, Achenbach Foundation for Graphic Arts

Mr A.W. FINCH, de passage à Bruxelles, invite Mr G. LEMMEN à déjeuner chez son ami Paul Du BOIS, auquel il présente ses amitiés ainsi qu'à sa très gracieuse moitié.

SAMEDI, 23 Ct à midi ½.

La plus chaude cordialité est de rigueur.

Si vous êtes le moins du monde embarrassés par le menu de samedi, sachez que nous nous contentons très bien d'un boustrink sauce Madère ou d'un simple rokkestow. ANF.

Mille Regrets, Chic Madame, le Petit Homme d'une Sorte d'l'instant pour Paris, laissant un Veuf éploré et ses enfants dans les larmes. C'dora dans pour eux — Moi. Vite rit, l'heur retour. J'reste...

82

Amédée Lynen
Cover for *Catalogue de la Grande Zwans Exhibition*, 1885
Lithograph
Willis Collection
210 x 138

'ZWANS' (Francophonic spelling 'zwanze') denotes a joke or spoof.[1] This catalogue of the first of two art exhibition parodies organized by L'Essor in Brussels is also a spoof, beginning with its macaronic title and the quite possibly fictitious numbering of the edition. (It does not appear to have been distributed through the normal book trade.[2]) The catalogue opens with a sarcastic explication of the cover design by Lynen.[3] The final paragraph of this text characterizes Lynen's allegory of art and folly as "autographic" (i.e., superficial, as the drawing on stone with which the cover design began). Next, an essay lampoons impressionism by announcing it has been superceded by a new school of art ("Any-Which-Wayism") characterized by utter carelessness of execution.

The exhibition catalogue lists the artists purportedly participating, mostly under names anagramatically or otherwise disguised (many to the point of being indecipherable). Some of these artists did lend works to the Grande Zwans Exhibition, but a number were just as surely represented only by others' satires of their works.[4] Especially ridiculed were members of Les XX, who in 1883 had seceded from L'Essor (e.g., Guillaume Vogels, 19; Fernand Khnopff, 21 and 32).

The spirit of the 1885 event was conservative.[5] The catalogue's brief biographies of the "exhibiting artists" and the descriptions of "their" works are replete with puns and oblique satires that must have been hilarious to well-informed contemporaries but whose humor is largely lost on later generations. A certain Le Graive, for example, is described as an incredibly gentle man who "never takes offense when he is called an architect"—a reference that leads to a tentative identification of the architect Edmond Legraive (died 1923) and is also a pun on that supremely offensive epithet in Brussels dialect, "architek."

The main catalogue is followed by a report of a mock painting competition, describing ten pictures on the subject "*Le beau c'est le laid* (Beauty is ugliness)." Among these pictures, identified mainly by punning devices, the one ascribed to Léon Frédéric—a

leading member of L'Essor—under the device "*Le beau et le laid sont des conventions*" is awarded a "dishonorable mention." If, as seems likely, this painting was Frédéric's *Interieur d'atelier* (1882, Musée d'Ixelles), which bears the device quoted, the joke is the catalogue's sarcastic description of an apparently serious allegory hauled out good-naturedly for the occasion by the artist who created it.[6] If not, the farce was more involved, depending perhaps upon some satirical rendering of Frédéric's earlier canvas with its strange inscription not obviously related to the subject depicted (a nude male model holding a gauze-draped skeleton and a stalk of wheat).

This publication concludes with a quotation "*post-farce*" from *Uylenspiegel au Salon de 1857*, the satirical exhibition review illustrated by Felicien Rops.[7] The quotation recalls the origins of the *zwans* exhibitions organized by L'Essor in the mock reviews and caricatures of official art shows published in Paris from the 1840s and from Brussels from the 1850s. In 1870 the Belgian photographer Louis Ghémar organized Brussels's first *zwans* art show. L'Essor's 1885 exhibition, held in the "museum" occupying the upper stories of the recently erected (1881) Passage du Nord in central Brussels, was, like the 1870 show, a benefit affair and accompanied by a souvenir catalogue. A second *zwans* exhibition in the Musee du Nord was organized by L'Essor in 1887, again for charitable benefit and again to lampoon Les XX and the newest trends in Belgian and French art. These and later mock art shows have been analyzed at length in two articles by Jacques Van Lennep.[8] In the first of these articles, Van Lennep points out the (inadvertent) contributions made by the Brussels *zwans* exhibitions to the development of modern art, arguing that the creations included in them and described in their catalogues prefigured dadaism, surrealism, and conceptual art as surely as they built upon principles of nineteenth-century caricature. The taste for humor and satire in fine art manifested in the *zwans* phenomena reposed upon a southern Netherlandish art tradition going back at least to the Gothic period.[9]

—A.W.

1. Fischer, *Bruxelles d'autrefois*, 152–156.

2. The catalogue is not listed in the *BB* for 1885 or 1886.

3. Van Lennep, "Les Exposition burlesques," 133.

4. Ibid., 134–135.

5. Ibid., 144.

6. Lesko, *Ensor*, 48, casts doubt on this generally accepted supposition but advances no convincing evidence to support her opinion. Lesko refers obliquely to the 1885 catalogue as evidence that *Intérieur d'atelier* was not in the *zwans* exhibition, yet the entry on p. 40, taken at face value, is unequivocal; the picture in question is reproduced by Lesko as Fig. 43.

7. Van Lennep, "Les Exposition burlesques," 130–132.

8. Ibid.; see also Van Lennep, "Les Expositions burlesques: Complements," 313–326.

9. See Maeterlinck, *Le genre satirique dans la peinture flamande* and *Le genre satirique, fantastique et licencieux dans la sculpture flamande et wallonne;* Fierens, *Le fantastique dans l'art flamand.* There is an ongoing, international parodic tradition in art and art-writing: see, for example, William Beckford, *Biographical Memoirs of Extraordinary Painters* (London, 1780); Bob Reisner and Hal Kaplow's irreverent *Captions Courageous or Comments from the Gallery* (London and New York, 1958); the pataphysical *Catalogue raisonné des oeuvres de l'école mentaliste* that were never painted (Paris, 1977); and Gary Larson, *Wiener Dog Art*, calendar for 1991–92.

83

François Maréchal
La Meuse, rue des glacis de la citadelle, 1893
Etching
Minneapolis Institute of Arts 1076
145 x 187

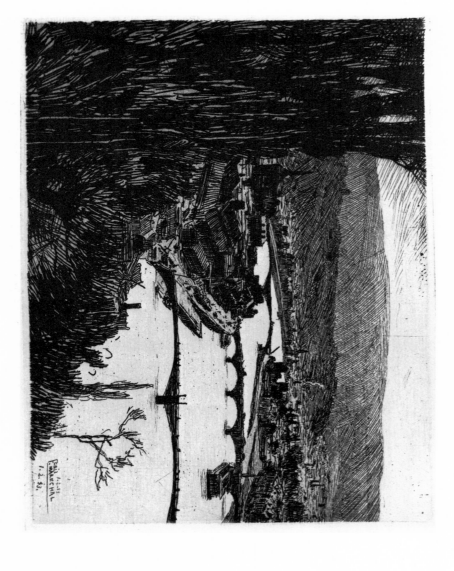

MARÉCHAL began making etchings in 1888. One of his favorite subjects was the vistas of the valley of the Meuse River in and around his city of Liège. Liège built the Citadel for strategic reasons in the eighteenth century. It sits atop the hills that form the valley around Liège and presents one of the most picturesque views of Liège. The mass of buildings on the left bank are Liège's University, along with the spire of the Église des Prémontré within the complex of the Bishop's Palace. Also clearly indicated are the footbridge, built in 1880, the 1843 pont de la Boverie (now called Pont Kennedy), and the former Pont de Commerce.[1] The right bank is dominated by private housing, as it is today. In the distance, industrial smokestacks can be discerned.

—S.L.

1. The pont de la Boverie, also called le Pont Neuf, led to a swimming complex, visible in the print; the complex was destroyed in 1922. The Pont de Commerce opened in 1866 and was destroyed in May 1940. It was not rebuilt until 1964 and was renamed the Pont Albert Ier. Françoise Léonard-Etienne, curator at the Cabinet des Estampes et Dessins, kindly provided me with this information.

84

François Maréchal
On Lécheu d'baie (A Toady at the Railing), 1895
Charcoal, conté crayon, and graphite
Cabinet des Estampes de la Ville de Liège, K.359/3
313 x 258

THE sites, inhabitants and waterfront of the industrial city of Liège formed the inspiration for Maréchal's prints and drawings. His figure studies often were depictions of the working class, a single figure as a metonymy for his/her class. As a major industrial center, Liège and its surroundings suffered more than other parts of the country in the wake of numerous labor strikes and mine closings. Many Liège artists, including Maréchal and Armand Rassenfosse (see cat. 110), depicted the consequences of the recession and the plight of the working class.[1] *On Lecheu d'baie* is a masterful example.

After meeting Fernand Khnopff in 1893, Maréchal was influenced by the older artist's handling of pastel and charcoal, as he was by Rassenfosse's experiments with Félicien Rops in soft-ground etching. This drawing relates to the work of all three. Using only gradations of black and grey, with the white of the paper creating highlighted areas, with a single color Maréchal evokes the fatalistic attitude of a man who has no work and makes no attempt to find employment. He sits, hands folded on his thighs, staring sightlessly, as if he has sat there all day and will remain. The figure forms a contrast with the cheerful houses whose bright lights and sense of well being permeate the background.[2] The figure is separated from such domesticity by the inky depths of the Meuse River.[3] The lights' reflections nearly touch him, but he is left in shadow, which further suggests his hopelessness.

On Léchau d'baie is a Walloon phrase for the type of man who, having nothing better to do, harasses the fishermen along the riverfront and keeps them from their work as well.[4] Using this phrase for his figure of an unemployed worker, Maréchal sketched a poignant yet ironic portrait of much of the Liège working class in the mid-1890s.

—S.L.

1. For additional illustrations and essays on *l'art social*, see Berlin: Neue Gesellschaft für Bildende Kunst, *Arbeit und Alltag*, and Charleroi: Palais des Beaux-Arts, *Art et Société en Belgique.*

2. The view across the Meuse may be the Quai des Tanneurs; Maréchal etched the site in 1908.

3. Maréchal's etching *Les quais, le soir* (1906, Liège: Cabinet des Estampes) is closely related to this drawing. Also a night scene, it is of a woman seen in shadow, looking out across the Meuse to the brightly-lit houses. For a reproduction of this and other of Maréchal's riverfront images, see Clercx-Léonard-Etienne, *Maréchal.*

4. Messrs. Ménage of Brussels and Broussart of Liège, specialists in the Walloon language, provided this analysis of the phrase, in conjunction with the image; I gratefully acknowledge their assistance. Walloon is a primarily oral language; an alternative spelling of the phrase is 'on létchêu d'baye.'

85

François Maréchal
Premier Mai (May Day), 1895
Drypoint
Cabinet des Estampes de la Ville de Liège, 2.3/3
290 x 195

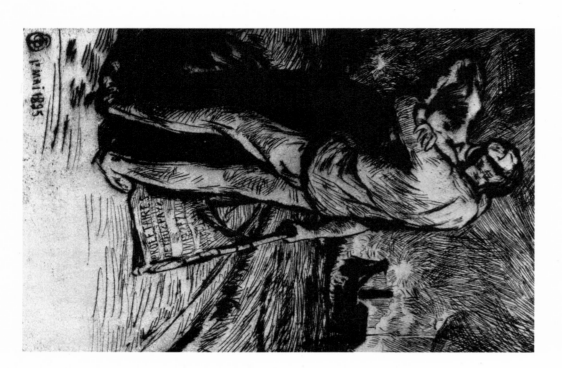

UNTIL 1886, the first day of May was marked by celebrations of the rites of spring. In the aftermath of the explosive anarchist demonstrations that took place in Chicago that spring, the first of May took on a second, more politicized meaning related to working class issues.[1] The Vooruit announced that beginning in 1889, Flanders would celebrate May 1 as a Labor Day.[2] The following spring *Le Peuple* announced that Wallonia also would set aside that

day.[3] Since that time, May Day has become synonymous with Labor Day in many countries.[4]

The young demonstrator in Maréchal's work puts down her May Day banner due to the temporary distraction of her lover's embrace. The industrial buildings in the distance give the reason for the demonstration. The banner's slogan, "Proletariat of all countries unite," echoes the sentiments of the international syndicalist movement in which Belgium played an important role.[5]

—S.L.

1. For a discussion of Haymarket, 1886, and the development of Labor Day in Belgium, see van Goethem, *De Roos op de Revers*, 38–39 and 51–65; and Foner, *May Day.*

2. Vooruit was the Ghent chapter of the Arbeidersbeweging; they published a newspaper of the same name. The 4 December 1889 issue announced that "geene werkstaking maar een Feestdag van den Arbeid moet het zijn op donderdag 1 Mei."

3. Launched in 1885, *Le Peuple* was the official organ of the Brussels chapter of the POB. Its 16 April 1890 announcement of the first of May as a labor day read, "La volonté et l'intérêt du parti ouvrier, de la democratie socialiste tout entière sont d'accord pour que le 1° Mai soit une fête de travail éclatante et pacifique."

4. In Belgium, May Day is often marked by a procession of socialists to Constantin Meunier's Monument to Labor in Laeken. In celebrating Labor Day on the first Monday of September instead of the first day of May, the United States has relinquished reference to the older tradition and to the labor-inspired meaning.

5. "Prolétaires de tous pays unissez-vous" echoes, for example, Karl Marx's plea, "Proletarier aller Länder Vereinigt euch!"

86

François Maréchal
Vox populi (The Voice of the People), 1895
Pen and ink with red, blue, and black pencil
Cabinet des Estampes de la Ville de Liège, K.359/1 Legs Emile D'Heur
250 x 270

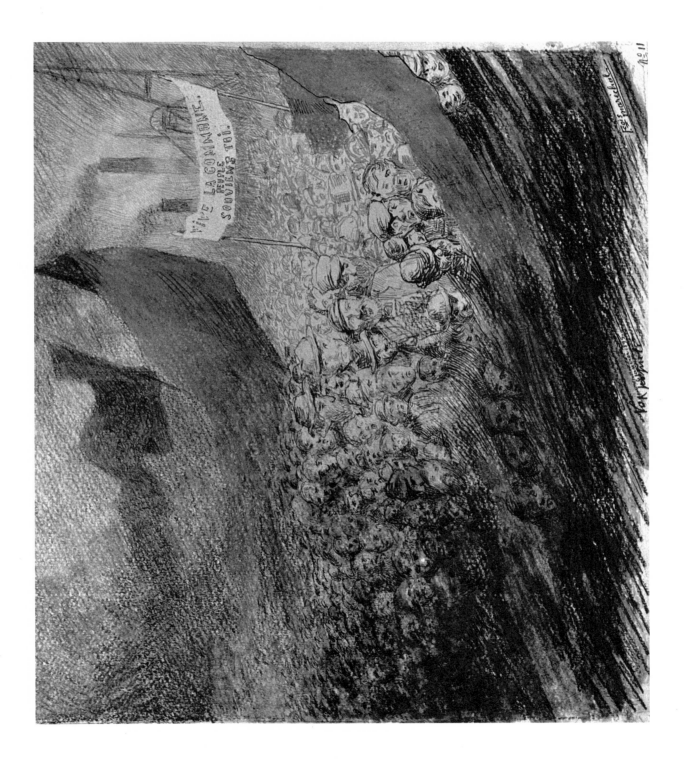

IN the aftermath of the general strikes of 1886 and 1893, as well as the 1893 election in which the POB gained 28 seats, scenes of labor unrest became favored subjects among many of the artists of the Belgian avant-garde (see also cat. 72, 85, 97, 116).[1] This masterful drawing by Maréchal presents the increasingly radicalized and fundamentally disgruntled Liégeois working class as a potentially violent teeming mass. The sweeping vortex of their march is echoed by the thickly rendered diagonals in the foreground of the drawing. In the background, two blazing smokestacks belch their ashen residue into the sky, adding to the filthy atmosphere that authors and artists during the time described as typical of the sky in the industrial sectors.[2]

Maréchal's drawing most likely refers to the events of 1886, rather than later strikes. On 18 March 1886 Liège anarchists organized a demonstration to commemorate the fifteenth anniversary of the Parisian Commune.[3] Though it began as a small yet vocal manifestation, the local police took immediate and violent action; within hours, seventeen protesters were wounded, fifty were arrested and 104 buildings were looted.[4] This crackdown did not end the protests and within twenty-four hours a call was sounded to mount a general strike throughout the industrial sector. Although the POB leadership had called for non-violent action, this order was not heeded. For the next two months, the protests continued and much property was destroyed.

Maréchal's figures are rendered as members of the lower class. The rounded leather hats and caps they wear identify their economic status as well as their professions. The leather hat, a precursor to the hard hat, was worn by miners, while the caps often were donned by fishermen. Although drawn almost a decade later, the scene echoes the events that took place in Liège during March and April 1886. Maréchal's workers carry banners reading "Death to the Bourgeoisie" and "Long live the Commune. People, do you remember?"—banners typical of the 1886 protests.[5]

—S.L.

1. The 1893 elections were particularly important to the working class as they were the first elections after the institution of universal male suffrage; the POB had worked for this since its inception in 1885.

2. This scene most likely refers to the early days of the 1886 protests because the smokestacks are in use. For literary descriptions of the industrial landscape of northern France and Belgium, see Emile Zola's *Germinal* (1885) and Camille Lemonnier's *Happe Chair* (1886).

3. The Parisian Commune was the major radical political action during the second half of the nineteenth century, made possible only by the French defeat in 1870 in the Franco-Prussian War. The protest was based on the need for a federated system for the working class; the communards adopted the red flag as the symbol of their struggles. This "red spectre" was violently suppressed and many of the leading communards fled the country (some to Belgium). They were not given amnesty until 1879–80.

4. For analyses of the 1886 strikes, see Bruwier et. al., eds., *1886 La Wallonie Née de la Grève?*

5. The text "Mort aux Bourgeois" has been almost completely rubbed out in this drawing, yet can be detected in the red banner in the lower right and in the black banner in the upper portion of the drawing. "Vive la Commune. People souviens toi" is clearly visible on the banner at the right.

87

Gustave Marissiaux
Intérieur ardennais (Ardennes Interior), 1901
Photogravure, from the album
Visions d'Artiste
Spencer Museum of Art,
Elmer F. Pierson Fund, 89.58:29
185 x 123

88

Gustave Marissiaux
Le Terril (The Slag Heap), 1905
Photogravure, from the album
Visions d'Artiste
Spencer Museum of Art,
Elmer F. Pierson Fund, 89.58:24
140 x 175

89

Gustave Marissiaux
Retour au 'coron' (Return to the Miners' Dwellings), 1905
Photogravure, from the album
Visions d'Artiste
Spencer Museum of Art,
Elmer F. Pierson Fund, 89.58:25
122 x 187

IN 1889 the Liège section of l'Association belge de photographie (the Belgian Association of Photography, ABP) was established.[1] Like its counterparts throughout Belgium, this organization joined amateur and professional photographers and provided members an annual exhibition as well as illustrated lectures by professional photographers.[2] The entrance fees of one to three francs paid to attend the lectures were often donated to local charities.

Although he began as an amateur photographer, Gustave Marissiaux quickly became a leader in the Liège ABP. Marissiaux made his living by creating quasi-Pre-Raphaelite portraits, but he is best remembered for a series of photographs, *La Houillère (The Coal Mine)*, he presented to the ABP in 1905.[3] The series, commissioned by the Liège coal syndicates and done in collaboration with Georges Kemna, of over 300 images details all aspects of the coal mining industry.[4] It is a marvelous example of early documentary photography and the most complete record of the daily working lives of the Belgian coal miners.[5]

Three years later Marissiaux published *Visions d'Artiste*, a more personal portfolio of photogravures he had worked on from 1901 to 1908.[6] The photogravures were produced by Paulussen of Vienna and the portfolio was introduced by printmaker Auguste Donnay of Liège.[7] This deluxe portfolio of thirty images presents a more intimate view of working-class life in industrial Wallonia and of peasants in the Ardennes region. It contains both scenes of domestic interiors (e.g. *Intérieur ardennais*) and of labor (e.g. *Le Terril* and *Retour au 'coron'*). Each of the images has been gently tinted in sepia or gray.

Typical of the contrast between *La Houillère*, created for a more public purpose, and the more private *Visions d'Artiste* is the image *Le Terril* from the later series. Whereas in images of slag heap workers in the first, larger series Marissiaux created close-ups of figures climbing and sorting coal on these manmade hills, here the artist silhouettes two workers on scaffolding against a muted sky.

—S.L.

1. The first section of the ABP was established in 1873.

2. For a history of the ABP see Liège: Musée de la Vie Wallonne, *La Photographie en Wallonie*, esp. 34–42.

3. The profits from Marissiaux's slide lecture went to the "Chauffoirs publics" and to "l'Ouevre des enfants moralement abandonnés"; each organization received 700 francs according to *Album des séances de projection de l'ABP*, section Liégeoise. For more information on *La Houillère* see Moreau, "Reportage photographique de Marissiaux."

4. The complete collection of 385 negatives, 304 slides, and 244 stereograms is housed in Liège in the Musée de la Vie Wallonne; the author is indebted to Mme. Dubois-Maquet for granting access to them.
 For information on Kemna see Liège: Musée de la Vie Wallonne, *La Photographie en Wallonie*, 106.

5. Images from this series are reproduce as figures 15, 16 and 18 in Levine essay this catalogue [p. 66 and 68].

6. Marissiaux, *Visions d'Artiste*.

7. Donnay [Liège 1862–Jette Saint-Pierre 1921] is best known for posters he made during the turn-of-the-century era.

LEFT—Catalogue 87
RIGHT—Catalogue 88
BELOW—Catalogue 89

90

Xavier Mellery
Oeuvre de la presse (Work of the Press), ca. 1879–1884
Lithograph
Bibliothèque Royale Albert 1er, Cabinet des Estampes, Quarto SIII 41239
210 x 144

THIS lithograph announces a ball to be held in recognition of the charitable works of the Belgian press. Mellery has incorporated a portrait of a working family that is similar to his famous renderings of the fishing communities on the small island of Marken. The father's pickax is a symbol of the family's hard work; the daughter holds a large, round loaf of bread of the kind that is still called *boerenbrood*, or "peasant bread" in Belgium. Distributing bread was one of the most important charitable activities of the press and therefore the bread in Mellery's lithograph symbolizes that charity.

The *Oeuvre de la presse* also held a variety of promotional events, including a burlesque exhibition, a staged assault at the Palace of the Academies, various festivals, a gala performance at La Monnaie, the Brussels opera house, and an extravagant series of staged "*Fêtes de Chevalerie* (chivalric festivals)" in 1891 in the *Grand' Place* in Brussels.[1] Though the ball announced by Mellery's invitation is not an exceptional event, it testifies to the artist's involvement with charity. Other artists who worked for the *Oeuvre de la presse* include Auguste Donnay, Gustav Den Duyts and Amédée Lynen, and Alexandre, the photographer who often collaborated with Khnopff (see cat. 60).[2]

—S.G.

1. D'Ardenne, "Lemaire," 25: "C'est sous ses auspices et le plus souvent grâce à son initiative que l'on a vu s'organiser: la première exhibition burlesque du Musée du Nord, le premier assaut d'armes ou palais des Académies, les fêtes de cette année au Marché de la Madeleine et au Bois de la Cambre, les représentations gala du théatre de la Monnaie, donnée avec le concours des artistes de l'Opéra-Comique et de la Comédie Française, enfin la présente fête de Chevalerie, qui couronne superbement cette série brillante."

2. Martens, *Ouevre de la Presse* 1891, 31–32.

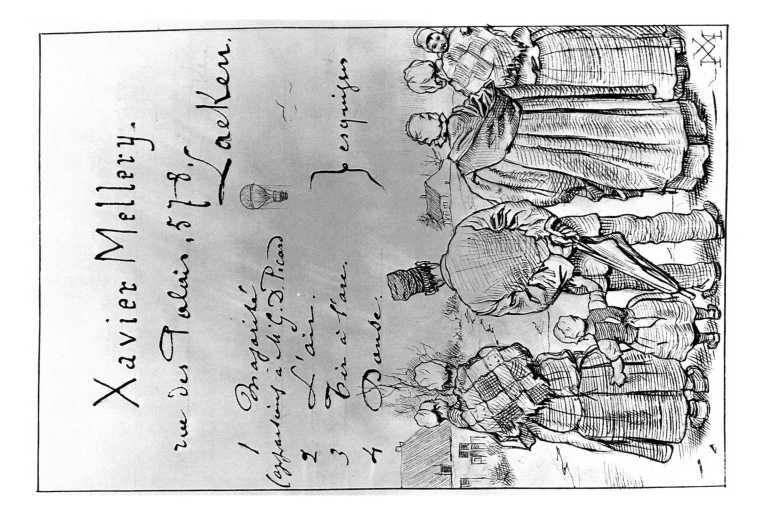

91
Xavier Mellery
Drawing for the 1888 Les XX catalogue
Pen and ink on paper
Private collection, Madrid
190 x 132

THE catalogue for the fifth Les XX exhibition, 1888, included facsimile reproductions of each artist's list of submitted works. Several of these lists, including that submitted by Xavier Mellery, were decorated with a sketch. Mellery's sketch of a group of people in a rural landscape watching an aerial balloon had its source in an earlier book illustration, *Une Vente à l'encan sur la Place des Halles*, which Mellery produced for Camille Lemonnier's *La Belgique*, published in Paris in 1888.[1]

Mellery's illustration for Lemonnier's text depicts a group of people, their backs to the viewer, watching auctioneers conducting their business as they lean out of the windows of their establishment. In the center is a man wearing a flat cap, holding an umbrella behind his back and leaning slightly to the left; beside him is a woman wearing a white ruffled bonnet and a hooded cloak. These figures are copied so exactly in the sketch on Mellery's list for the Les XX exhibition that it is probable that he traced them from his illustration or from preparatory sketches or photographs.[2]

Mellery did make a significant change in the placement of these figures for the sketch. Instead of the urban, mercantile setting of the *La Belgique* illustration, they are in an open landscape—a shift of milieu that may have been intended by the artist as a reminder of his earlier achievements as a recorder of life in remote settings. For instance, in 1885 Mellery's first works shown with Les XX included ten drawings and one watercolor showing peasants on the island of Marken. These Marken scenes, which originally grew out of a series of topographical illustrations for an essay by Charles de Coster, were generally praised by critics, among them Philéas Murr, who remarked upon the "savage, rude, and primitive aroma" of the subjects.[3]

Despite Mellery's success in 1885 with the charming Marken drawings and with the studies of regional types and customs published in *La Belgique* and echoed in the sketch reproduced in the 1888 Les XX catalogue, the works for that exhibition were radically different in subject and style from the artist's earlier work. Drawings such as *Majorité*, featuring allegorical figures drawn in *grisaille* on a gold ground, represent a departure from the world of observed reality in Mellery's earlier drawings and paintings and reflect his growing interest in the power of symbols and evocation. This shift was noted by at least one critic, who described Mellery's allegorical figures as inhabitants of a Nordic golden age. "Master of the art of interpreting one's native corner of the earth, [Mellery] is equally able to sing of the human form. . . . His creatures have lived in primitive nature, in the burning sun, among the ripe wheat, whipped by the North winds."[4] Thus Mellery's list reproduced in the 1888 Les XX catalogue brings together the two sides of the artist's works: the early naturalist drawings recalled by the sketch, and the drawings and paintings of mysterious or allegorical subjects, whose titles the artist penned on the page.

—K.P.

1. Lemonnier, *La Belgique*, 345; the first four *livraisons* were originally published as *La Belgique* in the *Tour Du Monde* series in 1881.

2. Mellery worked from photographs for the drawings of Marken, done around the same time; see Powell, "Mellery and Marken," 343–67.

3. Murr, "Le Salon des XX," 153.

4. M.W. "Le Salon des XX," *Le Soir* (7 February 1888): n.p.

92

Xavier Mellery
Sous la lampe (Under The Lamp), ca. 1895
Charcoal
Bibliothèque Royale Albert 1er, Cabinet des Estampes, SI 24386
114 x 153

"'FOLLOW me,' Xavier Mellery said to me one day at his house, fixing his large eyes on a corner of his studio, 'it's beautiful, like a portrait.'"[1] Thus Camille Lemonnier began an article about Mellery in the *Gazette des Beaux-Arts* in 1885. The unimpressive scene that Mellery found so appealing contained a few common objects: a plain cast-iron stove against the wall, an old faience plate hanging from a nail next to a Dutch clock, a fragment of a copy after an Italian master stretched on its frame. But, as Lemonnier

explained, these objects played an important part in the artist's theory of art: the revelation of the intense and mysterious expression concealed beneath the surface of things.

Mellery's goal of giving a voice to the silent realities of life, which Lemonnier elucidated in the 1885 article, would form the foundation for a group of extraordinary drawings. These were first exhibited under the collective title "La vie des choses" in 1889 and 1890, exhibited as "Emotions d'art: L'âme des choses"

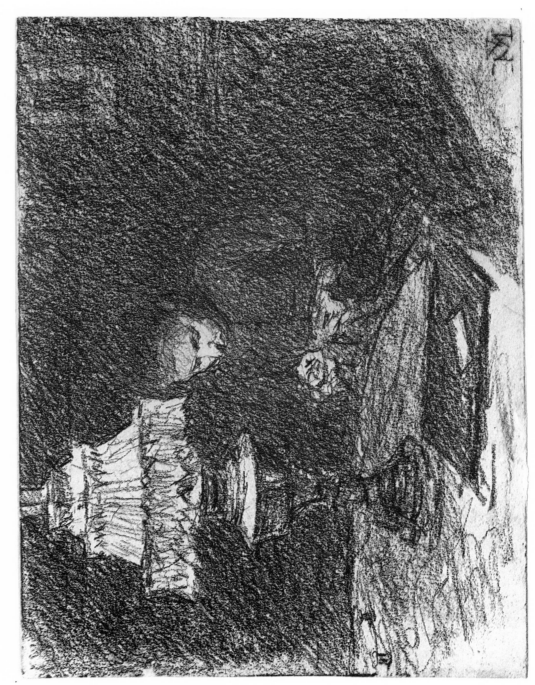

in 1895, and finally simply described as "L'âme des choses (The soul of things)" in the artist's correspondence and lists of works. From the first discussion of these works and the thoughts behind them in Lemonnier's pioneering article to the obituaries that followed Mellery's death in 1921, the drawings of "L'âme des choses" impressed viewers as one of the most unusual and significant statements of Belgian avant-garde art and literature. Mellery's drawings that invoke the hidden meaning behind surface appearances have parallels in symbolist poetry and art theory.

Although Sous la lampe is not specifically listed among the works in the "L'âme des choses" series, the drawing fits well into the context of Mellery's intimist drawings. The drawing projects a mood of meditative silence through its dark background and the figure obscured by the texture of the charcoal. Emerging only partially from the darkness into the pool of light cast by the shaded lamp, the figure remains private, anonymous, and even slightly mysterious. More than one critic noted that the emotional power of Mellery's works came not just from their subjects but from the way in which they were executed. The specific technique that evoked Mellery's meaning was his use of a uniformly dark, evenly worked surface in which the surface, as much as the specific subject, spoke immediately to the viewer. Max Sulzberger called this Mellery's "voile noir," the black veil that obscures the illusionistic qualities of space and perspective, while the critic J. in the Journal de Charleroi praised the artist's ability to voir noir, that is, to see black without altering the relative value of tones.[2] In Sous la lampe Mellery uses the obscuring dark shadows to illuminate an aura of silent solitude that cannot be seen, only felt.

—K.P.

1. Lemonnier, "Xavier Mellery," 425.

2. Sulzberger, "Exposition des XX-II," 2; and J. "Exposition des X," 27.

93

Xavier Mellery
Bruges (three drawings), ca. 1892
Charcoal, graphite, pen & black ink
Spencer Museum of Art, Spencer Fund, 89.69–71
198 x 295; 290 x 185; 190 x 289

As a dominant theme of Belgian symbolist literature and art, the canal city of Bruges was mythicized as an Other World, a stillpoint of the globe, a city-museum outside of time and particularly conducive to revery and introspection. Xavier Mellery uses the format of the triptych, with its religious connotations, to suggest the pacification offered by this holy city of the imagination. The reiteration of simple, whitewashed buildings, softly winding paths and narrow waterways in the three scenes creates a continuity and a mood of déjà-vu that is offset by subtle shifts of indistinct lighting,

gradations of atmospheric conditions, and seasonal changes of the slender poplars. The lethargy of the views of the triptych, in which all signs of human activity have been effaced, counters the disruptive motion of the modern world. Mellery here offers the alternative vision of a gentle, narcoleptic realm of uninterrupted slumber and release from the concerns of living. Mellery's white buildings, secretive and oblique, bear witness to a vanished population, recently disappeared. They suggest a state of blank virtuality, the essential promise of this site of protracted dream. —D.F.

94

Xavier Mellery
Béguines at Prayer, ca. 1894
Pen and brush and ink
302 x 473
The Museum of Modern Art, New York, Gift in Honor of Myron Orlofsky, 291.78

THE mysterious and reclusive life of the convent is recurrent in Mellery's work and in Belgian symbolist literature. For artists and writers of the turn of the century, entry into an order of nuns was a valid retreat from the inconsequential restlessness of life. In his 1889 "Notes on Pessimism," Georges Rodenbach summarized an essential decadent stance: "It is necessary to practice renunciation; instead of delighting in things, become detached from them, and frozen in inaction await the supreme promise, the immense peace of nothingness." [1] The peace of noth- ingness and the suspension of action emphasized by Rodenbach are evident in Mellery's arrested moment of antiphonal prayer, in which the nuns, a seated pri- oress and standing and turning respondents, are spec- tral quasi-presences, the slightest inflections of the encompassing penumbra. Intent upon the inner

mystery of which they are the vassals, the nuns serve as a figurative substitution for the symbolist artist engaged in a parallel quest for immanent divinity inherent in the creative act. The nun also represents the veiled and hidden, referring to the concealment and ephemeral revelation that is the essence of Mellery's symbolist art. Forms—stairs, column, choir stall, carving—are only a tenuous suggestion in this drawing. The facelessness of the bowing figures is a visual analogy of silent reclusion, as is the cavernous density of shadow defined by the shroud-like folds of white muslin worn by the order during prayer. Mellery evokes an uncertain space inhabited by anonymous, shade-like beings. Disengaged from the worldly activity that imposes identity, the veiled women are icons of quiescence, of absence from the known and openness to the ineffable.

—D.F.

1. Rodenbach, "Notes sur le Pessimisme," 208. In his poetry, Rodenbach evokes the béguines as his Sisters of Silence, con- sanguineous with the poet in introversion of the mind. Rodenbach's nuns lose themselves in the temporal suspension induced by the repetitive processes of chanting and lace-mak- ing, thereby crystallizing the absorption of the artist in the artistic process: "L'orgue dans le silence accroît ses velours noirs;/Et les voix se combinent comme des fils frêles/Qui doivent aboutir à être une dentelle," in Oeuvres 2, 265. Of interest in the context of the haunted, unearthly atmosphere of claustral life in Mellery's drawing are J.K. Huysman's repeated evocations of con- vent evensong in *En Route.*

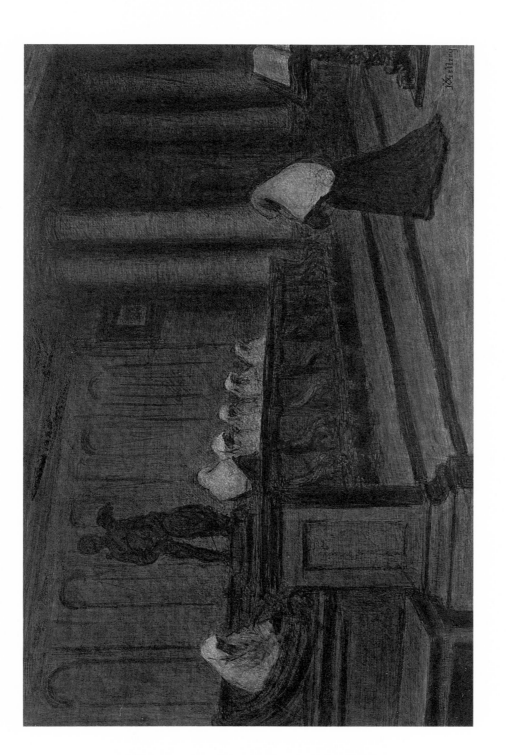

95

Constantin Meunier
La Glèbe, from Le Mort de Camille Lemonnier (The Soil, from Camille Lemonnier's The Dead Man), ca. 1882
Black chalk and pencil on paper
Musées royaux des Beaux-Arts de Belgique, 10.000/330
330 x 455

THE DEAD MAN by Camille Lemonnier is a novella of lust, betrayal and murder in the Belgian countryside, published in a small edition by Henry Kistemaeckers on 24 November 1881.[1] In the story, three middle-aged brothers—Balt, Bast, and the eldest, "idiot" Nol Baraque—own a paltry farm. A cousin, Hein, visits to tell them he has won 20,000 francs in a lottery. After the men share several celebratory drinks, the two younger brothers strangle Hein, steal his money, and bury him. Balt and Bast use a small portion of their ill-gotten wealth to quietly improve their lot. At first they are successful; their potato crop is plentiful and their pigs fat. Their fortune turns, however, when Balt becomes enamored of La Tonia, a tramp from the next village who already is married. First, their crops fail and then the brothers turn against each other. In the climax, Balt decides to kill Bast to gain control of the remaining fortune but both brothers die in the battle.

Like Emile Zola's Rougon-Macquart novels, Lemonnier's texts combine morality tales with careful attention to the details of life on the land or in the city. Often called "the Belgian Zola" for the naturalist details in his novels, Lemonnier became a leading figure in the Jeune Belgique literary renaissance of the 1880s. Among Lemonnier's better-known novels that detail the travails and tragedies of the Belgian working class are *Un Male* (1881) and *Happe Chair* (1886).

The year after the publication of *Le Mort*, a second, deluxe edition appeared with an etching after Meunier's drawing of *La Glèbe* as its frontispiece.[2] The drawing and the etching depict the brothers Balt and Bast strapped to their plough, tilling their field like beasts of burden.[3]

By focusing on an early episode in the story and not one of the dramatic scenes, Meunier's illustration serves as a commentary on the novel. Instead of the tragedy, the artist chose to depict the brothers' initial work ethic. *La Glèbe* is one of many illustrations Meunier would produce in collaboration with Lemonnier. Others include his images of the industrial landscape in *La Belgique* (1884) and *Au Pays noir* (ca. 1896).[4]

—S.L.

1. The story, dedicated to Edmond de Goncourt, was completed in October 1878 but not published for years because all of the Parisian publishers Lemonnier approached turned it down. Belgian publisher Henry Kistemaeckers, by this time, already had gained a reputation for handling pornographic and other problematical texts.

2. For additional information on the deluxe edition see Fayt, "Henry Kistemaeckers," 225-230; Baudet, *Kistemaeckers*, 196-197; and de Sadeleer, *Bibliothèque Littéraire*, lot 34. Meunier later reprised the subject of *La Glèbe* in a bronze relief that is now in the Musée Constantin Meunier.

3. The Musée Constantin Meunier owns some eight other sketches Meunier made as possible illustrations for *Le Mort*, including two versions of *Le Cadavre dans le fumier, La Prière*

devant l'autel, La Veillée du mort, Le Fantôme, La Tonia éclairant la lutte, Les Pieds passent toujours, and an untitled sketchbook page that contains the germ for the image of *La Glèbe*.

4. In addition to Meunier's numerous images of industry, *La Belgique* includes some of Xavier Mellery's most famous images of the Beguines of Bruges. *Au Pays noir* (*The Black Country*), published by Deman ca. 1896, contains etchings by Karl Meunier after his father's drawings of coal miners and the coal-mining district in southern Belgium.

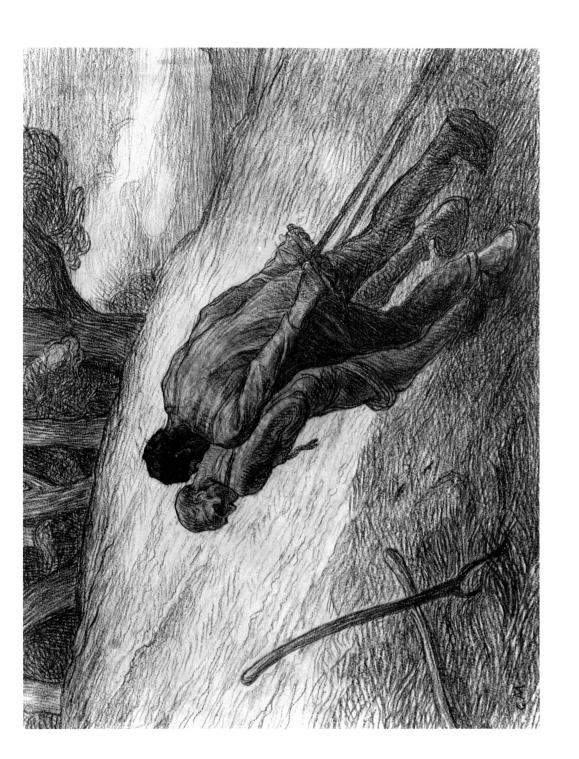

96

Constantin Meunier
Hécatombe (Slaughter), ca. 1887
Pastel and charcoal
Musées royaux des Beaux-Arts de Belgique, 10.000/279
645 x 823

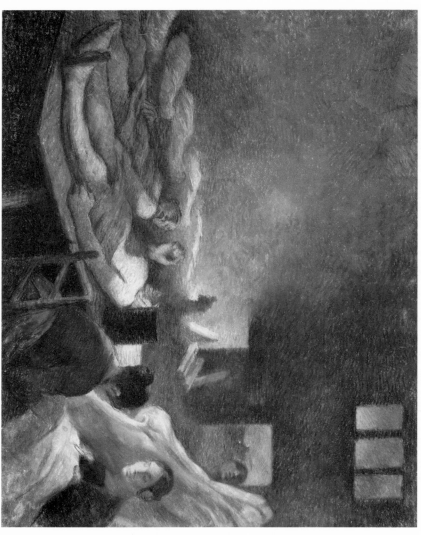

OFTEN dubbed the "artist of the Flemish collieries", Constantin Meunier's oeuvre constitutes a catalogue of the inhabitants and practices of the late nineteenth-century Belgian industrial world.[1] His works prior to 1887 often present a more generalized view of labor and the industrial landscape rather than specific events in Belgium's labor history. On 4 March 1887, however, Meunier was present at the catastrophic explosion at the "Puits de la Boule du Rien du Coeur" coal mine in Quaregnon; 113 miners were killed in a *grisou* (fire

damp). Working alongside the mine's physician, his friend and colleague Valentin van Hassel, Meunier completed a series of pastels that documents the aftermath of this tragic explosion.[2] *Hécatombe* depicts the *Salle des victimes*, the great hall where the victims were laid out to be identified. Represented with a kind of matter-of-factness—two women calmly sew burial shrouds next to the crumpled bodies of dead miners—this drawing provides little of the horror, stench, and drama that Meunier witnessed and van Hassel described.[3]

—S.L.

1. Sparrow, "Meunier," 75–86.

2. Meunier had known van Hassel since the mid-1870s when the latter was collaborating with Théo Hannon on the short-lived journal *L'Artiste*. For a discussion of Meunier's experiences at La Boule, see van Hassel, *Souffrance humaine*, 37–45 and Piérard, "Van Hassel et Meunier," 193–196.

3. A year later Meunier completed a life-size bronze sculpture based on his experiences at La Boule, *Le Grisou*, depicting a mother leaning over her dead son. It was exhibited at the 1889 Paris International Exposition and at the 1890 Salon in Brussels.

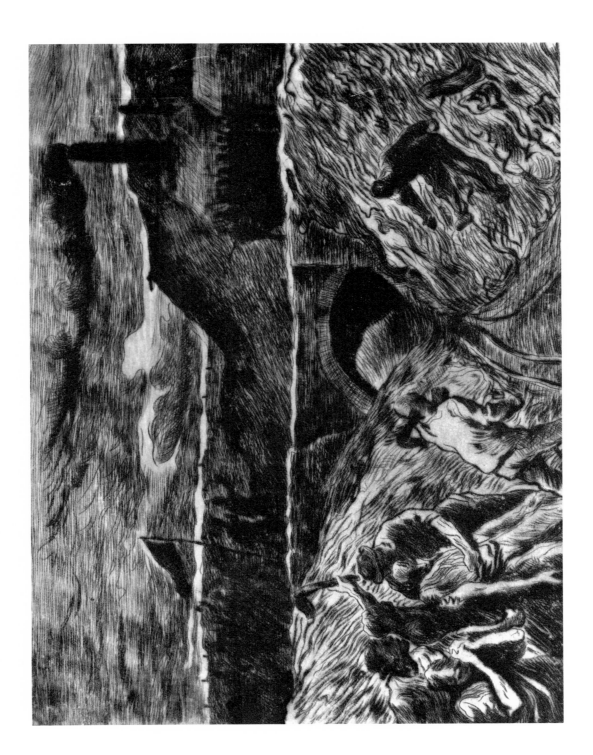

97

Constantin Meunier (Karl Meunier after Constantin Meunier)
Scène de grève (Strike Scene), before 1889
Etching
Bibliothèque Royale Albert 1er, Cabinet des Estampes, SII 127360
146 x 189

ON 18 March 1886, the fifteenth anniversary of the Parisian Commune, an anarchist demonstration was organized in the Liège industrial basin. Within hours, the police clashed with the small group of demonstrators and some fifty people were injured. In the months that followed, general strikes wreaked devastation throughout Belgian industrial sectors. A number of literary works and songs were written about this moment in Belgian history.[1] Among these was Louis Delmer's short story *Le Fils du gréviste*, on the effects of the strikes that year in the Borinage region. Published in 1889, Delmer's text included an etched version of Meunier's drawing of *The Strike* as its frontispiece.[2]

By 1880 Meunier was known as the artist par excellence of Belgian industry. This image presents both the radical nature of strikes and the injuries such actions often caused. Divided across a horizontal plane, the scene depicts in its upper register the belching smoke stack darkening the already polluted landscape of the coal mines. Beside it, a group of strikers march defiantly behind a banner.[3] In the bottom portion, another group of strikers, armed only with their mining hatchets, come to the aid of an injured laborer.

—S.L.

1. Throughout the waves of general strikes in Belgium (the most important ones occurred in 1886, 1893 and 1902), artists, song writers, and writers painted, composed and wrote of these job actions. For example, in the aftermath of the 1893 general strike a small pamphlet of drawings, songs and poems on the travails of the *Pays noir* ("Black Country") was underwritten by King Léopold II and sold to profit local charities; see *Au Pays noir*. I thank Steve Goddard for providing this reference.

2. Delmer, *Le Fils du gréviste*. The artist's son Karl produced the etching. Another, more famous but fictional account of the events of 1886 is Camille Lemonnier's *Happe Chair*.

3. Generally, depictions of the Belgian labor strikes include the red banner, a symbol of their socialist nature. In 1894 Ph. Lenoir published a short poem, "La Grève," that describes a similar scene; see *Au Pays noir*. Posters by Van Biesbroeck and Van Neste's [cat. 132 and 143] are full-color images containing the red banner.

98

Constantin Meunier
Mineurs, borinage (Miners, Borinage), published 1898
Lithograph (from the album *Temps Nouveaux*)
Spencer Museum of Art, Letha Churchill Walker Memorial Art Fund, 89.49
565 x 444

I N March 1896, Jean Grave, a French anarchist journalist, wrote to Camille Pissarro about his plan to produce a portfolio of some thirty lithographs by artists sympathetic to his weekly *Les Temps nouveaux*. The sales of these prints were to raise funds necessary to keep his periodical afloat.[1] Within a short time, Grave had secured drawings from Théo van Rysselberghe [cat. 151], Maximilien Luce, Théodore Steinlen, Henri Edmond Cross, Paul Signac [cat. 123], Camille and Lucien Pissarro, and Constantin Meunier.[2] Printed in editions of 250, the lithographs initially were sold individually, with fifty from each edition held back to be sold as a portfolio once the album was completed in 1903.

Meunier's *Mineurs, borinage* was the thirteenth image for the portfolio. It appeared on 10 December 1898.[3] As Meunier was not a printmaker, he provided Grave with a drawing from which a transfer lithograph was made. An undated letter from Meunier to Grave indicates that the artist did not expect any recompense for his donation to this "militant cause."[4] This was not the only time Meunier's work was published by the French anarchist press. Two years earlier, Maximilien Luce had created a series of ten drawings, "Les Gueules noires" ("The Black Mouths") after Meunier's sculptures. These drawings were published in serial form in Emile Pouget's *La Sociale*.[5] —S.L.

1. For the text of this letter see Dardel, "Les Temps Nouveaux," 18.

2. Signac's print ultimately was pulled from the portfolio series but he submitted other works, including *Les Démolisseurs* to Grave.

3. Meunier's family subsequently donated other objects for sale to a 1908 auction in support of Grave's newspaper.

4. Paris: Institut Français d'Histoire Sociale, Jean Grave Archives, #14AS-184A. My thanks to Susan Canning for providing this reference.

5. This series drew from works shown at Meunier's one-man exhibition at Siegfried Bing's L'Art Nouveau gallery, Paris. Meunier already was known to the Parisian artistic community but with this installation his reputation became firmly established.

99

Constantin Meunier
Mineurs à la descente (Miners at the Descent), before 1903
Grease pencil, sanguine, white, and orange chalk
Musées royaux des Beaux-Arts de Belgique, 3685
765 x 560

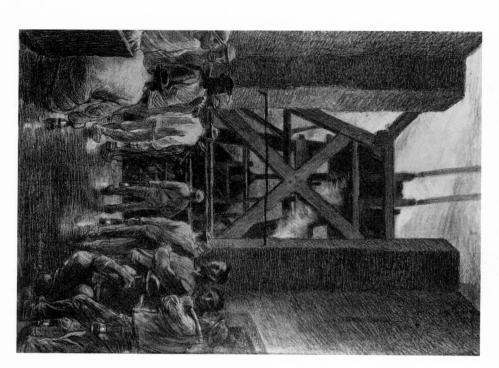

FROM 1878 until he died in 1905, Constantin Meunier rendered images of laborers who worked in the coal and metal industries in Belgium. While the artist's favored subjects were sculptures of the colliery workers, he created a large number of paintings and drawings of the monstrous architectural environments associated with those landscapes, including *Miners at the Descent*. The drawing presents the beginning of a work shift—a large group of miners are in the process of climbing into the cage that will take them into the mine. Dwarfed by the shaft's scaffolding, most of the men mill around the entrance while others wait their turn for the long descent.

Although this drawing was produced in the final years of his career, it is a subject that Meunier had depicted on several occasions, beginning in the 1880s. During the late 1880s, for example, Meunier produced a monumental painting of the same subject; it is in the Brussels City Hall.[1] Almost a decade later, in 1896, Karl Meunier created an etched version, *La Vieille charpente*, after one of his father's drawings of a night descent for *Au Pays noir*. This book, published by Deman, was a collaboration between the artist, his son, and naturalist writer Camille Lemonnier.[3]

—S.L.

1. The painting in City Hall has been called *La Vieille Charpente* and *Descente des Mineurs*. The left wing of Meunier's *Triptyque de la Mine* now in the Musée Constantin Meunier, Brussels, is another monumental version of the subject.

3. *Au Pays noir* was published in a deluxe edition of 175 copies. It contains nine etchings by Karl Meunier after drawings by his father and a short text on industry by Lemonnier; for further information on this text, see Fontainas, Luc and Adrienne, "Edmond Deman."

100

George Minne
Treurende moeder met twee kinderen (Grieving Mother with Two Children), 1888
Ink on paper
Private collection
360 x 267

THIS drawing is contemporary with and related to Minne's better-known sculpture of the same title.[1] The trio of grieving mother and two children on a barren rock forms a web of tangled limbs and hair, the lugubrious whole bound together by creeper-like tresses. Minne's three nudes seek succor from their grief in one another, their limbs all but fusing in a common matrix, a metaphor for their collective pain.

Compared to the plaster sculpture, the drawing appears rugged and uncompromising; the sculpture is more subdued—symmetry and compact masses dominate the form. The sculpted nudes, one of Minne's entries in the 1890 Les XX exhibition, are defined by dense blocks of raw matter that suggest bitter metaphors for their unbearable grief. Like the figures in the drawing, an encompassing sorrow grips them: head bent, faces lowered—the mother's face is lost in the open palms of her hands—they appear overpowered by some primordial sorrow. This expressed sorrow led some critics to view Minne's work in the context of "primitivism," in terms of raw, elemental, as yet unburgeoned life. Charles Van Lerberghe, who with Le Roy and Maeterlinck was a dedicated Minne supporter, after viewing the 1890 Les XX exhibition said, "Minne: sculptures of a primitive humanity hardly cut from the stone; they evoke for me as well a wailing, plaintive and anguished humanity—Minne could illustrate . . . Darwin."[2]

Though Van Lergreghe was referring to Minne's sculpture, his words could as well apply to Minne's drawing with its harsh outlines. Minne's drawing, like the plaster, stubbornly adheres to the compact block from which it seems to have been hewn. The drawing's affinity with its sculpted counterpart explains some of its most anomalous features: why the figures are so harsh, why many of the limbs seem dismembered, and the modeling of the child's leg makes it appear as a harsh, angular buttress, a free-standing rock.

As with other works by Minne of this period, these figures occupy a harsh landscape, a virgin terrain that harbors the primordial. The nudes seen to deny

time and appear to stare directly at death itself, particularly the standing youth with one eye peering from her parted hair. This single eye sets the tone for the drawing, recalling the haunting, Cyclopean eyes of figures by Odilon Redon, a comparison made by Van Lerberghe and other Belgian critics.

Redon's work was familiar to Belgian artists of the period; he showed several lithographs that featured his characteristic masks and eyes floating in space at the 1886 Les XX exhibition. A critic for *L'Art Moderne* noted that while Redon's work elicited from some the most "exalted dithyrambic" verses, others responded with cries of anger and "invectives" before what they considered to be "enigmas, nightmares,

disordered visions, hallucinations."[3] Four years later his work was received with much the same response as it appeared in concert with that of Les XX's new star, George Minne. Le Patriote reported with that Les XX was now offering the double spectacle of Redon and Minne. While the former offered an array of "incomprehensible works," the latter was not to be missed by "les aliénistes," or the lunatic fringe.[4] More than one critic was convinced that Redon and Minne had plumbed the same inane depths. Champal, the acerbic critic for La Réforme, remarked bluntly that Minne's plasters were but translations of Redon's enigmas, an observation other papers repeated in as many variations.[5] One perplexed critic wrote:

The public comes to a halt, astonished, at the Salon, before some disturbing sculptures: of a block, angular, hieratic figures with frenetic or doleful movements; these sculptures . . . recall Odilon Redon, but in plaster . . . They are by that artist from Ghent, George Minne.[6]

That Minne's contemporaries paired his work with Redon's, in retrospect, is almost to be expected: both Redon and Minne crafted figures that shocked and challenged, that were discomfiting. And though frightening to behold, they appeared convincing, thriving in their natural element. This natural element, especially for Minne's pen study of 1888, was nature in its primary state, in which man feels the most basic emotions at their greatest intensity. Thus, when Minne's more astute critics—especially Grégoire Le Roy—wrote that Minne's work speaks of anguish, a pain that denies time ("c'est la légende de la douleur à travers les temps"), they were asserting that Minne's work, like Redon's, goes back to pre-history in order to pursue the most primary emotions.[7] Free of polite conventions and untarnished by time, Minne's weeping mother thus expresses, "l'infini et l'éternel de la souffrance humaine."[8]

—A.A.

1. Minne's *Mère pleurant ses deux enfants* is in both plaster and bronze; for a reproduction of the plaster see Van Puyvelde, *George Minne*, Pl. 4, cat. no. 5; for the bronze see Hoozee, ed., *George Minne*, 82, Pl. 19.

2. See Van Lerberghe's comments under the heading "Exposition des XX" in his unpublished diary for 1889–1891, especially page 149 (Brussels: Musée de la Littérature, Bibliothèque Royale Albert Ier).

3. "Odilon Redon," *AM* (21 March 1886): 92.

4. "citons Odilon Redon avec des oeuvres incompréhensibles, et, à recommander aux aliénistes, George Minne, le sculpteur"; Byron, "Septième exposition annuelle des Vingt," *Le Patriote*, 20 January 1890.

5. "en M. Minne un sculpteur qui consentit à exécuter en plâtre les énigmes d'Odilon Redon!"; Champal, "Chez les XX."

6. See Krespel, "L'Art a L'Etranger."

7. Le Roy, "George Minne," 308.

8. Ibid.

101

George Minne
Treurende moeder (Grieving Mother), 1890
Pencil on paper
Museum voor Schone Kunsten, Ghent, 1985–L
409 x 309

ONE of the few works by Minne discussed in detail by his contemporaries, this drawing was known to a wide audience even before it was exhibited. The work was first discussed at length by Emile Verhaeren in the essay "Regarding a Drawing" in the January 1891 issue of *La Nation*; the article also mentioned Minne's work for Maeterlinck's *Serres chaudes* [cat. 102] and his frontispiece for *La Jeune Belgique* [cat. 104].[1] As a preface to his discussion of *Treurende*

moeder, Verhaeren reviewed Minne's recent achievements, the artist's growing celebrity, and his "infamous" reputation during exhibitions of the previous year. Minne's works in these exhibitions earned scathing criticism; characterized by the critics as "Congolese [fetishes] and troglodyte statuary."[2] But Verhaeren's article drew comparisons between Minne's works and those of certain "contemporary English painters"—presumably Burne-Jones and other

FIGURE F. George Minne, Study for *Treurende Moeder*, pencil, ca. 1890. Private collection.

late Pre-Raphaelites—and even to "certain Italian Primitive masters." "Perhaps Verhaeren had Fra Angelico's smooth, pellucid surfaces in mind as he praised Minne's own "manière lisse et plate.""3 With these references to current and past masters, Verhaeren introduced his subject with great enthusiasm. Minne's drawing, wrote Verhaeren, "frames religion and piety with humility.""4

The grieving mother holds a young child, naked and apparently ravaged by disease, against her shoulder while an older child stands at her side. The mother's bony, dry fingers and crossed palms prop the child's cold flesh in her own nearly-lifeless hands. His body is frighteningly severe, angles and harsh lines protruding from his frame. His sibling, propped against their mother and echoing her silhouette with her own cloak, holds her brother's feet and presses her lips to them, apparently grieving at his passing. Minne's figures float disconcertingly, their feet lost under long cloaks that arch in broad, sweeping rythms. The figures levitate and billow forth.

The mother is the most soulful of the group, a *pleurant* in contemporary dress she personifies grief. Echoing the gestures of late gothic Burgundian *pleurants*, she reels forward, head sunk in sorrow.5 Her path is dotted with falling dandelions, frail petals representing life's fragility. Her life deadened by her loss, she is, as Verhaeren observed, "the bent one, the bearer of all misery. Before her present distress, it was the distress of years past, a uniform and monotonous distress . . . for centuries and for always."6 Indeed, Minne's distraught mother is beyond the human. Her glassy stare—right eye rolled backwards, pupil lodged against the rim of the eye socket—is as indecipherable a gesture as the few rising and falling strands of hair that have broken free from her mantle to float in what appears to be an airless landscape.

Minne completed a related study during the same year that prefigures the finished work in numerous details [fig. F]. In the preparatory study the figures seem more firmly rooted to the earth. Also, the earlier drawing displays none of the smooth finish and determination of its more complete counterpart.

Minne's trio of wraithlike figures are discomfiting, benighted servants of grief, their lives reduced to an endless ritual of sorrow: the pious embraces, the ceremonious kiss on the child's feet, and the eerie wisps of hair all denote their servitude to sorrow. Even the precise lines of the drawing defining matte silhouttes accented with somber shades of grey project a mood of suffering.

A similar theme and cast of characters are in an engraving by Luke Fildes, *Houseless and Hungry*, which shows a mother wandering the streets of London, babe in arms and a little girl clinging to her skirt.7 But unlike works by Fildes and other Victorian artists of the 1870s who favored Dickensian dramas, Minne's grieving mother has none of their rhetoric or social overtones. The figures are not in any given setting and the work has none of the suggestions of temporality that pervade Fildes' print. It is, wrote Verhaeren, a picture of "instinctive sorrow . . . of pain beyond cause."8

Verhaeren believed that the public, an audience only too familiar with the grief that Minne had so artfully expressed, would see the same message in Minne's work. Verhaeren felt, however mistakenly, that "[Minne's art] is a popular art. It stems from the masses, and certainly, the masses can understand it."9 Verhaeren misunderstood the acuity of his public and the crowds attending the 1891 Les XX exhibition where *Treurende moeder* was shown were hardly sympathetic to this work.10 Minne's image only fed the fires that had raged at the exhibition the year before, in which Minne's work had so stolen the show. In 1891 Minne was joined by Gauguin, who was described by the critics as an "upstart," a "madman who was off to Tahiti for treatment."11 Outraged by Gauguin's entries, as they had been by Minne's the previous year, the critics paired the two and the press declared they deserved each other. One angry critic wrote, "M. Gougin [sic]. This joker—I can't imagine he takes himself seriously . . . M. Gougin [sic] who likens himself after the sculptor (!) Mine [sic]."12 Verhaeren, who recognized and appreciated the connections between Minne and Gauguin, rallied to defend Minne. Both artists, Verhaeren wrote, speak of the "future" while alluding to the past in order to "gather force and jump forward."13 With contemporary art "exhausted," he concluded, both Minne and Gauguin have "returned to the sources" of art itself; hence their modernity.

Indeed, Minne's *Treurende moeder* seems to look back in time in order to strive forward. Though the public had no appreciation for such imagery, the drawing soon became known to a clique of aesthetes as the best of George Minne and it was published in a deluxe periodical, the short-lived but famous *Van Nu En Straks* where it was extolled for suggesting a primary sense of time, echoing Verhaeren's views that Minne's chaste vision of pain rang a primordial, yet eminently modern, chord.14

—A.A.

1. Verhaeren, "A propos d'un dessin," *La Nation*; as reprinted in Fontaine, ed., *Pages Belges*, 145–150. Verhaeren regularly contributed art criticism and drama reviews to *La Nation*.

2. Ibid., 146. Verhaeren probably alludes to a lost work by Minne exhibited with Les XX in 1890, a plaster roundly reviled for suggesting "..a 'troglodyte' couple"; see Norton, "Les Nouvelles des Arts." Verhaeren's reference to "Congolese aesthetic" was spurred by criticism which intimated that Minne's work would be best appreciated by Africans: "M. Minne a le droit d'être satisfait; il a transporté parmi nous les pratiques des Africains. L'ignorance lui doit des remercie-ments," Verdavainne, "L'exposition des XX."

3. Verhaeren, "A propos d'un dessin," 145.

4. Ibid., 149.

5. Verhaeren refers to Burgundian fifteenth-century statuary and especially to the tomb of "Philippe Pot" in the Louvre; Ibid., 146.

6. Ibid., 149.

7. For a thorough study of Fildes' *Houseless and Hungry*, first published in the *Graphic* of 1869, see Treuherz, *Hard Times*, 53.

8. Verhaeren, "A propos d'un dessin," 150.

9. Ibid., 148.

10. Drawings *Treurende moeder, Le cordonnier* (1887), and *Treurende moeder met twee kinderen* [cat. 100] were all shown at Les XX in 1891; the three were owned by Grégorie Le Roy.

11. See Lagye, "Le Salon des XX."

12. Champal, "Chez Les XX."

13. Verhaeren, "Aux XX." For a fuller discussion of the links between Minne and Gauguin, see Alhadeff, "Minne and Gauguin."

14. Vermeylen, "George Minne," 1. Influenced by the English Arts and Crafts movement, *Van Nu En Straks* was an appropriate repository for Minne's Pre-Raphaelite drawing; for *Van Nu en Straks* see Hammacher, *Van de Velde*, 113.

102
George Minne
Illustration for Maurice Maeterlinck's *Serres chaudes* (*Hot Houses*), 1889
Relief print
Private collection, Brasschaat
202 x 147

CLOCHES DE VERRE.

O cloches de verre!
Etranges plantes à jamais à l'abri!
Tandis que le vent agite nos sens au dehors!
Toute une vallée de l'âme à jamais immobile!
Et la tiédeur enclose vers midi!
Et les images entrevues à fleur du verre!

IN May 1889, Maurice Maeterlinck published his first anthology of poems, *Serres chaudes*, a collection of verse with a peculiarly Belgian symbolist aesthetic defined by specifically Flemish overtones.[1] Fascinated by Ghent's many greenhouses, the poet drew a parallel between the kind of life which thrives in the cloistered aura of the hothouse—a claustrophobic enclosure that rarifies and filters sensations while harboring forms of life that would die if exposed to the harsh light and climate of the outside world—and the ambitions he held for his own poetry and plays. Maeterlinck felt his verses and the works by his literary and artistic compatriots Grégoire Le Roy, Charles Van Lerberghe, Georges Rodenbach, and George Minne all cultivated a similar aesthetic that sought and nurtured seclusion and withdrawal.[2] Maeterlinck sought the claustrophobia of the enclosed, an atmosphere like that of the hothouse, asserting that such an enclosure nurtures life. Maeterlinck recalled many

years later that as a boy, "nothing seemed more agreeable to me, more mysterious than those shelters of glass where the power of the sun reigned."[3] Equating the sun with heat and heat with that which is enclosed, Maeterlinck developed a private lexicon which sought communion with that which is "tenebrous," enjoying the self to descend within oneself to experience untapped and unknown resources.

Three years prior to the publication of Maeterlinck's anthology Rodenbach, with keen insight, wrote that Ghent, with its doleful skies, forced the young Maeterlinck to perceive life through "the glass of a firmly shut *serre*" which "the poet had sealed himself in forever."[4] Van Lerberghe, who had been following Maeterlinck's progress for several years, suggested the title for the poetry anthology. The poems have a strong religious undercurrent, influenced by Maeterlinck's study in 1885 of the Medieval Flemish mystic, Jan van Ruysbroeck.[5]

Maeterlinck's anthology of 33 poems included a frontispiece of one of Minne's most important graphic images (see cat. 104, fig. F) and a quartet of smaller illustrations.[6] One of these was a small drawing for the poem "Cloches de verre," shown here. Immersed in the symbolist aesthetic, both Minne and Maeterlinck understood that imagery must work autonomously, whatever its genesis. In symbolism both words and images strive for independence, neither dependent upon the other for its content. Leo Van Puyvelde,

Minne's official biographer, observed that "even if an image by Minne has a given rapport with a text, it does not translate it, it only evokes the emotion the writer has aroused and enlarges it by analogies . . . which go beyond the words themselves."[7]

Minne's image for "Cloches de verre" evokes a mood of sullen quiet, the strange stillness and dulling atmosphere conjured by the words and repetitious lines of *Serres chaudes*. The small picture, executed in a simple linear style meant to resemble a medieval wood engraving, shows a female nude crawling on all fours through a field of lilies, her hair cascading before her face; in her right hand she wields a scythe which she languidly wraps around the base of a tall lily stalk. Her pose—strangely still—echoes her own dreary form and the dull rhythms of the few single lily stalks that surround her. Minne's nude might voice the line from the poem, "Ayez pitié de l'atmo- sphère enclose!" Only that which favors stillness and muteness, like the closed atmosphere of Maeter- linck's hothouses, can nurture life. Maeterlinck's strange world of fevered enclosures, hothouses pun- gent with stifling heat, is echoed in the torpor of Minne's figures. *Serres chaudes* and Minne's figures metaphorically link darkness, or that which has not yet surfaced, and enclosure with fecundity.[8]

Maeterlinck's verse says that only the *serre* puri- fies; all that which lies outside it is polluted and false. Maeterlinck's characters, more bodiless voices than figures, await cleansing, purification by "the rain and the snow and the wind."[9] Minne's figure for "Cloches de verre," as muted as the dull echoes of Maeterlinck's verse, denotes a sense of loss; but far from sapping life, this loss spawns life as it rejects the cacophony which lies outside the *serre*.[10] Maeterlinck and Minne value only that which is inside, that which has withdrawn, that which lies mute. But as Minne's figure clearly suggests, one can- not accept the sanctuary of the *serre* without paying the price of listlessness, of a gnawing certainty that one will "remain forever a spectator before a forbid- den world."[11] Minne's nude, like Maeterlinck's voice, neither requires nor benefits from definition, for defi- nition admits light, clarity which paradoxically obfuscates the symbolist search for the closed and fecund shadows of the *serre*.

—A.A.

printed on a hand-operated press. Maeterlinck's recollections on this subject: "Nous voilà donc, mes deux amis, Grégoire Le Roy et le futur grand sculpteur Georges Minnes [sic], et moi devenu typographes . . . Nous ne pouvions travailler que le soir et la nuit, la journée étant réservée aux clients sérieux": Maeterlinck, *Bulles Bleues*, 204.

7. Van Puyvelde, *George Minne*, 54.

8. In a letter of 15 February 1890, a few months after the publica- tion of *Serres chaudes*, Maeterlinck explains that he is seeking an "immediate communion with the unknown, a direct con- tact with the fecund shadows of life (*les ténèbres féconde*) and all that which is inexplicable but which is in man": see in Gorceix, *Maurice Maeterlinck*, 297.

9. From the last stanza of the opening poem, "Serre chaude": "Mon Dieu! mon Dieu! quand aurons-nous la pluie,/Et la niege at le vent dans la serre!/[My God! when shall we have the rain,/And the snow and the wind in the *serre* !]"

10. For an alternate reading of Maeterlinck's outlook, see Haerens, "Minne as Book Illustrator," 41–48.

11. Gorceix, *Le Symbolisme en Belgique*, 99.

1. For a study of *Serres chaudes* as an expression of Belgian sym- bolism, see Gorceix, "De la spécifité du Symbolisme Belge" and "Y a-t-il un Symbolisme belge?" *Serres chaudes* was pub- lished 31 May 1889 in a limited edition of 155; for a history of the publication of *Serres chaudes* see Warmoes, "La Jeunesse de Maeterlinck," 29.

2. As early as 1889, critic Emile Verhaeren compared Maeterlinck, Le Roy and Van Lerberghe to Robinson Crusoe stranded on an island not unlike the cloistered atmosphere of Ghent. Isolated, as the *serre* isolates the life within its walls, Maeterlinck and his confères from Ghent, wrote Verhaeren, are "constraints de s'emprisonner en eux-mêmes, oubliant l'ingrat dehors": Verhaeren, "Maurice Maeterlinck," 58.

3. Maeterlinck, *Bulles Bleues*, 203.

4. Rodenbach, "Trois nouveaux poètes," 319.

5. Maeterlinck's close ties to Charles Van Lerberghe and his admiration for the works of Van Ruysbroeck are discussed in Hanse, "De Ruysbroeck aux Serres chaudes," 75–129.

6. For Minne's illustrations for the anthology see Hoozee, ed., *George Minne*, 44 and 86. Minne was involved in every aspect of the production of Maeterlinck's book; a limited edition

103

George Minne
Cover for Gregoire Le Roy's *Mon coeur pleure d'autrefois*
(*My Heart Longs for Other Times*), 1889
Relief print
252 x 187
A. & L. Fontainas Collection

Gregoire le Roy

Minne's design shows a female nude, head bowed, seated upon a rock in a craggy, imaginary landscape.[1] Long tresses of unkempt hair cover her face and most of her upper body. Two large trees, trunks intertwined and roots exposed, spread their dense, fleecy foliage towards the figure. As with Minne's title page for Maurice Maeterlinck's *La Princesse Maleine*, most of the page is blank, with the field of the rectangular design occupying little more than the upper one-fifth of the page.[2] The title is justified on the right margin under the illustration. The hyphenation and step arrangement of the title heightens its decorative element.

Minne's career was launched in 1889 with his illustrations for *Mon coeur pleure d'autrefois*, *La Princesse Maleine*, and Maeterlinck's *Serres chaudes*

[cat. 102]. In addition to the cover, Minne made several illustrations for *Mon coeur pleure d'autrefois*.

Le Roy's poems have a cloistered aura, the verses haunted by mute sorrows. The anthology of tranquil, hermetic images, as critic Van Lerberghe noted, transports the reader by the poet's reveries rather than by concrete ideas. "M. Grégoire Le Roy . . . is above all an aristocratic poet. . . . His art is exclusive and hermetic . . . he has rid his verses . . . of social concerns, of goals, or of poses. And so there are no ideas in his verses; that is a given."[3] The poems neither evoke transient sentiments nor illustrate anecdote; they are elusive and allusive.

Minne's haunting image, though it accompanies Le Roy's poems, also echoes themes with which Minne had been concerned in his drawings and a sculpture of the previous year. Both a pen drawing, *Treurende moeder met twee kinderen* [cat. 100], and a plaster from that period represent a grieving mother clutching her children.[4] Though linked to these 1888 works, Minne's grieving figure for Le Roy's book is different in several ways. Whereas the earlier works emphasize the primordial bonds between mother and child, the nude in this work seems bereft of attachments. Also, the landscape is more elaborate than the stark, barren stones that are the setting for the others. This weeping figure grieves alongside a floating canopy of foliage while a chain of ridges, curiously echoing her nude form, plunges past behind her.

The muted wails of the grieving figure would be heard as plaintive, nostalgic notes played against the remembrances of childhood and lost loves.[5] Minne's grieving woman seems privy to certain remembrances, recollections that find an echo in Le Roy's verses, which are characterized by silent mourning. The melancholic verse addresses the poet as "ce mendiant d'ancien parfums," a wanderer who pursues the arcane and dolorous scents of past reveries.[6] Minne knew of these sensibilities which, according to Maurice Maeterlinck, were the special province of women.

In an 1891 essay in *La Jeune Belgique*, Maeterlinck posited that women are privy to certain knowledge inaccessible to males. Women, like children, wrote Maeterlinck, are the initiated for they respond to "les relations éternelles" that define life.[7] Men, however, are limited to the concrete and measurable; women see "in three spheres," in the inherent, multiple, and inexplicable variances between objects or situations. Thus, Maeterlinck concluded, "all [woman's] senses are mystical" and they know that which men will never know.[8] "There exists unplumbed *sous-entendus* between woman and death, for example. . . . There is an understanding which [men] are excluded from. . . . they [women] seem to know where they are going."[9]

Minne's grieving nude is such a woman. She need not fear, for death and nature are her companions. Communing with nature she is party to that which is hidden, that which "grows in darkness," which is both desirable and essential, according to Maeterlinck. Using botanical metaphors, Maeterlinck wrote, "large parts of the plant develop secretly, and it is only on exposing certain surfaces that we suddenly notice an abnormal growth, one we had never suspected; branches overwhelmed with fruit, others dry and lifeless."[10] Like the plant, woman "develops secretly," celebrating all that is unknown, concealed and capricious. Like Maeterlinck's plant, Minne's solemn nude harbors concealed, unplumbed truths. In an analogy of ostensibly contradictory statements, Maeterlinck maintained that whatever is above is dark; that which is below is "lighted" or informed. Woman's knowledge stems from her familiarity with "darkness" or "le noir" (black); woman thrives in "le noir," that which is below but which is truly illumined.

For Maeterlinck that which is below or without light is necessarily associated with the unknown or, as he termed it, "le Symbole." "A Symbol is Allegory, organic and interior; it has its roots in darkness. Allegory is Symbolism as exterior; it has its roots in light, but its peak is sterile and faded. Allegory is a large, dead tree; it poisons the countryside."[11] For Maeterlinck, light detracts while darkness fills all with life. The allegory tree, with its roots exposed to daylight, "poisons" all that surrounds it. Conversely, symbolism corresponds to the tree of life that plunges its roots deep into the earth and, "*ses racines dans les ténébres* (with its roots in darkness)," thrives. Alive in its subterranean probing, it rejects as sterile that which is bathed in daylight. Values are thus inverted: darkness furthers fertility, light sterility.

The parallels between Minne's figures and Maeterlinck's explanations give a different relevance to the weeping figure for Le Roy's book. Her *côté morne*, her dark side, becomes a source of light. As a fertile font of well being, she communes with "les relations éternelles." Minne's mourning figure seems to personify Maeterlinck's definition of "le Symbole," a figure that thrives in the dark. Her hair screens her eyes from light, shielding from her sight all that lies outside herself. Paradoxically, without light's poison, Minne's sorrowful nude withdraws and blooms. The crossed tree trunks create a similar image. A long root that winds from one tree toward the figure plunges deep into the ground and the darkness while waves of foliage rise from the trunks in tiers. The fleecy tufts nearly fill the space around her, forming a sort of platform on which her pensive thoughts float—thoughts which speak of prayer, recollections and longing for a "bonheur d'Autrefois."[12]

—A.A.

1. Le Roy's *Mon Coeur pleure d'Autrefois* (Paris, 1889) was printed in a limited edition of 200 copies; it includes a heliogravure frontispiece by Fernand Khnopff and five illustrations by George Minne.

2. *La Princesse Maleine* was published in August 1889 in a limited edition of 30 copies at the press of Louis Van Melle, Ghent.

3. Van Lerberghe, "Un poète Gantois," 162.

4. For the drawing and the plaster see Hoozee, ed., *George Minne*, 80 Pl. 18 and 82 Pl. 19. The sculpture was one of many entries Minne exhibited in 1890 with Les XX; the drawing, in the collection of Grégoire Le Roy, was shown in 1891: for facsimiles of Les XX catalogues, see Brussels: Centre International pour l'Étude du XIXe Siècle, *Dix expositions annuelles*.

5. Van Lerberghe similarly commented, "Ses vers aux sons plaintifs . . . nous donnent un égale nostalgie de bonheur, de passé doux et frêle, presque d'enfance.": Van Lerberghe, "Une poète gantois," 159. As early as 1886, in perhaps the earliest published appreciation of Le Roy's work, childhood was mentioned: "Vers de souvenirs d'enfance et de mélancolie où l'on croit retrouver un reste de chansons de nourrices!": Rodenbach, "Trois Nouveaux poètes," 318.

6. From "Misère," *Mon Coeur pleure d'Autrefois.*

7. "Une vieille femme est aussi jeune qu'un enfant Elle ne voit rien isolément. En tout objet, elle semble voir . . . les relations éternelles de l'objet, plus exactement que l'objet lui même.": Maeterlinck, "Menu Propos," 36–37.

8. Ibid., 37. Maeterlinck views men as limited and bound to what he calls "l'Intelligence," while women, as "mystical beings," are bound to the unplumbed or "black" depths of "Reason."

9. Ibid.

10. Maeterlinck, *Cahier Bleu*, 165.

11. Maeterlinck, "Menu Propos," 38.

12. "Ce bonheur d'autrefois domino le livre de M. Le Roy": Van Lerberghe, "Une poète gantois," 159.

104

George Minne
Heliogravure from *La Jeune Belgique*, IX of 1890
Collection of Albert Alhadeff
185 x 135

THIS illustration, drawn with exacting precision, recalls Minne's frontispiece, created the year before, for Maeterlinck's *Serres chaudes* [fig. G, see also cat. 102].[1] The two illustrations are certainly contemporary—one might even conclude that they treat the same subject, for the style, technique and mood are practically identical. The illustration for *La Jeune Belgique* shows a disquieting, frenetic landscape brimming with groping foliage, a host of lily pads more reminiscent of frail swans than plants, and Minne's own distinctive brand of weeping willows. These trees assume almost a human form, locked in step, each perched atop a pyramidal hillock, receding to some unseen horizon. A whirlpool radiates from the left center of the picture, creating the impression that the stream stands nearly parallel with the picture plane, adding to the general unease evoked by the picture. As in the *Serres chaudes* frontispiece, several prone, nearly lifeless bodies enveloped in black robes dot the landscape, only their limp, pallid hands and an occasional ashen face identifying them as human forms. The sky is delineated by dark horizontal marks and blank areas that suggest slivered clouds. In spite of the suggestion of a horizon stretching into the distance, the illustration evokes a leaden, claustrophobic atmosphere.

In the middle ground near the vortex of the whirlpool, two figures embrace. The upper figure, positioned in a near-hanging or crucified posture above the other, is all but ensnared in the hair-like foliage of the willow behind them. The figure looks down, face eclipsed by the figure below, who looks up and presses their flat, pale face to the other's left cheek. The lower body consists of nothing more than upswept curves, roundels suggesting either hair or the weird willow foliage.

Minne's illustration might have been intended for Maeterlinck's play, *La Princesse Maleine* (1889), a work for which Minne provided the image for the title page.[2] The play is a symbolist drama peopled with frail, mad, and morose characters; it is set in a castle where the unearthly lamentations of dispossessed beguines resonate through the empty corridors. In the bizarre tale the forces of nature personify roles as substantive as those of the protagonists. Wind, rain, and lightning, accompanied by the ghostly light of the moon—these and a seemingly endless host of weeping willows—are the companions of Princess Maleine and her lover, Prince Hjalmar. The description in Maeterlinck's play of the willows "weeping on [Maleine's] face" is echoed in the postures of Minne's embracing couple by the whirlpool.[3] The lower figure

FIGURE G. George Minne, frontispiece for Maurice Maeterlinck's *Serres Chaudes*, photogravure, 1890. Private collection, Brasschaat.

recalls Hjalmar and the upper figure, Maleine, imprisoned by the fronds which nearly encapsulate her invisible body. In the play one of the characters even equates Hjalmar with a weeping willow, a characterization that assigns him a poignant role in the drama and reinforces the identification of the figures in Minne's illustration with the play.[4]

One of the most telling scenes in the play (Act II, scene 6) is a love scene between Maleine and Hjalmar, set within a cluster of willows during the dead of the night. As he awaits Maleine's arrival, Hjalmar notes with great anxiety that he has never seen the woods so strange. Such nights, he concludes, presage ill, and indeed, before Maleine reaches the garden, Hjalmar is warned of her impending downfall by a sudden shower of branches from the mysterious willows.

Maleine fears the willows and senses that their fate mirrors her own. Locked in her chambers by the wicked Queen Anne, Maleine fears the traces the tree's shadows mark upon the walls of her room (Act IV, scene 3). And in Act IV, scene 4, Anne enters Maleine's cell to announce that a weeping willow has fallen into the castle moat of the castle, an event that Maleine understands as an augury of her own fate.

If one relates the mood and story of *La Princesse Maleine* to Minne's illustration, the two figures by the whirling water can be interpreted as clasped in a fatal embrace. Their long strands of hair cascade over their backs and shoulders, wrapping the two in an indissoluble whole.[5] Clinging to one another, they also cling to the tall willow from which they emerge. The tree is a swaying form with an unmistakable human presence. In unison with the other willows, it sways against the horizon like a nodding witness to the drama taking place. The willows seem to conjure the image of the beguines of Maeterlinck's play, the sentient and lachrymal beings who toward the end of *La Princesse Maleine* chant "Libera nos, Domine !," heartrending cries addressed to the doomed lovers of Maeterlinck's play.

—A.A.

1. The frontispiece was published in *La Jeune Belgique* IX (15 January 1890). For the *Serres chaudes* frontispiece see Hoozee, ed., *George Minne*, 44 fig. 12.

2. For Minne's title page see Hoozee, ed., *George Minne*, 88, pl. 22. *La Princesse Maleine* was first published in Ghent in 1889 in an edition of thirty with Minne's title page. A second edition was published in 1890 in an edition of 155 by Louis Van Melle, Ghent. For Maeterlinck's account of the publication of the various editions of *Serres chaudes* and *La Princesse Maleine*, see Maeterlinck, *Bulles Bleues*, 203–205. Maeterlinck ran short of money for the publication of *La Princesse Maleine* after borrowing from family members to publish *Serres chaudes*; one can only speculate that this shortfall may have caused him to omit this work, which may have been intended as an illustration.

3. For a discussion of this theory, see Alhadeff, "Minne: Maeterlinck's fin de siècle Illustrator," 12; Haerens, "George Minne," in Hoozee, ed., *George Minne*, 45; Pudles, *Belgian Symbolist Artists*, 206.

4. Maeterlinck, *La Princesse Maleine*, Act II, scene 4. "ce saule pleureur de Hjalmar": Maeterlinck, La Princesse Maleine, Act I, scene 4.

5. Minne's device of using hair as an element binding lovers together precedes even Maeterlinck's use of the theme, especially as Maeterlinck developed it in *Pelléas et Mélisande* (Brussels: 1892), in this play, Act III, scene 1, Pelleas cries in ecstasy as he finds himself covered with Mélisande's hair.

105

George Minne
Illustration for Maurice Maeterlinck's *Alladine et Palomides*, 1894
Relief print
Private collection, Brasschaat
164 x 111

IN 1894 Minne was asked by Maurice Maeterlinck to illustrate a limited edition of poems and Maeterlinck's classic *Trois Petits Drames*, which included *Alladine et Palomides*. In planning the first project, a collection of poems eventually published under the title *Douze Chansons*, Maeterlinck made clear to his editor that he envisioned "twenty songs each of which were to be adorned with an image by George Minne."[1] By the following winter the collection was reduced to twelve poems, but Maeterlinck was still determined to have Minne as his illustrator. In a letter of 8 January 1895, he wrote, "there shall probably appear an anthology of a dozen of my songs each of which shall be adorned with a wood engraving by an artist of talent though not at all well known and whom I dearly care for: George Minne."[2]

Although the project as initially outlined was never realized— *Douze chansons* was finally published in 1896 with illustrations by Charles Doudelet—Minne did provide illustrations for Maeterlinck's *Trois Petits Drames*, published in 1894.[3]

Minne's twentieth-century biographer, Leo van Puyvelde, sensed that with his illustrations for these three plays, "Minne [was] in direct communion with the ideas and sentiments of [Maeterlinck]."[4] However, defining Maeterlinck's theatre as "théâtre de personnages de rêve," Puyvelde correctly argued that Minne's illustrations for the plays are not commentaries on Maeterlinck's text. For example, what Minne has captured in this illustration for *Alladine et Palomides* is the profoundly sad and passive spirit that impregnates this short drama. What he has rendered is the spirit of the poet, whose spirit was just then also his own.[5]

The illustration for *Alladine et Palomides* shows a female figure seated upon a small outcrop of rock, her long hair enveloping a lamb who nestles in her lap, licking her face. She bends forward towards the animal, cradling her own face with her hands which also part her thick hair to reveal her eyes and brow. Behind the figure, a horizontal band of wavy lines stretches from one side of the tiny composition to the other, creating the impression that she is seated near turbulent waters by a castle's moat. The linear,

almost striped black and white technique of the drawing creates a vertiginous feeling, an unease matched by the tenor of the Maeterlinck's play itself.

Alladine et Palomide is a tear-drenched tale of lovers forever pursued by death. The plot is dominated by revenge, jealousy, and madness, and it takes place in settings characteristic of Maeterlinck's work: the dark corridors, chilly chambers, moats and shadowy caves of a mysterious castle. Alladine comes to the dark castle of King Ablamore from her home in Arcadia. Quiet and given to weeping, she is accompanied by a lamb "night and day" who, according to Alladine, "understands all that happens" (Act I, scene 1). Alladine resists the king's advances but falls in love with Palomides, a young prince betrothed to the king's daughter.

Artless and naive, Minne's image of Alladine weeping as her lamb reaches up to lick a tear from her face is as ingenuous as it is elusive.6 Behind Alladine the rising and falling scalloped waves seem to suggest, as outlined in of Maeterlinck's drama, "dark waters which descend from the mountains and which churn against the [castle's] walls before heading out to sea."6

These dark, angry waters soon engulf Alladine's clairvoyant lamb, presaging Alladine's and Palomides' fate. Ablomore discovers Alladine's attachment for Palomides and in his jealousy binds her hands and mouth with her long hair (Act II, scene 2). Though Alladine is freed by Palomides, her will to live has been driven from her. Only tears, Palomides observes, form the remainder of Alladine's presence. Noting that she weeps while speaking, Alladine answers Palomides cryptically, "No, I have wept long; these are no longer tears."7 Maeterlinck's Alladine is but an expression of grief; a long, nebulous lament never to be plumbed. Focusing on Alladine's tears, Minne's illustration—Alladine's own closed silhouette suggesting the shape of a tear—captures the disoriented grief that defines Maeterlinck's play. As Minne conceived her, Alladine is inaccessible. She lies beyond reach on her flat mound, high above the waters, her hair veiling her body and that of her loving lamb. Her long hair screens her, confirming her remoteness to all who remain forever fascinated by her lachrymal self.—A.A.

1. Hermans, *Maurice Maeterlinck*, 65.

2. Ibid., 66.

3. For Minne's illustrations for *Trois petits drames* see Hoozee, ed., *George Minne*, 101 pl. 35.

4. Van Puyvelde, *George Minne*, 54.

5. Ibid.

6. Maeterlinck, *Alladine et Palomides*, Act II, scene 2.

7. Maeterlinck, *Alladine et Palomides*, Act IV.

8. Puyvelde's reading of the illustration is similar: "Elle pleure, et un brébis couchée près d'elle semble la consoler. Sa chevelure se répand sur le corps en ondulations lourdes et tristes et le murmure des vagues de la mer fait écho à la plainte de son âme." Van Puyvelde, *George Minne*, 54.

106

George Minne
Illustration for Emile Verhaeren's *Les Villages illusoires (Illusive Villages)*, 1895
Relief print
Private collection, Brasschaat
190 x 140

Wɪᴛʜ his series of illustrations for Maeterlinck's *Trois petits drames* completed, Minne began another set of four illustrations for Emile Verhaeren's *Les Villages illusoires*.[1] A note from the printer to Verhaeren provides *a terminus post quem* of 19 December 1894 for the works. Expressing great delight, the card reads, "I've finally received Minne's fourth *cul de lampe*: it is marvelous. I don't think Minne has ever done as well except, perhaps for his illustration for *Van Nu en Straks.*"[2]

Verhaeren's anthology of poems of rural life focuses on the lives of ordinary men and women brought low by death, sordid vice, and unspeakable crimes. Favoring a recherché rather than a naturalist vocabulary, Stephan Mallarmé found *Les Villages illusoires* an uncanny achievement. Verhaeren's poems, wrote Mallarmé, speak of a "primal silence . . . to be heard with a multitude of voices (though one is reading it alone); such are their infinite voices!"[3]

Unfortunately, Mallarmé's laudatory note does not mention Minne's illustrations, although one cannot help but wonder if Minne's illustrations might not have helped to spur Mallarmé's encomium. At least one critic equated Verhaeren's peculiar

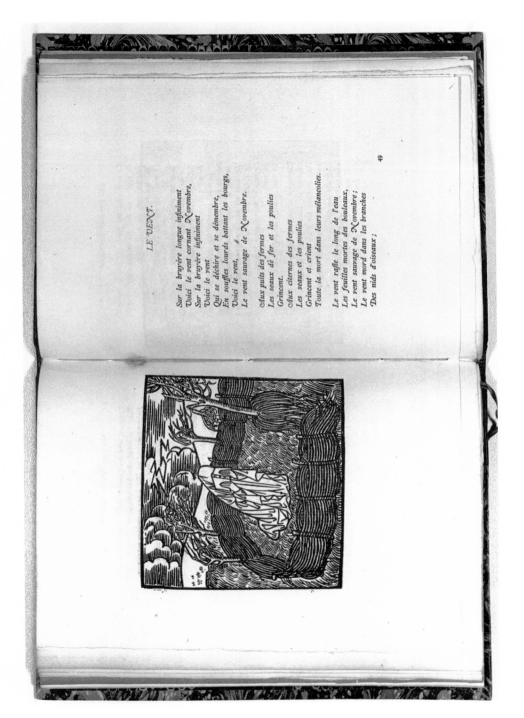

verse with Minne's equally peculiar images. Reviewing *Les Villages illusoires*, the critic wrote:

It makes little sense to reproach the artist [i.e. Verhaeren] for not following the cold and rigid lines of a school which created masterpieces in the past, but which, as with everything, applied to a given generation but not to another.

Are we about to reproach certain of our sculptors not having followed the rules of antiquity and are we to condemn George Minne, for example, for his obsessive creations ? His images have perhaps as much an effect on us as the most beautifully realized sentiments. And before such conclusions, shared by many others, why vituperate and reproach Emile Verhaeren for employing certain free rhythms.[4]

Minne's illustration for Verhaeren's poem *Le Vent* captures the primal silence that so affected Mallarmé. It conveys the unnerving tone of Verhaeren's poem with different, but similar imagery. Instead of the bucket and pulley grinding in a well that suggest death and its melancholy in the poem, a hooded figure—perhaps a Beguine in habit—kneels quietly on a grassy slope inside a wattle fence and buries her face in an open book. Bare, gnarled, wind-swept broken-branched trees surround her; above, tumultuous, lightning-filled skies rage. Before this searing image, one can all but hear Verhaeren's "cries of death in all their melancholy."

Though the figure sits in the eye of a storm, her robes are unruffled and she remains disconcertingly still. She seems to protect herself with the open book, holding it before her face as though it were a sacred icon. The pose of silent reverence suggests fifteenth-century images of the Virgin Mary kneeling on a grassy slope, surrounded by a wattle fence, adoring her newborn. Paralleling many of those images that picture the Virgin's silent acknowledgement of her son's fate, Minne's Beguine, her presence and behavior otherwise inexplicable, mutely acknowledges death's advent as delivered on Verhaeren's "dismembered" winds. The illustration casts a menacing chill. Though the figure's book is open, it is closed to the viewer. Knowledge, like the trees surrounding Minne's Beguine, is uprooted, fractured, and in its stead, to paraphrase Verhaeren, are the melancholic cries of death. Minne's figure remains poignantly inaccessible, like so many of his other figures, a frail "feuille morte" (dead leaf) before harsh winter winds.[5] —A.A.

1. *Les Villages Illusoires* was first published on 10 January 1895. For Minne's illustrations see Hoozee, ed., *George Minne*, 103 pl. 38.

2. The note is among the author's papers, Fonds Verhaeren, Brussels: Bibliothèque Royale Albert 1er.

3. From a note dated February 1895 in the Fonds Verhaeren, Brussels: Bibliothèque Royale Albert 1er. See Paris: Bibliothèque Nationale, *Verhaeren*, no.36; de Poncheville, *Vie de Verhaeren*, 324.

4. As quoted from an undated newspaper clipping in the files of the Fonds Verhaeren, Brussels: Bibliothèque Royale Albert 1er; both the name of the newspaper and the date of the clipping are missing, the review is signed "Roussel."

5. The image of fallen leaves in the November wind is found in Verhaeren's *Le Vent*: "Le vent raffle le long de l'eau/Les feuilles mortes des bouleaux,/Le vent sauvage de Novembre"

107

George Minne
Study for *Le Petit Agenouillé (The Small Kneeling Youth)*, 1896
Pencil on paper
Collection of Albert Alhadeff
255 x 195

THIS is one of Minne's few extant finished drawings of the 1890s; a study for a sculpture in marble of the same name.[1] The sculpture, also dated 1896, is the first of a series known as *les agenouillés*. The finely shaded pencil study is of a partially robed kneeling figure, head turned and pointed downwards towards its left. The figure's long, tapering arms and even longer hands are arranged in a self-embracing gesture. It is flanked by two smaller, yet similarly posed figures. One echoes the larger in gesture and dress, the other is nude, its neck craned in an acute angle, face turned towards the viewer. The sketch of a face with deep-set eye at the base of the larger figure's feet appears unrelated thematically to the trio of kneeling figures.

This page of drawings was once part of a sketchbook.[2] One of the richest collections of work in Minne's inventory, the sketchbook dates from Minne's study during the winter of 1895–1896 at the Académie Royale des Beaux-Arts in Brussels. His stay was especially productive, though marred by his eventual dismissal. According to his biographer, Puyvelde, students who were angered by administrative decisions organized protests; siding with the protesters, Minne quarrelled with the administration. Out of favor with the registrar, he was asked to leave—which proved especially painful for him, a married man and father of four children who needed the security the school offered.[3]

Though Minne's time at the academy was brief, it allowed him to develop his now-famous type of figure, *l'agenouillé*, the kneeling, nude youth. And though Minne had previously fashioned similar kneeling figures of a sort, the figures he developed in

the mid-nineties differ from earlier figures such as *L'homme et femme agenouillé* and *Saint Jean Baptiste*.[4] The figure of *l'agenouillé* is always nude and male; he crosses and locks his elbow against his chest. As this drawing demonstrates, one hand rests on the nape of the neck, the other on the upper part of his engaged arm. Above all, these nudes are defined by their quiescent manner. They are mute, withdrawn and introspective. Restraint and submission define their pose, a pose which from 1895 to 1899 Minne would define and redefine until it became his shibboleth.

In this example, the central figure seems poignantly vulnerable. Artless and without guile he kneels, protected neither by age nor experience. Figuratively, if not literally, he is unaware of his own body, for this body, as Minne conceived it, is not a functioning mechanism but an abstract entity that can only answer the call of the divine, what Maurice Maeterlinck called "l'infini."

In an 1896 essay, Maeterlinck expounded on this divine call; he wrote of "divine remembrances," recollections awakened by unobtrusive visions, "[a silent] tear, the slight gesture of a virgin, a falling drop of water," or a barely perceptible movement, a hand lying on the nape of a neck or resting gently on a forearm.[5] "Claps of thunder," wrote Maeterlinck, "are unnecessary to step, more or less, out of oneself and to stop, if only for a moment, on the doorstep of eternity."[6]

Minne's *agenouillé* stands still, as he must in order to hear the "tears" which sill awaken his spirit. To borrow Maeterlinck's imagery, Minne's *agenouillé* kneels on "the doorstep of eternity," a mute witness to his own "divine remembrances."[7]

—A.A.

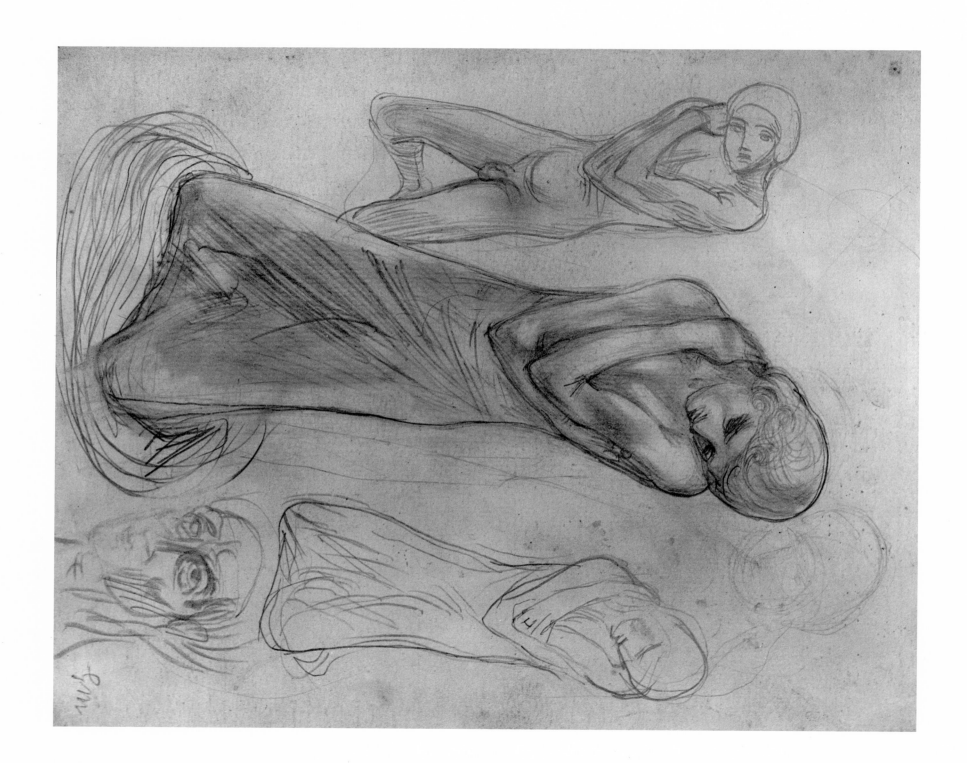

5. Observing that man does not need to be "shaken" in order to know the infinite, Maeterlinck wrote, "Le sage . . . regarde une larme, le geste d'une vierge, une goutte d'eau qui tombe; il écoute une penseé qui passe, presse la main d'un frère. . . . Il peut voir sans cesse ce que nous n'avez entrevu qu'un instant." Maeterlinck, *Le trésor des humbles*, 229–30.

6. Ibid., 230.

7. "les souvenirs divins qui dorment en nous": Ibid., 229.

1. The sculpture is cat. 53 in Hoozee, ed., *George Minne*, 118.

2. For the Ghent Sketchbook, see cat. 39 in Hoozee, ed., *George Minne*, 105. The sketchbook is in the collection of the Musée des Beaux Arts, Ghent.

3. The events leading up to Minne's dismissal are related in detail in Puyvelde, *George Minne*, 23; recently discovered documents confirm the same in its essentials. See also Brussels: MRBA, *Académie Royale*, 361–62, especially n8.

4. For *L'homme et femme agenouillé* and *Saint Jean Baptiste* see Hoozee, ed., *George Minne*, 90 pl. 26 and 47 pl. 48.

108

Armand Rassenfosse
Tête de hiercheuse (*Head of a Haulage Woman*), ca. 1891
Charcoal with brown and pink pastel
Musée d'Ixelles, Octave Maus 161
319 x 249

INSCRIBED at lower right in brown pastel:
à Octave Maus / A Rassenfosse

Depictions of *hiercheuses* are among Rassenfosse's most important works. Of these images, the undated drawing of the *Tête de hiercheuse* is unique. Whereas in most of his works on paper, the impact of his mentor Félicien Rops is clearly felt, here Rassenfosse experimented with the drawing techniques developed by neo-impressionist artists such as Georges Seurat. Rassenfosse saw the drawings Seurat exhibited at Les XX exhibitions in 1889 and 1891.[1]

Tête de hiercheuse provides parallels with a number of Belgian and French artists involved with the neo-impressionist and symbolist styles. It remains stylistically closest to Seurat's drawings, yet also shares affinities with Fernand Khnopff's pastels and Odilon Redon's mysterious illustrations, particularly in the dark background from which the figure's profile emerges. While Rassenfosse's works on paper often were in pastel hues and had a clearly recognizable setting for his figures, this almost-monochromatic drawing in charcoal, with highlights of ochre, brown and pink pastel, achieves both the neo-impressionist graphic touch and the suggestive character of symbolist art. In its association of the avant-gardist styles of neo-impressionism and symbolism with the political concerns and working class subjects of *l'art social*, Rassenfosse's work illustrates a response typical of the Liège artists.

—S.L.

1. Seurat's impact on Belgian artists came almost immediately on the heels of his installation of *Sunday Afternoon on the Island of the Grande-Jatte* [Art Institute of Chicago] at the 1887 exhibition. In 1889 the artist showed three drawings: *M. Paul Alexis, Au Concert Européen,* and *À la Gaîté Rochechouart.* At the memorial installation of Seurat's work at the 1891 Les XX exhibition, some ten drawings were exhibited to great acclaim.

109

Armand Rassenfosse
Le Baiser du porion / L'Amour en Pays Noir (The Foreman's Kiss / Love in the Black Country), 1892
Etching in brown ink, hand-colored
Museum of Fine Arts, Boston, Bequest of William Babcock, by exchange, M21693
191 x 127
Rouir 695

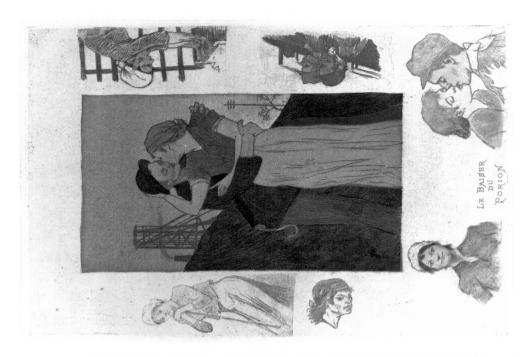

LIKE many of his contemporaries, Rassenfosse created a large number of images of the Belgian working class. Such images were quite popular in the closing years of the nineteenth century, in part because they presented a specifically Belgian subject, and in part because the enlightened art-going public was particularly interested in this social subject. Rassenfosse excelled in representations of *hiercheuses* (haulage women), both at rest and at work [cat. 108 and 110]. Unlike many of his colleagues, including his fellow Liégeois, Marissiaux, Rassenfosse usually presented his female laborers not in the middle of the strenuous physical exertions needed to push the coal wagons, but as denizens of the industrial landscape. Thus *Le Baiser du porion* is typical of Rassenfosse's prints of working-class Liège.

Artist Félicien Rops influenced Rassenfosse and this etching was created when Rops' influence on the younger artist was at its peak. Both Rops and Rassenfosse often experimented with the formal impact of their works by including the remarques (marginal sketches) in their completed prints (see cat. 122). These often form a commentary on the central image. For instance, in this etching the remarques include the tasks performed by the woman in hauling and shoveling coal, her likenesses, a second image of the embrace, and two men on their way to work.

Rouir has noted that Rassenfosse worked on at least three versions of the embracing couple between 1889 and its completion and publication date of 1892.[1] A dark *terril* or slag heap, scaffolding, and elevator—details that are ever-present in coal-mining landscapes—form the backdrop to the embracing couple.

That they are merely taking a short break from their labors is indicated by the hook that hangs from his banderolle, the smoking chimney, and their garb.—S.L.

1. Rouir, *Rassenfosse*, 685 no. 682. The definitive print was published by Pinceborde, Paris, in 1892.

110

Armand Rassenfosse
Hiercheuse (Haulage Woman), 1905
Soft-ground and drypoint
247 x 177
National Gallery of Art, Washington, Rosenwald Collection, 1951.10.386
Rouir 159

THROUGHOUT the turn of the century, the labor laws were being changed, particularly to protect the increasing numbers of women and children involved in heavy industry. Until the last decade of the nineteenth century, women worked alongside men in the mines. In 1889, however, it became illegal for women under the age of 21 to work underground.[1] Women continued to be employed in the mines in the Liège industrial basin and the regions known as *Pays Noir* (the Black Country) and the Borinage, although as *hiercheuses* and coal sorters.[2] As haulage women, they pushed the coal-filled carts from the mouths of the mines to the processing areas (see Levine essay, fig. 18).

For Belgian artists such as Constantin Meunier, who rendered the dignity of the working class, depictions of the young haulage women often were meant to symbolize all types of female heavy labor, since their work was among the most strenuous. Other artists, including in this instance Rassenfosse, depicted *hiercheuses* as promiscuous.[3] In this etching he depicts the worker in a moment of idleness. Seated on what is probably a slag heap, the woman confronts her beholder with a straightforward and inviting gaze, suggesting her sexual availability. Rassenfosse's depiction of her in this manner references the governmental discussions of promiscuity among young workers in the industrial regions. Haulage women often were seen as industry's counterpart to the urban prostitute (see Levine essay this catalogue, 67–69, and compare cat. 114 and 121).

—S.L.

1. Following the 1886 strikes throughout the industrial regions of Belgium, the government enacted a series of laws protecting the labor population. In 1889 children under the age of 12 were forbidden from working in the mines and women were granted a four week maternity leave. For an analysis of the transformation of the labor laws in Belgium as they pertained to women, see Dumont Walgrave, "La Femme belge," and Müller, "Frauenarbeit in Belgien."

2. Like many of his contemporaries, Rassenfosse used the Walloon pronunciation and spelling '*hiercheuse*' instead of the French orthography '*hercheuse*'; Another phonetic translitera-tion used during the late nineteenth century was '*hertcheûs*'; see Haust, *La Houillère Liégeoise*, 117–118.

3. Many Belgian artists depicted female industrial workers, including Constantin Meunier, Gustave Marissiaux, François Maréchal, Léon Frédéric and Cécile Douard.

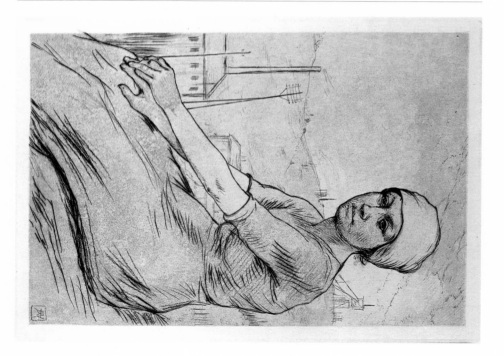

111

Félicien Rops
La Planche à l'arbre (The Etched Plate with the Tree),
ca. 1871
Soft-ground, aquatint, and drypoint on laid paper
Private collection
187 x 141
Exsteens 655 i/iii, Rouir 707 i/iii

112

Félicien Rops
La Planche à l'arbre (The Etched Plate with the Tree),
ca. 1871
Soft ground, aquatint, and drypoint on laid paper
Private collection
187 x 141
Exsteens 655 ii/iii, Rouir 707 ii/iii

LA PLANCHE À L'ARBRE is one of the experimental plates that Rops called "les pédagogiques" or pedagogical pieces.[1] Rops apparently used these plates as teaching aids when he was giving etching lessons around 1870–72. At this time he was still living at Thozée (his father-in-law's estate) and he was involved with the founding of the International Etching Society.[2] Rops explained these plates in a letter of 4 April 1878:

Since one can not always use new plates one is content to varnish in an inverted manner and to bite with acid across everything. Sometimes this gives unexpected and amusing results. I am writing this to you so that you can inform the public. My dear Maurice, regarding these ridiculous and grotesque Pédagogiques; they are of interest because of their playful spirit and their incomprehensible insanities. I am sure that those at

Thozée were never printed due to the lack of a press and the climate (they served to give lessons to my country neighbors - both men and women!)[3]

La Planche à l'arbre is covered with a variety of trials. In some cases these are simply patches where a particular mordant or ground has been applied, in others Rops has sketched in a variety of figures and the lovely tree that gives the plate its name. Many of these trials have been labeled in the plate so that the artist and his students can see which ground or mordant yielded which results. For example, "Seymour" refers to a ground used by Seymour Hayden, "Cire" to a wax ground, "Perchl." to perchloric acid, and "No. 5" to one of Rops' soft-ground recipes.[4] In the second state of the plate, two figures have been added at the lower left.

—S.G.

1. Rouir, *Rops. Les Techniques de gravure*, 17.

2. See Goddard essay, 77–78, this catalogue.

3. Rouir, *Rops. Les Techniques de gravure*, 17, letter to Maurice Bonvoisin (BR–ML, cote 3270–16):

"Comme on ne pouvait pas toujours se servir de planches neuves on se contentait de vernir en sens inverse et l'on fait mordre à travers tout. Ce qui donnait quelque fois des choses inattendues et les plus drôles. Je t'écris ceci pour que tu éclaires le public. Mon cher Maurice, à l'égard de ces ridicules et grotesques *Pédagogiques*, mais qui sont intéressantes à cause de leur esprit de folie et d'insanités incompréhensibles. Je suis certain que dans celles de Thozée jamais tirées à cause du manque de presse à cette époque (elles servaient à donner des leçons à mes voisins et voisines de campagne!) et à cette latitude."

4. Many of these are described fully in Rops' notebook, *Omnia artistique*, published by André Guyaux; Guyaux, *"Rops: Omnia artistique,"* 86 for the recipe for No. 5.

113

Félicien Rops
La Vieille masken, servante Anversoise (The Old Antwerp Servant), 1874–75
Heliogravure, drypoint and aquatint
Spencer Museum of Art, Letha Churchill Walker Memorial Art Fund, 89.54
150 x 122
Exsteens 273, Rouir 566

THIS print was published in the journal *L'Artiste* in April 1886. In a letter dated 20 April 1881 to Théodore Hannon, the founder of *L'Artiste*, Rops identifies the subject of this print as a type based on the elderly women servants that worked at the brothels in Antwerp.[1] Rops provides a narrative to accompany the image:

Rigid under her old hat the old woman(masken) stands on the threshold of the old house waiting for the suppliers and twenty years of probity, this is the austere figure of duty completed. Entering, she smiles softly and in her respectable voice cries into the stairway: 'Virginia this is a man who does not seem debauched!'[2]

Many of Rops' prints that deal with prostitution can be understood in the context of late nineteenth-century images of women as *femmes fatale*. Rops often portrays prostitutes, in prints such as *Mors syphilitica* [cat. 114], as bearers of disease and death, who with their wiles lead their victims to an untimely and painful end. However, in *La Vieille masken*, Rops shows us another side of prostitution and presents a sympathetic study of an elderly woman. Throughout his career, Rops created a number of prints that were studies of various types of elderly women. Among these are *La Vieille au chapelet* (Exsteens 265) and *Vieille Flamande* (Exsteens 204).

La Vieille masken is a significant print in Rops's oeuvre in terms of technique. It is an example of his use of the heliogravure process with which he and his followers, Armand Rassenfosse and Louis Moreels, experimented.[3] After the image was photomechanically etched onto the plate, the plate was further

worked in dry point and aquatint. The print is the first product of Rops's collaboration with the printer Léon Evely, who in the winter of 1874–75 became his heliogravure technician.[4]

—B.N.

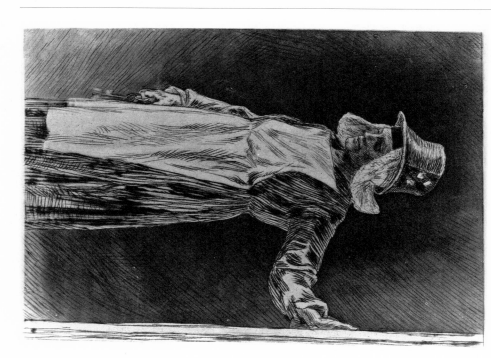

1. Hannon (1851–1916) was a good friend of Rops and a Belgian painter, printmaker, poet, and composer. He founded *L'Artiste* in 1875.

2. The hat is a variation of a *barada*, a hat type native to Liège; see Haust, *Dictionnaire Liégeois*, 63. Zéno, *Les Muses sataniques de Félicien Rops*, 114: "Rigide sous son vieux chapeau La vieille Masken, debout sur le seuil de la vieille maison attend les fournisseurs et vingt ans de

probité, c'est la figure austère du devoir accompli. Entrons, elle sourit doucement et de sa voix respectable crie dans l'escalier: Virginie c'est un Monsieur qui a l'air d'être pas un crapuleux!"

3. For Rops's use of photogravure see Kunel, "Rops et l'École de gravure" and Rouir, *Rops. Les Techniques de Gravure*, 19–26.

4. Rouir, *Rops. Les Techniques de Gravure*, 20.

114

Félicien Rops
Mors syphilitica (Syphilitic Death), ca. 1875
Drypoint, retouched with colored pencil
Musée royal de Mariemont
222 × 165
Exsteens 353 i/ii, Rouir 818

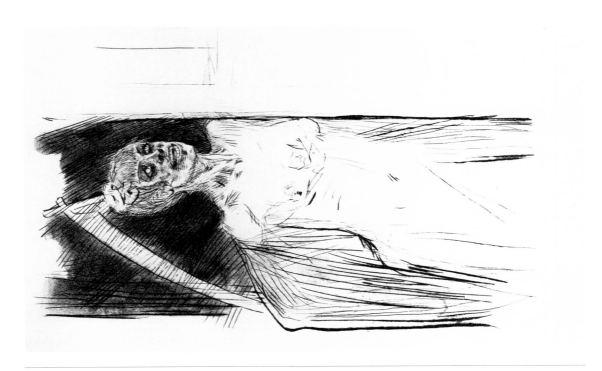

N OWHERE are the Nymphs of the pavé to be seen in greater force than on the Boulevards. As soon as the lamps are lit, they come pouring through the passages, and the adjacent rues, an uninterrupted stream, until past midnight. . . . Only glance at one of these creatures, and you will be entrapped in a moment unless you have the moral courage to resist.[1]

Rops' fascination with the modern world found its most eloquent and sometimes vicious expression in his numerous representations of prostitutes, whom he often depicted as the spreaders of syphilis.[2] *Mors Syphilitica* was created when new laws were being enacted to regulate cleanliness and the types of prostitution allowed in France and Belgium.[3] Depicted by both academic and avant-garde artists, the figure of the prostitute became a contentious example of urban modernity in that she often was viewed as a product of that environment while remaining on the margins of "proper" society.[4]

Rops' prostitute, set in a doorway with her face partially in shadow, invites prospective clients into the potential dangers of paid sex. At first glance, she may seem quite attractive in a slinky dress that hugs her curves and reveals her breasts.[5] (Rops added pink highlights to her nipples, lips, cheeks, and the flower in her hair). Unlike her fleshy counterpart in *Pornokrates* [cat. 121], who remains in the full blush of good health and who might be called the muse of sexual love, this more seasoned prostitute embodies a sexually-transmitted disease. Her face is skeletal and her association with the "grim reaper" is evoked by the scythe in the shadows behind her.[6]

—S.L.

1. *Paris After Dark: Night Guide for Gentlemen*, 13 ed., Paris, ca. 1870, as translated in Clayson, *Prostitution*, 93.

2. For comparison, see Rops' *La Mort qui danse*, ca. 1875; *Le Ridyck*, ca. 1865; *Au Coin de la Rue*, ca. 1881.

3. For a detailed history of the changing status of the prostitute in France, see Corbin, *Prostitution and Sexuality in France after 1850*, and Schaepdrijver, "Regulated Prostitution in Brussels." At least once, Rops portrayed a prostitute being cleansed of her diseases; see Rops' gouache *La Douche périnéale* from his series "Cent légers croquis sans prétentions pour réjouis les honnêtes gens," ca. 1878, in Brussels: Musée d'Ixelles, *Rops et la Modernité*, cat. 49.

4. For more on French representations of prostitutes, see Clark, *Paris in the Age of Manet*, esp. chap. 2, "Olympia's Choice"; Lipton, *Degas: Women and Modern Life*; Clayson, *Prostitution in French Art*; and Kendall and Pollock, eds., *Degas: Representations of Women*.

5. In a letter of 1878 written to Noilly, patron of the *Cent Croquis*, Rops wrote, "One must never draw a classical nude but the nude of today. One must not draw the breast of the Venus de Milo but the breast of Tata, which is less beautiful but is the breast of today": cited by Arwas, *Félicien Rops*, 7.

6. Rops often represented modern woman as providing a link between love (eros) and death (thanatos). For a recent discussion of this theme in art and literature, see Showalter, *Sexual Anarchy*.

115

Félicien Rops
La Chrysalide, 1876
Etching, drypoint, pen, and ink
Spencer Museum of Art, Elmer F. Pierson Fund, 91.4
233 x 115
Exsteens 601, Rouir 865 ii/ii

Tʜɪs etching was designed for the invitation to the 4 November 1876 opening of the first exhibition of the Brussels art exhibition society, La Chrysalide. It depicts the rise of the group and its coming triumph over conservative art. This proof is the second and final state of the etching; the text is handwritten by the artist and varies slightly from the printed version.

Rops depicts the demise of academic painting by showing the sarcophagus of "Pictura Academica" in decay, surrounded by spider webs and a caterpillar feasting on "La Chronique Artistique," a generic conservative art column. The new order of regeneration that La Chrysalide symbolizes is represented by the fluttering butterflies. After its gestation as La Chrysalide—the chrysalis—Belgian art will be liberated from the stranglehold of the academy and burst forth as a dazzling new creation.

La Chrysalide was one of several alternative art societies in Belgium that preceded Les XX and struggled against the conservative art establishment. It was patterned after the progressive La Société Libre des Beaux-Arts, to which Rops also belonged, and served as a prototype for the later group, L'Essor.

—J.B.

116

Félicien Rops
La Grève (The Strike, alternate titles: La Carbonière or La Charbonnière, The Coal Woman), 1876
Etching
Los Angeles County Museum of Art, Gift of Michael G. Wilson, M80.277.62
190 x 140
Exsteens 343 v/vii Rouir 758

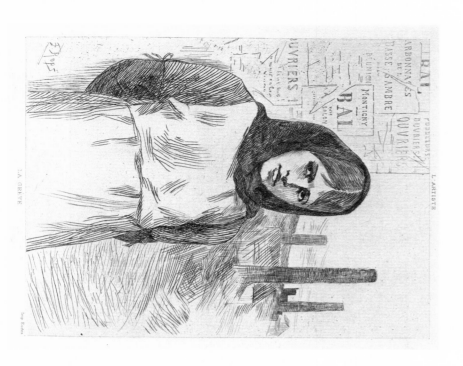

EACH time Félicien Rops installed works at the Les XX exhibitions, almost without exception, his objects became *succès de scandals.* Typical of the etchings and lithographs he submitted are his better-known pornographic and satanic works, such as the *Temptation of Saint Anthony* (exhibited 1884), *Pornokrates* (1886, cat. 121), or the *Diaboliques* (1889). At the final Les XX exhibition in 1893, however, Rops installed his largest group of works, including a rendering of the first state of *La Grève.*[1] As was the case with many of the graphics Rops sent to Les XX, *La Grève* had been conceived long before the XX came into existence. Rops had drawn the work in 1876 when he visited the collieries at Frameries, located in

the valley of the Basse-Sambre.[2] The exhibited work is the fifth and penultimate state. It was published by Eudes in the December 1885 issue of *L'Artiste.*[3]

In many of his works Rops gendered his images to correspond with the masculine or feminine nouns of the title.[4] In contrast to Meunier [cat. 97] and Maréchal [cat. 86], who depicted strike scenes peopled by male workers, Rops envisaged the strike, a feminine noun, quite literally here. Garbed in a typical industrial costume, his female striker wears a bandana, jumper, and the heavy gloves worn for handling coal. The posters contain a series of calls to action by workers at the coal mines of the Basse Sambre and an announcement for a ball at Montigny.

—S.L.

1. The first state was done in an edition of three: Rops, *Notes pour Hippert*, MI 3270/1 no. 58.

2. Rops, *Notes pour Hippert*, MI 3270/1 no. 54. I thank Eugène Rouir for providing me with this information. The Frameries collieries also were rendered on innumerable occasions by Constantin Meunier and other Belgian artists.

3. Founded in 1875 by Victor Reding, the journal *L'Artiste* published realist and naturalist works of literature and art. Théo Hannon became its editor in 1877. For a survey of literary journals devoted to contemporary subjects, see Juin, "Des écrivains belges."

4. As Edith Hoffmann has demonstrated in "Iconography of Rops," this is one of the many reasons that Rops's images of death and modernity comprise female subjects.

117

Félicien Rops
Le Pendu dans la forge (The Hanged Man in the Forge), ca. 1880
Study for frontispiece for Théo Hannon, *Rimes de joie*, 2nd ed.
Charcoal heightened in white gouache
The Cleveland Museum of Art, Gift of Louise S. Richards, 86.111
209 x 124

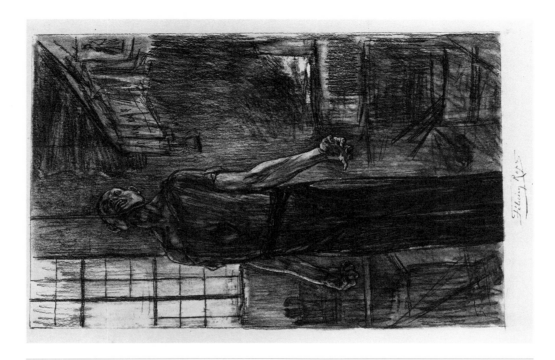

THÉO HANNON was one of the handful of literary figures closely allied to Les XX. Early in his career he was an etcher and watercolorist. Hannon was friends with James Ensor from their youth and he introduced Ensor to the Rousseau family.[1] Hannon also worked for the theater and founded the periodical *L'Artiste*.

Rimes de joie, a collection of poems, has been called his masterpiece in which "he rivaled with virtuosity his inspiration and model . . . Félicien Rops."[2] *Rimes de joie* was published in 1881 with a frontispiece and three etchings by Rops. Rops also designed a small poster announcing the book.[3]

Rops based *Le Pendu* on his 1878 drawing of a love-sick carpenter who had hung himself.[4] This drawing was altered to portray a blacksmith rather than a carpenter and was used by Brussels publisher Henry Kistemaeckers in several books, apparently without Rops' consent. It first appeared as an illustration for L.-A. Cladel's *Six morceaux de littérature* of 1880.[5] In 1883 Kistemaeckers published a second edition of *Rimes de joie* with *Le pendu dans la forge* as the new frontispiece.[6] The exhibited drawing served as the basis for a photogravure that was reworked by Rops in drypoint as it appeared in both Cladels' and Hannon's books. As it appears in *Rimes de joie* the image illustrates the first poem, "Corde sensible," whose title puns on the possible meanings "sympathetic chord" and "tangible hangman's rope."
—S.G.

1. Lesko, *James Ensor*, 30.

2. De Seyn, *Écrivains Belges*, 960–61. No source is given for the quote; "son oeuvre maîtresse: *Rimes de joie*, 'où il rivalise de virtuosité avec son inspirateur et son modèle, le peintre, graveur et dessinateur Félicien Rops.'"

3. For the poster see Rouir, *Rops. Les Techniques de gravure*, 61 no. 124.

4. Rouir, *Rops, Catalogue raisonné*, no. 697, gives this information from a letter from Rops to Hannon.

5. Rouier, *Rops, Catalogue raisonné*, no. 697 indicates that L.-A. Cladel's book of 1880 made use of the third state of Rops' retouched heliogravure, while Hannon's book of 1883 reproduces the second state.

 Baudet, *Henry Kistemaeckers*, 121, gives the following from a letter of 1893 from Rops to Hannon: "Je t'en ai voulu longtemps à cause de la saleté bête que tu avais laissé faire à ce polisson de Tristemacaire, qui avait mis, en tête de ton volume, *Le Pendu* que je lui avais 'donné' pour le livre de Cladel. Aujourd'hui, j'ai oublié cette sottise, ou plutôt cette petite lâcheté, que tu pouvais empêcher."

6. For Kistemaeckers see Canning essay this catalogue, 32.

118

Félicien Rops
Satan semant l'ivraie, Les Sataniques (Satan Sowing Tares, The Satanic Ones), 1882
Heliogravure reworked with softground
240 x 162
Los Angeles County Museum of Art, Gift of Michael G. Wilson, M.84.243.187
Exsteens 783, Rouir 927 iii or iv/iv

Rops described his plan to create an illustrated book on "The Satanic Ones" as early as 1878–79. It was to include twelve illustrations and texts on a modern woman's infatuation with and devotion to the devil (see also cat. 119).[1] Though the book was never completed, Rops produced five of the prints in two editions between 1882 and 1895.[2]

The first image in the series was *Satan Sowing the Tares*; Rops had painted this subject in 1867. It is a modernized, demonic version of the Biblical parable of the sower: "While men slept, his enemy came and sowed tares among the wheat" [Matthew 13:25] and "The field is the world; the good seed are the children of the Kingdom; but the tares are the children of the Wicked one" [Matthew 13:38]. In the painting, Satan spreads the seeds of evil over a rural environment,

however, in this heliogravure Rops transformed the field into the city of Paris. Rops' interpretation is written on some of his proofs:

Terrible and gigantic, dressed like a peasant, SATAN, the biblical Sower passes over, in great strides, the regions inhabited by men. At this moment, under a pale moonlight, he crosses Paris. His right foot is poised on the towers of Notre Dame. With a powerful gesture, he tosses the WOMEN who fill his floating apron, the disastrous seeds of crime and human despair. And, under the large brim of his Breton hat, he stares with an evil joy.[3]

By having Satan disperse miniature females to wreak havoc on the unwitting inhabitants of the modern city, Rops suggests it is women who are the cause of evil.[4]

—R.H. and S.L.

1. Two letters provide some of Rops' conception of this series. The first, from ca. 1878–79, is to an unknown recipient, BR-ML 3091–8, cited in Rouir, Rops, *Catalogue raisonné*: "Mon cher frérot, je t'envoie mes deux 'Sataniques.' Il faut absolument que cette affaire se fasse. Le grand livre saisissant, le grand livre de nudité et d'écorché, n'est pas fait. Nous devons le faire, nos esprits s'entendent . . . J'achèverai les planches à la roulette et au vernis mou ce qui leur ôterait tout aspect de photogravure et notre livre se trouvera fait. Nous aurons créé un le livre le plus extraordinaire du siècle. On pourra le mettre a n'importe quel prix, il se vendra. Avec deux couleurs on peut déjà faire une chose saisissante." The second, to Théo Hannon, 8 January 1883, as reproduced in Rouir, Rops, *Catalogue raisonné*, 117, reads in part: "Quant aux Sataniques, c'est une série de douze planches qui, à ce que je crois, sont ce qu'on avait fait de plus cruel dans le genre."

2. The series includes, in addition to *Satan semant l'ivraie*, *L'Enlèvement, L'Idole* [cat. 119], *Le Sacrifice*, and *Le Calvaire*.

3. "Terrible et gigantesque vêtu comme un paysan, SATAN, le semeur Biblique, passe à grandes enjambées pas dessus les contrées habitées par les hommes. En ce moment, sous un clair de lune blafard, is traverse Paris. Son pied droit se pose sur les tours de Notre-Dame. D'un geste puissant il jette à travers les espaces les FEMMES qui remplissent son tablier flottant, graines funnestes des crimes et de désespoirs humains. Et sous les larges bords de son chapeau breton, son regard étincelle d'une joie malfaisante."

4. Rops concludes his undated letter, BR-ML 3091–8, cited in Rouir, Rops, *Catalogue raisonné*, 117: "Enfin le livre doit prouver aux . . . futures que nous avions le mépris des fausses femmes de notre temps et que nous savions nous foutre de notre époque!"

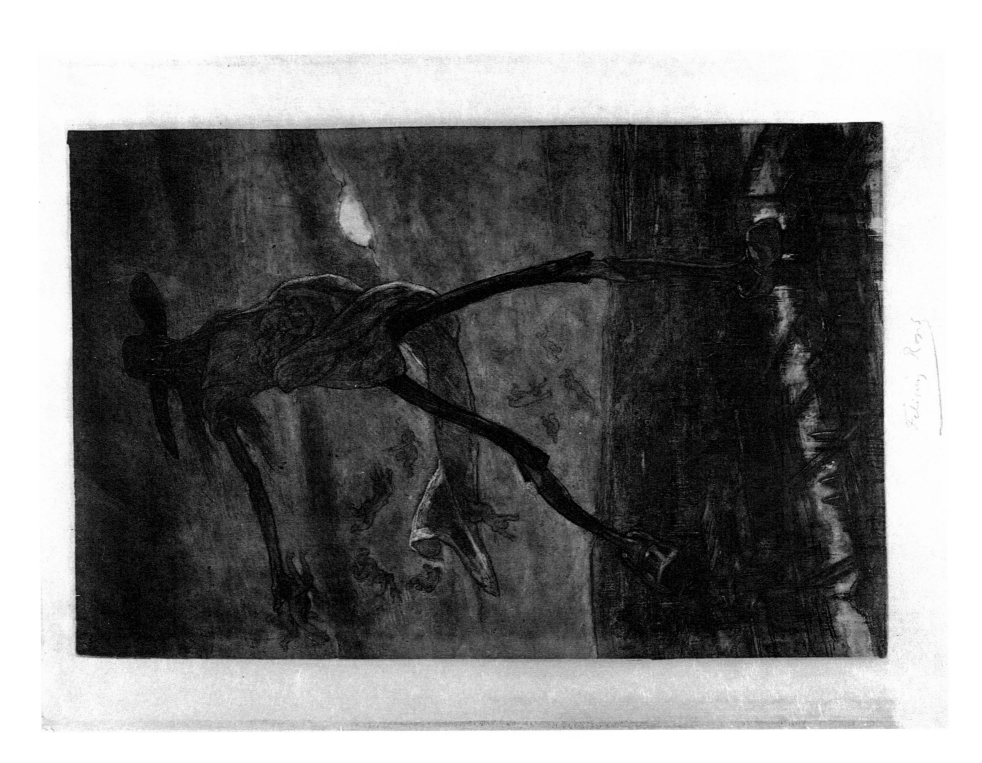

119

Félicien Rops
L'Idol, Les Sataniques (The Idol, The Satanic Ones), 1882
Heliogravure reworked with softground
Los Angeles County Museum of Art, Gift of Michael G. Wilson, M84.243.188
241 x 165
Exsteens 785, Rouir 933 iii/iii

ONCE characterized as a "painter who paints phalluses the way others paint landscapes," Rops' reputation today as a perverse artist derives from his many images of Satanic worship and different forms of sexual practice.[1] As at least one of his contemporary reviewers suggested, however, Rops' idea was not to create "little erotic scenes made for the delectation of old rakes. It is a profound, terrifying, entirely spiritual vision of the damnation of guilty flesh."[2]

Les Sataniques, a series on which the artist began working in 1878–79, was intended to present a "poem on the possession of woman by the devil."[3] *L'Idole* is the third of five extant images from this group. In it Rops depicted a diabolical version of Saint Theresa's religious ecstasy, in which the devotee has impaled herself on a grimacing statue of Satan.[4] The artist vividly described the scene:

Initiated into the infernal mysteries, the Woman entered into the peristyle of the Great Temple, where the troubling statue of the Master stands erect. In a superb burst of passion, the possessed one throws herself onto the impassive Idol and relieves herself, crazed and subjugated. It is a fact, the Woman belongs to Satan! Two phallic lamps supported by infantile and rudimentary beings lugubriously light the scene. At the bottom, an elephant-like being, product of infernal "zoocreations," guards the sanctuary while impregnating himself with his own trunk.[5]

Rops rendered the "damnation of guilty flesh" as muse-like in *Pornokrates* [cat. 122], as mortally dangerous in *Mors Syphilitica* [cat. 114], and other times as demonic. Each of his female types raise issues about sexual imagery that continue to be debated. Given the utter self-irony in his voluminous correspondence and his well-known flouting of the conventional family, *L'Idole* probably is best read with tongue firmly in cheek.[6]

In at least one letter written about this series, Rops clarified his idea that the woman descending into satanism was "une bourgeoise, [the] false wom[a]n of our era."[7] As he did on many other occasions, Rops here pillories the hypocrisy of bourgeois convention. In an era when middle-class women were to remain virtuous, Rops presents a woman who is neither virtuous nor circumspect in her sexual desires. She is naked, save for her expensive high heels, and clinging to the object of her desire. Rops distorts that object of desire by including the gargantuan phallic lamps that simultaneously contain masculine and feminine sexual attributes. Thus, while *L'Idole*, on one hand, might form a kind of passion play intended not to delight "old rakes" but to instruct them, it also makes fun of their prurient desires.[8]

—S.L.

1. "Peintre de phallus comme d'autres sont peintres de paysages": (author unknown, perhaps Félix Fénéon) *Petit Bottin des Lettres et des Arts*, 1886, as cited in Brussels: MRBA, *Félicien Rops*, 59 and 249. Leo van Maris recently discussed Rops' satanic and erotic imagery within a literary and psychoanalytic context, see van Maris, *Félicien Rops*, 15–50.

2. *Journal de Bruxelles*, 22 June 1890, as translated in Arwas, "Félicien Rops," 10. Joris Karl Huysmans similarly came to the artist's defence by suggesting that Rops did not set out to titillate, but to draw attention to evil. In a letter to Rops on *Pornokrates*, Edmond Picard wrote: "Hélas! excellent ami, il faut vous résigner; pour le *vulgum pecus*, inhabile à démêler votre art puissant et cruel, vous risquiez fort de n'être jamais qu'un pornagraphe. (Alas, excellent friend, you must resign yourself: for the *vulgum pecus*, unfit to disentangle your powerful and cruel art, you risk being seen as nothing more than a pornographer.)": cited in Lemonnier, *Félicien Rops*, 168.

3. "ce poème de la possession de la femme par le diable": cited in Delevoy et. al., *Félicien Rops*, 163.

4. Huysmans described this scene as "une Thérèse diabolique, d'une sainte satanisée (a diabolical Theresa, a satanized saint)": Huysmans, *L'Art moderne*, 354–55. Rops previously had explored the sexual nature of Saint Theresa's ecstasy in *Thérèse Philosophe* (1868). Other examples of Rops' sexual pairing of a woman with a statue include *Confidences I* and the final image from *The Satanic Ones, Le Calvaire* (1882).

5. Rops' description of the scene is on some of the proofs of the extant prints: "Initiée aux mystères inferenaux, La FEMME est entrée dans le péristyle du Grand Temple, où se dresse la troublante statute du MAITRE. Dans un superbe élan de passion la possédée se jette à corps perdu sur l'Idole impassible et se livre, affolée et subjuguée. C'en est fait, la FEMME appartient à SATAN! Deux lampadaire phalliques éclairent lugubrement la scène, soutenus par des monstres enfantins et rudimentaires. Au bas un être éléphantine, issus des zoocreations infernales, garde le sanctuaire et de sa trompe se féconde lui-même, formidablement."

6. Rops left his wife Charlotte during the 1870s to live with Léontine Duluc (with whom he had a daughter Claire, who later married Eugène Demolder) and her sister Aurélie for almost thirty years. Their voluminous correspondence suggests they found domestic harmony in this *ménage à trois*.

7. Rouir, *Rops: Catalogue raisonné*, 117, BR-ML 3091–8.

8. Rops did not think of himself as a pornographic artist. When asked by a journalist who was writing a book on pornographic artists for permission to include him, Rops replied "I thank you for your intention but if, as you believe, I have ever made some smutty drawings, it is precisely in hatred of this public of which you speak, and in order to lower my buttocks to the level of its face.": Mirbeau, "Félicien Rops," as translated in Arwas, *Félicien Rops*, 7.

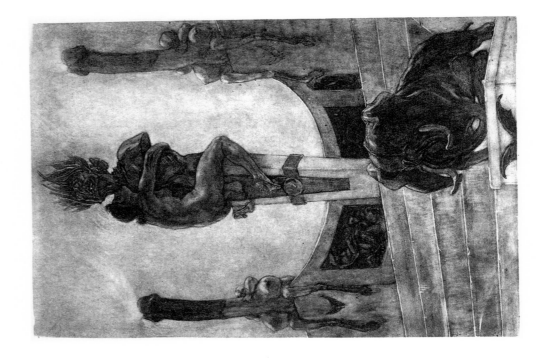

120

Félicien Rops
Le Vice suprême II (The Supreme Vice II), 1884
Heliogravure
Private collection
285 x 198
Exsteens 364

I N calling him "the unique master of the frontispiece," author J.K. Huysmans acknowledged Rops' preeminence in the field of literary illustration. From the 1860s until he died in 1898, Rops produced a large number of illustrations for works by authors who form a pantheon of turn-of-the-century literature, including Charles Baudelaire, Stéphane Mallarmé [cat. 122], Jules Barbey d'Aurevilly, Charles De Coster [cat. 117], Paul Verlaine, Théophile Gauthier, and Sâr Josephin Péladan.[1]

During the 1880s, Rops formed a close working relationship with Péladan.[2] *Le Vice Suprême* was designed in 1884 as the frontispiece for the first volume of Péladan's series on the decline of western civilization, *La Décadence latine*.[3] Depicting a modern Parisian couple dressed for a stroll along the boulevards of Paris, Rops' etching underscores the historical precedent for the decadence of modern life. With top hat and head in hand, the gentleman gallantly presents his female companion, who emerges coquettishly from her coffin, complete with fan and crinoline skirt. The pedestal relief on which they stand refers to the mythical founders of Rome, but in typical Ropsian irony, the artist also depicts the she-wolf and her two sons, Romulus and Remus, in an emaciated, skeletal state.

—R.H. and S.L.

1. Rops' frontispieces and illustrations include those for Baudelaire's *Les Epaves*, 1866; Barbey d'Aurevilly's *Les Diaboliques*, 1879; Théo Hannon's *Rimes de joie*, 1881; Villiers de l'Isle-Adam's *Akédisséri-l*, 1886; and Paul Verlaine's *Chair*, 1896. For a list of Rops' illustrations, see Delevoy et. al., *Félicien Rops*, 308–310.

2. Péladan's respect for Rops was such that he once wrote, "Between Puvis de Chavannes, the harmonious one, and Gustave Moreaus, the subtle one, Félicien Rops, the intense

one, closes the Kabbalistic triangle of great art": Péladan, "Les Maîtres contamporains," as translated in Arwas, *Félicien Rops*, 8. Rops created frontispieces for four more volumes of Péladan's series *La Décadence Latine: Femmes honnêtes*, 1885; *Curieuse!*, 1886; *L'Initiation sentimentale*, 1887; and A *Coeur perdu*, 1888.

3. Péladan's text, *Le Vice suprême, Etudes passionnelles de décadence*, Paris: Librairie des Auteurs modernes, 1884, was published with a preface by Barbey d'Aurevilly.

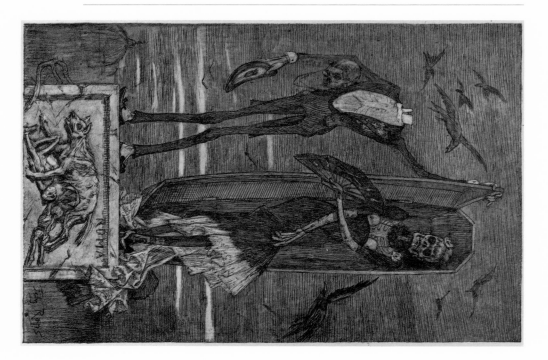

121

Félicien Rops
Pornokrates, after 1878
Heliogravure reworked with soft-ground, hand-colored
Private collection
385 x 279
Exsteens 435, Rouir 969 ii/ii

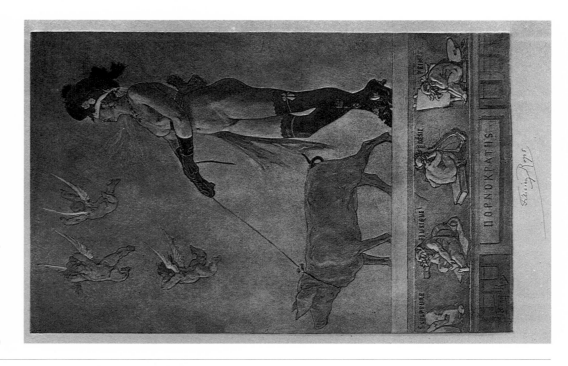

F ROM the 1870s on, Félicien Rops spent much of his time in Paris where, he often said, the effects of modernity were most readily apparent.[1] For Rops, modernity was best expressed in the figure of woman, whether she was *une bourgeoise* dressed in high fashion or a lowly streetwalker. While "real" prostitutes often were linked with the spread of disease [cat. 114], idealized prostitutes, who might be mistaken for their wealthier urban sisters, formed the inspiration for art.

The 1878 watercolor of *Pornokrates* was the scandalous success of the 1886 Les XX exhibition and solidified Rops' growing reputation as a pornographic artist.[2] Although Rops provided it with a Greek title, he has changed the figure's status from that of an ancient muse of love to a modern goddess of sex.[3] A letter written to the poet Henri Liesse in January 1879 provides the means for understanding this work:

I had the opportunity to see and kiss the black silk stockings with red flowers of a young girl whose lover is in Monaco. I placed her nude like a goddess, I had her wear long black gloves on these long beautiful hands that I clasped for three years, and on top, I coiffed her hair like those in Gainsboroughs, in black velours ornamented with gold, which gives the girls of our era the insolent dignity of women of the seventeenth century; and so, my *Pornocrate* is finished. The drawing pleases me. I want to show you this beautiful nude girl, shod, gloved and coiffed in black, silk, skin and velours, her eyes blindfolded, walking on a marble frieze, led by a pig with a 'golden tail' in front of a blue sky. Three loves [Cupids]—the ancient loves—disappear crying. . . . I made this in four days in a blue satin salon, in an overheated apartment, filled with odors, where the opopanax and cyclamen gave me a small fever beneficial to the production and to the reproduction.[4]

Depicting a young Parisian woman of indeterminate economic status, Rops presents a provocative vision of modern woman. She is naked rather than nude, realistically rendered rather than demurely sensuous. Love has no place in the modern world; even the ancient Cupids leave in tears. Blindfolded and located

atop a parapet, she haughtily walks a pig, an emblem of filth and temptation. Were it not for her brazen nakedness, she might be mistaken for a proper middle-class woman walking a well-bred dog. Adorned with the accoutrements of her trade (black hose, gloves, hat and jewelry), she parades not on the boulevards that were the streetwalkers' domain, but above the weeping personifications of the arts—suggesting that the modern prostitute is truly the new muse of the arts. —S.L.

1. An inveterate letter writer, Rops often recorded in them his opinions on the importance of modernity for artists. "Quand je dis qu'un peintre doit être de son temps, je crois qu'il doit peindre surtout le caractère, le sentiment moral, les passions et l'impression psychologique de ce temps [When I say that a painter must be of his time, I believe that he must above all else paint the character, the moral sentiment, the passions and the psychological impression of the time]": letter to Edmond Picard, 18 March 1878, as cited in Delevoy et. al., *Félicien Rops*, 137. A few years later, Rops said of the modern urban experience, "Je pourrais mettre 'j'ai vu' sur les machines que je fais. J'ai vue cela dans un restaurant des Champs-Elysées.' Je connais presque toutes mes femmes et les fais poser dans des toilettes pour arriver à plus de vérité. Je suis fous de la vie moderne, tu le sais, et je crois que, lorsqu'on veut la peindre, il faut venir dans les endroits où elle se manifeste avec le plus d'intensité: à Londre ou à Paris [I could put 'I've seen' on the works I make. 'I've seen this in an restaurant on the Champs Elysées.' I know almost all of my women and have them pose in their toilettes in order to arrive at the greatest reality. I'm crazy about modern life, you know this, and I believe that, if one wants to paint it, one has to be in the places where it [modernity] manifests itself with the greatest intensity: in London or Paris]": undated letter, ca. 1879, to Henri Liesse, as cited in Delevoy et. al., *Félicien Rops*, 146–147]).

2. Rops already had shocked his audience at the first Les XX installation with his watercolor of *The Temptation of Saint Anthony*. Both watercolors belonged to Edmond Picard.

3. For a discussion of the versions Rops made of this image, see de Sadeleer, ed., *Félicien Rops*, auction of 15 December 1990, lot 36.

4. "J'ai eu l'occasion de voir et de baiser les bas de soie noire à fleurs rouges d'une belle fille dont l'amant est à Monaco. Je l'ai mise nue comme une déesse, j'ai ganté de longs gants noirs ces belles mains longues que j'embrasse depuis trois ans, et là-dessus je l'ai coiffée d'un de ces grands gainsborough en velours noir, orné d'or, qui donnent aux filles de notre époque la dignité insolente des femmes du dix-septième siècle; et voilà ma Pornocrate est faite. Ce dessin me ravit. Je voudrais te faire voire cette belle fille *nue* chaussée, gantée et coiffée de noir, soie, peau et velours, et, les yeux bandées, se promenant sur une frise de marbre, conduite par un cochon à "queue d'or" à travers un ciel bleu. Trois amours—les amours anciens—disparaissent en pleurant. . . . J'ai fait cela en quatre jours dans un salon satin bleu, où l'opopanax et le cyclamen me donnaient une petite fièvre salutaire à la production et même à la reproduction": letter to Liesse, January 1879, as cited in Delevoy, et. al., *Félicien Rops*, 144–145.

122

Félicien Rops
La Lyre (The Lyre), 1887
Heliogravure and drypoint (central image); drypoint (border subjects)
Private collection
228 x 158
Exsteens 526 vi/vi, Rouir 822 iv/vi

DURING his career Rops created more than 100 illustrations and frontispieces for the publications of the most important poets and novelists of his generation, including Stéphane Mallarmé. The central image of *La Lyre* was the frontispiece for the first edition of Mallarmé's *Les Poésies* in 1887.[1] The following year a proof of this print was Rops' only work in the Les XX exhibition.[2] As Emile Verhaeren described it,

"a muse, sitting amongst the clouds on a haloed chair featuring a glowing question-mark back, holding up a superb and slender lyre from which the strings play *ad astra*. Two real hands make them resonate, while other agitated skeletal structured fingers fly around uselessly and powerlessly. On the socle at the bottom, the skulls of academicians and prize winners are haphazardly piled. The muse uses them as a foot rest."[3]

One of Rops' most patently symbolist prints, *La Lyre* visually evokes the sonority of music and its verbal equivalent in poetry. At the same time, the image iterates one of Mallarmé's favorite themes. It presents the elevated status of the misunderstood poet (Orpheus/Muse) who, having no audience in modern society, directs his music/poetry toward the infinite.

When Belgian publisher Edmond Deman decided to issue a new edition of Mallarmé's collection in 1891, the poet was enthusiastic about reprinting Rops' image, "We already have the magnificent Rops . . . an absolute masterpiece and *my real frontispiece*."[4] In August 1894, Rops agreed to let Deman republish the print only if he could rework it.[5]

Though the books contain only the central image of the lyre-playing muse, Rops' deluxe heliogravure edition, reworked in dry point and soft-ground etching, includes six margin figures. The rupture between the otherworldliness of the central image and its earthy counterpoints in the margins links it to the symbolist aesthetic in which suggestion, rather than description, is the goal.

—S.L.

1. The frontispiece was photomechanically reproduced for the book, which was originally published in an edition of 40 by *La Revue Indépendante*, Paris.

2. For the 1888 Les XX catalogue, each artist designed his or her own page. Rops' page contains an image of a lawyer and the text: "Félicien Rops Paris 21 Rue de Grammont/—*La Grande Lyre*/Frontispice pour les oeuvres de/Stéphane Mallarmé/(Appartient à Mr. Bennett)/Vous ne croirez si vous voulez, mais j'ai vu d'anciens forcats & même quelques vieux avocats qui avaient l'ai de parfaits honnêtes gens/FR/Croyez vous qu'un honnête homme ne préfererait pas avoir affaire à un routier, comme Dugueslin ou le connétable de Bourbon que ce Monsieur ci-dessus?": as reproduced in Brussels: Centre international pour l'étude de XIXe Siècle, *Dix expositions annuelles*, 154.

3. "Une muse, assise dans les nuages sur un siège à dossier figurant un point d'interrogation nimbé, dresse une lyre svelte et superbe dont les cordes filent *ad astra*. Deux mains réelles les font résoner, tandis que d'autres ossatures de doigts affolés volent inutiles autour et impuissants. Au bas, sur un socle s'entassent pêle-mêle des crânes d'académiciens et de lauréats. La muse pose les pieds dessus": Verhaeren, "Salon des XX," reprinted in *La Plume/Rops*, 443.

4. "Nous recourons au magnifique Rops . . . en tant qu'absolu chef-d'oeuvre et *mon vrai frontispice*": cited in Fontainas and Fontainas, "Edmond Deman," 513.

5. Rops' 1887 print, in addition to appearing in the *Revue Indépendante* edition, also was sold as an independent work. Rops made clear in a letter that to be fair to his earlier clients he would need to rework the image so it would be a different work; see Delevoy et. al., *Félicien Rops*, 232. The Deman edition was published in an edition of 150 with a title page designed by Théo van Rysselberghe.

123

Paul Signac
Au temps d'harmonie (In Times of Harmony), 1895–96
Lithograph
Sterling and Francine Clark Art Institute, 1967.18
376 x 502
Kornfeld & Wick 14

J EAN GRAVE published the first issue of his anarchist journal *Les Temps nouveaux* (*New Times*) on 4 May 1895; it remained in circulation until 1914.[1] It contained articles on a wide variety of topics, including anarchism and other political theory, to provide its readership with a firm basis in libertarian ideas and action. Each issue also contained a literary supplement.[2] *Les Temps nouveaux*, along with other, shorter-lived French anarchist publications such as Emile Pouget's *La Sociale* and *Le Père Peinard*, published the

images of a large number of artists who were sympathetic to the idea of *l'art social*. Like Pouget, Grave firmly believed that art could transform society by critiquing present conditions and by creating a vocabulary for depicting a better world in the future. In addition to Signac, Meunier and van Rysselberghe, painters and graphic artists including Camille and Lucien Pissarro, Maximilien Luce, Théophile Alexandre Steinlen, Frantisek Kupka, and Henri-Edmond Cross all provided images for *Les Temps nouveaux*.[3]

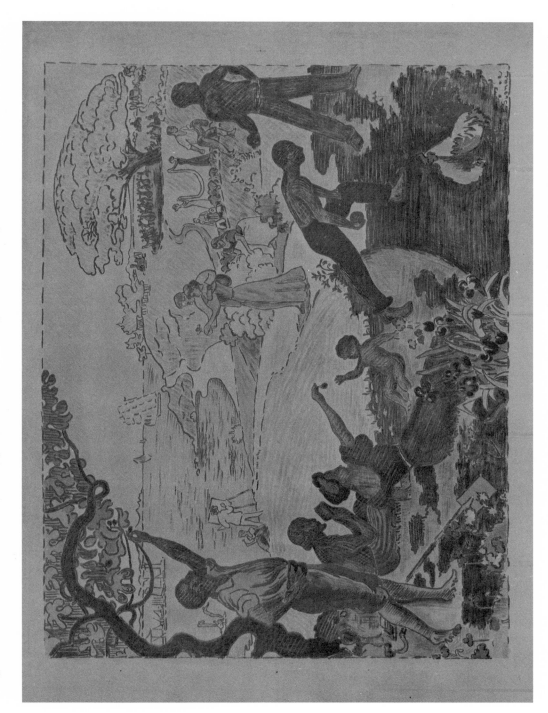

Although Signac did not believe an anarchist artist necessarily created anarchist art, his lithograph *Au Temps d'harmonie* depicts a new world order based on a classless society.[4] Derived from his monumental painting of the same title (now in the Mairie de Montreuil), the lithograph originally was created for, but subsequently deleted from, Grave's portfolio of thirty prints produced between 1896 and 1903 to benefit the journal.[5] The theme of this work was suggested to Signac by the phrase from militant anarchist Charles Malato, "The Golden Age is not in the past, it is in the future."[6] It presents a liberated populace at the sea shore partaking in wholesome familial recreation: fishing, picking fruit, playing *boules*, and dancing.

As Nochlin has suggested, Signac's utopian representation is in sharp contrast to his friend and fellow neo-impressionist George Seurat's vision of contemporary society in *Sunday Afternoon on the Island of the Grande Jatte* (1884–1886, Art Institute of Chicago).[7] Whereas Seurat located his painting within the cultural context of contemporary Parisian society, Signac's pastoral setting is less specific. Although recalling the arcadian tradition of Ingres and Puvis de Chavannes, Signac's seashore scene neither looks to the past nor idealizes it. Rather, as the contemporary clothing suggests, Signac's Golden Age is in the near future.

Unlike Seurat's image of a stratified society whose artificial pursuit of leisure is underscored by the stiffness of the strolling Parisians, Signac's groups freely mix, their relaxed and curving forms accentuating a harmonious union with each other and nature.

Signac's figures pursue leisure at the same time that they also produce culture, as embodied by the man painting and the group dancing in the background. Also in this utopia, leisure is envisioned to include a ship, train and factories, all signifying labor. Seurat gave preference to leisure over labor by placing the factories across the river from the Island of the Grande Jatte and focusing his painting on the promenade of the middle class. In Signac's utopia, however, leisure and labor are not antithetical but in balance. Moreover, while Seurat's figures remain aloof and self-absorbed, Signac's embrace and touch one another in a visual embodiment of the idea of free love. By incorporating these references to free love along with the representation of the union of labor and leisure in a rural setting at peace with nature, Signac thus presents in *Au Temps d'harmonie* the anarchist vision of a social utopia as articulated in the writings of Peter Kropotkin and Jean Grave.[8]

Although Signac presents here an image that embodies radical social theory, he chose to represent this ideology in a traditional manner. Indeed, even though the artist had employed a divisionist technique in his paintings since the middle of the 1880s, he did not use it for the prints he contributed to *Les Temps nouveaux*. This choice of a simplified and rather straightforward approach in *Au Temps d'harmonie* may indicate Signac's agreement with the didactic purpose of the journal and his desire to create within this context both a positive and recognizable image of a future anarchist society.

—S.L. and S.C.

1. According to Aline Dardel, the journal maintained a weekly circulation of 7,000 copies; "*Les Temps Nouveaux*," 5, 9, 39.

2. The literary collaborators of *TN* announced in the first issue, included such politically-engaged writers as Georges Eeckhoud, Octave Mirbeau, and the brothers Elie and Elisée Reclus. In addition, Grave published excerpts from the writings of the Russian anarchist theorist Peter Kropotkin.

3. For a complete list of artists associated with *TN*, see Bonafous-Murat, *Ouvriers et paysans*, and Dardel, *Les Temps nouveaux*.

4. In 1902, Signac clarified his thoughts on anarchism and art: "Justice en sociologie, harmonie en art: même chose. . . . Le peintre anarchiste n'est pas celui qui représentera des tableaux anarchistes, mais celui qui, sans souci de lucre, sans désir de récompense, luttera de tout son individualité contre les conventions bourgeoises et officel–les par un apport personel"; as cited in Herbert and Herbert, "Pissarro, Signac and Others," 9.

5. Signac decided that the printed version was not successful and pulled it from the series. He provided Grave with a large number of other works, including *Les Démolisseurs* (1896), and illustrations for issues in 1902 and 1906. In addition, he donated works raffled in 1899, 1900, 1901, 1908 and 1912. For further details on Signac's involvement with *TN*, see Dardel, *Les Temps nouveaux*, 45; Herbert and Herbert, "Pissarro, Signac and Others"; Hutton, "Science, Art, and Anarchism in the Neo-Impressionist Movement."

The history of the painting is equally interesting. In 1896, Signac exhibited the painting in Brussels at La Libre Esthétique. He hoped to find a permanent home for this monumental work (3x4 metres) at the Maison du Peuple in Brussels. After a series of negotiations, the Brussels membership declined Signac's painting. It remained in the artist's collection and was sold by his wife in 1938 to the Mairie de Montreuil.

6. In a letter to Cross, Signac refers to "Une phrase de Malato" (*Revue Anarchiste*)"l'âge d'or n'est pas dans le passé, il est dans l'avenir' pourrit être inscrite sur le cartel du futur tableau"; as cited in Herbert and Herbert, "Pissarro, Signac and Others," 9.

7. Nochlin, "Seurat's *Grande Jatte*," 139–142.

8. This interpretation of Signac's print is drawn from Hutton, *A Blow of the Pick*, 266–267.

124 [Plate 1]

Jan Toorop
Interior, ca. 1885
Watercolor on paper
Spencer Museum of Art, 90.81
300 x 434

IN the 1886 Les XX exhibition, Jan Toorop displayed a series of ten drawings titled "Le Village" ("The Village").[1] Siebelhoff gives the individual titles of the works:

Promenade ("Promenade")

Le Songe ("Dream")

La Mort ("Death")

L'Enterrement ("Funeral")

L'Enterrement qui suit ("The Burial that Follows")

Les Mauvais Langues ("The Slanderers")

Le Rendez-vous ("The Rendezvous")

Une Misérable Créature ("A Miserable Creature")

La Mère seule ("The Lonely Mother")

Dans le Nes ("In the Nes"—a poor section of Amsterdam)

It is generally believed that these drawings were intended to illustrate Toorop's story about a small town. Siebelhoff has suggested that the ten drawings may have been among the sheets in "an album with twenty-five drawings illustrating a novel written in Dutch by the artist himself [that] introduces us forcefully into the narrow intimacy of the poor."[2]

In *Interior* a seated woman either weeps or wipes her inclined forehead while an older woman leans in her direction as if to offer comfort. The table, littered with empty bottles and playing cards; the overturned chair; and the man lumbering off to the right further suggest domestic discord or some personal tragedy in this rustic interior. Unfortunately, Toorop's written narrative has not been found.[3] However, it is possible

that *Interior* was related to the "Le Village" series. Since the right third of the composition, as well as the figure behind the lamp, are unresolved, and the work is unsigned, the watercolor may have been abandoned.

After moving to the small town of Machelen near Brussels, Toorop became a member of L'Essor and, in late 1884, of Les XX. During these years he was deeply concerned with the lot of the poor, as "Le Village" suggests. William Degouve de Nuncques wrote in 1902 of Toorop's Machelen years, "He (Toorop) was always in contact with simple people; he liked to talk to them, and he took an interest in their work."[4] As Hefting has pointed out, additional evidence of Toorop's empathy for the poor is found in his paintings of 1884–85, done during a trip to London, and in the fact that he travelled to the Boringage mining region with Jules and Georges Destrée.[5]

Several elements of the composition, such as the kettle precariously perched on the stove, are directly related to the Toorop oil painting *Garenwinden* (*Winding Yarn*) of December 1883.[6] Both the painting and the watercolor are in muted, earthy tones similar to the palette used by Ensor in interior scenes such as *L'après-midi á Ostende* of 1881 (Antwerp: KMSK). While living in Machelen (where William Degouve de Nuncques, Guillaume Van Strydonck, and Henri de Groux were also living), Toorop became acquainted with Ensor and his early work through the exhibitions of L'Essor and Les XX.[7] These two artists, whose work around 1884 is similar, simultaneously were to move into their highly personal and symbolic works shortly after this.[8]

—S.G.

1. Robert Siebelhoff has generously shared with me the material that will be in his catalogue of the early work of Jan Toorop; the information for *Le Village* is no. 8547 in his catalogue. See also Canning, "The Salons of 'Les Vingt'," 110.

2. Siebelhoff, "Jan Toorop—Early Work" typescript, citing an article in *La basoche* 8, June 1885, 298–99.

3. Siebelhoff, "Jan Toorop—Early Work" typescript states only that "in a letter to Annie Hall there is indeed a fragment of the story which was to be translated by her from the French into English."

4. Hefting, *Jan Toorop* 1989, 11.

5. Ibid., 11.

6. I thank Maurice Tzwern for pointing this out to me. See the prospectus for Van Wezel, *Jan Toorop*, 6 no. 5, which gives the dimensions as 155.5 x 196.3 cm. and cites Siebelhoff, "The Early Development of Jan Toorop," I:33, II:189-191, 196, P8311 [not consulted].

7. Siebelhoff intro., "Jan Toorop—Early Work" typescript. See also Hefting, *Jan Toorop*, 11.

8. Delevoy, *Ensor*, 208, noted this parallelism as well.

125

Jan Toorop
Illusion, ca. 1893
Pastel or crayon with green and red pencil
Private collection
295 x 455

INSCRIBED in the lower left corner:

Jan Toorop "Illusion"/A Son. Altesse Royale la princesse/Louis Ferdinand/Le respecteusement et très sympathique-ment. (To her Highness the Royal Princess/Louis Ferdi-nand/respectively and very sympathetically.)[1]

This drawing was produced during the most important phase of Toorop's symbolist period and contains elements that figure in some of his most sig-nificant symbolist works, particularly *The Three Brides*, 1893.[2] The thornless rose in the lower right appears in many of Toorop's work of this period.[3] The two female figures in the foreground of *Illusion* are

related to the seraphim that appear in *The Three Brides* and other works.[4] We can date the appearance of this type of figure in Toorop's work as early as 1892 in *O Grave, Where is Thy Victory?*[5] Robert Siebelhoff has characterized Toorop's seraphim as having "Rossetti-inspired hairdos and Egyptian linear styliza-tions."[6] One possible inspiration for the form of Toorop's seraphim is the *wayang* puppets that were used in shadow plays in Toorop's native Java.[7] However, as Siebelhoff has noted, these puppets never had the masses of hair that we find in Toorop's fig-ures; the hair was an embellishment "probably derived from Pre-Raphaelite sources."[8]

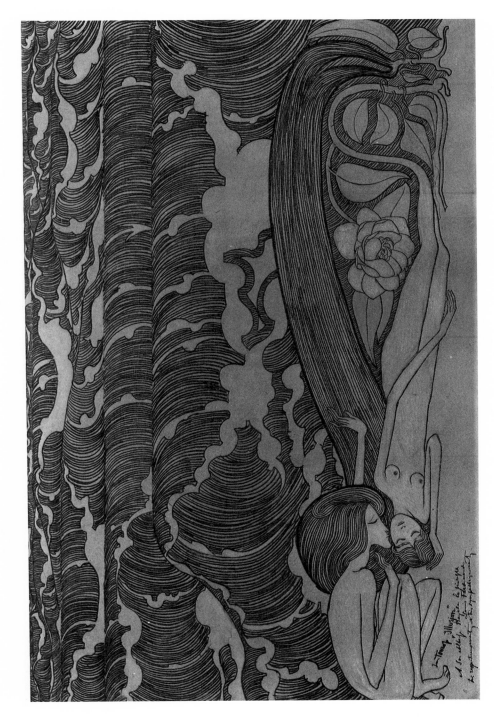

This type of hair can be traced back to a work which was stylistically an important prototype for Toorop's *The Three Brides*. In 1892 Toorop presented a drawing to his friend Floris Verster, a Leiden painter, to celebrate the latter's marriage. This drawing, *Aurora* or *Huwelijk* (*Marriage*), is of a nude female with the lower half of her body shrouded in "voluminous waves of undulating hair."[9] According to Siebelhoff, Toorop's use of linear patterns of abstract design represents an important contribution to the development of Art Nouveau.[10] In *Illusion* this use of undulating parallel lines to form abstract patterns is found in the hair and continues in the rolling waves that fill the upper three-quarters of the composition.

The year 1893 was a watershed in the establishment of Toorop's international reputation. Toorop's *The Three Brides* was introduced to an international audience in an article by Walter Shaw Sparrow in *The Studio*.[11] Also during this year Toorop's work was first seen by a German audience at the annual exhibition of the Genossenschaft at the Glaspalast in Munich.[12] As others have noted, it was significant that Toorop chose to exhibit with the Genossenschaft instead of with the newly-formed Munich Secession.[13] Toorop was persuaded to exhibit at the Glaspalast, in part, by the German painter Hans von Bartels despite the efforts of members of the Munich Secession to lure Dutch painters away from the Genossenschaft to exhibit with the Secession.[14] A letter from German artist Max Liebermann to Dutch artist Jan Veth, in early 1893, urges Veth and the Dutch artists to exhibit with the Secession instead of the Genossenschaft:

They [organizers of the Genossenschaft] . . . are putting on their usual exhibition and they'll be sending a certain Bartels to invite you to take part. Piglhein, the president of the *Sezession*, has just asked me to make sure that you come in with us . . . and I hope the Hollanders won't join in with those old fogies.[15]

The annual Genossenschaft exhibitions enjoyed the royal patronage of Luitpold, Prince Regent of Bavaria, and the support of Prince and Princess Louis Ferdinand of Bavaria.[16] It seems probable that Toorop presented *Illusion* to Princess Louis Ferdinand as a token of his appreciation for her support of the Genossenschaft or, possibly, to curry favor for commissions.

—B.N.

1. Born the Infanta Maria de la Paz, the Princess Louis Ferdinand (1862–1940) was the niece of Isabella II of Spain and in 1883 married Prince Louis Ferdinand of Bavaria; see Kern and Dodge, *Historical Dictionary of Modern Spain*, 569, and Echevarria, *Isabel II*, 204. The Prince and Princess resided in Nymphenburg; see Llorca, *Isabel II*, 318 and 323.

2. See Polak, *Nederlandse Schilderkunst*, 349, no. 28; Zilcken, "Jan Toorop," 282; Molekenboer, "Toorop—Im Haag," 549.

3. These works include *The Tennis Court*, oil, 1890; *The Knight at the Gate*, lithograph, 1892; and *The Three Brides*, 1893.

4. See Siebelhoff, "Three Brides."

5. Siebelhoff, "Three Brides," 238.

6. Ibid., 232.

7. Ibid., 231.

8. Ibid., 250n28.

9. Ibid., 240.

10. Ibid., 248.

11. Sparrow, "Toorop's 'The Three Brides.'"

12. See Bisanz-Prakken, "Toorop en Klimt." Toorop exhibited 17 works at the exhibition, 1 July–31 October 1893: Bisanz-Prakken, 206n12.

13. Makela, *Munich Secession*, 75–76. Vingtistes who exhibited at Genossenschaft included Fernand Khnopff and Henry van de Velde.

14. Zilcken, "Jan Toorop," 282.

15. Cited in Sillevis, "Years of Fame," 93; Makela, *Munich Secession*, 66.

16. Ludwig, *Kunst, Geld und Politik*, 106–07. See also Hummel, *Münchner Secession*, 71.

126

Jan Toorop with Henry van de Velde

Ik heb Gezaaid (I Have Sown), 1893

Tailpiece in *Van Nu en Straks*, 1st series, no. 2, 1893

Photomechanical or woodblock

Department of Special Collections, Kenneth Spencer Research Library,

University of Kansas

285 x 230

Spaanstra-Polak 2

L ATE in 1892, Henry van de Velde, then artistic director for the Flemish avant-garde periodical *Van Nu en Straks*, wrote to his fellow Les XX member, Jan Toorop, requesting a design for a tailpiece for the periodical's second number.[1] Van de Velde proposed an inverted triangular shape as a graceful way to make a transition from a block of text to an empty page. Toorop sent back a design that closely followed van de Velde's suggestion, but he made the design his own by incorporating a lanky figure derived from the Indonesian shadow puppets that he knew from his youth in Java. The figure is simultaneously ringing a bell, uttering sound, and sowing seed. These symbols and actions would seem to suggest musical harmony and fertility; for Toorop they doubtless suggested a specifically spiritual harmony and the cultivation of the soul. This design is closely related to one of Toorop's most significant symbolist compositions, *De drie bruiden* (*The Three Brides*, Otterlo:Rijksmuseum Kröller-Müller), that Toorop was working on late in 1892 and early in 1893.[2] This composition

has been summed up as an expression of "the artist's concern with universal principles, notably the dichotomy and tension between spiritual and material forces."[3]

Toorop's tailpiece was first used in van de Velde's article on Les XX (as exhibited here) and appeared a second time in the special issue of *Van nu en Straks* dedicated to Van Gogh.[4] Van de Velde's article on Les XX began with an ornament by a third member of the group, Georges Lemmen, showing the double X's emblematic of the group. In this article van de Velde laments that propaganda played down the fact that the first salon of the Antwerp group Association pour l'Art, which took place in May 1892, preceded Les XX in the exhibition of industrial art.

Van nu en Straks contains woodcuts, photomechanically produced relief prints, lithographs, and half-tone reproductions as illustrations. Toorop's *Ik heb gezaaid* is only referred to as a *slotversiering* (tailpiece) in the table of contents and is not identified as a woodcut.[5]

—S.G.

1. Joosten, "Van de Velde en Nederland," 18–19, dates the letter to late April or early May 1892.

2. Siebelhoff, "The Three Brides," 211–25, discusses the drawings of late summer through December 1892 that led to *De drie bruiden*, completed by mid-February 1892 (see 229).

3. Siebelhoff, "The Three Brides," 248, and Spaanstra-Polak, *Jan Toorop*, 9–10.

4. First series no. 3, 1893, 30.

5. With the exception of van de Velde's cover ornament [cat. 138], woodcut illustrations are usually carefully identified in *Van nu en Straks*.

FIGURE H. Letter from Henry van de Velde to Jan Toorop, 1892. Courtesy Koninklijke Bibliotheek, The Hague, KB TC C 148c, nr. 9.

127

Jan Toorop
Venise sauvée (Venice Preserved), 1895
Poster (lithograph), before letters
Museum of Fine Arts, Boston, Lee M. Friedman Fund, 1990.255
445 x 280
Spaanstra-Polak 15

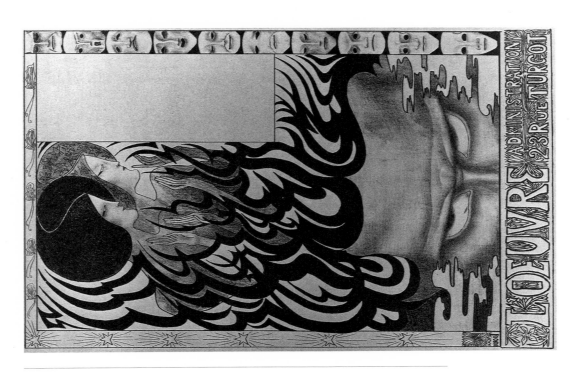

THE Théâtre de l'Oeuvre was founded in Paris by Lugné-Poe in 1893. An experimental theatre, the Théâtre de l'Oeuvre championed contemporary works by such writers as Maeterlinck, Ibsen, Jarry, Mallarmé, and Verlaine.[1] The playbills for these productions were produced by leading artists of a similarly symbolist bent, including Bonnard, Henri de Groux, Denis, Jarry, Munch, Roussel, Toulouse-Lautrec, and Vuillard. In this example, however, the play is a blank-verse tragedy by seventeenth-century British playwright Thomas Otway (1652–1685). *Venice Preserved* was based on the Abbé de Saint-Réal's *Histoire de la conjuration des Espagnols contre la Venise en 1618*.[2]

It has been proposed that Toorop received the commission to produce this playbill for the Théâtre de l'Oeuvre through his friend, the Dutch artist Philippe Zilcken who was living in Paris.[3] The exhibited proof of the playbill was printed before the letterset title and list of characters were printed in the box at the upper right. Aitken has proposed that the play's scheming protagonists (Pierre, Aquilina and Belvidera) are depicted.[4] Siebelhoff has suggested a source in Japanese prints for the sinister face at the bottom of the poster and the series of masks at the right.[5] —S.G.

1. Rubenstein, " The Avant-Garde in Theater and Art," 8.

2. *Encyclopedia Britannica*, 11th edition, vol. 20, 376–77 (New York, 1910-11).

3. Otterlo: Rijksmuseum Kröller-Müller, *Toorop*, no. 59.

4. Aitken and Josefowitz, *Artistes et Théâtres d'Avant-Garde*, 71.

5. Siebelhoff, "Jan Toorop - Early Work," typescript, no. 9534. For the face with a large brow, eyes rolled up into the head, and fiery hair, Jean Delville's *Portrait of Mrs. Stuart Merrill* of 1892 also comes to mind as a possible prototype.

128

Jan Toorop
Meisjeskopje (Head of a Woman), 1895
Lithograph in light brown ink
Josefowitz Collection
142 x 138
Spaanstra-Polak 12

THE subject of this lithograph is generally thought to be Jeanette Sophie Lucie Drabbe, however, there is not any convincing evidence to support this hypothesis.[1] Born in Utrecht in 1875, Miss Drabbe was the daughter of Major-General Johan Drabbe. Toorop regularly spent his summers in Domburg from 1897 until his death and there became friends with Miss Drabbe and her father. Miss Drabbe, also an artist, received painting lessons from W.J. Schütz in Middelburg. In Domburg she was given a great deal of instruction by Toorop and made both etchings and lithographs. She must have been an artist of considerable talent, for it has been reported that she made a portrait of Toorop which was such a striking likeness that it was, at one time, mistaken for a self-portrait by the artist.[2] She also helped Toorop with annual summer exhibitions in Domburg, which he organized and held in the small pavilion built to his specifications. In 1902 Jeanette Drabbe married Paulus Johannes Elout, director of the Bath and Beach Hotel in Domburg.

An impression of this lithograph now in a private collection bears the following inscription:

To Miss Drabbe from J. Th. Toorop. A lithograph in which I have both drawn on the stone and printed myself. Hang it in the living room for you and your father and mother (hang it in that beautiful dining room near you).[3]

In this image, Toorop uses a format similar to one often used by Fernand Khnopff, (see cat. 63) a female face viewed frontally and pressed right up against the picture plane. Also, as Khnopff often did, Toorop truncates the head of the subject at the forehead. Her face nearly filling the entire picture plane, she casts a penetrating gaze with faraway eyes typical of many symbolist depictions of women. The soft features of the subject are framed by a fingerprint-like mass of hair. This hair that seems to have a life of its own is found in many of Toorop's works. In addition to impressions in light brown ink, examples of this lithograph exist in grey and in yellow.

The print was published as Plate 9 in Portfolio 9 of De Nederlandsche Etsclub (The Dutch Etching Club). The Etching Club was founded in 1885 by Anton Der Kinderen, Jan Veth, and Willem Witsen to promote original printmaking by young Dutch artists.[4] It has been described as the artistic equivalent of the Dutch literary circle De Nieuwe Gids and held annual exhibitions in Amsterdam and The Hague alternately.[5] The exhibitions included the work of many prominent foreign printmakers. The Etching Club also published portfolios of prints by member artists. By the time the group dissolved in 1896 they had held seven exhibitions and published nine portfolios. There was an increase of interest in symbolist works at the annual exhibitions of 1893 to 1896 and an increase in the number of lithographs published in the portfolios. It was this rise in attention given to lithography that ultimately led to the dissolution of the Etching Club.

—B.N.

1. Spaanstra-Polak identifies the subject as Miss Drabbe; *De grafiek van Jan Toorop*, 23, no. 12. See also Hefting, *Toorop Een kennismaking*, 98. However, the author of the entry in the exhibition catalogue by Hefting, *Jan Toorop*, 86, no. 53, suggests that the subject is not Miss Drabbe based on a comparison with her known portraits. The only portrait of Miss Drabbe with which this author is familiar is Toorop's *General Drabbe and His daughter Mies*, 1898, where she is in three-quarters profile, which makes comparison with *Meisjeskopje* difficult.

2. Spaanstra-Polak, *De grafiek van Jan Toorop*, 23.

3. "Ann Miesje van J. Th. Toorop. Een lithografie (steentekening) die ik zelf op de steen getekend heb en gedrukt ook. Deze moet je maar in de huiskamer hangen voor jou en je Pa en Ma (hangen indie mooie eetkamer bij jullie)." Spaanstra-Polak, *De grafiek van Jan Toorop*, 23.

4. For information on De Nederlandsche Etsclub see Giltay, "De Nederlandsche Etsclub."

5. Giltay, "De Nederlandsche Etsclub," 119.

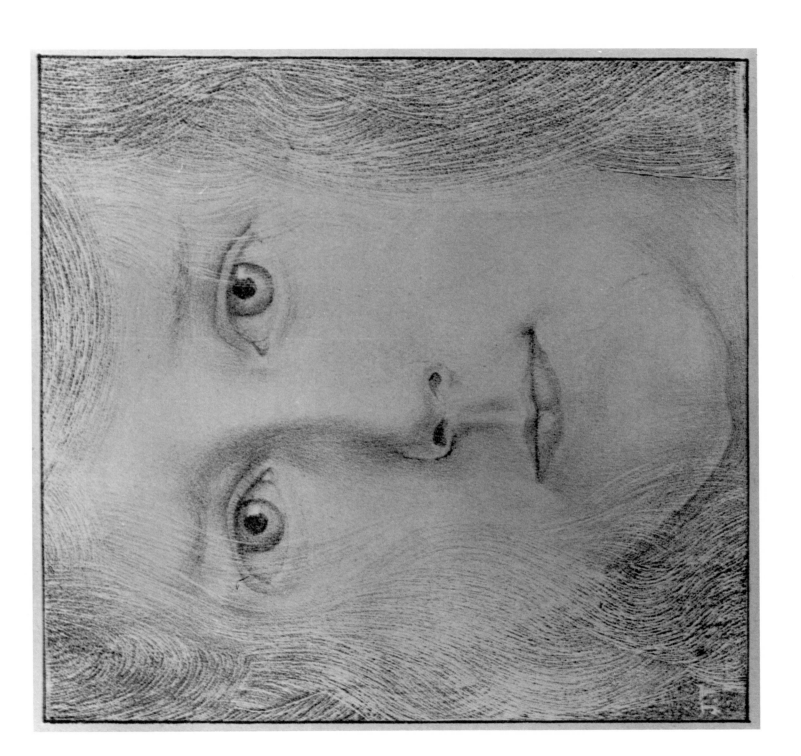

129

Jan Toorop
De Zaaier (The Sower), 1895
Lithograph
217 x 331
Spencer Museum of Art, Letha Churchill Walker Memorial Art Fund, 88.53
Spaanstra-Polak 16

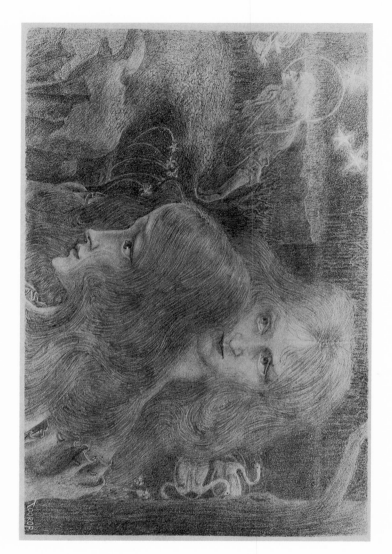

J AN TOOROP'S lithograph, *De Zaaier*, is based on a pencil drawing whose elements are clearly described in a text by the artist that is cited by Siebelhoff.[1] In this text the Sower (at the left in the lithograph) is specified as a spiritual sower and source of life; the swans, pond, and woods are associated with the Life of Dreams; the woman in profile represents Spiritual Longing; and the woman seen full-face represents Consciousness and Knowledge.[2] In its use of frontal and profile faces as allegories of spiritual longing and spiritual possession, *De Zaaier* recapitulates Toorop's

large pastel of 1893, *Le Désir et l'apaisement* (Paris: Musée d'Orsay).[3] But the faces in *Le Désir et l'apaise-ment* have been likened to those in Khnopff's pastel of 1891, *L'Offrande*, while the woman in *De Zaaier* is the artist's wife, Annie Hall, seen from two perspec-tives.[4] The lithograph is at once more intimate and less insistent on its allegory than the more Rosecrucian pastel of 1893.[5] Hefting has even asked if Toorop might have regarded this as his favorite print. According to Hefting, Toorop printed the lithograph himself on his own press in an edition of 100.[6] —S.G.

1. Toorop, "Bouw-en Sierkunst," 28, cited in Siebelhoff, "Jan Toorop—Early Work," typescript, no. 9503. I thank Mr. Siebelhoff for sending me a typescript of his entry on De Zaaier.

2. See also Polak, *Nedelandse Schilderkunst*, 294.

3. For *Le Désir et l'apaisement* see Rotterdam: Museum Boymans-Van Beuningen et. al., *Le Symbolisme en Europe*, 232–33. See also Spaanstra-Polak, *Jan Toorop*, 11 and 23n16.

4. Polak, *Nedelandse Schilderkunst*, 145–46 and 358n56.

5. Hefting, *Jan Toorop*, 113.

6. Ibid.

130

Jan Toorop
Dorpshuizen (Village Houses), 1897
Drypoint in brown ink
Fogg Art Museum, Harvard University Art Museums,
Anonymous Lender in Honor of William Robinson, 47.1989
165 x 145
Spaanstra-Polak 32

S PAANSTRA-POLAK points out that in early printings of this plate a light outline of a woman wearing typical Zeeland dress can be seen against the wall to the right.[1] This figure, scraped out by Toorop before the plate was printed, is faintly visible in the exhibited impression. Like several of Toorop's drypoints of the late nineties, *Dorpshuizen* evokes a peaceful coexistence of nature and the people who live and work close to the earth; nothing in this image suggests a modern industrial age. The timber for the houses and the gate is rough-hewn and the houses are constructed of humble local materials:

brick and tile. Even the iron braces on the walls of the buildings are crude and without embellishment.[2]

Trees often play a prominent role in Toorop's dry-points done between 1895 and 1898.[3] An alternate title for *Dorpshuizen* is *De dode boom* (*The Dead Tree*). The dead tree's intricately poised, bare branches still grace the dooryard of the tile-roofed house while the tree also serves as a fence post. With the added element of the thick woods of younger trees in the background, sustained contemplation of this drypoint inevitably leads to pondering not only humanity's integration in nature, but the cycle of life, death, and renewal. —S.G.

1. Spaanstra-Polak, *Jan Toorop*, 27 no. 32.

2. Cramp irons or anchors to reinforce brick walls were often finished with ornate ironwork; see examples in Haust, *Dictionnaire Liègeois*, 26.

3. There were nine drypoints in which trees figure prominently; Spaanstra-Polak, *Jan Toorop*, nos. 17, 19, 20, 22, 31, 32, 34, 39 and 40.

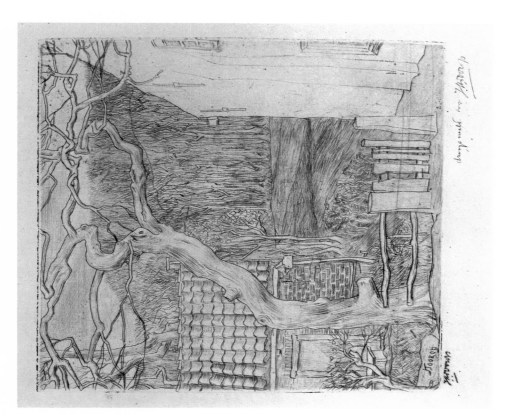

131

Jan Toorop

Sprokkelend Kind (Child Gathering Kindling), 1899

Drypoint in orange, 1st state, proof

The Museum of Modern Art, New York, acquired through the Lillie P. Bliss Bequest,

by exchange, 2656.67

164 x 194

Spaanstra-Polak 47

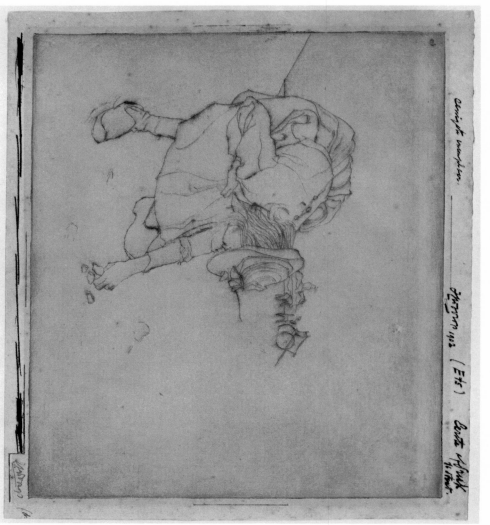

BEFORE completing this composition of a child gathering firewood, Toorop printed this impression of the drypoint in orange.[1] After eight years centered in Brussels, Toorop moved in 1890 to the Dutch coastal community of Katwijk aan Zee; he returned here for a second period around 1899–1904. This print of 1899 (inscribed in 1902) presumably shows a beach scene at Katwijk aan Zee. The figure riding a horse in the ocean and the two figures by the wagon on the beach may be working with a fishing net. In the second state of this drypoint the image is completed with the addition of a seated woman at the right, a woven basket, more items strewn about on the sand, and a horizon line. In a third state, he replaced the figure of the second woman with some tufts of grass and wooden planks. This beautiful impression of the first state of Toorop's *Sprokkelend Kind* is a fine example of the artist's mastery of pure drypoint.

—S.G.

1. Spaanstra-Polak, *Jan Toorop*, 30 no. 47; proofs were also printed in yellow.

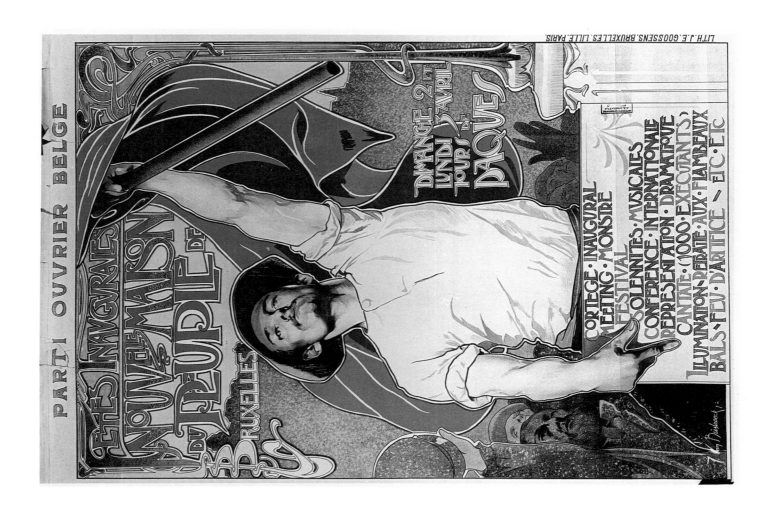

132
Jules Van Biesbroeck
Nouvelle Maison du Peuple (The New "House of the People"), 1899
Poster (lithograph)
Museum Vleeshuis, VH 38.5.10 593/637
1210 x 820

IN the years following the election reforms of 1893 and the subsequent parliamentary elections, which succeeded in seating 28 representatives from the POB platform, the POB membership of each of the major cities of Belgium—Brussels, Ghent and Antwerp—built new locals to demonstrate the party's recently-gained political power. On 2 and 3 April 1899, Victor Horta's art-nouveau Maison du Peuple, for the Brussels POB opened to great acclaim (Fig. 9).

Both the date and the building's style were significant. The celebration of this people's palace took place on Easter, transforming the holiest of Christian holidays into a "Pâques rouges" (Red Easter).[1] The two-day festivities included speeches, concerts, meetings, marches, the launching of the hot air balloon provided by the POB's newspaper Le Peuple, guided tours of the facility, fireworks, and several balls.[2] Thousands of Belgian workers from throughout the country, as well as leaders of the labor and socialist parties of France and Germany attended and participated in the events.[3]

Horta's building was not the first People's House in Belgium, but it was Belgium's grandest.[4] It included an auditorium for official meetings and concerts, a bakery, a clothing shop, a café, and the offices of the various syndicalist groups. With its "wall of glass," its sinuous lines, and the placards naming past and present leaders of radical politics lining the cornices, the Maison du Peuple proudly proclaimed its party's emergence as a new political power.

To commemorate the event, the Ghent-based socialist artist Jules van Biesbroeck, who already was beginning to distinguish himself as a sculptor of monuments dedicated to Belgian socialists, was commissioned to create the official poster. With its depiction of a young worker proudly holding the red banner associated with the POB in one hand and pointing to the events scheduled for the inauguration, this poster reflects the joining of art nouveau with labor politics like the building it celebrates. Similarly, Horta's dictum that a building should be a portrait of its inhabitants is beautifully reflected in the modern style used in this poster.[5] The POB was viewed as the party of the future and art nouveau was the style that best presented such a forward-looking attitude.[6]

Though the Maison du Peuple is not depicted in the poster, it is alluded to in two details. The undulating typographic design reflects the sgraffito on the Maison du Peuple and the organically-based column reproduces those Horta designed for the edifice; these form metonymies for the whole of the building. Three years later Van Biesbroeck was commissioned to make the poster for the new Vooruit building for the Ghent local of the Arbeidersbeweging (Workers movement). In lieu of the young male who dominates the Brussels poster, the artist presented a modern Marianne figure who, dressed in quasi-classical and military garb, points to a rendering of that celebrated Ghent building.[7]

—S.L.

1. Victor Horta wrote in his memoirs that this building should be "un palais qui ne serait pas un palais, mais une 'maison' où l'air et la lumière seraient le luxe si longtemps exclu des taudis ouvrier": Dulière, ed., Horta Mémoires, 48. "Pâques rouges" comes from a front-page article with that title on page one of the special edition of Le Peuple, daily newspaper of the POB, commemorating the inauguration 2–3 April 1899.

2. Special edition of Le Peuple, 4.

3. Leading French socialist Jean Jaurès was one of the foreign speakers; a complete listing of the activities and groups participating in the events in the special edition of Le Peuple, 4.

4. The original organizing meetings that led to the formation of the POB had been held in the Maison du Cygne on the Grand 'Place, Brussels, following its designation as a political party, the Brussels local moved to a former synagogue. In the aftermath of the 1893 elections, the Brussels chapter decided to create a grander edifice that would reflect its increasing political clout. For information on these shifts, see the essays by Levine, Strikwerda and Murphy in this volume; Weerdt, "Organisatie B.W.P."; Liebman, Les Socialistes Belges, vol. 3 "La Révolte et l'organisation."
The Ghent and Antwerp locals also built their People's Houses during the final years of the nineteenth century. For a survey of nineteenth century Maisons du Peuple, see Maisons du Peuple, esp. 10–72 and Schokkart and Stallaerts, Volks-en Gildhuizen, esp. 25–75.

5. In his memoirs, Horta wrote "C'était le temps où, synthétisant ma pensée, je proclamais que la maison était non seulement à l'image de la vie de l'occupant, mais qu'elle devait en être le 'portrait'": Dulière, ed., Horta Mémoires, 47.

6. The designs of the Help u Zelve building by Emile van Averbeke and Jan van Asperin, the Liberal People's House in Antwerp (1898), and new Vooruit Building (1899) by Fernand Dierckens in Ghent reflect a similar joining of modernity with radical politics. For an extended discussion of the Antwerp local, see the cat. 143.

7. Although Marianne was an allegorical, warrior-like figure associated with the French Revolution, she also became a favorite symbol for posters made at Vooruit.

133

Henry van de Velde
Jeunes paysans et paysannes faissant les foins (*Young Peasants Mowing*), ca. 1891
Pastel on gray laid paper
Bibliothèque Royale Albert 1er, Cabinet des Estampes, Plano SV 96792
417 x 316

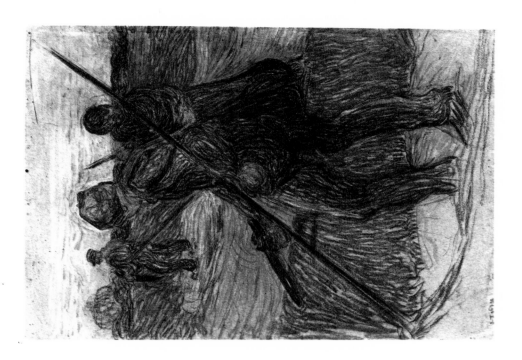

L IKE many of his contemporaries who grew up in urban areas, Henry van de Velde was fascinated by rural life. Inspired by the work of Jean-François Millet when he studied in Paris in 1884, van de Velde moved to a small village outside of Antwerp where he lived for four years. His first drawings of peasants at work or at rest date from this period. The artist continued to make these depictions that record what he called the "notes and attitudes" of peasant life until the early 1890's.

Though most of van de Velde's peasants were drawn from life, he rarely shows any detail or individual characteristics. Van de Velde, like Millet, preferred instead to represent his figures as archetypes representing the timeless and harmonious balance of the peasant with nature. In this harvest scene, the figures and their implements, set against the horizontal of the fields, create an engaging pattern that rhythmically moves the eye through the pictorial space. Undulating lines form into patterned shapes of contrasting colors of blues, yellows and greens. These lines both model the forms and join the peasants to the surrounding environment, depicting the symbiotic relationship that van de Velde believed existed between the peasant and the land.

Although the artist describes the peasants in a generalized way, his intent was not to dehumanize them but rather, like Millet, to stress the universality of their tasks. Through his accent on elemental form and poses that align with the formal arrangement of the scene, van de Velde represents what he views as the essence of peasant life in harmony with the cycles and rhythms of nature.

—S.C.

134

Henry van de Velde
Cover for Max Elskamp's *Dominical*, 1892
Woodcut
Private collection, Brasschaat
222 x 131

V AN DE VELDE'S design for the cover of Elskamp's volume of verse, *Dominical*, has been described as "one of the first deliberately asymmetrical typographical layouts in the history of book design," and as "one of the seminal works of art nouveau."[1] The image of the sea and shore at sunset is unified, in an almost spiritual sense, by the use of the singularly expressive element of heavy undulating lines.

135

Henry van de Velde
Dominical, 1892
Wooden block for the cover of the book by Max Elskamp
Stedelijk Prentenkabinet, Antwerp HB II/21
111 x 112 x 23

Elskamp and van de Velde became close friends after meeting in Latin class in Antwerp in 1876. By 1877 the two were disenchanted with their course work, and were known to take long walks together in the port area of their native city.[2] Their friendship was so close that their exact roles in realizing the cover design of *Dominical* is uncertain. The composition may go back to a drawing by Elskamp himself, as Paul Lissens has suggested.[3] Further, since Elskamp produced a large number of woodcuts during his career, there is a possibility that the block was designed by van de Velde and carved by Elskamp.[4]

The writing and drawing on the back of the wooden block appear to be van de Velde's. They can be meaningfully compared to a letter from van de Velde to Jan Toorop of April or May 1892 [Fig. G at cat. 126] concerning the commission of a design for the periodical *Van Nu en Straks*. The text on the block is difficult to decipher, but seems to concern the artist's observations about the possibility of creating tonalities with woodcut lines.[5] In addition to the drawing and this brief text, the back of the block displays a variety of trials made with a narrow wood engravers' chisel. In the lower left of the reverse is carved a sinuous line similar to that needed to carve the tightly articulated leaf-like form on the front of the block. Though the wooden block was certainly in the hands of van de Velde, given the closeness of the two friends it is nearly impossible to discern which of them, if either, did the actual carving of the block. Given that Elskamp's first woodcuts are generally dated a few years later than *Dominical*, it is possible that the block was carved by a specialist in wood engraving.[6]

The starting point for van de Velde's design is generally considered to be his drawing *Zon bij Zee* (*Sun with the Sea*, fig. 5), one of his first works in which the artist swept away the divisionist technique in favor of a purer abstraction.[7] Van de Velde himself credited the cover design of *Dominical* as the inspiration for *Van Nu en Straks* [cat. 138].[8] This initial period of book design, around 1892,

culminated in van de Velde's highly abstract rhythmical design for the cover of Elskamp's *Salutations dont d'angéliques* of 1893 [cat. 136].⁹

The *Dominical* collaboration between the twenty-nine-year-old artist and the thirty-year-old writer was a turning point in both their careers. This book, the title of which refers to Sunday as the Lord's day, was Elskamp's first important publication of verse. It revealed the author's dual interest in artistic simplicity and spirituality that was to lead to later preoccupations with Flemish folklore and, eventually, Buddhism. Van de Velde's design was among his first forays into the ecstatic organic forms that were to become the basis of art nouveau. Julius Meier-Graefe noted in 1898, "In the woodcut for the cover of the book *Dominical*, the lines mount up as if oppressed by the black that interrupts them, introducing the reader to the mood of the book that is marked by a melancholy joy. In this schematic composition, sea, shore, and clouds understand each other."¹⁰ —S.G.

1. Cambridge, Mass.: Harvard University, *The Turn of a Century*, cat. 80, 69–70. Baas and Field, *Revival of the Woodcut*, cat. 55, 93–94. See also the useful notes in de Sadeleer, *Max Elskamp*, nos. 1–4.

2. Elskamp, *Chansons et Enluminures*, 266 (chronology).

3. Baudin, "Typographiques de van de Velde," 1: 274–275, cited in Lissens "Van Nu en Straks," 133n84.

4. De Sadeleer, *Bibliothèque littéraire d'un amateur*, no. 12 (not paginated): "Aussi n'en faudrait-il pas conclure que le bois de *Dominical* fût gravé par Elskamp?" De Sadeleer also deduced that the block for the cover was among those left to the city of Antwerp by Elskamp, conserved at the Plantin-Moretus Museum; we are happy to confirm this here. The block is a hand-carved commercial "type-high" end-grain block, such as those used in the wood engraving trade.

5. "Dans partis marquée toutes lignes serait horizontales [lesquels?] *blancs réservés serai gris*! (In the stamped [or marked] parts all lines will be horizontal whose *remaining whites will be gray*!)"

6. Elskamp's first woodcuts are generally dated to 1895, three years after the work under consideration; see Elskamp,

Chansons et Enluminures, 272 (chronology). Roger Cardon has found some documentary evidence that may indicate that the block was carved by a professional wood engraver—we anticipate the publication of this evidence.

7. See Baas and Field, 93, and Canning, "Symbolist Landscapes of van de Velde," 134-36.

8. Van de Velde, *Geschichte meines Lebens*, 94n4.

9. *Dominical* was printed 7 March 1892, only months before his letter to Toorop concerning the tailpiece for the second number of *Van Nu en Straks*. This is probably also the period in which van de Velde was working on the cover for *Van Nu en Straks*, the first mention of which is not until November 1892. See van Dijk et. al, *Van Nu en Straks* 1, 290, letter 282.

10. "Dans le bois pour la couverture du livre *Dominical*, les lignes montantes comme oppressées par le noir qui les interrompt introduisent le lecteur dans l'esprit du livre, empreint d'une joie mélancolique. Dans cette compostition schématique, mer, rivages, musages se devinent encore.": Meier-Graefe in *L'Art Decoratif*, cited in de Sadeleer, *Bibliothèque Littéraire d'un Amateur*.

136

Henry van de Velde
Cover for Max Elskamp's *Salutations dont d'angéliques* (*Salutations, Some Angelic*),
1893
Woodcut decorations
Private collection, Brasschaat
229 x 184

Max Elskamp.
Salutations,
dont d'angéliques.

Paul LACOMBLEZ, éditeur.

THIS is the second of three books by van de Velde's childhood friend, Max Elskamp, for which van de Velde designed the covers. *Dominical, Salutations* and *En Symbole vers l'Apostolat* were printed by J. E. Buschmann of Antwerp and published by Brussels editor Paul Lacomblez. *Salutations* was issued 1 May 1893 in an edition of 203.

Van de Velde designed the cover at the same time he was working on the layout and ornamentation of the new Flemish journal *Van Nu en Straks*. Both the journal and the *Salutations* cover reveal van de Velde's evolving abstract ornamentation that had begun the previous year with *Dominical*. Bizarre shapes and quick changes of scale, combined with thin and thick strokes, give the cover an explosive quality. The juxtaposition of blue ink on the white background produces a vibrant counterpoint of positive and negative space. Perhaps in the interest of legibility, van de Velde separated the lettering from the decorative rectangle. The solid letters of "Salutations" are surrounded by quivering accents, while the open letter forms of the surrounding words spill out onto the paper.

—J.B.

137

Henry van de Velde
Paysage (Landscape), ca. 1893
Black chalk on pink paper
Bibliothèque Royale Albert 1er, Cabinet des Estampes, Folio SV 96796
239 x 308

Henry van de Velde's first contact with decorative art was through the Japanese prints he saw in the collection of his friend Max Elskamp. Van de Velde later viewed at Les XX exhibitions numerous examples of decorative art and design, including posters by Henri Toulouse-Lautrec and Jules Cheret, the illustrated books of Walter Crane, and the designs of Georges Lemmen.

Van de Velde began experimenting with decorative art in 1891. That year he made several designs for tapestry projects; *Paysage* is one of these. It was more than

likely exhibited at the 1892 Les XX exhibition. With its swaying forms, simplified shapes and rhythmic, energetic line, *Paysage* presents an imaginary world full of whimsy and child-like fantasy. All of the forms have been reduced to flat shapes joined by an undulating curvilinear line. Here and there the artist jotted in colors, indicating that he planned to fabricate the scene as a tapestry. Although this tapestry was never made, in its simplifications and color arrangement it is similar to a tapestry van de Velde did complete, *Angel's Watch*, exhibited at Les XX in 1893. —S.C.

138

Henry van de Velde
Cover of *Van Nu en Straks* (From
Now On), 1st series, no. 3, 1893
Wood engraving
Department of Special Collections,
Kenneth Spencer Research Library,
University of Kansas
285 x 230

139

Henry van de Velde
Cover of *Van Nu en Straks* (From
Now On), 2nd series, no. 3, 1896
Wood engraving
Department of Special Collections,
Kenneth Spencer Research Library,
University of Kansas
225 x 185

140

Henry van de Velde
Van Nu en Straks (From *Now On*)
Wooden block for cover of second
series, ca. 1895
Archief en Museum voor het
Vlaamse Cultuurleven
204 x 157 x 21

WITH the willful decision to disband Les XX in 1893, the impetus that sought a young and vital new art moved to two other arenas in Belgium: Edmond Picard's La Maison d'Art in Brussels, and the Antwerp-based, Flemish periodical, *Van Nu en Straks*.[1] Meanwhile, the intended heir to Les XX, Octave Maus' new group La Libre Esthétique, looked increasingly to France for direction, although it played an important role in promoting Belgian decorative arts.

The editors of *Van Nu en Straks*, described their mission in a brief statement in the first issue in April 1893:

Van Nu en Straks has a double purpose. It is primarily a periodical for the young in the Southern Low Countries, an expression of the will and thought of the latter, without aesthetic dogma, without smacking of a

school—a free organ of the avant-garde dedicated to the art of now and curious about the art still in genesis—that of tomorrow—here and in other countries. The publication also forms a work of book art, handsomely decorated by artists—and as little as possible left to industrial mechanical means. There will be one series of ten numbers of this periodical published.[2]

In fact, *Van Nu en Straks* was to go through two series, the first running until October 1894 and the second from January 1896 until December 1901. The journal had four editors; van de Velde was artistic director.[3] As the prospectus for the journal announced, the decorations were mostly to be in woodcut and photomechanical relief ("zincografie"). Reproduced were works by Henry de Groux, A.J. Der Kinderen, G.W. Dijsselhof, James Ensor, Willy Finch,

Marguerite Holeman, R.N. Roland Holst, Georges Lemmen, Xavier Mellery, Constantin Meunier, Georges Minne, Jan Thorn-Prikker, Jan Toorop, Henry van de Velde, Vincent van Gogh, Théo Van Rysselberghe, and Jan Veth.[4]

By mid–1892, when the plans for *Van Nu en Straks* were reaching a high pitch, van de Velde had worked through impressionism and neo-impressionism, all but abandoned painting, and begun to investigate design and the decorative arts. His pioneering work in art nouveau design began to take form in his first book projects—covers for Max Elskamp's poetry collections [cat. 134–136]—and the two cover designs and vignettes for the first and second series of *Van Nu en Straks*.

In his autobiography, van de Velde recalled of his first *Van Nu en Straks* cover design, "I sketched a decorative composition in which the letters of the title were cast in a free, aggressive linear play."[5] Van de Velde's jiggling, serpentine letters spill from the crest of a breaking wave, across the framing border, and into the open space below. The word "Nu" (now) is on the cusp of the wave and the frame, while the word "Straks" (soon, presently), appears outside of the conventional picture frame, in the future.[6]

The second series of *Van Nu en Straks* was predominantly literary in orientation. For the cover, van de Velde designed a purely art nouveau design with undulating plant forms surrounding a marquis of sorts, in which the title and contents were typeset. The hand-carved wooden block gives evidence that the artistic director of the periodical still opted for non-mechanical means of producing images when possible. The wooden block is a "type-high" end-grain block in which the set type could be inserted into the

block itself, with the image and text being printed at one pass in the press.

Van de Velde's two cover designs for *Van Nu en Straks* show the rapid evolution from an intuitive, almost playful phase of art nouveau (a term that has been attributed to van de Velde) to a more elegant and formulaic period.[7]

—S.G.

1. For the demise of Les XX, see Block, *Les XX and Belgian Avant-Gardism*, chap. 7. For La Maison d'Art, see Block, "La Maison d'Art."

2. *Van Nu en Straks*, first series, 1 (April 1893): 2: *"Van Nu & Straks"* heeft een tweevoudig doel. Het is vooral: het tijdschrift der jongeren uit Zuid-Nederland, eene uiting van het willen & denken der laatstgekommenen,—zonder aesthetische dogmata, zonder school-strekking—een vrij voorhoede-orgaan gewijd aan de kunst van Nu, nieuwsgierig naar de kunst-nog-in-wording— die van Straks—hier en in 't buitenland. Die uitgave vormt ook een werk van boek-kunst, door kunstenaars stoffelijk verzorgd, en waarin zoo weinig mogelijk aan 't werktuiglijk industriele zal worden overgelaten. Er wordt van dit tijdschrift eene reeks van tien nummers uitgegeven."

 The literature on *Van Nu en Straks* is extensive. See especially Dijk et. al., *Van Nu en Straks*; Musschoot, "Van Nu en Straks," 45–59 and intro. to *Van Nu en Straks*; Ghent: Sint-Pietersabdij, *Van Nu en Straks*; and Lissens, "Van Nu en Straks."

3. The editors were Cyriel Buysse (1859–1932), Emmanuel de Bom (1868–1953), Prosper van Langendonck (1862–1920), and August Vermeylen (1872–1945).

4. The prospectus is reproduced in Lissens, "Van Nu en Straks," last page (unpaginated): "Buiten de tekst-ornamenattie, meestal in houtsneê en in zincografie, zal het tijdschrift oorspronkelijke platen bevatten van" (a list of artists follows, not all of whom actually provided images for the journal." For 'zincograph' see glossary.

5. Van de Velde, *Geschichte meines Lebens*, 63, as cited and trans. in Baas and Field, *Woodcut in France*, 94 and 94n4.

6. The four editors appear in a photomontage in this "future" area, grouped below and in front of van de Velde's composition; illustrated in Ghent: Sint-Pietersabdij *Van Nu en Straks*, cat. 2. AMVC V 147/P, 126.207/24.

7. Selz, *Art Nouveau*, 33, suggests van de Velde's use of the phrase "art nouveau" in *Déblaiement d'art* of 1894 may be the first use of the term in reference to the art of the turn of the century.

141 [Plate 17]

Henry van de Velde
Tropon Eiweiss Nahrung (Tropon, Nourishment from Eggwhite), 1898
Lithograph (from *Pan*)
Spencer Museum of Art, Letha Churchill Walker Memorial Art Fund, 88.63
308 x 198

ONE of the hallmarks of the 1890s was the successful collaboration of art and industry. This was brought about, in part, by the willingness of progressive companies to entrust their advertisements to contemporary artists. One of the most famous instances involving a member of Les XX is Toorop's large poster for Delftsche Slaolie (Delft Salad Oil), ca. 1895. Another is the poster and packaging designs for the Tropon works by Henry van de Velde.[1] Van de Velde's designs for the Tropon works, a firm that produced nourishing products from eggwhite, are remarkable in their application

of pure art nouveau for commercial advertising.[2] Van de Velde has used the serpentine "whiplash" motif of art nouveau to imply eggwhite issuing forth from cracked eggshells, with the separated yolk adding a bit of color. Similar versions of the poster appeared in both German and French language editions and the poster was so successful that it was reproduced in the progressive German periodical *Pan*, which also published an article by van de Velde on modern furniture.[3] The exhibited version of van de Velde's poster is the four-color lithograhic version published by *Pan*.

—S.G.

1. For Toorop's Delftsche Slaolie see Prokopoff and Franciscono, *The Modern Dutch Poster*, 12, pl. 5. A number of van de Velde's designs for the Tropon works are illustrated in Brussels: Palais des Beaux-Arts, *Art nouveau Belgique*, 335, no. 387; another appears in Sembach, *Henry van de Velde*, 11.

2. Brussels: Palais des Beaux-Arts, *Henry van de Velde*, 41.

3. The French version is essentially the same composition, with the text "Tropon est l'aliment le plus concentre." Both the reproduction of the poster and van de Velde's article, "Ein Kapitel ueber Entwurf und Bau moderner Moebel," appeared in *Pan* 4 (1898).

142

Henry van de Velde
Album moderner Damenkleider (Album of Women's Clothes), cover
and plate 5, Tea Gown, 1900
Letterpress and photomechanical reproductions
Bibliothèque Royale Albert 1er, Cabinet des Estampes, Quarto
400 x 250

A LBUM *moderner Damenkleider* was a collaboration between Henry van de Velde and his wife, Maria Sèthe (1867–1943). Van de Velde designed the cover and the women's dresses; Sèthe wrote an essay on the clothing designs and modeled in some of the photographs, including the one reproduced here. The cover design, typical of van de Velde during this period, features an undulating line that animates the page and the text through modulation in complexity and form. A similar use of linear pattern is found on the tea-gown Sèthe wears—moving and curving lines on the yoke and trim complement the garment's flowing shape.

When he gave up painting in 1893, van de Velde began to develop his ideas on design in a course on industrial and ornamental arts that he taught in Antwerp

and Brussels, and in a series of published essays. In his teaching and writing, van de Velde concluded that the only way that art would both reflect modern life and be socially responsible was to become ornament. Line played a central role in his theory of ornament and, as seen in these examples, represented both the architecture of form and the dynamic force of nature as expressed through the style of the individual artist.

The photograph of Maria Sèthe in the tea-gown exhibits both the origin and flaws of van de Velde's

Henry van de Velde
Tea-gown. Rückansicht.

design theory. On the one hand, the arrangement in the photo reflects van de Velde's influences: Japanese prints, neo-impressionism, symbolism, and the music of Wagner. The gown, reminiscent of dresses in Pre-Raphaelite paintings, is a distinct departure from the then-fashionable, tightly-silhouetted female form. On the other hand, this arrangement of a woman in a salon also expresses an essentially middle-class viewpoint in which women had leisure time to appreciate, or even play music. When linked with the decoration of the salon, the image suggests, as do the other photographs that accompany the essay, that a woman is just one more accessory in the harmonic equilibrium of the home.[1]

Though it is true that much of van de Velde's design theory is inscribed with the bourgeois values of his background and artistic training, he also sought in these dress designs to free the woman's body from the confinement of the traditional corset. The dynamic design of the cover treats the text and the layout as an integrated whole, not separate elements as they had been treated in the past.

Another break with tradition was the important role Sèthe played in the production of the pamphlet. Not only was she her husband's muse, as the photograph makes clear, but as the author of the text, she was the spokeswoman for her husband's ideas. The couple's closeness and shared aesthetic was reciprocal. It was Sèthe who introduced van de Velde to the Arts and Crafts movement and to the work of William Morris and other English designers. She worked side by side with him, helping produce his fabric and wallpaper patterns, and theirs was an equal partnership, as attested to by their correspondence (now in the Brussels Royal Library). The *Album moderner Damenkleider* represents both van de Velde's ornamental theory and his loving union with Maria Sèthe.

—S.C.

1. Aubry, "Van de Velde," 293–306.

143

Alfred Van Neste
Help U Zelve (Help Yourself), 1904
Poster [lithograph]
Museum Vleeshuis, VH 38.5.10 345/637
1220 x 810

THIS intriguing poster by Alfred van Neste weaves together symbols of mass politics with new artistic forms at the same time that it reaffirms local identity and the Flemish past. The poster is an invitation to an evening of popular entertainment at the Antwerp Volkshuis (People's House), run by the workers section of the Liberal party. Both the Liberal workers and the Volkshuis—which housed a consumer cooperative, offices and an auditorium—were often known by the name *Help U Zelve* (Help Yourself). The Volkshuis had been built in 1898 in the art nouveau style, to symbolize the marriage of new architectural and artistic trends with the workers' movement.

Although acquainted with new European trends in painting and printmaking, van Neste remained extremely popular in Antwerp for his ability to capture local scenes. By age 24 he had been named the official poster and costume designer for Antwerp's municipal festival. Avant-garde art generally was less popular in the Flemish-speaking parts of Belgium, such as Antwerp, than it was in bilingual Brussels and the French-speaking regions, but van Neste's use of innovative elements is an example of how new and old could be melded together. Van Neste was thus a natural choice to design a poster for the Liberal workers' organization, which was anxious to establish itself as a competitor to the growing Socialist and Catholic working class movements. Antwerp was one of the few Belgian cities where the largely middle and upper-class liberals enjoyed a strong following among the workers, a large number of whom were relatively skilled, well-paid artisans working on diamonds or other luxury items.

Van Neste portrays the young worker raising a banner in his sign of victory in such a way as to evoke simultaneously modernity, Flemish nationalism, and a deep-rooted Antwerp identity. In the upper left hand corner, he cuts through the letters of "Help U Zelve Antwerp" as though the viewer were meeting him face on, leading a demonstration. Unlike more stylized posters of scenes, van Neste's worker is caught in

motion. In his left hand the worker is holding a hammer as a sign of labor or workers' potential power; in his right hand he holds the banner with the carefully placed words, *"Voor't Volk en Vaderland"* (For the People and Fatherland).

The turn of the century saw a rise in nationalist movements everywhere, many of them among suppressed ethnic or religious groups. In Belgium, the Dutch-speaking Flemish resented the dominance of the French language and culture and Antwerp was the capital of Flemish consciousness. Catholics, Liberals, and Socialists all appealed to workers to see *'t Volk*

(the people) as both the oppressed lower classes and as Flemish-speakers snubbed by the Francophone upper class. A rising sun above the lettering on the banner lights the way to the future; the figure is in a fresh green. Thus, Flemish identity, which French-speakers sometimes scorned as the patriotism of a backward group, could be associated with the workers' movement, as a modern, liberating force.

Van Neste carefully balances the modernity and radical message of the poster with more moderate elements. "Fatherland" could mean Belgium, and not only Flanders, implying that Flemish consciousness need not threaten the existing state. The slogan "Help Yourself" could serve as a rebuke to the communitarian Socialists and an encouragement to indi-vidualism. On the lower left background is the outline of the Antwerp Cathedral of Our Lady. On the other hand, the cathedral is in shadow, while the Liberal Volkshuis on the right is lighted; this suggests that the Liberal Volkshuis workers are passing by the old, symbolized by the Catholic church. Yet at the same time, the cathedral is so familiar a symbol of Antwerp and so centrally placed in the heart of the city, that van Neste appears to be joining the church and the Liberal Volkshuis as two institutions that both equally enjoy the "rights of the city." Like the cathedral, whose tower serves as a link to the city's glorious past as a Flemish cultural and economic center, so the Liberal Volkshuis can rally the working class of Antwerp.

—C.S.

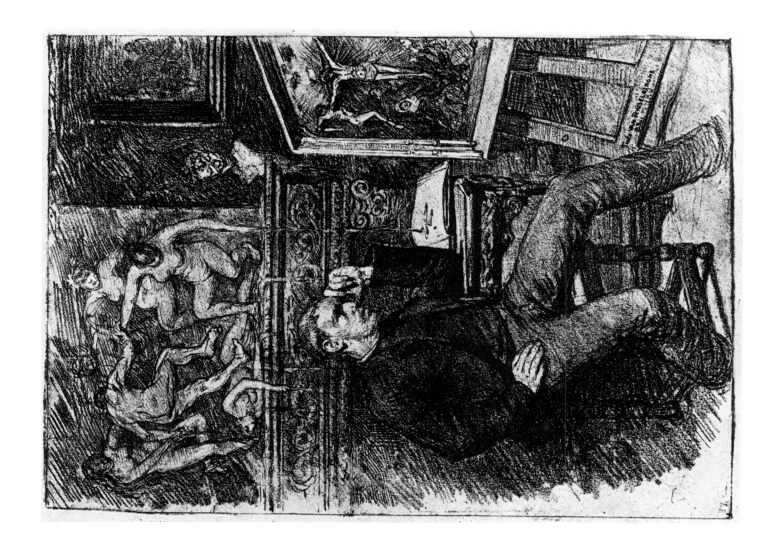

144
Théo Van Rysselberghe
Frontispiece for Emile Verhaeren's *Contes de minuit* (*Midnight Tales*), by 1884
Softground etching
Bibliothèque Royale Albert 1er, Cabinet des Estampes, Quarto SIII 46148
131 x 95 (page size 210 x 140)

THEO VAN RYSSELBERGHE'S frontispiece is a faithful interpretation of the first story in Verhaeren's *Contes de minuit*, published in Brussels by Finck in 1884. The opening "Conte Gras" (Fleshly Tale) is a work of grotesque satire in which a wealthy aesthete, Ernest Vinx, leads a not very earnest life, shut away in a wing of his Antwerp mansion indulging in erotic fantasies inspired by his collection of Teniers and Jordaens, scenes of Flemish Kermesses and ancient bacchanalia populated with women of abundant charms. "During his naps after drinking bouts, his head would roll through purple dreams; he saw himself as the lover of a gigantic Venus by Jordaens; he kissed her eyelids, he warmed his torso with incredible embraces, he drowned in a tide of flesh."[1] The erotic reveries of this modern Tannhauser are interrupted when he inherits a gothic crucifixion scene that he installs in his sanctum. His "fleshly" paintings rebel at the intrusion of this alien and emaciated divinity and literally dissolve in droplets of fat. Verhaeren's "conte gras" is thus a sly cautionary tale of the power of artwork to influence its surroundings and to transform the life of the collector. The story is also Verhaeren's droll exposition of an essential dichotomy of Flemish art and character, which encompasses the exuberant and Rubensian as well as the spiritual and introverted figures of the primitives.

Vinx is not described in Verhaeren's tale but Van Rysselberghe endows him with the massive, leaden physique associated with sloth.[2] An inert, black-clad figure firmly planted in his study, Van Rysselberghe's Vinx contemplates his recently acquired Golgotha in the familiar attitude of Dürer's Melencolia I, idle hand in lap and brooding, ponderous head leaned against a fist. Van Rysselberghe's Melancholy shares the inaction and dark, intellectual force of Dürer's prototype. Dürer, however, had depicted the melancholy of the creative artist, bewinged and surrounded by tools, momentarily abandoned.[3] Van Rysselberghe depicts the melancholy of the idle decadent, lost in unreal projections inspired by the art he has collected. In his perplexity over the Christian mystery, which he faces at eye-level and in the light source, Vinx is unaware that his callipygian nymphs have begun melting from their canvas. A leering marble faun, teetering at the edge of the mantlepiece, one breast dissolved, signals the defeat of Pan. Yet, the face of the grinning satyress remains intact and serves as an emblem of the sardonic mode of Verhaeren's *Contes de minuit*.

—D.F.

1. Verhaeren, *Contes de minuit*, 9.

2. See Snyder's discussion and Dürer's Melencolia I in *Northern Renaissance Art*, 318.

3. Panofsky, *Albrecht Dürer*, 160–166.

145

Théo Van Rysselberghe
Poster for the 1889 Les XX exhibition, 1889
Lithograph in blue ink
Musées royaux des Beaux-Arts de Belgique, Archives de l'art contemporain
1412 x 872

THE poster for the sixth annual exhibition of Les XX combines the group's logo, designed by Fernand Khnopff, with a hand-drawn title set on a background of dots, and a list of Vingtistes and *invités* printed from set type.[1] Although the work is not signed or monogrammed, the poster is attributed to Van Rysselberghe on the basis of a letter written in 1889 to Octave Maus "The poster is ruined. I do not like it at all... Do you want to come and see it or write to Monnom so they will send it to you? If you think I should, I will work on it again... It will be done right at Monnoms, and directly on the stone, in two hours."[2] Maus did not ask Van Rysselberghe to create another poster until the 1896 exhibition of La Libre Esthétique.

Like the 1889 Les XX exhibition, the poster for the event caused a stir in Brussels. One critic ranted, "The dot is in full fashion. The wafer triumphs along the entire gallery wall. The poster itself has not escaped attack—smallpox has spotted it abominably."[3] Neo-impressionism had taken firm hold at Les XX, where Georges Seurat and Camille Pissarro were now joined by the Vingtistes Anna Boch, van de Velde, Toorop and Van Rysselberghe. This trend was seen by some as a disturbing foreign invasion that threatened to undermine the cultural patrimony of Belgium. Those artists who were attracted to this style were labeled "Les Bubonistes." The conservative *La Fédération Artistique* stated that Van Rysselberghe's conversion to neo-impressionism was pernicious to his work and that "pointillism kills everything in him that is original and strong."[4]

The Les XX catalog of 1888 had contained drawings in the pointillist style by Albert Dubois-Pillet and Willy Finch. It seemed only a natural progression to the Vingtistes that Van Rysselberghe's poster should be "spotted" as well.

—J.B.

1. In addition to the Les XX logo, Khnopff designed the 1891 exhibition poster; illus. in Delevoy et. al. *Fernand Khnopff*, 262.

2. "*L'affiche est ratée. Je ne l'aime pas, mais pas du tout.... Veux-tu aller la voir ou écrire à Monnom qu'on te l'envoie? Si c'est ton avis, je la recommencerai... Ce sera fait, chez Monnom même, et directement sur la pierre, en deux heures*": quoted in Chartrain-Hebbelinck, "Lettres de Van Rysselberghe à Maus," 69.

3. "*Le petit point est à la mode, le pain à cacheter triomphe sur toute la rampe. L'affiche elle-même n'y a pas échappé: la variole l'a abominablement piquetée*": "Chronique Artistique," 2 February 1889.

4. "L'Exposition des XX," *La Federation Artistique*, 163.

146

Théo Van Rysselberghe
Maria Sèthe, 1891
Conté crayon
Art Institute of Chicago, 1955.638
311 x 352

MARIA SÈTHE, the fiancée (and later, wife) of Henry van de Velde, sits with her back to the viewer, playing the piano by lamplight. Van Rysselberghe, strongly influenced by the conté crayon drawings of Georges Seurat, employs a single cross-hatched stroke to define all of the forms. He uses the white of the paper as a source of light, illuminating Maria's face and dress, the sheet music, and vertical accents of the wall paneling and mirror. The rich, deep blacks of the conté crayon contrasting with these passages of light create a halo effect around Maria's head and an overall ambience of intimacy and reverie. Only after we have

observed Maria and the reflection from the lamp in the background mirror, do we see that Maria has an audience: a female figure in the right hand corner. (For more on Maria Sèthe, see cat. 142)

This drawing is similar in mood to Lemmen's conté crayon *Au Piano*, also of 1891, in which Lemmen's sister, Julie, is seen from the rear as she plays the piano.[1] Although both drawings are ostensibly about music-making, they are in reality an attempt at visualizing the ineffable: the act of listening to music. Van Rysselberghe, like Lemmen and van de Velde, was attracted to Georges Seurat's neo-impressionist theories.

One of Van Rysselberghe's most accomplished pointillist paintings, *Maria van de Velde*, also depicts Maria at the harmonium (1891, Museum of Fine Arts, Antwerp). —J.B.

1. Illustrated in Cardon R., *Georges Lemmen*, 98.

147

Théo Van Rysselberghe
Portrait of Maria Van Rysselberghe, 1894
Pencil on paper
A. & L. Fontainas Collection
300 x 240

INSCRIBED: pour Madeleine Gevaert 6 déc. 94 VR

This drawing depicts the artist's wife, Maria Monnom (1866-1959), who was the daughter of Sylvie Monnom, director of the publishing house that published Van Rysselberghe's posters and the Les XX and La Libre Esthétique catalogues.[1] The work is dated 6 December 1894 and is dedicated to Madeleine Gevaert, the future wife of Octave Maus.[2]

Van Rysselberghe was a prolific portraitist throughout his career. He painted his first pointillist portrait, *Alice Sèthe*, in 1888, shortly after his conversion to neo-impressionism. His oil portraits from that time until 1900 are exclusively pointillist. One of his most elegant works is the full-length painting of Maria, *Madame Van Rysselberghe* (Otterlo: Kröller-Müller Museum), painted about 1892. However, unlike the genre-portrait of Maria Sèthe [cat. 146], this portrait-drawing of Maria Van Rysselberghe is not rendered in the pointillist style. Instead, Van Rysselberghe employed a variety of techniques: long feathery strokes to delineate his sitter's body; a darker, denser line in the background, which gives a more plastic form to the body and differentiates it from the ground; and delicate cross-hatching for the face.

Unlike Van Rysselberghe's formal oil portraits, where the sitter is situated in a well-defined social and artistic context, the setting here is minimal.[3] The quilted arm of the chair merely suggests a sitting room. Maria's wedding ring, buckle and brooch are

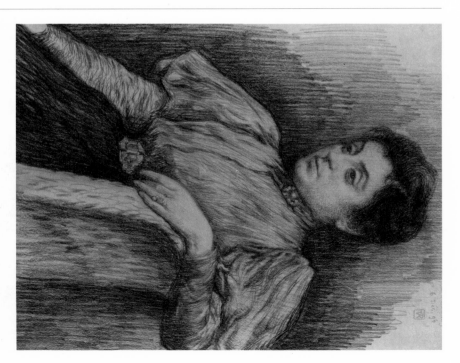

her only ornaments. Instead, the contrasts of light and dark concentrate our attention on her introspective gaze, emphasizing the psychological world of the sitter.

—J.B.

1. An 1885 portrait of Maria Monnom by Fernand Khnopff is reproduced in Delevoy et. al., *Fernand Khnopff*, 236.

2. Madeleine Simon was the widow of Dr. Gustave Gevaert; she and Maus were married in 1903. She wrote the principal historical account of Les XX, *Trente Années de lutte pour l'art*.

3. For more formal portraits, see *Portrait of Anna Boch* (Springfield Museum of Art) or *Maria van de Velde* (Antwerp Museum of Art).

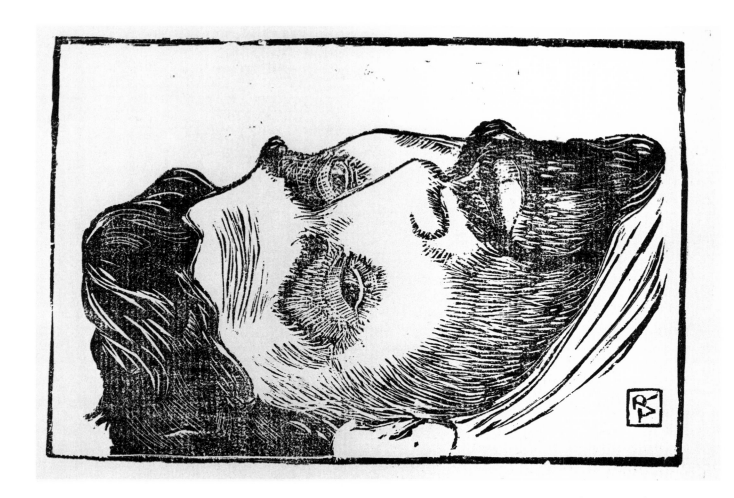

148
Théo Van Rysselberghe
Portrait of Jan Toorop, ca. 1895
Woodcut on brownish, machine laid paper
Los Angeles County Museum of Art, purchased with funds provided by Mr. and Mrs.
Fred Grunwald, 86.7
184 x 133

VAN RYSSELBERGHE'S portrait of Dutch artist Jan Toorop is the result of a warm friendship between the two. Van Rysselberghe and Toorop most probably met in the early 1880s when they joined the Brussels exhibition society L'Essor. Both also were Vingtistes; Van Rysselberghe was a founding member and Toorop joined the group for its second exhibition, in 1885. Toorop helped introduce the works of Seurat, Redon and the Vingtistes into Holland through the Panorama te Amsterdam (Panorama Society of Amsterdam) in 1889 and the Kunstkring (Art Circle) at The Hague in 1892.[1]

Van Rysselberghe received many commissions for formal portraits throughout his long career, producing the largest body of neo-impressionist oil portraits of any artist. His woodcut of Toorop, however, is a personal work that was never exhibited in his lifetime.[2] Van Rysselberghe's design faithfully renders Toorop's striking features, thick wavy head of hair, and coarse beard while also capturing the expression of his intense personality. Painter Maurice Denis, Van Rysselberghe's friend and admirer, noted that "what happens behind each face preoccupied him more than he dared admit. He spoke instead of volumes, of color, of composition, a bit to mask his uneasiness about personality, and psychological likeness."[3]

The portrait of Toorop appears to be Van Rysselberghe's only surviving woodcut. During the summer of 1894, he confessed his first experiments in the medium to Lucien Pissarro (whose woodcut book illustrations set a standard that has never been matched), "I am outfitted to cut the woodblock and shortly will begin the first massacre."[4] Several weeks later he informed Pissarro that these attempts were not at all successful, but added that "the craft really draws me and I am counting on redoing it."[5] It is tempting to place this undated woodcut close to Van Rysselberghe's period of experimentation with the medium, circa 1895; however, it is curious that he would have considered so strong a print to be a failure.

—J.B.

1. For more on the exhibition at The Hague, see Siebelhoff, "The Hague Exhibition." For van de Velde's involvement see Joosten, "Van de Velde en Nederland."

2. Van Rysselberghe did a double-portrait of Toorop and Dario de Regoyos, ca. 1889, that was shown at his first posthumous retrospective in 1927, but this woodcut seems to have been exhibited only at his second major retrospective in 1962. The 1927 exhibition, *Théo Van Rysselberghe: Exposition d'ensemble*, was held from 25 November–6 December and contained 119 paintings, 4 pastels, 15 watercolors, 53 drawings, 24 etchings, and 5 sculptures. The second, even larger exhibition, *Rétrospective Théo van Rysselberghe*, was at the Musée des Beaux-Arts, Ghent, from 1 July–16 September 1962; curated by Paul Eeckhout. The woodcut of Toorop was cat. 282.

3. "Mais ce qui se passe derrière un visage le préoccupait plus qu'il n'osait le dire: il parlait de volumes, de couleur, de composition, un peu pour masquer son inquiétude du caractère, de la ressemblance psychologique": in intro. by Denis in *Théo Van Rysselberghe*.

4. "Je me suis outillé pour tailler le bois et je commencerai ces jours-ci le premier massacre": Van Rysselberghe to Pissaro, 4 July 1894, (Oxford: Ashmolean Museum).

5. The original reads, "J'ai essayé un bois—mais bien trop difficile—et je l'ai raté—dans les hauts prix—Cependant le métier m'attire beaucoup et je compte bien en refaire.": Van Rysselberghe to Pissaro, 12 August [1894], (Oxford: Ashmolean Museum).

149

Théo Van Rysselberghe
Cover for Emile Verhaeren's *Almanach*, 1895
4 proofs (blue, orange, purple, green) on silk
Relief prints
Bibliothèque Royale Albert 1er, Réserve Précieuse
210 x 405 each

150

Théo Van Rysselberghe
Mars (March), 1895
Illustrations in Emile Verhaeren's *Almanach*
Relief prints, copy in green
Private collection
210 x 200

As the year 1900 approached, many almanacs combining artistic and literary contributions were printed. The many versions of the "Almanach des Muses" of the eighteenth century may have served as a general model for these. Probably the most famous of the late nineteenth-century literary/artistic almanacs was *Almanach* with verse by Emile Verhaeren and decorations by Théo Van Rysselberghe (one of Van

Rysselberghe's designs also was used to ornament the fifth number of *Van Nu en Straks*).[1]

Almanach was printed on the presses of van Rysselberghe's mother-in-law, Veuve Monnom, and published by Dietrich & Co. in Brussels. The cover of intertwined morning-glory vines has been called "a perfect balance of Art Nouveau decorative form and typography."[2] The almanac begins with a calendar for the year that includes the phases of the moon; each group of three months is framed in a floral rinceau. It was available on fine Japan or Van Gelder paper, with the cover and decorations printed in one of four colors: blue, green, orange, and violet—each of which is exhibited in a proof impression on silk. These four colors and van Rysselberghe's four full-page drawings evoke the four seasons. The smaller zodiac images at the beginning or end of the poems suggest the twelve months that are the subject of Verhaeren's poems. For example, the opening that is exhibited shows a ram, emblematic of the constellation Aries and the month of March, at the top of Verhaeren's poem "C'est Mars!" ("It is March!"). On the facing left page is Van Rysselberghe's drawing *Les Errants* (*The Wanderers*) that accompanies Verhaeren's poem of the same title for February.

Van Rysselberghe's cover and ornaments were presumably printed from photomechanical relief blocks. They are inevitably referred to as drawings (not woodcuts) in contemporary descriptions and even

by Van Rysselberghe (see below).[3] It can hardly be an accident that the reviewer of *Almanach* for *The Studio* (who considered the book "a very charming thing") took the review as an opportune moment to speak about the suitability of photomechanical relief for certain images:

the idea of the woodcut is peculiarly suited for photo-reproduction; the drawing in bold thick lines loses nothing worth mentioning, even in an ordinary 'zinco' of commerce. Indeed, when printed on rough paper, it needs a strong lens and some amount of technical skill to decide whether it be an impression from a wood-block or a metal *cliché*.[4]

Max Elskamp, who worked extensively in wood-cut but occasionally made use of photomechanical relief printing, makes it clear that photomechanical processes were on the same footing as other artistic mediums.[5] In discouraging his friend Jean de Bosschère from carving his own woodcuts to "orna-ment his thoughts," Elskamp wrote, "it is physically impossible to tell the difference between a woodcut and a zincograph. I consider the former a great loss of time, without mentioning that the cost of the wood is infinitely greater than gillotage."[6]

The title page announces that the book is for sale at the offices of L'Estampe Original in Paris. Van Rysselberghe had written to the director of L'Estampe Original, André Marty, on 15 October to announce

the collaborative venture. He stated that he was working on the drawings for "a calendar in verse by Verhaeren" while at an inn, the Auberge du Mozegat, in Hemixem, a small town on the river Scheldt near Antwerp.[7] Verhaeren followed up with a letter 6 November 1894 telling Marty that the calendar was coming along well and that Van Rysselberghe's drawings had been sent off to "the serious and prudent Mr. Dietrich."[8]

The rural population had long relied on almanacs for following the devotional calendar and the agricultural year. These humble but universal associations were not lost on the avant-garde authors and artists. The almanac format invited pictorial and literary contributions that struck a chord with calendric themes such as the labors of the months, the passage of time, nature's cycles—all of which find some expression in Verhaeren's verse or Van Rysselberghe's drawings.[9]

Although not the first of its kind, the exquisite example of the Verhaeren/Van Rysselberghe almanac may have encouraged a progeny of similar, but generally much less opulent productions. For the years 1896–98, *La Mercure de France* issued an *Almanach*

des Poetes, illustrated by the Belgian artists Auguste Donnay and Armand Rassenfosse.[10] The nineteenth-century Belgian artistic calendar finds an interesting conclusion in *Le Calendrier des Bergers & des Bergères (Shepherd's & Shepherdess' Calendar)*, printed in 1899 by publisher N. Heins, Ghent. It includes facsimile reproductions of the woodcuts used in the famous almanacs published by Guy Marchant, *Le Compost et Kalendrier des Bergiers* and *Le Compost et Kalendrier des Bergères* (first published in 1493.)[11] The Heins calendar also includes a work by a contemporary, predominantly Belgian poet for each month: Camille Lemonnier, Georges Rency, Maurice de Ombiaux, Rodrigue Serasquier, Georges Marlow, Albert Mockel, Cyriël Buysse, Lucien De Busscher, Paul Gérardy, Emile Verhaeren, Richard Ledent, Albert Guequier, and Max Elskamp. None of these later almanacs approached the Verhaeren/Van Rysselberghe *Almanach* in appropriateness of word, typography, and image and their relationship to each other; however, the Heins almanac in particular emphasizes the relevance of historical printed almanacs to contemporary poets and artists. —S.G.

1. *BB* 20, no. 11 (November 1894), 282, no. 372; for the 15 other almanacs published in Belgium for 1895, see 282–85, nos. 373–87. The ornament from the title page of *Almanach* appears in *Van Nu en Straks* 5 (1894), 6 and 18, cited in Ghent: Sint-Pietersabdij, *Van Nu en Straks*, 105, no. 204.

2. Cambridge, Mass.: Houghton Library, *Art Nouveau—Jugendstil Books*, 72–74, no. 85.

3. For example, see de Mont, "Théo van Rysselberghe," 10.

4. *The Studio* 4 (1895), XXXII. I thank Bill North for bringing this review to my attention. For 'zincograph' and 'cliché' see glossary.

5. Elskamp's *Alphabet* makes use of photomechanical border designs, though the key images are apparently carved in wood.

6. Guiette, *Elskamp & Bosschère*, 49; letter of 2 November 1913: "Mon cher Jean, puisque nous parlons gravure, je dois te dire que je suis revenu de l'idée de graver soi-même le décor dont on désire orner sa pensée, et cela parce qu'il est *matériellement impossible de distinguer une gravure exécutée sur bois d'une zincographie*. Je considère qu'il y a en ceci une perte énorme de temps; sans compter que le bois est infiniment plus coûteux que le gillotage (dont le coût est de 7 centimes le centimètre carré]! ce qui n'est rien à côte du buis, qui coûte très cher, et surtout du temps qu'on perd à obtenir un effet *identique* à celui que donnent les procédés mécaniques." For 'gillotage' see glossary.

7. Getty Center, 870525-11 "R"; letter from Van Rysselberghe to Marty: "Auberge du Mozegat à Hemixem—près Anvers, 15 October 94 . . . Je suis venu m'installer ici pour travailler à un

'calendrier' en vers de Verhaeren, que j'ornerai de dessins et qui dout paraita le 1r Xbre prochain—j'irai à Bruxelles une ou peut-être deux fois d'ici cette date, pour m'occuper des details de l'impression." Van Rysselberghe had also written to Lucien Pissaro on 16 September 1892 about his residency in Hemixen, which he described as "near the water"; I thank Jane Block for bringing this reference to my attention.

8. Getty Center, 870525-15 "V–Z"; letter from Van Rysselberghe to Marty: "Le calendrier s'avance tres bien. Les dessins de V. Rysselberghe ont emballé le grave et prudent M. Dietrich."

9. Elskamp's *Six Chansons de pauvre homme pour célébrer la semaine de Flandre* [cat. 16], though not in almanac format, shares this association of the common folk and the reckoning of time.

10. Poets included in the 1896 issue are ALbert Mockel, Robert de Souza, André gide, Camille Mauclair, Gustave Kahn, Stuart Merrill, Francis Jammes, Vielé-Griffin, Henri de Régnier, A.-Ferdinand Hérold, André Fontainas, and Emile Verhaeren. Alfred Jarry, who is conspicuous by his absence from the contributers to *Almanach des Poetes*, offered his own *Almanach du Père Ubu* in 1899 and 1901—wittily illustrated by Jarry himself. Arnaud, Jarry, 330–31, noted that Jarry's exclusion from the Mercure de France almanacs may have caused him to publish his own.

The artists' almanac culminates in the *Blaue Reiter Almanach* of 1912 by the German Expressionist group Die Blaue Reiter (The Blue Rider).

11. The first editions were in 1491, the first with woodcuts in 1493.

151

Théo Van Rysselberghe
Les Errants (The Wanderers), 1897
Lithograph (from album Les Temps Nouveaux)
Jane Voorhees Zimmerli Art Museum, Herbert Littman Purchase Fund, 1986.0888
423 x 514

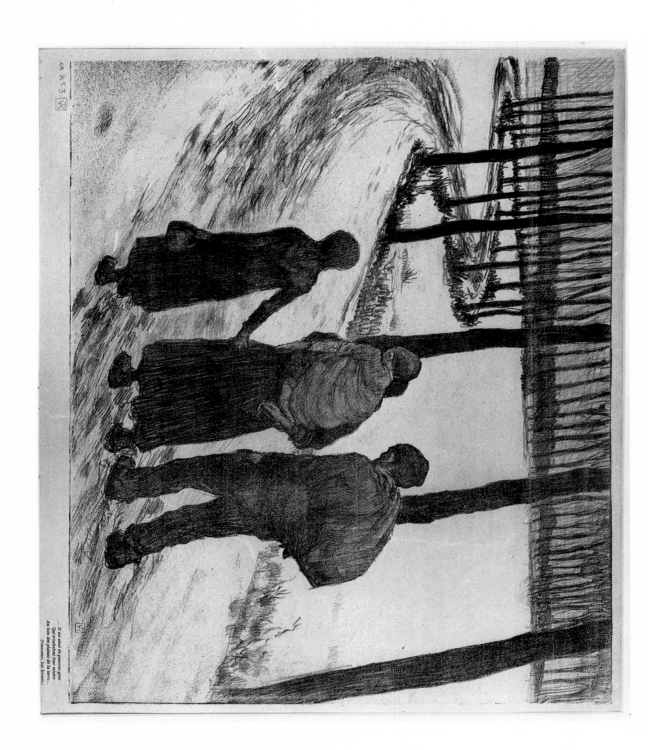

O N 25 March 1896, Jean Grave, editor of the French anarchist periodical *Les Temps Nouveaux* (*New Times*), wrote to his friend Camille Pissarro, to ask advice about a plan to produce a series of thirty lithographs to sell to benefit the journal.[1] Artists who were well known to Pissarro and Grave were to be asked to contribute a drawing to be rendered as a print. The project was begun quickly, and the prints were sold singly as they were produced, with about fifty of each set aside to form the portfolio when all the prints had

been realized (in 1903).[2] Théo van Rysselberghe was the seventh artist to offer a work to *Les Temps Nouveaux*. (Meunier's *Mineurs, Borinage* [cat. 98] was the thirteenth. Paul Signac's lithograph *Au temps d'harmonie* [cat. 123] had been planned for the portfolio, but was withdrawn.)[3] Van Rysselberghe donated ten works of art to *Les Temps Nouveaux* between 1897 and 1909, many of which were raffled off in fund-raising events.[4]

Like Meunier's *Mineurs, Borinage*, *Les Errants* was probably a transfer lithograph, in which case the artist simply supplied Grave with a drawing on paper. The drawing (perhaps lightly treated with a solvent) was placed face down on a clean lithographic stone that was then run through the printing press, transferring the drawing to the stone. It is probable that the artists were instructed to draw with appropriate materials to facilitate this process (transfer paper and lithographic crayon, for example). Due to imperfections in the transfer or printing processes, there are two light horizontal bands at the top of the work that have not been printed well, and there are several reticulated areas where solvent seems to have been applied too aggressively.

This drawing for *Les Temps Nouveaux* is clearly based on a Van Rysselberghe work done earlier in collaboration with Verhaeren. The text by Emile Verhaeren in letterpress at the bottom of the lithograph is taken from his poem "Les Errants," which appeared in his collection *Almanach*, illustrated by Van Rysselberghe [cat. 149 and 150]. The second line of the poem has been deleted to make it more appropriate for an anarchist magazine.

We know that van Rysselberghe enthusiastically offered his assistance to Grave, but that he also felt that his own drawings did not naturally lend themselves to this cause; he considered his attempts at works of a purely literary or philosophical motivation to be failures.[6] In *Les Errants* he could offer an uncontrived composition for *Les Temps Nouveaux* that was thematically relevant to the journal's mission.

The scene of displaced or indigent families was not uncommon in Belgium, particularly after the mobilization of many workers following the general strikes of 1893, and it was taken up as a theme by several Belgian artists, most prominently by Eugène Laermans.[7] Van Rysselberghe gives the theme of the indigent family a specifically Belgian setting; winding lanes lined with evenly-spaced poplars are common to the Flemish countryside, particularly in the polders to the west of Antwerp and north of Ghent.[8] Even with the heightened perspective, it is easy for us to imagine that we are following this group and to empathize with their plight.

—S.G.

1. Dardel, "Les Temps Nouveaux," 18.

2. Ibid., 20, also gives the total edition as 250 (a first edition of 150 sold out quickly, and a second printing of 100 was added).

3. Ibid., 34.

4. Ibid., 46: "1 lithographie en noir, *Les Errants*, 1897,—couverture de la brochure no. 9,—1 dessin dans le journal, 21.10.1905 (reprise);—dons aux tombolas de 1899, février 1900, 1908, 1912,;—dons de trois eaux-fortes en 1909. (—1 lithograph in black, *Les Errants*, 1897,—cover for the brochure no. 9;—1 drawing in the journal, 21 October 1905 (repeat),—gifts to the raffles of 1899, February 1900, 1908, 1912,;—gift of three etchings in 1909.)"

6. See Van Rysselberghe letter to Grave of 1905, given in Ibid., 13.

7. See, for example, Schwandt, "Eugen Laermans."

8. According to Schwandt, 260, the wave of emigrants reached its highest level between 1886 and 1895, with many streaming into Antwerp to travel overseas.

152 [Plate 18]

Théo Van Rysselberghe
N. Lembrée, poster for the Lembrée Gallery, 1897
Color lithograph
The Cleveland Museum of Art, Mr. and Mrs. Charles G. Prasse Collection, 68.257
625 x 443

IN Théo Van Rysselberghe's poster for the Brussels print gallery, N. Lembrée, on the fashionable Avenue Louise, an elegantly attired collector avidly examines the stock of graphic works *chez* Lembrée. The client's poise and statuesque pose are charmingly contrasted with her energized hat and whimsical hairpins. The anthropomorphic telephone with Lembrée's number prominently displayed is a clever commercial "plug." The right-hand corner of the composition bears the artist's monogram and the name of his only printer: Imprimerie Veuve Monnom, the press of his mother-in-law, Sylvie Monnom.

The 1890s saw the creation of a strong Belgian school of poster artists. Posters of the French masters Jules Chéret and Henri de Toulouse-Lautrec were introduced into Belgium by Les XX and l'Association pour l'art. In January 1894 a large international exhibition of poster artists in Brussels did much to acquaint Belgian artists with the possibili-ties of applying high artistic standards to commercial design. By May of 1896 Alexandre Demeure de Beaumont was able to organize an exhibition devoted solely to Belgian poster artists, in Toulouse, France. Six months later he published *L'Affiche Belge* (*The Belgian Poster*), still a standard work on the subject.

In his book Demeure de Beaumont included Van Rysselberghe's poster for La Libre Esthétique of 1896. Van Rysselberghe drew elegant female art patrons for both the 1896 and 1897 posters for that organization. Lembrée clearly admired these works; his own poster repeats the basic form of the 1897 prototype.[1] Although the Lembrée poster bears no date, it was undoubtedly designed in 1897. It was presumably drawn after the poster for the 1897 La Libre Esthétique, which was printed in February; in 1897 it was published in the important book, *Das Moderne Plakat* as well as in "The Studio" of London.[2] —J.B.

1. Lembrée framed the works for La Libre Esthétique exhibitions; Bailly-Herzberg, *Correspondance de Pisarro*, 52. Lembrée is in the Brussels city directories of the period under the heading "cadres" (frames). Van Rysselberghe designed two ads for the gallery that were published in *AM*, 23 February 1896, 64, and 3 January 1897, 8.

2. Sponsel, *Das Moderne Plakat*, 57.

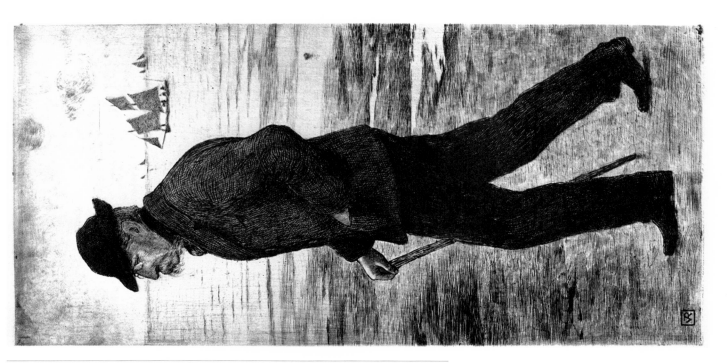

153

Théo Van Rysselberghe
Emile Verhaeren au bord de la mer (Emile Verhaeren at the Shore), ca. 1898
Etching in dark brown and sepia
Bibliothèque Royale Albert 1er, Cabinet des Estampes, Plano SIII 9081
448 x 224

VAN RYSSELBERGHE has depicted the Belgian poet, dramatist, and art critic Emile Verhaeren walking along the Flemish coast in his characteristic red jacket, spectacles and drooping mustache. His form is carefully balanced by the silhouette of a sailboat whose abstraction suggests the Japanese prints so admired by both men.

Verhaeren was drawn to painting almost as much as he was to poetry. Because he was closely tied both to the symbolist poets and to artists of Les XX and La Libre Esthétique, his art reviews are especially illuminating. The close friendship between Verhaeren and Van Rysselberghe began in 1883. One year later, the artist was working with Verhaeren on book illustration, a collaboration that led Van Rysselberghe to ornament nearly every important work by the poet.

Van Rysselberghe was drawn to the illustrative poet's countenance very early in their association. On 6 July 1884 Théo wrote to Verhaeren, "I wish to do several portraits . . . and would like to do yours. I have thought a lot about it. You have a good head—your red Jordanesque coloring, your great golden mustache and your comical eyes!"[1] Over the years Van Rysselberghe depicted Verhaeren in a variety of poses and media, culminating in 1903 with the large group portrait of Verhaeren reading, *La Lecture.*

—J.B.

1. "Je voudrais faire quelques portraits . . . Je voudrais aussi beau coup faire le tien. J'y ai songé, tu as une bonne tête—ta couleur rougeaude, jordanesque, tes grosses moustaches dorées et tes yeux comiques!". Eeckhout, *Théo Van Rysselberghe*, 39, no. 60. For more on the friendship between Verhaeren and Van Rysselberghe see Mabille de Poncheville, "Verhaeren and Van Rysselberghe."

154

Théo Van Rysselberghe
Decoration for George Flé's *Poésies mises en musique pour chant et piano*
(*Poetry Set to Music for Song and Piano*), 1898
Photomechanical ornaments
Private collection, Brasschaat
252 x 182

VAN RYSSELBERGHE'S decoration of twenty head and tailpieces, cover, and title page for his friend, composer Georges Flé (1862-1937), was executed in the beautifully fluid style he had forged in *Almanach* [cat. 149 and 150] and that culminated in his monumental *Histoires Souveraines* of 1899 [fig. 60]. Flé's collection of his musical arrangements of the poetry of Victor Hugo, Paul Verlaine, Auguste Villiers de l'Isle Adam and others is printed in brown, with green vignettes and orange calligraphic titles of

the pieces. Flé's musical transcriptions of the poetry were first played in 1897 at a benefit concert at La Libre Esthétique to raise funds for the establishment of a Verlaine monument.

Although the ornaments are characterized by a flowing graceful line, several are more rectilinear. These more geometric shapes presage Van Rysselberghe's work for the German translation of Verhaeren's poetry by Stephan Zweig, *Ausgewählte Gedichte*, of 1904.

—J.B.

155

Théo Van Rysselberghe
Two separations for Deman catalogue cover, by 1898
Pencil and black ink
A. & L. Fontainas Collection
257 x 187; 234 x 187

V<small>AN</small> R<small>YSSELBERGHE</small> began illustrating books for his friend Emile Verhaeren in 1884; they were published by the art-book firm of Edmond Deman. Thus, it is not surprising that Deman should turn to the artist to design the cover for the 1898 catalogue of books *Publications de la Librairie E. Deman*. The catalogue was issued in both orange and green or navy blue and bluish green. The two colors necessitated separate plates for two press runs: "cliché A," hand-drawn and lettered, bears the title of the catalogue and the dress of the model; "cliché B" the remainder of the image. These draw-ings were photoengraved onto the plates from which the covers were printed with the desired combination of colors.

Van Rysselberghe chose for his subject a woman engrossed in reading while sitting before a curtain of sunflowers. The woman is similar to the female patrons that were the subjects of his poster for the Gallery Lembrée [cat. 152] and for his La Libre Esthétique posters of 1896 and 1897. In fact, the model of the 1896 La Libre Esthétique poster, with pose reversed, bears a strong resemblance to the figure posed on the Deman catalogue cover. —J.B.

156

Théo Van Rysselberghe
Three blocks used by Deman, ca. 1899–1905
Photomechanical relief blocks
A. & L. Fontainas Collection
10 x 24; 19 x 92; 40 x 33

THESE three blocks bear Van Rysselberghe designs that were used for vignettes on books published by Edmond Deman: top left, Emile Verhaeren's *Les Heures d'Après Midi*; top right, Robert de Souza's *Les Modulations sur la Mer & la Nuit*; and, bottom, Auguste Villiers de l'Isle-Adam's *Histoires Souveraines*. The original drawings that Van Rysselberghe made for Deman's books were photoengraved on plates that were nailed to "type-high" blocks of wood. The blocks were then locked into the appropriate chases containing the hand-set letters for the accompanying text. This system eliminated the necessity for woodcut or engraved images; an artist's design, no matter how calligraphic, could be faithfully reproduced alongside the printed text. In addition, let-

ters themselves could be hand-drawn in imitation of a new typeface without actually having to cut one.

The three works for which these blocks were prepared are among Van Rysselberghe's best. *Histoires Souveraines*, published in 1899, is the culmination of Van Rysselberghe's art nouveau style (see also fig. 60). The floral motif with undulating interlacing curves shown here served as a tailpiece for the Villiers' story "L'Aventure de Tsë-i-la," p. 243. The roses used on the title page of Verhaeren's work (repeated on pp. 14 and 18) are more geometric and faceted, betraying their later (1905) date. Van Rysselberghe had already left the mellifluous world of art nouveau in favor of the Austrian and Germanic penchant for legibility and sharpness of line.

—J.B.

157

Théo Van Rysselberghe
Pont à Monnikendam (Bridge at Monnikendam), late 1890s
Etching in greenish-black on van Gelder paper
Josefowitz Collection
238 x 296

THE bustling port of Monnikendam is in North Holland, north of Amsterdam. Its picturesque harbor attracted Van Rysselberghe during his travels in the late 1890s, often in the company of Paul Signac, his good friend and companion of these years. Monnikendam appears frequently as a subject in Van Rysselberghe's work; Signac exhibited a watercolor *Le*

Moulin à Monnikendam (Mill at Monnikendam) at the 1900 La Libre Esthétique.

Pont à Monnikendam is one of a group of etchings of the sea town. Van Rysselberghe paid particular attention to the way the sun lights the decorative pilings of the bridge and plays on the three sails in the right-hand corner of the composition. In its subject

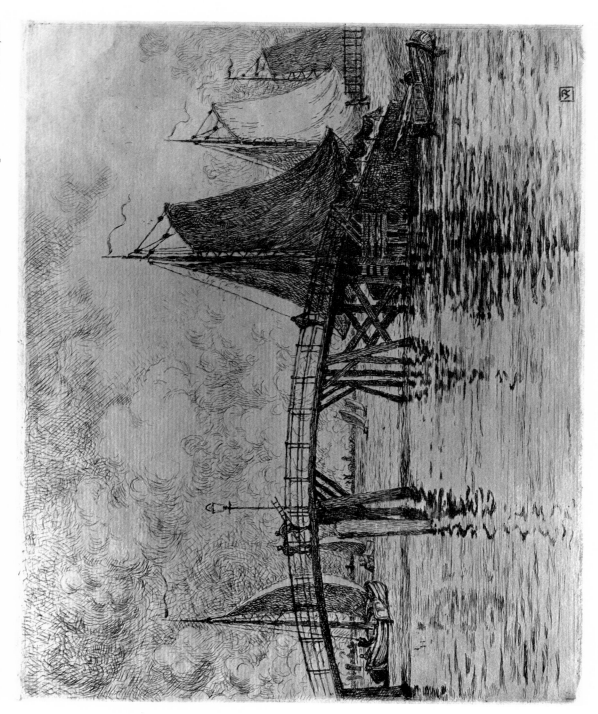

matter and handsome execution, it recalls James McNeill Whistler's etchings, such as *Old Battersea Bridge* of 1879. Whistler's three appearances at Les XX exhibitions (he was an *invité* from its premiere season, 1884) gave Van Rysselberghe ample opportunity to study the master's technique.

Van Rysselberghe was experimenting with etching by 1892 and continued to work in the medium throughout his career. His etchings were greatly admired by his contemporaries. He was invited to show them at the 1899 "Vereinigung bildender Künstler Österreichs," Vienna Secession; he was included among the illustrious printmakers in *Modern Etching and Engraving*, published in 1902 by *The Studio*; and his etchings were praised by the French critic Camille Mauclair.[1] Van Rysselberghe felt a great affinity with etching, in contrast to his frustration with the woodcut. He explained to art critic Pol de Mont, "I will continue my experiments with etching as this medium captivates me and is my province."[2]

Van Rysselberghe exhibited the largest number of etchings in 1901 at both La Libre Esthétique and in Venice at the International Exhibition. Although this etching was not shown there, others set in the same region were, including *Fishing Boats Returning to Volendam* [cat. 158].

—J.B.

1. The volume from *The Studio* was edited by Charles Holme; Fernand Khnopff wrote the section on Belgium, see Khnopff, "Etching and Engraving." See also Mauclair, "Van Rysselberghe."

 Van Rysselberghe also exhibited his etchings at the Galerie Laffitte, Paris, 1895; Le Salon de l'Art Nouveau, 1895; and La Libre Esthétique, 1898.

2. "Je continuerai mes essais d'eau-forte, parce que ce moyen me séduit beaucoup et qu'il est de mon domaine."; de Mont, "Van Rysselberghe," 15.

3. Van Rysselberghe showed eight etchings at La Libre Esthétique, 1–31 March; and twelve etchings in Venice, 22 April–31 October.

158

Théo Van Rysselberghe
Vissersboten terugkerend te Volendam (Fishing Boats Returning to Volendam), ca. 1900
Etching and aquatint in green
Spencer Museum of Art, Phillips Petroleum Foundation, Inc., 86.3
260 x 435

I N this scene of Dutch fishermen returning to shore in inclement weather, the patterns formed by masts, rigging, pennants flying in the breeze, and sails add visual interest to ordinary events. This etching is related to Van Rysselberghe's *Flotille de Pêche*, created for André Marty's portfolio of prints, *l'Estampe Originale*.[1] Stylistically, *Flotille de Pêche* is more geometric and more decoratively abstract, showing the influence of Japanese prints. In *Vissersboten terugkerend te Volendam* Van Rysselberghe relied less on the rigors of geometry and included more naturalistic details, such as the fishermen. It is this movement away from a purely decorative construct towards a greater realism that allows this work to be dated circa 1900.

Van Rysselberghe loved the Belgian coastline of Knokke, and the islands to the north in Zeeland and Northern Holland, especially the towns of Volendam, Monnikendam and Edam, the subjects of several of his etchings. He introduced his friends Lucien and Camille Pissarro, Toulouse-Lautrec, and Paul Signac to the charms of Zeeland. Indeed, it is Paul Signac's marinescapes such as *Concarneau: Fishing Boats*, 1891 (New York: The Metropolitan Museum of Art), that first come to mind when viewing the Van Rysselberghe etching. The rhythmic placement of Van Rysselberghe's fishing boats particularly recalls the Signac. Writing to Lucien Pissarro in October 1893, Van Rysselberghe extolled the virtues of "the beautiful autumn month" he spent in Holland and particularly recommended Volendam.[2] –J.B.

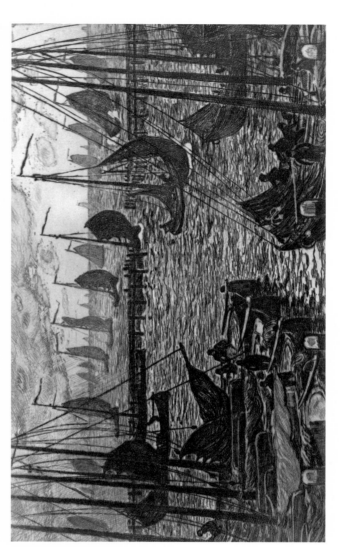

1. For more on the portfolio, and an illustration of Van Rysselberghe's lithograph, see Boyer et. al., *Printmaking in France*, 115. *Flotille de pêche* was published, with the title *Barken in Volendam*, in the Austrian avant-garde review *Ver Sacrum* 2 (1899).

2. Letter from Van Rysselberghe to Pissarro, 19 October 1893 (Oxford: Ashmolean Museum): "Comme ce beau pays vous enthousiasmerait et comme vous en tireriez parti. . . Retenez ces noms: dans la Zuiderzée le îles d'*Urk* et de *Marken*; et, au N. d'Amsterdam, *Volendam*. Et tâchez d'y aller, un jour! Sûrement vous y feriez de belles choses."

159

Guillaume Van Strydonck
Paysage (Landscape), 1885
Drawing
Musée d'Ixelles, Octave Maus 224
253 x 305

ALTHOUGH he trained as an academic painter at the Brussels Academy from 1876 until 1884, Van Strydonck was interested in realist theory and, in addition to his academic studies, he attended a free studio where he worked directly from nature. *Paysage* is representative of Van Strydonck's training and realist style. The view is of a typical Belgian farm house with its land divided by hedges. Van Strydonck renders the scene with a precise and delicate line that underscores an almost photographic approach to detail. The artist arranged the scene in a series of horizontal planes, broken by the verticals of barren trees.

By placing the house asymmetrically on the horizon line, he adds complexity to what would otherwise be uninteresting topography. The view is from an elevated perspective, perhaps from a hill or a window opposite the house. This perspective suggests the proprietal glance toward a favored spot of either the artist or Octave Maus, who owned the drawing.

Paysage was in a portfolio of works in Maus' collection. In the early 1880s Van Strydonck, as did several other Vingtistes (including Charlet, see cat. 2), gave Maus a drawing as testimony of their friendship. When Maus died the portfolio was given to the Musée à Ixelles.

—S.C.

Bibliography

"À l'Exposition de Bruxelles." *RGB* 1 (November 1897): 67–71.

Abeels, G. "Les Communications dans et vers la Ville aux XIXe et XXe siècles." In *La Région de Bruxelles: Des Villages d'Autrefois à la Ville d'Aujourd'hui*, 232–245. Eds. A. Smolar-Meynart and J. Stengers. Brussels: Crédit Communal, 1989.

Adams, Brooks. "Ensor as a 1980s Artist." *Print Collector's Newsletter* 19, no. 1 (March–April 1988): 10–12.

Adeline, Jules. *Les Arts de Reproduction Vulgarisés.* Paris: Ancienne Maison Quantin, Librairies-Imprimeries Réunies, [1894].

Agulhon, Maurice. *Marianne into Battle.* Cambridge and Paris: Cambridge University Press, 1981.

Aitken, Geneviève and Samuel Josefowitz. *Artistes et Théâtres d'Avant-Garde: Programmes de théâtre, illustrés, Paris 1890–1900.* Paris: Musée de Pully, 1991.

Alhadeff, Albert. "George Minne: Fin de Siècle Drawing and Sculpture." Ph.D. Diss., New York University: The Institute of Fine Arts, 1971.

―――. "George Minne: Maeterlinck's fin de siècle Illustrator." *Annales de la Fondation Maurice Maeterlinck* 12 (1966): 7–42.

―――. "Minne and Gauguin in Brussels: An Unexplored Encounter." In *La Sculptura nel XIX Secolo*, 177–88. Ed. H.W. Janson. Bologna: XXIV International Congress for the History of Art, 1982.

Alpers, Svetlana. *The Art of Describing: Dutch Art in the Seventeenth Century.* Chicago: The University of Chicago Press, 1987.

Alvin, M. *Exhibition d'eaux-fortes de Rembrandt, d'Adrien Van Ostade. etc. au Cercle artistique et littéraire de Bruxelles.* Brussels: 1855.

Antwerp: Hessenhuis. *Culturele Affiches te Antwerpen in Kunsthistorisch Perspectief, 1880–1914.* L. Denys, 1991.

―――: Museum Plantin-Moretus. *Exposition Du Livre Moderne: Catalogue.* 1904.

―――. *De drukkerij en uitgaverij J.-E. Buschmann te Antwerpen 1842–1967.* 10–22 November 1967.

Arbeit und Alltag: Soziale Wirklichkeit in der Belgischen Kunst 1830–1914. Berlin: Neue Gesellschaft fur Bildende Kunst, 1978.

Arnaud, Noël. *Alfred Jarry, d'Ubu roi au Docteur Faustroll.* Paris: La Table Ronde, 1974.

Arnay, Albert. "Chronique littéraire." *Le Réveil* 8 (November–December 1896): 321.

Aron, Paul. "Les Arts et les lettres en 1886." In 1886, *La Wallonie née de la grève?* by Bruwier, et. al., 151–66. Brussels: Editions Labor, 1990.

―――. *Les Écrivains belges et le socialisme (1880–1913). L'expérience de l'art social: d'Edmond Picard à Emile Verhaeren.* Brussels: Editions Labor, 1985.

―――. "Le symbolisme belge et la tentation de l'art social: une logique littéraire de l'engagement politique." *Les Lettres romanes* 40 (1986): 316.

Arwas, Victor. "Félicien Rops." In *Félicien Rops*, 3–11. London: Arts Council of Great Britain, 1976–77.

Aubry, François. "Henry van de Velde ou la négation de la mode." *Revue de l'institut de Sociologie* (1977): 293–306.

Au Pays noir, plume et crayon. Charleroi: Jos. Delaune, 1894.

Baas, Jacquelin, and Richard Field. *The Artistic Revival of the Woodcut in France 1850–1900.* Ann Arbor: The University of Michigan Museum of Art, 1984.

Baedeker, Karl. *Baedeker's Belgium and Holland.* Leipzig: Karl Baedeker, 1910.

Bailly-Herzberg, Janine. *Correspondance de Camille Pissarro Tome 3/1891–1894.* Paris: Presses Univeritaires de France, 1980.

Baudet, Colette. *Grandeur et Miseres d'un editeur belge: Henry Kistemaeckers (1851–1934).* Brussels: Labor, 1986.

Baudin, Fernand. "Books in Belgium." In *Book Typography 1815–1965 in Europe and the United States of America*, 3–36. Chicago: The University of Chicago Press, 1966.

―――. "Le dessin du caractère." In *Art nouveau Belgique*, 198–204. Brussels: Palais des Beaux-Arts, 1980–81.

——. "La formation et l'évolution typographiques de Henry van de Velde (1863–1957)." *Quærendo* 1 (October 1971): 272–73 and 2 (January 1972): 55–73.

Baumann, Emile. *La Vie terrible d'Henry de Groux.* Paris: Grasset, 1936.

Beardsmore, Hugo Baetens. *Le Français Régional de Bruxelles.* Brussels: Presses Universitaires de Bruxelles, 1971.

Belloni, Andrea P.A., ed. *A Day in the Country: Impressionism and the French Landscape.* Los Angeles: Los Angeles County Museum of Art, 1984.

Berg, Christian. "Dix-Neuf lettres de Max Elskamp à propos des Six chansons imprimées par Henry van de Velde." *Le livre et l'estampe* 16 (1970): 151–76.

Bergmans, Paul. "Siret." *BN* 22. Brussels: Emile Bruylant, 1914–20: cols. 643–50.

Berlin: Neue Gesellschaft für Bildende Kunst. *Arbeit und Alltag: Soziale Wirklichkeit in der Belgischen Kunst, 1830–1914.* 1979.

Bienenstock, Jennifer A. Martin. "Gari Melchers and the Belgian Art World." In *Gari Melchers, A Retrospective Exhibition,* 75–110. St. Petersburg, Florida: Museum of Fine Arts, 1990.

——. "The Insel-Verlag 'Zarathustra': An Untold Tale of Art and Printing." *Pantheon* 45 (1987): 129–137.

Bisanz-Prakken, Marian. "Jan Toorop en Gustav Klimt." *NKJ* 27 (1976): 175–209.

Block, Jane. "The Art Poster in Belgium." In *Homage to Brussels, The Art of Belgian Posters 1895–1915,* Jane Block and Trudy Hansen. New Brunswick, N.J.: Jane Voorhees Zimmerli Art Museum, 1992.

——. "La Maison d'Art. Edmond Picard's Asylum of Beauty." In *Irréalisme et Art Moderne. Le voies de l'imaginaire dans l'art des XVIIIe, XIXe, et XXe siècles / Mélanges Philippe Roberts-Jones,* 145–62. Ed. Michel Draguet. Brussels: Section d'Histoire de l'Art et d'Archéologie de l'Université Libre de Bruxelles, 1991.

——. "A Neglected collaboration: Van de Velde, Lemmen, and the Diffusion of the Belgian Style." In *The Documented Image: Vision in Art History,* 147–164. Syracuse: Syracuse University Press, 1987.

——. "A Study in Belgian Neo-Impressionist Portraiture." *Art Institute of Chicago Museum Studies* 13 (1987): 36–51.

——. *Les XX and Belgian Avant-Gardism 1868–1894.* Ann Arbor: UMI Research Press, 1984.

——. "What's in a Name: The Origins of 'Les XX.'" *BMRBA* (1981–84): 135–141.

Bloy, Léon. *Le Mendiant ingrat (Journal de l'auteur) 1892–1895.* 2 vols. Paris: Mercure de France, 1928.

——. *Oeuvres de Léon Bloy.* 15 vols. Ed. Jacques Petit. Paris: Mercure de France, 1964–1975.

Bloy, Léon and Henry de Groux. *Correspondance Léon Bloy et Henry de Groux.* Paris: Éditions Bernard Grasset, 1947.

Bonafous-Murat, Arsène. *Ouvriers et paysans. L'estampe témoignage et protestation, 1830–1915.* Paris: Ateliers Breg, 1983.

Bouillon: Musée Ducal. *Paysages et Villegiature pour une princesse (1869–1912).* 1 July –30 September 1983.

Bown-Taevernier, Sabine, ed. *Aspecten van het Symbolisme. Tekeningen en Pastels.* Antwerp: Museum voor Schone Kunsten, 1985.

Boyer, Patricia Eckert, and Phillip Dennis Cate. *L'Estampe originale: Artistic printmaking in France 1893–1895.* Zwolle: Waanders Publishers, 1991–92.

Braet, Herman. *L'accueil fait au Symbolisme en Belgique 1885–1900.* Brussels: Palais des Academies, 1967.

Brenan, Gerald. *The Spanish Labyrinth* [1943]. Cambridge: Cambridge University Press, 1980.

Breuer, A., ed. *Nos contemporains.* Ixelles-Brussels: Imprimerie Economique A. Breuer, 1904.

Brewster, Carrie. *James Ensor, Self Portrait in Prints, 1886–1931.* Purchase: Neuberger Museum, State University of New York at Purchase, 1990.

Brooklyn: The Brooklyn Museum. *Belgian Art 1880–1914.* 1980.

Brown, Frank Chouteau. *Letters & Lettering: A treatise with 200 examples.* Boston: Bates & Guild Company, 1906.

Bruneel-Hye de Crom, M. "L'Exposition de Tervueren et l'Art Nouveau." In *Tervueren 1897.* Tervueren: Musée Royal d'Afrique Centrale, 1967.

Brussels: ASLK/CGER. *Kunst & Camera / Art & Photographie.* 28 November 1980 – 11 January 1981.

——: Banque Lambert. *Vie des Femmes 1830–1980.* (Europalia) 1980.

——: Centre International pour l'Etude du XIXe Siècle. *Catalogue des dix expositions annuelles Bruxelles.* 1981.

——: Galerie d'Exposition Avenue de la Toison d'Or 56. *Bruxelles, À la Toison d'Or, Une Maison d'Art à Bruxelles.* n.d.

——. *Bruxelles, "À la Toison d'Or, 't Gulden Vlies."* [no. 2. Notice sur la Maison d'Art]: n.d.

——: Gallery J. & A. Le Roy Frères. *Catalogue de la Collection de Tableaux Anciens et Modernes; Aquarelles, Dessins, Eaux-Fortes, Lithographies de M. Edmond Picard.* 26 March 1904.

——: Musée d'Ixelles. *Rops et la Modernité. Oeuvres de la Communauté Française. Acquisitions récentes (1988–1990), Choix d'oeuvres.* Belgium: Editions IPS: 1991.

——: MRBA. *Académie Royale des Beaux-Arts de Bruxelles, 275 ans d'enseignement.* Crédit Communal/Gemeentekrediet, 1987.

——. *A.W. Finch, 1854–1930.* 1992.

——. *Félicien Rops 1833–1898.* 1985.

——. *Palais des Beaux-Arts. Art nouveau Belgique.* 1980–81.

——. *Henry van de Velde, 1863–1957.* 1963.

——. *James Ensor.* 1929.

Bruwier, Marinette, Claude Desama, Nicole Caulier-Mathy, and Paul Gérin, eds. 1886, *La Wallonie née de la grève?* Brussels: Editions Labor, 1990.

Bruylants, Jan. *Fridolien, Volksdrama in Vijf Bedrijven en Zes Tafereelen.* Antwerp: Ch. Mortelmans, 1864.

Buet, Charles. "Le Christ aux Outrages." *La Plume,* de Groux issue: 248–50.

Burn, D.L. *The Economic History of Steel-Making, 1867–1939.* Cambridge: Cambridge University Press, 1940.

Burty, Philippe. "Les Eaux-fortes de M. Henri Leys." *Gazette des Beaux-Arts* 20 no. 5 (May 1866): 467–77.

Busine, Laurent. "Jules Destrée et Henry de Groux: analyse d'une correspondance." In *Autour de Jules Destrée*, 69–82. Charleroi: Institut Jules Destrée and Brussels: Centre culturel de la Communauté Française Wallonie, 1986.

Buyck, Jean F. "Antwerp, Als Ik Kan, and the Problem of Provincialism." In *Belgian Art 1880–1914*, 71–80. Brooklyn: The Brooklyn Museum, 1980.

———. *Antwerpen 1900, Schilderijen en tekeningen 1880–1914.* Antwerp: Koninklijk Museum voor Schone Kunsten, 1985.

———. "De Kunstkring Als Ik Kan en zijn betekenis voor het culturele leven te Antwerpen in de tachtiger jaren van de XIX de eeuw." In *Als Ik Kan*, 9-23. Antwerp: Museum voor Schone Kunsten, 1973.

Cambridge, Mass.: Houghton Library, Harvard University. *The Turn of a Century, 1885–1910: Art Nouveau—Jugendstil Books.* 1970.

Canning, Susan M. "Le Cercle des XX." Brussels: Tzwern-Aisinber Fine Arts, 1989.

———. *Henry van de Velde (1863–1957), Paintings and Drawings* Antwerp: Koninklijk Museum voor Schone Kunsten and Otterlo: Rijksmuseum Kröller-Müller, 1988.

———. "A History and Critical Review of the Salons of 'Les Vingt': 1884–1893." Ph.D. Diss., The Pennsylvania State University, 1980.

———. "The Symbolist Landscapes of Henry van de Velde." *Art Journal* 45 (Summer 1985): 130–36.

Cardon, Roger. *Georges Lemmen (1865–1916).* Antwerp: Petraco-Pandora, 1990.

Cardon, Valerie. "L'Art Indépendant, 1887–1888 ou le combat pour un art nouveau à Anvers." Memoire: Catholic University of Louvain, 1987.

Casier, J. "Fête d'Art organisée par la Section gantoise le 7 mars 1907." *Bulletin de l'Association belge de photographie* 34 (1907): 161.

Cassirer, Ernst. *Language and Myth.* New York: Dover, 1943.

"Catalogue de l'exposition des XX." *Art et Critique* (1 February 1890): 76–77.

"Cercle Artistique, Littéraire et Scientifique." *Le Précurseur* (11 May 1852): 1.

Charleroi: Institut Jules Destrée, and Centre culturel de la Communauté française Wallonie, Brussels. *Autour de Jules Destrée.* 1986.

———. Palais des Beaux-arts. *Art et Société en Belgique, 1848–1914.* 1980.

Chartrain-Hebbelinck, Marie-Jeanne. "Les Lettres de Paul Signac à Octave Maus." *BMRBA*, 18, no. 1–2 (1969): 52–102.

———. "Les lettres de Théo Van Rysselberghe à Octave Maus." *BMRBA* (1966): 59–75.

Chipp, Herschel B. *Theories of Modern Art, A Source Book by Artists and Critics.* Berkeley, Los Angeles and London: University of California Press, 1968.

Chlepner, B.S. *Cent ans d'histoire sociale en Belgique.* Brussels: Institut de sociologie Solvay, 1956.

Claes, Jean. "Le Travail de la femme." *Le Peuple* (16 December 1885).

Clark, Samuel. "Nobility, Bourgeoisie, and Industrial Revolution in Belgium." *Past and Present* 105 (1984): 140–175.

Clark, T.J. *The Painting of Modern Life: Paris in the Age of Manet and His Followers.* Princeton: Princeton University Press, 1984.

Clayson, Hollis. *Painted Love: Prostitution in the French Art of the Impressionist Era.* New Haven and London: Yale University Press, 1991.

Clercx-Léonard-Etienne, Françoise. *François Maréchal, 1861–1945* Liège: Cabinet des Estampes, 1980.

Closson, Ernest and L. Van den Borren, eds. *La Musique en Belgique du Moyen Age à nos jours.* Brussels: La Renaissance du Livre, 1950.

Clough, Shepard B. *A History of the Flemish Movement in Belgium.* New York: R. H. Smith, 1930.

Coats, Alice M. *Flowers and Their Histories.* New York: McGraw Hill, 1971.

Commission du travail instituée par arrêté royal du 15 avril 1886. Brussels: 1887.

Commission Flamande: Installation, Délibérations, Rapport, Documents Officiels. Brussels: Korn, Verbruggen, 1859.

Conférence de jeune barreau d'anvers, exposition du croquis et de la caricature juridiciaires, catalogue. Antwerp: Buschmann, 1904.

Conférence de jeune barreau d'anvers, exposition du document juridiciaire, catalogue. Antwerp: Buschmann, 1911.

Conférence du jeune barreau de Bruxelles. 50me Anniversaire. Exposition du souvenir professionnel. 14 Février 1891. Brussels: Veuve Ferndinand Larcier, 1891.

Conférence du jeune barreau, Fête Jubilaire, Omnia Fraternèl. Brussels: Ferdinand Larcier, 1891.

"Conservation des Estampes." *RGB* 6 no. 6 (March 1903): 62–63.

"Constantin Meunier." *La Revue de Bruxelles*, special number. December 1978.

Corbin, Alain. *Women for Hire: Prostitution and Sexuality in France after 1850.* Trans. Alan Sheridan. Cambridge and London: Harvard University Press, 1990.

Craeybeckx, Jan. *Arbeidersbeweging en Vlaamsgezindheid voor de Eerste Wereldoorlog.* Brussels: Koninklijke Academie voor Wetenschappen, Letteren, en Schone Kunsten van België, 1978.

Crane, Walter. *Of the Decorative Illustration of Books Old and New.* London: George Bell and Sons, 1896.

Croquiz, Albert. *L'Ouvre Gravé de James Ensor.* Geneva and Brussels: Editions Pierre Cailler, 1947.

Cuvelier, Guy. *Félicien Rops*. Brussels: Lebeer Hossmann, 1985.

d'Ardenne, Jean. "Gustave Lemaire." In *Oeuvre de la Presse 1891, Fêtes de Chevalerie, Grand'Place*, ed. Ad. Mertens 22–25 np, nd.

Dardel, Aline. "*Les Temps Nouveaux*" *1895–1914, Un hebdomadaire anarchiste et la propaganda par l'image*. Paris: Dossiers du Musée d'Orsay, 1987.

Davignon, Henri. *L'Amitié de Max Elskamp et d'Albert Mockel (lettres inédites)*. Brussels: Palais des Académies, 1955.

Day, Kenneth. "Books in Belgium." In *Book Typography 1815–1965 in Europe and the United States of America*, 3–36. Chicago: University of Chicago Press, 1966.

Deconinck, M. "Origine et Evolution des Surfaces Vertes de l'Agglomération Bruxelloise, de la Fin du XVIIIe siècle à nos jours." *Bulletin Trimestriel, Crédit Communal de Belgique*, 36, 141 (1982):175–200.

De Belder, J. "Structures Socio-Professionnelles." In *Bruxelles: Croissance d'une Capitale*, 227–234. Ed. Jean Stengers. Antwerp: Mercatorfonds, 1979.

De Croës, Catherine, and Françoise Clercx-Léonard-Etienne. *François Maréchal 1861–1945 Graveurs et dessins, Collection du Cabinet des Estampes de la Ville de Liège*. Liège: Cabinet des Estampes, 1908.

Defourney, M. "Formulation de l'Esprit Nouveau." In *Histoire de la Belgique Contemporaine*, volume II. Brussels: Albert Dewit, 1919.

de Heusch, Serge Goyens. *L'Impressionnisme et le Fauvisme en Belgique / Het Impressionnisme en het Fauvisme in Belgïe*. Brussels: Musée d'Ixelles (Ludion), 1990.

De Leener, Georges. *Le Marche charbonnier belge*. Brussels: Goemaere, 1908.

Delevoy, Robert L. "Les Arts appliqués à la vie quotidienne." In *Henry van de Velde, 1863–1957*, 31–45. Brussels: Palais des Beaux-Arts, 1963.

——. *Ensor*. Antwerp: Fonds Mercator, 1981.

Delevoy, Robert L., Catherine De Croës and Gisele Ollinger-Zinque. *Fernand Khnopff*. Brussels: Lebeer Hossmann, 1987.

Delevoy, Robert L., Gilbert Lascault, Jean-Pierre Verheggen, and Guy Cuvelier. *Félicien Rops*. Lausanne, Paris: Bibliothèque des Arts, 1985.

Delmer, Louis. *Le Fils du grèviste*. Brussels: Société belge de librairie, 1889.

Delsemme, Paul. "Le mouvement naturaliste dans le cadre des relations littéraires entre la france et la belgique francophone." *RUB* (1984):7–26.

Delteil, Loys. *Le Peintre Graveur Illustré (XIXe et XXe siècles)* 19, *Henri Leys, Henri de Braekeleer, James Ensor*. Paris: chez l'auteur, 1925.

De Maeyer, Charles. "Fernand Khnopff et ses modèles." *BMRBA* (1964 1/2):43–56.

de Marez, Guy, and A. Rousseau. *Guide Illustré de Bruxelles, Monuments Civils et Religieux*. Brussels: Touring Club Royal de Belgique, 1979.

Demolder, Eugène. "Chronique Littéraire" *Le Coq Rouge* 1 (May 1895):54.

——. "Une exposition du livre belge. À Jacques Des Cressonnières et Max Hallet." *AM* 20 (19 August 1900):261–263.

——. *James Ensor, Mort mystique d'un théologien*. Brussels: Lacomblez, 1892.

——. *La Légende d'Yperdamme*. Paris: Mercure de France, 1896.

——. *Le Royaume authentique du Grand saint Nicolas*. Paris: Mercure de France, 1897.

De Mont, Pol. "Les Artistes de Pays-Bas, Théo van Rysselberghe / Zuid-en Noordnederlandse Kunstenaars: Théo van Rysselberghe." *Kunst & Leven / L'Art & La Vie* I, no. 1 (1902): 1–15.

——. "Die Graphischen Künste im heutigen Belgien und ihre Meister." *Die Graphischen Künste* 23, 24 (1900 and 1901).

de Munck, Emile. *Proposition à la Société d'Archéologie de Bruxelles pour qu'elle prête son concours au développement des Arts Graphiques en Belgique ... suivie d'une Notice de A. Desaucourt sur les auteurs & imprimeurs de la vignette, de l'en-tête de page, du cul-de-lampe & de la lettrine qui ornent le titre & texte de cette proposition*. Brussels: Xavier Havermans, 1888.

——. "Le Tombeau des Estampes." *RGB* 2 no. 5 (September 1898):49.

Deneckere, Marcel. *Histoire de la Langue Française dans les Flandres 1770–1823*. Ghent: Romancia Gandensia, 1954.

Denis, Maurice, intro in Brussels: Galerie Giroux. *Théo Van Rysselberghe: Exposition d'ensemble*. 1927

de Sadeleer, Pascal. *Bibliothèque Littéraire d'un Amateur*. Brussels: Galerie Simonson, 28 May 1988.

——, ed. *Collection exceptionnelle de Dessins, Gravures, Peintures de Félicien Rops*. Brussels: Librairie Simonson, 15 December 1990.

——. "Max Elskamp et la presse privée." In *D'Un livre à l'autre*, 15–19. Morlanwelz: Musée royal de Mariemont, 1986.

——. *Max Elskamp. Poète et graveur Catalogue raisonné d'un ensemble exceptionnel de son oeuvre littéraire et graphique*. Brussels: Librarie Simonson, 1985.

de Schaepdrijver, Sophie. "Regulated Prostitution in Brussels, 1844–1877: A Policy and Its Implications." *Newsletter of the International Association for the History of Crime and Criminal Justice* 10 (November 1986).

Deschamps, Léon. "Paul Lacomblez." *AM* 13 (23 July 1893):233–35.

——. "La Renaissance Belge." *La Plume* 3 (15 June 1891):195–6.

De Seyn, Eugène. *Dictionnaire des écrivains Belges, Bio-Bibliographie*, 2 vols. Bruges: Excelsior, 1930–31.

——. *Dictionnaire Historique et Géographique des Communes Belges*, 2 vols. Brussels: A. Bieleveld, 1933–34.

de Souza, Robert. *Modulations sur la Mer & La Nuit*. Brussels: Edmond Deman, 1899.

Destrée, Jules. *Les Art Anciens du Hainaut, Conférences*, (Exposition de Charleroi 1911, Groupe des Beaux-Arts). Brussels: G. Van Oest, 1911.

————. [untitled discussion of Constantin Meunier]. *La Plume* 350 (15 November 1903): 78.

————— and Emile Vandervelde. *Le socialisme en belgique*. Paris: V. Giard and E. Briere, 1903.

Destrée, Olivier Georges. *Les Préraphaélites. Notes sur l'art décoratif et la peinture en angleterre*. Brussels: Vve Monnom for MM. Dietrich & cie, 1894.

————. "Die Schmuckkünstler Belgiens: Georges Lemmen." *Dekorative Kunst* 1 (December 1897): 105–111.

De Weerdt, Denise. "Organisatie B.W.P. (1885–1914)." In *Geschiedenis van de Socialistische Arbeidersbeweging in België*, 423–431. Antwerp: S.M. Ontwikkeling, 1960.

Documents relatifs au travail des enfants et des femme dans les manufactures. Brussels: 1871.

Dommanget, M. *Histoire du premier mai*. Paris: Société universitaire d'éditions et de librairie, 1953.

Dommartin, Léon. "Profession de foi." In *L'Art libre* no. 1 (15 December 1871): 1–3.

Dooijes, Dick, and Pieter Brattinga. *A History of the Dutch Poster, 1890–1960*. Amsterdam: Scheltema and Holkema, 1968.

Drion, Prosper. *Les Graveurs Liégeois Contemporains*. Liège: Aug. Bernard, 1905.

Dulière, Cécile, ed. *Victor Horta Mémoires*. Brussels: Ministrère de la communauté française de Belgique, 1985.

Dumont, Georges-Henri, and Jo Walgrave. "La Femme belge et le travail (1830–1980)." In *Vie des Femmes 1830–1980*, 59–71. Brussels: Banque Bruxelles Lambert (Europalia), 1980.

Echevarría, José María Moreno. *Isabel II Biografía De Una España En Crisis*. Barcelona: Ediciones 29, 1973.

Eeckhout, Paul. *Rétrospective Théo Van Rysselberghe*. Ghent: Museum voor Schone Kunsten, 1962.

Egbert, Donald Drew. *Social Radicalism and the Arts*. New York: Alfred A. Knopf, 1970.

Eggerickx, T. and M. Poulain. "1,000,000 de Bruxellois: Esquisse Démographique des Communes de la Région Bruxelloise." In *Les Dossiers Bruxellois*, no. 12/13. Brussels: DIRE, 1990.

Eisenman, Stephen F. "Allegory and Anarchism in James Ensor's *Apparition: Vision Preceding Futurism*." In *Record of the Art Museum, Princeton University* 46 no. 1 (1987): 2–17.

Elskamp, Max. *Chansons et Enluminures*. Brussels: Editions Jacques Antoine, 1980.

Emich, Karl (Count zu Leiningen Westerburg). *German Book Plates, an Illustrated Edition of German and Austrian Ex-Libris*, trans. G. Ravenscroft Dennis. London: G. Bell and Sons, 1901.

The Encyclopedia Britannica, 11th edition, 29 vols. New York, 1910–11.

Ensor, James. *Mes Ecrits*. Liège: Editions Nationales Liège, 1974.

Elesch, James N. *James Ensor. The Complete Graphic Work, The Illustrated Bartsch* vol. 141. New York: Abaris Books, 1982.

Estrada, Yolanda. "The Salon de la Plume (1892–1895)." Ph.D Diss., University of Kansas, 1991.

"Exposition de Noir et Blanc à L'Essor." *AM* 2 no. 30 (23 July 1882): 238.

"L'Exposition des XX." *La Federation Artistique* (26 January 1890): 163.

"L'Exposition des XX: L'Art Jeune." *AM* 4 (12 February 1884): 49.

Exposition du Souvenir Professionel, Catalogue. Special number of *Le Jeune Bareau d'Anvers* (21 October 1893).

Faider-Thomas, Th. "Anna Boch et le groupe des XX." In *Miscellanea Jozef Duverger. Bijdragen tot de Kunstgeschiedenis der Nederlanden*, vol. I, 402–10. Ghent: Vereniging voor Geschiedenis der Textielkunsten, 1968.

Farmer, John David. *Ensor*. New York:The Art Institute of Chicago and The Solomon R. Guggenheim Museum, 1976.

Fayt, René. "Un Éditeur des naturalistes: Henry Kistemaeckers." *RUB* 4–5 (1984): 217–39.

"Félicien Rops et l'École de Gravure en Belgique." *AM* (3 July 1881): 140–41.

Ferniot, Paul. "Catalogue de l'oeuvre de Henry de Groux." *La Plume*, de Groux issue. 285–87.

Fierens-Gevaert, Hippolyte. "La Bonté de Meunier." *Le Samedi* 13. (8 April 1905): 2.

Fischer, Frans. *Bruxelles d'autrefois*. Brussels: Editions Labor, 1944.

Foner, P.S. *May Day, A Short History of the International Workers' Holiday*. New York: International Publishers, 1986.

Fontainas, Luc and Adrienne Fontainas. "Biographie et bibliographie d'Edmond Deman." *Bulletin du Bibliophile* 3 (1986): 309–379 and 4 (1986): 485–582.

Frangia, Maria Luisa. *Il Simbolismo di Jean Delville*. Bologna: Patron, 1978.

Frankfurt am Main, Frankfurter Kunstverein, Steinernes Haus am Römerberg. *Pastelle und Zeichnungen des belgischen Symbolismus*. 1988.

Friedman, Barry, et. al. *Fernand Khnopff and the Belgian Avant-Garde*. Chicago: David and Alfred Smart Gallery [New York: Barry Friedman Ltd.]: 1983.

Friedman, Donald Flanell. *An Anthology of Belgian Symbolist Poets*. New York and London: Garland, 1992.

————. *The Symbolist Dead City. A Landscape of Poesis*. New York and London: Garland, 1990.

Furlough, Ellen. *The Politics of Consumption: Consumer Cooperation in France, 1830–1950*. Ithaca: Cornell University Press, 1990.

Fusco, Peter, and H.W. Janson, eds. *The Romantics to Rodin*. Los Angeles: Los Angeles County Museum of Art, 1980.

Garvey, Eleanor M. *The Turn of the Century, 1885–1910: Art Nouveau–Jugendstil Books*. Cambridge, Mass: Harvard University Press, 1970.

Gaspar, Camille. "Max Elskamp, subtil et délicat artisan du livre." *Le Livre et l'Estampe* (15 July 1934): 66.

Gepts-Buysaert, Gilberte. "Afterword: the Social Context of Belgian Art." In *Belgian Art: 1880–1914*. New York: Brooklyn Museum of Art, 1980.

Gergely, Thomas. "La notion de naturalisme en Belgique francophone." *RUB* (1984): 89–108.

Ghent: Sint-Pietersabdij (Centrum voor Kunst en Cultuur). *Van Nu en Straks, Belle Epoque in Vlaanderen*. 1983.

Gide, André. *L'Immoraliste*. Paris: Georges Cres et Cie, 1917.

Gille, Valere. "Lettre à Albert Giraud, De l'Originalité et de la Personnalité." *La Jeune Belgique* 15 (1896): 42.

Gillet, Luois. "Sur Henry de Groux." *La Plume*, de Groux issue. 267–72.

Gilsoul, Robert. "La Theorie de l'Art pour l'Art chez les Écrivain's Belges." *Memoires, Academie Royale de langue et de littérature francais de Belgique* (1936): 6–404.

Giltay, Jeroen. "De Nederlandsche Etsclub (1885–1896)." *NKJ 27, 19de Eeuwse Nederlandse Schilderkunst* (1976): 91–125.

Goedée, M. *De standbeelden van het Brusselse studuis*. Brussels: 1985.

Gorceix, Paul. *Les Affinitées allemandes dans l'oeuvre de Maurice Maeterlinck*. Paris: Presses Universitaires de France, 1975.
———. "De la spécificité du Symbolisme Belge." *Bulletin de l'Académie Royale de Langue et de Littérature Française* 56 (1978).
———. *Le Symbolisme en Belgique*. Heidelberg: C. Winter, 1982.
———. "Y a-t-il un Symbolisme belge?" *Cahiers roumains d'études littéraires* 3 (1980).

Grote Winkler Prins Woordenboek. Amsterdam: Elsevier, 1982.

Guequier, Albert. "Tablettes." *Le Réveil*, 6. (October-December 1895): 234.

Guiette, Robert. *Max Elskamp*. Paris: Pierre Seghers, 1955.
———. *Max Elskamp & Jean de Bosschère, Correspondance*. Brussels: Palais des Academies, 1963.

Guntrip, Henry. *Schizoid Phenomena*. New York: International University Presses, 1969.

Guyaux, André, ed. and intro. "Félicien Rops: Omnia artistique" *Le livre & l'estampe* 28 no. 109–110 (1982): 7–81.

Hall, James. *Dictionary of Subjects and Symbols in Art*. New York: Harper & Row, 1974.

Haesaerts, Paul. *James Ensor*. Stuttgart: G. Hatje, 1957.

Hammacher, Abraham Marie. *Le Monde de Henry van de Velde*. Antwerp: 1967.

Hanse, Joseph. *Histoire Illustrée de la littérature belge de langue francais*. Brussels: La Renaissance de Livre, 1926.

———. "De Ruysbroeck aux Serres chaudes et La Genèse de l'Intruse." In *Le Centenaire de Maurice Maeterlinck (1862–1962), (1862–1962)*, 75–129. Brussels: Académie Royale, palais des Academies, 1964.

Harker, Margaret. *The Linked Ring: The Secession Movement in Photography in Britain, 1892–1910*. London: Heinenman, 1979.

Haust, Jean. *Dictionnaire Liègeois*. Liège: H. Vaillant-Carmanne, 1933.

Havermans, Xavier. "Blanc et Noir." *RGB* 2 no. 7 (November 1898): 71–2.

Hefting, Victorine. *Jan Toorop*. The Hague: Gemeentemuseum, 1989.
———. *Jan Toorop, Een kennismaking*. Amsterdam: Bert Bakker, 1989.

Heller, Reinhold. "The Art Work as a Symbol." In *Fernand Khnopff and the Belgian Avant-Garde*, 10–16. Ed. Barry Friedman, et. al. Chicago: David and Alfred Smart Gallery (New York: Barry Friedman Ltd.): 1983.

Herbert, Robert L. *Georges Seurat 1859–1891*. New York: The Metropolitan Museum of Art, 1991.
——— and Eugenia Herbert. "Artist and Anarchism, Unpublished Letters of Pissarro, Signac and Others." *The Burlington Magazine*. (Nov.–Dec. 1960): 517–22.

Herbert, Eugenia. *The Artist and Social Reform: France and Belgium, 1885–1898*. New Haven: Yale University Press, 1961.

Hermans, Georges. *Les premières armes de Maurice Maeterlinck*. Ghent: Ledeberg, 1967.

Hind, Arthur M. *A History of Engraving & Etching*. New York: Dover, 1963.

Hoffmann, Edith. "Notes on the Iconography of Félicien Rops." *Burlington Magazine* 123 no. 937 (April 1981): 206–18.

Holme, Charles, ed. *Modern Etching and Engraving*. London and New York: Office of the International Studio, 1902.

The Holy Bible (The New Oxford Annotated Bible). New York: Oxford University Press, 1973.

Hoozee, Robert, ed. *George Minne en de kunst rond 1900*. Ghent: Museum voor Schone Kunsten, 1982.
———. *Vlaams Expressionisme in Europese Context 1900–1930*. Ghent: Museum voor Schone Kunsten; Brussels: Ludion, 1990.

Hoozee, Robert, Sabine Bown-Taevernier and J.F. Heijbroeck. *Ik James Ensor: Tekeningen en Prenten*. Ghent: Museum voor Schone Kunsten; Brussels: Ludion, 1987.
———. *James Ensor, Dessins et Estampes*. Antwerp: Fonds Mercator, 1987.
———. *Moi James Ensor*. Ghent: Museum voor Schone Kunsten; Brussels and Paris (Albin Michel), 1987.

Howe, Jeffrey W. "Mirror Symbolism in the work of Fernand Khnopff." *Arts Magazine* (September 1978): 112–118.
———. "The Sphinx and Other Egyptian Motifs in the Work of Fernand Khnopff: The Origins of 'The Caresse'." *Arts Magazine* (December 1979): 162.

——. *The Symbolist Art of Fernand Khnopff.* Ann Arbor: UMI Research Press, 1982.

Hunisak, John. "Images of Workers: from Genre Treatment and Heroic Nudity to the Monument to Labor." In *The Romantics to Rodin* edited by Peter Fusco and H.W. Janson, 52–60. Los Angeles: Los Angeles County Museum of Art, 1980.

Hüter, K.H. *Henry van de Velde. Sein Werk bis zum ende seiner Tätigkeit in Deutschland.* Berlin: Akademie-Verlag, 1967.

Hutton, John. "A Blow of the Pick: Science, Art, and Anarchism in the Neo-Impressionist Movement." Ph.D. Diss., Northwestern University, 1987.

Huysmans, Joris Karl. *Against the Grain (A Rebours).* New York: Dover, 1969.

——. *L'Art moderne. Certaines.* Paris: Stock, 1889. Reprint, Paris, 1976.

——. *En Route.* New York: Dutton, 1920.

——. "L'Exposition des Indépendants en 1880," reprinted in *L'Art moderne.* Paris: Stock, 1902.

Hymans, Henri. "Oeuvres de Henri Hymans, études et notices relatives à l'histoire de l'art dans les Pays-Bas." *La Gravure*, vol. 1. Brussels: M. Hayez, 1920.

Iannone, Lucia P. *Goya / Los Caprichos.* New Haven: Yale University Art Gallery, 1981.

Ireson, J. C. *L'Oeuvre Poétique de Gustave Kahn (1859–1936).* Paris: A.-G. Nizet, 1962.

Jacquelin. "Le Livre Illustrée." *Le Petit Bleu du Matin* (26 February 1896).

Janssens, Jacques. *James Ensor.* New York: Crown Publishers, 1978.

Jennissen, Emile. *Le Mouvement Wallon.* Liège: La Meuse, 1913.

"Jeune Belgique d'Autrofois, Jeune Belgique d'Aujourd'hui." *AM* 4 (16 November 1884): 371.

Joosten, J.M. "Henry van de Velde en Nederland, 1892–1902 Belgische Art Nouveau en Nederlandse Nieuwe Kunst." In *Cahiers Henry van de Velde*, 6–48. 1974.

Jos, Dirick. *Ex-Libris Belges.* Brussels: Xavier Havermans and Misch & Thron, 1912.

Juin, Hubert. *Histoires étranges et récits insolites.* Paris: Livre Club du Librairie, 1965.

——. "Notes à propos des écrivains belges dans leurs rapports avec la class laborieuse." In *Art et Société en Belgique 1848–1914*, 101–109. Charleroi: Palais des Beaux-arts, 1980.

Kendall, Richard and Griselda Pollock, eds. *Dealing with Degas: Representations of Women and the Politics of Vision.* New York: Universe, 1991.

Kern, Robert W. and Meredith D. Dodge, eds. *Historical Dictionary of Modern Spain, 1700–1988.* New York: Greenwood Press, 1990.

Khnopff, Fernand. "À propos de la photographie dite d'art." *Annexe aux Bulletins de la Classe des Beaux-Arts. Communications présentées à la classe en 1915–1918.* Brussels: Académie Royale de Belgique, 1919.

——. "L'Art Anglais." In *Annuaire de la Section d'art et d'enseignement de la Maison du Peuple*, Vandervelde, Emile, et. al., 30. Brussels: E. Blondiau, 1893.

——. "Belgian Book-plates." *The Studio* Special Winter No. (1898–99): 73–78.

——. "L'eau-forte et la Pointe-séche." *AM* (1901): 164–65 and 180–82.

——. "In Memorium: Sir Edward Burne-Jones, Bart. A Tribute from Belgium." *The Magazine of Art* 22 (1898): 524.

——. "Is Photography Among the Fine Arts? A Symposium." *The Magazine of Art* 23 no. 4 (1899): 156–58.

Klinkenberg, Jean-Marie. "L'idéologie de la littérature nationale (1830–1839)." *Studia Belgica* (1980): 135–153.

Koch, Robert. "A Poster by Fernand Khnopff." *Marsyas* 6 (1950–53): 72.

Kornfeld, Eberhard W., and Peter A. Wick. *Catalogue raisonné de l'oeuvre gravé et lithographié de Paul Signac.* Bern: Kornfeld and Klipstein, 1974.

Kossmann, E. H. *The Low Countries 1780–1940.* Oxford: Oxford University Press, 1978.

Kunel, Maurice. "Félicien Rops et l'École de gravure liégeoise." *La Vie Wallonne* 25 no. 254 (2e Trimestre 1951): 78–89.

Kurgan-van Hentenryk, G. "Economie et Transports." In *Bruxelles: Croissance d'une Capitale*, 216–226. Ed. Jean Stengers. Antwerp: Mercatorfonds, 1979.

Lagye, Gustave. "L'Art jeune." *La Federation Artistique* (23 February 1884): 147).

——. "Fleurs de Rhetorique." *La Federation Artistique* (8 March 1884): 163.

Lambrechts, Marc. *Fin de Siècle. Dessins, pastels et estampes en Belgique de 1885 à 1905.* Brussels: Galerie CGER, 1991.

Larisch, R. von. *Beispiele künstlerischer Schrift*, 3 vols. Vienna: Anton Schroll and Co., 1900 – 1906.

——. *Über Leserlichkeit von ornamentalen Schriften.* 1904.

——. *Unterricht in ornamentaler Schrift.* Vienna: K.K. Hof- und Staatsdruckerei, 1905.

Lebeer, Louis. *The Prints of James Ensor.* New York: Da Capo Press, 1971.

Ledent, A. "Esquisse d'Urbanisation d'une Capitale: Bruxelles, son Passé, son Avenir." *La Vie Urbaine*, no. 41. 321–349.

L. D. L. "Le Salon de la Libre Esthétique: Les Livres." *AM* 14 (25 March 1894): 94.

Lee, Ellen Wardwell. *The Aura of Neo-Impressionism: The W.J. Holliday Collection.* Indianapolis Museum of Art: Indiana University Press, 1983.

Legrand, Francine-Claire. *Le Groupe des XX et son temps.* Brussels:Musees royaux des Beaux-Arts de Belgique, and Otterlo: Rijksmuseum Kröller-Müller, 1962.

——. "Les lettres de Ensor à Octave Maus." *BMRBA* 15 no. 1-2 (1966): 17–50; no. 8, 25–26.

Lemaire, Claudine. "August Vermeylen en Van de Velde, Voogeschiedenis van het tijdschrift ' Van Nu en Straks'." *Archhief en Bibliotheekwezen in België* (1965): 84–96.

Lemmen, Georges. "A.W. Finch, peintre, graveur, céramiste." *L'Art Décoratif* IX (April–September 1899): 231–234.

———. "Chronique d'Art: La Libre Esthétique." *Le Réveil* 4 (March 1894): 178.

———. "James Ensor." *La Plume*/Ensor: 697.

———. "Moderne Teppiche." *Dekorative Kunst* 1 (December 1897): 97–105.

———. "Walter Crane." *AM* 11 (1 March 1891): 67–69; and (15 March 1891): 83–86.

Lemonnier, Camille. "Les Artistes Belges: Xavier Mellery." *Gazette des Beaux-Arts* 31 (1885): 425–36.

———. *La Belgique.* Paris: Hachette, 1888.

———. *Courbet et son oeuvre.* Paris: Alphonse Lemerre, 1878.

———. *L'École Belge de Peinture, 1830–1905.* Brussels: G. Van Oest, 1906.

———. *Félicien Rops, l'Homme et l'Artiste.* Paris: Floury, 1908.

———. *Happe Chair.* Paris: Monnier de Brunhoff et Cie, 1886.

———. *Le Mort.* Paris: Éditions Michel de Maule, 1987.

———. "Pour Servir de Préface au Salon de 1872." *L'Art Libre*, 1 (August 1872): 241.

Le Roy, Grégoire. "George Minne." *AM* 28 (September 1890): 308.

Lesko, Diane. *James Ensor, the Creative Years.* Princeton: Princeton University Press, 1985.

Levine, Sura. "Art Nouveau Sculpture in Belgium." In *Les Feux de l'Art Nouveau.* Hokkaideo: Hakodate Museum of Art, 1988.

Liège, Musée de la Vie Wallonne. *La Photographie en Wallonie, des origines à 1940.* 1980.

Liebman, Marcel. *Les Socialistes belges, 1885–1914.* Brussels: Vie ouvrière, 1979.

Liebrecht, Henri. *Histoire du Livre et de l'Imprimerie en Belgique.* Brussels: Le Musée du Livre, 1934.

Lipton, Eunice. *Looking into Degas: Uneasy Images of Women and Modern Life.* Berkeley: University of California Press, 1986.

Lissens, J. Paul. "Het prospectus van de eerste reeks van het tijdschrift 'Van Nu en Straks'." In *Verslagen en Mededelingen van de Koninklijke Academie voor Nederlandse Taal- en Letterkunde,* 109–44. 1977.

"Le Livre Belge." *L'Art Moderne* 12 (30 July 1893).

Llorca, Carmen. *Isabel II y su tiempo.* Madrid: ISTMO, ca.1984.

Loubier, Jean. "Die Kunst im Buchdruck." *Zeitschrift für Bücherfreunde* 2 (February 1899).

La Louvière: Musée des Arts et Métiers. *Retrospective Anna Louviérois. Anna Boch, Eugène Boch.* [Paul Leduc] 1969.

———. : Salle Communale des Expositions. *Trois Grands Peintres Louviérois (1848–1936) & Eugène (1855–1941) Boch.* 1958.

Ludwig, Horst. *Kunst, Geld und Politik um 1900 in München: Formen und Ziele der Kunstfinanzierung und Kunstpolitik während der Prinzegenternära (1886–1912).* Berlin: Gebr. Mann, 1986.

Mabille de Poncheville, A. *Vie de Verhaeren.* Paris: Mercure de France, 1953.

Madrid: Fundación Caja de Pensiones. *Darío de Regoyos 1857–1913.* 1987.

Maeterlinck, Maurice. *Bulles Bleues.* Monaco: Éditions du Rocher, 1948.

———. *Cahier Bleu.* Reprinted in Annales de la Fondation Maurice Maeterlinck 22 (1976).

———. "Me Albert Maeterlinck." *Le Jeune Barreau* 1 no. 20 (1 June 1893): 77–78.

———. "Mon Propos." *La Jeune Belgique* (1891): 36–37.

———. *Oeuvres.* Brussels: Jacques Antoine, 1980.

———. *Le trésor des humbles.* Paris: Société du Mercure de France, 1907.

Maisons du Peuple, Architecture pour le peuple. Brussels: Archives de l'architecture moderne, 1984.

Makela, Maria. *The Munich Secession: Art and Artists in Turn-of-the-Century Munich.* Princeton: Princeton University Press, 1990.

Marissiaux, Gustave. *Visions d'Artiste.* Portfolio with intro. by Auguste Donnay. Liège: Vaillant-Carmanne, 1908.

Maroy, Pierre. "L'Evolution de la Législation Linguistique Belge." *Revue du Droit Public et de la Science Politique en France,* 82 (1969): 449–501.

Mathews, Andrew Jackson. *La Wallonie, 1886–1892. The Symbolist Movement in Belgium.* New York: King's Crown Press, 1974.

Mauclair, Camille. "Théo van Rysselberghe." *L'Art Décoratif* 9 (March 1903): 81–89.

Mauprat. "Le movement artistique: L'Exposition des XX." *High Life* (20 February 1887).

Maus, Madeleine Octave. *Trente Années de Lutte pour l'Art, 1884–1914.* Brussels: l'Oiseau Bleu, 1926.

McGough, Stephen C. *James Ensor's "The Entry of Christ into Brussels in 1889."* Ph.D. Diss., Stanford University, 1981. New York: Garland, Outstanding Dissertations in the Fine Arts, 1985.

McKay, John P. *Tramways and Trolleys: The Rise of Urban Mass Transport in Europe.* Princeton: Princeton University Press, 1976.

McRae, Kenneth D. *Conflict and Compromise in Multilingual Societies: Belgium.* Waterloo, Ontario: Wilfrid Laurier University Press, 1986.

Mecœnas (Théo Hannon). "Les Apporteurs de Neuf." *La Chronique* (11 February 1887): 2.

Meier-Graefe, Julius. "Die moderne Illustrationskunst in Belgien." *Zeitschrift für Bücherfreunde* 1 no. 10 (January 1898): 505–19.

Meier-Graefe, Julius, and Rudolf Kautsch. *Die neue Buchkunst: Studien im In-und Ausland.* Weimar: Gesellschaft der Bibliophilen, 1902.

Meirsschaut, Pol. *Les Sculptures de Plein Air à Bruxelles: Guide Explicatif.* Brussels: Emile Bruylant, 1900.

Mertens, Ad, ed. *Oeuvre de la Presse 1891, Fêtes de Chevalerie, Grand'Place.*

Mirbeau, Octave. "Félicien Rops." In *La Plume,* Rops issue: 488.

Moerman, André A. "Na 1830: een nieuwe start onder François-Joseph Navez." In Brussels, MRBA, Académie Royale des Beaux-Arts de Bruxelles, 275 ans d'enseignement, 87–90. Brussels: Crédit Communal, 1987.

Mokyr, Joel. Industrialization in the Low Countries 1790–1850. New Haven: Yale University Press, 1976.
———. L'Industrie en Belgique: Deux siècles d'evolution 1780–1980. Brussels: Credit Communal et Credit à L'Industrie, 1981.

Molekenboer, Th. "Jan Toorop—Im Haag." Deutsche Kunst und Dekoration 12 (1899): 549.

Mommen, André. De Belgische Werkliedenpartij 1880–1914. Ghent: Masareel Fonds, 1980.

Moreau, Yves. "Le Reportage photographique de Gustave Marissiaux sur les charbonnages liégeois au début du vingtième siècle." In 1886, La Wallonie née de la grève?, 25–40. Eds. Marinette Bruwier et. al. Brussels: Editions Labor, 1990.

Morel, Dominique. "Ensor et la France (1) L'influence de l'art français sur la peinture d'Ensor." In James Ensor, 67–73. Paris: Petit Palais, 1986.

Morlanwelz: Musée royal de Mariemont. D'Un livre à l'autre. 1986.

Moulaert, Jan. De Vervloekte Staat, Anarchisme in Frankrijk, Nederland en België, 1890–1914. Amsterdam: Ekologische Uitgeverij, 1981.

Müller, Maria Magdalena. "Frauen Arbeit in Belgien." In Arbeit und Alltag: Soziale Wirklichkeit in der Belgischen Kunst 1830–1914. Berlin: Neue Gesellschaft fur Bildende Kunst, 1978.

Murphy, Alexander B. The Regional Dynamics of Language Differentiation in Belgium: A Study in Cultural-Political Geography. Chicago: University of Chicago Geography Research Paper no. 227, 1988.

Murr, Philéas. "Les Jeunes chez eux: Le Salon des XX." Chronique des Beaux-Arts (1885): 153.

Musschoot, Anne Marie. Introduction to Van Nu en Straks, 1893–1901. Een vrij voorhoede-orgaan gewijd aan de kunst van Ne, nieuwsgierig naar de kunst-nog-in-wording — die van Straks. Bloemlezing, 's-Gravenhage: Martinus Nijhoff, 1982.
———. "Van Nu en Straks: A Flemish Art Nouveau Periodical, 1893–1901." Dutch Crossing (August 1988): 45–59.

Neuville, Jean. "La Condition ouvrière au XIXe siècle." In Art et Société en Belgique, 1848–1914, 27–35. Charleroi: Palais des Beaux-arts, 1980.

"New Publications." The Studio 4 (1895/95): 33.

Nijland-Verwey, Mea. Kunstenaarslevens. Assen: Van Gorcum & Company, 1959.

Nochlin, Linda. "Seurat's Grande Jatte: An Anti-Utopian Allegory." The Art Intistitute of Chicago Museum Studies 14 no. 2 (1989): 139–42.

North, Bill. "Khnopff and Photography: Theory and Practice." Unpublished paper, University of Kansas, 1990.

Numans, A. Cours d'Aqua-forte à l'usage des artistes et des amateurs. Brussels: A.-N. Lebègue et Cie., 1885.

Ollinger-Zinque, Gisèle. Ensor by himself. Trans. Alistair Kennedy. Brussels: Laconti, 1976.
———. "Fernand Khnopff et la photographie." In Kunst & Camera / Art & Photographie, 19–29. Brussels: ASLK / CGER, 28 November 1980 – 11 January 1981.

Ostend: Musée du Livre. Liste Sommaire d'Oeuvres Littéraires des Auteurs Belges d'Expression française. Brussels: VveFerdinand Larcier, 1943.

Otterlo: Rijksmuseum Kröller-Müller. J. Th. Toorop, De jaren 1885–1910, 1978.

Panofsky, Erwin. The Life and Art of Albrecht Dürer. Princeton: Princeton University Press, 1943.

Paris: Bibliothèque Nationale. Emile Verhaeren: Exposition organisée pour le centième anniversaire de sa naissance. 1955.
———: Grand Palais. Peintres de l'imaginaire, Symbolistes et Surréalistes belges. 1972.
———: Musée d'Orsay. Musée d'Orsay, catalogue sommaire illustré des arts décoratifs. Paris: Reunion des musées nationaux, 1988.
———: Petit Palais. James Ensor. 1990.

"Paul Lacomblez." L'Art Moderne 13 (23 July 1893).

Perinet. "Picorée." Coq Rouge 2 (June 1896): 142 and 191.

Picard, Edmond. "L'Art et La Revolution." AM 6 (15 July 1883): 225.
———. "L'Art et la Révolution." AM (18 and 25 July and 1 August 1886).
———. "Le jeun mouvement littéraire." AM 3 (15 July 1883): 222.

Piérard, Jean. "Le Docteur Valentin van Hassel et Constantin Meunier." La Revue Nationale. 7 September, 1974: 193–196.

Pion, Léonce. "Cutsem (Henri-Emile Van)." BN suppl. vol. 13 (1979–80): 140–46.

La Plume
———. de Groux issue, La Plume 239–240 (1 & 15 April 1899).
———. Ensor issue, La Plume 232 (15 October 1898).
———. Meunier issue, La Plume 350 (15 November 1903).
———. Rops issue, La Plume 172 (15 June 1896).

Poggioli, Renato. The Theory of the Avant-Garde. Cambridge: Harvard University, Belkamp Press, 1968.

Polak, Betina. Het Fin-de-Siècle in de Nedelandse Schilderkunst. 's-Gravenhage: Martinus Nijhoff, 1955.

Powell, Kirsten H. "Xavier Mellery and the Island of Marken." Jaarboek van het Koninklijk Museum voor Schone Kunsten Antwerpen (1988): 343–67.

Prokopoff, Stephen S., and Marcel Franciscono. The Modern Dutch Poster. Krannert Art Museum: University of Illinois at Urbana-Champaign, 1987.

Pudles, Lynne. "Solitude, Silence, and the Inner Life: A Study of Belgian Symbolist Artists." Ph.D. Diss., University of California, Berkeley, 1987.

Puissant, Jean. "La Belgique de 1830 à 1914." In *Art et Société en Belgique, 1848–1914*, 9–26. Charleroi: Palais des Beaux-arts, 1980.

———. "Le Naturalisme en Belgique, expression littéraire de la crise ou de la prospérité?" *RUB* (1984): 109–118.

Quievreux, Louis. *Dictionnaire du Dialecte Bruxellois*. Brussels: Charles Dessart, 1951.

Ranieri, L. *Leopold II: Urbaniste*. Brussels: Hayez, 1973.

Rapetti, Rodolphe. "Léon Bloy et Henry de Groux." *Léon Bloy, Cahiers de l'Herne* (1988): 375–84.

Remouchamps, Victor. "Le Monde Intérieur." *Le Réveil* (January 1894): 25.

Rewald, John. *Post-Impressionism from Van Gogh to Gauguin*. New York: Museum of Modern Art, 1962.

Riegger-Baurmann, Roswitha. "Schrift im Jugendstil." *Börsenblatt für den Deutschen Buchhandel* 14 [21 April 1958]: 507–520.

Riley, Raymond. *Belgium*. Boulder: Westview Press, 1976.

Roberts-Jones, Philippe. "Willy Finch, une Maître de l'art en Belgique." In *A.W. Finch, 1854–1940*, 13–17. Brussels: MRBA, 1992.

Rodenbach, Georges. "Notes sur le Pessimisme." *Evocations*. Paris: Renaissance du Livre, 1924.

———. *Oeuvres* 7 vols in 3. Genève: Slatkine, 1978.

———. "Trois nouveaux poètes." *La Jeune Belgique* 5 [July 5 1886]: 319.

Roelandts, Oscar. "Etude sur la Société Libre des Beaux-Arts de Bruxelles." *Mémoires, Académie Royale de Belgique, Classe des Beaux-Arts* 4 (1935): 5–116.

Romein, Jan. *The Watershed of Two Eras: Europe in 1900*, translation by Arnold Pomerans. Middletown, Conn.: Wesleyan University Press, 1978.

Rooses, Max. *Art in Flanders*. New York: Charles Scribner's Sons, 1914.

———. "Leys, Jean-Auguste-Henri." *BN* 12 (1892–93): cols. 65–79.

———. *Oud-Antwerpen / Le Vieil Anvers*. Brussels: E. Lyon-Claesen, 1894.

Rops, Félicien. *Notes pour Hippert*. Brussels: Bibliothèque Royale Albert 1er, Musée de la Littérature.

Rouir, Eugène. *Armand Rassenfosse: Catalogue raisonné de l'oeuvre gravé*. Brussels: Claude Van Loock, 1984.

———. *Félicien Rops: Catalogue raisonné de l'oeuvre gravé et lithographié. Vol. I, Les lithographies; vol. II, Les eaux-fortes, cat. 273–663; vol. III, Les eaux-fortes, cat. 664–975*. Brussels: Claude Van Loock, 1992.

———. *Félicien Rops: Les Techniques de gravure*. Brussels: Bibliothèque royale Albert 1er, 1991.

———. *150 Ans de gravure en Belgique*. Brussels: C.G.E.R., ca. 1980.

"R. Von Larisch—Wien: Beispiele künstlerischer Schrift." *Deutsche Kunst und Dekoration* 7 (October 1900): 53–64.

Rouzet, Anne. "Les Ex-Libris Art Nouveau en Belgique." *RUB* (1981–83): 87–92.

Rowntree, B. Seebohm. *Land and Labour Lessons from Belgium*. London: Macmillan and Co., 1910.

Royer, Emile. *Plaidoirie de M. Emile Royer du Barreau de Bruxelles pour l'Anarchiste Jules Moineau*. Brussels: Editions Deman, 1894.

Rubenstein, Daryl R. "The Avant-Garde in Theater and Art." In *The Avant-Garde in Theatre and Art: French Playbills of the 1890s*. Smithsonian Institution Traveling Exhibition Service, 1972.

Ruttiens, R. *Amédée Lynen*. Brussels: 1923.

"R. Von Larisch—Wien: Beispiele Künstlerisher Schrift." *Deutsche Künst und Dekoration* 7 (October 1900): 53–64.

Saarland-Musseum: Moderne Galerie Saarbrücken. *Anna Boch und Eugène Boch. Werke aus den Anfängen der modernen Kunst*. 1971.

Sand, Robert. "Les Graveurs Wallons." In *Exposition de Charleroi 1911, Groupe des Beaux-Arts, Les Arts Anciens du Hainaut, Conférences*, 199–233. Ed. Jules Destrée. Brussels: G. Van Oest, 1911.

San Nicolás, Juan. *Darío De Regoyos*. Barcelona: Diccionari Ràfols, Edicions Catalanes, S.A.

Sayre, Eleanor. *The Changing Image: Prints by Francesco Goya*. Boston: Museum of Fine Arts, 1974.

Schaar, Eckhard and Ulrich Rüter. *Was die Bilder erzählen, Graphik aus sechs Jahrhunderten*. Hamburg: Hamburger Kunsthalle, 1991.

Schiller. see von Schiller

Schmitz, Marcel. *Henry de Groux*. Brussels: Conférences de la Diffusion artistique des Musées Royaux des Beaux-Arts, 24 January 1943.

Schmitz, Yves. "Carton de Wiart." *BN* 41, 164–66.

Schokkaert, Luc and Rik Stallaerts. *Onder Dak, Een Eeuw Volks-en Gildhuizen*. Ghent: Museum van de Vlaamse Sociale Strijd, 1987.

Scholermann, Wilhelm. "Beispiele künstlerischer Schrift." *Archiv für Buchgewerbe*, 37 (1900): 467–472.

Schoonbaert, Lydia M.A. "'Gazette des Beaux-Arts' en' 'The Studio' als inspiratiebronnen voor James Ensor." /KMSKA (1978): 205–21.

———. *James Ensor*. Zürich: Kunsthaus and Antwerp, Museum voor Schone Kunsten, 1983.

Schorske, Carl. *Fin-de-siècle Vienna*. New York: Alfred A. Knopf, 1975.

Schreurs, Fernand. *Les Congrès de Rassemblement Wallon de 1890 à 1959*. Liège: Institut Jules Destrée, 1950.

Schwandt, Anita. "Leben auf dem Lande, Eugeen Laermans—soziale Wirklichkeit und Bildaussage." In *Arbeit und Alltag: soziale Wirklichkeit in der belgischen Kunst, 1830–1914*, 258–65. Berlin: Neue Gesellschaft für Bildende Kunst, 1979.

Selz, Peter. *Art Nouveau, Art and Design at the Turn of the Century*. New York: Museum of Modern Art, 1959.

Sembach, Klaus Jürgen. *Henry van de Velde*. New York: Rizzoli, 1989.

Showalter, Elaine. *Sexual Anarchy*. New York: Viking, 1990.

Siebelhoff, Robert. "The Early Development of Jan Toorop." Ph.D. diss. University of Toronto, 1973.
———. "Jan Toorop—Early Work." typescript. n.d.
———. "The Three Brides, a drawing by Jan Toorop." *NKJ* 27 (1976): 221–261.
———. "Toorop, Van de Velde, Van Rijsselberghe and The Hague exhibition of 1892." *Oud Holland* 95 (1981):97–107.

Signac, Paul. *Eugène Delacroix au Néo-Impressionnisme*. Paris: Editions de la Revue Blanche, 1899.

Siret, Adolphe. *La Gravure en Belgique, son situation, son avenir*. Ghent: L. Hebbelynck, 1852.

Sizeranne, Robert de la. "Is Photography Among the Fine Arts? A Symposium." *The Magazine of Art* 23 no. 3 (1899): 102–05.

Snyder, James. *Northern Renaissance Art*. New York: Abrams, 1985.

"Société des Aquafortistes belges." *L'Art de l'Imprimerie* nos. 18–19 (January 1890): 206–08.

Société Internationale des Aquafortistes sous la patronage de S.A.R. la Comtesse de Flandre. Statuts, 4 December 1869. Brussels: J.H. Briard, 1870.

Solvay, Lucien. *L'Art Espagnol*. Paris and London: Jules Rouam and Gilbert Wood and Company, 1887.

Spaanstra-Polak, Bettina. *De grafiek van Jan Toorop*. Amsterdam: Rijksprentenkabinet, Rijksmuseum, 1968.

Sparrow, Walter Shaw. "Constantin Meunier: The Artist of the Flemish Collieries." *The Studio* XI/52 (15 July 1897): 75–86.
———. "Herr Toorop's 'The Three Brides'." *The Studio* 1 (1893): 247–48.

Spencer, Isobel. *Walter Crane*. New York: Macmillan Publishing Co., Inc., 1975.

Sponsel, Jean-Louis. *Das Moderne Plakat*. Dresden: Verlag von Gerhard Kühtmann, 1897.

Stark, David. "Charles de Groux and Social Realism in Belgian Painting, 1848–1875." Ph.D. Diss., Ohio State University, 1979.

Stavelot: Musée de l'Ancienne Abbaye. *William Degouve de Nuncques*. 1979.

Strikwerda, Carl. "Urban Structure, Religion, and Language: Belgian Workers, 1880–1914." Ph.D. Diss., University of Michigan, 1983.

Taevernier, Auguste. *James Ensor, Catalogue illustré de ses gravures, leur description critique et l'inventaire des plaques*. Ghent: N.V. Erasmus Ledeberg, 1973.

Tannenbaum, Libby. *James Ensor*. New York: The Museum of Modern Art, 1951.

Taylor, A.J. "The Coal Industry." In *The Develpment of British Industry and Foreign Competition, 1875–1915*, 44. Ed. Derek Aldcroft. Toronto: Toronto University Press, 1968.

ter Laan, K. *Nederlandse Spreekwoorden Spreuken en Zegswijzen*. Brussels and Amsterdam: Elsevier, 1979
———. *Van Goor's Folkloristisch Woordenboek van Nederland en Vlaams België*. The Hague: Van Goor Zonen, 1974.

The Hague: Kunstkring. *Tentoonstelling van schilderijen en teekeningen van eenigen uit "XX" en uit de "Association pour l'art"*. 1892.

Thiery, A. and E. van Dievoet. *Catalogue complet des oeuvres dessinées, peintes et sculptée de Constantin Meunier*. Louvain: Nova & Vetera, 1909.

Tibbe, Lieske. *Art Nouveau en Socialisme, Henry van de Velde en de Parti Ouvrier Belge*. Amsterdam: Kunsthistoriese Schriften 5, 1981.

Tielemans, Em. H. "Notes sur les Ex-libris Dessinés par Fernand Khnopff." *L'Ex-Libris* I no. 1 (November 1913) 5–10.

Tralbaut, Marc. "De Braekeleeriana - III." *Antwerpen* 10 no. 4 (December 1964): 160–176.

Treu, Georg. *Constantin Meunier*. Dresden: Kunsthandlung Emil Richter, 1898

Treuherz, Julian. *Hard Times: Social Realism in Victorian Art*. London: Lund Humphries, 1987.

Tricot, Xavier. *Ensoriana*. Oostende: L'Hareng Saur, 1985.

Underhill, Evelyn. *Mysticism*. New York: Noonday, 1955.

Uzanne, Octave. "Couvertures Illustrées de Publications Etrangères." *Art et Décoration* 5 (January/June 1899): 38.

van de Perre, Paul. "Quelques notes de portée pratique sur l'oeuvre gravé de James Ensor. De la discrimination à faire entre les divers tirages. Compliments aux catalogues méthodiques de l'oeuvre." *Le Livre et l'Estampe* 4 (1 September 1955): 22–32.

Van der Haegen, H., Pattyn, and C. Cardyn. "The Belgium Settlement System." In *West European Settlement System*, ed. H. Van der Haegen, special issue of *Acta Geographica Lovaniensia* 22 (1982): 251–363.

Vandermotten, C. and P. Vandewattyne. "Les Etapes de la Croissance et de la Formation des Armatures Urbaines en Belgique." In *La cité Belge d'Aujourd'hui: Quel Devenir?*, ed. C. Preudhomme and L. Viaene-Awouters, special issue of *Bulletin Trimestriel du Crédit Communal de Belgique* 39 (1985): 154.

Vandervelde, Emile. *Annuaire de la Section d'art et d'enseigne-ment de la Maison du Peuple*. Brussels: E. Blondiau, 1893.
———. *Le Parti Ouvrier Belge, 1885–1925*. Brussels: Eglantine, 1925.

van de Velde, Henry. *Geschichte meine Leben.* Edited and translated by Hans Curjel. Munich: Piper, 1962.

———. *Recit de ma Vie.*

van Dijck, Leen, J. Paul Lissens and Toon Saldien, eds. "Het ontstaan van Van Nu en Straks, een brieveneditie 1890–1894." *Studia Flandrica* 3, 2 vols. Antwerp: Centrum voor de studie van het vlaamse cultuurleven, 1988.

van Goethem, Geert. *De Roos op de Revers.* Ghent: AMSAB, 1990.

van Hassel, Valentin. *Sur les sentiers infinis de la souffrance humaine.* Brussels: Imprimerie médicale et scientifique, 1927.

Van Lennep, Jacques. "Les expositions burlesques à Bruxelles de 1870 à 1914: l'art zwanze — une manifestation pre-dadaiste?" *BMRBA* 19, no. 2/4 (1970): 127–150.

———. "Les expositions burlesques à Bruxelles de 1870 à 1914: Complements." *BMRBA* (1985 1–3): 313–326.

Van Lerberghe, Charles. "Un poète Gantois (*Mon Coeur pleure d'autrefois*)." *La Wallonie* 4 (1889): 162.

Van Puyvelde, Leo. *George Minne.* Brussels: 1930.

van Linden, Albert. "Octave Maus et la Vie Musicale belge." *Memoires, Academie Royale de Belgique, Classe des Beaux Arts* (1950): 5–98.

van Maris, Leo. *Félicien Rops over kunst, melancholie & perversiteit.* Amsterdam: Synopsis, 1982.

van Schoor, J., ed. *Herman Teirlinck, Brussels 1900.* Antwerp and Amsterdam: Elsevier Maneau, 1981.

Van Velthoven, Harry. "Taal en Onderwijspolitiek te Brussel 1878–1914." *Taal en Sociale Integratie, 4* (1981): 261–387.

Vanwelkenhuyzen, Gustave. "De l'Uylenspiegel à la Jeune Belgique." In *Vocations Littéraires,* 9–24. Paris: Librairie Minard, 1959.

Van Wezel, G.W.C. *Jan Toorop, 1858–1928.* Prospectus. Amsterdam: 1989.

Verhaeren, Emile. "Confession de Poète." Reprinted in *Impressions,* 9–16. Paris: Mercure de France, 1926.

———. *James Ensor.* Brussels: Van Oest, 1908; reprint Brussels: Editions Jacques Antoine, 1980.

———. *Pages Belges.* Ed. Fontaine, André. Brussels: Renaissance du Livre, 1926.

———. "Les Gothiques Allemandes." *AM* 33 (15 August 1886): 259.

———. "Le Symbolisme." *AM* (April 1887): 115–18.

———. *À Marthe Verhaeren. Deux cent dix-neuf lettres inédites 1889–1916.* Paris: Mercure de France, 1951.

———. *Les Villages Illusoires.* Brussels: Labor, 1978.

Verhaeren, Emile, and Darío de Regoyos. *España Negra.* Madrid: Taurus ediciones, n.d.

Vermeylen, Gustave. "Nota over de pleisterbeelden van George Minne." *Van Nu en Straks* 4 (1893): 1.

Vervliet, Raymond. "Lever de rideau: les precurseurs." In *Les Avant-gardes littéraires en Belgique,* 87. Brussels: Labor, 1991.

Voet, Leon. "Max Rooses 1839–1914." *Antwerpen* 10 no. 2 (July 1964): 75–81.

von Schiller, Johann Christoph Friedrich, *Schillers Werke,* 42 vols. Weimar: Hermann Böhlaus Nachfolger, 1943.

Waller, Max. "Chronique bruxelloise." *La Revue Indépendante* (October 1888): 11.

Ward, Martha. "Impressionist Installations and Private Exhibitions." *Art Bulletin,* 73 (December 1991): 599–622.

Warmoes, Jean. "Une amitié: Théo Van Rysselberghe et Emile Verhaeren." *Les Beaux-Arts,* (29 June 1962): 2.

———. "La Jeunesse de Maeterlinck ou la poésie du mystère." *Annales de la Fondation Maurice Maeterlinck* 6 (1960).

———. *Valère-Gille et la jeune Belgique, autographes provenant de sa bibliothèque.* Brussels: Bibliothèque Royale Albert 1er, 1978.

Waxweiler, Emile. "Heures de travail et salaire dans l'industrie belge." *Revue d'économie politique.* (1902): 576–607.

Weimar: Grossherzogliches Museum fur Kunst und Kunst Gewerbe. *Ausstellung von Werken der Modernen Druck und Schreib Kunst.* 1905.

Weisgerber, Jean. "La Jeune Belgique et cent ans d'avant garde." *Bulletin, Academie Royale de Langue et Littérature Française* 59 (1981): 206–223.

Wellens, Robert. "Braekeleer (Henri-Jean-Auguste De)." *BN* 39 (1976): cols. 142–54.

W.F.—D. "Art Centres." *The Artist,* 29 (December 1900): 208–209.

Warrack and Perkins, *The Belgian Connection: Symbolism, Post-Impressionism, Art Nouveau; books illustrated by artists associated with the groups Les XX and La Libre Esthetique in Brussels, together with contemporary documents and periodicals 1884–1914.* Vol. 22 of the Warrack & Perkins catalogue. Oxfordshire: Warrack & Perkins, 1976.

Willis, Alfred. "Flemish Renaissance Revival in Belgian Architecture (1830–1930)." Ph.D. Thesis, Columbia University, 1984.

Wodon, Marguerite. "Hannon-Rousseau (Marie-Sophie-Joséphine-Pauline-Jeanne, dite Mariette)." *BN* suppl.IX (1971): cols. 405–10.

Zéno, Thierry. *Les muses sataniques de Félicien Rops.* Brussels: les éperonniers, 1987.

Zicken, Philippe. "Jan Toorop." *Wiener Rundschau* 3 no. 12 (1898–99): 282.

———. "Jan Toorop." *Elsevier's Geïllustreerd Maandschrift* 15 (1898): 105–129.

Zolberg, Aristide R. "The Making of Flemings and Walloons: Belgium, 1830–1914." *Journal of Interdisciplinary History,* 5, 2 (1974): 179–235.

Index

Names and titles with a particle are alphabetized by the particle (e.g., Henry de Groux under "d" and Van nu en Straks and Théo Van Rysselberghe under "V"); articles are ignored (e.g., La Chrysalide under "C" and The Studio under "S"). Footnotes are not indexed.

Exhibited Artists and Writers

Following the parenthesis are the years of membership in Les XX; 'inv.' indicates they were not members, but were invited to exhibit with the group; 'w' indicates writers whose works are included in the exhibition.

Boch, Anna (Belgian, 1848–1933) 1886–93
Charlet, Frantz (Belgian, 1862–1928) 1884–93
Degouve de Nuncques, William (Belgian, 1867–1935) inv. 1893
de Groux, Henry (Belgian, 1867–1930) 1887–90
Delville, Jean (Belgian, 1867–1953)
de Regoyos, Dario (Spanish, 1857–1913) 1884–93
Elskamp, Max (Belgian, 1862–1931) w
Ensor, James (Belgian, 1860–1949) 1884–93
Finch, Alfred William (Belgian, 1854–1930) 1884–93
Khnopff, Fernand (Belgian, 1858–1921) 1884–93
Lemmen, Georges (Belgian, 1865–1916) 1889–93
Lemonnier, Camille (Belgian, 1844–1913) w
Le Roy, Grégoire (Belgian, 1862–1941) w
Lynen, Amédée (Belgian, 1852–1938)
Maeterlinck, Maurice (Belgian, 1862–1949) w
Maréchal, François (Belgian, 1861–1945)
Marissiaux, Gustave (Belgian, 1872–1929)
Mellery, Xavier (Belgian, 1845–1921) inv. 1885, 88, 90, 92
Meunier, Constantin (Belgian, 1831–1905) inv. 1885, 87, 89, 92
Minne, George (Belgian, 1866–1941) 1891–93
Rassenfosse, Armand (Belgian, 1862–1934)
Rodenbach, Georges (Belgian, 1855–98) w
Rops, Félicien (Belgian, 1833–98) 1886–93
Signac, Paul (French, 1863–1935) 1891–93
Toorop, Jan (Dutch, born Java, 1858–1928) 1885–93
Van Biesbroeck, Jules (Belgian, 1839–1919)
van de Velde, Henry (Belgian, 1863–1957) 1889–93
Van Neste, Alfred (Belgian, 1874–1969)
Van Rysselberghe, Théo (Belgian, 1862–1926) 1884–93
Van Strydonck, Guillaume (Belgian, 1861–1937) 1884–93
Verhaeren, Emile (Belgian, 1855–1916) w

Photo credits

A.C.L., Brussels: figs. 3, 8–14, 17, 19, 27; cats. 12, 19, 22, 48, 49, 76, 95, 96, 99, 132, 143, 145.

Allen Press: cats. 11, 17, 24, 31, 33, 39, 40, 44, 50–54, 61, 87–89, 93, 98, 113, 115, 129, 158.

Archief en Museum voor het Vlaamse Cultuurleven: cat. 140.

Archives Henry van de Velde, Abbaye de la Cambre, Brussels: fig. 7.

Art Institute of Chicago: illus. B; cats. 20, 41, 73, 146.

Bibliothèque Royale, Brussels: figs. 5, 6, 20, 25, 26, 32–34, 37, 39–43, 51–57, 60, 62–64; illus. A, D; cats. 6, 9, 60, 66, 84–86, 90, 92, 97, 133, 137, 142, 144, 149, 153.

Jon Blumb: figs. 21–24, 29, 68; plates 1, 6, 17, 19; illus. C; cats. 13, 16, 21, 51–54, 93, 105, 126, 138, 139, 158.

Sterling and Francine Clark Art Institute: plate 3; cats. 45, 123.

Cleveland Museum of Art: plate 18; cats. 35, 36, 117.

Ditmar Bollaert & Karel Moortgat: cats. 23, 26, 37.

Felix Firry: cats. 56b, 64.

Fine Arts Museum of San Francisco: cats. 29, 81.

Haags Gemeentemuseum: fig. 4.

Harvard University Art Museums: cats. 7, 130.

Samuel Josefowitz: cats. 128, 157.

Koninklijke Bibliotheek, The Hague: illus. G.

Kruty: figs. 1, 2, 31, 45, 46, 48, 49, 50, 58, 59, 65–67, 70, 71.

Los Angeles County Museum of Art: fig. 28; cats. 116, 118, 119, 148.

Metropolitan Museum of Art, New York: cat. 8.

Minneapolis Institute of Arts: cat. 83.

Municipal Printroom, Antwerp: cat. 135.

Musée d'Ixelles: plate 13; cats. 2, 4, 71, 72, 108, 159.

Musée royaux de Beaux-Arts de Belgique, Brussels: plates 7, 8.

Musée Royal de Marimont: cat. 114.

Museum of Fine Arts, Boston: fig. 30; cats. 80, 109, 127.

Museum of Modern Art, New York: cats. 32, 65, 94, 131.

Museum voor Schone Kunsten, Ghent: plates 2, 15; cat. 42, overleaf p. 262.

National Gallery of Art, Washington: cats. 25, 34, 110.

Newberry Library, Chicago: fig. 69.

New York Public Library: cat. 47.

Philadelphia Museum of Art: cat. 27.

Princeton University Library: cat. 79.

Speldoorn: fig. 61; cats. 55, 147, 155.

University of Illinois/Urbana, Champagne: figs. 35, 36, 44, 47.

Victor's Photography: cat. 151.

Victoria & Albert Museum: fig. 38. Piet Ysabie: cat. 101.